P9-AQV-977

LEONARDO DA VINCI

ORIGINS OF A GENIUS

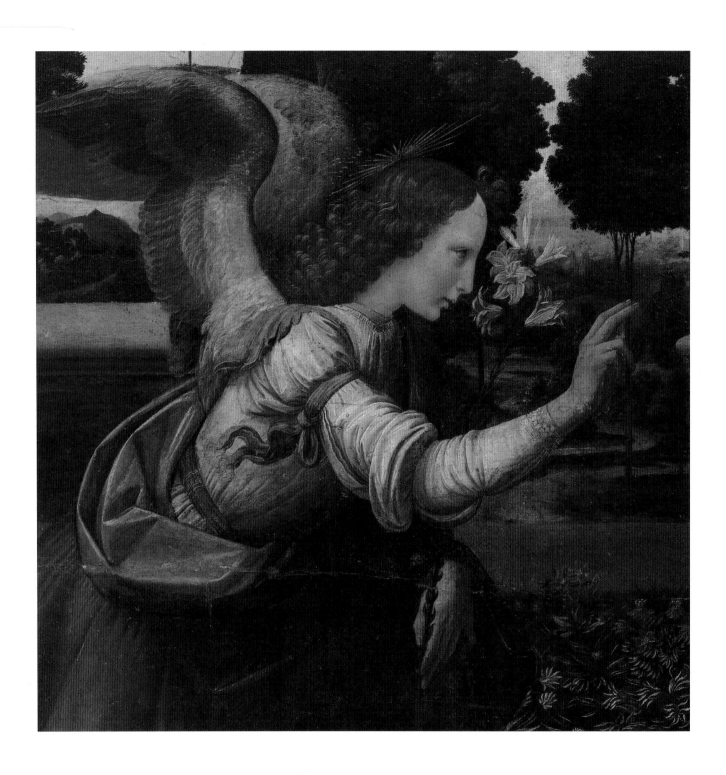

David Alan Brown

LEONARDO DA VINCI

ORIGINS OF A GENIUS

Yale University Press · New Haven & London

Published with the assistance of the Getty Grant Program

Designed by Gillian Malpass

Printed in Singapore

Library of Congress Cataloging-in-Publication Data

Brown, David Alan, 1942–
 Leonardo da Vinci: origins of a genius / David Alan Brown.
 p. cm.
 Includes bibliographical references and index.
 ISBN 0-300-07246-5 (cloth: alk. paper)
 1. Leonardo, da Vinci, 1452–1519 – Criticism and interpretation.
 I. Title.
 ND623.L5B78 1998
 759.5—dc21 98-15164
 CIP

A catalogue record for this book is available from
The British Library

Frontispiece: Leonardo, *Annunciation*. Detail.
Galleria degli Uffizi, Florence.

NOTE ON THE ILLUSTRATIONS: Measurements of works of art
are given in feet and inches in the text,
and both in feet and inches and in centimeters in the notes.
Height precedes width.

Contents

Preface and Acknowledgments

THIS BOOK PRESENTS the most complete account ever offered of Leonardo da Vinci's early works and the evidence they provide about his creativity. It is addressed to anyone seriously interested in the subject: the text can be read by non-specialist and scholar alike, while the extensive critical apparatus is consigned to the notes. There the scholar will find catalogue-type information, together with references to what has previously been written about the works discussed in the text.

In a book about origins, it should be stated that this one got its start some thirty years ago as a Yale University seminar report on *Ginevra de' Benci*, which the National Gallery of Art in Washington had just acquired. The author, then an art history graduate student, little expected to become, seven years later, the curator in charge of the same painting. Meanwhile, he published his first scholarly article, on the Uffizi *Annunciation*, in 1971. The opportunity to inspect the Munich *Madonna*, unframed, with L.H. Heydenreich in the late 1970s further expanded the scope of inquiry. Work on the project (by then conceived as a book) was set aside in the 1980s, while the author completed a monograph on a Leonardo follower, only to be resumed in 1991, with the aid of an Ailsa Mellon Bruce Curatorial Fellowship from the Gallery's Center for Advanced Study in the Visual Arts. The stint at CASVA, as the Center is familiarly known, allowed the author to put material collected over two decades in order for writing. Another Gallery fellowship, this one from the Robert H. Smith Foundation, offered the chance to study the technical evidence relating to the Uffizi *Baptism* and *Annunciation* and to compare it with what was available for the other early works.

The author's research was conducted mainly in museum collections, as well as in the Libraries and Photo Archives of the National Gallery, the Kunsthistorisches Institut in Florence, and the Harvard University Center for Italian Renaissance Studies at Villa I Tatti. Friendly colleagues there and elsewhere are too numerous – and the ways they have helped, too various – to be named here; they are thanked instead in the notes. Mention must be made, however, of Renee Fitzpatrick and William Breazeale, who both provided much bibliographic assistance, and of J. Russell Sale, Susan Arensberg, and Nicholas Penny, whose sympathetic but not uncritical readings greatly improved the text. The author is grateful also to John Nicoll, Gillian Malpass, Ruth Thackeray, and Sheila Lee for all they accomplished in turning his manuscript into the book here offered to the reader.

1 Detail of Fig. 89.

Introduction

IN THE MERCHANT–IVORY PRODUCTION OF *A Room with a View* the aesthete Cecil, displaying his discernment, alludes to Leonardo's *Ginevra de' Benci*. This interpolation by the filmmakers may seem apt today, but it is actually an anachronism. For at the beginning of the twentieth century, when E. M. Forster's novel was first published, *Ginevra* and Leonardo's other early works were not well accepted. Bernard Berenson, in particular, deplored them. And his colleague Jens Thiis, in the only book-length treatment of the early Leonardo to appear before this one, rejected all of the paintings that will occupy us here. There is no proper study of Leonardo's formation, in fact, and the reasons are not hard to find. Despite his subsequent fame, almost no factual information exists about the aspiring artist. All we really know is that he studied with Andrea del Verrocchio, the leading Florentine master of the day.

Leonardo's and Verrocchio's works have often been confused, moreover, as have those of Andrea's other pupils Lorenzo di Credi, Perugino, and Ghirlandaio. As a result, the literature on Leonardo's beginnings deals mainly with attributions. The question is whether the Uffizi *Annunciation* (Fig. 63), *Ginevra de' Benci* (Fig. 89), the *Madonna of the Carnation* (Fig. 122), and part of the Uffizi *Baptism* (Fig. 128) are by him or not.[1] Even after such experts as Wilhelm von Bode had identified these works as Leonardo's, other connoisseurs as reputable as Berenson were reluctant to accept them. A bitter debate ensued (for which see the Appendix) between those who took the traditional view that Leonardo was a prodigy from the start and those who allowed for a more gradual evolution toward his maturity – nature versus nurture. For the skeptics Leonardo's supposed beginnings did not measure up to the world-renowned masterpieces by which he changed the history of art. And yet the *Madonna of the Rocks*, the *Virgin and Child with St. Anne*, and the *Mona Lisa* owe a great deal to Leonardo's earlier works and to the training and inspiration he received as a youth in Florence.

Fortunately scholars have now reached a consensus that the pictures which concern us are indeed by Leonardo, but they still disagree about when he painted them. Some experts date the *Annunciation* and its cognates toward the end of his first Florentine period, in which case Leonardo would have practically nothing to show for his previous years with Verrocchio. The initial premise on which this book is based is that the above-mentioned paintings, together with a small number of related drawings, constitute a distinct group in terms of their authorship and date. They appear to have been completed by Leonardo in Verrocchio's shop between 1472 and 1476, when the pupil was in his early twenties. And the issues they raise have to do not with classification but with his much-vaunted creativity. The popular notion of Leonardo as a universal genius is not unwarranted. Working as a painter, sculptor, architect, botanist, anatomist, and engineer, he excelled in a variety of tasks. And the way he united art and science obviously gives him a

2 Detail of Fig. 113.

special appeal in our technological age. But whereas the young Leonardo's renderings of machines are little more than copies, his paintings and associated drawings from the same time are full of promise.[2] Leonardo's first known pictures are just as beautiful as his later ones, in fact, and in some ways they are even more interesting. If they borrow elements from other artists and are not wholly new in style, the early works incorporate many novel ideas and techniques, and they anticipate a number of Leonardo's favorite themes and preoccupations. It is precisely their lack of homogeneity (creative leaps combined with missteps) which makes them so fascinating.

This unevenness means, however, that Leonardo's early works cannot be analyzed as if they were stylistically uniform, in the manner of his mature masterpieces. Chapters 1 and 2 set the stage by placing Leonardo's first paintings in the context of artistic production in Florence. Vasari says that Leonardo looked back to Masaccio, and there is visual evidence that he studied the works of Filippo Lippi as well.[3] But it was Verrocchio and his rival Antonio Pollaiuolo who played by far the largest role in Leonardo's development. Verrocchio's extraordinary inventions were formulated primarily in sculpture, and both he and his most brilliant pupil attempted to translate them into painting.[4] In Leonardo's hands, however, Andrea's highly expressive sculptural prototypes underwent a profound transformation. For, unlike his teacher, Leonardo adopted the Netherlandish medium of oil to give the forms he painted an unprecedented softness and transparency. Also reacting to Verrocchio's inadequacy as a naturalist, Leonardo turned to Pollaiuolo for guidance in representing the natural world. As Leonardo used them, his two principal sources complemented each other.

Seeking to place Leonardo's early paintings and drawings in context, this book belongs to the current art-historical genre of workshop studies, with the difference that we are dealing not with a group but with an outstandingly gifted individual, his relation to his teacher, and his role in the shop. Chapters 3 through 6 accordingly focus on pictures or projects which the young Leonardo executed jointly with Verrocchio or on his own. One of these pictures, here attributed in part to Leonardo, would be his very first effort as a painter. The aim in each case is not to categorize the works but rather to explain, as far as possible, how they were designed and painted. The method adopted here is basically one of comparing Leonardo's paintings with those by other artists he took as sources and with his own preparatory studies and sketches. From these comparisons, involving similarities and differences, we can deduce considerably more than might be expected about the young artist's intentions, choices, and decisions. Recently gathered technical evidence also provides new insights about how Leonardo produced the paintings in question. At times, scrutinizing the early works for clues and connections brings us so close to the young Leonardo that we feel we are almost peering over his shoulder or into his mind. Admittedly, the evidence is scanty. But by bringing the pertinent works into proper relation to each other, we can reach a clearer understanding of his origins as an artist.

Leonardo's ranks of admirers regard him as the epitome of the Florentine Renaissance. But Verrocchio or Pollaiuolo, perhaps, better sum up the spirit of the age. Leonardo was often at odds with his contemporaries, and nowhere more so than in his attitude toward nature. He would have held the largely Aristotelian world view, of man as the microcosm of a universe made up of four basic elements, that the fifteenth century had inherited from the Middle Ages. He also presumably subscribed to the Christian concept of nature as God's creation. But

personal observation and imagination clearly played a more important role in shaping Leonardo's vision than did anything he might have read or absorbed. And since the locus of his activity was an artist's workshop, he tested his perceptions of nature, not in learned debate, but against those that other painters recorded in their works.

Petrarch, in his famous ascent of Mont Ventoux in 1336, had admired the views, only to heed, once he reached the summit, Augustine's admonition to look inward.[5] Though his account might seem to suggest a new awareness of landscape, the humanist, in effect, turned his back on nature, unlike Leonardo, who climbed a similar peak to observe the terrain in his equally famous Uffizi drawing (Fig. 87) of 1473. Petrarch's fifteenth-century descendants, including Leon Battista Alberti and Marsilio Ficino, might extoll the beauties of the Tuscan countryside. But they never separated nature from human concerns, whether these were practical or pleasurable. The culmination of this "country life" sort of nature appreciation, centering on hunting, farming, and the villa, is found in Lorenzo de' Medici's poetry.[6] Though his vivid descriptions betray a remarkably keen feeling for the natural scene, Lorenzo still shared the prevailing concept of the outdoors as a setting for humankind.

Even as a youth, it seems, Leonardo found this view unacceptable. His own concept of nature as nature was radically different, and long before he put it in writing, it is adumbrated in his early paintings and drawings. Young Leonardo's deep curiosity about plants and animals and his superior ability to represent them set him apart, of course. But where he most differs from his fellow painters is in his precocious understanding of the forces and processes behind natural phenomena – light, atmosphere, and movement or growth. At this stage in his development, Leonardo's approach was still largely a matter of perception and intuition; it did not yet involve the systematic investigation of optics, anatomy, hydraulics, and a host of other scientific subjects that he undertook later in his career.[7] Luckily for Leonardo, the new medium of oil and the technique with which he applied it proved ideal for representing the immaterial qualities at the heart of his vision of the natural world.

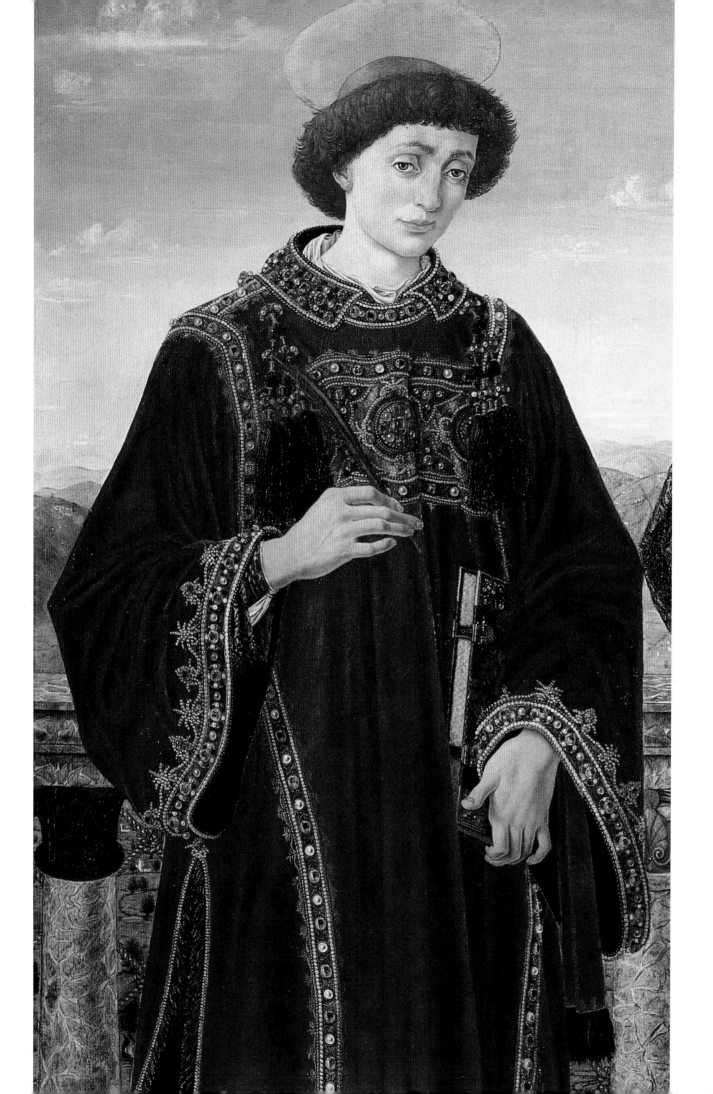

1 Rivalry and Realism: Verrocchio and Pollaiuolo

FOR ALL THEIR ORIGINALITY, Leonardo's early works have a Verrocchiesque character that can be explained only by examining the milieu in which they were created. Before his apprenticeship, almost nothing is known about Leonardo, whose childhood is a closed book. He was born on Saturday April 15, 1452, in or near the hilltown of Vinci, 20 miles west of Florence, the illegitimate son of Ser Piero da Vinci and a country girl named Caterina. Leonardo was brought up in the household headed by his paternal grandfather, who listed the lad as a dependant in his tax return of 1457.[1] By this time Leonardo's father was probably working as a notary in Florence, where he settled in 1469. Becoming highly successful in his profession, Ser Piero even drew up legal documents for several of his son's patrons, including the Medici. And yet, despite the fact that he came from a long line of notaries, Leonardo seems to have received only the primary education of the time: reading (in the vernacular, not Latin, which he taught himself later), writing, and arithmetic (practical mathematics using an abacus). The boy's lack of a literary training suggests that his artistic abilities came to light at an early date, and Vasari may well be right that Ser Piero therefore chose for his first (and for a long time only) son a career as an artist.[2]

The account of Leonardo's formation that Vasari gives in his *Vite de' più eccellenti pittori, scultori ed architettori*, first published in 1550, resembles the fictionalized one he supplied for Giotto, who also initiated a new era in the history of art.[3] Giotto's teacher was said to have discovered the boy drawing sheep, and Leonardo similarly showed remarkable talent at a very young age,

> never neglecting design and working in relief, those being the things that appealed to his fancy more than anything else. Knowing the boy's soaring spirit, Ser Piero, when he saw this, one day took some of his drawings to Andrea del Verrocchio, who was his close friend, and asked his opinion whether Leonardo would do anything by studying design. Andrea was so amazed by these early efforts he advised Ser Piero to have the boy taught. So it was decided that Leonardo should go to Andrea's workshop. The boy was greatly delighted, and not only practised his profession, but all those in which design has a part.[4]

Vasari admired Leonardo's versatility in some clay sculptures, portraying heads of smiling women and children, and in various architectural and engineering projects he mistakenly ascribed to the artist's youth.[5] As for paintings and drawings, the author of the *Vite* apparently had firsthand knowledge of two early works by Leonardo that belonged to members of the Medici family, which Vasari served as court artist: a tapestry cartoon representing Adam and Eve in a verdant Paradise; and a painting of the *Madonna with a Vase of Flowers* once in the possession of Pope

3 Detail of Fig. 8.

Clement VII. Both displayed the painter's precocious skill in rendering nature.[6] Two further paintings Vasari viewed as early works by Leonardo – a *Head of Medusa* and an *Angel* – were kept in the *guardaroba* of Duke Cosimo de' Medici.[7] The writer's flattering praise for these (lost) pictures prefaced his remarks on the final product of the artist's first Florentine period, the unfinished *Adoration of the Magi*, which from the time it entered the Uffizi in the seventeenth century has always been accepted as Leonardo's. Though he extolled the realism of these works, Vasari clearly had no precise idea of their style, which he failed to distinguish from that of Leonardo's maturity.[8]

Vasari amplified his acquaintance with Leonardo's art by means of anecdotes which illuminate the writer as much as his subject.[9] The most colorful of these tales demonstrates Leonardo's ability, even as a boy, to make whatever he depicted seem real. The artist's father, the story goes, brought his son a shield that a peasant working for him wanted to have painted. After preparing the circular panel, Leonardo resolved to do a monster to "terrify all beholders." Drawing upon a variety of repulsive creatures he collected for the purpose, the young artist portrayed a "monster of poisonous breath, belching . . . fire from its eyes and smoke from its nostrils, of truly terrible and horrible aspect."[10] When Leonardo presented the painting, Ser Piero was suitably frightened, though afterwards he sold it for profit, offering his servant a poor substitute.

The story of the shield, however telling, cannot be verified, and scholars doubt that the work on which Vasari's narrative rests ever existed.[11] Another of his anecdotes concerns an actual painting, however, and one that has survived – the *Baptism of Christ* (Fig. 18) in the Uffizi. From his written sources in the *Libro* of Antonio Billi and in the so-called Anonimo Gaddiano, Vasari learned of the altarpiece that Verrocchio had painted for the monastery church of San Salvi.[12] An early sixteenth-century guidebook to Florence added that Leonardo had contributed an angel (Fig. 111) to the picture.[13] Though the sources spoke merely of collaboration between master and pupil, Vasari interpreted their joint venture as a matter of jealous rivalry. Leonardo, he reminded his readers,

> was placed with Andrea del Verrocchio in his childhood by Ser Piero, and his master happened to be painting a St. John baptizing Christ. For this picture Leonardo did an angel holding some garments; and although quite young, he made it far better than the figures of Andrea. The latter would never afterwards touch colours, chagrined that a child should know more than he.[14]

Recounting the same episode in his life of Verrocchio, Vasari placed the angel first among Leonardo's juvenilia, as if to suggest that the superiority he demonstrated in the painting was innate.[15] And that is exactly how he described Leonardo's gifts, as "marvelous" and "divine" by contrast to what he saw as Verrocchio's plodding efforts. In Leonardo the

> heavens [bestowed] upon a single individual beauty, grace, and ability, so that whatever he does, every action is so divine that he outdistances all other men, and clearly displays that his genius is the gift of God and not an acquirement of human art.[16]

The topos of a pupil eclipsing his master recurs in the biographies of Raphael, Titian, and Michelangelo.[17] But the triumphant emergence of Leonardo in Verrocchio's workshop signaled for Vasari not just a change of style but the advent of a new artistic age. In the progressive scheme of the *Vite*, Leonardo's contribu-

tion to the *Baptism* was pivotal: though linked to Verrocchio's antiquated manner, the angel heralded the fledgling artist's future greatness as the inventor of what we call the High Renaissance.[18]

Vasari stated that Ser Piero apprenticed his son to Verrocchio, and he made the same assertion about Leonardo in the biographies of three other artists whom he regarded as fellow pupils – Lorenzo di Credi, Pietro Perugino, and the considerably younger Gian Francesco Rustici.[19] His claim is borne out by a note of Leonardo's alluding to Verrocchio's method for constructing the copper *palla*, or sphere, set atop the lantern of the dome of Florence Cathedral in 1471.[20] Andrea began this engineering project in 1468, but whether Leonardo came to him before its inception or after it was under way is still a matter of debate. One school of thought holds that Leonardo entered Verrocchio's shop about 1466, when he was thirteen or fourteen years old, a common age to begin an apprenticeship.[21] And if Leonardo joined the guild in 1472, when he is cited as belonging to the painters' confraternity, he would have had the usual six-year training period. Other writers, assuming that Leonardo accompanied his father to Florence, believe that he went to Verrocchio in 1469.[22] It is true that the works Leonardo painted independently in Andrea's shop can all be assigned to the following decade. Nevertheless, the earlier date of 1466 seems preferable. An apprenticeship lasting only two or three years is too brief to explain the evident mastery of Leonardo's first known paintings and drawings. And it does not admit the possiblity, raised in chapter 3, of his collaboration with the master on other works yet to be identified.

To judge from two documents of 1476, which state that he was staying with Andrea, Leonardo remained in the shop for at least a decade. The first records that on April 9 "Lionardo di Ser Piero da Vinci sta con Andrea de Verrochio," and the second, dating from June 7, reiterates that he "manet cum Andrea del Verrochio."[23] These notices indicate that Leonardo was not just working but actually living under Verrocchio's roof, rather than in the house Ser Piero had taken on the site of the future Palazzo Gondi, across the street from Palazzo della Signoria.[24] Verrocchio, befitting his lower status as an artist, resided in the via dell'Agnolo in the more modest parish of Sant'Ambrogio, the church where he is buried. The location of the workshop where he carried on his trade is unknown. Perhaps his house accommodated a ground-floor shop, or he may have rented quarters elsewhere in the city. All we can be sure of is that wherever the master worked during the period of Leonardo's training, around 1480 he transferred his shop to premises behind the cathedral previously occupied by Donatello.[25]

The significance of the documents linking Leonardo to Verrocchio can hardly be exaggerated: they prove what we could otherwise only glean from Vasari and infer from their works, that he was the older master's pupil. Yet these records cite Verrocchio merely to identify Leonardo. Their main content, once it became known, created a dilemma for scholars. For the sources revealed that Leonardo, along with three other men – a goldsmith, a tailor, and a member of one of Florence's leading families, the Tornabuoni – was accused of committing sodomy with a notorious male prostitute named Jacopo Saltarelli. Fortunately for us (but not for him), Leonardo was, among "several dozen people" served by Saltarelli, one of the few to be named. The denunciation of April 9, 1476, made anonymously to the Ufficiali di Notte in charge of public morals, was first dismissed for lack of proof, but was brought up again on June 7, only to be dismissed once more, with the proviso that the case might be reconsidered on receipt of further evidence. The archival records containing the charges against Leonardo were not

fully divulged until 1896, more than four centuries after his scrape with the law.[26] Scholars scandalized by the documents implying that Leonardo was not a paragon of virtue then tried to discount them, just as some of the same critics dismissed the youthful works which demonstrated that he was not a prodigy.[27] The revelation of Leonardo's probable homosexuality thus coincided, broadly speaking, with the rediscovery of his first paintings, and both changed for ever the idealized image of the artist that had prevailed up to that time. Though inconclusive, the accusation against Verrocchio's pupil did appear to have some basis, Kenneth Clark admitted, in light of his later life and work, and it was Clark, significantly, who first integrated the painter's sexuality and his early pictures into our modern view of Leonardo as a creator.[28]

Speculation about the roots of Leonardo's sexuality and its significance for his art goes back to a famous essay of 1910 in which Sigmund Freud sought clues to his personality in a childhood dream the artist later recalled.[29] Homosexuality is now generally agreed to be more than just a matter of individual psychology. Yet despite widespread interest in the social or cultural factors influencing homoeroticism in the Renaissance, we still do not know whether the apprentice-ship system in the arts, particularly the master-pupil relationship, fostered some kind of homosexual subculture.[30] The fact that the documents accusing Leonardo of sodomy place him in Verrocchio's house, where he stayed even after joining the painters' confraternity, has inevitably led to the suspicion that their relation was more than merely artistic. Verrocchio never married, and neither did Leonardo, for that matter, but it was not unusual for Renaissance artists to remain single. Of the painters we shall encounter as Leonardo's fellow pupils, Botticelli was, admittedly, a bachelor accused of practicing sodomy with an apprentice, but Perugino was happily married.[31]

A close bond undoubtedly existed between Verrocchio and the young Leonardo, but what effect their decade-long attachment had on their art is difficult to determine. Renaissance artists still treated mainly religious themes, and the vast majority of their work was commissioned so that its content was not a matter of unbridled self-expression. If the kind of homosexual sensibility found in such later figures as, say, Diaghilev and Nijinsky entered into Renaissance art at all, it may have taken the form of an androgynous male type particularly associated with the Florentine Quattrocento.[32] Leonardo defined this ephebic type better than any other artist except Botticelli, as we shall see. In Verrocchio's work a famous example is the bronze *David* (Fig. 5) in the Bargello, ordered by the Medici and sold by them to the Signoria in 1476. The curly-haired biblical hero is popularly believed to be a likeness of Leonardo, even though we have no authentic portrait or description of the young artist for comparison.[33] Scholars have doubted the identification because the statue, representing an adolescent, is usually dated to the time just before its sale, when Leonardo was twenty-four years old. But recently the bronze has been reassigned, on the basis of style and technique, to the mid-1460s, when Leonardo had just arrrived in Verrocchio's shop.[34] The question can also be approached from the standpoint of David's visage (Fig. 4), which does not conform to Verrocchio's habitual broad-faced type (Fig. 19) of youth. David's aristocratic features have considerable individuality, leaving open the possibility that his figure was modeled on Leonardo, whose youthful beauty "could not be exaggerated," according to Vasari.[35] If Verrocchio's bronze really does celebrate his pupil's beauty, then the first glimpse we catch of Leonardo in the shop is not as a practicing artist but as the object of appreciation.

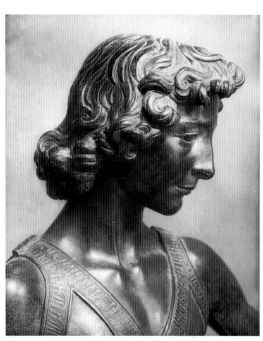

4 Detail of Fig. 5.

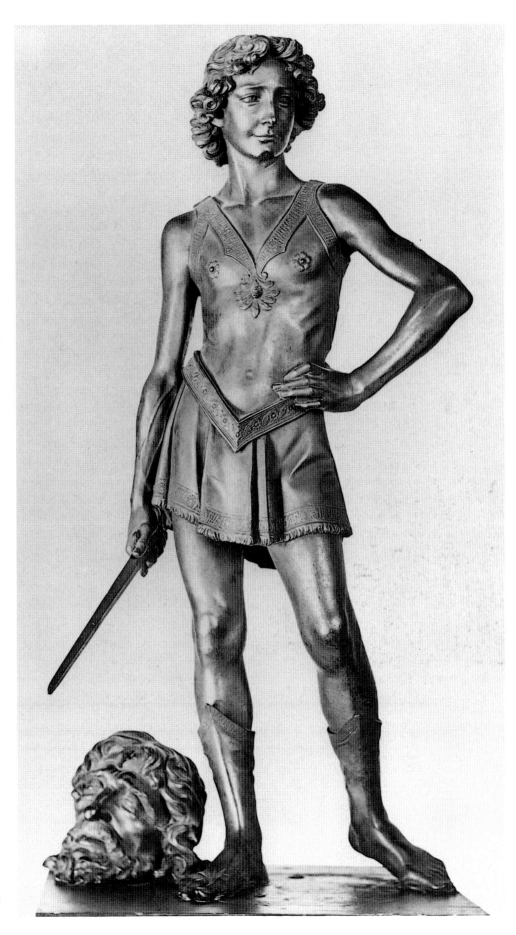

5 Verrocchio, *David*, bronze, Museo Nazionale del Bargello, Florence.

6 *Woodcut portrait of Verrocchio illustrating* the 1568 edition of Vasari's *Vite*, National Gallery of Art Library, Washington.

Though the portrait (Fig. 6) of Andrea that Vasari used to illustrate the *Vite* credits his versatility both as painter and sculptor, Verrocchio's current reputation rests primarily on a couple of works in bronze carried out over a long period of time. A new kind of artist, Andrea was not so prolific as his predecessors. He created relatively few works, but each is a masterpiece of great originality and technical ingenuity. In this, as in much else, he provided a model for Leonardo. Born Andrea di Michele Cioni in Florence in 1435, Verrocchio first trained as a goldsmith, but according to his tax return of 1457 abandoned the craft for lack of work.[36] Then he apparently took up marble carving, which he may have learned from Desiderio da Settignano.[37] Desiderio's death (and Bernardo Rossellino's) in 1464, followed by Donatello's two years later, left the way open for Andrea. By the time Leonardo joined him in the mid-1460s, Verrocchio was on the way to succeeding Donatello as the Medici family's most favored sculptor.

The chief source of information about Verrocchio and his patrons is an inventory, drawn up by his brother Tommaso in 1496, eight years after Andrea's death. It records works ordered by the Medici but not fully paid for.[38] Apart from the bronze *David*, the list includes two funerary sculptures in the church of San Lorenzo. The first is the tombstone for Cosimo de' Medici, head of the family and virtual ruler of Florence.[39] Following his death in 1464, Cosimo's tomb was erected by his son Piero, who, in turn, was buried, together with his brother Giovanni, in the second and much more elaborate monument (Fig. 53) in the church sacristy. Andrea completed this tomb in 1472 at the behest of Piero's sons, Lorenzo and Giuliano, who strove to continue the artistic and literary patronage begun by their grandfather. Among the other items Tommaso listed are several works in a variety of media which the young Leonardo would have known, including the polychromed terracotta relief (Fig. 21) of the *Resurrection of Christ* from the villa Cosimo built at Careggi, as well as some painted standards and decorated armor that Verrocchio made for festivals and tournaments organized by the Medici.

In working for the city's most illustrious family Verrocchio not only competed with Donatello's legacy; he had a living rival in Antonio Pollaiuolo. This artist, who counts just below Andrea as Leonardo's chief source of inspiration, was the most versatile master of the century. When in 1457 Verrocchio complained he could not find work as a goldsmith, Pollaiuolo won (a share in) the commission for the reliquary cross for the Florentine Baptistery, suggesting that he may have blocked Verrocchio's path to pre-eminence. In the following years the two artists repeatedly vied for patronage, especially from the Medici, and during the period in which Leonardo frequented Verrocchio's shop, their competition became particularly intense. We have seen that Verrocchio obtained the commission for the metal sphere crowning the cathedral dome, but not until Pollaiuolo had advised about the casting method and its estimated cost.[40] Both artists provided tournament armor, banners, or horse trappings for Lorenzo de' Medici's famous *giostra*, or joust, in 1469, Verrocchio for Lorenzo himself and Pollaiuolo for a lesser contender.[41] Several years later Verrocchio competed against Pollaiuolo (and other goldsmiths) to provide four reliefs to complete the fourteenth-century silver altar of the Baptistery (now in the Museo dell'Opera del Duomo). After submitting models, each artist was allotted one scene, and their contributions can still be compared on opposite sides of the altar.[42] Other more revealing cases of rivalry between the two masters and their workshops will be discussed below.

Slightly older than Verrocchio, Pollaiuolo (1431/32–1498) practiced the gold-

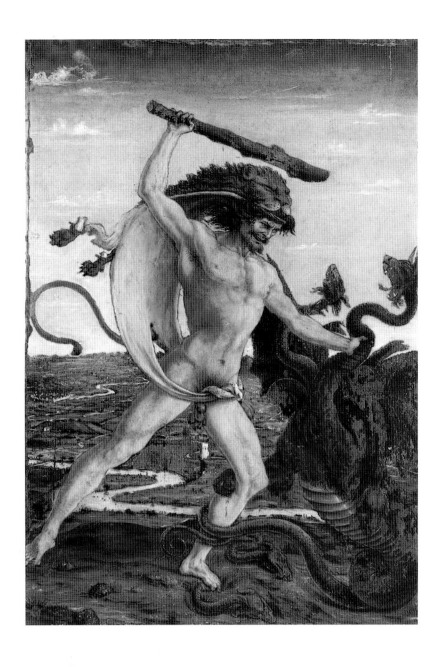

7 Antonio Pollaiuolo, *Hercules and the Hydra*,
Galleria degli Uffizi, Florence.

smith's trade in a workshop in the via Vacchereccia near the Mercato Nuovo. This shop, Vasari asserted, was the most sought-after of its kind in Florence, and scholarly attention has accordingly focused on the metalwork Antonio produced there. He overlapped in this arena with Verrocchio. But sometime in the 1450s Pollaiuolo branched out into painting.[43] Though he drew on half a century of Florentine innovations, Antonio's master is unknown, and his first major pictorial achievement is lost. This consisted of a series of three large canvases depicting the *Labors of Hercules*, which Pollaiuolo painted about 1460 for the great hall of the Medici palace. The cycle, associating the mythic hero with the artist's patrons, created a sensation to judge from the many copies in various media that it inspired.[44] Since the rise of Christianity, pagan subjects had never been treated on this scale, and the commission gave Pollaiuolo full scope to display his skill in depicting muscular male nudes in violent action. His tiny panel of *Hercules and the Hydra* (Fig. 7), one of a pair recording the original compositions, allows us to imagine their over-life-size figures. Ironically, one early source misattributed the

Hercules series to Verrocchio, who must have envied Pollaiuolo's success in launching his new endeavor.[45]

Pollaiuolo's next major painting lacked the prestige of the Medici commission but was in its own way no less innovative. In its semi-public setting, moreover, the work may have had an even greater impact on contemporaries. Completed in 1467, the *St. James between Sts. Vincent and Eustace* (Fig. 8) was the crowning glory of the newly erected mortuary chapel of the Cardinal of Portugal in San Miniato al Monte. The young prelate's untimely death seems to have inspired those involved with his monument – nearly all the leading masters in Florence except Verrocchio – to new heights, and the ensemble of painting, sculpture, and architecture they created is one of the supreme achievements of the Florentine Quattrocento.[46] On the altar wall Pollaiuolo painted a pair of foreshortened angels raising curtains to reveal the picture of St. James and his companions (a copy has replaced the original, now in the Uffizi). The illusionistic device of the curtain-raising angels, together with the framed altarpiece, produces the effect of a "window opened in a wall through which we look at something . . . recognizably related to a world we know."[47]

The world of this recently cleaned picture is not ours, of course, but that of the artist and his contemporaries. The altarpiece features three male saints standing on a balcony backed by a balustrade through which appears a distant landscape. The saints are all elegantly attired in the fashion of the day. Vincent, on the left, wears a dalmatic decorated with pearls and precious stones, while the cardinal's patron saint James, in the center, has a robe draped over a magnificent ankle-length velvet gown brocaded with gold. He may well be the best-dressed pilgrim in Italian art. Not to be outdone, Eustace, on the right, sports a lavish ermine-lined tunic over a doublet, the sleeves of which are woven with gold brocade forming a stylized floral design. Painstakingly rendered in every detail, the resplendent garments worn by the figures reveal Pollaiuolo's intimate knowledge of luxury cloth manufacture: he has captured the precise sheen of fabrics gleaming with gold (Fig. 3).[48] And as if to remind us that Antonio was trained and worked throughout his career as a goldsmith, the gemstones and gold ornaments in the picture are also painted with a knowing eye. Indeed, Eustace's collar and James's hat band may indicate the kind of jewelry Pollaiuolo himself fashioned.[49] Many painters, including Botticelli, Ghirlandaio, and Credi – to name only those who worked in Verrocchio's shop – were initially trained as goldsmiths, but in no other case is the link between painting and metalwork so close as it is with Pollaiuolo. In fact, we can speak of a goldsmith aesthetic to characterize his work as a whole.[50]

The sartorial aspect of the altarpiece, which Antonio emphasized, is precisely the one to which his contemporaries would have been most receptive. To them the saints' splendid garments would not only have looked strikingly realistic; they would also have had a special meaning, since the lucrative cloth-weaving industry was central to the Florentine economy. In this time of periodic financial crisis, wool manufacturing had long been in decline. But the luxury cloth industry was prospering.[51] The silk guild to which Antonio, as a goldsmith, belonged, set standards for the workmanship of Florentine cloth to guarantee its superiority. Indeed, the merchant-chronicler Benedetto Dei reported in 1472 that the "magnificent and highly prized" goods produced by no fewer than eighty-three silk-weaving firms (plus seventy-four goldsmiths' shops and fifty-four gemsetters) were unsurpassed throughout the world.[52] The Florentines themselves shared the taste for sumptuous fabrics, part of a late Quattrocento trend towards conspicuous

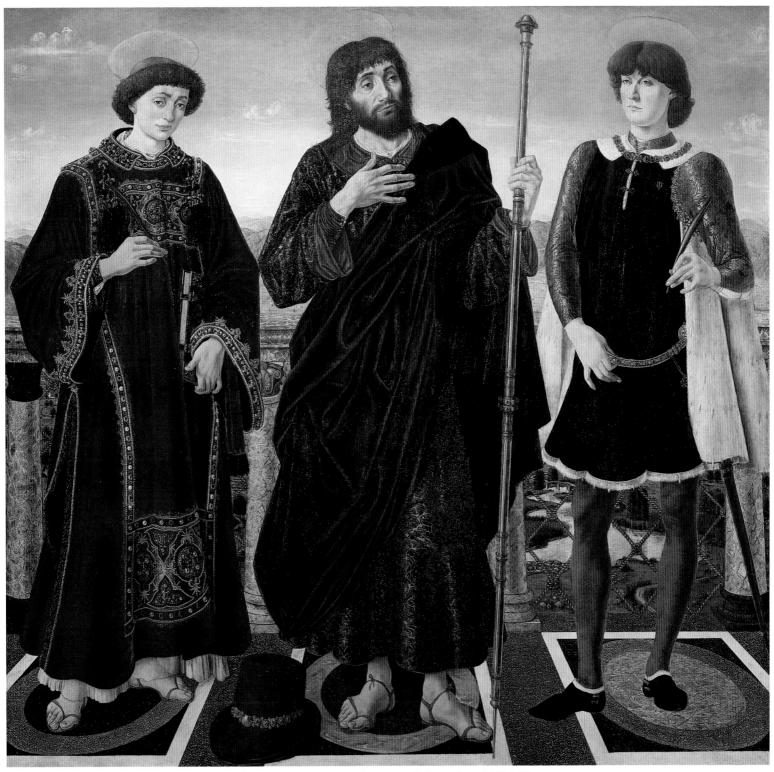

8 Antonio and Piero Pollaiuolo, *St. James between Sts. Vincent and Eustace*, Galleria degli Uffizi, Florence.

consumption, often noted by historians. This is the context in which the ostentatious dress of Pollaiuolo's saints must be seen. Another document of 1466 – Luca Landucci's proud and meticulously detailed account of his wife's luxurious bridal outfit – further suggests how viewers approached Antonio's painting of the same date.[53] The picture offered an exact reproduction of material objects to which the culture attached the highest importance; that was the reality it imitated.

Pollaiuolo's painting was quite unlike anything the Florentines had seen before. To be sure, a comparable display of finery marked Benozzo Gozzoli's mural decoration of the Medici palace chapel of 1459. But it was Antonio's method of simulating luxury textiles that was new. Gozzoli had applied gold and tempera-based pigments after the fresco had dried.[54] Domenico Veneziano had also stretched the limits of the traditional tempera medium in portraying the gem-studded garments in his *St. Lucy* altarpiece, now in the Uffizi. Pollaiuolo, according to Vasari, preferred to paint his picture in oil.[55] With no corroborating technical evidence, there are only visual clues to suggest that the artist evolved a mixed technique – an oil-tempera emulsion or oil glazes over tempera – to capture effects impossible to achieve with tempera alone. The use of oil allowed for a more detailed and nuanced description of form and light, enabling the painter of the *Three Saints* to render the various textures of skin, hair, brocade, fur, gems, metal, and multicolored stone. His brushwork, unlike the small hatched strokes characteristic of tempera, became invisible as such, thereby contributing to the sense of the picture as a material illusion of the objects depicted.[56]

Though Pollaiuolo's altarpiece seems to have been completed primarily in oil, it must be emphasized that the exact nature of the binding medium could be determined only by technical analysis of minute paint samples taken from the picture. The whole question of paint media in the fifteenth century, especially during the so-called transitional period when the young Leonardo and other Italian artists were experimenting with oil, is still the subject of debate.[57] Vasari's account of the introduction of oil painting into Italy – Antonello supposedly learned the technique from Jan Van Eyck, its inventor – has been rejected by scholars, who no longer sharply divide oil from tempera but allow for their joint or concurrent use over a long period of time. Yet it remains true that while medieval painters used oil for specific purposes, its artistic possibilities as a medium were first exploited by Netherlandish artists. The important point, in any case, is not whether scientific analysis can detect the presence of oil in paint layers, but that the artist manipulated whatever medium he adopted to achieve illusionistic effects unavailable to earlier masters. Pollaiuolo's lustrous treatment of textures, unprecedented in Florentine painting, points to a northern source, like Roger van der Weyden's *Entombment*, now in the Uffizi, or his so-called Medici *Madonna* in Frankfurt, both of which Antonio could have seen.[58]

This kind of tactile description of reality became a hallmark of Pollaiuolo's revolutionary new style of painting. In the work Vasari regarded as his masterpiece, the *Martyrdom of St. Sebastian* (Fig. 9), completed about 1475 for the Pucci Chapel in SS. Annunziata and now in the National Gallery, London, the carefully depicted life-size figures in the foreground appear before a distant landscape (Fig. 10) that is painted with remarkable freedom. By this time Antonio understood that the oil medium permitted both a looser and a more detailed application of paint.[59] Pollaiuolo concentrated on the human form. But the panoramic landscapes in his pictures are of special interest as a precedent for Leonardo. Florentine painters had long favored rocky backdrops for their figure compositions. This tradition was

9 Antonio and Piero Pollaiuolo, *Martyrdom of St. Sebastian*, National Gallery, London.

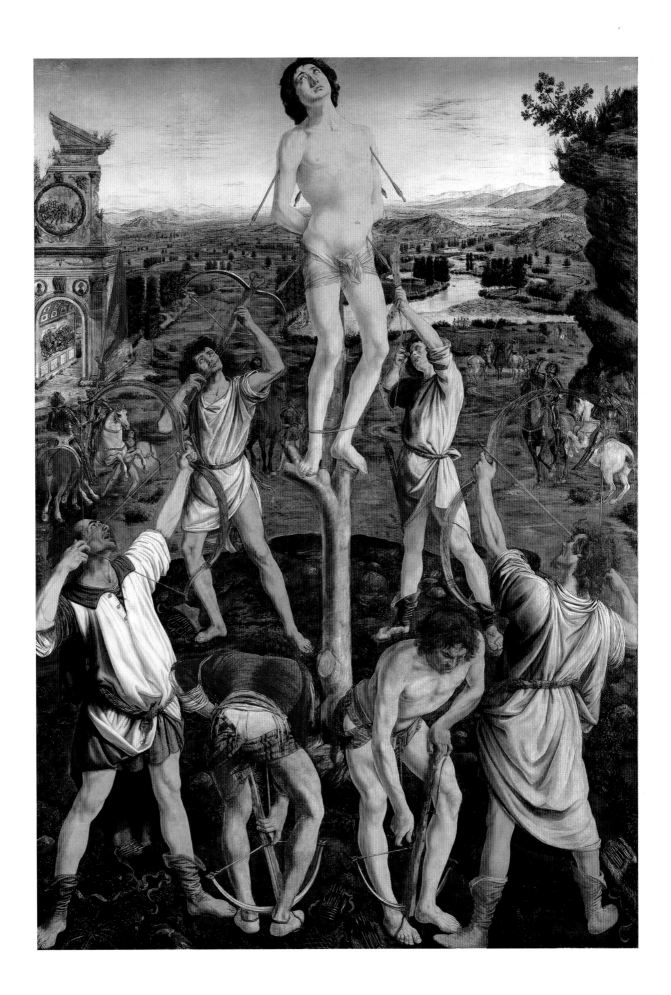

updated by Gozzoli in his Medici Chapel murals, in which castles and bright green foliage give the landscape the look of a tapestry in keeping with the richness of the decoration. The first artist (aside from Piero della Francesca) to break with the traditional scheme was Alesso Baldovinetti, who opened up the background in the *Nativity* he painted in 1460 for the same church that would house Pollaiuolo's *Martyrdom*. The broad plain in Baldovinetti's fresco, dotted with trees and traversed by a river meandering toward a mountainous horizon, established a new formula; but in terms of the way they render natural forms, his landscapes are scarcely less conventional than Gozzoli's.[60]

The real innovator was Pollaiuolo, who adopted Baldovinetti's bird's-eye view but with a different result. Antonio's depiction of nature varies in a realistic way according to the vantage point of the beholder. Scattered about the foreground in the *Martyrdom* is a profusion of plants that are just as carefully observed as the soldiers' costumes and weapons; they testify to a genuine feeling for nature that, among Florentine masters of the day, only Leonardo shared. Behind the archers the plateau drops off, and a rocky cliff and triumphal arch frame the middle distance. Groups of horsemen, diminishing in scale, lead to the background, where the river and the hills rising from the plain dissolve in haze as they approach the horizon. The topographical character of the scene as the Arno river valley is indicated by the walled city of Florence at the upper left. But the landscape does not appear to record a specific site, and the impetus for it was not simply curiosity about nature. In Pollaiuolo's time the prosperity of Florence depended on the Arno river. A vital artery linking the city to the sea, it was also an indispensable source of water for manufacturing.[61] Like the cloth lovingly portrayed in the *Three Saints*, the river depicted in the *Martyrdom* and many other of Pollaiuolo's works had a profound economic and cultural relevance for the artist and his audience.

Since young Leonardo strove for recognition in the same culture in which Pollaiuolo flourished, we need to consider the broader context in which their works were created, that of Medicean Florence during the years from Cosimo's death in 1464 to that of his grandson Giuliano in 1478. Our view of the Renaissance is biased in favor of the visual arts, so that when we think of Florentine culture under Lorenzo de' Medici (in power from 1469 to 1492), Botticelli's *Primavera* first comes to mind, not the painting's literary sources – Marsilio Ficino, among others – which are now read mainly by specialists. In the fifteenth century, however, the vast majority of artists labored like craftsmen in a culture in which literature occupied the central place. Or we might say that there were two cultures. One was made up of shops in which masters and their pupils, mostly from the artisan class, produced works of every description.[62] Their hectic activity contrasted with that of the poets and scholars, reading, thinking, and writing. To grasp the difference between the two spheres of cultural endeavor, we need only compare how Ficino and his counterpart Verrocchio were treated by their mutual patrons. The Medici installed the philosopher, whom they revered, in a country house near Careggi, while neglecting to compensate the sculptor for numerous works the family had commissioned.[63]

Because they were ignorant of Latin, the language of learning, artists were excluded from almost any kind of intellectual pursuit. And yet despite this handicap and the liability of their low social status, certain gifted and intellectually ambitious masters, like the ones who concern us here, aspired to the highbrow world of the writers. Their cause was promoted by the only Quattrocento humanist with a deep interest in the visual arts, Leon Battista Alberti (Fig. 11), who

10 Detail of Fig. 9.

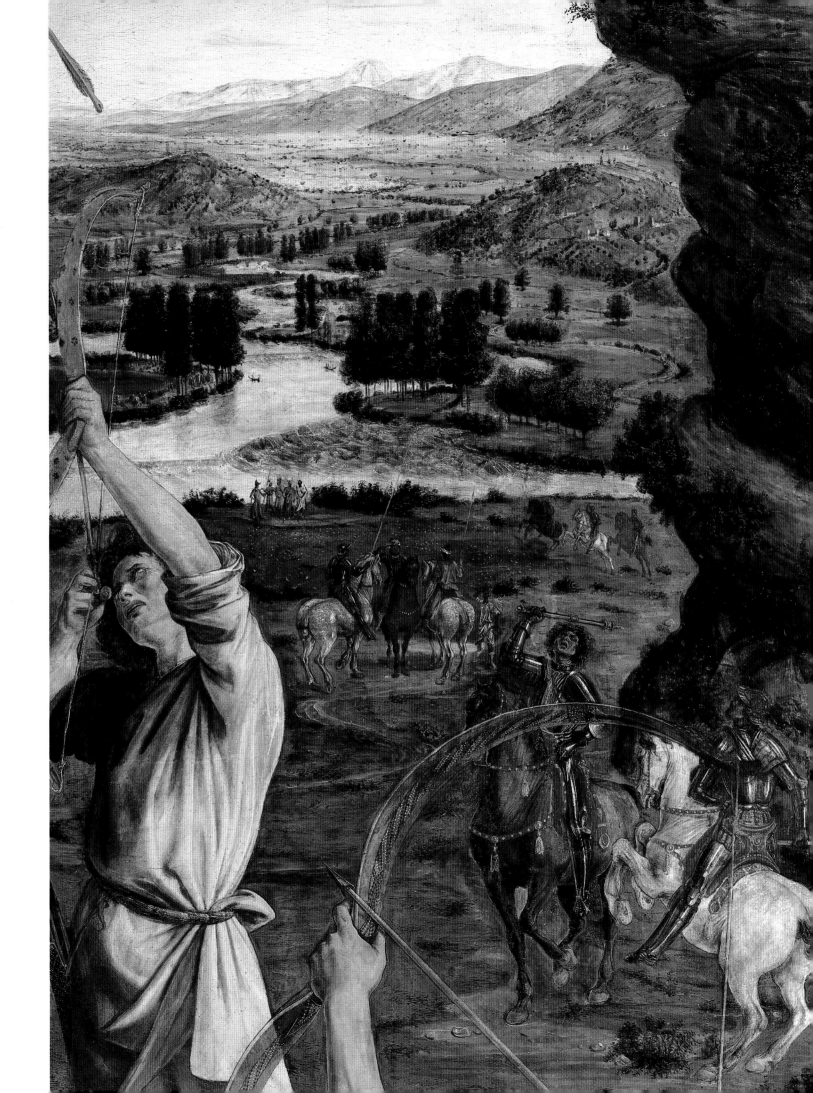

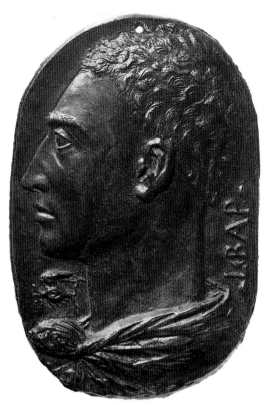

11 Leon Battista Alberti, self-portrait medallion, bronze, National Gallery of Art, Washington, Samuel H. Kress Collection.

claimed full stature for artists as creators. Alberti realized that any change in the status of artists depended on a new concept of art, and the one he advanced was developed further by Leonardo when he took up the challenge. Newly arrived in Florence after a long exile, Alberti was inspired by the artistic revolution he encountered there to compose the first modern treatise on painting. He translated his Latin text of 1435, *De pictura*, into Italian the following year so that his artist friends might profit from it.[64] Manuscripts of the Italian version, dedicated to Brunelleschi, must have circulated in artists' workshops. And various aspects of Alberti's theories seem to have engaged the young Leonardo, as we shall see.[65] The first part of the treatise, demonstrating the mathematical basis of art in optics and perspective, was fundamental, for it was the painter's mastery of geometry, according to Alberti, which raised him above the rank of mere craftsmen and which entitled his efforts to a place among the liberal arts. Comparing it to a window, Alberti defined painting as an illusionistic counterpart of visible reality.[66]

Painting was approached as art on two levels in the Quattrocento, and both have been studied by Michael Baxandall. The first, which the author calls the "period eye," represents skills, such as preaching, surveying, or even dancing, which ordinary viewers brought to the experience of art.[67] The second approach, which is of greater interest here, involves the cultivated elite of the time, both the literati and the art patrons whom they educated; here Baxandall focuses on what writers said about art and artists.[68] Their remarks reveal certain criteria for evaluating works of art that were drawn largely from ancient rhetoricians. But apart from standards such as "ornato," the overwhelming preference of the critics was for the exact imitation of nature. The concept of imitating nature has multiple connotations and allows for diverse styles, and students of Renaissance aesthetics have been at pains to define its meaning more precisely.[69] For our purposes, the term (as used by the ancient writer who will chiefly concern us) signifies the virtuoso display of an artist's skill in imitating visual reality. Such feats of skill involve not just expert workmanship, always highly prized in Florence, but verisimilitude. Ostensibly constituting an objective record, the realistic depiction of nature, in fact, varied considerably from artist to artist, and it was also culturally conditioned, as we have seen in the case of Pollaiuolo.

Whatever form realism took in painting, writers from Boccaccio onwards linked it with the revival of antiquity.[70] Since examples of ancient painting were virtually unknown in the Renaissance, critics and artists curious about their forebears turned for information to classical authors, above all to the Elder Pliny. This Roman encyclopedist, who died in the eruption of Vesuvius in A.D. 79, esteemed the visual arts, and the account he provides of them in his *Natural History* is by far the most comprehensive and authoritative to survive from the period.[71] Digressing from his main concern with mineralogy, Pliny's chapters on the history of art (Book XXXV deals with painting) articulate an evolutionary scheme of artistic progress which later influenced Vasari. The ancient masters, led by Zeuxis, Parrhasios, Protogenes, and Apelles, each contributed to the development toward greater naturalism, according to Pliny, and in doing so they competed with one another to imitate nature most convincingly. Their rivalry was couched in terms of familiar anecdotes about grapes fooling birds and so on, for the artist's goal in painting a picture was to deceive not only the beholder or his fellow artists but even nature itself. The specifics of the kind of *trompe-l'oeil* realism described by Pliny are less important than his basic message, which was that the legendary classical masters vied in demonstrating their ability to represent nature accurately,

each one attempting to out-perform his rivals by perfecting some particular branch of art. Only the most renowned of Greek painters, Apelles, combined all of his predecessors' achievements.

Pliny's assessment was fundamental for later writers, including Alberti, who consulted it for his own account of ancient art.[72] Lorenzo Ghiberti made similar use of the same source for the first book of his *Commentarii*, showing that an enterprising artist-turned-art-theorist could also gain access to the text.[73] Manuscripts of the *Natural History* circulated widely before the first printed editions began to appear around 1470.[74] Leonardo himself owned a printed copy of Pliny's encyclopedia.[75] The title he records in his library was probably Cristoforo Landino's Italian translation, which came out in 1476, followed by numerous later editions.[76] These authors turned to Pliny's chronicle and other ancient testimony for guidance in approaching the visual arts, and there was nothing (apart from the language difficulty) to prevent artists from doing the same. The most famous Florentine masters, among them Pollaiuolo, Verrocchio, and Leonardo, were often compared with Apelles or Phidias, and these comparisons, to the extent that they were not mere flattery, may well have suggested the relevance of the classical heritage for current practice.[77] There appears to be a definite correlation, in this sense, between the kind of imitative realism Pliny extolled and the spectacularly naturalistic effects achieved by Pollaiuolo. But that does not mean that Antonio sought advice from the text in painting his pictures. Rather, Pliny's treatment of ancient art provided a key element in the framework of attitudes and values in which the Renaissance artist worked. Pliny described – and seemed to call for – dazzling displays of illusionism in painting, and Pollaiuolo responded.

Since his example led both Verrocchio and Leonardo to paint as they did, the question of how contemporaries viewed Pollaiuolo's work is important for understanding theirs as well. Even if Ficino's praise for Antonio as "noster pictor et sculptor insignis" did not make his works canonical, he was undoubtedly emulated by other artists.[78] In a letter of the 1460s, the Florentine Jacopo Lanfredini praised Pollaiuolo as the "chief master in this city, and perhaps that has ever been, and this is the common opinion of all who understand such matters."[79] The patron who commissioned the *Martyrdom*, Antonio Pucci, evidently shared Lanfredini's esteem for Pollaiuolo, whom he paid the unheard-of sum of 300 *scudi* for the picture, "declaring that he was hardly reimbursing him for the colors."[80] The anatomical accuracy of the executioners and the way they are rotated so the same figure can be seen simultaneously from different angles must have enthralled Pucci, as it did Vasari three quarters of a century later.[81] For the culturally sophisticated patron and others among the merchant elite who "understood such matters," the painting afforded a miraculous demonstration of the artist's skill in representing nature or rather what it was in nature that they found important – the amazingly foreshortened soldiers and their weapons, shown before a familiar landscape. It was not only the pagan subjects he treated, but his ability, exploiting the new oil medium, to counterfeit nature with a goldsmith's mastery of detail, which qualified Pollaiuolo to participate in the revived classicism of his time.

Pollaiuolo's meticulously detailed style was ideally suited for small devotional or mythological panels. But with large-scale decorations or altarpieces, such as the nearly 10-feet-high *Martyrdom*, the painter had to execute a wealth of precise details which constituted the reality of the representation. The looser brushwork Antonio occasionally employed was only a partial solution to the problem. The immense labor involved in completing monumental works in his new realistic style

obliged him to seek assistance. Pollaiuolo, accordingly, employed his younger brother Piero (1441/43-96) in this capacity. Though Antonio specified that (the seventeen-year-old) Piero assisted him in finishing the *Labors of Hercules*, the documentary evidence for their collaboration is ambiguous or misleading. Both artists were paid 100 florins in advance for the altarpiece in the chapel of the Cardinal of Portugal, but that does not help us in determining their respective shares in the picture.[82] And the documentation about their working arrangements is even more puzzling.[83] Antonio divided his shop with other goldsmiths, while Piero used part of a small house (next to the family dwelling) to exercise his calling as a painter. There is no record of any premises where the two brothers worked together, and yet, according to Vasari, they repeatedly joined forces.[84] The problem is that the early sources look favorably on Piero (Vasari even makes him Antonio's teacher), whereas the visual evidence of their pictures clearly demonstrates Antonio's superiority. The sheer ineptitude of Piero's signed or documented works shows that despite recent misguided attempts to redeem him, Berenson was right to disparage his efforts.[85]

Scholars will probably never agree on the precise division of labor in collaborative ventures like the *Three Saints* or the *Martyrdom*.[86] For our purposes it is enough that Antonio, used to working on a small scale, frequently turned to Piero for assistance in executing his designs. The level of accomplishment Piero brought to the task can be seen in the Berlin *Annunciation* (Fig. 12), acknowledged to be mostly his own independent work.[87] In this overwrought and clumsy picture,

12 Piero Pollaiuolo, *Annunciation*, Gemälde-galerie, Berlin.

Piero in effect produced a caricature of his brother's style. Such large-scale paintings for which Piero was wholly or partly responsible point to a problem inherent in the workshop system that had long prevailed in Florence. There and elsewhere in Italy both the arts and the crafts were a family affair, guild rules making it cheaper for close relatives to become members. Where artisans producing a commodity were concerned, it mattered little that father and son or brothers were not equally gifted. But pictures like the *Three Saints* or the *Martyrdom* have a complex aesthetic structure that could easily be compromised if one of their joint creators lacked the aptitude of his partner. Nevertheless, Antonio (evidently cherishing the brother with whom he is buried) employed Piero as an assistant despite his lack of talent. Reflecting the difference in age and ability, however, Piero's role was that of a subordinate. And the projects he carried out were not limited to painting. Before helping to construct Antonio's two great papal tombs in Rome, for example, he vied for the commission for another sculptural monument, this one commemorating Cardinal Forteguerri in Pistoia Cathedral. Acting as his brother's surrogate, perhaps, Piero here took on Verrocchio as a rival. The commission had first been awarded to Andrea on the basis of a model (Fig. 136) he submitted which differs considerably from the monument in its present much-altered state.[88] The price Verrocchio asked was deemed too high, however, and the church authorities subsequently opted for Piero's plan, which was probably cheaper. Lorenzo de' Medici, deemed an expert judge in matters of taste, was called in to arbitrate the contest; after comparing both artists' models, he seems to have decided in Verrocchio's favor.

Antonio Pollaiuolo, we have found, was greatly admired by his patrons, to judge from their testimony, and his innovations in subject matter, style, and technique undoubtedly impressed Verrocchio as well. The difference is that while the *cognoscenti* had little concern as to how Pollaiuolo created his pictures, Andrea approached them from the inside, analyzing as a fellow artist the accentuated realism for which Antonio was becoming famous. Sometime in the later 1460s, Verrocchio proceeded to take up painting in emulation of his rival. He did so – and this is of crucial importance here – at the very moment when Leonardo began to work with him. Had Verrocchio not taken up the brush at this time, Leonardo might conceivably never have become a painter.

2 Verrocchio the Painter and His Shop

Verrocchio's reputation as a painter has suffered from Vasari's disparaging appraisal of his work as "somewhat hard and crude." And the Vasarian notion that Andrea abandoned painting in disgust likewise led critics to demean his efforts. The artist's paintings "do not stir the imagination," Clark complained. "The world they create for us is the prosaic world of a practical man; whereas in Verrocchio's sculpture there is a suggestion of the incalculable forces and fantasies which we associate with Leonardo."[1] Yet, if the *Christ and St. Thomas* group at Orsanmichele in Florence had a lasting impact on the painter of the *Last Supper*, Verrocchio's pictures cannot be dismissed as irrelevant to Leonardo's formation. On the contrary, they served as a springboard for the younger artist to develop his own radically different style, and for that reason it is essential for us to know what Andrea painted. The difficulty is that while his influence on other artists is undeniable, Verrocchio's output as a painter remains unclear: we can broadly identify his style but not a core of agreed-upon autograph works.

Three extant paintings, all of them altarpieces, are linked with his name by documents and early sources. One, the so-called *Madonna di Piazza* (Fig. 144), still *in situ* in Pistoia Cathedral, is documented within Verrocchio's lifetime as having been ordered from him, while the other two, the *Baptism* (Fig. 18) from San Salvi and a *Virgin and Child Enthroned with Saints* (Fig. 24), now in the Museum of Fine Arts, Budapest, are attested as Verrocchio's by Vasari and, in the case of the Uffizi picture, his written sources.[2] Comparison shows, nevertheless, that these three works, though similar in style, are not by the same hand. Most scholars now agree with Vasari that the Pistoia altarpiece was executed by Credi. The *Baptism* is not entirely by Verrocchio either. And the Budapest *sacra conversazione* has been plausibly assigned to a minor figure who worked in Verrocchio's shop. Thus, none of the paintings associated with Andrea at an early date is unequivocally by him. To these large productions must be added an equally problematical series of smaller devotional pictures in Verrocchio's style. Consisting mostly of paintings of the Virgin ascribed to the master by Bode, few of these works were accepted by later writers, who distributed them among various members of the shop.[3] Their attributions are so contradictory, in fact, that some scholars even began to doubt whether Andrea had ever been a painter.[4]

Despite the occasional claim that Verrocchio was only an entrepreneur or teacher of painting, it is hard to see how he could impart a skill he failed to practice. Nor is there any lack of documentation to show that Andrea was active in this field. Much of this evidence will emerge in the following pages; here it may suffice to mention that Tommaso's inventory of his brother's works includes two painted tournament standards, one of 1469 and another of 1475, as well as a (lost) portrait painting of Lucrezia Donati for Lorenzo de' Medici.[5] In addition, Verrocchio was paid in 1475 for supplying another processional banner, for the city

13 Detail of Fig. 29.

23

of Carrara, which provided marble to Florentine sculptors.[6] To these commissions should be added the fact that he belonged to the painters' confraternity in 1472. Of course, such records do not necessarily mean that Verrocchio himself practiced painting. But given the frequency with which he was called a painter, it seems fair to assume that he worked in that capacity.[7]

By contrast with earlier monographs on Verrocchio, which deal only marginally with this aspect of his art, Günter Passavant made a special study of Andrea as a painter. In his extremely thorough handling of the subject, published in 1959, the author reconstructed Verrocchio's painted oeuvre by comparison with his sculpture.[8] After a careful review of the documentary evidence and the literature, Passavant allotted an entire chapter to each of the five pictures he accepted as authentic. Around Verrocchio's share in the *Baptism* he grouped the *Madonna with the Seated Child* (Fig. 29); the *Crucified Christ with Sts. Jerome and Anthony Abbot* (Fig. 15); the *Tobias and the Angel* (Fig. 38); and part of the Pistoia altarpiece (Fig. 144). As for the chronology of these works, Verrocchio's style evolved, according to Passavant, from the sculptural *Madonna, Christ,* and *Tobias,* which he placed in that order in the late 1460s and early 1470s, through the *Baptism,* dating from about 1475, to the altarpiece in Pistoia, which, after Andrea began it in the late 1470s, was completed by Credi during the next decade.

Having examined this comparatively neglected side of Verrocchio, Passavant then published a comprehensive edition of the artist's work in all media.[9] Fortunately for non-specialists, the section on paintings summarizes the conclusions reached earlier. The merit of Passavant's analysis is that it succeeds in separating Verrocchio's own efforts from the imitations of his pupils and followers and in offering a cogent definition of the painter's style as the pictorial equivalent of his sculpture; both emphasize the solidity of forms in motion. But the virtue of Passavant's study – its focus on Verrocchio's individuality – is also its failing in that the author's attributions of works surrounding the master are less persuasive. Nor do we gain much real understanding of Andrea's role as head of a busy workshop or of how the shop functioned to produce paintings.

Painstaking though it is, Passavant's reconstruction did not prove definitive. The evidence regarding Verrocchio as a painter is so scanty that other scholars have continued to offer opposing views about his development. In each case, however, the pictures they have given to Andrea, while reflecting his style, seem to belong to other artists. Thus, the additions one writer proposed turn out to be largely by Botticini.[10] Another candidate, a half-length *Virgin* (Fig. 14) in the Courtauld Institute Galleries, London, which prompted John Shearman's re-evaluation of early Verrocchio, shows stylistic affinities with a second *Virgin* in the Hermitage, St. Petersburg; indeed both appear to be the work of an unidentified personality between Verrocchio and Pollaiuolo.[11] And lastly the Budapest altarpiece (Fig. 24), though restored to Andrea by Konrad Oberhuber, still finds the majority of critics favoring his pupil Biagio d'Antonio.[12]

Three of the pictures Passavant ascribed to Verrocchio – the *Madonna,* the *Tobias,* and part of the *Baptism* – appear consonant in style and quality and are, therefore, convincing as his work. And the *Crucified Christ with Sts. Jerome and Anthony Abbot,* formerly in the church of Santa Maria in Organo, at Argiano, south of Florence, is possibly by the artist, too. The divergence of opinion about this small altarpiece (missing since 1970) might make it seem a poor choice to mark Andrea's début, yet the various solutions offered have a common thread in our artist.[13] And if the picture really is by him, as seems likely, it offers a valuable clue

14 Verrocchio workshop, *Virgin and Child,* Courtauld Institute Galleries, London.

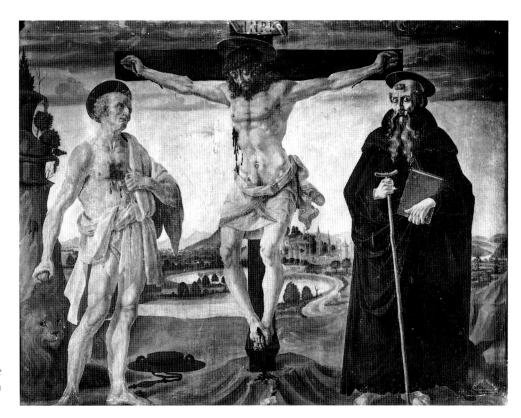

15 (?)Verrocchio, *Crucified Christ with Sts. Jerome and Anthony Abbot,* formerly Santa Maria in Organo, Argiano, near Florence.

to his beginnings as a painter. These have to do with Pollaiuolo, but that is not to say that Verrocchio ever studied with his arch-rival. Rather, Antonio's work served Andrea as a constant reference point. The most striking figure in the picture is that of St. Jerome, who, turning toward Christ with a rapt expression, lends a dramatic note to the otherwise meditative scene. The beardless ascetic type of the saint was introduced into Florentine painting by Castagno.[14] But he was not Verrocchio's only source, as two other representations reflecting the Castagno type can be associated with Pollaiuolo. One of these, a bust-length *St. Jerome* in the Palazzo Pitti, Florence, is so close to the foreshortened head of Verrocchio's saint that it has even been ascribed to him.[15] And the other, a detached fresco of the kneeling saint from the church of San Domenico in Pistoia, has also recently been given to Andrea.[16] Both works appear to be by different hands close to Pollaiuolo, which raises the question of whether Andrea knew some depiction of Jerome by Antonio. The existence of such a work is rendered more likely by a fifteenth-century Florentine engraving (Fig. 16) of the penitent saint, which reflects a Pollaiuolo drawing in the Uffizi.[17] All this suggests that Andrea may, like the authors of the devotional panel, the fresco, and the print – and like Leonardo, as we shall see – have found his inspiration in Pollaiuolo.

With attention focused on St. Jerome, the significance of the Christ figure for Verrocchio's origins as a painter has been overlooked. The bony, broad-featured face, framed by curly hair, is typical of Andrea. But it is the figure's nearly nude body that concerns us here. In contrast to Castagno's more summary anatomical renderings, Verrocchio's Christ displays the "gladiator physique" of Pollaiuolo's nude male figures.[18] The taut muscular torso and arms and the bent sinewy legs (also of Jerome) recall the rugged anatomies of Antonio's celebrated *Hercules* cycle

16 After Pollaiuolo, *St. Jerome in Penitence, with Two Ships in a Harbor,* engraving, National Gallery of Art, Washington, Rosenwald Collection.

(Fig. 7). Working for the Medici, Andrea would have had ample opportunity to study the canvases Pollaiuolo had painted for their palace on via Larga. The derivation shows that Verrocchio was deeply impressed by what he saw. More than any other artist of his time, in fact, he was prepared to emulate Pollaiuolo's supreme skill, without ever equaling his rival's achievement.[19] Vasari later admired Verrocchio's restoration of an antique statue of *Marsyas*, belonging to Lorenzo de' Medici, as a display of his mastery of anatomy, and he further linked Andrea with Antonio for his expertise in constructing the human figure.[20] As far as we know, Verrocchio did not perform dissections (that came later with Leonardo); he simply adopted Antonio's anatomical formulas. Andrea's originality here lies in the way he combined Christ's downcast gaze with a heroic torso to create a powerful image of resignation and triumph over death.

What is possibly Verrocchio's first picture thus shows him under the sway of Pollaiuolo. The *Crucified Christ* also raises the question of how and from whom Andrea learned to paint. He seems to have taken up painting relatively late in his career (being first recorded in that role in 1469), when he was already an established sculptor. Since Verrocchio cannot have had the usual kind of apprenticeship, must we conclude that he was self-taught? Not likely, given the level of accomplishment reached in his paintings. He must have received some instruction, but from whom? Castagno died in 1457, ruling him out as a potential teacher. And Pesellino died the same year, further narrowing the field. Passavant's theory that Verrocchio was a pupil, alongside Botticelli, of Filippo Lippi at Prato in the early 1460s is untenable on stylistic grounds, though it is true that the vacuum Lippi's prolonged absence created in Florence may have encouraged Andrea to enter the field.[21] Other authors have favored Baldovinetti as Verrocchio's master.[22] Here at least there is a congruence in that the two artists, together with Pollauiolo, constitute a group of realists from the second half of the century, who shared some of the same scientific interests, as well as a common source in the work of Castagno: they started where he (and Domenico Veneziano) left off. What is dubious about all these theories is the presumption that Andrea would, at this stage in his career, have sat at the feet of a peer. More likely, he learned the technique of painting in tempera on panel from a minor practitioner, whose tutelage left no trace on his style. That is exactly how another goldsmith proceeded, according to Vasari, who said that the Bolognese Francesco Francia kept "in his house for many months persons in the profession who taught him the means and manner of painting in such a way that . . . he quickly mastered the practice."[23] Unlike Francia, however, Andrea never seems to have mastered the art of fresco, and so, of course, he never taught it to his pupils Leonardo and Lorenzo di Credi. This is of some importance in view of the experimental approach Leonardo later took to mural painting.

However Verrocchio acquired the rudiments of painting, the question of the origin of his style remains. The example of Pollaiuolo's realism, with its emphasis on the particular, the concrete, and the palpable, was foremost in his mind. And Andrea frequently turned to Antonio for compositional ideas as well, as if to invite comparison with his own creations. But he never adopted his rival's style, and as a result their works are seldom confused. Pollaiuolo's pictures betray a goldsmith's highly detailed approach, while Andrea, once he determined to take up painting, faced the problem of how to translate his own style as a sculptor working mainly in bronze into two dimensions. By the mid-1460s, Verrocchio had a readily available model in the emerging art of engraving. Having begun as a cheap method

of producing religious images, engravings (often colored) were rapidly becoming fine art, Mantegna's visit to Florence in 1466 no doubt having hastened the process.[24] Since the new medium had its origin in goldsmith's work, Andrea could easily have grasped the relevance of printing images from copper plates. Even so he obviously did not set out to imitate prints in his pictures. More like a bridge between relief work and painting, engraving suggested a way to visualize the arrangement of sculptural forms on a flat surface. Significantly, the products of such major early Florentine printmakers as Baccio Baldini and the so-called Master of the Vienna Passion offer numerous analogies with Verrocchio's figural compositions. In many of the engravings, there is a like emphasis on clearly defined figures occupying the foreground at the expense of their setting, barren except for some stylized plants and trees. Whatever his precise relation to printmaking, Verrocchio's work betrays the same near-exclusive preoccupation with the human figure.[25]

With the *Baptism of Christ* (Fig. 18), whose critical fortune is traced in the Appendix, Verrocchio's career as a painter began in earnest. No document records the author or date of the picture; nor do we know anything about the circumstances surrounding its origin.[26] Partly for that reason it is one of the most discussed works in the history of art. Amidst the diversity of opinion, writers agree that the execution of Verrocchio's design is not homogeneous and that the disparity of style results from a collaboration between the master and one or more assistants. The tradition handed down by Vasari and his sources limited Leonardo's contribution to the angel, with the rest of the picture belonging entirely to Verrocchio. Subsequently, Leonardo's share was enlarged to include much of the landscape background and the figure of Christ as well. Verrocchio's role then was further reduced when the main figures in the altarpiece were claimed for Botticelli.[27] All these views contain a measure of truth. We can take the early sources at their word that the *Baptism* was painted by Verrocchio and Leonardo. And the connoisseurs were right that the pupil's share – of which more later – went beyond the angel. It is also true that, omitting Leonardo's part, the painting is still not uniform in style. But that does not mean it is the product of additional helpers. Rather, Verrocchio himself seems to have worked on the picture in two distinct stages. The second campaign is represented by the frontal angel, which must have been done at the same time as Leonardo's in the mid-1470s. What concerns us here is the original state of the *Baptism* in the late 1460s, when, working single-handedly, Andrea was finding his way in a new and unfamiliar field.[28]

When Leonardo went to him for instruction, in fact, Verrocchio himself was still learning how to paint. For his composition, with Christ flanked by the striding Baptist and a pair of kneeling angels, he again turned to Pollaiuolo, to his relief of the same theme on the reliquary cross surmounting the altar of the Florentine Baptistery.[29] Trained as a goldsmith, Andrea would not have hesitated to model his altarpiece, measuring nearly 6 feet high by 5 feet wide, on such a small prototype.[30] The link with his own sculpture is even more cogent. While he was beginning work on the *Baptism*, Verrocchio also undertook the monumental bronze *Christ and St. Thomas* (Fig. 17), made to replace a statue by Donatello in the niche belonging to the Mercanzia (Merchants' Tribunal) at Orsanmichele. The statues were not installed until 1483, but the commission dates from as early as 1466, and the project – the figure of Christ at least – was under way throughout the period of Leonardo's activity in the shop; he must have followed its progress closely.[31] The problem in each case was how to integrate Christ with a second figure. The

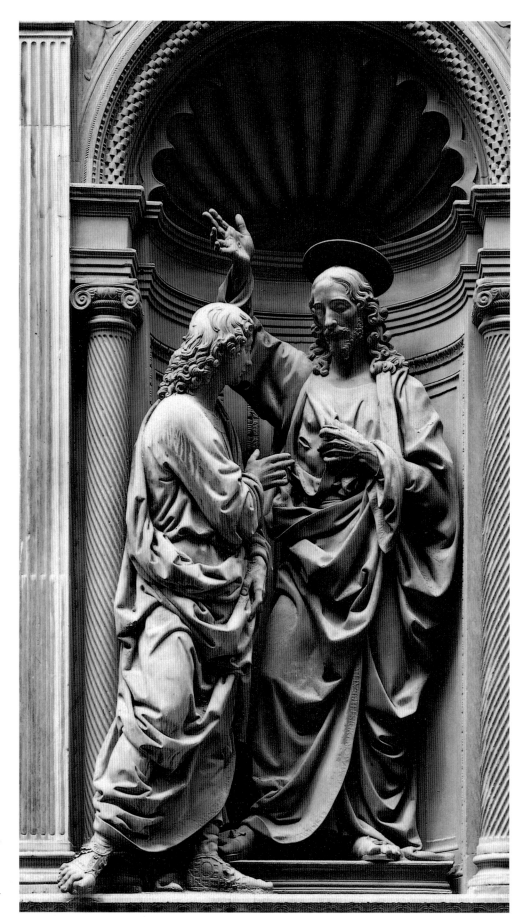

17 Verrocchio, *Christ and St. Thomas*, bronze, Orsanmichele, Florence.

18 (*facing page*) Verrocchio and Leonardo, *Baptism of Christ*, Galleria degli Uffizi, Florence.

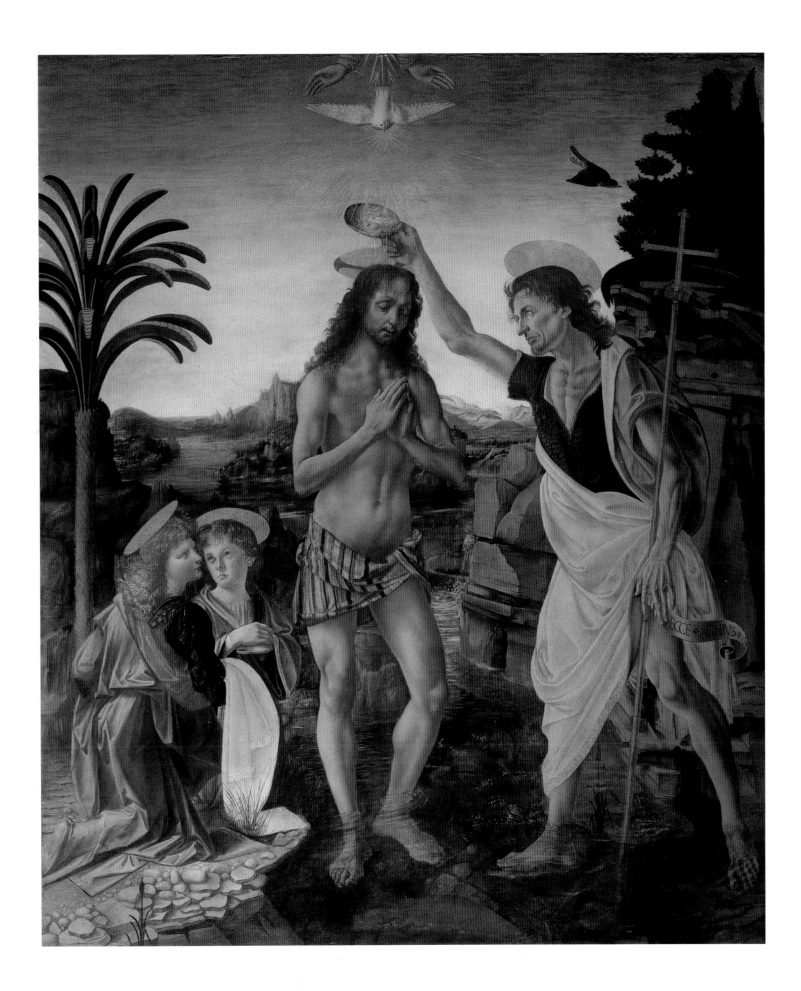

19 Verrocchio, *Head of an Angel*, Gabinetto Disegni e Stampe, Galleria degli Uffizi, Florence.

solution Verrocchio adopted for the bronze with Thomas turning sharply toward Christ recalls the approaching Baptist in the painting. It is even possible, since the sculptor/painter pursued both works simultaneously, that the way Christ's hand is raised over Thomas was suggested by the Baptist's anointing gesture. St. John's other arm, its veins, tendons, and muscles protruding in an anatomical display worthy of Pollaiuolo, has numerous parallels in Andrea's oeuvre.[32]

Verrocchio's original conception for the angels, before Leonardo became involved, is harder to determine. Tradition called for one or more attendants to hold Christ's garments, and there is a black chalk drawing of a youthful head (Fig. 19) by Andrea in the Uffizi, which has been connected with his angel in the painting.[33] The drawing, its outlines pricked for transfer, is a cartoon fragment. But the angel's head in the drawing is significantly larger than its counterpart in the picture. And there are other differences too: the squarer head in the drawing has a lowered glance and (barely visible) wings attached, whereas the wingless being in the painting gazes at his companion. A clue to the relation between drawing and

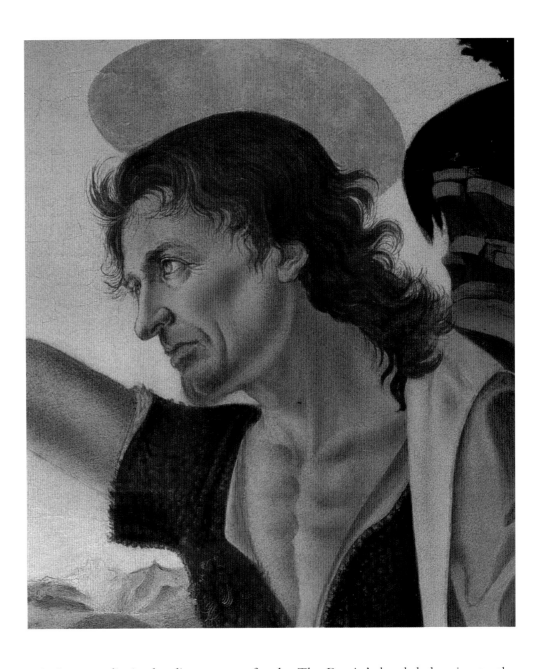

20 Detail of Fig. 18.

painting may lie in the discrepancy of scale. The Baptist's head, belonging to the first stage in the evolution of the altarpiece, is also noticeably larger than that of Christ, whose figure, judging from its style, was painted together with the angels. Could the drawing be Verrocchio's original idea for the right-hand angel, on the same slightly larger scale as the Baptist?[34]

Whether Verrocchio's design for the angels was carried out on the panel and subsequently changed is an issue discussed in the chapter dealing with Leonardo's intervention. The rest of the picture that was not overpainted – the Baptist (Fig. 20) and most of the foreground – has the same character as the Uffizi drawing, with its firm, schematic modeling.[35] Verrocchio, it should always be remembered, was first and foremost a sculptor, and so he naturally took that approach to painting, as did Pollaiuolo, who also practiced both arts. Verrocchio's case, however, involves a more direct translation of sculptural values (and not just a wealth of precise detail) into painting. Since sculpture and painting were a continuum in his shop (Vasari states that he turned from one to the other), it is not surprising that

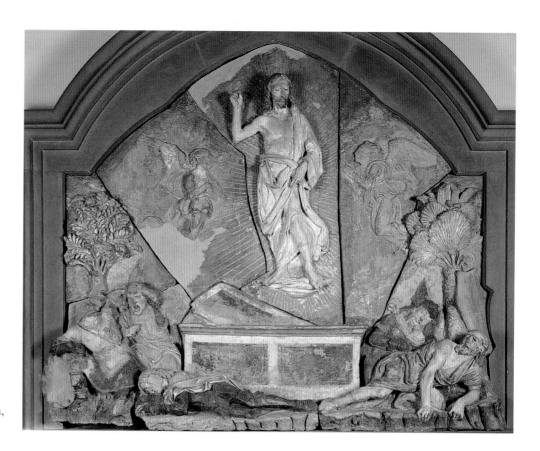

21 Verrocchio, *Resurrection of Christ*, terracotta, Museo Nazionale del Bargello, Florence.

the *Baptism* shows a marked affinity in conception and style with Verrocchio's polychrome terracotta relief of the *Resurrection of Christ* (Fig. 21) in the Bargello in Florence.[36] This relief, of special interest as the only extant work by Andrea that Leonardo directly quotes, was made sometime in the late 1460s for the Medici villa at Careggi, where it was discovered.[37] To grasp the relation between the two works, we must first subtract the pupil's share from the *Baptism*. What remains is starkly sculptural (Fig. 22). Even the landscape motifs – the sharp palm fronds and striated rocks surmounted by trees – almost seem to have been modeled in clay or cast in bronze. And the way they are placed on a platform like props for the figures is analogous to the relief.[38] Verrocchio's feeling for nature and his skill in describing it were evidently much inferior to those of Pollaiuolo.

Also unlike his rival, Verrocchio never seems to have learned how to paint in oil. As far as we can determine from a visual appraisal of his pictures (no media tests have yet been performed), he adopted the traditional egg-based tempera technique, in which forms are built up with a system of finely hatched brushstrokes visible on the surface. Though Andrea never developed the same facility in painting that he had in sculpture, the linearity of tempera, with its emphasis on contours, suited him exactly. Before Leonardo completed it in oil, the *Baptism* must have had an effect not unlike that of pigmented sculpture, in which color is applied to forms modeled in relief.[39] The link between Verrocchio's painting and sculpture – their essential unity – which seems so striking today, was not lost on his contemporaries either, to judge from the praise that Raphael's father Giovanni Santi bestowed on Andrea in his *Rhymed Chronicle*, in which the artist is spoken of as "crossing the bridge" between the two fields.[40]

Considerably larger than the Argiano *Crucified Christ*, the *Baptism* remained

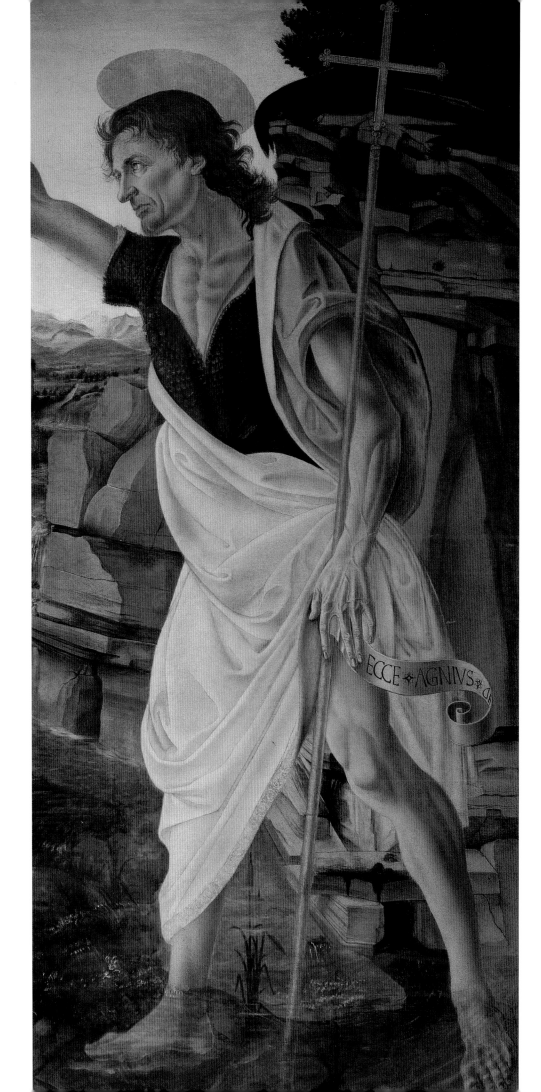

22 Detail of Fig. 18.

unfinished for several years. Such delays in completing projects seem to have been the rule in Verrocchio's *bottega*. The Pistoia altarpiece, for example, was not delivered until a decade or so after it was ordered, and another "quadro grande" was still in the shop at the time of the master's death in 1488. The latter was probably left incomplete, as its subject (unlike others on the list of works Credi inherited) is not specified.[41] Years later Verrocchio's failure to finish paintings puzzled Vasari, who wrote that Andrea "prepared cartoons . . . for narrative pictures and afterwards began to execute them in colors, but for whatever reason they remained unfinished."[42] Like Pollaiuolo, Verrocchio needed assistance in fulfilling large-scale painting commissions, and he may also have wanted to expand his activity as a painter beyond what he could personally accomplish. For both of these reasons he seems to have recruited a group, or rather a series, of helpers beginning with Leonardo around 1466. Fortunately, without an Achilles heel in the form of an incompetent painter-brother, Andrea could turn to the most gifted members of the younger generation, whom he chose for their ability.[43] Though often lumped together, the artists whose services he enlisted actually fall into two separate categories. The first, including Leonardo and Lorenzo di Credi, consists of pupils, who started out as apprentices and afterwards stayed in the shop as long-term assistants. The second and more numerous category is made up of previously trained assistants. This group divides in turn into the above-mentioned Biagio d'Antonio and Botticini, who soon switched allegiance to other masters, and into a second subgroup formed by Botticelli, Ghirlandaio, and Perugino, who became famous in their own right. A few other assistants remain anonymous.[44] To the pupils and assistants, then, should be added a host of followers, like Luca Signorelli, who were lastingly influenced by Andrea, but whose works are not close enough to his to posit a stay in the shop, where they would have encountered Leonardo.

The humanist Ugolino Verino hailed Verrocchio as a "fountain from whom painters imbibed whatever [skills] they have" and as the "master of painters whose fame [literally, name] flies through every city of the Tyrrhenian region."[45] Verino's statement to the effect that Andrea educated the best Italian painters of his day has led to the widespread notion that his shop was crowded with prodigies. The *bottega* may indeed have been the crucible for a generation of Florentine artists, but that does not necessarily mean that the painter/helpers were all there at the same time. Some shops, like the well-documented one of Neri di Bicci, employed a variety of assistants to meet the demand for the master's work.[46] Other artists, like Fra Angelico, hired assistants, in the sense of journeymen, to complete particular projects as needed.[47] But there is nothing to suggest that Andrea ever ran a kind of factory, nor did he undertake such large-scale short-term projects as a fresco cycle, requiring temporary help. In fact, there is no reason why Verrocchio's principal assistants, apart from the long-staying Leonardo, should not have succeeded each other, rather than coinciding all at one time. That said, the artists involved did not just drift in and out of the shop; they were there for a purpose. If we recall the dynamic underlying much of Verrocchio's work – competition with Pollaiuolo – his goal may have been simply to find a suitable painting assistant, a talented Piero Pollaiuolo, let us say. There is every possibility that Verrocchio's first choice, the young Leonardo, quickly proved to be as dilatory as we know him to have been later.[48] If Leonardo did not spearhead the production of paintings, Andrea would have been obliged to bring in Botticelli, Ghirlandaio, Perugino, Credi, and the others, arriving, overlapping, and departing more or less in that order. Significantly, their shop work, in so far as it can be identified today,

is not interrelated, except for having Andrea as a common source. The turnover of talent, assuming it took place, indicates that Verrocchio's *bottega*, as far as painting goes, was probably not the sort of vast collective enterprise that his chief assistants (other than Leonardo) subsequently set up.[49]

As Martin Kemp has noted, our understanding of the early Leonardo would be greatly improved if we had a better idea of how painting was pursued in Verrocchio's shop.[50] Unfortunately, there are no written agreements, identifying the master's assistants and stipulating the length and terms of their employment, no account books, no contracts or commissions, and no payment records to indicate how the shop functioned as far as painting is concerned.[51] The available documents – Andrea's tax returns or the legal charge placing Leonardo in the *bottega* – either reveal nothing about their art or are misleading, as is the notice about the *Madonna di Piazza*, which names Verrocchio, even though the picture was, as the recent cleaning demonstrates, painted by Credi.[52] Consequently, the inner workings of the shop can only be reconstructed from the art produced there. Alas, even the visual record is unsatisfactory, for while the documented paintings (except the Pistoia altarpiece) are lost, those that survive are not signed or dated. Faced with these obstacles, scholars have been hard put to explain the organization and practice of painting in the shop. The validity of their hypotheses not only rests on the correctness of the attributions on which they are based; it also depends on how well the paintings in question fit into a plausible scheme describing their relation to each other and to later and more certain works by the same artists.[53] One such scheme involves collaboration, now the catchword in workshop studies. The practice was commonplace, to be sure, but Verrocchio for his part does not seem to have had a cadre of collaborators: the only painters with whom he worked jointly were his pupils, first Leonardo and then Credi, and the nature of the collaboration varied in each case according to their merits.[54] Meanwhile, the older and more independent assistants were engaged in turning out works in the master's style. The effort to differentiate between these Verrocchiesque products admittedly runs contrary to the cooperative spirit in which they were made. But differentiate we must if we wish to understand the context from which Leonardo emerged.

Three years or so after Leonardo joined Verrocchio, the Pollaiuolo brothers won a major painting commission for a series of *Virtues* to decorate the council chamber of the Mercanzia. Both Andrea and Antonio had already received orders from the same patron, the former for the *St. Thomas* group at Orsanmichele and the latter for designing the set of embroideries with scenes from the Baptist's life, now in the Museo dell'Opera del Duomo. The history of the *Virtues* indicates that Verrocchio, having recently taken up painting, intervened in the hope of securing one or more of the figures for himself.[55] The visual evidence, including that of drawings related to the *Virtues* in the Uffizi, further suggests that Antonio and Andrea relied on assistants to carry out the project. The competition, in other words, involved both the rivals and their shops. Piero Pollaiuolo obtained the commission in August 1469, but Antonio was clearly the creative force behind his brother's efforts. It was he who furnished the design on the reverse of *Charity*, and after that panel was accepted, Antonio also painted the greatly superior *Prudence* to serve as a guide for Piero, the quality of whose work he was asked to guarantee.[56]

Later that year, however, Verrocchio submitted a design for *Faith*, which the council, meeting on December 18, rejected in favor of the Pollaiuolo brothers. Andrea's cartoon is lost, but a version of it survives in the Uffizi. Though sometimes attributed to Botticelli, the drawing (Fig. 23) appears to be by Biagio

23 Biagio d'Antonio, *Faith*, Gabinetto Disegni e Stampe, Galleria degli Uffizi, Florence.

d'Antonio.[57] If, as the drawing suggests, the unsuccessful cartoon for *Faith* was actually the work of Verrocchio's assistant, it would help to explain the paltry sum Andrea was paid for it and why the master failed to win the commission. Whatever the case, we must turn for a moment to Biagio, who seems to have been the first acolyte, after Leonardo, to enter the shop. Vasari and others mistook Biagio's *Virgin and Child Enthroned with Saints* (Fig. 24) in Budapest as Verrocchio's, as its style is close to his share in the *Baptism*.[58] The altarpiece is, in fact, the largest and most ambitious of a group of panels, dating from the late 1460s, in which Biagio imitated the hard surface of the master's style but not its underlying solidity, which reflects his origins as a sculptor.[59] Not surprisingly, perhaps, the year after the Mercanzia débâcle we find Biagio sharing a shop with another artist.[60] His later work betrays an increasing involvement with Ghirlandaio.

Biagio's limitations can hardly have escaped his master, who, if he wished to surpass the Pollaiuolo *Virtues*, needed more expert assistance. Fortunately, help came his way, not from Leonardo, as we might expect, but from Sandro Botticelli. With his aid, it would seem, Andrea turned failure into success. Botticelli completed the *Fortitude* (Fig. 25), now in the Uffizi together with the six other *Virtues* for the Mercanzia, in mid-1470 after a patron procured the commission on his behalf.[61] The picture is unique in his oeuvre. Seated on an elaborate throne, the elongated figure conforms to the formula established by the Pollaiuolo brothers,

24 Biagio d'Antonio, *Virgin and Child Enthroned with Saints*, Museum of Fine Arts, Budapest.

25 Sandro Botticelli, *Fortitude*, Galleria degli Uffizi, Florence.

but the facial type is distinctly like Verrocchio's (Fig. 19), and the style, for all its fluid grace, is deeply indebted to him as well. Trained as a goldsmith, according to Vasari, Botticelli here produced a stunning masterpiece in the new realistic mode.[62] The question arises, then, of whether the artist painted his most Verrocchiesque work as a member of Andrea's shop. Was Botticelli working for Verrocchio, who used the younger and, it must be admitted, more gifted painter as a surrogate in the competition with Pollaiuolo? If Andrea and Sandro did join forces, it cannot have been for long, as the latter already had his own shop in 1470.[63] The notion that Botticelli was a major player in the *bottega*, assisting Andrea on the *Baptism* and other paintings, can be dismissed, therefore, on documentary as well as stylistic grounds.[64] As for the *Fortitude*, there is no way of knowing whether it was executed under Verrocchio's auspices, but it does look strikingly like the master's work, and so it must have appeared to his contemporaries. In that sense at least, Botticelli's picture, compared with Piero Pollaiuolo's insipid *Virtues*, would have constituted a triumph for Verrocchio.

The *Fortitude* is a special case, for the genre in which Andrea's shop excelled was the half-length Madonna. No such devotional images by the Pollaiuolo brothers survive, suggesting that Antonio acknowledged his rival's superiority in this category and left it to him. The concept of Verrocchio's influence, customarily invoked in discussing these Madonnas, is unhelpful, as it begs the question of how the assistants assimilated his art. The works painted in the shop reveal a pattern whereby the master supplied a small number of models for his assistants to imitate. This method of exercising artistic control differed from the mechanical way that Verrocchio's marbles were reproduced in cheaper materials, like stucco, which were frequently painted and gilded.[65] In contrast to the sculptural replicas, the high-quality Madonnas painted in the *bottega* have a more complex origin in that the prototypes they imitate were varied according to the individual author. The Virgin's head in one of these paintings (Fig. 14) diverges from Verrocchio's usual type to echo Roger van der Weyden.[66] A second version of the *Madonna with the Blessing Child* in Frankfurt adopts the same basic figure group, but in a different setting.[67] Yet another variant of Verrocchio's now-lost prototype, by the young Perugino (Fig. 33), is discussed below.[68] Though presumably supervised by Verrocchio and bearing his stamp, these works differ in detail and in scale (showing they do not employ a cartoon by the master). As for the commercial side of their production, we do not know whether they were commissioned from Andrea, completed on his behalf, and sold, like the Pistoia altarpiece, as his own work, nor do we know whether the assistants received a fixed salary, as Credi did later, or were paid, as it were, for piecework.

Of all these half-length Madonnas, the one in the Metropolitan Museum, New York (Fig. 26), comes closest to Verrocchio in its strongly plastic style.[69] The author of the painting, Passavant suggested, was probably Francesco Botticini, who seems to have gravitated to Verrocchio's shop around 1470.[70] Whether Botticini's or not, the Child standing on a parapet has been thought to reflect a motif Verrocchio glimpsed on a documented trip to Venice in 1469.[71] In reality, the infant is based on Andrea's own invention, as we can tell from a sheet of life-studies by him in the Louvre (Fig. 28).[72] This pen and ink drawing shows a precision of eye and hand that prefigures Leonardo's rapid sketches of infants in motion. From it we can understand why Andrea was called Verrocchio or "true eye," a nickname punning on his remarkably keen powers of observation.[73] Aside

26 Verrocchio workshop, *Virgin and Child*, Metropolitan Museum of Art, New York.

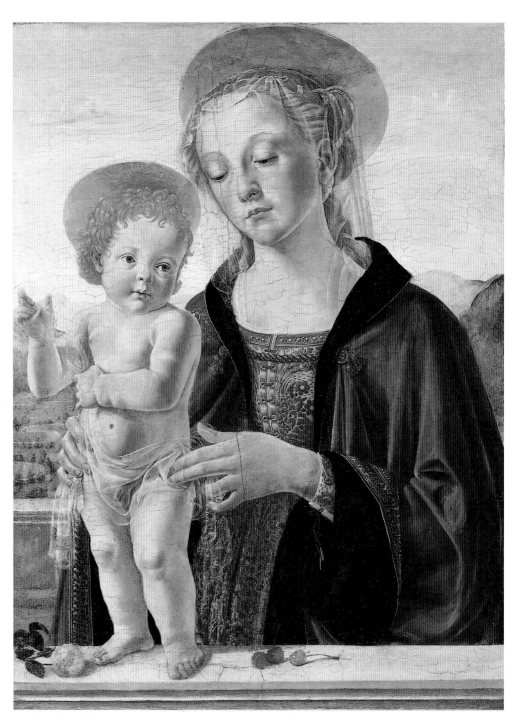

27 Verrocchio workshop, *Studies after a Model for an Infant*, formerly art market, London.

28 Verrocchio, *Studies of Infants*, pen and ink, Département des Arts Graphiques, Musée du Louvre, Paris.

from life-studies, he also made use of three-dimensional models. One such model is recorded in a shop drawing (Fig. 27) in which an infant, identical with the one in the painting, appears in three different views.[74] The creative procedure of the master and his painting assistants thus becomes clearer: Verrocchio drew upon his experience as a sculptor and draughtsman to formulate pictorial prototypes. The example they set for Andrea's helpers was not rigid, however. And the assistants' styles did not have to be absolutely uniform either. Indeed, before abandoning it, Leonardo would stretch the master's style to its limits.

Another picture by Verrocchio had the same paradigmatic function, inspiring a

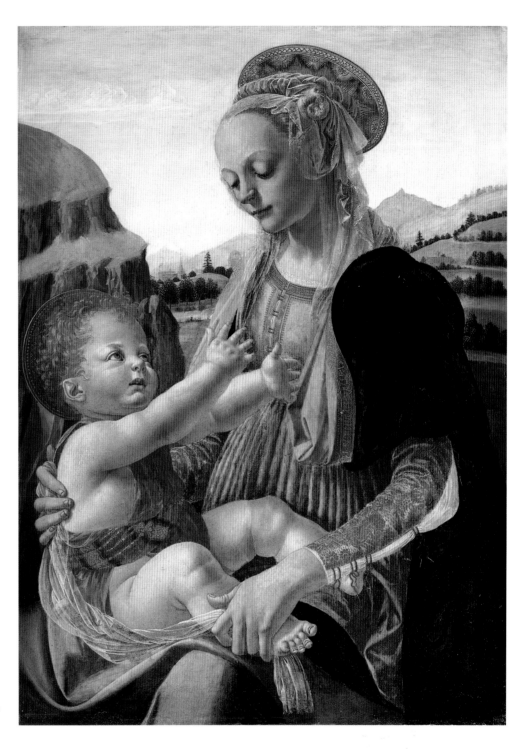

29　Verrocchio, *Madonna with the Seated Child*,
Gemäldegalerie, Berlin.

second series of Madonnas that includes Leonardo's in Munich (Fig. 122). In this
instance, however, the prototype – the *Madonna with the Seated Child* (Fig. 29) in
Berlin – survives. Since Bode first acquired the panel in the 1870s, his attribution
to Verrocchio has found wide acceptance.[75] The composition, with the three-
quarter-length Virgin seated sideways and holding the Child on her lap before a
landscape background, may derive, as Passavant has claimed, from a similar formu-
lation by Filippo Lippi.[76] But the resemblance ends there. In style Verrocchio's
picture does not recall Lippi or any other painter; instead, in a way peculiar to him,
it was conceived and executed like a relief rendered in two dimensions.[77] Because

it is homogeneous, moreover, the *Madonna* offers a better indication of his manner than does the *Baptism*.[78] As in a relief, the massive figure of the Virgin defines the pictorial space. And the treatment of her costume adds to the effect of something powerfully real, both the red and gold brocaded sleeves and the light blue robe, which turns back over her shoulder and supports the infant. The spontaneity of the Child (Fig. 30), eagerly reaching out to his mother, recalls the Louvre sheet once more, and his action and her tender glance give the picture a distinctly psychological dimension. By setting off the figures, the landscape, such as it is, serves the artist's goal of expressing their interaction.[79] Andrea's depiction of nature appears all too perfunctory compared with the obvious delight he took in rendering the veil coiling around the Virgin's head (Fig. 13). Though he borrowed this motif from Lippi, Verrocchio gave it an artificial quality that is entirely his own. We are reminded of the ancient Polygnotus, whom Ghiberti credited with being the first to paint women with elaborate hairdresses in order to demonstrate the nobility of art.[80]

A variant of Verrocchio's picture (Fig. 31) in Washington suggests that its author Domenico Ghirlandaio may, like Biagio d'Antonio, Botticelli, and Botticini, have been associated with Andrea.[81] In this *Virgin and Child*, dating from the mid-1470s, the composition and motifs, like the sturdy infant's colorfully striped sash, derive from Verrocchio. But the style of the painting finds a closer analogue in the artist's own frescoes with their broad treatment of forms.[82] Taken as a whole, Ghirlandaio's works show that he really belonged to the monumental current in Florentine painting begun by Masaccio and carried on (and considerably modified) by Filippo Lippi.[83] "Pronto, presto, e facile," as Vasari described him, Domenico strove to simplify Verrocchio's hyper-realism, which was unsuited for fresco. But when he was not painting frescoes in country churches outside Florence, the young Ghirlandaio might have found Verrocchio's *bottega* a convenient base for working in the city. Indeed, a few panel paintings are contested between the two artists. Though lacking Verrocchio's sharp plasticity, these works are nearer to him in style than is the Washington picture. And their links with the shop are such that one of them (Fig. 32), known from its former owner as the Ruskin *Madonna*, has even been ascribed to Leonardo. Most aspects of this damaged but important picture, now in Edinburgh, including the way the space is organized architecturally, point to Domenico as its author.[84] And the interior setting in another of the disputed paintings, a *Virgin and Child* in the Louvre, given to Ghirlandaio by Berenson, betrays the same keen interest in Netherlandish art taken by other members of the shop.[85] A third *Virgin and Child*, whose attribution is debated between Andrea and Domenico, in the monastery at Camaldoli, goes back to the (lost) Verrocchio prototype with the standing Child.[86]

The last of Verrocchio's pre-trained assistants (as opposed to his pupils) seems to have been Pietro Perugino. The proof of his activity in the shop goes beyond the variants that he, like Ghirlandaio and the others, made of the master's prototypes. Three times Vasari cited the Umbrian artist as having studied with Verrocchio alongside Leonardo and Credi.[87] Scholars tended to downplay Perugino's membership in the *bottega* until Federico Zeri supplied the visual evidence needed to corroborate Vasari in the form of a group of Verrocchiesque paintings he and others have attributed to the younger artist.[88] Zeri's reconstruction has not been universally accepted, however, and it is true that the early oeuvre he proposed for Perugino is not all homogeneous.[89] Two of the attributed paintings of the Virgin

30 Detail of Fig. 29.

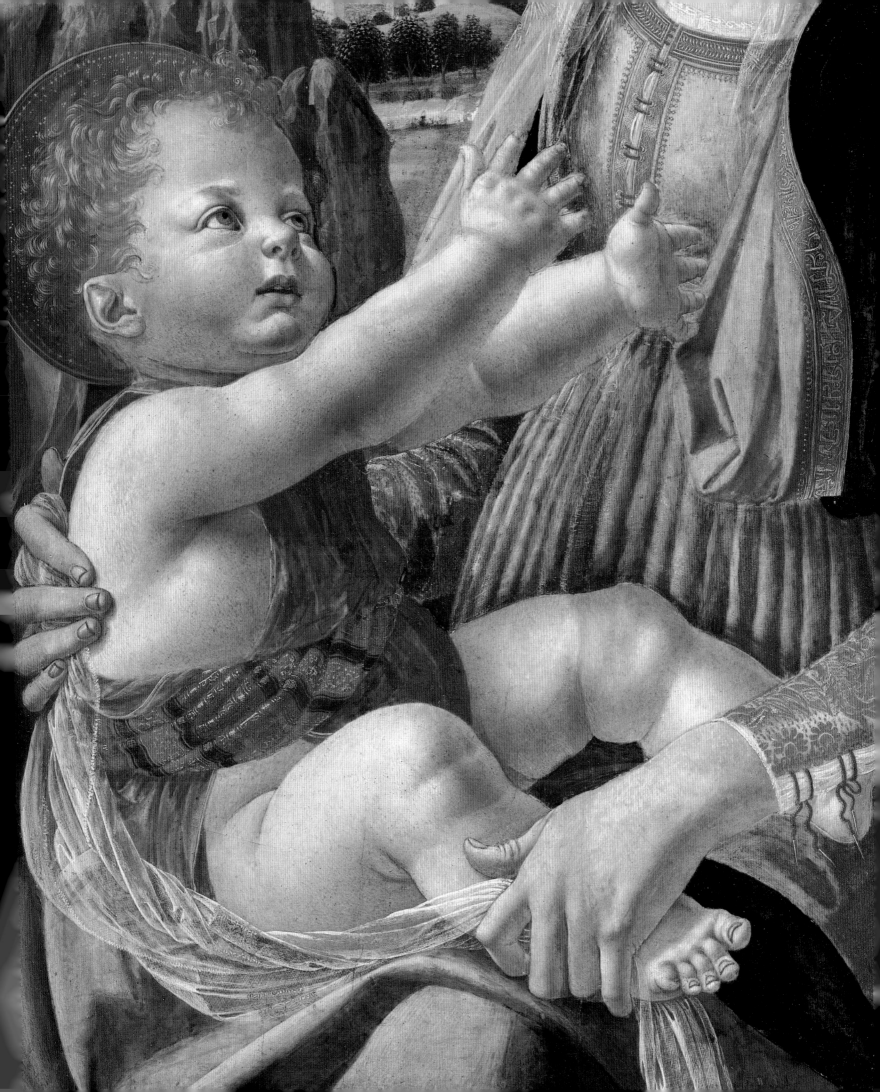

31 (*above left*) Domenico Ghirlandaio, *Virgin and Child*, National Gallery of Art, Washington, Samuel H. Kress Collection.

32 (*above right*) Ghirlandaio in Verrocchio's shop, *Virgin and Child* (the Ruskin *Madonna*), National Gallery of Scotland, Edinburgh.

are nevertheless convincing, and I shall focus on them in trying to determine Perugino's relation to his master.

The *Madonna with the Blessing Child* (Fig. 33) in Berlin reflects the Verrocchio composition echoed in other works examined above. The figure types and motifs, like the stone parapet or the Virgin's veil and the multicolored sash she winds around her son, are characteristic of Andrea, as is the palette with its emphasis on bright red, blue, and green. But the picture is not by him, as has often been claimed.[90] Comparison with the master's autograph *Madonna* (Fig. 29) in the same museum reveals a totally different sensibility at work in each case. The cool luminous flesh tones, blonde hair, and delicate modeling of the figures all point to the young Perugino as the author of the *Madonna with the Blessing Child*. The spacious landscape, receding into the distance and echoing the gentle mood of the figures, goes beyond anything in Verrocchio, and so do the jewels decorating the Virgin's dress.[91]

Like the Berlin picture, the *Virgin and Child* (Fig. 34) by the same hand betrays a personal approach to Verrocchio consistent with Perugino's later works. Here

42

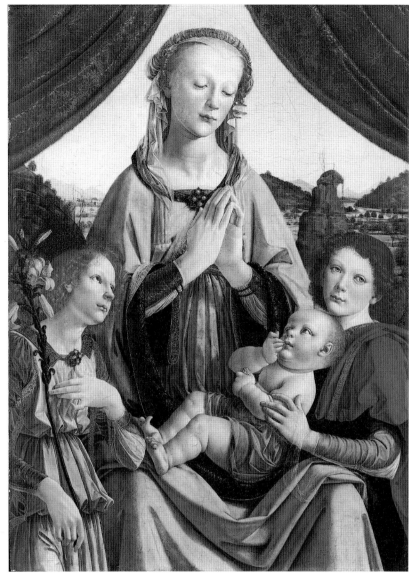

33 (*above left*) Perugino in Verrocchio's shop, *Madonna with the Blessing Child*, Gemäldegalerie, Berlin.

34 (*above right*) Perugino in Verrocchio's shop, *Virgin and Child with Angels*, National Gallery, London.

the protagonists are symmetrically flanked by two angels, one holding a lily and the other supporting the Christ Child on the Virgin's lap. The landscape setting, in which brocaded curtains open onto hills sloping to meet the Virgin's shoulders, is enough to disqualify Verrocchio as the author of the picture.[92] In his shop only Perugino was capable of such spatial clarity – his Umbrian heritage – and the over-refined figural treatment is equally characteristic of the younger artist. Rich textures and lavish ornament here take precedence over the vigor Andrea always gave to his figures.[93] This decorative tendency is best seen in the extensive use of gold for patterned fabrics and jewels; the artist even "gilded the lily." Perugino's Virgin forms the apex of a tall pyramid, and this, combined with her gesture of hands clasped together, has reminded scholars of the Uffizi *Baptism*.[94] It has even been suggested that the angel on the left (Fig. 35) specifically recalls Leonardo's contribution to the altarpiece. If that is the case, the London picture is the only *Madonna* we have examined so far that reflects his presence in the shop.[95] Significantly, perhaps, Giovanni Santi paired Perugino and Leonardo as "two youths equal in age and affection" in his chronicle.[96] The two artists who had worked side

43

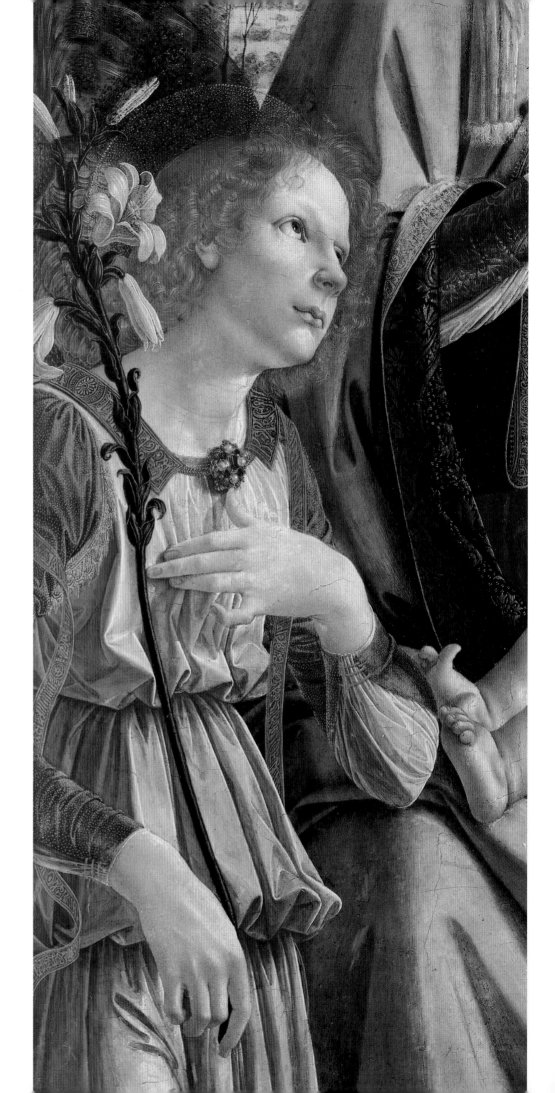

35 Detail of Fig. 34.

by side in Verrocchio's shop must then have seemed more evenly matched than they do now, when Leonardo's superiority is taken for granted. Perugino and Leonardo easily surpassed Andrea as a painter, and reacting to his inadequacy as a naturalist, they both developed original conceptions of landscape. An almost feminine delicacy further differentiates their work from that of the master, as does the tendency they share to sweeten the emotion in his paintings.

This chapter has offered a glimpse into the complexities of the shop which employed Leonardo for the first decade or so of his career. Verrocchio's *bottega* seems to have operated, as far as painting goes, by balancing conflicting goals. The master ensured a degree of conformity among the gifted young painters who assisted him by providing models – at least two half-length Madonnas, one extant and the other lost, as well as the *Baptism* and the *Tobias*, the latter to be discussed in the next chapter. It was through imitating these "translations" of his sculpture that Verrocchio's painting assistants, unversed in marble and bronze, mastered his forcefully realistic style. At the same time Andrea seems to have allowed his helpers considerable freedom; he did not suppress but encouraged individual performance. As a result the works they produced in the shop offer a spectrum of interpretations in which their own distinctive traits come across: Botticelli's feeling for line, Ghirlandaio's tendency to simplify, and Perugino's spaciousness and suavity. What differentiates their work from Andrea's is not so much style or quality as inflections which vary according to each artist's temperament and previous experience. The pictures in which the assistants sorted out their identities in relation to the master are, therefore, not routine shop products. The arrangement by which they were made worked well enough for a while, but it was inherently unstable, in that the practitioners of the shop style, as we may call it, continued to develop individually. The minor talents, Biagio d'Antonio and Botticini, were drawn to their betters, Ghirlandaio and Botticelli, and all these artists, along with Perugino, stayed in the *bottega* for only a short time before becoming full-fledged masters. Under Verrocchio, they made rapid progress toward self-sufficiency, setting up shops and taking on assistants of their own. All but Leonardo, that is.

3 The Apprentice

L EONARDO'S GENERALLY ACCEPTED EARLY PAINTINGS – the Uffizi *Annunciation*,
Ginevra de' Benci, the Munich *Madonna*, and part of the *Baptism* – appear too
accomplished to be his very first efforts. They date from the 1470s, when the
young artist was emerging as an individual in Verrocchio's shop. But if Leonardo
entered the *bottega* as early as 1466 or thereabouts, what, after learning how to
prepare and use materials, did he produce during the years of his apprenticeship?
As a beginner, he had no aesthetic ideal of his own, so the paintings and sculpture
proposed for him here have long passed as Verrocchio's. How can they be shown
to reveal Leonardo's presence? Before examining this hitherto unexplored phase of
his formation, we should recall what Vasari and his sources found most telling
about Leonardo's early works. Along with the baptismal angel and the Medusa,
Vasari described an

> Adam and Eve sinning in the Earthly Paradise, a cartoon for a door-hanging, to
> be woven in Flanders of gold and silk and sent to the King of Portugal. Here
> he did a meadow in grisaille, with white highlights, containing much vegetation
> and some animals, unsurpassable for finish and naturalness. There is a fig tree,
> the leaves and branches beautifully foreshortened and executed with such care
> that the mind is amazed at the amount of patience displayed. There is also a
> palm tree, the rotundity of the dates being executed with great and marvelous
> art, due to the patience and ingenuity of Leonardo.[1]

The cartoon, which, Vasari said, was given to his friend and patron Ottaviano de'
Medici by Leonardo's uncle, is lost, and supposed echoes by other artists lack its
key element – the plethora of carefully rendered natural forms.[2] Nevertheless, it is
this kind of painstaking nature depiction which may help us to distinguish
Leonardo's work as an apprentice.

The first painting in which Leonardo's hand can be plausibly identified is
Verrocchio's *Tobias and the Angel* (Fig. 38) in the National Gallery, London.[3] This
work belongs to a series of similar representations of the theme, which was highly
popular in Florence during the last third of the fifteenth century. In order to
invoke the saint's protection over their offspring, merchants who sent their sons
away on family business, it has been argued, frequently commissioned pictures of
the Archangel Raphael guiding the young Tobias.[4] As for the London painting,
Passavant's attribution to Verrocchio is essential for understanding its true signifi-
cance.[5] For this unassuming little panel, made for an unknown patron and often
dismissed as shopwork, turns out on closer examination to be one of the most
fascinating pictures of the entire Quattrocento. More than any other painting by
Andrea, it is the direct outcome of his rivalry with Pollaiuolo, whose own much
larger version of the theme (Fig. 37), now in the Galleria Sabauda, Turin, is
identical with one which Vasari cited at Orsanmichele.[6] That work was executed

36 Detail of Fig. 38.

37 Antonio and Piero Pollaiuolo,
Tobias and the Angel, Galleria Sabauda,
Turin.

38 (*facing page*) Verrocchio and
Leonardo, *Tobias and the Angel*,
National Gallery, London.

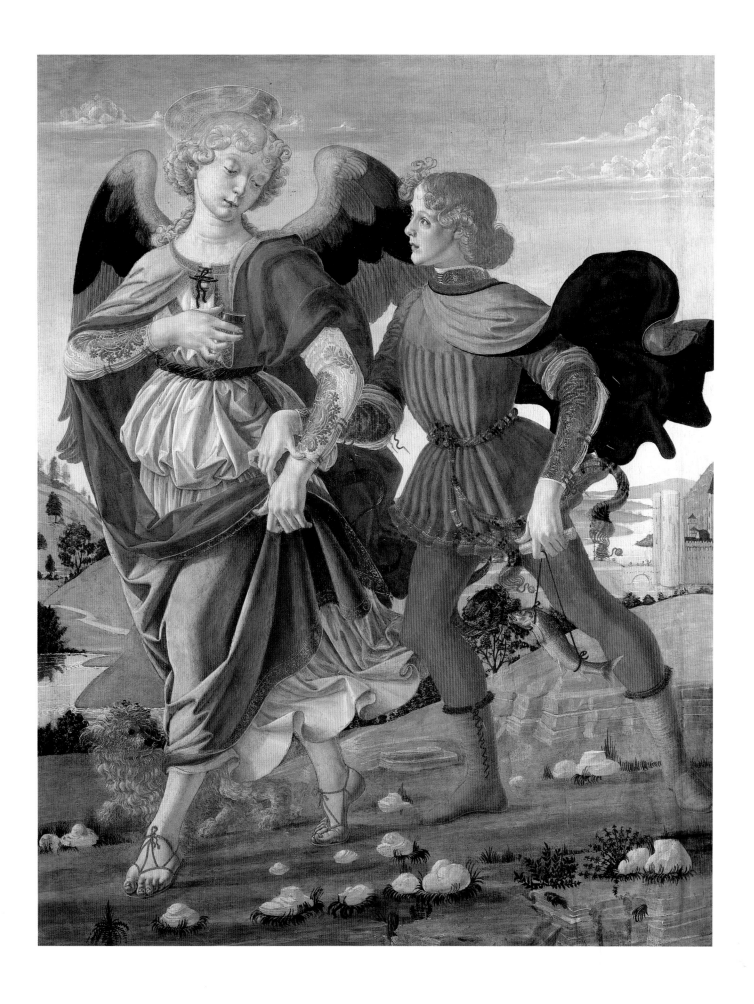

by both brothers in oil, according to Vasari, though the poor condition of the Turin picture does not allow for any clear division of hands.[7] The composition, at any rate, is typical of Antonio with the near-life-size archangel and his companion shown against a vast plain crossed by a winding river. Both figures are fashionably dressed (Tobias wears a traveler's hat) in the manner of the artist's *Three Saints* from San Miniato. And the plants strewn about the foreground are equally realistic, as is the fish Tobias carries on a string. Unlike the monster the boy catches in the biblical text (the Apocryphal Book of Tobit), Pollaiuolo's carp is obviously portrayed from life. The fish's entrails, with which Tobias will cure his father's blindness, are contained in the small jar Raphael holds in his right hand, a metal object of the sort that Antonio fabricated.

While carrying out his own Orsanmichele project, Andrea could easily have inspected Pollaiuolo's picture displayed on a pier inside the church. That he did so is suggested by the close similarity between their depictions, from the basic scheme of large-scale figures striding over a plateau before a distant landscape to details like Tobias's scroll recording the debt he was sent to collect. Assuming that Verrocchio sought to surpass Pollaiuolo's example here as elsewhere, the differences between the two paintings can be seen as Andrea's "corrections" to his model. The main differences concern the figure group, which Verrocchio has given a greater sense of energy and movement. He switched the stance of Raphael and Tobias, who walk hand in hand in the London version, their garments billowing out behind them. And in place of the vacuous expressions in his prototype, Andrea's protagonists exchange meaningful glances. Passavant has aptly compared Verrocchio's treatment, with Tobias pressing forward and Raphael turning back, to the *Baptism* (Fig. 18) and the *Christ and St. Thomas* (Fig. 17).[8] All three creations, in progress in the late 1460s, share a powerful psychological content missing in the work of Andrea's rival. Verrocchio's method of integrating diverse figures in terms of pose, gesture, and expression must have deeply impressed the young Leonardo, whose own manner of psychological portrayal it seems to have prompted.

Since the time of the famous competition for the Baptistery doors in 1401, Florentine artists had made rival versions of the same theme. In the *Tobias* Verrocchio measured himself against Pollaiuolo. The improvements considered so far heightened the devotional impact of the London picture. Other changes favored a greater realism along the lines laid down by Pliny. In his effort to outdo Antonio, Andrea, like his ancient predecessors, sought to create a more convincing illusion of reality. To achieve this goal, he incorporated sculptural elements in his painting. Thus the angel's draperies – the tunic and robe held up to make it easier to walk – seem to have been carved out of marble. And the left hands of Tobias and the archangel, while based on Antonio's, also have an exaggeratedly plastic quality. Their repetition within this picture and in others from the shop (Figs. 29 and 33) points to the use of casts or models of hands, a practice Verrocchio was said to have adopted.[9] For Andrea realism meant the three-dimensionality of relief sculpture, and that is how he conceived his painting. But some aspects of visible reality, like the angel's wings or the landscape, were not amenable to this approach, and here his challenge to Pollaiuolo fell short. The bright-colored appendages Verrocchio gave to his angel are no match for the feathered wings arching protectively over Tobias, which Antonio may have studied from a swan or goose. The motif of the waterside castle that Andrea borrowed from Flemish painting looks clumsy, and the stereotyped clumps of grass and stones offer further proof, if needed, of his indifference to nature.[10]

39 Detail of Fig. 38.

40 Detail of Fig. 18.

Inexperienced as he was at portraying flora and fauna, what was Verrocchio to do about painting the dog and fish that accompany Tobias on his journey? Contrary to what might be expected from an artist whose nature depiction was so deficient, the animals in the London picture, like their human counterparts, outclass Pollaiuolo's. The delightful little dog (Fig. 36) in particular, amiably trotting alongside Raphael, far surpasses its model.[11] Though the small white dogs in both works belong to the same breed, the Bolognese terrier in the London painting is so much more lifelike it must rely on nature studies of the sort that Leonardo produced.[12] As for its execution, the painter manipulated his (tempera) medium to evoke the dog's fluffy coat, just as Van Eyck had done in painting the household pet in his famous *Arnolfini Wedding*.[13] But the Italian set himself an additional task, that of capturing the sprightly movement of Tobias's canine companion.

To account for its superiority over other *Tobias* depictions, William Suida ascribed the dog, as well as the fish, to the young Leonardo in Verrocchio's shop.[14] Unfortunately, only one critic found Suida's proposal worthy of further consideration.[15] Passavant and other scholars writing on Verrocchio dismissed it, perhaps because Suida had a propensity for discovering Leonardo's hand in works in which he did not participate.[16] And yet there is much to recommend his hypothesis for this painting. The dog's coat (Fig. 39) is strikingly similar to the long rippling hair of Leonardo's angel (Fig. 40) in the *Baptism*. Indeed, the terrier's and the angel's curls are almost interchangeable. With its head turned and foreleg raised, mimicking Raphael's posture, the dog also anticipates the over-sized ermine in Leonardo's later *Portrait of a Lady* in Kraków; both animals, however realistic in form and action, are interpreted in the same unmistakably personal idiom.[17] In the *Tobias*, then, young Leonardo may already have proved himself a worthy successor to Apelles' ancient rival Protogenes, whose masterpiece was said by Pliny to have featured a miraculously painted dog.[18]

Like the faithful dog, the fish (Fig. 42) in the London picture was added over the landscape which, with the increased transparency of the paint, now shows through.[19] The two surface details were not an afterthought, however. Pivotal to the story, the fish is a smaller, more accurate, and livelier version of Pollaiuolo's carp: open-mouthed, it appears to swim in the air.[20] And its iridescent scales are brilliantly captured in shimmering specks of gray and white. Even more striking is the head (Fig. 41), especially the liquid eye, which is rendered with a painterly freedom that is truly astonishing. Though still using the traditional medium and technique in which he was trained, Leonardo, nevertheless, achieved remarkable results. But that is not all. Leonardo's fresh-caught fish, if we accept it as his, appears to be the only one in all the Tobias depictions to be shown as eviscerated. In the story, Tobias removes the gall to use as a remedy in restoring his father's sight. In portraying it as bloody, Leonardo shows a real sympathy for the fish's plight, not surprising in one whose compassion for animals was well known. Vasari recounted how he bought and freed caged birds, and a contemporary of the artist's wrote from overseas about a certain tribe "so gentle they do not eat anything which contains blood, nor will they allow anyone to harm a living thing, like our Leonardo da Vinci."[21]

In representing Tobias's dog and fish not as mere attributes but as sentient beings in motion, Leonardo, though only a beginner, spurned the approach to nature that shaped the Turin picture, in which the dog is isolated and the fish is in profile. These characteristics together define a method of animal portrayal going back to

41 Detail of Fig. 38.

42 Detail of Fig. 38.

the turn of the century. At that time Lombard painters and miniaturists recorded their observations of birds and beasts in model-books, which were frequently copied and culled for use in finished works of art.[22] The subjects favored by these artists – horses, hounds, hawks, and hares – were the ones that figured prominently in the courtly hunting culture of their aristocratic patrons. And consistent with their function, the animal images tended to be single static profiles, suggesting that the original models were dead specimens. By mid-century the *natura morta* tradition had spread to Florence. Paolo Uccello, whose animal studies were admired by Vasari, incorporated a variety of fauna, real and imaginary, in the decorations that he, along with Benozzo Gozzoli, painted for the Medici palace.[23] The animals that abound in Gozzoli's *Procession of the Magi*, realistic though they are, lack the vitality that marks Leonardo's first effort as a painter/naturalist. The young artist's achievement here indicates that he was already on the way to gaining that unique understanding of nature for which he was later to become famous. In depicting these and other animals Leonardo must have studied them from life, and he must have done so not once to serve as a pattern but repeatedly, synthesizing his observations in images that surpass any single model.

Verrocchio and his contemporaries would have regarded the dog and fish Leonardo added to the London picture as being of little importance compared with the figures. E. H. Gombrich, nevertheless, linked the animals in the painting with the youthful Tobias, distinguishing their "visually concrete" portrayal from the more symbolic mode of the angel.[24] If Gombrich is right about the connection, we are led to ask whether Leonardo did not have a share in the Tobias as well. Interrelated as they are, the figures of Raphael and his companion could have been designed only as a pair, so the overall conception of the youth must be due to the master. Their style is also basically the same. Some elements, like the boy's blue-gray tunic or red hose, which appear no different from the rest of the picture, could be by Verrocchio or by the pupil following in his footsteps. Despite its consistent style and quality, however, other aspects of the figure betray a

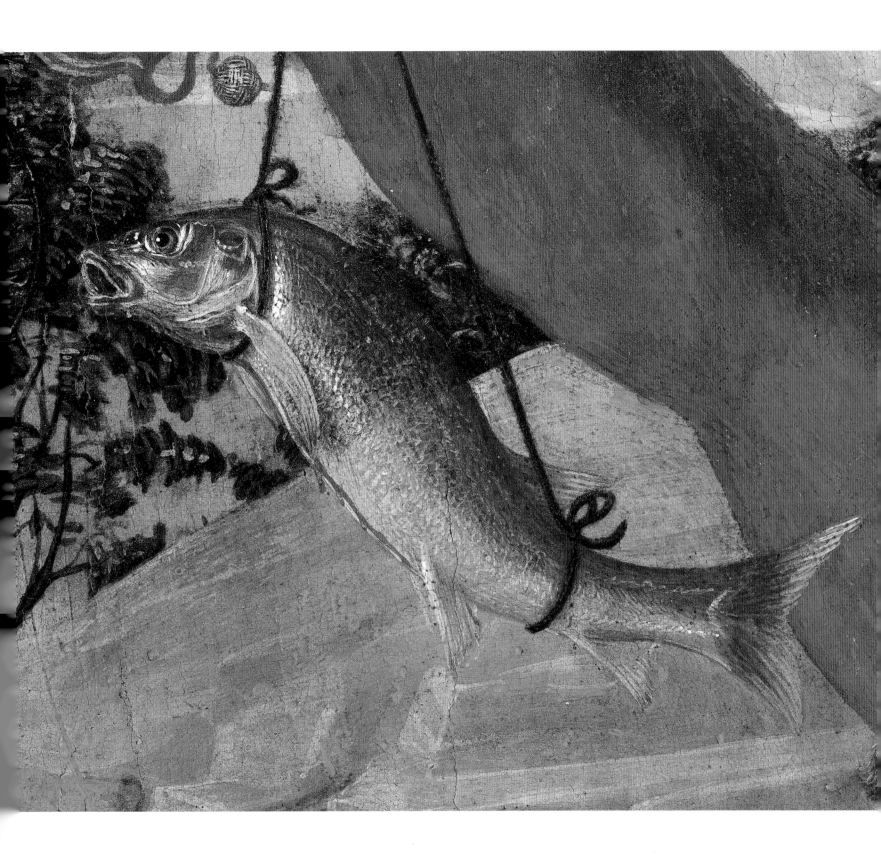

personality distinct from the master's. It may seem odd to divide a single figure in this manner, and yet that is exactly how Tobias was designed, and may have been executed, as a composite of individual details: the boy's already-mentioned left hand, his right hand resembling the angel's and that of the Virgin in the Uffizi *Annunciation* (Fig. 64), and the multicolored sash tied around his tunic can all be found in other works made in the shop.

Examined under a microscope, the London panel also betrays two different technical procedures, and these form an additional basis for distinguishing Leonardo's part in the Tobias.[25] Verrocchio used "shell gold" (powdered gold applied with a brush) to decorate the borders of Raphael's robe, giving them the rich effect of precious metalwork.[26] In contrast to this (partly reinforced) gold paint ornamenting the angel's robe, the garments of his companion, including the sash (but not the boots), are decorated with yellow ocher that appears gold in color. The technique of yellow pigment imitating gold is associable with Leonardo, who later expressed contempt for painters who used real gold in their pictures.[27] In the *Tobias* the artist whom we take to be Leonardo was probably applying a precept he learned from Alberti, who had censured gold application in his treatise: "There are some who make excessive use of gold, because they think it lends majesty to painting [but] there is greater admiration and praise for the artist in the use of colours."[28]

Apart from color, there is no material difference between the white and the red brocaded sleeves of the figures. Here Verrocchio, like his pupil, employed yellow pigment to represent the gold threads of Raphael's sleeves (Fig. 43) (and halo as well). It is the way each artist portrayed the design of the sleeves – the standard type of pomegranate – that varies. True to his origin as a goldsmith, Verrocchio adhered closely to a stylized floral pattern for Raphael's sleeves.[29] In Tobias's collar and sleeves (Fig. 44), however, the design motif is no longer clearly legible, having been painted illusionistically to suggest how such a brocade, if crumpled, would appear to the eye.[30] The golden-yellow lining of Tobias's tunic, rolled up to display his doublet, similarly anticipates the creased look of the cloth in the center of the Louvre *Madonna of the Rocks*. While Verrocchio painted the sumptuous fabric as woven, his pupil's brushstrokes describe highlights on gold threads, not the threads *per se*. Significantly, Leonardo may be the only one of Verrocchio's painting assistants who was not trained as a goldsmith. His broken method of representing textiles offers the first hint that Leonardo did not share the metalworker's sense of form Andrea brought to painting, preferring to pursue optical effects instead.

Tobias's head (Fig. 46) may also be by Leonardo. Compared with the facial type Verrocchio adopted for Raphael, the boy's delicate features are more sensitively modeled and superior in their grasp of structure.[31] The head is effectively silhouetted against the darkest part of the angel's wing, just as Leonardo set off Gabriel's profile (Fig. 77) before a tree in the *Annunciation*. And the way the beautiful youth looks up adoringly at his guide anticipates the angel (Fig. 111) Leonardo later added to the *Baptism*. His curly hair also differentiates Tobias from his companion, whose clumped locks recall those of the bronze *David*.[32] Highlights break Tobias's hair into strands, with those on top forming a forelock that becomes a kind of Leonardo signature. Tossing in the air like waves, the unruly curls convey the same sense of motion as the fluttering cloak and sash. The boy's hair, like his sleeves, suggests that Leonardo had been reading a vernacular version of Alberti, who

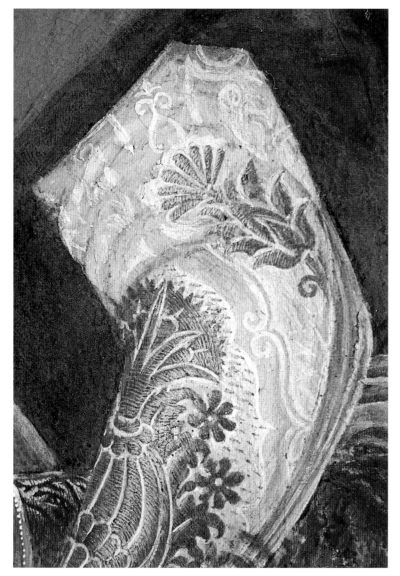

43 (*above left*) Detail of Fig. 38.

44 (*above right*) Detail of Fig. 38.

called for hair in painting to "twist around as if to tie itself in a knot, and wave upwards in the air like flames."[33] To achieve this effect, Leonardo seems to have experimented with left-handed brushstrokes in the hair above the ear (Fig. 45): when viewed under a microscope, certain of the hatchings here taper upwards to the left with the movement of the artist's wrist.[34]

Before executing the curly-haired Tobias, Leonardo may well have made preparatory studies for the boy's head. None of them survives, but several such drawings of heads with curly hair are listed among the early Florentine works the artist took to Milan about 1482.[35] The list even includes "four studies for the panel of Saint Angelo," that is, a painting of the Archangel Raphael (or Michael, since Gabriel normally occurs in scenes of the Annunciation). Aside from this tantalizing reference to a panel which might correspond to the one in London, the list plainly reveals its author's obsession with curly hair, which, Vasari says, later delighted Leonardo in the person of his disciple Salai.[36]

Leonardo's share in the London picture – the animals and some, if not all, of the figure of Tobias – is his earliest identifiable accomplishment as a painter. A new

45 Detail of Fig. 38.

spirit shines forth in these details which anticipate the artist's later work. They exhibit personal traits – a special feeling for nature, a predilection for subtle modeling, and a fondness for curly hair – more than a personal style, and they reveal a mind at once more rational and more imaginative than Verrocchio's. At this stage Leonardo's role was defined and delimited by the master, who evidently recognized his pupil's gifts and exploited them as a resource in the competition with Pollaiuolo. Comparing Leonardo's part in the *Tobias* with the same passages in Pollaiuolo's picture (Fig. 37), who would not award Verrocchio the palm? And yet if Andrea's pupil was more than just a promising talent, the features of the painting that look like his work seem to have gone unappreciated at the time (and for centuries afterwards). Botticini, for example, took the *Tobias* as a model for his own versions of the theme, including the large Verrocchiesque altarpiece of the *Three Archangels* in the Uffizi, but he never repeated Leonardo's animals.[37] And the young Perugino in his *St. Sebastian* at Nantes echoed the elegance of Tobias but not his élan.[38] Verrocchio, nevertheless, continued to employ Leonardo as a collaborator. In fact, the younger artist's contribution to the *Tobias* may even have led to his participating in the *Baptism* as well. Though the work assigned was similar – another ephebe and some natural elements – the altarpiece was much larger and more demanding, and years would pass before the pupil completed his task.

The *Tobias* demonstrates that Leonardo, though only an apprentice, had mastered many of the skills needed to practice successfully as a painter. But that cannot be all he did during the six years or so of his training. Since the main activity of Verrocchio's shop was sculpture, we may wonder whether Leonardo did not also assist the master with works of plastic art. The young painter was certainly proficient in sculpture. Not only could he carry it out in "marble, bronze, and clay"; he claimed to be "equally versed" in both arts.[39] And Leonardo would surely have learned from Verrocchio how to use clay or wax models, as well as life drawings, in preparing pictures. Vasari confirms that Leonardo "in his youth executed certain heads of smiling women in terracotta, of which casts are still made, and likewise heads of children which seem to have come from the hand of a master."[40] Multi-talented like Verrocchio, Leonardo was – and this is fundamental for understanding his achievement – the only one of Andrea's painting assistants who also pursued sculpture. The problem is that not a single authenticated piece of sculpture by Leonardo survives; consequently, attributions to him lack a firm basis.[41] The attributions, such as they are, fall into two main categories: *modelli* for, or a share in the execution of, Andrea's works in marble or bronze; and Verrocchiesque stuccos and terracottas of the type described by Vasari. Since a sculptor as skilled and innovative as Verrocchio is not likely to have needed a pupil's help in designing his works, nor in executing the smaller ones, better candidates for Leonardo's authorship should probably be sought among the as yet unattributed examples of the master's style. Unfortunately, the connoisseurship of Quattrocento sculpture has seriously lagged behind that of painting, and scholars' efforts to identify examples by Leonardo's hand have so far proved disappointing.[42] Until a systematic search is undertaken, the problem may be approached from a different angle by asking whether he did not serve the master in a more limited way, consistent with his intervention in the *Tobias*. Are there works of sculpture, in other words, in which Leonardo supplied Andrea with his sorely needed skill in representing nature?

46 Detail of Fig. 38.

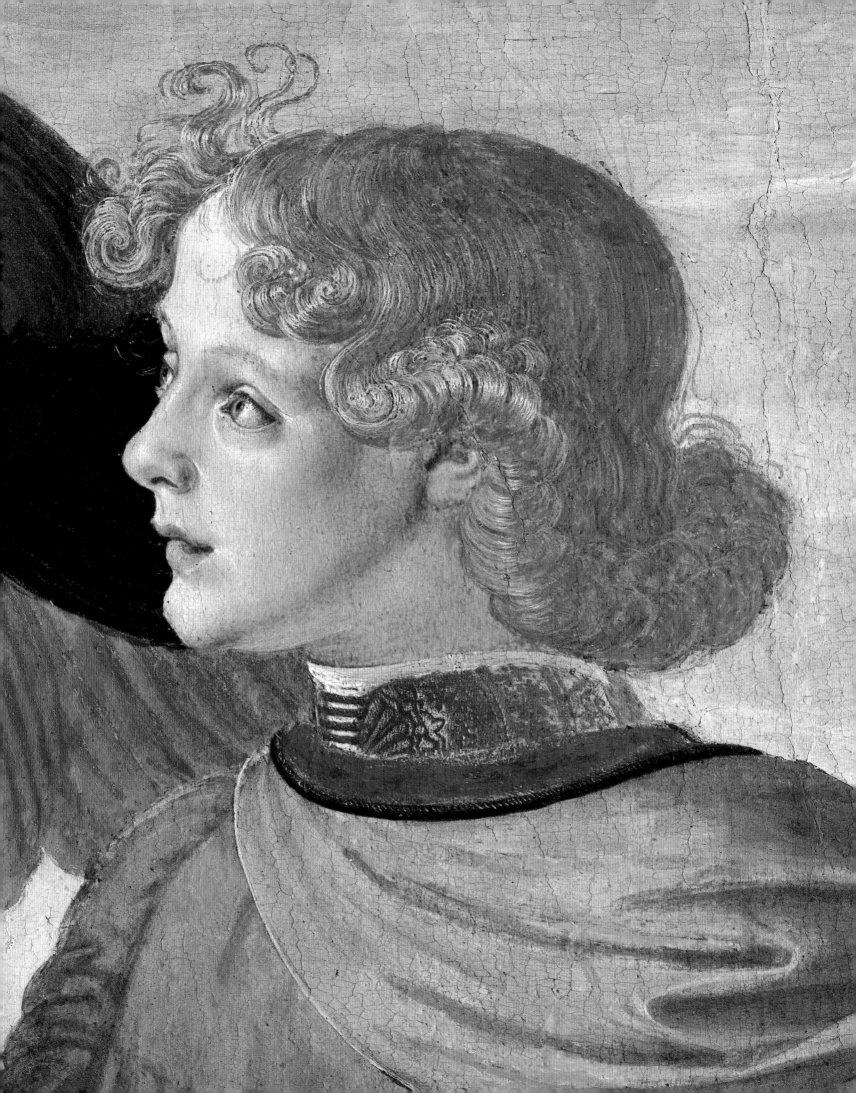

Verrocchio may indeed have used Leonardo's talents as a naturalist on a project not previously connected with the younger artist. Following his sources, Vasari stated that the marble lavabo (Fig. 48), or wash-basin, in the Old Sacristy of San Lorenzo was begun by Donatello, who was largely responsible for the sculptural decoration of Brunelleschi's church.[43] But compared with the colored stucco roundels and bronze doors Donatello did for the sacristy, the lavabo, located in a small room to the left of the altar, displays the distinctly different relief style of Verrocchio.[44] In creating the lavabo, Andrea pointedly ignored his predecessor's achievements. He also broke with the architectural type of wall basin in Florence Cathedral and elsewhere.[45] Instead of the usual putti in a niche flanked by pilasters, Verrocchio's design features a bowl-shaped basin surmounted by a vase, out of which rises a conical shaft terminating in a (now broken) torch. Behind these projecting elements is a low-relief panel centering on a green marble disk, topped by a lunette and framed by a red marble arch. The ornament of the lavabo is no less imaginative. Apart from oak wreaths around the vase and the disk, it consists mainly of animal motifs: a falcon and a lion's head, as well as three pairs of dragons, dolphins, and sphinx-like creatures. The decorative vocabulary derives in a general way from Desiderio's Marsuppini monument in Santa Croce, as has often been pointed out. But the variety of Verrocchio's animal imagery is unprecedented in an ecclesiastical work on this scale. In fact, the lavabo is so original, not to say odd, that Passavant claimed it was pieced together from a secular fountain.[46] Also attempting to account for presumed alterations to Verrocchio's design, another scholar proposed that the lavabo was moved to its present site from the place in the sacristy now occupied by the Medici tomb of 1472 (Fig. 53).[47]

The lavabo does not seem bizarre, however, in the context of other works employing the same imagery. These were made for, or represent the taste of, Piero de' Medici, who from 1464 to 1469 succeeded Cosimo as head of the clan, of the bank they owned, and of the state they controlled. Sometime during this period, approximately coinciding with Leonardo's apprenticeship, Piero seems to have ordered the lavabo from Verrocchio. No document records the commission, but the lunette displays the patron's personal emblem – the falcon holding a diamond ring – and his motto SEMPER, inscribed on the ribbon. The diamond-ring device and the motto are repeated, alongside the Medici coat of arms, on the vase. And the red, white, and green of the marbles were Piero's colors.[48] Long overshadowed by those of his son Lorenzo the Magnificent, Piero's patronage and collecting activities have only recently been given the attention they deserve.[49] It was, for example, Piero, not Lorenzo, who most likely commissioned Pollaiuolo's *Labors of Hercules* and Verrocchio's bronze *David*, if the latter can be dated to the 1460s. Piero's infirmity (he was called the Gouty), nevertheless, predisposed him to precious objects he could appreciate privately, like antique coins and gems and illuminated manuscripts (including Pliny's *Natural History*), of which he was an avid collector. His taste for the ornate also informs the highly elaborate tabernacles built for him in San Miniato and SS. Annunziata. Like them, the lavabo resembles an enlarged version of the small finely wrought items described in Medici inventories. One work in particular, a codex (Fig. 47), lavishly decorated for the young Lorenzo but featuring his father's portrait in a medallion, associates Piero with a pair of pedestal vases flanked by dolphins and bat-winged sphinxes, resembling those of the lavabo.[50]

The animal motifs of the lavabo have been traced to secular fountains, known today through contemporary engravings.[51] But they may also reflect Piero's taste.

47 Francesco Rosselli, manuscript illumination. Detail. Biblioteca Medicea Laurenziana, Florence.

48 (*facing page*) Verrocchio, lavabo, marble, Old Sacristy, San Lorenzo, Florence.

The borders of manuscripts made for him abound in birds and beasts.[52] A sheet of drawings in the Uffizi, bearing his personal device, also represents a variety of creatures, real and imaginary, similar to those of the lavabo.[53] And the Medici palace decoration, which Piero undertook, was a veritable menagerie, including not only Gozzoli's chapel frescoes but also Uccello's *Combat of Lions and Dragons* and Pesellino's *Hunt*. Like those animals, the falcon in the lunette and the dolphins of the basin of the lavabo are in profile. Not surprisingly, the stylized bird has often been mistaken for an eagle, and the dolphins appear equally unconvincing.[54] The low-relief carvings of the lavabo – the falcon, the dolphins, and the wreath surrounding the disk – are often distinguished from the sharply projecting ones, and they do differ in the degree of naturalism of the motifs portrayed. The greater veracity of the animals shown three-dimensionally (the garland around the vase is too damaged to assess) can be explained best, perhaps, by allowing Leonardo a role in the project.

The central lion's head (Fig. 49) ornamenting Verrocchio's basin is much closer to nature than are the similar motifs created by his predecessors. Bernardo Rossellino's tomb in Santa Croce has been cited for comparison, and other examples could be adduced as well.[55] Andrea's own earlier work does not prepare us for the animal either, so that Leonardo comes once more to mind.[56] The lion was a symbol (the Marzocco) of Florence, and Verrocchio's apprentice would have had ample opportunity to study the beasts which the city government kept caged behind the Palazzo della Signoria, across from his father's house.[57] The lion on the lavabo, with its detailed features and flowing mane, is carefully observed. And its expression seems oddly winsome, like that of an animal peering out from behind the bars of its cage. No life-study serves to connect Leonardo with the basin, but the craggy beast does resemble the lion's head ornamenting the armor in his early *Bust of a Warrior* (Fig. 59) in the British Museum.[58] Thus, it seems possible that Leonardo helped Andrea design the lion's head on the lavabo, transforming the traditional type of decorative mask into a living being carved in stone.[59]

We cannot be sure that it was Leonardo who breathed life into the lavabo lion; he is simply the most likely candidate. But there are firmer grounds for believing he may have been involved in the design of the dragons. The problem is that the conical shaft with the dragons' bodies and the vase with their heads were carved separately, leading several authors to conclude that the beasts, in their present form, with the neck imagined as continuing beneath the wreath, were not an integral conception.[60] The recent restoration of the lavabo did reveal extensive damage to the wreath, over which water spilled into the basin.[61] And it confirmed that the shaft was cut at the bottom. Other evidence suggests, nevertheless, that this element and the vase were designed, if not carved, together. Dragons similarly straddle the holy-water stoup Antonio Federighi carved before 1467 for Siena Cathedral.[62] And the bodies of Verrocchio's dragons are nearly identical with the hybrid creatures on the basin, which are not actually sphinxes but female-headed creatures composed of twisting serpent's tails, lion's clawed feet, and bat-like wings. Dragons were customarily represented with pointy-nosed heads.[63] Pollaiuolo, nevertheless, modified the standard type, giving the mythical hydra slayed by Hercules (Fig. 7) canine heads. Antonio's innovation caused Vasari to exclaim that "nothing more lifelike could possibly be seen; the venomous nature, the fire, the ferocity, and the rage of the monster are so effectively displayed that the master merits the highest praise and deserves to be imitated in this respect by all good artists."[64] Indeed the Verrocchio shop seems to have emulated Pollaiuolo

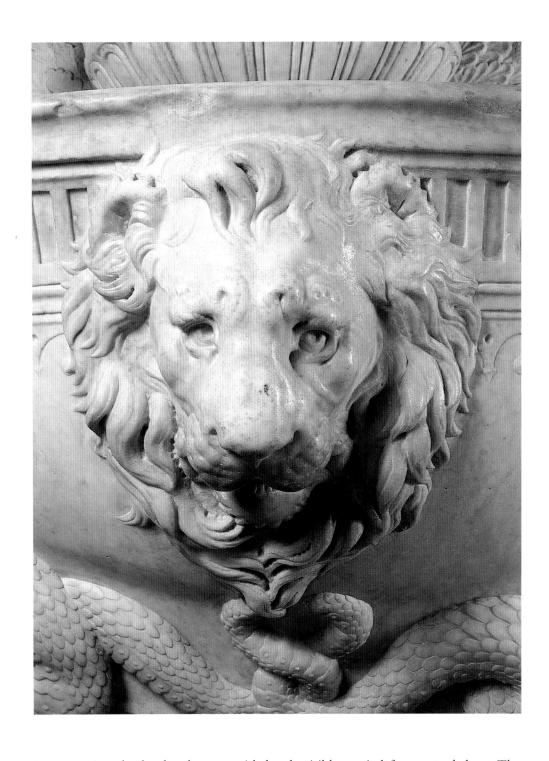

49　Detail of Fig. 48.

in portraying the lavabo dragons with heads visibly copied from actual dogs. The breed resembles a mastiff or guard dog.[65] Out of their fierce (but now damaged and discolored) mouths issued water for handwashing before the celebration of the mass.

The dragons' coiling tails have reminded writers of Leonardo, who loved twisting forms.[66] And, in fact, the tails display the same sinister quality of the intertwined serpents in a drawing by the artist at Windsor Castle.[67] The dragons' canine heads (Figs. 50 and 51) are equally characteristic. Life-studies by Leonardo cannot be connected with them any more than with Tobias's terrier in the London picture, though if they survived, the drawings would probably resemble his well-

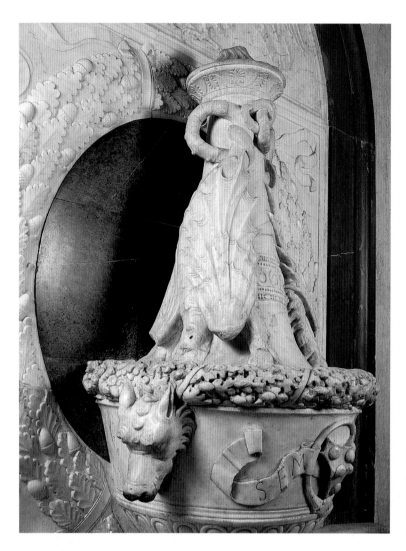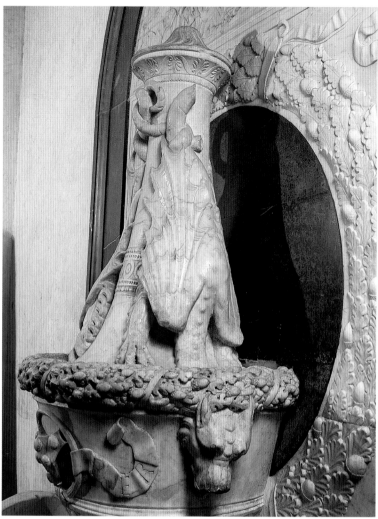

known studies of a bear.[68] It is the written recipe that Leonardo the art theorist offers for representing a dragon that is relevant here. To make such a fantastic creature seem real, he instructs the artist to base its components on animals found in nature. "If you wish to make an animal, imagined by you, appear natural – let us say a dragon, take for its head that of a mastiff or hound."[69] The catalogue continues with a lion, tortoise, and other living models, but it is the dog which is of particular interest. Leonardo's prescription for a composite dragon follows his own practice, at least as far as the canine head is concerned. On a fairly early sheet by the artist (Fig. 52) are depicted four dragons in metalpoint, two of which were gone over with pen and ink.[70] The type of dragon is the same as those of the lavabo: lion's feet, bat wings, a spiraling tail, and a sinuous neck ending in what appears to be a dog's head. The two dragons drawn in metalpoint, one of them scarcely visible, are closest to their sculptural counterparts. Their crouching posture is one that Leonardo consistently favored in depicting the most varied animals.[71] Another monster young Leonardo made to appear real was the Medusa shield, which he supposedly painted for his father. Leonardo could also make the real seem fantastic, as in the dragon he was said to have constructed – a lizard to which he attached a beard and other draconic attributes in order to frighten his associates at the papal court.[72] The mature Leonardo transmitted this zoological

52 Leonardo, *Studies of Dragons*, Royal Library, Windsor.

bent to artists who formed his circle – Rustici, Piero di Cosimo, and Sodoma. He also praised Giotto's skill in depicting animals; it was this trait (and not his monumentality) which, according to Leonardo, first distinguished his predecessor as an artist.[73]

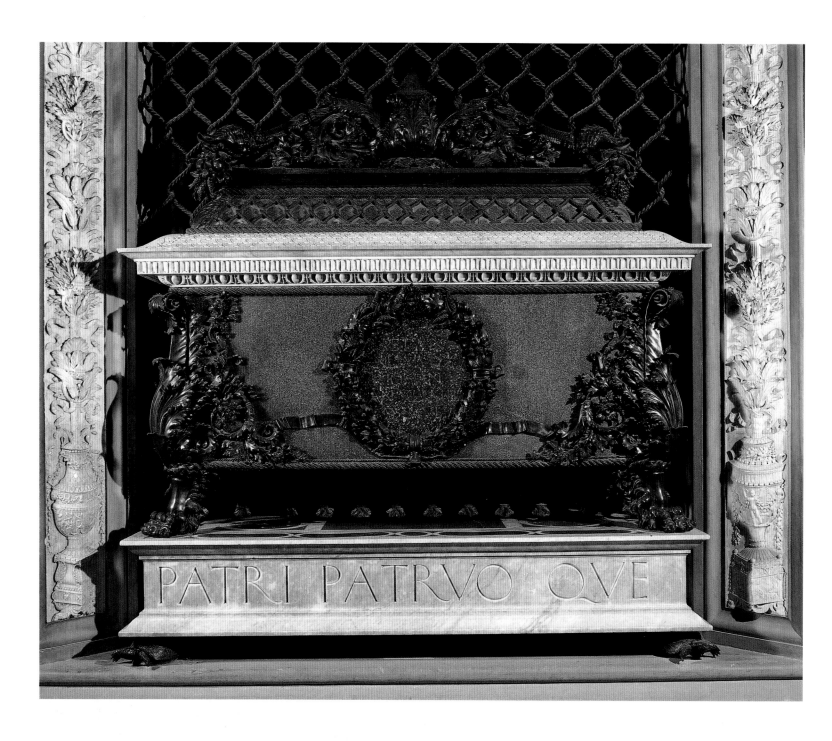

53 Verrocchio, tomb of Piero and Giovanni de' Medici. Detail. Old Sacristy, San Lorenzo, Florence.

After the death of Piero de' Medici in 1469, Verrocchio took up his tomb (Fig. 53), commissioned by Piero's sons Lorenzo and Giuliano, whose names are inscribed on the base. The deceased was buried, together with his brother Giovanni, in the double-sided sarcophagus Andrea erected in an arched opening in the wall between the Old Sacristy and the adjacent chapel, which also belonged to the Medici. The variety and richness of the materials employed – bronze, marble, porphyry, and serpentine – the lack of figural decoration and overt symbolism, and the unusual design, resembling a small-scale reliquary, make the tomb unique among Florentine funerary monuments. And the lavish ornament is a *tour de force* of bronze casting. Since the monument (dated 1472) was designed and constructed during the latter part of Leonardo's apprenticeship, it is not surprising that, like so

many other of Verrocchio's sculptures, it was credited in part to the younger artist. The tomb's "pictorial" qualities in particular seemed to reflect his intervention.[74] But the net of twisted rope, the shadowy foliage, and the coloristic effects are better explained in terms of Verrocchio's style and sources.[75] The pupil's participation may be seen in another feature of the tomb – the four bronze tortoises (Fig. 54) that support the marble base. The tortoises are symbolic.[76] More important here, their strikingly realistic forms and lively (if slow) movement were no doubt studied from nature.[77] The life-size creatures may even have been made from casts of an actual tortoise, as one writer has proposed.[78] The source for the motif was probably the three tortoises supporting the triangular base of Antonio Pollaiuolo's bronze statuette of *Hercules and Antaeus*, another Medici commission, now in the Bargello.[79] Who better than Leonardo, Verrocchio must have felt, to devise tortoises that would surpass those of his rival?

Leonardo demonstrated a special talent for depicting animals in the *Tobias*, and the tomb offered further proof of that ability. But the tortoises, while serving as supports for the sarcophagus, play only a minor role compared with the leafage, which constitutes its principal decoration. Writers, beginning with Vasari, have tended to treat the foliate ornament as a whole, whereas it actually falls into three separate categories. Carved in marble in the archway are alternating clusters of palm and laurel, entwined with the Medici ring device. The palm fronds cannot be distinguished from feathers, and the laurel branches betray the same lack of feeling for nature. Verrocchio's real passion lay in the exuberant acanthus foliage.

54 Detail of Fig. 53.

55–7 Details of Fig. 53.

Classical in origin, the stylized motif of acanthus stemming from the lion's paw feet had already been used by Desiderio for the Marsuppini monument. And Andrea had adopted the same combination for his bronze candlestick of 1468 (Rijksmuseum, Amsterdam). At San Lorenzo he infused it with an energy all his own, as the leafwork spreads, large and luxuriant, over the tomb.

Verrocchio, it is fair to say, was not a naturalist, so if we eliminate him in this context, Leonardo emerges as the most likely candidate to have designed the bronze wreaths on both sides of the tomb. Encircling roundels with inscriptions commemorating the deceased, the wreaths (Fig. 55) include a variety of the most minutely described fruit and foliage.[80] Similar plants pour out of the shell cornucopias on top of the sarcophagus. The realism of the intertwined leaves (Fig. 56), with their serrated edges and delicately delineated veins, and of the cones and berries (Fig. 57) appears almost uncanny in the medium of bronze. To achieve this sort of detailed botanical accuracy, nature studies, like Leonardo's of a lily (Fig. 78), or clay models of living specimens would presumably have been required. Verrocchio seems to have used Leonardo in this case to compete with Lorenzo Ghiberti's son Vittorio, whose frame for the south Baptistery doors set a high standard for representing plants in bronze.[81] The realism of Vittorio's gracefully arranged flora, however, pales by comparison with the Medici wreaths. Though completed less than a decade after the younger Ghiberti's work, they are the product of a distinctly new approach to nature, based on fresh observation of living examples. The truth-to-organic-life that characterizes the wreaths brings to mind Vasari's praise for the "foreshortened leaves" and "lovingly detailed branches" of Leonardo's cartoon of the *Garden of Eden*, and it leads directly to the garlands decorating the lunettes above the *Last Supper*.[82]

The *Tobias*, the lavabo, and the tomb may be joint undertakings in which the young Leonardo had a share. Dating from the late 1460s, they would represent his earliest activity in Verrocchio's shop. The attribution of these works in part, or in a sense, to Leonardo is conjectural in that the usual criterion for distinguishing master and pupil – quality – does not apply in his case. Instead, I have sought to identify as Leonardo's those parts of Verrocchio's works which betray a superior skill in representing nature and a subtlety and sensibility differing from Andrea's, an admittedly subjective process. If we can be reasonably confident that Leonardo completed the figure of Tobias, what about the mysterious sphinx (Fig. 58) on the left of the lavabo? Just as Tobias differs from his companion, so has this sphinx also been contrasted with her forthright counterpart on the right.[83] Her snake-like coiffure suggests the lost *Medusa*, and her delicately modeled face brings the Annunciatory angel (Fig. 77) or even *Mona Lisa* to mind. Whether the strange beauty of this figure can be credited to Leonardo is difficult to say. But there can be no question about the vitality of the animals and plants in these works. They pulse with life. Since Verrocchio, unlike Pollaiuolo, seems to have cared little about nature as such, he left its investigation to his apprentice, whose task it became to extend the new realistic canon to the portrayal of animals and other natural phenomena. In effect, Leonardo remedied Verrocchio's deficiency, the complementarity of their talents forming the basis for a long-lasting collaboration, whereby Andrea employed his pupil's special ability on these and other works produced in the shop.[84]

Leonardo – if the preceding account of his earliest activity is acceptable – was the first of a long line of artists who functioned as nature specialists in their masters' studios. Of course, artisans had long devoted themselves to genres requiring special

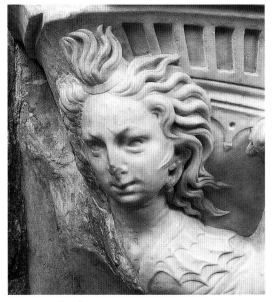

58 Detail of Fig. 53.

talent and training, such as the painting of cloth banners, horse trappings, or, in the case of Apollonio di Giovanni, marriage chests.[85] Or they specialized in certain techniques, like the Della Robbia with their glazed terracottas, or, more aptly, Orsino Benintendi, who was said by Vasari to have assisted Verrocchio in making wax votive images.[86] Still other artists tended to work on a certain scale, like Bartolomeo di Giovanni, who, having studied with Ghirlandaio, executed predellas and background groups in his master's works.[87] But Leonardo's specialization was new. It presupposes that Verrocchio recognized the boy's aptitude for representing nature and had him perform those tasks for which he was particularly suited. Because it was rational and efficient and allowed for greater individuality, the method subsequently produced a series of nature specialists, including Giovanni da Udine, who added still-life details to Raphael's works, and Lambert Sustris, who painted landscapes Titian was too busy to execute.[88] The culmination of these painter/naturalists was Caravaggio, who is supposed to have completed flora for his teacher. Like Leonardo before him, Caravaggio favored ephebes and nature motifs, which he combined in his well-known *Lute Player* (Hermitage, St. Petersburg).

In the process leading from Verrocchio's initial conception of these works to their final execution, Leonardo seems to have played a part. But if the younger artist painted the elements he designed for the *Tobias*, did his role also extend to making models of the sculptural motifs for which he was responsible? And did he go on to assist Verrocchio in realizing them in marble or bronze? Though pupils regularly carried out minor details in their masters' sculptures, with uneven results, Leonardo may have been an exception. He certainly disdained the labor of carving marble, contrasting the din and dust it raised with the painter's fastidious art.[89] Leonardo's remarks, usually thought to criticize Michelangelo, may refer instead to his stint in Andrea's shop. While he undoubtedly learned how to make sculpture there, Leonardo's contribution to the master's work may have been limited to providing expertise or to executing passages that can no longer be identified.[90] Whatever the case, Leonardo did take an early interest in sculpture, as his famous drawing of the *Bust of a Warrior in Profile* (Fig. 59) demonstrates. Unlike the panel painting, the lavabo, and the tomb, in which he might have participated, this large sheet is incontestably autograph. And it raises the issue of how Verrocchio succeeded – outside the normal shop practice – in inspiring his most gifted pupil.

More than any other early work by Leonardo, the drawing can be understood only in context, and for that reason we must consider the group of objects by or after Andrea to which it is related. "Two heads in metal, one representing Alexander the Great in profile, and the other a fanciful portait of Darius, each a separate work by itself in half-relief, and varied in the crests, armor, and other details" are cited in Vasari's life of Verrocchio as having been given by Lorenzo de' Medici to King Matthias Corvinus of Hungary.[91] Though sent by Lorenzo, along with other gifts, the two warrior reliefs may have been ordered by his father Piero.[92] Both are lost. The *Darius* is known through several glazed terracotta copies by the Della Robbia, in Lisbon (Fig. 61) and elsewhere, and these are compared below with Leonardo's drawing, which records the same composition. The problem of the companion piece depicting *Alexander* is more complicated. Here, two marble reliefs survive, and both have been claimed as Andrea's original, assuming that Vasari erred in calling the material bronze. The first of the contenders, a sculpture inscribed with Scipio's name in the Louvre, has been given to young Leonardo as well.[93] The relief is not by him, however, and its medium, inscription, and etiolated style also disqualify it as Verrocchio's lost *Alexander*.[94] The

59 Leonardo, *Bust of a Warrior in Profile*, Department of Prints and Drawings, British Museum, London.

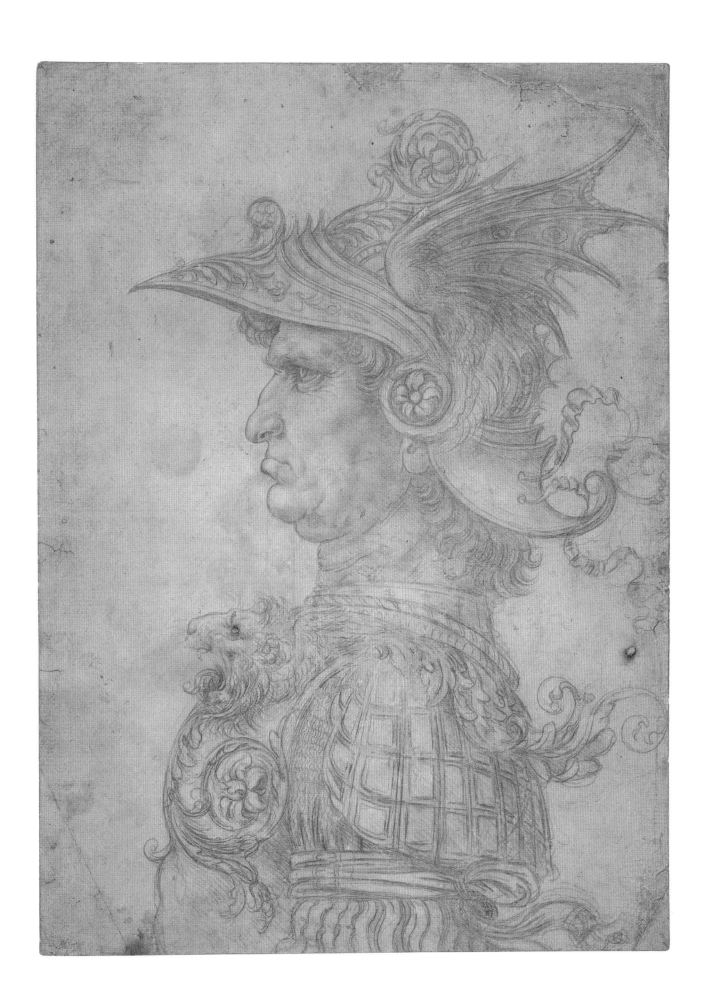

60 Verrocchio, *Alexander*, National Gallery of Art, Washington, Gift of Therese K. Straus.

Scipio appears to echo the second marble relief (Fig. 60) which, having come to light in the 1920s, is now in the National Gallery of Art in Washington.[95] This work was identified as Andrea's long-lost original by the scholar who first published it in 1933; since then the *Alexander* has succeeded the *Scipio* as the focus of scholarly debate, with most writers regarding it as autograph.[96] Two major

61 After Verrocchio, *Darius*, Museu Nacional de Arte Antiga, Lisbon.

Verrocchio experts doubted the relief's authenticity, however, and their hesitancy to accept it forms the starting-point for this discussion.[97]

The profuse ornament of the relief – its *horror vacui* – may look odd when compared with Verrocchio's mature productions, like the *Beheading of the Baptist*, in which the decorative elements are more restrained. Attempts to date the *Alexander* to around 1480 on the basis of style or political context are, therefore, unconvincing.[98] But the warrior reliefs need not have been commissioned by Lorenzo, who came to power in 1469, even if he presented them as gifts. In fact, the style and imagery of the *Alexander* – its excesses – are closely similar to those of the lavabo (Fig. 48), another disputed work that was made for Lorenzo's father. There we encountered the dog-headed dragon crouching on the helmet. The screaming head of the breastplate likewise recalls that of a soldier in the *Resurrection* (Fig. 21).[99] And the curls framing Alexander's face and neck resemble those of Raphael in the *Tobias* (Fig. 38). These are early works by Verrocchio, dating from the late 1460s, and so is the *Alexander* to judge from its vigorous design, strong plasticity ("half-relief"), and highly elaborate detail. Detractors of the piece object that Verrocchio, who fashioned parade armor for the Medici, could never have created such an unfunctional helmet. Nor, they say, can Alexander's cuirass conceal his missing shoulder. The fantastic armor and awkward pose of the figure,

with the head in profile and the bust in three-quarter view, are satisfactorily explained, however, in terms of the current of taste to which the relief belongs. Alexander's armor combines fantasy with reminiscences of the antique in the manner of a series of contemporary Florentine engravings of men in fanciful military attire.[100] But whereas the motifs in the engravings are whimsical, those in the Washington relief appear strangely real. The menacing dragon perched on the helmet, the winged gorgon's head, and the acanthus leaves overlapping the hero's cloak all pulse with an energy that the *Alexander* analogues fail to capture. The triton and nereid of the epaulet are not merely decorative either (note the male figure's extended hand). Their realistic treatment brings some antique prototype – an engraved gem belonging to Piero de' Medici, perhaps – to life.[101]

The untrammeled realism of the relief poses the question of whether Leonardo might not have had a hand in the creation of this work, as well as the lavabo. The dog-headed dragon and the carefully observed conch shell of the helmet, the similar shell form of the epaulet merging with the water rippling around the triton, and the gorgon's head meant to strike terror, like the *Medusa* Leonardo made for his father, could all be his contribution.[102] It cannot be ascertained that Leonardo participated in the *Alexander,* but he would surely have known the relief if it was produced in Andrea's shop. His drawing in the British Museum (Fig. 59) records the companion piece depicting the Persian king whom Alexander defeated. If the Washington marble corresponds to the relief sent to Corvinus, Alexander is, or was, shown facing his adversary, who looked to the left in strict profile. In the glazed terracotta replicas (Fig. 61) from the Della Robbia workshop, Darius wears a dolphin-crested helmet and a cuirass with a winged lion's head on the breastplate and a coiled dragon on the shoulder-guard.[103] Floral rosettes and ribbons complete the *all'antica* ensemble. Though Leonardo's drawing, like the terracottas, translates Verrocchio's original (marble or bronze) into a different medium; it is no mere copy.[104] As scholars have rightly seen, the younger artist played down the ornament of his prototype, omitting the dolphin and dragon in favor of a psychological interpretation of the ancient warrior.[105] With his knitted brow and protruding lower lip, Leonardo's *Darius* embodies the pugnacious spirit of the Renaissance *condottiere,* or mercenary captain. At the same time the decorative plant motifs seem to have taken on a life of their own, as if the armor were sprouting foliage and flowers. Tendrils and ribbons toss in the air, like Tobias's wavy curls (Fig. 46) in the London picture.

Given its highly finished character, the drawing cannot be a preparatory study for Verrocchio's relief, as has sometimes been claimed.[106] Rather, Leonardo freely copied the relief in metalpoint on cream-colored prepared paper. This painstaking technique, which the young artist and his contemporaries adopted for figure studies, lacks the spontaneity of Leonardo's famous pen-and-ink sketch (Fig. 87) of the Arno valley, and the British Museum drawing has, accordingly, been dated toward the end of his early Florentine period, around 1480.[107] But the careful rendering of detail and the method of modeling forms with separate left-handed strokes could equally point to a date in the mid-1470s, when Leonardo was still in Verrocchio's shop, or even earlier.[108] The extremely subtle tonal gradations found here appear also in the beautiful figure of the Annunciation angel (Fig. 77) and in the absence of a Leonardo drawing after Alexander, the angel may be taken as Darius's antetype. The handling of the shoulder is similar in each case, and so is the way plant and animal forms merge on the cuirass and the Virgin's lectern (Fig. 64).[109] This concern with potentially awkward transitions is peculiar to Leonardo,

who sought to unify disparate forms by flowing curves. In both the drawing and the painting Leonardo reinterprets the ornamental motifs he borrowed from Verrocchio in such a way that they could never be carved in marble or cast in bronze. As a pictorial paraphrase of a sculptural prototype by the master, the *Bust of a Warrior* heads the series of Leonardo's early works dealing with the same issue as it affects painting.

Leonardo later counseled young artists to draw after sculpture, but the British Museum study is more than an exercise in how to convey the appearance of three dimensions in drawing or painting.[110] The physiognomic types Verrocchio invented for Alexander and Darius and the contrast between them obviously had a strong effect on Leonardo's sensibility, to judge from the way they recur again and again in his work. The ideal types of the confronted warriors took on an obsessive character in Leonardo, appearing not only in paintings like the *Last Supper* and the *Battle of Anghiari* but also in the drawings of old men and youths that fill the pages of his notebooks.[111] Likewise, the parallel implied between the belligerent warrior and the roaring lion of his breastplate becomes explicit in the younger artist's work.[112] Verrocchio's imagery and love of fantastic ornament thus had a profound and lasting impact, but the pupil may also have affected his teacher. Though Berenson contended that Leonardo's *Bust* derived from the soldier on the right in Verrocchio's *Beheading of the Baptist*, the opposite may be true, that the aggressive psychology of that figure and of the equestrian statue of *Bartolomeo Colleoni* in Venice was inspired, rather, by the fierce warrior in the drawing.[113] And Verrocchio may have used Leonardo's ideas for other works as well. Andrea's *Putto with a Dolphin* in the Bargello, Florence, has been ascribed to Leonardo.[114] It is not by him, but the idea of squeezing water out of the squirming dolphin does recall the younger artist's series of drawings of an infant grasping a cat.[115] The sketches were apparently made in the late 1470s, so the bronze *Putto*, if it depends on Leonardo, would date from after he had left the shop. But this postscript about the give and take between Verrocchio and his former pupil lies beyond the scope of the present chapter, which aims to show how Leonardo, while still an adolescent, brought a naturalistic component to Andrea's work which gave the master an edge over his rival Pollaiuolo.

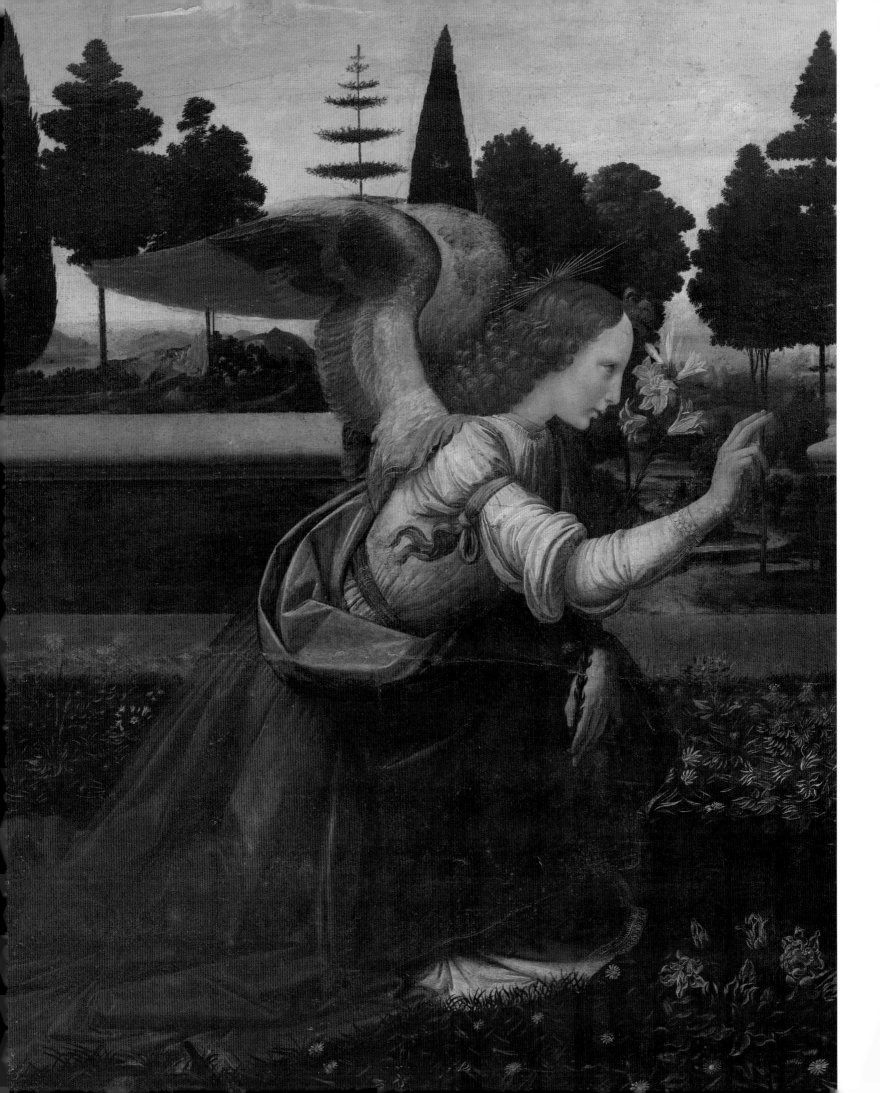

4 The *Annunciation*: Science and Sensibility

THE FIRST NOTICE OF Leonardo as an artist, dating from 1472, does not refer to any specific work of art. Instead, it documents the twenty-year-old's membership in the Florentine confraternity of painters. Founded in the fourteenth century and dedicated to St. Luke, the confraternity was made up primarily of all sorts of painters, for whose needs it provided. In return, the members paid fees to the organization, recorded in the so-called *Libro rosso*, or ledger, which after a hiatus begins in 1472 and goes up to 1520. The membership list includes Piero and Antonio Pollaiuolo (the latter called "orafo e dipintore"), as well as Verrocchio ("dipintore e intagliatore") and three of the younger generation who served him as assistants, Botticelli, Ghirlandaio, and Perugino (all designated "dipintori"). The entry concerning "Leonardo di Ser Piero da Vinci dipintore" debits him for the sum of 6 *soldi*; 5 more *soldi* for the confraternity's offering on the Evangelist's feast day; an annual membership fee of 16 *soldi* payable in monthly installments; and an additional sum of 5 *soldi*.[1] The other artists owed the same amounts.[2] Leonardo's mention here does not mean that he (or his fellow members) first enrolled in the confraternity in 1472. Nor does it identify him as a full-fledged master (fifteen-year-old Filippino Lippi also belonged). We might deduce that Leonardo's apprenticeship was over and that he could now begin working independently if inclusion in the confraternity of St. Luke meant membership in the painters' guild as well, but that is not necessarily the case either, as Botticelli and Perugino did not join the guild until 1499. Though they shared a common membership, the confraternity was distinct from the Arte dei Medici e Speziali (Guild of Physicians and Pharmacists). Together with a few other assorted trades, painters belonged to that guild because they obtained their materials from the "speziali." They were supposed to register before undertaking any work that came under its jurisdiction, but in practice the control the guild exercised over artistic affairs had long been in decline. Indeed, many artists, preferring not to join, flouted its rules and regulations.[3]

If Leonardo matriculated (the relevant guild books are missing) at the usual age of about twenty, he might have proved his proficiency in the form of a "masterpiece" produced entirely on his own. A work fitting that description exists – the *Annunciation* (Fig. 63), the first of four pictures that Leonardo would now complete in the shop. With that one painting his output (consisting of a share in the *Tobias*) more than doubled, raising the issue of what he had been doing. The explanation for why Verrocchio's apprentice painted so little is that, while his colleagues were busy launching their careers, young Leonardo was raising questions about nature and how to represent it that never even occurred to them. The result of his researches is the *Annunciation*, which went to the Uffizi in 1867 from the monastery of San Bartolomeo a Monte Oliveto outside Florence. Though the identity of the patron and the particular site for which the picture was commis-

62 Detail of Fig. 63.

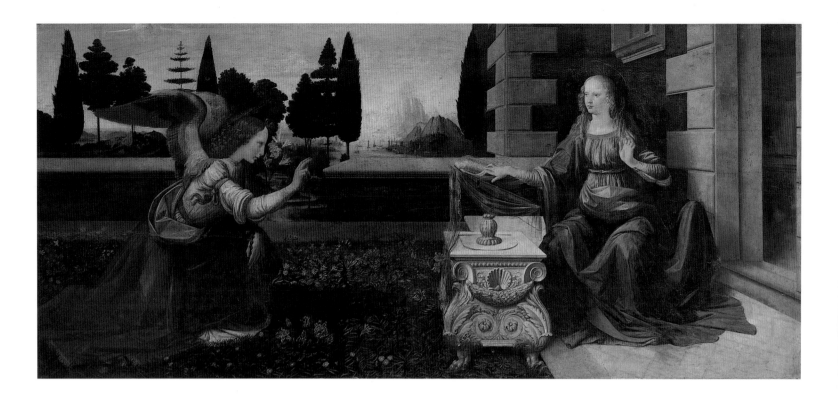

63 Leonardo, *Annunciation*, Galleria degli Uffizi, Florence.

sioned are unknown, the monastic church was reconstructed in 1472, and c.1472–73 is a likely date for the painting on the basis of style.[4]

Combining innovative and lyrical passages with borrowings and mistakes, the *Annunciation* is the work of an immensely gifted artist who was still immature. The deficiencies of the painting led one author to revive the old attribution to Ghirlandaio.[5] And they prompted others to call it a typical shop product commissioned from Verrocchio, designed by him, and executed by Leonardo and a fellow pupil.[6] Persistent doubts about Leonardo's authorship have centered on the figure of the Virgin Annunciate (Fig. 64). She lacks emotion, scholars have complained.[7] And the crooked little finger of her right hand is a mannerism that Verrocchio and his pupils shared. The hand rests, moreover, on the near side of the book in a spatially illogical position.[8] The over-prominent lectern also derives from the master; its rich ornament recalls the Medici tomb (Fig. 53).[9] But these shortcomings – defects and shop usages – are the sign of a young, not a lesser artist. And the oft-criticized disjunction between parts of the picture simply represents the way the young Leonardo and his contemporaries composed their works in terms of details. Therefore, writers who have concluded that this is his first known painting are right.[10] It was completed during the early 1470s, when he was just beginning to emerge as an individual personality in the shop. Already he had begun to think about narrative in a new way: a closer look shows that the hand Leonardo featured has a function, that of keeping the Virgin's place in her book.[11] The painter then coordinated this gesture, denoting a momentary interruption, with that of Mary's left hand, expressing welcome or, more likely, surprise at the angel's message that she would miraculously conceive. Here we find the germ of Leonardo's portrayal of the apostles reacting to Christ's announcement that one of them would betray him in the *Last Supper*.

The Virgin's pose seems to have preoccupied Leonardo from the beginning of his work on the picture. A drapery study (Fig. 65) in Rome, one of the most

64 Detail of Fig. 63.

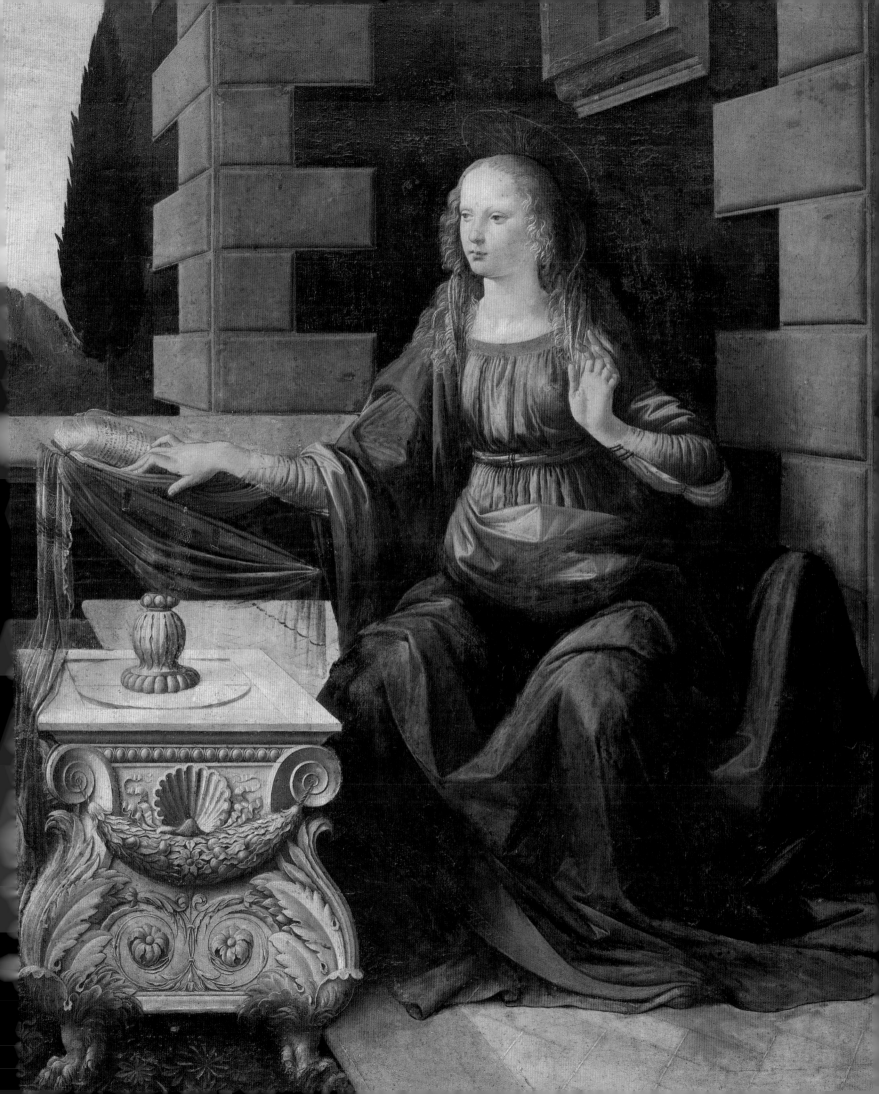

65 Leonardo, *Drapery Study for a Kneeling Figure*, Istituto Nazionale della Grafica, Palazzo Corsini, Rome.

admired of the artist's drawings, provides an intriguing glimpse into his creative process.[12] In this sheet Leonardo elaborated on the traditional medium of metalpoint, heightened with white, by using a brown wash and bright red-colored surface to create a strikingly pictorial effect. The figure, shown kneeling to the left,

has long puzzled scholars, among whom Berenson took it for a Virgin posed like an angel with one knee raised.[13] We are reminded of Gabriel in the little *Annunciation* (Fig. 147) in the Louvre, which has, in fact, been associated with the drawing.[14] But the upper body, lacking wings, and the lowered glance identify the subject of the sheet as a Virgin Annunciate. Remarkably, Mary's profile is depicted two or three times in slightly different positions, the earliest example of Leonardo's ability to envisage several solutions for the same figure simultaneously.[15] Her left arm also appears to be drawn more than once, held to the breast and extended over a sketchy form that may be meant as a lectern. Leonardo must have realized that the jutting knee would conflict with the lectern, and that may explain why he finally opted for a seated Virgin in the picture.[16] The real reason for experimenting with the raised knee, in any case, is offered by the drapery shown cascading over it. Like the waterfall in his landscape sketch (Fig. 124) in the Uffizi, the drapery falls and flows out in swirling eddies that are unmistakably Leonardo's.

The personal quality of the Rome drawing is lacking in other drapery studies (Figs. 66, 67, 68) that scholars have connected with the *Annunciation*. They belong to a different category which, as it is key to understanding the picture, should be examined in some detail here. Made with a brush in gray-brown wash, highlighted with white, on gray prepared linen (rather than paper), the drawings correspond to a procedure Leonardo is said to have used in Verrocchio's shop. Vasari describes how the young artist "sometimes made clay models, draping the figures with rags dipped in plaster and then drawing them painstakingly on fine cambric or linen in black and white with the point of the brush. The results," he added, "were marvelous, as may be seen by the examples in my book of drawings."[17] Some sixteen or so sheets fitting that description have survived, and though none can be traced to Vasari's collection, they have on his authority been attributed to Leonardo in the 1470s. The method used for the drawings was not altogether new: Piero della Francesca had copied draped models, according to Vasari, and Filarete's *Treatise on Architecture* of around 1450 similarly recommended drawing from models covered in glue-soaked cloth.[18] But whatever their antecedents (the Donatello-inspired draperies in Filippo Lippi's early works are akin to Leonardo's), the linen studies form a distinct group. As much like paintings as drawings, they share the same concern with describing the fall of light on folded cloth.

Basically there are two opposed theories about who did these drawings, that they are nearly all by one hand (Credi, Ghirlandaio, and Fra Bartolomeo have also been proposed) or that they can be divided among several artists. Though Berenson espoused the first view in line with his reattribution to Leonardo of works he had previously given to Verrocchio, another connoisseur of Leonardo's drawings, A. E. Popham, objected that the technique was probably in general use in Verrocchio's shop. With only the smallest differences separating the studies, Popham preferred to leave the question of their authorship open until they could be shown together.[19] Some of the drawings were gathered for exhibitions in Florence and Paris, commemorating the five-hundredth anniversary of Leonardo's birth, and a group of them went on tour in America in 1980.[20] But it was not until 1989 that all but one were reassembled for the first time since they were made. This exhibition was held at the Louvre to celebrate the acquisition of two linen studies from a private collection, which joined the four already in the museum.[21] Understandably, the organizers and lenders ascribed the sheets to Leonardo. But did Verrocchio's apprentice really invent the technique? And did he alone practice it in the *bottega*? Vasari, who never claimed all the linen studies for one artist, stated

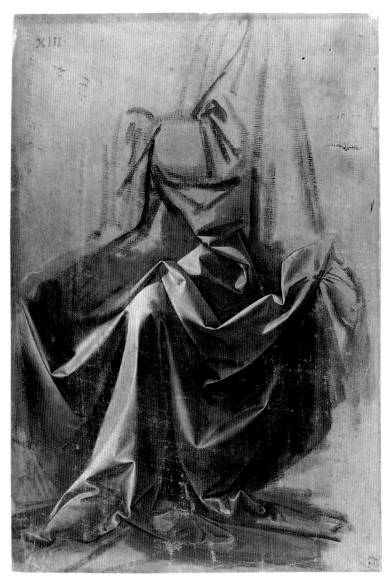

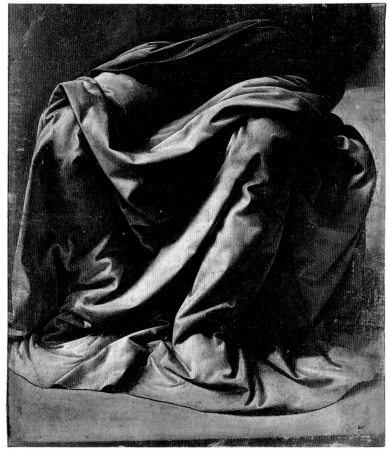

66 (*above left*) Verrocchio, *Drapery Study*, Département des Arts Graphiques, Musée du Louvre, Paris.

67 (*above right*) Ghirlandaio, *Drapery Study*, Département des Arts Graphiques, Musée du Louvre, Paris.

that Credi adopted a similar procedure, implying that this was a shop practice in which Leonardo excelled.[22]

Now mostly in the Uffizi and the Louvre, the drapery drawings on linen are the product of one mind, which could only be that of the master, and of several hands, his and those of his assistants. They arose, perhaps, in connection with the Orsanmichele group, in which Christ's robe displays remarkably similar folds.[23] In any case, the drawings epitomize the sculptural sense of form Verrocchio brought to painting. Their strong light-dark contrasts suggest that in illuminating the models the master and his pupils used candles, and their concentration on virtuoso light effects has a strong aesthetic appeal. But the drawings were not done for their own sake, nor with specific pictures in mind. Instead they were exercises utilized, when the need arose, for paintings. From the master's standpoint the method functioned to unify the shop style, as did other kinds of models he and his disciples employed. Attributing the drawings to different hands is extremely difficult, therefore. So far, writers have agreed on how to approach the problem – dividing the drawings up according to the different drapery styles of the artists involved – but not on the attribution of individual sheets.[24] Verrocchio's studies (Fig. 66)

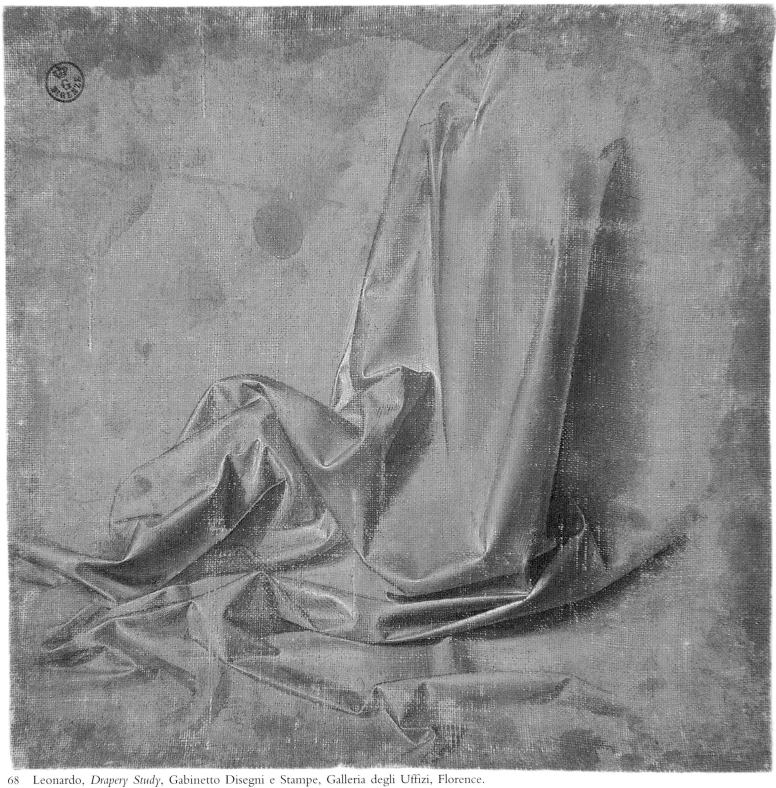

68 Leonardo, *Drapery Study*, Gabinetto Disegni e Stampe, Galleria degli Uffizi, Florence.

ought to have sharply angular folds, as in the Christ at Orsanmichele, while Leonardo's (Fig. 68) would be distinguished by a greater subtlety in the handling of light and shade. The remaining drawings, with folds tending to create patterns, have generally been given to the young Ghirlandaio. But as a measure of how difficult the problem is, some of those sheets might well be by Perugino, rarely discussed in this connection.

No fewer than seven of the linen drapery studies have been connected with the *Annunciation*.[25] Three relate to the robe of the kneeling angel (and his counterpart in the *Baptism*), and two of these, including a sheet (Fig. 68) in the Uffizi, are likely to be by Leonardo.[26] But neither of the latter two studies agrees exactly with the draperies in the paintings, indicating that other drawings corresponding more closely to the painted forms must have existed and are lost. Four drapery studies for seated figures have also been linked with the robe of the Virgin Annunciate. One of these (Fig. 66) appears closer to Verrocchio than to Leonardo, while two others seem to be shop work (Ghirlandaio or Perugino?) of the highest quality.[27] The last of the drawings associated with the *Annunciation* is the most spectacular of all, the drapery study (Fig. 67) for a seated figure in the Louvre.[28] This celebrated sheet actually corresponds to the Virgin's drapery in Ghirlandaio's San Giusto altarpiece, of the early 1480s, in the Uffizi. Scholars balked at taking from Leonardo what they regarded as the finest in the series – and thus jeopardizing his authorship of the others – until two Ghirlandaio experts courageously revived an old attribution to their artist.[29] Despite the persistent view that only Leonardo could be responsible for the drawing, the conclusion that Ghirlandaio did it after leaving Verrocchio's shop seems inescapable. Unlike the draperies made for study purposes and used as their creators saw fit, however, the Louvre sheet was destined for a specific picture.

Evolved according to the method practiced by Verrocchio and his pupils, the draperies in the *Annunciation* look exactly like what they represent – stiffened cloth. No less plastic than the lectern, they appear unnatural, as their complicated folds do not reveal the disposition or movement of the body beneath. It has even seemed from the way the Virgin's robe covers her lap and the chair that she has three knees! The aim in making these drawings and utilizing them for painting was to rival nature, and not only Pollaiuolo, in portraying reality. But the result, like the process, was artificial, as Leonardo came to realize. He made the bodily forms beneath the drapery of the baptismal angel (Fig. 111), completed a few years after Gabriel, more legible. And by the time of the Benois *Madonna* (Fig. 142) of c.1478–80 the artist largely abandoned the method he had used to construct drapery in his master's shop. He spelled out his reasons for doing so in a trenchant criticism of the process. In his notes on painting Leonardo enjoined artists portraying draperies to articulate the texture of the cloth and the limbs underneath.[30] He allowed for embellishment, but only in "part of the figure where [the folds] can be assembled and fall appropriately between the limbs," which perfectly describes the arrangement of fabric in the early metalpoint study (Fig. 65) of a posed model, as well as in the Virgin's robe in the *Madonna of the Rocks*.[31] Leonardo thus looked upon the linen studies as a brief experiment that led to the stiffly unrevealing draperies in the *Annunciation*. But the drawings also had a lasting importance, as we shall see, in providing a basis for the tonal structure of the painted draperies – and by extension the rest of the picture.

In creating the *Annunciation* Leonardo took up the challenge of the Pollaiuolo version of the subject (Fig. 12) now in Berlin. Except, perhaps, for the landscape,

featuring a view of Florence from the Medici villa at Careggi, this altarpiece is mainly the work of Piero Pollaiuolo. Completed by him soon after the Mercanzia *Virtues* about 1470, it betrays, even more than the *Tobias* (Fig. 37), a problem inherent in the new realism.[32] In Piero's hands the painstakingly executed detail characteristic of Antonio becomes, through sheer accumulation, stultifying. The profusion of gems, for example, or the ornate interior adorned with variegated marbles draws attention away from the story to a display of the artist's skill. However much contemporaries savored it, this kind of virtuoso realism must have seemed to Leonardo to defeat the artist's chief goal of creating a convincingly real representation of the world around him.

With no Annunciation by Verrocchio to serve as a counter-model, Leonardo was obliged to turn elsewhere for guidance. The size of his picture, a rectangle measuring some 3 by 7 feet, would have been determined by its intended location.[33] But Baldovinetti's oblong *Annunciation* in the chapel of the Cardinal of Portugal might have suggested the format Leonardo adopted, as well as his portrayal of the Virgin seated upright and gesturing toward the angel. Another source, especially for the motif of the angel kneeling in profile in a garden, was Filippo Lippi's lunette-shaped *Annunciation* from the Medici palace, now in the National Gallery, London.[34] Though Leonardo omitted Lippi's dove of the Holy Ghost, he adhered in other respects to the way Florentine artists had traditionally represented the theme. In fact, no painting as revolutionary as the *Annunciation* was ever more conventional in its iconography.[35]

Leonardo's widely spaced figures are linked by their architectural setting. An opening in the low wall behind them frames the angel's head and hand, while the quoins marking the doorway and a corner of the Virgin's dwelling anchor her figure. The paved terrace and enclosed garden suggest a villa overlooking the countryside, but what is most important about the painted architecture is its scale. Leonardo has avoided the "dollhouse effect" of earlier Annunciation scenes by showing only a small section of the building behind the Virgin.[36] The colonnaded loggias favored by his predecessors demonstrated their classical taste and skill in perspective but at the cost of plausibility. Here, in conformity with what Alberti advocated in *Della pittura*, the setting is kept simple and scaled to the figures.[37] Concentrated on the right side of the painting, Leonardo's architecture (Fig. 69) is defined in terms of orthogonals, or lines receding toward a vanishing-point on the horizon, according to the rules of linear perspective codified in Alberti's treatise.[38] Like the painted draperies, Leonardo's perspective follows a shop practice established by Verrocchio, whom Vasari called a "prospettivo," intent on geometry and other scientific pursuits.[39] The younger artist's first attempt at a perspectival construction is correct enough, but he made an error in positioning the Virgin, as we have seen. Though it emphasizes the figures, the sharply receding perspective does not, in fact, go hand in hand with them.

Raising his right hand in salutation, the angel (Fig. 62) is the true protagonist of the painting. The preparatory study for his sleeve (Fig. 76) at Oxford confirms the attribution of the picture to Leonardo.[40] The drawing also shows how carefully the young Florentine could depict clothing.[41] But unlike the drapery studies discussed above, this sheet, in pen and brown ink, has the vibrancy of the Uffizi landscape sketch (Fig. 87). The sleeve in the drawing is almost, but not quite, the same as that in the painting, where the violet-gray sash tied around Gabriel's arm flutters alongside his chest. This small but significant change, like the addition of the pale blue epaulet, conveys a greater sense of movement, and that is exactly how

69 Perspective diagram of the Uffizi *Annunciation*. From Martin Kemp, *The Science of Art* (New Haven and London, 1990), p. 45, pl. 73.

Leonardo conceived the angel. As the agent in the drama, Gabriel could not be omitted simply because Leonardo had, in Courbet's words, "never seen an angel." But Leonardo could make the figure he imagined appear convincingly like a winged being who has just alighted. Gabriel, accordingly, leans forward, placing his weight on his bent left leg, and extending his right leg backwards.[42] He is not shown at rest, as in other Annunciation scenes, but completing an action which has unsettled the Virgin. In Leonardo's dynamic concept, moreover, the angel's wings are correctly attached, as if growing at the shoulder, and they are raised, as if flapping. Years later the artist would undertake a systematic study of bird flight.[43] For now, the sober color, curved shape, and softly feathered texture of the angel's wings suggest that, taking a hint from Pollaiuolo (Fig. 37), he studied actual birds as an aid in visualizing the air-borne messenger.[44]

Even apart from the bird wings that equip him for flight, Gabriel is no ordinary angel. The *Profile of a Youth* (Fig. 71) on a double-sided sheet in the Uffizi records Leonardo's first idea for the angel's head (Fig. 77).[45] Stylistically similar to the sleeve study, the fragmentary profile is also in pen and ink. And it shares the same features as the painted head, including the forelock. On the front side of the sheet is the *Profile of a Man* (Fig. 72) resembling the *Bust of a Warrior* (Fig. 59) in the British Museum. Next to this head that of the youth on the reverse is repeated (only the eye, mouth, and chin are now visible), showing that Leonardo, in one of his earliest surviving drawings, had already come upon the device of contrasting the juxtaposed profiles of youth and age. This opposition, which must have

70 Leonardo, *Study of a Sleeve*, Christ Church Picture Gallery, Oxford.

71 (*above left*) Leonardo, *Profile of a Youth*, Gabinetto Disegni e Stampe, Galleria degli Uffizi, Florence.

72 (*above right*) Leonardo, *Profile of a Man*, Gabinetto Disegni e Stampe, Galleria degli Uffizi, Florence.

fascinated the artist since it recurs throughout his work, originated in Verrocchio's *Alexander* (Fig. 60) and *Darius* reliefs, as we have seen.[46] In the Uffizi sheet, however, Leonardo concentrated on the heads, omitting the *all'antica* aspect of his prototypes. The ideal of youthful beauty he defined by contrast with the mature head then became infinitely more expressive in the painting. The angel (Fig. 77) has an otherworldly grace that makes Leonardo's Tobias (Fig. 46) look like a mere lad. Beyond his role as a symbol of spiritual aspiration, however, Gabriel's mysterious beauty seems for the first time to crystallize Leonardo's innermost feelings. The almost feminine allure of his face, framed by soft curls, anticipates later examples (Fig. 145) of the artist's favorite androgynous type. At the same time, the angel shares some of the seriousness and self-possession of Leonardo's mature creations.

Technical examination of the Uffizi picture has shown that Leonardo's initial conception of the angel's head differed from its present appearance.[47] X-rays reveal that the head (Fig. 74) was originally inclined more to the right, and the glance was lowered. This and other *pentimenti*, according to Passavant, would be Leonardo's corrections to the panel he believed was first painted by Ghirlandaio.[48] But the changes revealed by the x-radiograph actually appear to be Leonardo's

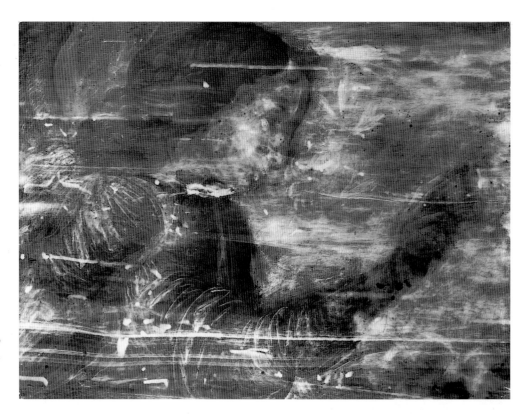

73 Leonardo, *Profile of a Youth*, Gabinetto Disegni e Stampe, Galleria degli Uffizi, Florence.

74 (*above right*) X-radiograph of the angel's head in the *Annunciation*.

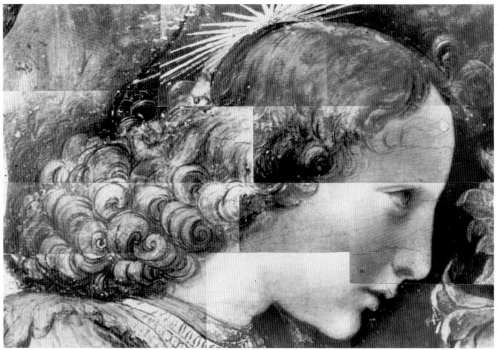

76 Leonardo, *Water Studies*. Detail. Royal Library, Windsor.

75 (*right*) Infra-red reflectogram of the angel's head in the *Annunciation*.

77 (*facing page*) Detail of Fig. 63.

improvements to his own previous work.[49] The angel's head was adjusted to set it off against the dark foil of the tree. And the hairline, originally farther to the right, was also moved back, as shown by infra-red reflectography. Penetrating the paint layers, the reflectogram (Fig. 75) of the angel's head betrays Leonardo's under-drawing for the curls framing the face and falling down the back of the neck. A virtual signature of the artist, the swirling forms here strongly resemble those

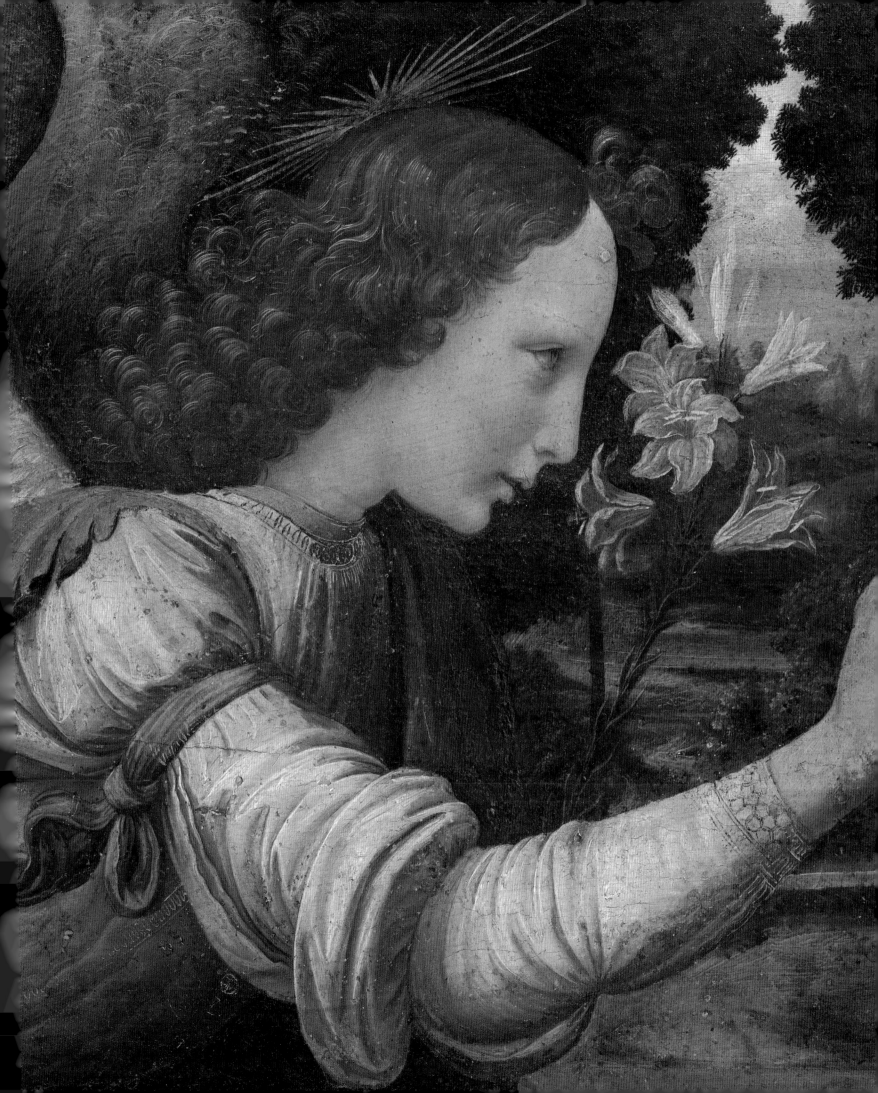

used for water in the artist's later drawings (Fig. 76).[50] The curvilinear patterns they share mark both hair and water as interrelated parts of nature, as Leonardo saw it. Throughout his work from the angel's curls to the final so-called deluge drawings, he imposed a highly personal spiraling form on a variety of natural phenomena.[51]

Leonardo also shifted Gabriel's head to accommodate the lily he holds in his left hand. In no other *Annunciation*, perhaps, is the flower so closely juxtaposed to the angel's face (Fig. 77). Unlike the long-stemmed plant in the Pollaiuolo version (Fig. 12), the flower here joins with Gabriel, almost as if he were contemplating it the way the Christ Child scrutinizes the bloom held up to him in the Benois *Madonna* (Fig. 142).[52] To judge from the flowery stalk slightly indicated in front of the Uffizi profile (Fig. 71), the angel and the lily were inseparable in Leonardo's mind. He studied the lily itself (symbolic of the Virgin's purity) in a drawing (Fig. 78) at Windsor Castle.[53] This sheet is the sole survivor of a series of early studies of "flowers copied from nature" which the artist records in the list of works he took to Milan.[54] Compared with what passed for accuracy in the woodcuts illustrating contemporary herbals, Leonardo's *Lilium candidum* set a new standard for botanical representation.[55] Manifestly drawing from a living plant, he captured not only the appearance of the flower but also its growth from buds to blossoms branching out from the stem as in nature. Outlining the contours in pen and ink and modeling the petals and leaves in sepia washes, heightened with white, against a yellow-colored ground, Leonardo gave the plant a distinctly three-dimensional character reminiscent of those (Figs. 55–7) he may have designed for the Medici tomb. And yet despite the fact that the drawing is pricked for transfer, the lily is not identical with the one framed by the angel's head and hand (Fig. 77). Leonardo reinterpreted the plant in the painting, altering its angle and scale and the precise arrangement of the flowers: only the pattern of growth is the same. He used the drawing merely as a basis for the freer rendering in the picture, unlike his fellow pupil Perugino, who strove to copy Leonardo's study of a lily in the London *Virgin and Child with Angels* (Fig. 35).[56]

Nature studies like that of the lily presumably lie behind the other flowers (Fig. 79) in the *Annunciation*, just as they may have gone into portraying the "meadow containing much vegetation" in the tapestry cartoon of the Garden of Eden. In describing that lost work in which plants played such an important role, Vasari mentioned only a fig and a palm tree, however. The other species depicted there may have been no more recognizable than are the grasses and flowers massed in the foreground of the Uffizi picture. As only a few of the latter can be identified, the murky garden in which they grow is puzzling from a botanical standpoint.[57] Contrary to what we might expect, Leonardo, after scrupulously drawing the lily, abandoned botanical accuracy for his painting, in which the plants are suggested but not meticulously described. In adopting truth to nature as his overriding goal, Leonardo must have noticed how earlier artists had isolated flora for their decorative beauty and symbolism so that the flowers they painted, however superior to the specimens in herbals, shared the same unnatural clarity.[58] Taken together, moreover, their flowers form an artificial ensemble, like the *millefleurs* tapestries by which they were inspired. Artists could not approach landscape except in this manner, according to Ficino, who related how Apelles, when he wished to paint a field he saw, did so one blade of grass at a time.[59] In Leonardo's case, nevertheless, detailed observation of individual forms yields to a more convincing impression of the meadow as a whole.

78 Leonardo, *Study of a Lily*, Royal Library, Windsor.

Like the Virgin's dwelling, the flower-strewn plot in the *Annunciation* may reflect Leonardo's knowledge of fifteenth-century villa gardens.[60] But the plants he painted in light tones on a darker ground are not just scattered haphazardly. They "twist and surge like little waves," Clark said, displaying the "turbulence [Leonardo] felt to be the essence of nature."[61] Specifically, they are swept by the force of the angel/aviator's descent.[62] The medium that both sustains his flight and suffuses the meadow is air. Leonardo subscribed to the ancient belief that air, linked to water below the sky, was dense and moist.[63] But though well established as a concept, atmosphere was hardly ever represented in painting.[64] The notion of air as a more or less dense medium affecting visual perception seems to have led Leonardo, long before he theorized about it, to submerge the plants in the *Annunciation*, and the same idea also governs the background (Fig. 80). For the first time ever, Leonardo depicted the theme in a broad landscape combining linear with aerial or atmospheric perspective. An opening in the garden wall leads along a winding path to a grove of trees silhouetted against the horizon. A Netherlandish-inspired harbor scene with mountains towering above it is featured in the distance. Doubtless following his own experience, as well as some northern example, Leonardo gave this realm where mountains and sea blend with the sky a hazy, light bluish cast. The background appears this way, not for aesthetic effect, but because that is how such a fantastic landscape would look to the observer.

The innovative outdoor setting in the *Annunciation* shows Leonardo's portrayal focused on nature as it was viewed under certain conditions of air and light. Since

79 Detail of Fig. 63.

80 (*facing page*) Detail of Fig. 63.

the traditional tempera technique he adopted for the *Tobias* could never capture such effects, Leonardo turned to oil. As the Netherlandish masters had developed it, the oil medium had the advantage over tempera that the brushstrokes are blended to create a more convincing illusion of form and space.[65] As far as we know, Verrocchio never worked in oil, but he may well have encouraged his pupil to do so as a challenge to Pollaiuolo's mastery of the new technique. From being the shop's nature specialist, then, Leonardo also became its designated technical innovator. His experiments with oil alone would place his early works in the vanguard of Florentine Quattrocento painting.

In none of these works has the binding medium been scientifically identified, as the available methods – staining tests and gas and liquid chromatography – all require taking paint samples. Until a "non-destructive" method is found, visual analysis is the only means of assessing the nature of his medium. The assumption that Leonardo used oil, alone or in conjunction with tempera, was borne out when in 1994 the author, David Bull, and Maurizio Seracini examined the *Annunciation* and the technical evidence Seracini had gathered about it.[66] This joint effort of an art historian, a conservator, and a scientist clarified much that was previously unknown or misunderstood about the picture – above all, the claim that two hands worked on it.[67] The technical examination also showed that the condition of the paint, under the discolored varnish, is better than expected, with losses in the figures' robes, the architecture, and along a horizontal crack running from the left edge through the angel's left hand. Since no pounce marks are visible in the reflectogram, Leonardo may not have used a cartoon to transfer the design onto the panel. Instead, he made a brush underdrawing, visible not only in the angel's hair (Fig. 75) and draperies, but also in the cypress trees. Left in reserve, the regularly spaced cypresses were part of the initial design, unlike the other trees painted in around the angel's wings and head. The foliage, glazed with copper resinate green, has turned brown.

Since his teacher worked only in tempera, Leonardo must have taught himself to paint in oil by a process of trial and error. In Florence and other centers where experiments with oil were under way in the 1470s, the technique was still relatively unfamiliar.[68] Leonardo's lack of experience with it caused the wrinkling visible in and around the Virgin's head (Fig. 81) in the x-radiograph.[69] Shrinkage from oil, which dried unevenly in the paint layers, can also be made out in her draperies. As he worked over the painting, however, Leonardo gained confidence in mixing oil with his pigments. Exploiting the flexibility of the medium, he caught the creamy smoothnesss of the marble lectern (Fig. 64) and the delicate transparency of the veil falling over it. The vigorous brushwork in this and other light-colored passages, like the angel's shirt or the sky, could never be obtained with tempera. Leonardo's technique here departs from that of his teacher, and it also differs from his own later procedure, in which practically all traces of the brush are eliminated.[70] Only in the angel's and the Virgin's robes does the artist's touch become labored, and that is because he was following the linen studies. The most remarkable aspect of his technique is the fingerpainting found throughout the *Annunciation*. The slow-drying oil medium allowed the artist to blend the wet paint with his hands, and not only the brush, leaving tell-tale papillar marks (Fig. 82). In creating a soft-focus effect by dabbing the paint with his fingers, Leonardo seems to have preceded such painters as Giovanni Bellini, who also left fingerprints on their works.

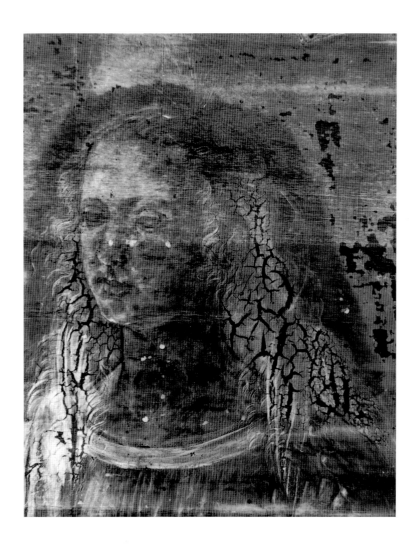

82 X-radiograph of the *Annunciation*. Detail.

Leonardo may really have enjoyed painting the *Annunciation*, which he seems to have executed rapidly, not over a long period of time, as is sometimes claimed. The paint has a brio that recalls, or rather anticipates, the art of Venice. In Leonardo's case, this freedom of handling came from a lifelong love of experimentation: he here delighted in exploring the possibilities of oil. But his use of the new medium also had a serious purpose, for it permitted a greater tonal range than tempera. As Shearman has shown in a fundamental study of Leonardo's color and light, the *Annunciation* is the first work in which he set out to achieve an overall tonal unity.[71] Earlier artists had adopted a variety of modeling systems that generally resulted in a patchwork of different hues and values. Leonardo's solution to the problem was to model forms with black. His revolutionary method accounts for the subdued tonality of the *Annunciation*, as does the artist's palette, consisting mainly of earth tones which overshadow the reds and blues of the figures. Like the medium, the specific pigments he adopted have not been scientifically identified. And without cross-sections of paint samples, it cannot be determined whether Leonardo used a dark underpaint here, as he did in the unfinished works from the latter part of his first Florentine period (Fig. 140). What we can observe is that the modeling in the upper layers of the *Annunciation* is inconsistent. The figures' robes display a full range of values from dark to light, and they merge with the garden, on which the angel casts a shadow. But the flesh tones, lacking depth, look flatter.

The pale faces in particular appear detached from the rest of the painting, which thus seems to have been modeled much as it was composed, in sections.

Leonardo's tonal modeling, however incomplete, points the way to his mature works. Its source, aside from the shadow effects in certain works by Filippo Lippi, lies in Verrocchio's shop.[72] The master's sculpture, particularly the *Christ and St. Thomas* (Fig. 17), has often been credited with inspiring his pupil's *chiaroscuro*.[73] The bronze group was not installed until mid-1483, after Leonardo had left Florence for Milan. But the work was in progress as early as the late 1460s, when Verrocchio conceived the two-figure composition. Preparations under way then and in the early 1470s, before the figure of Christ was cast, may have included clay models studied under controlled light to simulate the effect of the semi-enclosed niche at Orsanmichele.[74] Unfortunately, none of this preparatory material survives, except, perhaps, for one of the drapery studies on linen, which has been connected with the Christ figure.[75] Whether this drawing is by Verrocchio or Leonardo, it raises the possibility that the linen studies might have indicated the tonal approach the younger artist took to painting. In making these drawings (with a brush) Verrocchio and his other assistants failed to apply their lessons to the paintings for which they served. Leonardo alone seems to have made this crucial step. The problem remained of how to model the rest of the picture consistently with the draperies, and here, as far as the landscape goes, the example of another grisaille may be relevant – the Garden of Eden in the lost tapestry cartoon.

Leonardo's approach, using tonal color and light to unify the composition, suggests that he was seeking further guidance from Alberti's treatise, which pre-scribes not only perspective but "rilievo" or the illusion of relief obtained through modeling with black and white.[76] In attempting to put these theories into practice, Leonardo must have hoped that Alberti's definition of painting as a "liberal" or intellectual pursuit would apply to his own efforts. Today it seems inconceivable that the *Annunciation*, in which Leonardo's master allowed him to strike out in new directions, was ever mistaken as Verrocchio's. Leonardo's success in imitat-ing nature could no longer be measured in terms of vivid details, like Tobias's dog or fish. The more complex, all-encompassing reality he sought to portray in the *Annunciation* consisted, as he later wrote, of "sea, land, trees, animals, grasses, [and] flowers, all of which are enveloped in light and shade."[77] Though Leonardo's nature is not the ideally beautiful one envisaged by Alberti, he distin-guished, as did his predecessor, between mere imitation of nature's forms – what the ancients called *natura naturata* – and a grasp of the forces behind it – *natura naturans*.[78]

The *Annunciation*, in effect, announces a number of themes central to Leonardo's achievement: his interest in architecture and concern with narrative; his somber coloring and experimental technique; and, above all, the deep kinship he felt with nature. Surpassing the work of his contemporaries, the picture is the product of an extraordinary intellect and a talent to match. In it Leonardo treated separately observed and studied details in sequences that are conceptual and not just formal or aesthetic. Thus, the curly-haired angel (Fig. 62) is powered by convincingly realistic wings to a landing that stirs the plants and startles the Virgin. And the shadowed complexity of the angel's treatment extends to the landscape around him. Indeed, the angel bearing a divine message may be taken as a kind of self-image of the artist and his goals. Leonardo/Gabriel, we might say, confronts the Virgin and the orderly world of her surroundings with a strikingly new vision of nature as the artist experienced it.[79] Subtlety and mystery are not qualities usually

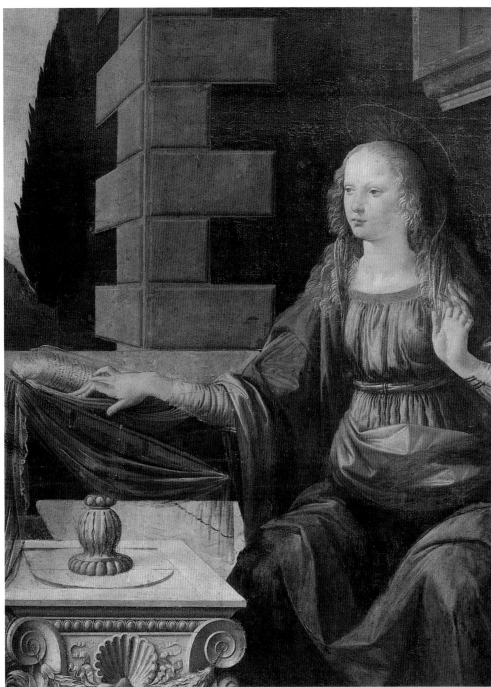

associated with science. And yet Leonardo's picture is both romantic and rational: however evocative, the scene of the angel appearing to the Virgin at twilight was conceived and executed in a spirit of scientific inquiry, and for Leonardo it would have had the same validity as the geometrically constructed architecture.

How could Leonardo, working in Verrocchio's bustling shop, have managed to integrate all the strands in the *Annunciation* into an overall scheme? In fact, the genesis of the picture remains puzzling, as the few surviving drawings for it do not include composition sketches. The only such drawing from this period – the *Aristotle and Phyllis* (Fig. 84) in the Kunsthalle, Hamburg – is not related to any known painting by the artist.[80] Generally speaking, this and Leonardo's other early

drawings fall into two separate categories according to the medium employed: studies elaborated in metalpoint and ones made rapidly in pen and ink. Like the linen drawings, both types go back to his teacher, and all but two of them (the aged profiles) were made for paintings. In addition, they are all left-handed, that is, the metalpoint and pen strokes slope from left to right, not as with the right hand, from right to left. Sketched in pen and ink on grayish-blue prepared paper, the Hamburg drawing belongs to the latter group. It has sometimes been dated later in Leonardo's career, but the unsystematic shading resembles the studies (Figs. 70 and 71) for the angel.[81] And the awkward relation of the protagonists and the inept perspective of their setting likewise betray the draughtsman's inexperience.[82] The inscription in Leonardo's mirror writing on the reverse comments on the subject of the drawing.[83]

The humorous story of Aristotle humiliated by Phyllis became popular in the late Middle Ages.[84] Infatuated by the consort of his pupil Alexander the Great, the ancient philosopher agreed, in return for her favors, to let her ride him like a horse. As in a contemporary Florentine engraving (Fig. 85) of the theme, Leonardo's drawing shows the scholar on all fours, with Phyllis on his back,

84 (*facing page top*) Leonardo, *Aristotle and Phyllis*, Kunsthalle, Hamburg.

86 Detail of Fig. 21.

83a–c (*pages 94–5*) Detail of Fig. 63.

85 (*facing page bottom*) Florentine, fifteenth century, *Aristotle and Phyllis*, engraving, Albertina, Vienna.

brandishing a whip.[85] The artist dispensed with the bridle and ornate costumes of the print, however, in favor of an emotionally charged portrayal that owes much to Verrocchio. The way Leonardo contrasted the two figures before a shadowy niche may well have been suggested by the master's preparations for *Christ and St. Thomas* (Fig. 17). And his dramatic depiction of an anguished Aristotle, turning to look back over his shoulder, was clearly inspired by another work by Andrea – the soldier crouching in the lower right (Fig. 86) of the *Resurrection* relief from Careggi. Apart from the *Bust of a Warrior*, this is the most direct borrowing from Verrocchio in all of Leonardo's oeuvre.[86]

The purpose of Leonardo's drawing is unknown. It might be a study for a wall or furniture panel, as allegories of love and fortune, inspired by Petrarch's *Trionfi* (of which Andrea owned a copy), were favorite subjects for secular paintings.[87] Or it may have served for a temporary decoration marking an important occasion, like the marriage of Lorenzo de' Medici in 1469. Verrocchio is known to have done the "adornamento e aparato" when Duke Galeazzo Maria Sforza of Milan and his wife visited Florence as Lorenzo's guests in March 1471.[88] Though Tommaso's inventory fails to specify which decorations Andrea contributed, 1471 would be a suitable date for the Hamburg drawing on the basis of style. The task involving the drawing, in any case, fell to Leonardo, who may have found it congenial. The story, with its warning against women and their wiles, might have appealed to the misogyny reflected in his notebooks. At least it allowed him to poke fun at the venerated philosopher whose authority he was later to question.[89] Sharpening the satire with a kind of Boccaccian immediacy, Leonardo depicted Aristotle in his chamber, crawling from the bed symbolic of lust toward the writing desk and window (with an hourglass) representing his intellect.

Another drawing – the celebrated pen-and-ink sketch of a landscape (Fig. 87) in the Uffizi – undoubtedly had a personal meaning for Leonardo.[90] It is also his first dated work, as the inscription in the artist's backwards writing in the upper left corner of the sheet refers to the feast "day of Holy Mary of the Snow, August the 5th, 1473."[91] Leonardo's panorama has long been recognized as a landmark in the history of nature depiction, and yet the question remains as to why he did it.

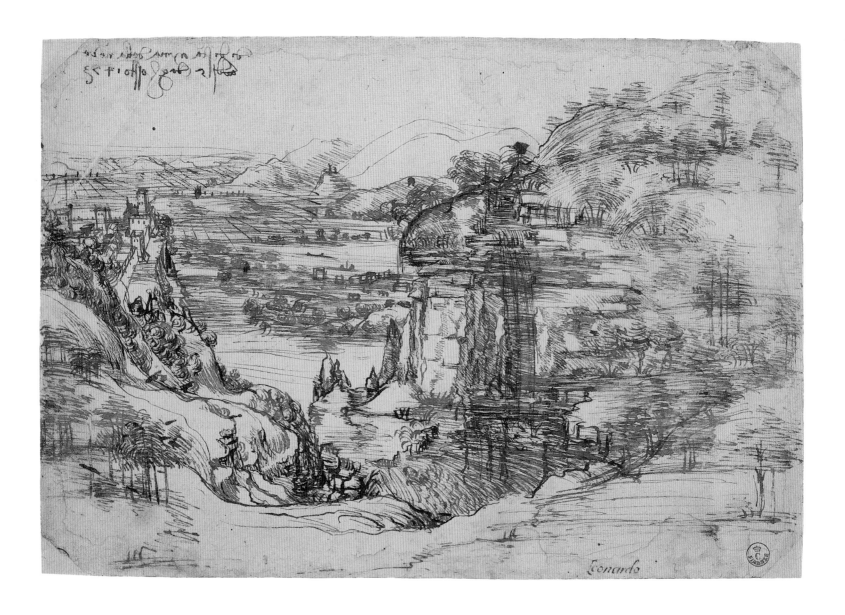

87 Leonardo, *Landscape Study*, Gabinetto Disegni e Stampe, Galleria degli Uffizi, Florence.

Ostensibly the product of an excursion on foot or horseback into the Tuscan countryside, the sketch might be interpreted in a proto-Romantic vein, as if its creator had gone "wandering lonely as a cloud," enraptured by nature's wonders. But the drawing must have had a purpose beyond that of seeking inspiration in nature. Landscape in the Early Renaissance, far from being a self-sufficient genre, served merely as a background for the main subject in a work of art.[92] And the independent landscape studies Leonardo made for scientific purposes came much later. The Uffizi sketch must explore a problem that arose in connection with Leonardo's activity as a painter.

The notion frequently encountered in the literature that Leonardo, on a visit to Vinci, simply recorded the scenery he saw there misses the point.[93] Related as it is to the Arno valley, the drawing cannot have been conceived independently of the topographical type of landscape (Fig. 10) Pollaiuolo had developed from earlier precedents.[94] In the absence of a suitable model by Verrocchio, his rival offered the compositional framework for the Uffizi sketch. Leonardo, accordingly, chose a high viewpoint, as if the itinerant Tobias (Fig. 38), with pen in hand instead of a fish, had turned to survey the panorama spread out behind him. And Leonardo

98

also took over the formula of tree-topped rocks framing a river valley that stretches toward a mountainous horizon. But Verrocchio's pupil could not simply copy Pollaiuolo's landscapes; he had to improve on them.

Critiquing Pollaiuolo's solution on the basis of firsthand observation, the sketch succeeds in capturing the character of a particular place, whether it was done directly from nature or from memory. Leonardo turned the river winding through his predecessor's paintings into a broad waterway that merges with the land, and he omitted the familiar view of Florence. In delineating the landscape, he seems to have cared less about the fertile plain, in fact, than the rocky outcrop on the right. This motif is not original either.[95] But Leonardo's treatment of it, with water falling into a pool carved from the rock, appears to be unprecedented.[96] The cascade in a chasm must have stirred his imagination, for he featured it at eye-level, even though the castle perched on the other summit overlooking the valley is seen from above. The waterfall recurs again and again in his later drawings and writings, in which he exhorted the painter to represent "rivers that descend from high mountains."[97]

Young Leonardo took advantage of the freedom Verrocchio granted his assistants to develop his own concept of landscape. With the Pollaiuolo formula in mind, the twenty-one-year-old ventured to explore a specific (if not identifiable) site. The drawing that resulted is literally a landmark recording an intense experience of nature, like Petrarch's ascent of Mont Ventoux, for which the inscription gives the exact date. Leonardo's response to the landscape was personal, and so too were the means he used to express it. Falling water and rustling trees on the slopes are rendered with the same lively left-handed pen strokes as the study for the angel's sleeve (Fig. 70).[98] The artist's sketchy technique is the graphic equivalent of the oil medium he used to depict the landscape permeated by light, atmosphere, and motion in the *Annunciation*. Addressing representational issues raised by paintings in Verrocchio's shop, both the drawing and the picture make their contribution in areas that were marginal to the master's goals as an artist. The next work Leonardo painted would extend his preoccupation with nature and its portrayal beyond the confines of the *bottega* into the larger context of Florentine culture.

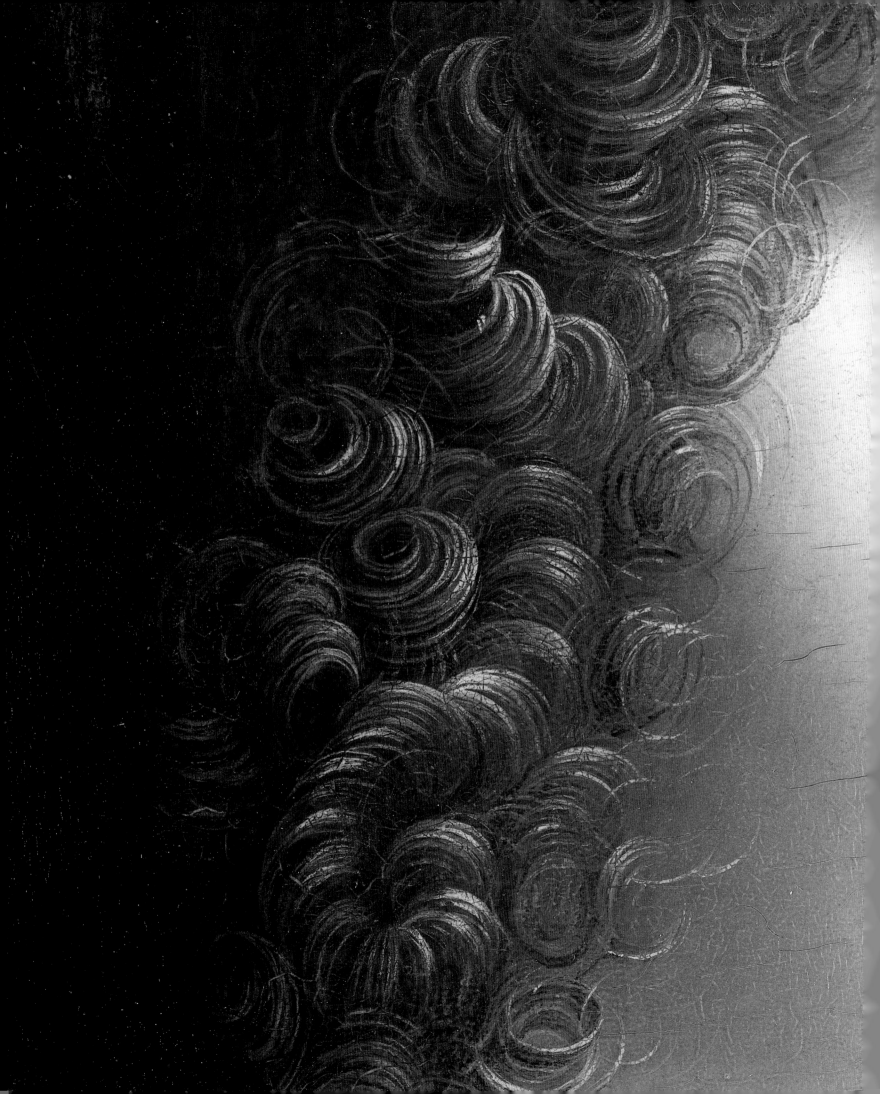

5 Ginevra de' Benci:
The Nature of the Portrait

FOR HIS NEXT PICTURE Leonardo took what he had accomplished in the category of religious art and, again moving the subject outdoors into nature, applied it to portraiture. The work in question, acquired from the Liechtenstein Collection in 1967 for the National Gallery of Art in Washington, is the double-sided portrait of *Ginevra de' Benci*.[1] Leonardo's painting had entered the collection in Vienna and Vaduz by 1733, the date of a seal on the reverse. Its previous ownership is unknown.[2] The front side of the panel (Fig. 89) portrays the young lady in a landscape, while the back (Fig. 90) depicts a wreath of laurel and palm encircling a sprig of juniper. Entwined around the plants is a scroll with a Latin inscription meaning "Beauty Adorns Virtue"; the fact that the wreath is truncated at the bottom indicates that the panel, measuring about 15 inches square, was cut down in the past.[3] Despite its less than complete state, however, the picture is very well preserved. Conservation treatment in 1990 underscored its extraordinary delicacy of execution.[4] And the conception is no less remarkable: in what is probably the most complex portrait thus far attempted in Florence, young Leonardo grappled with the problem of how to represent the sitter. Because it was overshadowed by *Mona Lisa*, sixteenth-century Florentine writers refer to Leonardo's portrait of Ginevra d'Amerigo de' Benci only briefly. Antonio Billi praised its lifelikeness ("painted with such perfection that it was none other than she") in conventional terms that the Anonimo Gaddiano later echoed ("completed so perfectly that it seemed to be not a portrait but Ginevra herself"). Vasari's praise for the portrait "as a most beautiful thing" in the *Vite* offers little more, having been based, it seems, on his sources rather than on firsthand acquaintance with the painting.[5]

It was the German scholar Wilhelm von Bode who established our basic knowledge about *Ginevra de' Benci*. More than a century ago he connected Vasari's citation with the portrait in the Liechtenstein Collection and attributed it to Leonardo.[6] Adopting a suggestion of Aby Warburg, Bode then proposed that the juniper (*ginepro* in Italian), depicted as a landscape element on one side of the panel and emblematically on the other, punned on the sitter's name.[7] He cited as further evidence for the identification a variant (Fig. 92) of the painting, then in the Pucci Collection, Florence, which also associates the sitter with a juniper and which is inscribed on the reverse "Ginevera de Am . . . Benci." In this work the lady holds a ring, which led Bode to surmise that the missing portion of the Liechtenstein panel originally included the subject's hands. These were represented, he argued, by Leonardo's beautifully expressive *Study of Hands* (Fig. 93) at Windsor Castle.

Before considering the portrait and the issues it raises in detail, we need to review the sitter's biography, starting with the few facts of her life that can be

88 Detail of Fig. 89.

89 Leonardo, *Ginevra de' Benci*, National Gallery of Art, Washington, Ailsa Mellon Bruce Fund.

90 Leonardo, *Ginevra de' Benci* (reverse), National Gallery of Art, Washington, Ailsa Mellon Bruce Fund.

established by documents.[8] Ginevra was born the daughter of Amerigo de' Benci, a wealthy Florentine banker, in August or September 1457.[9] She was brought up in the palazzo the family acquired in 1462 by turning two houses into a single dwelling which still stands as nos. 14–16 in the via de' Benci. It was there on January 15, 1474 (1473 Florentine year), that the sixteen-year-old Ginevra married Luigi di Bernardo Niccolini. Her large dowry of 1400 florins reflected the economic disparity between the two families.[10] The Niccolini had been prominent in the government of Florence for generations, but compared with the Benci, they were not rich. Luigi, moreover, was twice as old as his bride, and he had been married before.[11] Though he became *Gonfaloniere* (chief magistrate) of the city in 1478 and one of six *Priori* in 1480, the cloth-weaving business that Luigi and his brothers inherited from their father in 1470 declined, leading him to claim in his tax return of August 15, 1480, that he had "more debts than property." He also reported that his wife Ginevra, then twenty-three years old, had been sick and "in the hands of doctors for a long time."[12] The couple remained childless, and the Niccolini family fortunes did not improve either, so that on Luigi's death in 1505, his brothers were unable to repay Ginevra's dowry. She lived on, in spite of poor health, until about 1520.[13]

Soon after Ginevra's marriage an event occurred which, apart from Leonardo's portrait, is her chief claim to fame. On one of his two missions to Florence (Jan. 1475–April 1476 and July 1478–May 1480), the Venetian ambassador Bernardo Bembo adopted the local chivalric fashion and chose Ginevra as the object of his platonic love. Both were already married, and Bembo (1433–1519) was even older than Ginevra's husband, so the liaison between them was a matter of convention, not an illicit romance. Their mutual devotion accordingly found expression in a series of Petrarchan poems by writers in the Medici circle. These poems – six by Landino, four by Alessandro Braccesi, and one by Naldo Naldi – are addressed to Bembo or Ginevra in celebration of her beauty and virtue.[14] Unfortunately, the poets' praise for the beloved's "snow-white brow" and "crimson lips" is purely rhetorical and tells us nothing about her actual appearance. We cannot even be sure from the literary descriptions whether she was, in fact, beautiful. As for Ginevra's character, we learn only that she possessed the same virtues as other women of her class: over and over again she is said to be chaste. Two sonnets dedicated to Ginevra by none other than Lorenzo de' Medici likewise stress her chastity. Though difficult to interpret, these poems seem to refer to an incident which prompted the lady to flee to the country.[15] We get a better glimpse of Ginevra's personality from a letter written to her from Rome on August 17, 1490, by a Florentine lute player on intimate terms with both the Benci and Niccolini families.[16] His "magnificent patroness" had commissioned the writer, who signed himself "G. H.," to get her some mother-of-pearl rosaries and wax discs stamped with the Lamb of God and blessed by the Pope. At the papal court, "G. H." said he had extolled Ginevra (and her sisters) for their manners, clothes, and conversation. Impressed, the Roman ladies wished to read something written by this paragon. To oblige them, "G. H." asked her to send him a copy of the poem which began "I ask your forgiveness, and I am a mountain tiger."[17] If we are to believe what Ginevra said of herself, beneath that cool exterior in her portrait beats the heart of a tigress.

What we know about Ginevra has been used, understandably, to interpret her portrait. When the National Gallery acquired the painting, it was compared with *Mona Lisa*, which, as a Kennedy-era loan, had enthralled millions of visitors to

Washington. In the past scholars had been reluctant to accept the Liechtenstein portrait because it lacked Mona Lisa's mysterious smile. Now more than one art critic also found the new acquisition antipathetic.[18] Ginevra, in short, had an "image problem," and it became necessary somehow to link her portrait with Mona Lisa's as equally characteristic products of the same creator. If a painted figure should express the "motions of the mind," as Leonardo contended, then Ginevra's sullen mood must reflect some inner sadness.[19] Her "mysterious fascination" might be "inexplicable," but one could account for the lady's pallor at least by recalling her husband's claim that she had been "sick for a long time."[20] The Gallery's Director John Walker (who succeeded in obtaining the picture) offered a different explanation for Ginevra's brooding aspect. Interpreting the sonnets about her love affair literally, he argued that the sitter was shown as disconsolate over Bembo's departure from Florence. For Walker this "earliest of all psychological portraits" formed a tragic counterpart to *Mona Lisa*.[21]

The psychological reading of the poems was grafted onto the portrait to make the sitter a more living personality. Bembo might even have commissioned the picture, Walker suggested, and Jennifer Fletcher's discovery that the wreath of laurel and palm on the reverse was his device lent support to that hypothesis.[22] If Leonardo portrayed Ginevra as Bembo's grief-stricken beloved, the painting would have to have been created in the late 1470s. Most scholars have, accordingly, dated it around 1480 by attraction to the literary records.[23] And yet if we consider *Ginevra de' Benci* simply as a painting, apart from the sitter's biography, it demonstrably belongs with the works Leonardo did in Verrocchio's shop, not the Benois *Madonna* (Fig. 142), which he completed about 1480 after setting out on his own. Clark's dating of the Washington picture to the mid-1470s is confirmed by its close stylistic resemblance to the *Annunciation* (Fig. 63).[24] As in that work, the portrait combines the most consummate artistry with what, in the case of another artist, would be called fumbling: in the process of delineating the sitter's features, for example, Leonardo flattened her head.[25] At this stage, we can conclude, his interest in anatomy went only skin deep. The wrinkling of paint in the landscape (Fig. 110) likewise shows that the young artist still lacked a complete command of the oil technique he had first adopted for the Uffizi picture.[26] The pronounced indebtedness of the portrait to Verrocchio equally marks it as an early work.

If Ginevra's portrait – the front side at least – is dated approximately to the time of her marriage in January 1474, the question arises as to whether it is a nuptial painting. In works that can be identified as marriage portraits, like the Gozzadini diptych (Fig. 91) in the Lehman Collection at the Metropolitan Museum, the bride is customarily shown on the right, facing her spouse on the left. Since Ginevra's portrait does not conform to this type, it more likely celebrates her betrothal to Niccolini, which took place sometime during the four-month period following the death of his first wife in August 1473.[27] A girl's *sposalizio* (engagement), when she and her future husband exchanged rings and agreed to the alliance contracted by their families, was a milestone in her life.[28] In Ginevra's case, her father having died in 1468, it was presumably her older brother (and eventual heir) Giovanni who arranged the union. And it may also have been Giovanni who ordered the portrait (from Verrocchio, who then assigned it to Leonardo) to celebrate his sister's impending marriage. Made as part of the wedding preparations, the pre-nuptial portrait, if it remained in the Benci household, would have served to remind family and friends of the absent Ginevra. Alternatively, it may have been sent to Niccolini as an image of his prospective bride or brought to his house with

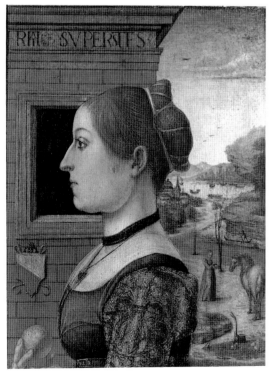

91 Emilian, fifteenth century, *Lady of the Gozzadini Family*, The Metropolitan Museum of Art, New York, Robert Lehman Collection, 1975.

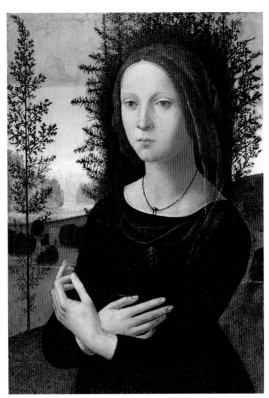

92 Attributed to Lorenzo di Credi, *Portrait of a Lady*, The Metropolitan Museum of Art, New York.

93 Leonardo, *Study of Hands*, Royal Library, Windsor.

Ginevra's trousscau. Whatever the case, an unexpected outcome of the commission – that is, of Leonardo's visits to Palazzo Benci to record Ginevra's features – was that he and her brother Giovanni became lifelong friends. Some thirty years later Giovanni and Leonardo exchanged a map of the world, books, and semi-precious stones.[29] Even more significant is Vasari's statement that Leonardo's unfinished *Adoration of the Magi* belonged in his day to Giovanni's son, called Amerigo after his grandfather, suggesting that this work, too, had been entrusted by the artist to his friend.[30]

Ginevra's portrait, the lower part of which was cut down after suffering some damage in the past, may originally have included her hands. That is how Bode and others reconstructed it, as we have seen. But in completing the truncated wreath on the back (Fig. 90), Möller thought the missing section measured only 6 inches, which could hardly have accommodated the sitter's hands.[31] On the assumption that Leonardo's picture was originally a half-length based on the same height-to-width ratio as other related portraits, it would have to have been cut at the side as well as the bottom. And, in fact, saw marks are visible along the right edge.[32] The present panel, minus the missing portions, is nearly square. To gain an approximate idea of its original appearance, we may turn to the previously mentioned variant (Fig. 92) now in the Metropolitan Museum. This portrait of an unknown lady holding a ring before an arboreal background is attributed to Lorenzo di Credi, but in some ways it looks more like the work of the Credi pupil whom Berenson dubbed "Tommaso."[33] Though the reverse of the portrait is inscribed "Ginevera de Am . . . Benci," the sitter portrayed is clearly not the same as Leonardo's.[34]

A better indication of Ginevra's hands may be found, perhaps, in the study at Windsor (Fig. 93), which has repeatedly been connected with the painting.[35] While allowing that the portrait may once have had hands similar to those shown on the sheet, scholars have tended to date the drawing somewhat later in Leonardo's career.[36] And yet in its meticulously finished style and technique – metalpoint heightened with white on buff-colored paper – the drawing recalls the *Drapery Study* (Fig. 65) in Rome and the *Bust of a Warrior* (Fig. 59) in the British Museum. All three works would seem to date from the same time, namely, the earlier part of Leonardo's first Florentine period. If that is the case, then the Windsor drawing could have served as a preparatory study for Ginevra's portrait. Even more telling than its relation to the other highly finished drawings is the analogy in shape and shading between the slim, long-fingered hands in the drawing and those (especially the left hand) of the angel in the *Annunciation* (Fig. 62). If young Leonardo could paint hands like these, why could he not also draw them?

The hands in the drawing are not posed one above the other, as has often been claimed; rather they are shown resting together at waist level. This arrangement is repeated twice on the sheet, and in each case one hand is fully modeled while the other is merely sketched in. To reconstruct Ginevra's original attitude, therefore, the two finished hands must be joined, thereby functioning as a base for her head and shoulders. In the half-length image that results (Fig. 94), both hands and head are lit from the upper right and both are in three-quarter view.[37] Between the thumb and index finger of the more finished right hand are represented stems and leaves, suggesting that the sitter once held a sprig of some plant. This motif of holding what was probably a flower links Ginevra's portrait to a series of contemporary depictions of ladies in the same attitude, both northern and Italian.[38] The sitters in these portraits offer an unseen suitor (Luigi Niccolini in Ginevra's case),

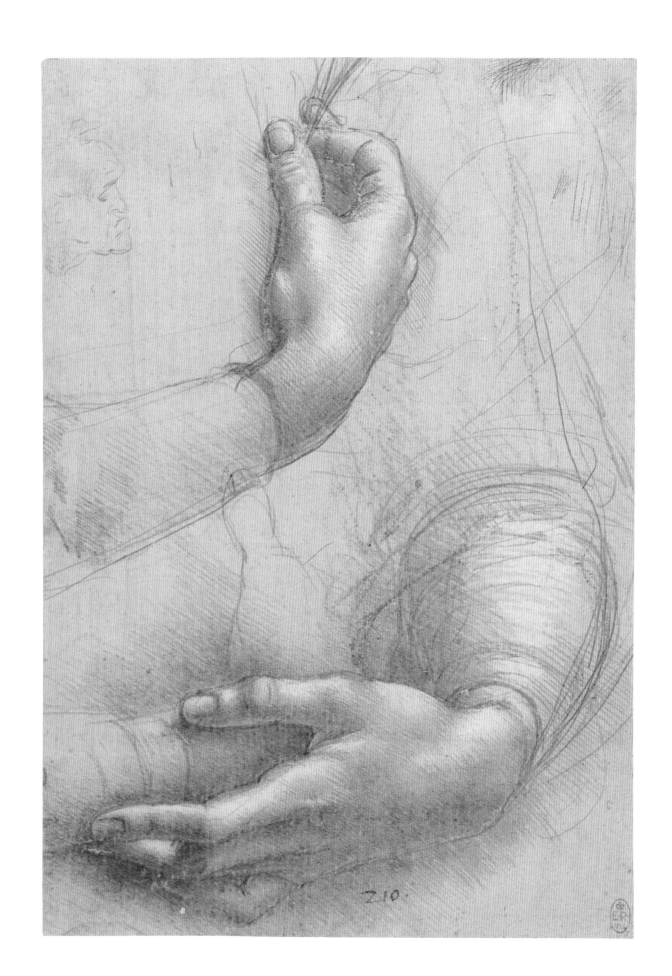

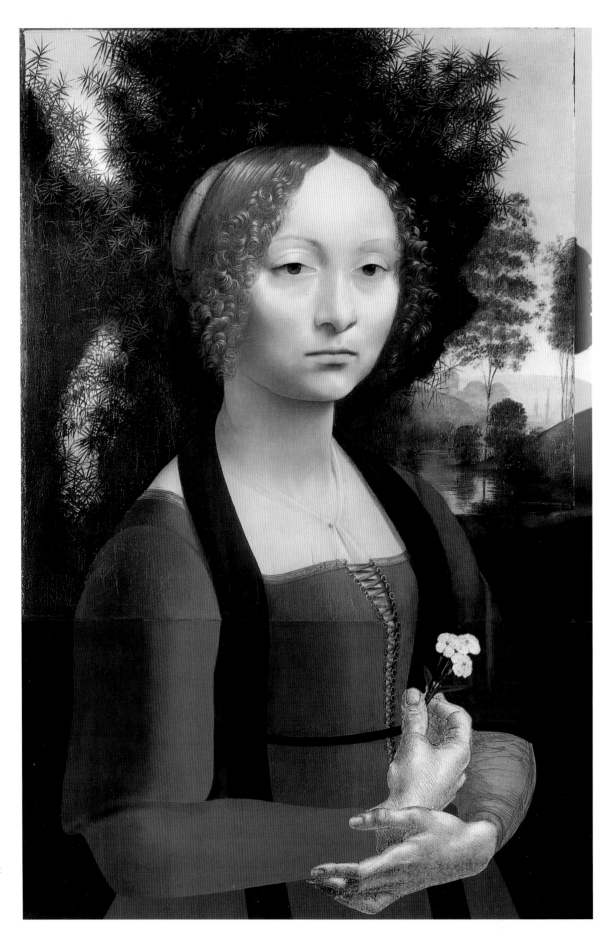

94 Computer reconstruction
of *Ginevra de' Benci*, Department
of Imaging and Visual Services,
National Gallery of Art,
Washington.

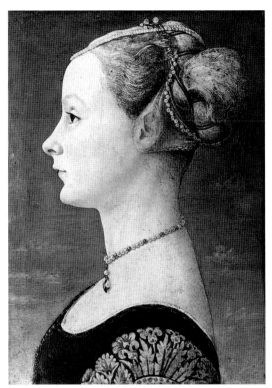

flowers symbolizing love or chastity.[39] Beyond its obvious suitability for a betrothal painting, the leitmotif of holding flowers must have had a personal meaning for Leonardo, who returned to it again and again in his early works.

In *Ginevra de' Benci* Leonardo broke with the long-standing Florentine tradition of portraying women in profile.[40] Even Antonio Pollaiuolo, innovative as he was, conformed to the standard type, as shown by a series of bust-length female portraits produced in his shop. The finest of these is the enchanting *Profile of a Young Lady* (Fig. 95) in the Museo Poldi-Pezzoli, Milan, which displays the virtues and limitations of the type.[41] Antonio's unsurpassed ability, using the new oil medium, to depict jewels and textiles serves to establish the sitter's wealth and status, while his masterful line accurately describes her features. The hairdress in particular is a *tour de force*. And yet the sitter, with her limbs omitted and the head seen from the side, does not engage the viewer as Ginevra does.[42]

In seeking an alternative to the static profile, Leonardo had to look no further than the shop where he worked. Verrocchio's *Lady with a Bunch of Flowers* (Fig. 96) is unquestionably related to *Ginevra*, though scholars are undecided as to whether

95 Antonio Pollaiuolo, *Profile of a Young Lady*, Museo Poldi-Pezzoli, Milan.

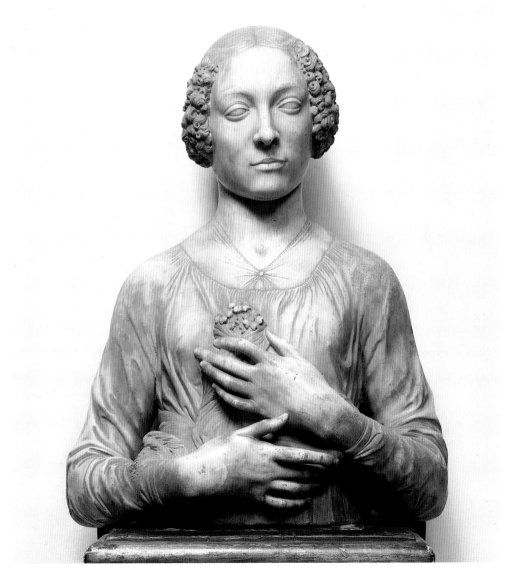

96 Verrocchio, *Lady with a Bunch of Flowers*, Museo Nazionale del Bargello, Florence.

Leonardo based his portrait on the master's or whether the sculptor was here influenced by his pupil.[43] Because of the extraordinarily beautiful hands, which mark an advance over the earlier head-and-shoulders type of sculpted bust, the marble has even been attributed to the young Leonardo and the sitter identified as Ginevra de' Benci.[44] But the new half-length conception of the portrait bust is surely Verrocchio's achievement, and the (round or square) shape of the head and the facial features in each work are by no means identical. Only the inclusion of the hands holding flowers and the coiffure, with tightly curled ringlets framing the face, are truly comparable.

Ginevra de' Benci adopts a model by the master which Leonardo proceeded to transform. Like the Verrocchiesque lectern in the *Annunciation* (Fig. 64), Ginevra's image translates a sculptural prototype into a softly pictorial context. The way the lady appears surrounded by a landscape has suggested to Martin Kemp that young Leonardo was here rehearsing some of the theoretical concerns of his later writings.[45] At issue was the *paragone* (rivalry) between painting and the other arts. In this debate over the nature of representation Leonardo argued for the painter's special ability to portray intangible phenomena, like mists, rivers, and reflections.[46] Painting also takes advantage of color and its own intrinsic lighting to create a virtual reality beyond the scope of sculpture. Compared with its Verrocchio source, then, *Ginevra de' Benci* offered a precocious visual demonstration of the superiority of painting over sculpture – heresy in a *bottega* so oriented toward the plastic arts.[47] Leonardo's ambivalence about sculpture – he gladly used three-dimensional models for painting but abhorred the mechanics of stone carving – far from being a purely theoretical matter, must in part reflect the conditions he endured (the "crashing of hammers") in the shop where he trained.[48]

Possibly based on a life mask, the bluntly realistic head of Verrocchio's bust contrasts with the lady's graceful hands pressing flowers to her breast. For the distinctly different way Ginevra's face was conceived and painted, Leonardo seems to have turned to another source – a portrait by Petrus Christus that belonged to the Medici. Relatively few examples of Netherlandish art were available in Florence at this time.[49] Verrocchio, ever the sculptor, ignored them, but his pupils, including Leonardo, incorporated various aspects of northern style and technique in their own work.[50] Taken by scholars as a touchstone of Leonardo's interest in northern art, *Ginevra de' Benci* betrays a striking resemblance to the *Portrait of a Lady* (Fig. 97) by Petrus Christus in the Gemäldegalerie, Berlin.[51] Even if the latter is not, as has often been stated, the female portrait by the artist cited in the inventory of Lorenzo de' Medici's collection dating from 1492, it must resemble that work.[52] And assuming that Christus's documented panel was in the Medici collection as early as the 1470s, it could have inspired the way Ginevra's delicately modeled doll-like head is set on a slender neck and shoulders. Not only the three-quarter pose but even the features – the tightly closed mouth and the odd-looking almond-shaped eyes – and the frontal gaze and somewhat doleful expression are similar in both the Washington and Berlin portraits.

How can Ginevra be depicted realistically and in her own character when her portrayal so closely resembles that of an unrelated sitter by another artist? Though presumably incorporating the lady's own physiognomy, Leonardo's Netherlandish-inspired likeness is clearly not a straightforward record of her appearance.[53] Nor does it capture her unique personality in the sense of a modern psychological portrait. Leonardo's method of imposing a characterization on the sitter can be seen best, perhaps, in her hair. As in Verrocchio's bust, the arrangement of the hair

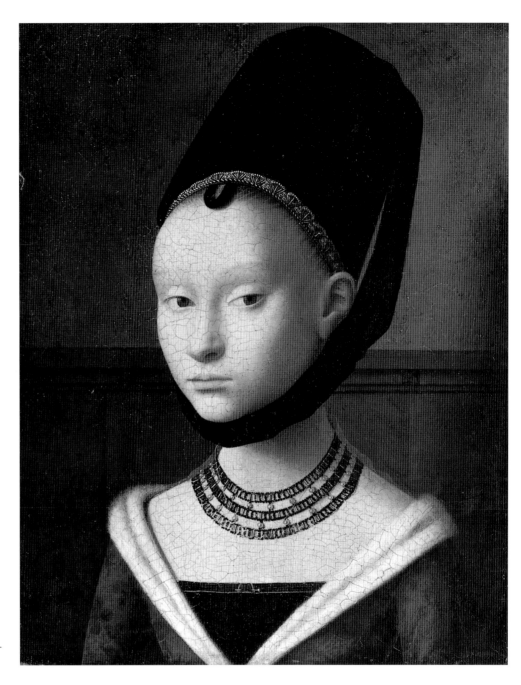

97 Petrus Christus, *Portrait of a Lady*, Gemälde-galerie, Berlin.

– parted in the middle, falling at the sides, and pulled back in a bun behind the head – is a matter of fashion. But the curls clustered around her face (Fig. 98) specifically recall Gabriel's in the *Annunciation* (Fig. 77), and the turbulent tresses in both works anticipate Leonardo's later studies of swirling water (Fig. 99). Ginevra's "angelic" curls, no less than her slitted eyes and stony expression, mark her portrait as a composite of elements seen, borrowed, and imagined. To this must be added the likelihood that, in quoting so obviously from a rare panel treasured by the Medici – Ginevra's portrait would certainly have looked Netherlandish – Leonardo was associating the sitter and her relatives with that family and their cultural renown. The Benci were, in fact, Medici partisans, Ginevra's father and grandfather having both served as managers of the Medici bank.[54]

99 Leonardo, *Deluge Study*. Detail. Royal Library, Windsor.

98 (*facing page*) Detail of Fig. 89.

100 (*right*) Detail of Fig. 89.

101 Infra-red reflectogram of *Ginevra de' Benci*. Detail.

For the sensitive rendering of Ginevra's features Leonardo made a preliminary cartoon which he transferred to the gesso ground of the panel by means of pouncing. During technical examination with an infra-red thermal imaging camera, pounce marks were discovered demarcating the sitter's eyelids (Fig. 101), nostrils, and upper lip.[55] To paint her porcelain-like skin, then, the artist evidently adopted the new medium of oil, alone or in combination with tempera. No analysis of the medium has yet been performed, but there are clear signs of Leonardo's use of oil. The way light and shadow merge imperceptibly in the pale translucent flesh (Fig. 100), glazed over with a rose tint for the lips and cheeks, and effects like the transparency of the lady's kerchief or the gleaming highlights of her hair could have been obtained only with oil. Leonardo's less-than-perfect mastery of the new technique we have already observed in connection with the wrinkled paint of the landscape on the right.[56] Also visible on the portrait side of the panel

102 and 103 Details of Fig. 89.

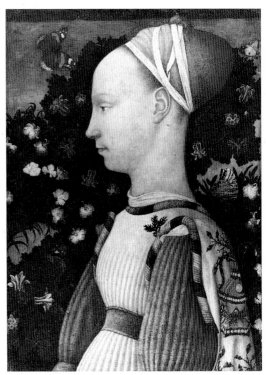

104 Pisanello, *Portrait of an Este Princess*, Musée du Louvre, Paris.

are the same kind of distinctive papillar marks (Figs. 102 and 103) found throughout the *Annunciation*, where Leonardo subtly and precisely blended the still-malleable paint with his fingertips (and palms) to create a soft-focus effect. Under magnification, the artist's prints are discernible in the paint surface and in x-radiography. They occur mainly in areas where forms, like the face joining the hair or the sky meeting the juniper, merge.[57] Manipulating the wet paint with fingers and brush, Leonardo engineered the fundamental change in painting technique that took place in Verrocchio's shop. Andrea's preference for a sculptural style of painting and his willingness to give Leonardo a free hand meant that it was the pupil, not the master, who pioneered the new technique.

For his portrayal of Ginevra in a landscape Leonardo may also have looked to Netherlandish painting. The nearest parallels occur in the work of Hans Memling, who has repeatedly been cited as Leonardo's source.[58] Memling was much admired by Florentine bankers and merchants, who acquired portraits, devotional panels, and even altarpieces from the artist in Bruges.[59] And the method that Leonardo adopted for aerial perspective is one that the northern master perfected: green hills and trees turn to blue the closer they are to the horizon, where the blue sky fades to white. The problem is that the Memling analogues, in which the sitter is placed in or directly before a landscape, all postdate Leonardo's picture, while the northerner's portraits of the early 1470s still pose the subject in an interior framing a landscape view.[60]

Whether Memling influenced Leonardo or not, the landscape background in Ginevra's portrait most closely resembles that in the *Annunciation* (Fig. 83). Both works feature watery mists and reflections, in which Leonardo exploited the fluidity of the oil medium.[61] The landscape vignette in the portrait, however, preserves only a trace (in the tiny towers) of the human activity implied by the harbor in the Uffizi picture. In this respect and in the sketchy treatment of the foliage, the portrait landscape recalls the drawing of 1473 (Fig. 87). No less innovative than the drawing, Leonardo's portrait is the first to be painted in Florence in which the sitter is at one with nature. Even the lady's costume forms a unity with her environment. Unlike the prosperous-looking females portrayed by Leonardo's contemporaries (Fig. 95), Ginevra is soberly attired in a brown dress edged with gold.[62] The black stole over her shoulders and the sky-blue laces of her bodice add to the cool, muted tonality. Does this unified color scheme indicate a rapport between the lady and the world of nature that she inhabits? More likely Leonardo was applying the issues that had concerned him in the *Annunciation* — man and nature, figure and landscape — to the category of portraiture.

In most fifteenth-century portraits with landscape backgrounds, the subject's head is silhouetted against the sky. Leonardo preferred to depict his sitter seated or standing before a juniper bush. Encircling her head, the juniper (*ginepro*) makes a punning allusion to Ginevra's name, just as the laurel (*lauro*) was used to refer to Lorenzo de' Medici. And since Ginevra's portrait is not a simple likeness, the juniper also helped to identify her. A similar method of screening off a portrait sitter is found in Pisanello's marvelous little panel (Fig. 104) in the Louvre.[63] Wearing a sprig of juniper on her bodice, the lady (sometimes identified as Ginevra d'Este) is shown in profile against a tapestry-like backdrop of flowering shrubs. There is no reason to believe Leonardo ever knew this courtly production, in which the flowers — carnations and columbines — and butterflies nearly overwhelm the sitter. Closer in spirit to *Ginevra* is the artist's own *Annunciation* angel (Fig. 62): the two curly-haired, pale-faced figures holding flowers (Fig. 94) are like

siblings. The difference is that Leonardo took the tree motif that serves as a foil for Gabriel's head and moved it forward in the portrait for reasons that Shearman has explained: the juniper not only frames the head, it also provides a semi-enclosed setting so that the lighting could be controlled in the interest of tonal unity.[64]

By contrast with the "impressionistic" foliage in the background, the juniper is treated with an almost obsessive attention to detail.[65] At first glance the spiky thicket recalls the dark mass of greenery behind Pisanello's lady. But closer inspection reveals an intricate network of needle-like leaves (Figs. 1 and 106) affording glimpses of distant landscape bathed in bluish haze – an effect Leonardo later described in his notes on painting.[66] Had Vasari seen Ginevra's portrait, he would surely have praised the juniper, as he did the fig tree in the cartoon of the *Fall*, "its leaves and branches beautifully foreshortened and executed with such care that the mind is amazed at the amount of patience displayed." Like Leonardo's *Lily* (Fig. 78), the juniper sets a new standard of botanical accuracy, far surpassing the specimens shown in contemporary herbals (Fig. 105).[67] Significantly, Leonardo omitted the berries the botanist found essential for their medicinal properties, opting instead to portray the plant, not as a discrete object, but, as he perceived it, enveloped in light and atmosphere.

105 German, illustration of a juniper in the *Gart der Gesundheit*, 1485, woodcut, National Library of Medicine, Bethesda, Maryland.

106 Detail of Fig. 89.

Leonardo's juniper not only denotes the sitter's name; its prickly evergreen foliage also symbolizes chastity.[68] For a young bride-to-be like Ginevra, the virtue of chastity was paramount in the eyes of her family and fiancé.[69] Like the landscape with the juniper, the emblematic reverse of the portrait (Fig. 90), centering on a sprig of the same plant, reflects this moral imperative. But what we now see may not have been Leonardo's original idea for the back of the panel. Rather, he first seems to have envisaged a figural design consistent with the theme of marital virtue. The evidence for an earlier version of the portrait reverse lies in a sheet depicting a *Lady with a Unicorn* (Fig. 107) in the Ashmolean Museum, Oxford.[70] According to legend, the unicorn – an equine creature with a shaggy goat-like coat and a single horn projecting from its forehead – could only be captured by a chaste maiden.[71] The legendary beast thus became a symbol of virginity or chastity.[72] Leonardo's drawing shows a maiden pointing (the first instance of this gesture in his work) to a docile unicorn tethered to a tree. Walker noted the resemblance between Ginevra and the female figure in the drawing, but his suggestion that the sketch possibly served for her portrait on the front side of the panel is unacceptable; it could be preparatory for the reverse, however.[73] The design is enclosed within framing lines, indicating that Leonardo meant to make a picture of it, and the proportions agree with those of the portrait in its original state. The severe demeanor of the maiden, seated in three-quarter view in a landscape, is comparable with Ginevra's, and so are her costume and coiffure. Turning to look at the viewer, she even has the same round face and features as Ginevra. And the tree in the drawing sets off the maiden's head just as the juniper enhances Ginevra's pale countenance in the painting. As for its style, the dress in the drawing is treated like the Oxford sleeve (Fig. 70), while the freely sketched tree (a juniper?) recalls those in the landscape of 1473 (Fig. 87).

Had Leonardo completed his scheme for an allegorical reverse, his painting would have resembled several contemporary portraits which associate a female sitter with a unicorn symbolizing her chastity.[74] The most famous of these is Piero della Francesca's Montefeltro diptych in the Uffizi, in which the duke's wife is shown in profile bust on the front side of the portrait and as a tiny full-length figure riding on a cart pulled by unicorns on the reverse.[75] Piero's pair of double-sided portraits recall such medals as the one in which Pisanello paid tribute to Cecilia Gonzaga's chastity (she chose to enter a convent) in the form of a unicorn on the reverse.[76] Less well known but closer in some ways to Leonardo's conception is the above-mentioned *Lady of the Gozzadini Family* (Fig. 91), in which the sitter appears twice, bust-length in profile and as a smaller full-length figure accompanied by a unicorn in the landscape background.[77]

Leonardo never carried out the allegorical reverse he seems to have projected for Ginevra's portrait. He may simply have left the back of the panel unpainted until, several years after the sitter's marriage, a motive for completing it arose in the changed circumstances of her life. When he again took up the idea of a painted reverse, he appears to have briefly reconsidered his earlier scheme of the *Lady with the Unicorn*.[78] But he abandoned that solution in favor of one which signified more than a single aspect of the lady's character. The back of the panel (Fig. 108) is painted with an *impresa* (device) consisting of a garland of laurel and palm branches encircling a juniper sprig.[79] Surrounding the plants is a scroll bearing the Latin motto "Virtutem Forma Decorat," which has been interpreted to mean "Beauty Adorns Virtue."[80] The stone-colored plants and scroll, shown against a simulated red porphyry background, present an emblematic "portrait" of Ginevra: the laurel

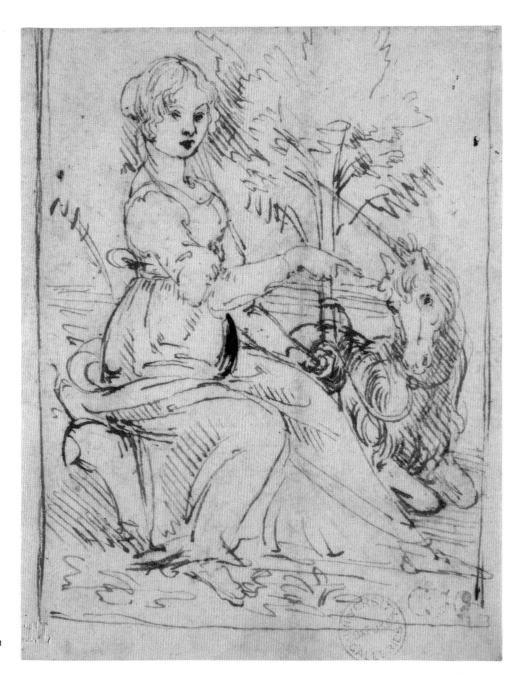

107　Leonardo, *Lady with a Unicorn*, Ashmolean Museum, Oxford.

and palm commonly symbolized intellectual and moral virtue, while the Latin word for beauty artfully twines around the juniper.[81] The technique in which the leaves and scroll were painted over the irregularly scattered background dots appears to be tempera rather than oil.[82] For the back to be visible, the painting may have been suspended from a ring or displayed on a chest and turned around for viewing.

Fletcher's discovery that the wreath of crossed laurel and palm is Bernardo Bembo's personal emblem lends credence to the hypothesis that he may have commissioned the portrait reverse on one of his missions to Florence.[83] Soon after arriving in the city (accompanied by his wife), Bembo took part in the tournament held by Giuliano de' Medici in 1475, for which Verrocchio and Leonardo made a standard.[84] The Venetian ambassador quickly won the friendship of luminaries in

108 Computer reconstruction of *Ginevra de' Benci* (reverse), Department of Imaging and Visual Services, National Gallery of Art, Washington.

the Medici circle. And his enthusiasm for Florentine humanist culture led him to emulate Lorenzo and Giuliano de' Medici in choosing an ideal *donna*.[85] Like the tournament, their affair was a courtly pastime, and both belonged to the revival of chivalry promoted by the Medici. Bembo's involvement, however, could apply only to the back of the Washington panel, as the style of the front predates his arrival in the city. But how can we be sure that the wreath, joined here with the juniper and motto proper to Ginevra, is really Bembo's? Perhaps he borrowed it from her, as another writer has proposed.[86] Recent examination of the portrait reverse with an infra-red camera has, to the contrary, revealed beneath the present inscription other letters (Fig. 109) corresponding to Bembo's own motto "Virtus et Honor."[87] The discovery of his motto beneath Ginevra's confirms that Bembo did indeed devise the reverse (and incidentally that she is the sitter). At first he evidently had his emblem painted on the back of the portrait; then, retaining the laurel and palm whose symbolism applied equally to Ginevra, he added the juniper from the completed front side of the panel.[88] Bembo may have encountered prototypes for the back of Ginevra's portrait in Venice, as such decorated reverses, in which simulated marble stood for the enduring nature of the sitter's virtues, are particularly associated with Jacometto Veneziano.[89] The precise visual form that

109 Infra-red reflectogram of the motto on the reverse of *Ginevra de' Benci*.

Leonardo gave to Bembo's conception was, of course, determined by the artist's own experience, in this case of Verrocchio's Medici tomb (Fig. 53) of 1472, with its red porphyry sarcophagus and banderoles winding around foliate wreaths.[90] Though ignorant of Latin, Leonardo's treatment of the motto (incised in the gesso) also emulated the beautifully scripted lettering on the tomb.

Compared with its analogues, the reverse of Ginevra's portrait stands out for its elaborate (though not obscure) symbolism. Leonardo has exemplified the lady's character visually, as Petrarch had portrayed his beloved Laura in words.[91] If Bembo commissioned the reverse and conceived its design, as seems most likely, he did so in the spirit of the poems his humanist friends dedicated to him.[92] In their verses Ginevra's beauty and virtue, far from being in conflict, are conjoined, as they appear on the back of Leonardo's painting. Landino's poems in particular provide a key to understanding the motto "Virtutem Forma Decorat" that Bembo devised.[93] The basic concepts underlying the poems go back in turn to Ficino, the dean of Florentine humanists. In 1462 Amerigo Benci, Ginevra's father, had given Ficino a rare codex containing one of Plato's dialogues.[94] Inspired by Plato, Ficino's theory that beauty led through love to the divine found expression in his commentary on the *Symposium*.[95] Ficino presented a manuscript of the commentary to Bembo, who annotated it, and, in one instance where Landino is cited, penned in Ginevra's name.[96] Here in the margins of Ficino's manuscript we

encounter the same constellation – Ginevra, her platonic lover Bembo, and his friend Landino – that lies behind the reverse of Leonardo's painting.

Leonardo's double-sided portrait depicts Ginevra de' Benci as the embodiment of virtue. Painted in the months preceding her marriage, the front side presents a prospective bride. The reverse also celebrates the lady's beauty and chastity but does so in emblematic terms appropriate to her subsequent role as Bembo's beloved. Leonardo portrayed Ginevra in a highly individual way but not, in our sense at least, as an individual in her own right. His painting is not only a portrait but a picture of nature, in which the artist saw the sitter in the light of his own preoccupations: her pale luminous skin and golden hair combine with the juniper leaves and the distant scene (Fig. 110) to form a sequence of tonal and textural effects that is unprecedented in Florentine art. Well we might ask whether the spiky juniper serving as a visual metaphor for Ginevra is an extension of the sitter or vice versa. In the end Ginevra's personality remains an enigma. Does the gaze she directs at the viewer reflect the chaste disdain of a courted lady before her suitor? Or does it betray the underside of Ginevra's character suggested by the single line of her poetry that survives?[97] Whatever the case, *Ginevra de' Benci* is a pivotal work. The "likeness" side of the portrait, showing the sitter in an airy landscape, is close in style and presumably in date to the *Annunciation*. And in a way peculiar to Leonardo the various elements making up the painting demonstrate the same complex web of relations. The "learned" reverse, on the other hand, like Botticelli's *Primavera*, forms one of those fascinating intersections between the artistic world of the *botteghe* and the sphere of high culture represented by Ficino and his ideas. From now on a cultural sophistication missing in Leonardo's earlier work marks the paintings and drawings he would undertake in Verrocchio's shop.

110 Detail of Fig. 89.

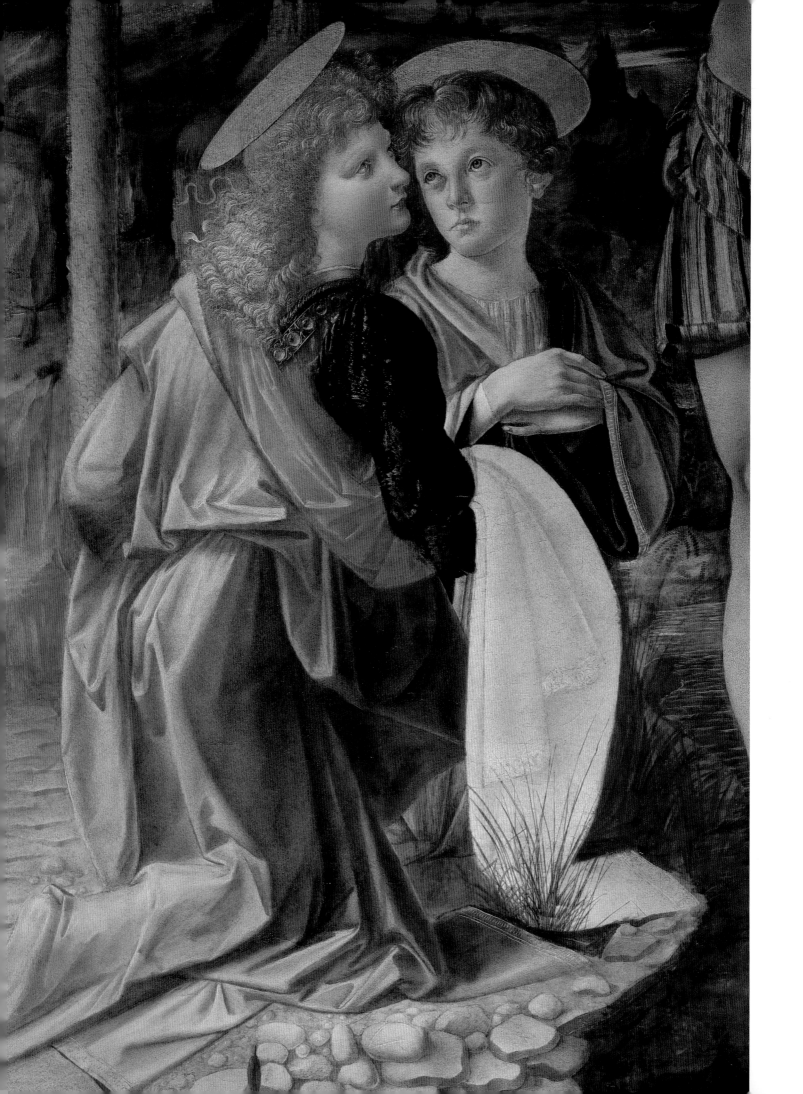

6 The Collaborator

"THE MEDICI CREATED AND DESTROYED ME," Leonardo penned on a late folio in the compilation of his writings known as the Codex Atlanticus. This cryptic remark could refer either to doctors (*medici*), whom the artist distrusted, or to the Medici family, who were his patrons.[1] Scholars opting for the latter possibility believe that the family members referred to are Lorenzo, who would have supported the young Leonardo, and his sons Giovanni and Giuliano.[2] Though Leonardo's biography offers little basis for this hypothesis, it is natural to suppose that Lorenzo was his first patron.[3] When he succeeded his father as *de facto* ruler of Florence in 1469, Lorenzo ushered in what came to be seen as a Golden Age. He not only fostered the arts at home but also sent artists abroad to enhance Florentine prestige.[4] One of these artistic ambassadors was Leonardo, who, according to the Anonimo Gaddiano, fashioned a lute for Lorenzo as a gift to Duke Lodovico Sforza.[5] Lorenzo was also the arbiter of taste who favored Verrocchio over Piero Pollaiuolo in the Forteguerri monument commission. His own taste ran to antiquities, which lends credence to the Anonimo's further claim that Lorenzo, before sending Leonardo to Milan, had him work in the Medici sculpture garden at Piazza San Marco.[6] The garden functioned as a kind of school of which Michelangelo was the most famous product.[7] There Verrocchio and Leonardo could also have studied classical sculpture the Medici had collected, perhaps in connection with the antiquities Andrea is said to have restored for Lorenzo.[8] Verrocchio seems to have been Lorenzo's favorite artist, responsible for the Medici tomb and the decorations for the Sforza visit, in the creation of which Leonardo may have been involved. But Lorenzo commissioned few such works, and the evidence points not to him but to his charismatic younger brother Giuliano (Fig. 112) as the first Medici to appreciate Leonardo's talents. Though overshadowed by Lorenzo in his own lifetime and afterwards, Giuliano (1453–78) received the same humanistic education and may also have shared Lorenzo's love for culture.[9] Unfortunately, Giuliano's assassination in the Pazzi conspiracy on April 26, 1478, has made him better known as a martyr than as a patron.[10] Leonardo depicted his murderer Bernardo Bandini hanging from a window of the Bargello in a drawing that was probably meant to serve for an admonitory painting, such as other artists like Botticelli are known to have done.[11]

On January 29, 1475 (1474, Florentine year), Giuliano won the prize in a tournament arranged by the Medici and held in Piazza Santa Croce. Celebrated in Poliziano's *Stanze per la giostra*, Giuliano's triumph, more than any other single event, marked the apogee of Medici *fortuna* before his assassination three years later. The tournament, dedicated to Giuliano's *innamorata*, Simonetta Vespucci, was held in honor of an alliance concluded between Florence, Venice, and Milan in the preceding November. It featured a host of contenders, splendidly attired and accompanied by men-at-arms, retainers, trumpeters, and standard bearers. Known

112 Botticelli, *Giuliano de' Medici*, National Gallery of Art, Washington, Samuel H. Kress Collection.

111 Detail of Fig. 128.

113 Verrocchio and Leonardo, study for a tournament standard, Gabinetto Disegni e Stampe, Galleria degli Uffizi, Florence.

afterwards as the Giostra of Giuliano, the tournament and especially the procession that preceded it are enthusiastically described in contemporary accounts, and these enable us to reconstruct partially the brilliant visual aspect of the event.[12]

Such an occasion certainly provided painters of the city with commissions, from both Giuliano and Lorenzo.[13] From the list drawn up by Verrocchio's brother of works the Medici ordered, we know that Andrea made a standard for this tournament: "For painting a standard with the cupid (*spiritello*) for the joust of Giuliano."[14] Scholars have connected Verrocchio's documented standard with a sketch (Fig. 113) depicting a winged Cupid about to surprise a recumbent female, identified either as Venus or, more likely, a nymph asleep after gathering flowers.[15] The importance of this small sketch in the Uffizi cannot be overstated. Rare enough as one of Verrocchio's few known drawings, the sheet is, perhaps, the only survivor of a whole category of Renaissance draughtsmanship that has disappeared. The format and composition suggest that it was a preliminary design for a triangular-shaped cloth pennant of the kind shown in a *cassone* panel (Fig. 114) illustrating another tournament held in the same piazza.[16]

Since the sketch became known about a century ago, its attribution to Verrocchio, Leonardo, Credi, or another member of the shop has been hotly debated.[17] Scholars now tend to agree, however, that Verrocchio and Leonardo made the drawing together.[18] The younger artist's characteristic left-handed hatchings are visible in the landscape, and he seems to have been involved in the figure composition as well. The preliminary black chalk sketch, indicating the disposition of the figures, is surely by Verrocchio, who, as head of the shop, would

114 Florentine, fifteenth century, *Tournament*. Detail. Yale University Art Gallery, New Haven, Conn, Jarves Collection.

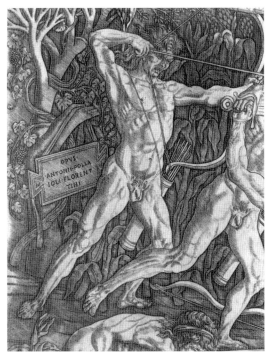

115 Antonio Pollaiuolo, *Battle of the Nudes*, engraving. Detail. National Gallery of Art, Washington.

have been responsible for the design of the standard. Verrocchio's pupil then worked out the master's unresolved sketch, reinforcing the figures in pen and ink, and, using the same medium, carefully adding the plants and the rocky ledge on which the nymph reclines. The difficulty Leonardo faced in defining the forms adumbrated by his master can be seen in the figure of Cupid (Fig. 2), who, approaching the nymph from behind the rock, draws an arrow from the quiver and unfastens the laces of her bodice. The spatial illogic of Cupid's pose – the way his head and limbs project forward while the rest of his body remains behind the ledge – is reminiscent of the similar mistake Leonardo made in the *Annunciation*, in which the Virgin (Fig. 64) sits behind, but gestures in front of, the lectern. Conceivably that work, too, may have involved a rough draft by Verrocchio carried out by his pupil.[19]

Verrocchio left the landscape in the Uffizi sketch entirely to Leonardo. By this time the younger artist had demonstrated his superiority at depicting nature in the *Annunciation* and *Ginevra de' Benci*, and it is understandable that he should have been given an analogous task in designing the standard. The long-stemmed plants which display his botanical skill have been identified as a species of the tall grass known as millet.[20] Since Leonardo overcame his master's deficiency in landscape by turning to Antonio Pollaiuolo for guidance, it is not surprising to find similar plants in that artist's famous engraving of the *Battle of the Nudes* (Fig. 115).[21] The use of tall plants behind nude males, armed with bows and arrows, in contemporary portrayals of pagan themes by the two rival workshops can hardly be coincidental.[22] The plant in the print is symbolic, it has been argued, and Leonardo, incorporating similar verdure in the Uffizi drawing, may have meant to underline the significance (albeit different) of his subject. For the artist's contemporaries millet stood for conjugal fidelity because it was thought to be incorruptible.[23] Like the juniper in Ginevra's portrait, the plants in the drawing do not just demonstrate Leonardo's ability as a botanist; they also show his inventiveness by alluding to the innocently slumbering maiden in whose heart Cupid is about to arouse an uncontrollable passion.

In assigning the plants to Leonardo, Verrocchio may simply have wished to rival the naturalism vaunted by Pollaiuolo. But Leonardo evidently aimed higher: the oddly swirling motion of the lowermost leaves curling in a rosette has no precedent in the straightforwardly realistic vegetation in Pollaiuolo's engraving. The spiral configuration is found throughout Leonardo's oeuvre, however, linking the plants shown here with other natural phenomena such as waterfalls and tumbling curls. The appearance of this signature motif in the Uffizi sketch reveals that the young artist was evolving the concept of nature as a vital, all-encompassing force that informs his later work. The spiral growth pattern was, or would become, a formula in which Leonardo went beyond botanical accuracy to lend forms in nature the same sense of heightened animation that Verrocchio reserved for the figures in his paintings.

The collaboration that resulted in the tournament standard did not conform to the customary division of labor in Florentine workshops, in which the master conceived a work and supervised its execution, keeping the most important parts for himself. We have found that Leonardo took part in the preliminary design process, working as a true collaborator. Once Andrea had broadly outlined the composition, he seems to have concentrated on the figure of the nymph. The flowers gathered in the folds of her drapery recall the motif which distinguishes the Bargello bust (Fig. 96) from its predecessors. The action of Cupid likewise

116 Leonardo, *Adoration of the Magi*. Detail. Galleria degli Uffizi, Florence.

117 Verrocchio, *Study of an Infant's Head*, Fitzwilliam Museum, Cambridge.

finds an analogue in the master's work. In contrast to allegorical portrayals of the winged god, Cupid is the real protagonist of the Uffizi drawing: stealing upon the scene, he precipitates the arousal of the nymph. Verrocchio's dynamic conception of the subject as a narrative event compares with his treatment of the monumental bronze group of *Christ and St. Thomas* (Fig. 17), in which the young apostle approaching Christ is shown with outstretched hand, in his doubt delicately fingering an opening in the Savior's garment.

The Uffizi sketch vividly characterizes the intruder and the hapless object of his mischief. If Verrocchio himself captured the alluring mood of the nymph, he seems to have left the precise definition of Cupid up to his pupil. Nothing reveals the close working relation or interaction between the two artists better than this figure, for which Verrocchio drew upon Leonardo's imagination – his affinity for ephebic types – and not only his representational skill. After Verrocchio had indicated Cupid's role in the composition, Leonardo seems to have devised his smiling countenance.[24] The facial type and expression – even the tilt of the head – are repeated in the similar figure of an inquisitive page (Fig. 116), peering at the Virgin from behind a rock, in the *Adoration of the Magi*. It was the Cupid that came to mind when Verrocchio's brother cited the *spiritello* to designate the standard Andrea made for the tournament. To us, looking at Leonardo's work in retrospect, the figure seems remarkable not only in itself but also for the intimate relation it bears to plant forms representing the world of nature. The young god's pale face, framed by curly hair and set off against a screen of foliage, recalls that of the Annunciatory angel (Fig. 77), and the same arrangement was adopted for *Ginevra de' Benci* (Fig. 89). These early paintings help us to envisage the lost tournament standard, which seems to have left an indelible impression on Leonardo. Echoes of it can still be detected in his later drawings of *Leda and the Swan*, in which the female subject is surrounded by swirling plants that amplify her sensual mood.[25]

Another drawing by Verrocchio for the standard (Fig. 118), in the British Museum, has rightly been called "one of the unsurpassed peaks of Renaissance draughtsmanship."[26] In black chalk heightened with white, the drawing is a study, on the scale of the finished work, for the head of the nymph in the Uffizi sketch. The link between the two is offered by the rough draft (Fig. 119) on the verso of the sheet, in which the same life-size head is supported by a hand, exactly as in the smaller sketch for the whole figure.[27] The reverse exemplifies Andrea's sculptural method, blocking out forms as he would have begun to carve them.[28] But if the sculptor is reflected on that side of the sheet, the recto reveals how painterly Verrocchio's drawing style had become during the half-decade or so which separates this study from that for the angel's head (Fig. 19) in the Uffizi *Baptism*.[29] Exploiting the softness of the chalk medium, Andrea modeled the nymph's facial features and coiled hair in subtle contrasts of light and dark. Earlier he had limited this kind of pronounced *chiaroscuro* to the drapery drawings. Now Verrocchio applied it to figure studies, not only this one but also the highly expressive *Study of an Infant's Head* (Fig. 117) in the Fitzwilliam Museum, Cambridge, which can be dated fairly late in his career.[30] Compared with the schematically modeled Christ Child in the Berlin *Madonna* (Fig. 29) of the late 1460s, the Fitzwilliam study, like the double-sided sheet in the British Museum, demonstrates the increasing complexity of Verrocchio's art. The reason for the advance must lie in his principal medium – sculpture – and in particular the Orsanmichele group (Fig. 17), as it was evolving in these years. But there is no evidence to suggest that the master ever extended this sort of emphatic modeling to the field of painting, with

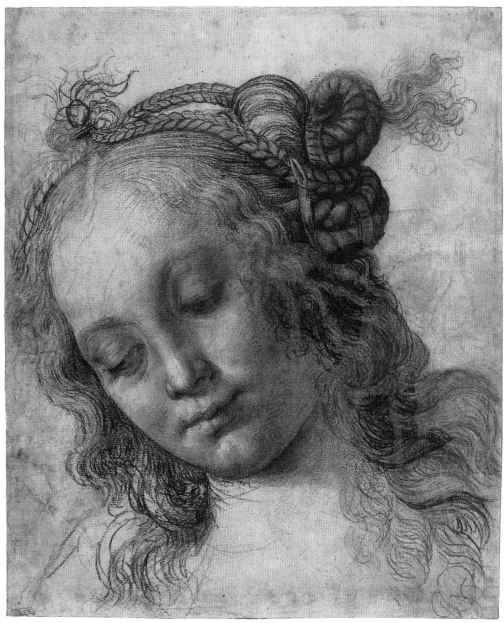

119 Verrocchio, *Study of a Female Head* (reverse), Department of Prints and Drawings, British Museum, London.

118 Verrocchio, *Study of a Female Head*, Department of Prints and Drawings, British Museum, London.

except possibly for the Virgin's head in the Berlin picture (Fig. 13) which has a depth and refinement of shading that goes beyond that of the Child in her arms. Verrocchio – or Leonardo if we assume that Andrea still lacked the necessary skill as a painter – may have retouched the head several years after the picture was completed.[31]

Involved as he was with the standard project, Leonardo would surely have known the British Museum drawing and admired it, not only for its soft modeling. According to Vasari, Leonardo frequently imitated such heads by the master, "beautiful in expression and in the arrangement of the hair."[32] While the pupil's version of Verrocchio's aging warrior survives (Fig. 59), there is no corresponding drawing of the female type, though two are listed among the works Leonardo took to Milan.[33] What is perhaps the loveliest of all these Verrocchiesque sheets (Fig. 120), in the Louvre, has been identified as a study for the head of the Virgin in

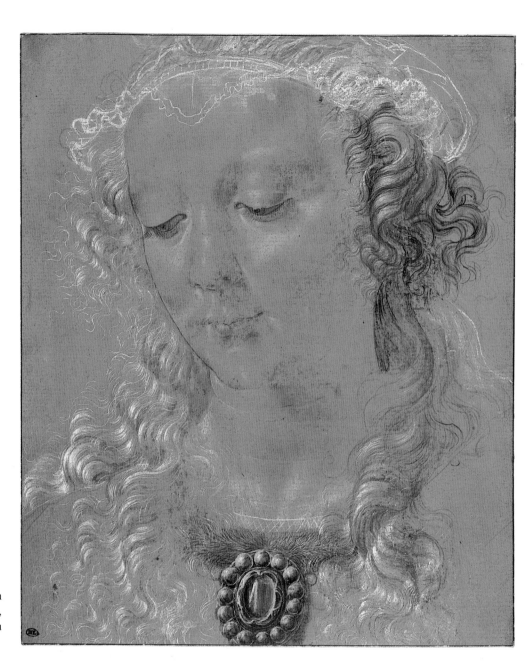

120 Here attributed to Perugino in Verrocchio's shop, *Study of a Female Head*, Département des Arts Graphiques, Musée du Louvre, Paris.

Leonardo's *Madonna of the Carnation* (Fig. 121) in the Alte Pinakothek, Munich. But while it obviously comes from the Verrocchio shop, the over-refinement of the drawing argues for the young Perugino, not Verrocchio or Leonardo, as its author.[34] The point is that, like the warrior, these female heads represent an ideal type which Verrocchio invented and which his pupils inflected each in their own way. In the case of the Munich picture, Leonardo seems to have taken over the head of the nymph and used it for the Virgin.[35] Her elaborately braided hair, heavy-lidded eyes, and lack of a halo differentiate this newly expressive Virgin from the lackluster type (Fig. 64) Leonardo had previously adopted. Could the writer Sabba da Castiglione have had this *Madonna*, and not only Leonardo's mature creations, in mind, when he called the artist "Verrocchio's disciple, as seen in his sweetness of expression. . . ."?[36]

121 Detail of Fig. 122.

The close relation between the *Madonna of the Carnation* (Fig. 122) and its

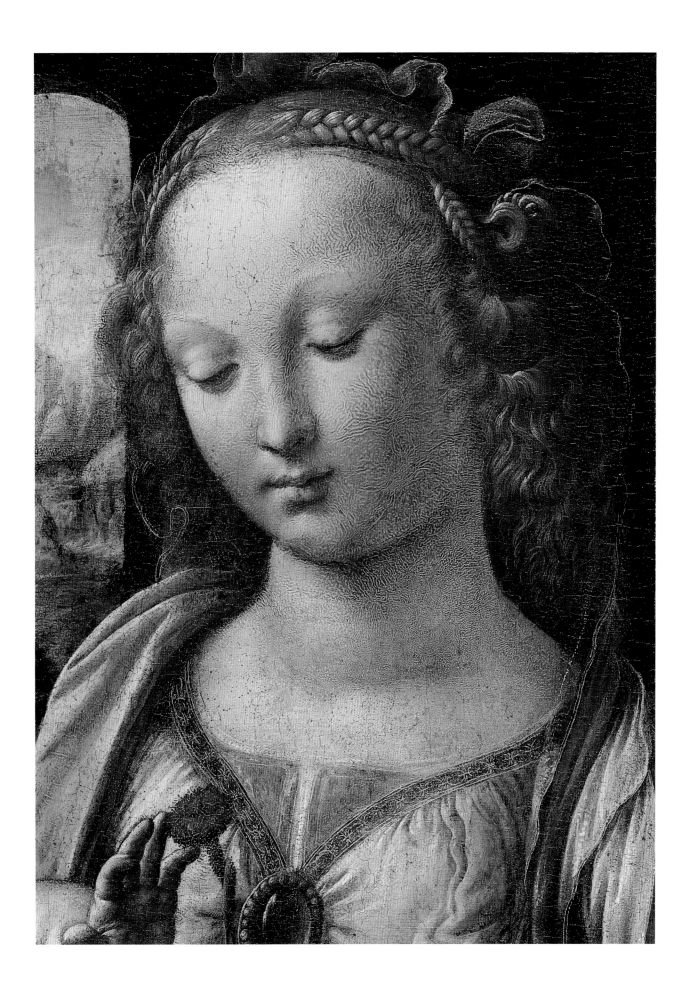

Verrocchio model dates the painting to the mid-1470s, making it the third in the series of Leonardo's generally accepted early works.[37] The panel, measuring some two by one-and-a-half feet, is cut down by nearly an inch on the left side; otherwise it is in good condition.[38] Acquired (as a Dürer) by Dr. Albert Haug at auction in the Bavarian town of Günzburg, the picture was sold by him to the Munich museum in 1889. Its earlier history is not definitely known. The museum curator Adolph Bayersdorfer, who first recognized the *Madonna* as Leonardo's, sought to identify it with the Leonardo *Madonna with a Vase of Flowers*, which, according to Vasari, belonged to Pope Clement VII. And yet despite its possible provenance, the work found little favor with later critics, including Clark, who dubbed it Leonardo's "least successful picture."[39] The theories espoused in the literature that the painting was merely begun by Leonardo or that it was a copy of a lost work, though unjustified, seek to account for the rather disagreeable impression it makes.[40] The wrinkling in the *Annunciation* and in *Ginevra de' Benci* also affects the *Madonna*, marking it as an early and still experimental production. But the technical defect here involves the shadowed parts of the flesh tones, so that the faces of the Virgin and Child are somewhat disfigured.

The relief-like treatment of the figures, and not just the Virgin's type, makes the Munich *Madonna* the most Verrocchiesque of all Leonardo's early pictures. Drawing on half a century of experimentation with the theme, the master had established two main precedents for depicting the Virgin and Child in sculpture and painting.[41] His first solution, now known only through echoes of a lost marble and a possible lost cartoon or painting (Figs. 26 and 33), represented the half-length figure of the Virgin behind a parapet on which the Child was also shown standing. The second type, seen in the Berlin picture (Fig. 29), portrays the Virgin seated with the Child on her lap. While Verrocchio's other pupils, in adopting his prototypes, maintained the distinction between the standing and seated types, Leonardo chose to combine them in a single work. His Virgin, posed frontally behind a ledge, resembles those of his fellow pupils, even to the right hand gently supporting the infant, while the seated Child (Fig. 123) derives from the alternative model in Berlin.[42] But what a difference between the two infants! Though the chubby type and lively attitude are similar, Leonardo's infant is truly newborn. Naked and nearly hairless, he is anatomically exact, and his movement and expression are motivated specifically by the carnation, which gives the picture its name.

Unlike Verrocchio, Leonardo placed his protagonists in a domestic setting. The theme of the Virgin flanked by arched windows he may have found in Netherlandish painting.[43] In Leonardo's case, however, the side walls of the interior are not visible, so the figures seem detached from the background.[44] The Virgin's chamber is more like a backdrop than an enclosure, the reason for which becomes apparent once we consider the chief innovation of the picture – its *chiaroscuro*.[45] As in Leonardo's previous works, the figures are set off against a dark foil. But here the use of light and shade to define forms, like the Virgin's expertly foreshortened left hand or the fatty folds of the Child's body, is much more complex. In particular the way Leonardo has modeled the infant's boldly disconnected left arm and hand anticipates the sophisticated treatment of light in the *Madonna of the Rocks*. In addition, the bright hues of the Virgin's garments are subdued by deep shadows so they appear consistent with the olive-brown cushion resting on the ledge. Though the light comes from the upper left, rather than the windows, the shadowy interior provides a pretext for Leonardo's sharply focused

122 Leonardo, *Madonna of the Carnation*, Alte Pinakothek, Munich.

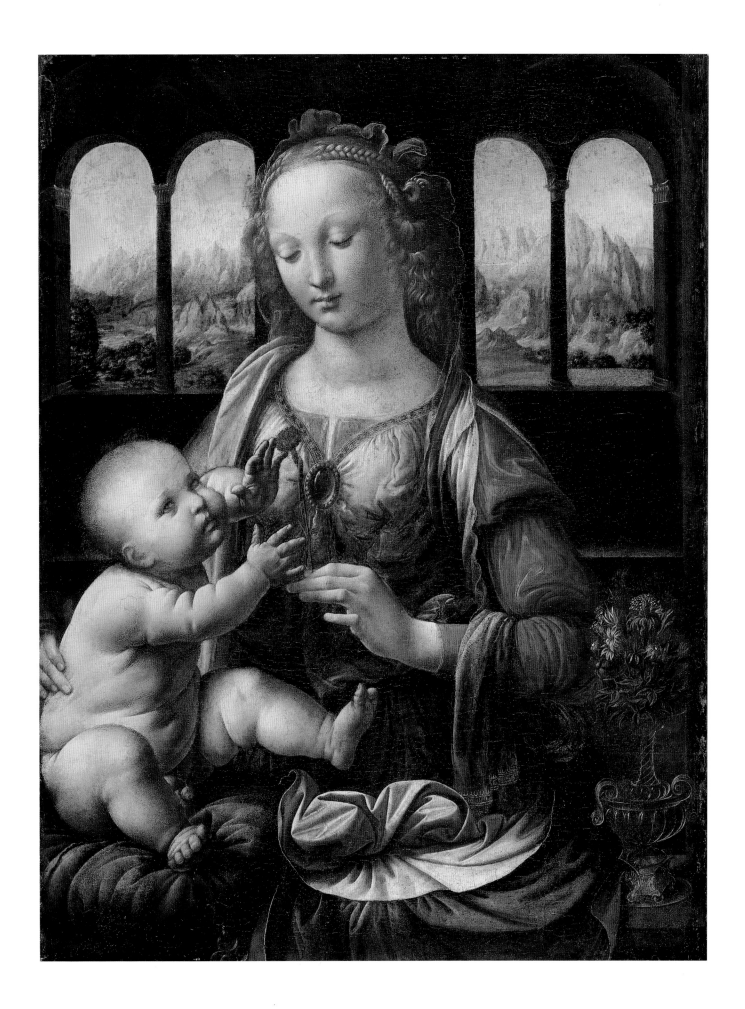

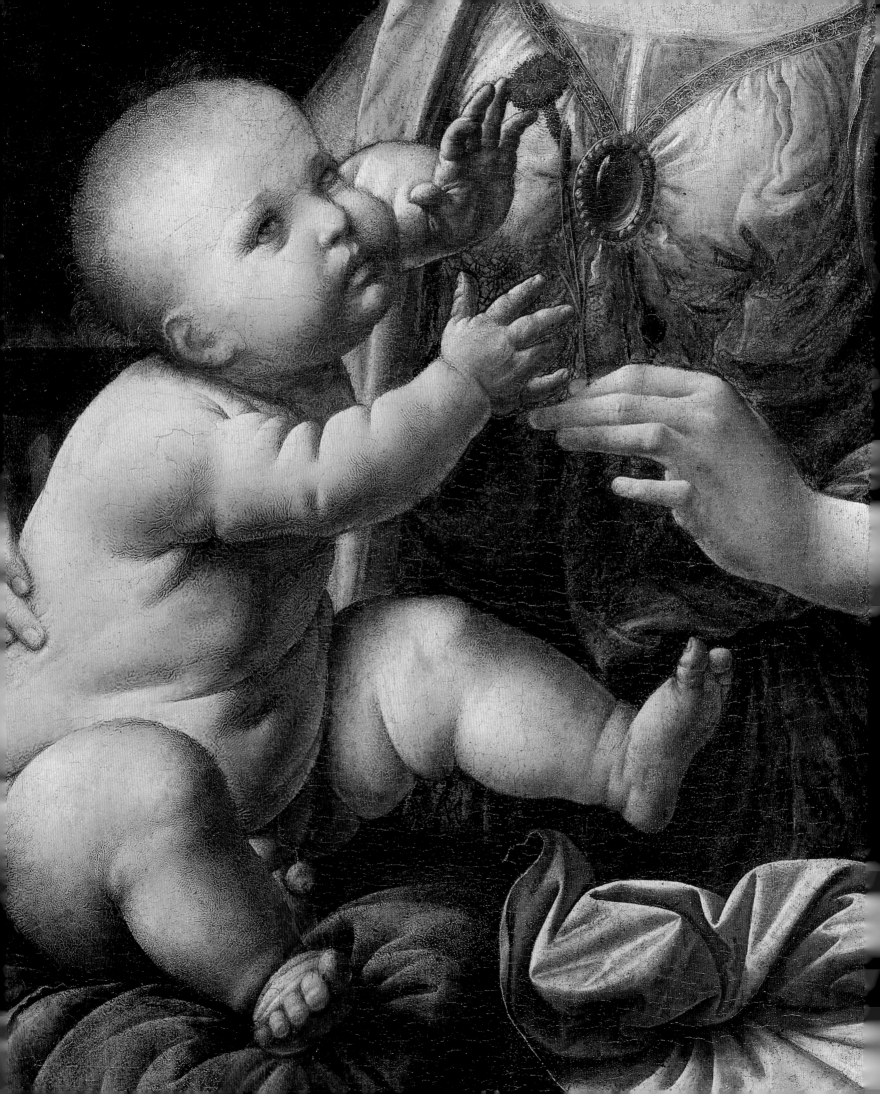

illumination. For the first time his *chiaroscuro* creates, throughout a picture, fully three-dimensional forms rivaling the roundness of sculpture.

Leonardo's *Madonna of the Carnation* also develops his by now familiar horticultural device of a figure holding flowers (Figs. 62 and 94). In the lower right corner he placed a crystal vase of blooms that Vasari singled out for praise.[46] This motif, symbolizing the Virgin's purity, sets the painting apart from the others produced in the shop, and gave rise to the notion that it was Netherlandish. Yet the flowers are not rendered individually, as in the northern copy in the Louvre, but as a bunch.[47] Their lack of specificity (the colors repeat those of the Virgin's garments) led one botanical expert to deny the *Madonna* to Leonardo.[48] But only he could have painted the flowers in the vase, which almost seem to have been plucked from the meadow in the *Annunciation*. Among them the Virgin has selected a long-stemmed carnation which she holds up to the Child.[49] Since the blood-red carnation offered by the Virgin presages her son's future sacrifice, Leonardo's domestic scene has a poignant meaning.[50] Its devotional content is not unique, however, as we see by comparing Botticelli's contemporary *Madonna of the Eucharist* in the Isabella Stewart Gardner Museum in Boston.[51] Where Leonardo differs from his fellow pupil is in making the Child's reaction to the flower the focus of his composition.

Vasari's praise for the non-existent dewdrops on the flowers has been taken to mean that he never saw the *Madonna*. And yet, eyewitness or not, he knew the picture was early, and he adds that it had belonged to the Medici Pope Clement VII (1523–34). Since that pope, as Giulio de' Medici, was the illegitimate son of Lorenzo's ill-fated brother, it may have been Giuliano who originally commissioned the painting. According to this scenario, Giuliano, while still in his twenties, would have ordered the picture from Leonardo (or Verrocchio). Then after the patron's violent death in 1478, his infant son Giulio, brought up by the Medici, would have inherited it.[52] The hypothesis that Giuliano commissioned the *Madonna* from the young artist who had just completed a standard for his tournament accords well with a dating for the painting, on the basis of style, to the mid-1470s.

Household Madonnas such as Leonardo's are seldom documented, but two details in the painting hint at the possibility of a Medici commission. In place of conventional tassels, the artist chose to ornament the cushion on which the Child is seated with a cluster of crystal balls (Fig. 122). As they seem to be unique to this picture, not appearing in any other half-length Madonna in sculpture or painting, the balls may be presumed to have a special significance.[53] To a contemporary Florentine they might well have suggested the Medici *palle* (balls) often represented in the margins of manuscripts or other works of art and architecture made for that family. Leonardo had already used a juniper to identify the sitter in his portrait of *Ginevra de' Benci*, and he may equally have introduced the Medici emblem here. Another inconspicuous clue to the patron's identity may be offered by the double-arched windows of the Virgin's chamber, recalling those Michelozzo had designed for the palace where Giuliano lived.[54] Beyond that, the courtly air of the Virgin, with her exuberant tresses and jeweled brooch, and the (for Leonardo unusual) use of gold to decorate the borders of her garments, the cushion, and the vase, points to a patron from among the upper echelons of the Florentine patriciate.[55] Even if the Virgin does not represent Giuliano's favorite Simonetta Vespucci, as has been claimed, she clearly reflects an ideal of secular beauty that flourished in the Medici circle.

123 Detail of Fig. 122.

Dark and gleaming as a bronze relief, Leonardo's *Madonna* is already well on the way to his mature achievement. Forms are accurately depicted down to the smallest details, whose richness aimed to satisfy Medici taste. Other aspects of the picture show the artist's personal side. Much as we might admire the puckered folds of the Virgin's dress, for example, it is the veil and robe descending from her shoulders (Fig. 126) that capture the viewer's attention. As in Leonardo's later water studies, the veil spills over the Virgin's forearm and onto the vortex formed by the golden yellow lining of her robe.[56] This is the same formula Leonardo had used for the drapery study for a kneeling Virgin (Fig. 65) and for the sketch of a waterfall in a rocky gorge (Fig. 124). As for the landscape viewed through the windows in the painting (Fig. 125), it, too, is a product of the artist's imagination. Taking a cue from Filippo Lippi's wilderness landscapes, with their fantastic rock formations, Leonardo constructed his scenery out of jagged peaks towering over the gentler slopes of a valley.[57] Any reassuring traces of human activity, such as those in the backgrounds of the *Annunciation* (Fig. 80) or *Ginevra de' Benci*

124 Detail of Fig. 87.

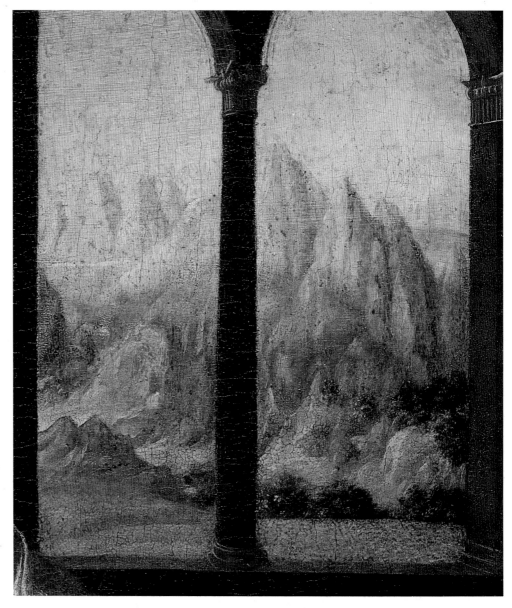

125 Detail of Fig. 122.

126 (*facing page*) Detail of Fig. 122.

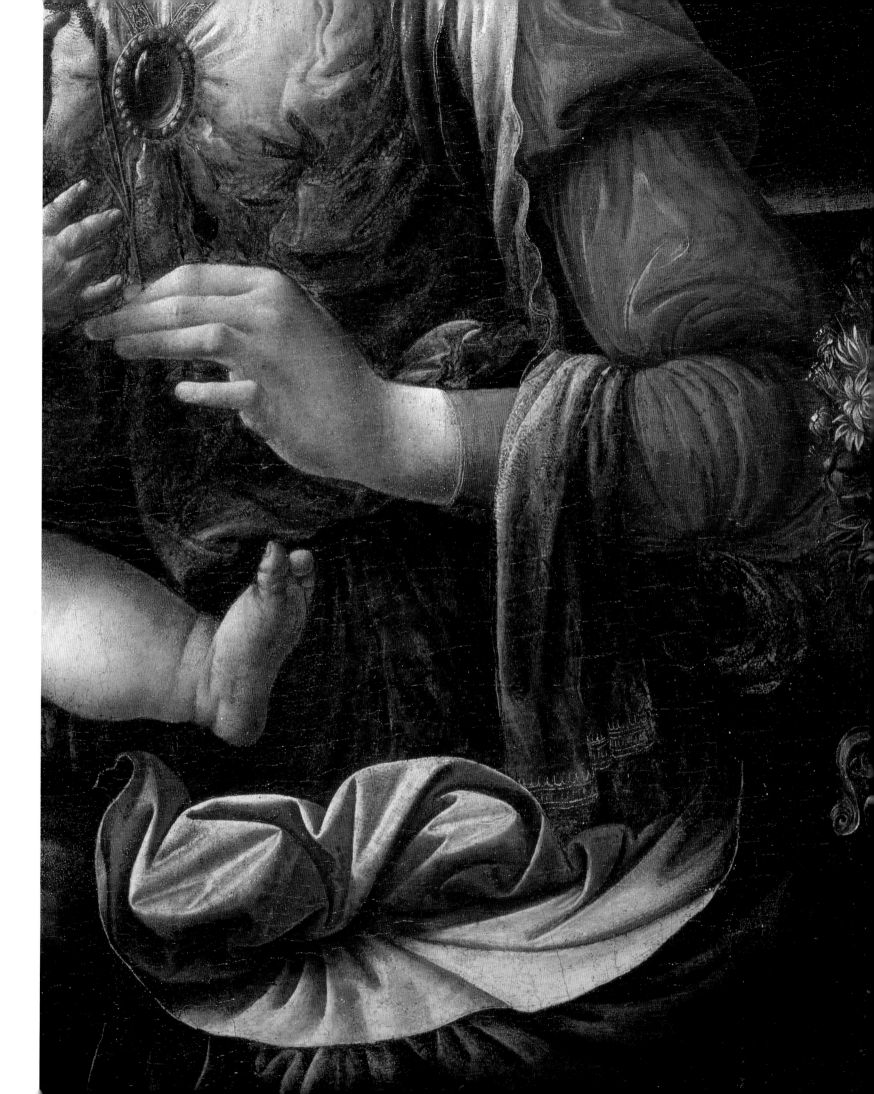

128 Verrocchio and Leonardo, *Baptism*, Galleria degli Uffizi, Florence.

(Fig. 110), have been eliminated. This is a purely fictional nature, made to seem plausible by the young painter's increasing mastery of atmospheric perspective.

While Leonardo was thus developing as an artist, the most impressive painting hitherto undertaken in the shop – the *Baptism of Christ* (Fig. 128) – sat unfinished. Verrocchio seems to have begun the altarpiece in the late 1460s, when he first took up the brush. The rather crudely handled parts of the picture, consisting mainly of the Baptist, the palm, and the rocky ledge surmounted by trees, represent his efforts to turn sculpture into painting. But faced with the task of completing so large a work in what was to him an uncongenial medium, Verrocchio (or Leonardo if Andrea turned it over to him) procrastinated. Now, however, with Pollaiuolo's brilliantly accomplished Pucci altarpiece (Fig. 9) as a goad, Andrea resumed work on the project in the mid-1470s, this time with Leonardo's assistance.[58] The younger artist had already proved his ability in the works he painted independently in the shop. And he had carried out the master's intentions for the tournament standard, taking responsibility for the *spiritello* and the adjacent bit of landscape. Significantly, the early sources credit Leonardo with just such an ephebic type – the angel kneeling in profile – in the *Baptism*, and later writers expanded his participation to include the landscape above the angel and his companion. Berenson and other scholars have argued that Leonardo also altered the figure of Christ.[59] But if they agree that Leonardo repainted his teacher's work in a different style and technique, the division of hands – who did which part – is still not entirely clear. Nor do we know exactly why Leonardo intervened. Did he collaborate with his master? Or, as critics now tend to believe, did Leonardo revamp the picture on his own long after it was begun?[60]

When it was first published in 1954, the x-radiograph of the painting raised as many questions as it answered. The evidence it provided was interpreted to mean that Leonardo, besides modifying the landscape which his master had previously painted in tempera, also repainted the left-hand angel and the body of Christ in oil.[61] The radiograph seemed to show that three different techniques had been adopted for the figures: the famous angel and the Christ not only differed from Verrocchio's Baptist but also from each other, it was said, perhaps because of damage to the angel's head. The radiograph also demonstrated – and this can be verified – that Christ's flesh tones were painted with the artist's fingers as well as the brush (Fig. 130).[62]

The opportunity to examine the back of the panel (made up of six vertical planks) further revealed the existence of some black chalk sketches, which cannot be confidently attributed to either Verrocchio or Leonardo.[63] Consisting of decorative volutes and candelabra and of two nude male figures, the drawings are shop doodles, not preparatory studies, though the nudes, one standing and the other striding (Fig. 127), are related in pose to the protagonists of the painting. They exhibit what might be called the collective mentality of the master and his assistants during the years while the altarpiece was in progress, and that can be summed up in sculpture of the sort represented by the Medici tomb and by Pollaiuolo. The more energetic nude in particular recalls a series of prototypes by Antonio, from the *Hercules* to the warriors in the engraving and in the *Martyrdom of St. Sebastian*.

A better idea of how Verrocchio and Leonardo combined their talents has recently begun to emerge with the new, more thorough technical studies made in connection with the recent cleaning of the *Baptism*. This evidence, comprising an improved x-radiograph (Fig. 129) and an infra-red reflectogram, has been taken to

127 Figure sketches on the reverse of the Uffizi *Baptism*.

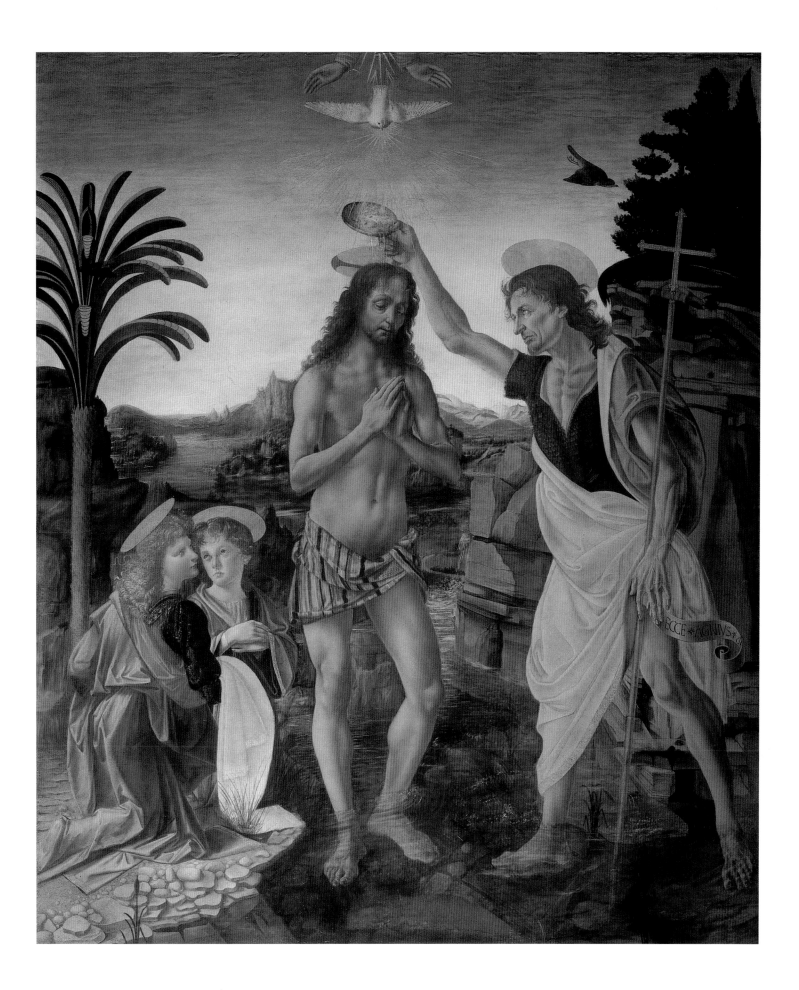

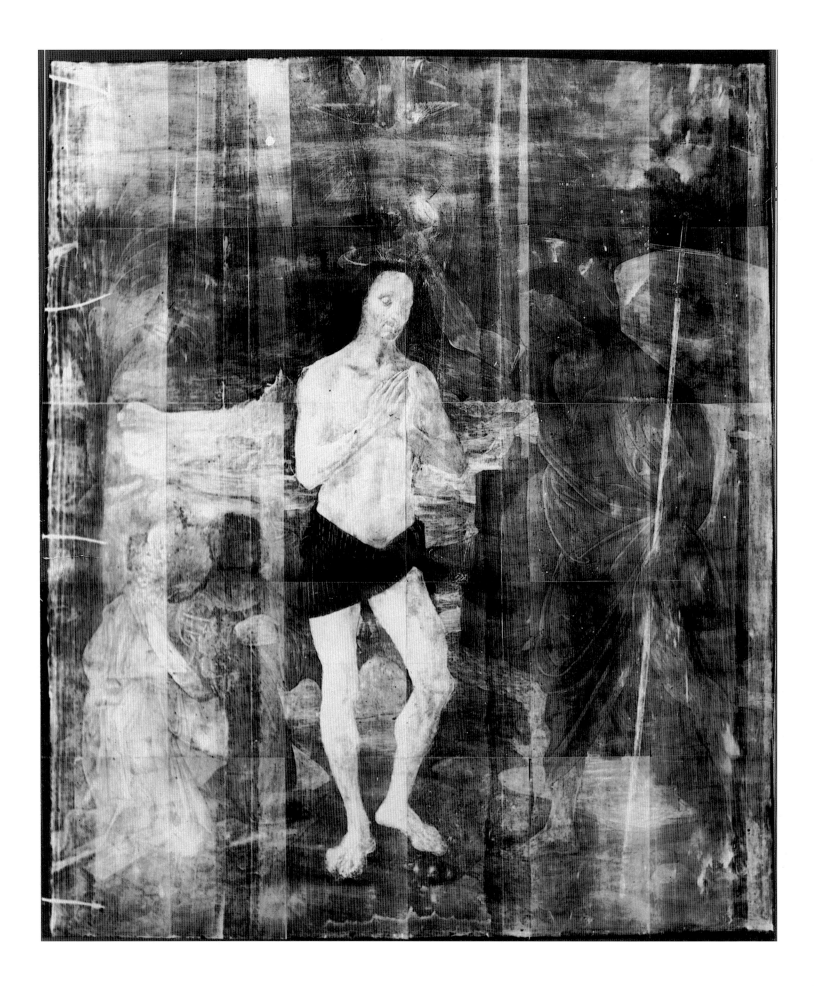

130 Detail of Fig. 128.

131 X-radiograph of the Uffizi *Baptism*. Detail.

129 (*facing page*) X-radiograph of the Uffizi *Baptism*.

confirm differences already noted between various passages in the painting.[64] But are there really three or more artists at work here, one who did the angel on the left and the distant landscape; another responsible for the second angel, the Baptist, and the rocky cliff; and a third who would have executed the figure of Christ? Careful re-examination of the *Baptism* and the scientific material pertaining to it in 1994–95 by the team that investigated the Uffizi *Annunciation* has produced the results summarized below. The radiograph actually suggests that two, not three, hands worked on the picture, as there is a clear distinction between the dense build-up of paint, involving the use of white lead (opaque to x-rays, it shows up white in the radiograph), in the head and body of Christ, the distant landscape on both sides of his figure, and the angel's hair and drapery, on the one hand, and the tempera-based execution (darker in the radiograph) of the Baptist, the second angel, much of the foreground, the dove of the Holy Spirit, and the hands of God the Father, on the other. All of the sections attributable to Leonardo (by comparison with the angel attested by the literary sources) were executed in oil or in some oil-tempera combination, with the artist using his fingers nearly as much as the brush (Fig. 130).

The radiograph betrays some slight contour changes to the Christ, including his right foot, which is now turned more to the viewer. But these *pentimenti* do not point to the existence of an earlier version of that figure by Verrocchio. On the contrary, the Christ appears to have been designed and executed during the second of the two separate campaigns in painting the picture. The evidence relating to Leonardo's angel (Fig. 131) is equally clear on this point. The body with the head turned over the shoulder is now as it was originally. Only the features and expression may have been changed, perhaps accounting for the lack of density in painting the face.[65] Leonardo also seems to have altered the brocaded sleeve. Lightly drawn in metalpoint on the gesso ground, the regular design visible in the radiograph was painted more freely, like Tobias's brocade (Fig. 44) in the London picture, only in oil: Leonardo typically suggests, and does not define, the pattern. His fluid painting of the angel's hair is damaged around the ear because of a knot hole in the panel, and the gold halo painted over the hair is a later addition.

Christ's robe held by the angel and that of the Baptist are identifiable as Verrocchio's work, as they share the same low paint density in the radiograph as the second angel.[66] It might be assumed that that angel belonged, with Christ's precursor, to the first phase in the genesis of the *Baptism*, but the figure must have been conceived and executed together with that of his more famous companion, as they plainly form a pair.[67] While consonant technically with the Baptist, the second angel is somewhat more advanced in style, closer to the nymph's head (Fig. 118) than to the Uffizi drawing (Fig. 19) that originally served for the figure. It would seem, therefore, that when he returned to the painting in the mid-1470s, Verrocchio added the partial figure of the angel – except for the hands, which, appearing white in the radiograph, are probably by Leonardo. Here as elsewhere the radiograph reveals a pattern of darker and lighter zones corresponding to Verrocchio's and Leonardo's respective shares in the painting. Unfortunately, however, without cross-sections of paint samples, the layer structure cannot be analyzed to determine the full extent of Verrocchio's work on the panel. The technical evidence, in any case, does not exclude the possibility that the master allowed an assistant less gifted than Leonardo to carry out a few minor details, like the Baptist's ineptly lettered scroll, which cannot compare with the beautiful script carved on the Medici tomb or painted on the reverse of *Ginevra de' Benci*.

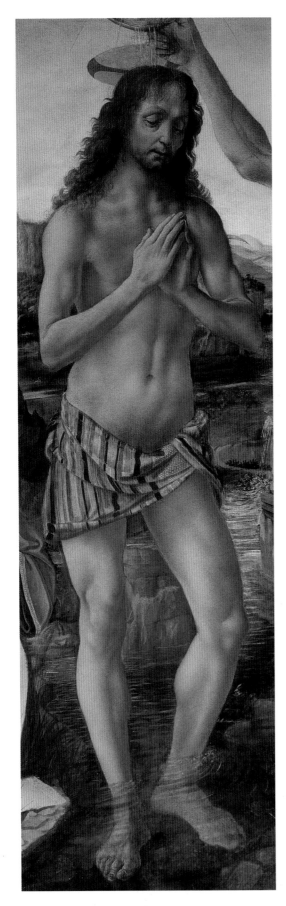

Turning from process to results, we find that the figure of Christ (Fig. 132), conceived on a slightly smaller scale than that of John the Baptist, is the focus of the narrative. On axis with the dove and the cup of water poured over his head, Christ gathers the adoring glances of the precursor and the left-hand angel, who both turn toward him. Looking downwards and joining his hands in prayer, Christ's calmly self-possessed demeanor contrasts with their ardor in a way that looks forward to the *Last Supper*. The detailed anatomical understanding displayed by Christ's body, moreover, is greatly superior to the schematic treatment of the Baptist. The prototype for this anatomical definition could, in Florence at this time, only be Pollaiuolo – not the tiny relief that provided the composition of the *Baptism* but the artist's paintings, in particular the Pucci altarpiece (Fig. 9). The legs of the soldier bending over toward the right in Antonio's picture were clearly a specific model that Leonardo tried to emulate.[68] The younger artist's attention to detail surpasses Pollaiuolo's, however, even including Christ's pubic hair, painted in over the striped loincloth that was a Verrocchio shop property. Leonardo also went beyond Pollaiuolo in modeling forms with the utmost nuances of light and shade, much as he did the infant's body in the Munich *Madonna* (Fig. 123).

The softening effect of Leonardo's oil glazes can be observed in the landscape background (Figs. 133 and 134) as well. Since he altered the view that Verrocchio had in all likelihood already completed, the pupil's changes to his master's work are corrections and not simply additions.[69] Leonardo's modifications to the landscape are extensive. The delicately observed grasses beside the angel and the little ferns he painted in the foreground contrast with Verrocchio's coarsely rendered vegetation, some of which is visible in the radiograph under the rocks Leonardo brushed in on the left. Leonardo widened the river winding through the picture, obliterating some small motifs in the background and submerging plants and the Baptist's feet on the pebbly shore. The flame-like peaks towering over the lake or stream were painted with the same brio as in the *Annunciation*, while Verrocchio's tamer conception is just visible beneath Leonardo's oil layers. The mountains have for highlights thin ridges of white paint, exactly like those used to define the figures of the angel and of Christ.

In recasting the landscape he found unsatisfactory, Leonardo again followed Pollaiuolo's example. As in the Uffizi sketch (Fig. 87), he adopted Antonio's basic scheme (Fig. 10) for ordering nature, that of a river meandering through a valley. The cascades in the Jordan also probably derive from Pollaiuolo, as does the device of aerial perspective he shared with the Netherlandish masters, in which objects become vaguer and paler as they recede into the distance.[70] Exploiting the oil medium to gain atmospheric effects outside Antonio's range, Leonardo's moisture-laden landscape shifts in color from brown to gray-blue toward the horizon. But if the background in the *Baptism* recalls Pollaiuolo's panoramas, Leonardo rejected that artist's topographical approach. Instead, he portrayed a fantastic landscape resembling the mountainous vistas in the Munich *Madonna*, in which no signs of human life or activity can be found. Leonardo's earlier depictions are also depopulated, but they suggest a human imprint in the form of fields or fortified towns. The purely imaginary landscape Leonardo painted in the *Baptism* is not a view at all but represents a new way of seeing and depicting nature in terms of the elemental forces of rock and water. This approach to landscape leads to *Mona Lisa* and links Leonardo across the centuries to Turner, who similarly used light and atmosphere to evoke the power and mystery of nature.

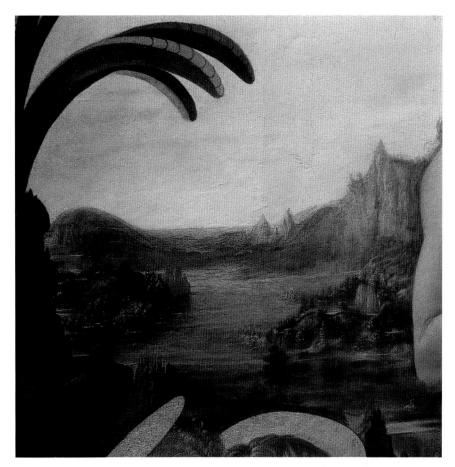

133 Detail of Fig. 128.

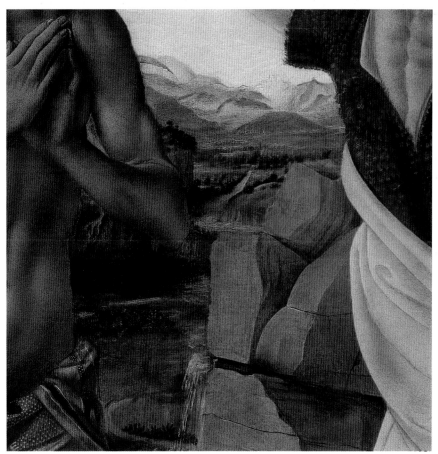

132 (*facing page*) Detail of Fig. 128.

134 Detail of Fig. 128.

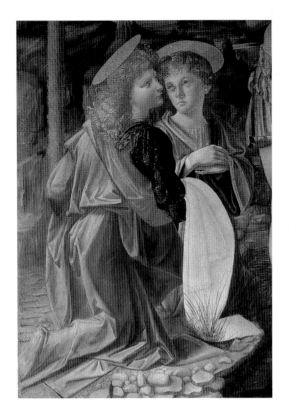

135 Detail of Fig. 128.

136 Verrocchio, clay model for the Forteguerri monument. Detail. Victoria and Albert Museum, London.

137 (*facing page*) Detail of Fig. 128.

Verrocchio's angel, turning to regard his companion, presupposes Leonardo's (Fig. 135), and the two figures were jointly executed. But who was responsible for their conception? Neither artist had ever attempted to paint such a complicated pose as that of the angel, seen diagonally from behind with the head turned over the shoulder.[71] Since his turning movement anticipates the angel's *contrapposto* in the *Madonna of the Rocks*, the design of the figure has always been credited to Leonardo.[72] And a precedent for his posture has been identified in the work of Filippo Lippi.[73] The torsion of Leonardo's angel goes well beyond Gabriel's relatively simple pose (Fig. 62) in the *Annunciation*, and along the path that leads from one to the other, the artist may once again have found inspiration in a sculptural work of his master – the small clay model (Fig. 136) for the Forteguerri monument, specifically, the wingless angel supporting the mandorla to the left of Christ.[74] If it occurred, such a borrowing from a three-dimensional prototype by Andrea would be entirely consistent with young Leonardo's practice. The angel's gray-blue drapery, with its sharply angular folds, is also constructed according to the Verrocchio shop method, though it shows more than was customary of the body underneath.

What is most original about the angel, then, is not his attitude, which Leonardo seems to have borrowed from Verrocchio, but his quality of expression. A kind of sacred *spiritello*, he kneels beside a tuft of grass in another of those juxtapositions of man and nature that were becoming a major theme in Leonardo's art.[75] The angel's fashionable air, moreover, particularly his dark brocaded sleeve bordered by a band of crystal spheres, constitutes a further link between Leonardo's share in the *Baptism* and the more or less contemporary Munich *Madonna*.[76] Unlike the ostentatious array of fabrics and jewels found in Pollaiuolo, the angel's doublet seems all the richer for being isolated. Leonardo's angel literally outshines Verrocchio's. His radiant beauty also transcends that of Gabriel, kneeling in profile, in the *Annunciation*. Lacking wings, the angel facing Christ (Fig. 137) turns in such a way that his golden hair streams over his shoulder like cascading water. And the splendor of his hair, tied with a blue ribbon, corresponds, in turn, to the spiritual intensity of his "glance, which," as L. H. Heydenreich noted, "observes the event but at the same time seems directed inward" or beyond, into the future.[77] Leonardo here uses the oil medium in an entirely new way to reveal the angel's temperament. The difficult foreshortening of the features, which seems to have given the artist trouble, must have necessitated considerable study on his part. No drawings for the angel survive, but the list of works he drew up in connection with his trip to Milan includes a "head portrayed from Atalante, who raises his face."[78] We are led to ask whether Atalante Migliorotti, the gifted young musician who accompanied Leonardo on his journey, might not have served as a model for the San Salvi angel.[79] Whatever the case, the angel's rapturous face and rippling hair represent an ever more expressive ideal of masculine beauty that Leonardo would continue to develop.

Leonardo's contribution to the *Baptism* attests to the fruition of his art, as the figures of Christ and the angel and the landscape background are all paralleled in the works of his maturity. The contrast offered by his share in the painting, particularly the famous angel, has often been used to belittle the efforts of his teacher. But that does a disservice to Verrocchio. The traditional workshop system, with its emphasis on conformity and productivity, would doubtless have thwarted Leonardo's growth. Though running an enterprise of this sort in which the younger artist was of limited use to him, Andrea, to his credit, resolved,

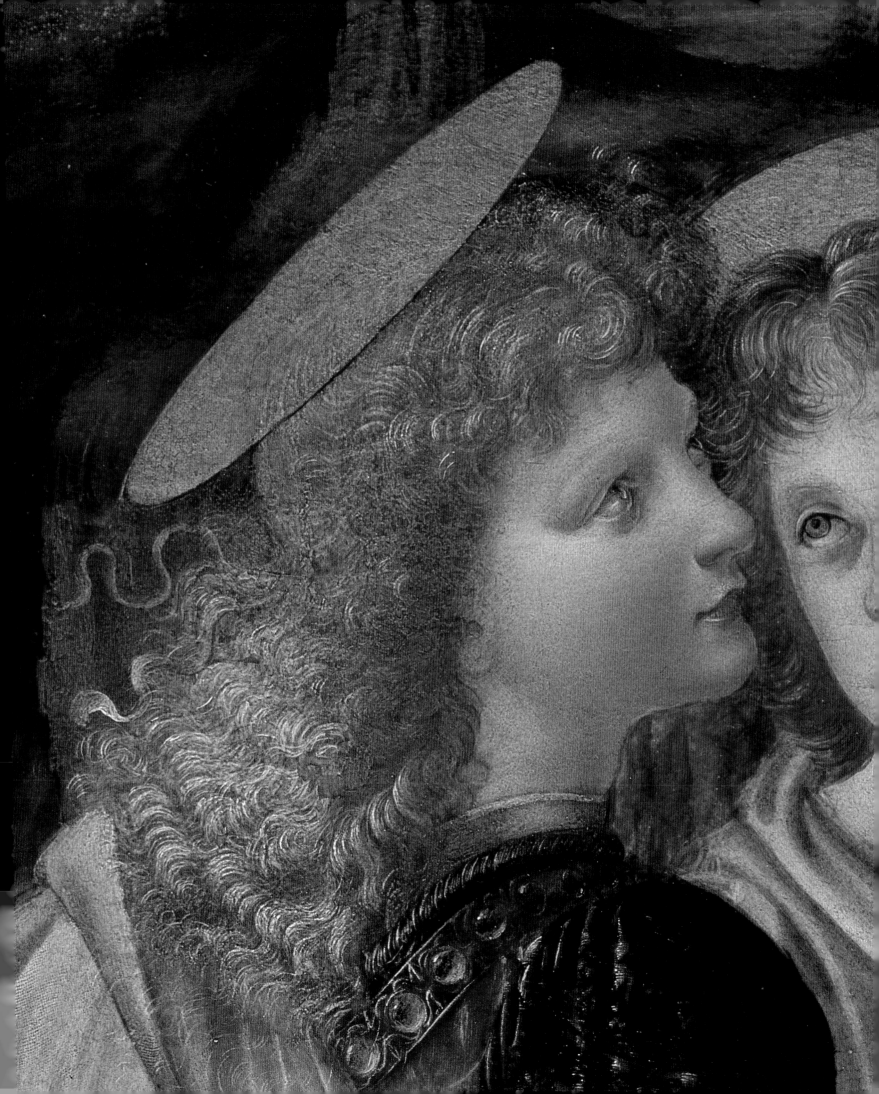

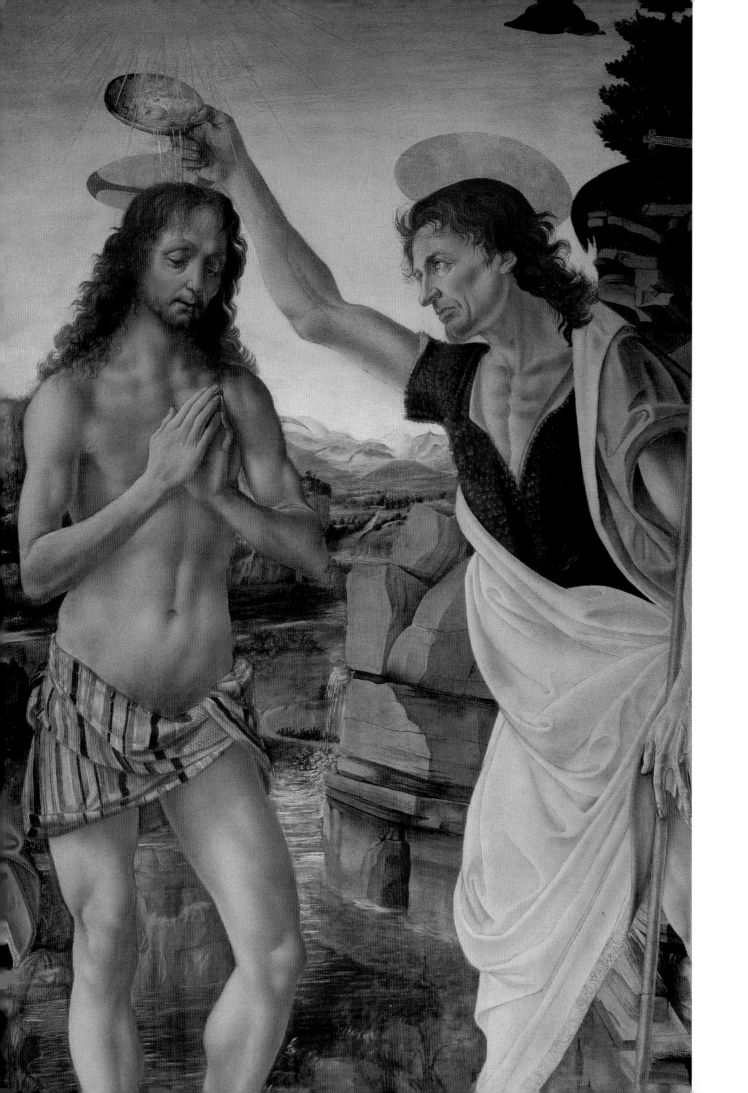

nevertheless, to incubate Leonardo's genius. The advantage of their working relationship was that, while making up a deficiency of the master's, it offered the pupil a chance to develop his own ideas about art and nature and to find new ways to express them in his work. In this sense Verrocchio was not only Leonardo's teacher but also the first in a succession of patrons, culminating in the king of France, who fostered his creativity. And yet while Leonardo was thus encouraged to make pictures his way, his style obviously had to be more or less consistent with Andrea's. The two artists' early collaboration on the *Tobias* meshes their work so that it has a uniform effect. But having subsequently granted Leonardo sufficient freedom to develop a distinctly personal style, Verrocchio was forced to admit that, by the time of the *Baptism*, his pupil had outgrown him. As Leonardo's "improvements" indicated, their styles by now diverged to the point where they were incompatible. And the cleavage between the two conflicting pictorial styles, one sculptural and the other painterly, one literal and earthbound and the other observant yet visionary, implied a challenge to Verrocchio's mastery. It seems altogether fitting that whereas Leonardo's Tobias looks up to Verrocchio's portrayal of the boy's guardian angel, the figures Andrea painted in the *Baptism* gaze with wonderment at those contributed by his pupil.

However extraordinary, the psychological dimension of Leonardo's angel does not seem to have impressed his contemporaries from the moment it was created. The London *Virgin and Child* (Fig. 34), which Perugino painted in Verrocchio's shop, borrows, and treats equally, both angels from the *Baptism*. And the qualities distinguishing Leonardo's figure were also lost on two other pupils of the master, Credi and Ghirlandaio, who, in echoing the *Baptism*, ignored its most conspicuous feature.[80] Similarly, several miniatures representing the same subject from the *bottega* of the Florentine illuminator Attavante, though routinely cited as evidence of Leonardo's influence, actually show the contrary.[81] They, too, retain the composition of the *Baptism* while altering Leonardo's angel. What is now regarded as the most outstanding aspect of the picture was overlooked, in fact, until the renowned author of the *Last Supper* returned to Florence in 1500.[82]

138 Detail of Fig. 128.

7 Epilogue

L EONARDO LEFT VERROCCHIO'S SHOP sometime between mid-1476, when the sodomy accusation places him there, and the beginning of 1478, when he won his first recorded commission. With his disaffiliation from Andrea about 1477, Leonardo entered the later – and some would argue more creative – phase of his first Florentine period, which lasted until he departed for Milan about 1482. During this time, Leonardo broke not only with the example of his former teacher but also with his own earlier work. The revolutionary change that occurred in his art resulted from a shift in focus from the finished painting to the process leading up to it. Significantly, while only a few preparatory studies survive for the Verrocchiesque pictures Leonardo completed before leaving the *bottega*, numerous drawings can be connected with paintings from the second phase, none of which is entirely finished. This change goes beyond a shift of emphasis, however, for Leonardo's newly achieved status as an independent master seems to have released his creative energies. Instead of adapting Verrocchio prototypes, the ex-pupil now searched for fresh solutions.

Let us look briefly at two pictures from the second phase to see how they compare with his earlier work. Because of its close similarity to the unfinished *Adoration of the Magi*, the *St. Jerome* (Fig. 140) in the Pinacoteca Vaticana has always been accepted as a late work from Leonardo's early years in Florence.[1] The artist brought this fairly large panel only to the state of a monochrome underpainting, which served to establish its tonal structure. Much about the picture looks familiar. The aged saint and roaring lion hark back to the expressive types of man and beast that Verrocchio had juxtaposed (Fig. 59). And the method of placing the protagonist's head against a dark foil was a standard practice of Leonardo's. In other respects, however, the painting draws inspiration, more than ever before, from Andrea's rival, specifically from Pollauiolo's design for an emaciated St. Jerome, kneeling in penitence in the wilderness, as recorded in a contemporary print (Fig. 16).[2] For all its indebtedness, however, Leonardo's painting demonstrates a concern with the anatomy and anguished expression of the saint that exceeds Antonio's. The prominence the younger artist has given to Jerome's attribute, pairing the saint and the lion as if they were equal, is unique to him.

The *St. Jerome* is not the first of Leonardo's works that is unmistakably his in design and execution. The Benois *Madonna* (Fig. 142) in the Hermitage is so characteristic of the artist that, after coming to light at an exhibition in St. Petersburg in 1908, it quickly won over the same authorities who disputed his earlier pictures. Critics have also agreed in dating the *Madonna* to the late 1470s.[3] We know from an inscription in Leonardo's own hand on a sheet of studies in the Uffizi that he began working on two Madonnas in the autumn of 1478.[4] One of these is generally agreed to be the Hermitage picture. The operative word here is "began," for even now the painting is not entirely complete, lacking a landscape

139 Detail of Fig. 155.

140 Leonardo, *St. Jerome*, Pinacoteca Vaticana, Rome.

viewed through the window in the Virgin's dimly lit chamber. Like Leonardo's other early works housed outside Florence, the Hermitage painting seems, after centuries of obscurity, to have come out of nowhere. Transferred early in the nineteenth century from its wood support to canvas, the *Madonna* is not well preserved, though it is technically successful, without any of the wrinkling that mars its predecessor in Munich. A trace of Verrocchio's influence survives in the Virgin's brooch, but his Berlin *Madonna* was not the starting-point for Leonardo's conception. The actual source for the compact grouping of the Virgin and Child has been identified in two marble reliefs by Desiderio da Settignano, one of which

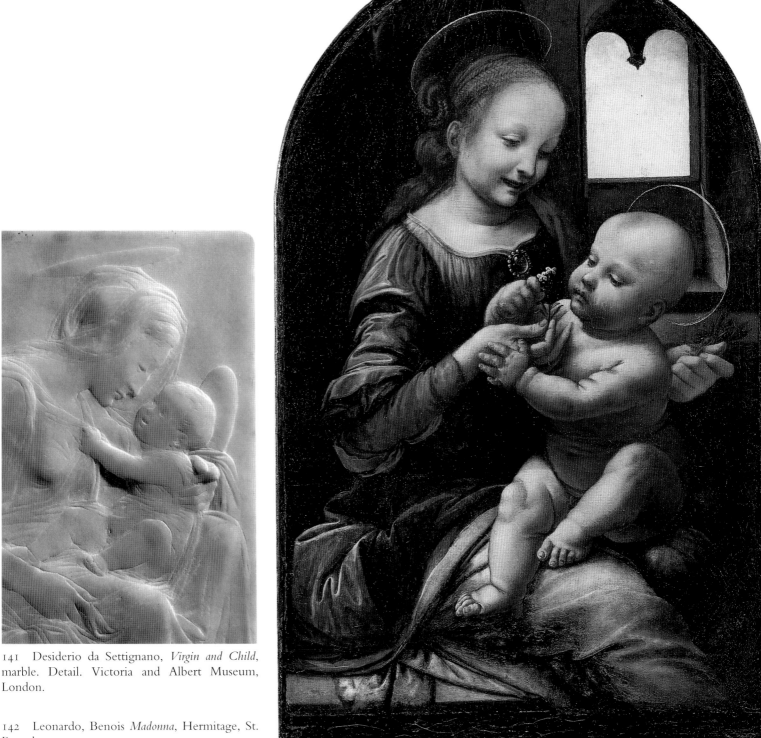

141 Desiderio da Settignano, *Virgin and Child*, marble. Detail. Victoria and Albert Museum, London.

142 Leonardo, Benois *Madonna*, Hermitage, St. Petersburg.

(Fig. 141) is in the Victoria and Albert Museum, London.[5] As Passavant has observed, "apart from the attraction which Leonardo must have felt for the sensibility of Desiderio and the grace of his figures, it is clear that Desiderio's pictorial vision . . . suited him better than Verrocchio's three-dimensional sculp-

tural approach."[6] Leonardo's choice of Desiderio as a model, together with that of Pollaiuolo for the *St. Jerome*, suggests a sudden widening of his artistic horizons.

The Desiderio borrowing shows that Leonardo could still consult sculpture when formulating a composition: the model had changed but not the practice. But the use of a ready-made source does not imply dependence. It merely left Leonardo free to focus on his principal goal of pictorial realism. He achieved this in the Hermitage picture by simplifying the profusion of detail that still marks the Munich *Madonna*. Infra-red reflectography has revealed, for example, that wavy locks originally framing the Virgin's face were eliminated in the final version. The vase of flowers in the earlier *Madonna* has been omitted, too, and the draperies, especially the robe looping over the stone bench on which the Virgin is seated, are arranged more functionally. Throughout the painting, in fact, individual forms are strictly subordinated to the interplay of heads and hands in the center of the composition. The Virgin presents a flower, identified as a cruciform bitter herb, to the Child, who scrutinizes it with the curiosity of a budding botanist.[7] As Heydenreich noted, "only the most penetrating observation could capture, down to the last detail, the absorbed expression with which the Child reaches for the blossom, as if to understand as well as possess it."[8] The Child's action and his mother's obvious delight in it are mirrored in their poses and expressions, and it is here, in the way they are grouped, that the main innovation of the *Madonna* lies. A new principle of design integrates the figures into a complex unity of the sort found in all of Leonardo's subsequent works. This integration is the product of a series of rapidly sketched pen-and-ink drawings that either served for the Hermitage picture or are otherwise related to it. The closest of these sketches (Fig. 143) blocking out the composition is amazingly abstract.[9] Under an arched top, the figures are components in a scheme that would lead, through many (lost) detail studies, to the finished work. Only by means of such sketches, in which Leonardo explored a variety of possibilities, could he arrive at the definitive solution embodied in the painting. The large number of period copies and variants of the Benois *Madonna* testifies to the efficacy of his new method.[10]

Painted toward the end of his first Florentine period, the *St. Jerome* and the Benois *Madonna* are in a style approaching that of Leonardo's maturity. It seems fitting, therefore, that he should have received at this time the first commission of which there is any record. On January 10, 1478 (1477, Florentine year), he was asked to paint an altarpiece for the chapel dedicated to St. Bernard in the Palazzo della Signoria. Significantly, this prestigious commission, having been awarded to Piero Pollaiuolo three weeks earlier, was turned over to Leonardo, possibly through the intervention of the Medici.[11] By this time Leonardo was presumably working on his own. But since he must have kept up with the shop that had until recently employed him, we can assume that Leonardo's triumph over Piero Pollaiuolo would have reflected on Andrea as well, just as Botticelli's *Fortitude* (Fig. 25) had done. The difference is that while Botticelli duly completed his assignment, Leonardo only seems to have started the altarpiece, for which he received an initial payment in March 1478.[12] After that the commission passed to Ghirlandaio and then to Filippino Lippi, whose *pala*, dated 1485, is now in the Uffizi. Whether Leonardo was absorbed in designing this large picture or was daunted by the labor required to complete it, he failed to execute the St. Bernard altarpiece.

Leonardo was not prolific and, in that sense at least, he had never been an ideal collaborator for Verrocchio. If Andrea wanted to multiply his meagre efforts as a painter, he needed an assistant who was less original but more diligent. As if in

143 Leonardo, *Studies for the Virgin*. Detail. British Museum, London.

answer to Verrocchio's prayers, Leonardo's exact opposite now appeared in the form of Lorenzo di Credi. Born about 1459, Credi trained as a goldsmith, according to Vasari, after which he "went to Andrea del Verrocchio, who was then working as a painter. Under that master and with Pietro Perugino and Leonardo da Vinci as companions, friends, and rivals, he diligently studied painting."[13] Though it is doubtful whether the considerably younger Credi ever competed with his fellow pupils, he may well have overlapped with them if, as Vasari seems to imply, he entered the shop as an apprentice around the mid-1470s. Credi is first recorded in the *bottega* as a poorly paid painting assistant in 1480.[14] He took charge of the shop shortly afterwards when Verrocchio went to Venice to work on the equestrian statue of Bartolomeo Colleoni. Upon the master's death in 1488, Credi became his principal heir and executor.[15]

Just as Credi carried on the Verrocchio shop, so his work represents a continuation, well into the sixteenth century, of Andrea's style as a painter. The key to understanding the relation between the master and his favorite pupil-turned-foreman lies in the *Virgin and Child Enthroned between Sts. John the Baptist and Donato* (Fig. 144), known as the *Madonna di Piazza* after the oratory for which it was painted. Like the Uffizi *Baptism*, on which Leonardo collaborated, this square-shaped altarpiece in Pistoia Cathedral is a cooperative effort. The oratory (now the Chapel of the Sacrament in the cathedral) also contains a marble portrait relief of 1475 commemorating Bishop Donato de' Medici, as well as his tombstone.[16] In Vasari's time the painting went under the name of Credi.[17] But a document of 1485, calling for the "nearly finished" altarpiece to be completed, has, from the time it was first published, lent credence to the notion that Verrocchio, not Credi, was primarily responsible for the work.[18] The leading proponent of this theory is Passavant, who, in distinguishing Verrocchio's contribution from Credi's, tried to define a late style for the master.[19] The opposing view, that Credi did the altarpiece, has also found advocates from Vasari onwards. This theory similarly gains support from a document, according to which Credi painted an otherwise unknown "altarpiece of Our Lady and other things" for Verrocchio.[20] Credi's biographer, Gigetta Dalli Regoli, having studied the *Madonna di Piazza* in depth, concluded that he alone executed it.[21] Recent cleaning of the picture confirms that its style is entirely homogeneous.[22] And it is characteristic of Credi.[23] For like Andrea's other painting assistants, Lorenzo developed his own (rather monotonous) version of the master's style. The smooth brushwork, soft draperies, and light-hued palette are typical of Credi, who in executing the Pistoia altarpiece offered Verrocchio what every great artist earnestly desires – an extra pair of hands.

Paradoxical as it may seem, the only known picture documented as Verrocchio's was actually painted by his pupil. Andrea did not contribute so much as a brushstroke to the work, so there may be some truth to Vasari's claim that he gave up painting. Contemporaries, nevertheless, would have regarded it as his. And, as head of the shop, he was surely responsible for its initial design. The document of 1485 refers, in fact, to such a drawing provided by the master. Though no composition sketch for the picture survives, two detail studies for the Virgin and Child attest to Verrocchio's involvement in its preparatory stage.[24] The genesis of the work is complex, however, and that is where Leonardo comes in. The document of 1485 states that the *pala* would have been finished six years earlier if Verrocchio had been fully paid for it. We can deduce, therefore, that it was begun before 1479. The exact date of commission is unknown, but it may well go back to the time of the bishop's portrait of 1475, when Leonardo was still in the shop.

144 Lorenzo di Credi, *Madonna di Piazza*, Pistoia Cathedral.

here

145 Leonardo, *St. John the Baptist*, Royal Library, Windsor.

146 Lorenzo di Credi, *Study for St. John the Baptist*, Département des Arts Graphiques, Musée du Louvre, Paris.

Scholars have sought, accordingly, to detect his presence in the work.[25] Though Leonardo had no part in executing the altarpiece, he may have helped with its design as the creative force behind the figure of the Baptist. The sheet of drawings in the Uffizi that refers to two Madonnas which Leonardo began in 1478 mentions the city of Pistoia.[26] And another drawing by the artist bears directly on the question of his authorship. A leading expert on the early Leonardo, W. R. Valentiner, claimed that a metalpoint study of *St. John the Baptist* (Fig. 145) at

Windsor served for that figure in the painting.[27] The drawing is datable stylistically to the mid- to late 1470s, when the altarpiece was begun, and the position of the legs corresponds in both works.[28] Yet the conception of the saint looking out at the viewer is totally different. Instead of the mature ascetic shown in the painting, Leonardo represented John as a languorous youth. True, other artists, like Filippo Lippi or Ghirlandaio, had already portrayed Christ's precursor as a boy.[29] But Leonardo's depiction, in contrast to theirs, is disturbingly sensual. The Baptist's nudity can be accounted for, as this is a study from the life, but not his seductive smile. The combination recalls the *spiritello* of the tournament standard (Fig. 113), with the difference that the present subject was the patron saint of Florence. The ideal of youthful male beauty that Leonardo articulated in the angels in the *Annunciation* and the *Baptism* has here unmistakably been eroticized.

Asked to join in planning the Pistoia altarpiece, Leonardo typically began with an ephebe. And if he conformed to the pattern of his collaboration with Verrocchio, the idea of opening up the painted architecture to a pair of landscape vistas might also be due to Leonardo. Then his involvement with the project apparently ceased. It was up to Credi to give Leonardo's irreverent conception pictorial form. Lorenzo's *Study for St. John the Baptist* (Fig. 146) in the Louvre retains the turning pose and intercessory role Leonardo had envisaged for the figure.[30] But in coarsening the delicate features and cloaking the slender limbs, Credi effectively censored his prototype. The process of adaptation he began in the drawing then continued in the picture, where a bearded and more rugged Baptist points to the Christ Child.[31] Like other figures painted in the Verrocchio shop, that of St. John in the *Madonna di Piazza* is a composite. It is not just his pose that derives from Leonardo, but also his gesture of holding the reed cross, which recalls the angel's left hand (Fig. 62) in the Uffizi *Annunciation*.

Credi has been called Leonardo's first pupil.[32] Vasari claimed that Lorenzo particularly imitated Leonardo's "finish," but that is a quality Credi shared with Verrocchio.[33] Rather, it was Leonardo's style which impressed the younger artist. The little *Annunciation* (Fig. 147) in the Louvre testifies to Credi's admiration for Leonardo's work and to his inability to understand it.[34] The attribution history of the painting, having gone from consensus to controversy, is exactly the opposite of that affecting Leonardo's autograph early works. In the late nineteenth century the picture was regarded as the touchstone of Leonardo's early style. Then Berenson demoted it to "Credi retouched by Leonardo," and Clark eventually removed it from the Leonardo canon.[35] In Clark's memorable phrase the *Annunciation* was "in the position of a beautiful orphan, who is suddenly discovered to have a number

147 Lorenzo di Credi, *Annunciation*, Musée du Louvre, Paris.

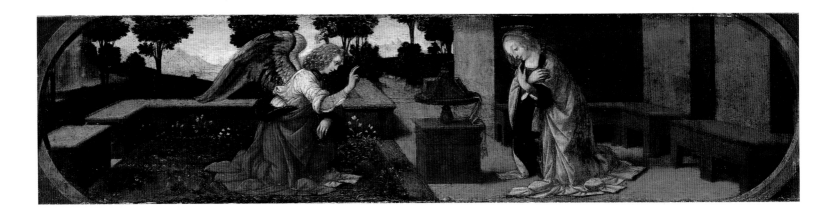

154

of undesirable relations."[36] For Valentiner had convincingly identified the Louvre picture as belonging to the predella of the *Madonna di Piazza*, and another scholar had discovered its companion piece in the *St. Donato and the Tax Collector* (Fig. 148), now in the Worcester Art Museum.[37] All three works – the main section of the altarpiece and the two surviving predella panels – were apparently executed by Credi. The only question is whether Leonardo had a hand in the *Annunciation*, as a few scholars still claim.[38]

The attribution issue is confused by the date of the painting. Bode believed that this was Leonardo's earliest work. But later writers, noting its muted tonality, were closer to the mark in dating the picture toward the end of his first Florentine period.[39] The *Annunciation* is a later variant of the one from Monte Oliveto (Fig. 63). At first glance the Louvre version may appear more accomplished than its predecessor. It is more advanced in style, reflecting a knowledge of the works that Leonardo did soon after leaving Verrocchio's shop (Fig. 142). But closer inspection reveals an almost total misunderstanding of what the earlier *Annunciation* was about. Credi took this work of great subtlety and complexity and reduced it, suppressing some elements and simplifying others, like the richly decorated marble lectern and the stiffly shaped draperies, which mark the picture as a product of Verrocchio's *bottega*. The narrow predella format dictated that both protagonists be shown kneeling. Credi brought them closer together in an enclosure formed by the garden wall and the wooden benches behind the Virgin. The perspective scheme governing the picture thus ignores the dichotomy Leonardo set up between the right and left sides of his painting.[40] Nature counts for little in Credi's *Annunciation*: the plants around the angel are conventional, and so is the landscape formula into which Leonardo's mysterious scenery has been transformed. Credi's static treatment of Leonardo's angel similarly misses the point. Besides the resting pose, all the most characteristic features of the angel have been altered: the fluttering sash is omitted, the wings are unconvincingly feathered and attached, and the lily rises above the head. The Louvre picture, therefore, reflects the Uffizi *Annunciation* but not the ideas contained in it. However indebted to Leonardo, the panel hardly differs from the right-hand scene (Fig. 148) of the predella, in which there is a comparably symmetrical arrangement of figures and setting, as well as the same subdued color scheme.[41] Both works, together with the missing predella panel, probably represent that part of the Pistoia altarpiece that was still unfinished in 1485.

Though not by Leonardo, the Louvre *Annunciation* is linked with a drawing widely regarded as the masterpiece of his early period. The drawing, a *Study of a*

148 Lorenzo di Credi, *St. Donato and the Tax Collector*, Worcester Art Museum, Worcester, Mass., Theodore T. and Mary G. Ellis Collection.

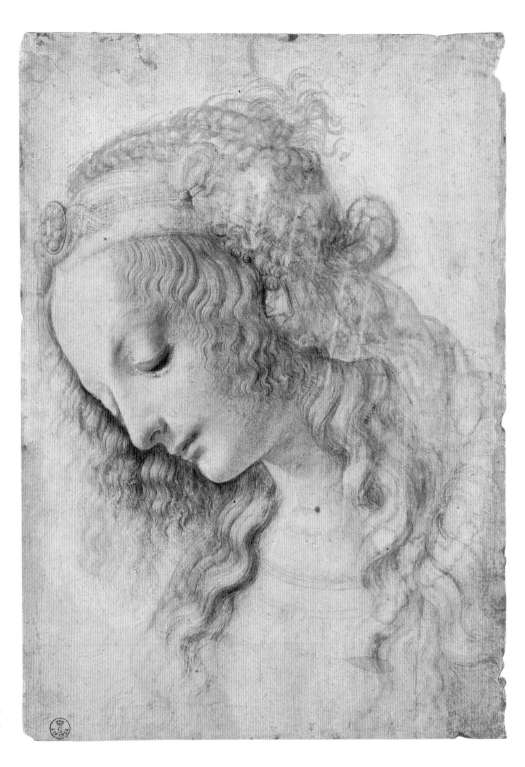

149 Lorenzo di Credi, *Study of a Female Head*, Gabinetto Disegni e Stampe, Galleria degli Uffizi, Florence.

Female Head (Fig. 149) in the Uffizi, forms a counterpart to Leonardo's *Bust of a Warrior* (Fig. 59).[42] Both sheets reflect an interest in Verrocchio's expressive types. In pen and gray and brown washes heightened with white, the Uffizi study is so pictorial that it was used as an illustration in a history of Italian painting.[43] Its superficial charm subsequently aroused skepticism, but there is no basis for the claim that the *Female Head* was a copy.[44] Today the drawing is almost unanimously accepted as Leonardo's, either as a preparatory study for the Virgin Annunciate or as an independent effort used for her figure in the painting.[45] As can readily be

seen, the drawing is too complicated to have been made for the simpler and smaller head of the Virgin in the picture. Rather, it belongs to the series of studies of heads of women that Vasari associated with Verrocchio and his shop.[46] The hair in particular, with the locks elaborately coiled or falling loosely around the face and shoulders, recalls the coiffure in Andrea's *Study for a Nymph's Head* (Fig. 118).[47] Leonardo took the British Museum drawing as a model for the Virgin's head in the Munich *Madonna*, as we have seen. Credi then seems to have followed his example, similarly adopting the Uffizi study for use in the Louvre painting.[48]

The pose of the head, lowered in near profile to the left, resembles that in a group of drawings of female heads by various members of the shop.[49] But the Uffizi study differs in one crucial respect: the oddly protruding forehead appears in three-quarter view, while the facial features are almost in profile. This inconsistency recurs in the painting, in which the Virgin shares the same bulging forehead with the angel. Since the little *Annunciation* is in all likelihood by Credi, the question arises as to whether the drawing, displaying the same defect, might not be his too. A closer look at the sheet shows that aside from the faulty foreshortening, which might be due to the artist's youth, it lacks the vitality found in everything that Leonardo touched. Not only is the drawing over-refined, like the Louvre study (Fig. 120) here ascribed to Perugino, it is overdone. The strands of hair, for example, are represented individually, like the fringe of the carpet in the *Madonna di Piazza*. We are reminded of Credi's training as a goldsmith and of Vasari's praise for the meticulous care with which he finished his works.

If the Uffizi drawing is by Credi, then a painting which displays the same sort of preciousness – the *Madonna of the Pomegranate* (Fig. 150) in the National Gallery of Art, Washington – is also likely to be his work.[50] Measuring only six by five inches, this tiny panel is obviously a product of the Verrocchio shop. But whether the master himself or Credi or Leonardo painted it is still a matter of debate.[51] Understandably, the attribution to Andrea finds no support among scholars who take the Berlin *Madonna* (Fig. 29) to represent his style.[52] Berenson long maintained that the little painting was by Credi, even after his employer, the art dealer Joseph Duveen, acquired it in 1930.[53] And Clark agreed, aptly contrasting the *Madonna* with Leonardo's "charmless [but] vital" version of the theme (Fig. 122) in Munich.[54] Other critics, in order to accommodate both works in Leonardo's oeuvre, dated the *Madonna of the Pomegranate* to the very outset of his career.[55] The majority of writers hesitated to accept the painting, however.[56] And thus matters stood until Pietro Marani, citing its exquisite delicacy, recently revived the theory that the miniature-like *Madonna* was Leonardo's earliest achievement.[57]

The technical investigation of the panel undertaken at the National Gallery of Art in 1991 indicates that while the medium is probably oil, the two key elements marking Leonardo's experimental use of the medium – fingerpainting and the wrinkling caused by uneven drying of the layers – are not found in the *Madonna of the Pomegranate*. The picture was painted conventionally by an expert craftsman. Examination under a microscope, moreover, shows that the shadows around the Virgin's facial features have been reinforced, giving her a more Leonardesque appearance. In fact, comparison of the photographs made before and after the newly acquired *Madonna* was restored in 1930 shows that, to buttress the Leonardo attribution, the Virgin's face was subtly "Leonardized."[58] The much-admired *sfumato* effect of the Virgin's curls and veil also results more from abrasion to the paint layers than the artist's original intention. Even before considering the

150 Lorenzo di Credi, *Madonna of the Pome-granate*, National Gallery of Art, Washington, Samuel H. Kress Collection.

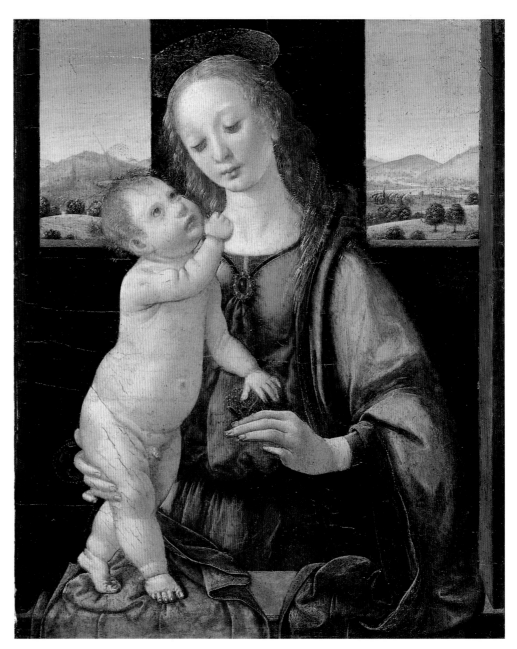

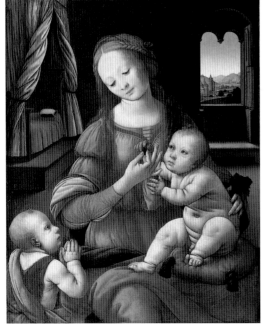

151 Lorenzo di Credi, *Virgin and Child with the Infant St. John*, Gemäldegalerie, Staatliche Kunstsammlungen, Dresden.

picture's style and sources, then, what can be established about its condition and technique leads away from Leonardo.

The *Madonna of the Pomegranate* may be the earliest and smallest of several Madonnas by Credi based on Leonardo prototypes. Another of these works, the *Virgin and Child with the Infant St. John* (Fig. 151) at the Gemäldegalerie in Dresden, is little more than a pastiche of the Munich and Benois Madonnas, with at least one other Leonardo model, all in a style resembling that of the Pistoia altarpiece (Fig. 144).[59] The sources for the Washington picture are even more complex, and the way they were used provides a clue about its authorship. Vasari mentions as Credi's first works a Madonna "the design being taken from one of Andrea's" and a "far better picture copied from one by Leonardo da Vinci [which] could not be distinguished from the original."[60] This account, echoing Vasari's story about the famous angel, indicates that Credi's early work was essentially derivative, based

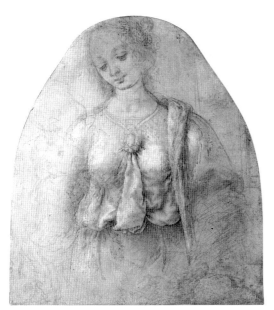

152 Lorenzo di Credi, *Virgin and Child*, Kupferstichkabinett, Staatliche Kunstsamm-lungen, Dresden.

153 Infra-red reflectogram of the *Madonna of the Pomegranate*. Detail.

first on Verrocchio and then on Leonardo. Such a formula well describes the *Madonna of the Pomegranate*, the composition of which recalls one of the two basic Madonnas developed in the shop (Figs. 14, 26, and 33), except that the Christ Child, instead of blessing the viewer, turns toward his mother.[61] Awkwardly off-balance, the Child has a specific source in Leonardo's *Madonna* in Munich (Fig. 122). It is worth considering the relation between these two works in detail. But first we must note that Credi copied Leonardo's infant in a drawing in the Uffizi.[62] And Lorenzo repeated the Child in another drawing (Fig. 152) attributable to him in Dresden.[63] This sheet is basically a drapery study for the Virgin's bust in the *Madonna of the Pomegranate*. To her left the Child is lightly sketched in two positions. In one he appears lower down, as in the Leonardo source, while in the other he is shown standing, as in the finished painting. This and other details in the drawing confirm that Credi took the Munich *Madonna* as a guide: they echo the prototype and at the same time prepare for the Washington picture.[64]

Like the Louvre *Annunciation* (Fig. 147), the *Madonna of the Pomegranate* reduces a work by Leonardo to a smaller scale, and comparison demonstrates that the two Madonnas, like the two Annunciations, are not by the same artist. In almost every respect, it can be shown, the author of the *Madonna of the Pomegranate* misunderstood his prototype. The Virgin's wispy hair and flaccid draperies, for example, lack the sense of rhythm Leonardo expressed in sweeping curves. The Child's flesh is wrinkled without being fat. And the figures have gilded haloes, which Leonardo avoided. But the main difference concerns the relation between the Virgin and Child. In each work they are united in a common action. The artist who did the Washington picture grafted the head of Leonardo's infant, looking upwards, onto the standing Child, and he substituted a pomegranate for Leonardo's carnation. The baby holds up a miniscule ruby-red seed he has plucked from the fruit offered by his mother. Signifying the Resurrection, the pomegranate is an appropriate symbol, but the way the motif is treated here lacks Leonardo's focus. Particularly telling is the manner in which the Virgin holds the pomegranate. Her hand appears ineptly foreshortened compared with its Leonardo model.[65] But the main point is that the Virgin holds the pomegranate, not like a fruit in the hand, but as if it were a flower, between her fingers. This sort of error would never have been made by Leonardo, even as a beginner.[66]

Leonardo's painting, however important for the *Madonna of the Pomegranate*, was not its only source. Vasari mentions that Credi studied alongside Perugino, so it should not be surprising that Verrocchio's Umbrian pupil also seems to have had a role in inspiring the picture. In the *Virgin and Child* (Fig. 34), plausibly ascribed to Perugino, we find the same motif of the Child holding a pomegranate seed. The bright hues of light blue, red, and green, further link the two paintings, as opposed to Leonardo's dark tonality, and so does a certain delicacy of touch. The curtains Perugino used to close off the landscape might seem to differentiate his picture, but that was the original idea for the *Madonna of the Pomegranate* too. Technical examination, using an infra-red camera, has revealed similarly sloping contours (Fig. 153) in the underdrawing, though the curtains were finally omitted in favor of a (darkened) green cloth of honor behind the Virgin.[67] As for the landscape vistas themselves, the tree-dotted hills in the *Madonna of the Pomegranate* are utterly unlike Leonardo's fantastic mountains. They recall instead the Netherlandish type of landscape then becoming popular in Florence.[68] Above all, this charming but conventional little panel lacks any evidence of the *sine qua non*

of all Leonardo's early works – his passionate absorption in nature. If we discount the effect of softness caused by abrasion, the figures and their draperies and the landscape forms in the *Madonna of the Pomegranate* are remarkably like those in the recently cleaned pictures by Credi in Pistoia and Dresden. The Verrocchiesque composition and palette in the Washington painting and its dependence on Perugino, as well as Leonardo, suggest that it may be Credi's earliest extant work.

As the only one of Verrocchio's pupils to take a serious interest in Leonardo, Credi deserves credit. And if he was unable to build on Leonardo's example, he could at least lead other artists to it. In fact, his knowledge of Leonardo's activity seems to have earned him a crucial role as intermediary: he made his mentor's early works available to a younger generation of masters, who could profit from them. The paintings Leonardo completed in Verrocchio's shop were not readily visible, after all. The *Annunciation* and the *Baptism* were ensconced in convent churches outside the city, while the Munich *Madonna* and *Ginevra de' Benci* graced private houses. Given their location, it is not surprising that these works were essentially ignored at the time they were painted. The young Perugino may have paid lip-service to them (Fig. 34), but a better understanding of Leonardo's youthful achievement came only later. Leonardo himself was in Milan during the late Quattrocento. But with Credi providing access, Piero di Cosimo, Fra Bartolomeo, and Mariotto Albertinelli explored the paintings Leonardo had left in Florence. Anticipating the efforts of art historians four centuries later, these enterprising young artists made what might be called the first rediscovery of Leonardo's early works.

Credi's echoes of Leonardo could not have replaced the originals as a source of inspiration. The variants Lorenzo did of *Ginevra de' Benci*, for example, either substitute a pomegranate for Leonardo's juniper or omit the plant motif alto-gether.[69] It was the slightly younger Piero di Cosimo (born c.1461) who tried to come to terms with Leonardo's innovation. Piero did so not in a portrait but in a mythological picture of the type in which he excelled. The painting in question, the *Finding of Vulcan* in the Wadsworth Atheneum (Hartford, Conn.), portrays a bevy of nymphs who discover the young god.[70] One of the nymphs (Fig. 154), turning toward her companion, is featured against a dark screen of juniper in a contrast of pale flesh, silky hair, and spiky foliage that specifically recalls Leonardo's formulation.[71] The novelty of the portrait, associating the female figure with a tree, was thus not lost on Piero, who shared Leonardo's love of fantastic nature and strange types.[72] The youthful St. John the Evangelist in Piero's *Immaculate Conception* (Fig. 155) in the Uffizi is also closer in form and spirit to Leonardo's androgynous Baptist (Fig. 145) than is Credi's adaptation of that figure in the Pistoia altarpiece. If Lorenzo stuck circumspectly to the pose, Piero reveled in the unorthodox psychology of his prototype.[73] Next to the Evangelist in Piero's painting the lovely figure of St. Catherine, her delicate profile turned to the light, similarly captures the special appeal of Leonardo's angel (Fig. 137) in the *Baptism*.

Like Piero di Cosimo, Fra Bartolomeo turned to Leonardo's early works for inspiration. Vasari states that, following his apprenticeship with Cosimo Rosselli, Bartolomeo (born 1472) began to study "con grande affezione le cose di Lionardo da Vinci."[74] But Bartolomeo's own early paintings are so similar in style to Lorenzo di Credi's, we can assume that they were closely associated and that Credi facilitated Bartolomeo's study by guiding him to the works both artists took as models.[75] As Everett Fahy has noted, "Leonardo's experiments with light and

154 Piero di Cosimo, *Finding of Vulcan*. Detail. Wadsworth Atheneum, Hartford, Conn.

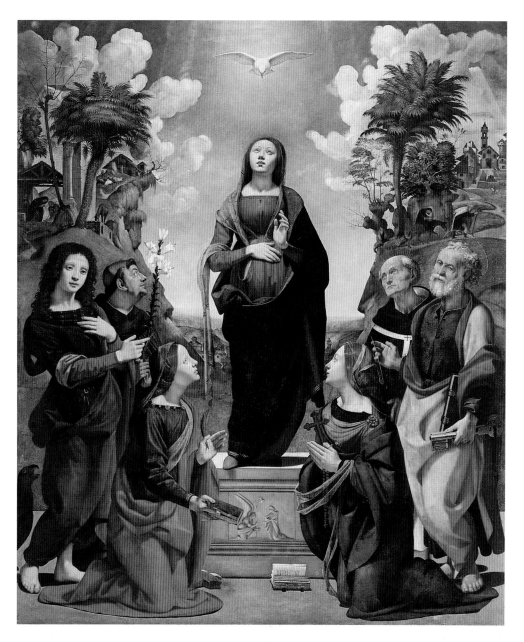

155 Piero di Cosimo, *Immaculate Conception*. Galleria degli Uffizi, Florence.

156 Fra Bartolomeo, *Holy Family*. Detail. Galleria Borghese, Rome.

color, with chiaroscuro and sfumato, fired Bartolommeo's imagination just as, only slightly earlier, they had fired the bizarre fancy of Piero di Cosimo. Furthermore, Leonardo's new treatment of the human figure, his use of contrapposto as a means of attaining fluidly balanced compositions, left a strong imprint on the earliest works that can be identified as Bartolommeo's."[76] His tondo of the *Holy Family* in the Galleria Borghese, Rome, for example, already demonstrates a profound understanding of Leonardo's methods.[77] The figure of Joseph (Fig. 156) in particular recalls the unfinished *St. Jerome* (Fig. 140), as well as one of kneeling kings in the *Adoration of the Magi*. Bartolomeo's complex lighting, which betrays a knowledge of Verrocchio shop drapery studies, is a *tour de force* going beyond what the young Leonardo had achieved.

Even more revealing is Bartolomeo's *Virgin and Child with the Infant St. John* (Fig. 157) in the Metropolitan Museum.[78] Though this work, like the tondo, dates

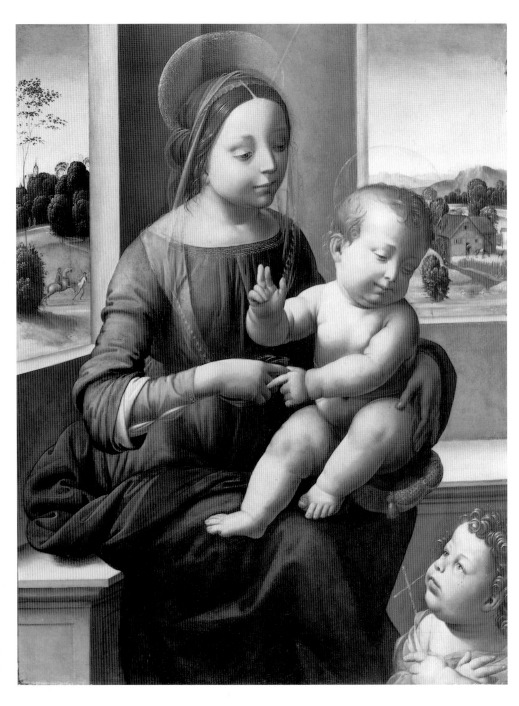

157 Fra Bartolomeo, *Virgin and Child with the Infant St. John*, The Metropolitan Museum of Art, New York.

from the mid-1490s, when the artist was still only a beginner, his choice of models and the way they are coordinated are remarkably sophisticated. The background landscape, featuring a mill, is Netherlandish in origin.[79] The figures, on the other hand, derive from Leonardo's Benois *Madonna* (Fig. 142).[80] Concerned as he was with Leonardo's *chiaroscuro* and *contrapposto*, Bartolomeo naturally focused on the master's pictures of the late 1470s, in which they are clearly expressed. But the younger artist may also have found his way back to the works Leonardo completed in Verrocchio's shop. The Baptist's curls, for example, resemble those of *Ginevra de' Benci* (Fig. 98), just as an analogue for the Virgin's proper left hand is found, not in the Benois *Madonna* (Bartolomeo omitted the flower motif and changed the gestures), but in the Windsor drawing (Fig. 93) for Ginevra's hands.

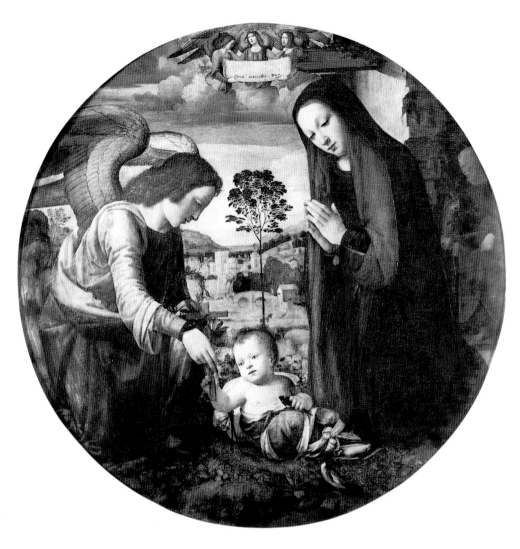

158 Mariotto Albertinelli, *Adoration of the Child*,
Palazzo Pitti, Florence.

The relation between the figures and their setting in the Borghese tondo hints at another of Leonardo's earlier works – the Uffizi *Annunciation* (Fig. 63). Whether Bartolomeo knew the *Annunciation* or not, his associate Mariotto Albertinelli was clearly fascinated by the angel in the painting. Two years younger than Bartolomeo, Albertinelli adopted both his partner's style and his sources. For the background in his *Adoration of the Child* (Fig. 158) in the Palazzo Pitti, for example, Albertinelli took over the landscape from Bartolomeo's Volterra *Annunciation* of 1497.[81] But for the extraordinarily beautiful figure of the angel Albertinelli seems to have looked to Leonardo.[82] To be sure, Albertinelli altered his prototype: the angel's shadowed face and brilliantly colored draperies differ, as does his action. But Albertinelli's adaptation captures the spirit of the original better than Credi's more literal version (Fig. 147). For what Albertinelli owes to Leonardo is not just the details of the angel's tender glance, the compact mass of curly hair, and the convincing placement of his wings. Like Piero di Cosimo in his derivation from *Ginevra de' Benci*, Albertinelli grasped the essence of Leonardo's figure – the sense it conveys of a mysterious link with nature.

Albertinelli had probably already completed his tondo when Leonardo returned unexpectedly to Florence in April 1500. Meanwhile the older master's style had matured into what is known as the High Renaissance, and having just completed

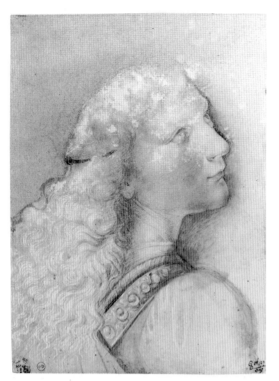

159 After Leonardo, *Head of an Angel*, Biblioteca Reale, Turin.

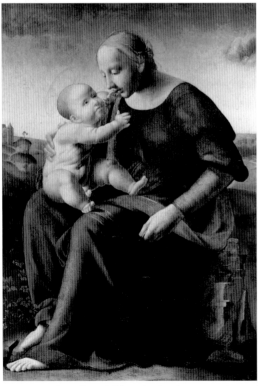

160 Circle of Ridolfo Ghirlandaio, *Virgin and Child*, Walters Art Gallery, Baltimore.

the *Last Supper* for his erstwhile patron in Milan, he came back as a famous artist. Leonardo then began the series of masterpieces, now mostly in the Louvre, which clinched his reputation as Italy's greatest living painter. Marveling at the *Mona Lisa*, the *Virgin and Child with St. Anne*, and the *St. John the Baptist*, a wider circle of artists curious about Leonardo's beginnings seem to have sought out his early works. The drawing (Fig. 159) made after the head of Leonardo's baptismal angel, in Turin, probably dates from this time.[83] Albertini's guidebook of 1510, which mentions the angel, suggests that interest had shifted from the *Baptism* as a whole to Leonardo's share in the painting. The figure of the angel, though known earlier to only a handful of artists, became famous in retrospect, when its far-reaching implications were realized in the works Leonardo created after his return. Painters adopting Leonardo as a source might even amalgamate his early works with the later ones. Thus, a *Virgin and Child* (Fig. 160) from the circle of Ridolfo Ghirlandaio, now in the Walters Art Gallery in Baltimore, combines a Virgin based on Leonardo's *St. Anne* with a Child whose figure derives unmistakably from the Munich *Madonna* (Fig. 122).[84]

The search for early Leonardo was part of a larger process of penetrating his work in general. Of all the artists who sat at his feet, none studied Leonardo more assiduously than Raphael. After having trained with the one Verrocchio pupil with whom Leonardo seems to have had a rapport, namely Perugino, Raphael arrived in Florence late in 1504. There he set out systematically to master Leonardo's new formal and expressive language.[85] The result can be seen in some of the younger artist's most popular Madonnas. The majority of these are based on Leonardo's *Virgin and Child with St. Anne*. But one recently rediscovered example – the *Madonna of the Carnations* (Fig. 161) belonging to the Duke of Northumberland at Alnwick Castle – goes back to the Benois *Madonna* (Fig. 142).[86] Raphael may have been led to Leonardo's picture, as Fra Bartolomeo was earlier, by Lorenzo di Credi, with whose work he was familiar.[87] Whatever the case, Raphael's interpretation reflects an approach to Leonardo quite different from those taken by Credi and Bartolomeo. Whereas Credi was at sea and Bartolomeo was all seriousness, Raphael was susceptible to the charm, and not only the pyramidal grouping and *chiaroscuro*, of his prototype. Typically, however, in retaining the theme of the Virgin with flowers, Raphael loosened Leonardo's tightly woven figures. And his Child no longer regards the flowers offered to him with the attention of a botanist.

Leonardo's fellow artists took over this or that aspect of his early production without ever coming to terms with it as a whole. Their attitude was probably not unlike that of the best modern student of Leonardo's art, Kenneth Clark, who tended to regard the early works as stepping-stones toward the *Mona Lisa* or the *Virgin and Child with St. Anne*. Clark found Leonardo's first paintings poetic but not very original or personal. And he was not surprised "that an earlier generation of critics was unable to accept them [for] the early pictures are less good than we should expect them to be . . . [They] must be enjoyed in detail," he believed, "or 'read backwards' in light of his later work."[88] In evaluating Leonardo's initial efforts, Clark and other writers, nevertheless, failed to consider them sufficiently in terms of the shop where they were made. Detached from their context and "read backwards" in light of his more celebrated masterpieces, the early paintings could only seem disappointing in that the elements they share with Verrocchio and his other pupils looked like shortcomings. Yet the work of any individual, even one as gifted and innovative as Leonardo, benefits – and can only really be understood – if it is examined in relation to the group to which he belonged.

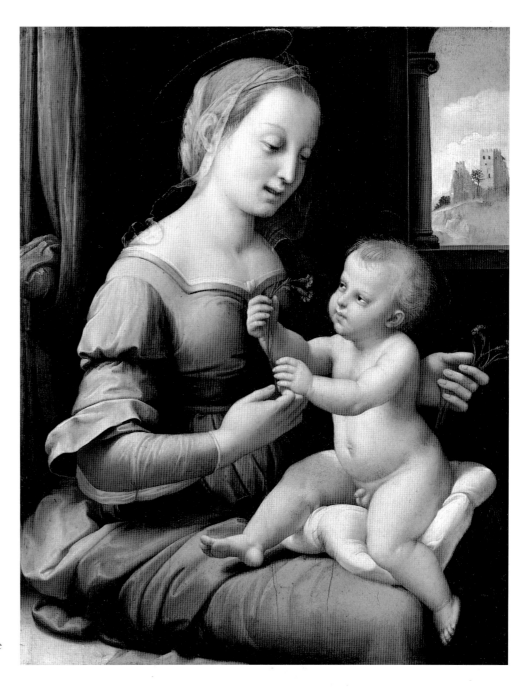

161 Raphael, *Madonna of the Carnations*, Duke of Northumberland, Alnwick Castle.

About the time Leonardo came to study with him, we found, Verrocchio took up painting and, rivaling the equally versatile Antonio Pollaiuolo, exploited his pupil's special ability to represent nature. *Tobias and the Angel*, assuming that Leonardo executed it jointly with the master, would be his very first painting. The young artist rapidly outgrew his limited role as Verrocchio's nature specialist, however, and with Andrea's indispensable support (he was a resource as well as a source), Leonardo went on to paint the Uffizi *Annunciation*, *Ginevra de' Benci*, the Munich *Madonna*, and a share of the *Baptism*, in which he first emerges as a clearly defined individual. Even in Verrocchio's shop, with Andrea as a teacher and Botticelli and Perugino as peers, the youth from Vinci stood out. But Leonardo was not a prodigy in the usual sense. The task he set himself, that of adapting the highly detailed, sculpturally oriented realism of Verrocchio and Pollaiuolo, was not

easy, and his early works, consequently, are not flawless. However they succeed in re-envisioning the sculptural style he had inherited, moreover, Leonardo's first paintings and drawings are not just a formal basis for his later achievement. For these earliest manifestations of his genius gave rise to the paired themes of the ephebe and of nature that would occupy the artist throughout his career.

Along with his extraordinary intelligence and ability, Leonardo's psychological make-up, particularly his probable homosexuality and an adolescent experience of nature, helped to define his artistic goals. Lacking other evidence about these personal matters, we must rely on Leonardo's pictures for what they reveal about his beginnings as an artist. Almost from the start, it seems, he saw the world differently from his contemporaries. Adumbrating a vision that he would later develop in countless notebook pages, the early works show the young artist already embarked on his lifelong pursuit of re-creating nature in art. The concept of nature as organic, vital, and interconnected may not have been new, but no one before Leonardo had expressed it pictorially. In his precocious vision, plants surge around a beguiling youth (Fig. 2), tendrils sprout from a cuirass (Fig. 59), hair coils in ringlets (Fig. 77), water plunges through a rocky chasm (Fig. 87), a tree frames a lady sitting for her portrait (Fig. 89), the Madonna offers flowers (Fig. 122), and all this in the most subtly nuanced envelope of light, shadow, and atmosphere. Using his fingers as well as the brush, Leonardo found in the newly introduced oil medium the ideal means to express this nascent vision of a natural world in flux. Indeed, his intellectual and artistic goals are indissociable from the fluid technique with which they were realized. As a painter/naturalist, Leonardo still had much to learn from observing and analyzing the world about him, but the mature products of his mind and hand, though deeper, are no more engaging than those which have concerned us here. The early works reveal throughout the presence of their endlessly fascinating creator.

Appendix The Rediscovery of Leonardo's Early Works

DURING THE CENTURIES IN WHICH *Mona Lisa* and Leonardo's other mature works became cultural icons, his first efforts as a painter remained almost totally unknown. The rediscovery of the Uffizi *Annunciation*, *Ginevra de' Benci*, the Munich *Madonna*, and of Leonardo's full share in the Uffizi *Baptism* was an achievement of modern art history. After the publication of the *Vite*, Vasari's successors lost sight of the *Baptism*, which, for him, marked Leonardo's début as a painter. In fact, writers on Leonardo do not appear to have known the altarpiece directly for over two hundred and fifty years![1] Toward the mid-eighteenth century an effort was made to seek out the work in the monastery of San Salvi, beyond the city walls near the Porta alla Croce. But Vasari's Florentine editor could not find the painting, as it had been transferred to another Vallombrosan convent, that of Santa Verdiana, where it long went unnoticed.[2] Though critics thus lacked the key to Leonardo's beginnings, they still felt obliged to round out his oeuvre with a few youthful works. Luigi Lanzi, in his widely read *Storia pittorica* of 1795–96, even tried to define a hypothetical manner for the young Leonardo, "less powerful in the shadows and less varied in the drapery folds."[3] But Lanzi's attributions were not based on visual criteria. Instead, he gathered from his reading a heterogeneous group of "early" pictures, a number of which he admitted were dubious.[4] Lanzi championed, above all, the *Head of Medusa* (Fig. 162) in the Uffizi, of which he was director. The attribution of this strange seventeenth-century picture to

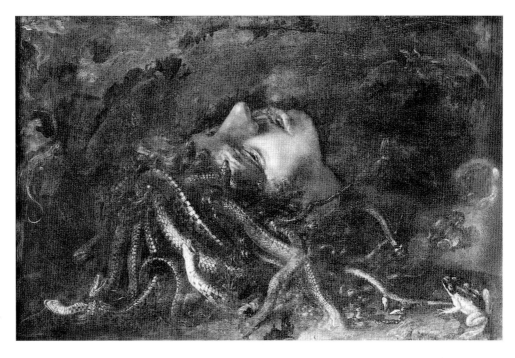

162 Formerly attributed to Leonardo, *Head of Medusa*, Galleria degli Uffizi, Florence.

Leonardo persisted, on the strength of Vasari's account of such a work belonging to the Medici, until the artist's first paintings finally came to light.[5] The catalogue of works claimed to be Leonardo's varied from author to author until Carlo Amoretti drew up the definitive list to date in his pathfinding biography published in 1804.[6] As far as Leonardo's life was concerned, Amoretti set new standards of accuracy, relying upon documents and the artist's own manuscripts, but he made no comparable attempt to re-examine Leonardo's painted oeuvre critically.[7]

What Amoretti and others lacked was an authentic early painting by Leonardo to use in making attributions from the standpoint of style rather than the testimony of Vasari. Just such a work did come to light during the Napoleonic era when, with the suppression of religious institutions, Verrocchio's long-lost *Baptism* was rediscovered and brought to the Accademia in Florence in 1810.[8] By this time the angel was a legend, even though no one writing about the picture since Vasari was likely to have seen it. Henceforth Leonardo's creation (recognized as the figure on the left) could be compared with the *Head of Medusa* and the other far-fetched attributions, with the result that they gradually disappeared from the literature on the artist. A younger generation of scholars, headed by the highly respected Carl Friedrich von Rumohr, now began to revise the Leonardo canon. Lamenting the inadequacy of Vasari's account, Rumohr added several early works to Leonardo's oeuvre, but in the more skeptical climate he helped to foster, his attributions fared no better than those of his predecessors.[9]

For a while the angel and the *Medusa* coexisted uneasily, but as the spurious additions to Leonardo's oeuvre were discredited and no convincing new ones arose to take their place, Leonardo's share in the *Baptism* emerged as his only certain early work. This was the Romantic period, moreover, and the angel now took on a meaning even Vasari had not envisaged for it. If he saw Leonardo's figure as the forerunner of a new artistic era, later writers regarded its ideal beauty as absolute.[10] Isolated as it was, the angel stood as a symbol of Leonardo's budding genius, like Athena sprung full-blown from the brow of Zeus. With this rediscovery, then, the mystery surrounding Leonardo's origins only deepened. Even after his other early works were identified, the angel continued to enjoy a status rivaling that of his most famous creations.[11] Outside the field of art history Leonardo's role in the picture inspired a Victorian novel about his youth, in which Verrocchio's lovestruck pupil immortalized, in the guise of the angel, a fictional daughter of the master named Angela![12]

No one felt the fascination of Leonardo's angel more keenly than Giovanni Battista Cavalcaselle, the pioneering scholar who sketched it in preparation for the survey of Italian painting he and his English collaborator J. A. Crowe brought out in 1864–66. Titled *A New History of Painting in Italy*, the book draws upon Cavalcaselle's annotated sketches, which record works he had seen.[13] In the case of the *Baptism*, Cavalcaselle drew the figure group, noting its wooden anatomy and drapery folds, as well as a detail of Leonardo's angel.[14] The latter sketch (Fig. 163) juxtaposes the heads of both angels in the picture, facilitating the comparison Vasari had made between Verrocchio's contribution and that of his pupil.[15] Photographs of Leonardo's figure, with or without its companion, would soon attest to its popularity with the art-loving public.[16] Meanwhile Crowe and Cavalcaselle stressed how the angel anticipated Leonardo's later work.[17] Still, if Leonardo brought about an artistic revolution by rejecting Verrocchio's manner, as Vasari asserted, it was essential to know what that manner consisted of. In fact, the authors dealt with Leonardo primarily in relation to Verrocchio whose activity as

163 G. B. Cavalcaselle, sketch copy of the angels in the Uffizi *Baptism*, Biblioteca Marciana, Venice.

a painter was their main concern. His sole autograph picture was the *Baptism*, according to Crowe and Cavalcaselle, who used it to dismiss erroneous attributions.[18] The focus they placed on Verrocchio meant that Leonardo's early work could no longer be discussed apart from his teacher.

Leonardo "must undoubtedly have produced some fine and interesting pieces previous to the creation of the great ones which brought him fame," Crowe and Cavalcaselle opined.[19] But as long as the notion of the artist's style encompassed not only the *Last Supper* and his masterpieces in the Louvre but also the exaggerated imitations by pupils and followers – the Leonardesque, in other words – his utterly different early works could never be identified. The task of purging Leonardo's oeuvre and thus paving the way for the rediscovery of his early works was undertaken by Gustav Friedrich Waagen, a protégé of Rumohr who became the first director of the Berlin Gallery.[20] Though said to be so nearsighted that he "could not judge of a picture unless he almost touched it with his nose," Waagen, like Cavalcaselle, had an extensive firsthand knowledge of art works throughout Europe.[21] He wrote two books on English collections, including the National Gallery, where he rightly reattributed a treasured Leonardo to Luini.[22] Waagen's judgment was again confirmed in the case of the portrait (Fig. 89), then in the Liechtenstein Collection in Vienna, which he tentatively ascribed to the young Leonardo.[23] Having made the sole convincing attribution of a youthful work to Leonardo since the angel in the *Baptism* reappeared, Waagen counseled fellow connoisseurs to search for the artist's other early achievements among the output of Verrocchio's shop.[24]

Happily his advice was taken by Karl Eduard von Liphart, a friend of Rumohr and Cavalcaselle who was the center of the German artistic colony in Florence.[25] When the *Annunciation* (Fig. 63), then believed to be by Domenico Ghirlandaio, was brought to the Uffizi from the suppressed convent of San Bartolomeo at Monte Oliveto outside Florence in 1867, it was Liphart who recognized Leonardo as its true author. Though Liphart's new attribution perplexed some scholars, it was adopted by the gallery.[26] And it was not lost on a brilliant young scholar-aesthete named Adolph Bayersdorfer, who frequented Liphart in Florence and who played an even more important role in rediscovering the early Leonardo.[27] Examining the *Baptism* in the Accademia, Bayersdorfer observed that Leonardo's contribution was not limited to the angel: he must also have painted, or rather repainted in oil, the figure of Christ, as well as the distant landscape, which recalled that of *Mona Lisa*.[28] Bayersdorfer noted that the mountainous vista in the *Baptism* resembled even more closely the landscape viewed through a pair of windows in the *Madonna of the Carnation* (Fig. 122), which he accordingly ascribed to the young Leonardo. In 1889 Bayersdorfer succeeded in acquiring this hitherto unknown painting – the fourth early work by the artist to come to light – for the Alte Pinakothek in Munich, of which he was curator.[29]

Waagen's approach was that of a cataloguer and Liphart and Bayersdorfer wrote almost nothing, so it was left to a colleague, the formidable Wilhelm von Bode (Fig. 164), to integrate their discoveries into the first coherent picture ever offered of Leonardo's beginnings as an artist. A disciple of Liphart, Bode was director of the Kaiser-Friedrich Museum in Berlin during its heyday before the First World War.[30] However wide-ranging (he was an expert on Rembrandt and on Oriental rugs), Bode's deepest and most abiding interest lay in the Italian Quattrocento. After acquiring Verrocchio's *Madonna* (Fig. 29) for the museum in 1873, Bode tried to establish the sculptor's painted oeuvre.[31] Rejecting Vasari's claim that

164 Photogravure of Wilhelm von Bode, in *Verzeichnis der Schriften von Wilhelm von Bode*, Berlin and Leipzig, 1915.

Verrocchio gave up painting, he took the Berlin *Madonna* and the Uffizi *Baptism* as a standard for making further attributions to the artist.[32] None of these proved very convincing, however, and neither did Bode's proposals of painting and sculpture for Leonardo.[33] He did succeed, however, in a series of scholarly contributions spanning nearly half a century, in debunking the mythical view of young Leonardo as a divinely inspired genius, little changed since the time of Vasari, and he did so without denigrating the artist's creativity. In 1882 Bode denied the priority of the angel in the *Baptism*, which he found more advanced than the Uffizi *Annunciation* and the closely linked portrait (Fig. 89) in the Liechtenstein Collection.[34] The latter two showed that Leonardo's earliest efforts, on a par with those of other artists, were tentative, with some elements, like the lectern in the *Annunciation*, recalling Verrocchio and others foretelling the younger artist's mature masterpieces. Leonardo's share in the *Baptism* (not limited to the angel) and his other early works could be distinguished, according to Bode, on the basis of his innovative use of oil as opposed to the traditional medium of egg tempera employed by Verrocchio.

Re-examining Leonardo's production, Bode later added the little *Annunciation* (Fig. 147), which had entered the Louvre in 1863 as Lorenzo di Credi. He cited as support for the attribution the resemblance between the Virgin's head and the female profile (Fig. 149) in the Uffizi, which, then as now, was widely believed to be by Leonardo.[35] In the same essay of 1887 Bode identified the sitter of the Liechtenstein portrait as Ginevra de' Benci, whose likeness by Leonardo was mentioned in Vasari and his sources.[36] He also found a place for the Munich *Madonna* in the Leonardo corpus.[37] The author returned to the problem of Leonardo's formation for the last time in his collected *Studien* of 1921.[38] Expanding upon his earlier findings, Bode raised the hitherto unexplored issue of Leonardo's role as a sculptor in Verrocchio's shop, particularly with regard to the *Lady with a Bunch of Flowers* (Fig. 96) in the Bargello, which he did not hesitate to ascribe to the younger artist.[39]

The German rediscovery of the early Leonardo, showing that he did not begin as a prodigy, provoked fierce opposition. In particular it ignited a debate between Bode and his Italian adversary Giovanni Morelli that owed as much to animosity as it did to art. Morelli had devised a revolutionary method of attribution based on the comparison of hands and other minor details in paintings, which he believed to be characteristic of a given artist.[40] Morphological idiosyncrasies promised to offer a quasi-scientific basis for rejecting works like those Bode and his cohorts assigned to the young Leonardo.[41] Even before Bode addressed the issue, Morelli cited the angel's hands to demonstrate that the Uffizi *Annunciation* was by Ridolfo Ghirlandaio, the son of the artist to whom it was formerly ascribed.[42] Later he came upon a "Leonardo" *Madonna* (Fig. 151) in the Dresden Gallery, which "opened a chasm" dividing him from his German rivals. Reattributing that work to a Flemish copyist of Verrocchio, Morelli launched a full-scale attack on Bode, whose views on Leonardo and his master threatened to cause the most "dire confusion in the history of Italian painting."[43]

Morelli specially investigated Verrocchio's drawings, attributing to the artist the magnificent study (Fig. 118) in the British Museum.[44] The obvious resemblance between this head and that of the Virgin in the Munich *Madonna* (Fig. 122) led him to identify the author of the picture (which he knew only from a photograph) as the same Flemish imitator he held responsible for the Dresden *Virgin and Child*. "To connect such a caricature with the great name of Leonardo," Morelli de-

165 Photograph of Bernard Berenson, in the Archive, Harvard University Center for Italian Renaissance Studies, Villa I Tatti, Florence.

clared, "is treason. . . ."[45] Morelli's notion of Flemish imitators was not taken seriously. But his claim that *Ginevra de' Benci* was by Verrocchio proved more persuasive, at least among his followers.[46] Despite their differences, Morelli agreed with Bode in ascribing the Louvre *Annunciation* to Leonardo; indeed, both scholars claimed credit for having first identified its supposed author.[47] Unlike the disputed works, this little picture seemed to anticipate the mature Leonardo.

Morelli's interest in Leonardo was stimulated by his disciple Jean Paul Richter, then at work on his fundamental anthology of the artist's writings.[48] In the correspondence they exchanged, Morelli and Richter returned again and again to the vexed question of Leonardo's beginnings.[49] And it was Richter who introduced Morelli, shortly before the latter's death in 1891, to the man who would become his chief disciple – Bernard Berenson (Fig. 165). Berenson's rise to fame and fortune is too well known to need rehearsing here.[50] Twenty years younger than Bode, Berenson left Boston for Italy in 1887, where he found his true vocation in the study of Italian painting. He soon established himself as an authority in the field, largely through the impact of his four essays on the Italian painters of the Renaissance, with their lists of pictures he accepted as authentic. The catalogue of Verrocchio's and Leonardo's works in Berenson's *Florentine Painters* of 1896 conforms more or less to Morelli's views.[51]

Berenson's laconic lists only contradicted Bode's attributions; it was left to Morelli's other partisans to argue against them. They agreed that the pictures Bode ascribed to Leonardo were uncharacteristic and unworthy of him. Osvald Sirén, in a monograph first published in his native Swedish (1911) and then in English (1916) and French (1928), contrasted Leonardo's part in the *Baptism* with what he regarded as the dubious efforts of an assistant of Verrocchio dubbed "pupil A."[52] Woldemar von Seidlitz, a German scholar who broke with Bode, also tried to show that the Uffizi *Annunciation*, the Liechtenstein portrait, and the Munich *Madonna* were by a Verrocchio pupil.[53] Unlike the Louvre *Annunciation*, which Seidlitz joined in ascribing to Leonardo, these pictures lacked the crucial factor of expression – the enigmatic smile – that animated *Mona Lisa*.[54] Indeed, a photograph (Fig. 166) of the Leonardo Room in the Uffizi, taken in 1913 – just before the Louvre portrait returned to Paris following its theft in 1911 – makes clear how Seidlitz and his fellow skeptics, when they compared the *Annunciation* with *Mona Lisa*, could find it hard to believe that two such different paintings were by the same artist.[55]

At this time the scholarly debate was shifting from the Verrocchiesque character of the disputed works to the elements of Leonardo's advanced style they failed to exhibit. Another self-proclaimed Morellian, the Norwegian Jens Thiis, deplored the same "phlegmatic" facial expressions that Seidlitz had found wanting. In his book on the youthful Leonardo, translated into English in 1913, Thiis scornfully rejected all the problematical pictures, even the angel in the *Baptism*, which, for him, did not measure up to the *Adoration of the Magi*.[56] The author divided the contested works into three groups: the Uffizi *Annunciation* and the Liechtenstein portrait were at least partly by Verrocchio, he felt, while the "dull and lifeless" *Madonna* in Munich he dismissed as a northern imitation. Leonardo's angel, together with some other pictures Thiis found similar in style, were assigned to the so-called "Alunno di Andrea [del Verrocchio]," an art-historical personality he invented, like Berenson's better-known "Amico di Sandro [Botticelli]."[57]

The controversy stirred up by Thiis caught writers of art-historical surveys between the two factions: if Cavalcaselle, revising his *History*, attempted to ignore

166 Leonardo Room in the Uffizi, photograph, 1913, Archivio degli Uffizi, Florence.

the conflict, Bode rewrote Burckhardt's *Cicerone* to reflect his own views.[58] Meanwhile, with the choice of candidates narrowed to Verrocchio or a member of his shop, the contested pictures appeared both in monographs on Leonardo and in ones on his teacher. And the attribution question now became entwined with another dispute over the respective merits of the two artists. Eugène Müntz, the leading French expert on the Renaissance, took the position that Verrocchio learned as much from Leonardo as Leonardo did from him.[59] Predictably, writers on Verrocchio disagreed; to advance his claims as a painter, two of them followed Berenson in crediting the master with his pupil's early works, including the angel in the *Baptism*.[60]

The quarrel abated only when the disputants took a non-partisan approach to the problem. Re-examining each attribution in a dispassionate spirit, Adolfo Venturi, the dean of Italian scholars, reversed himself and accepted the debated

works. In his multi-volume survey entitled *Storia dell'arte italiana* (1901–40), Venturi had at first assigned the Liechtenstein picture and the Munich *Madonna* respectively to Credi and the Verrocchio shop.[61] By the time of his Leonardo monograph published in 1920, however, he was beginning to look more favorably on the portrait, and in the ninth volume of his survey (1925) it appears as the painter's first work.[62] The *Madonna* was also deemed worthy of Leonardo, whom Venturi treated, at Verrocchio's expense, as the real genius in the shop.[63] The tide opposed to the Leonardo attributions now began to turn in their favor, aided by the appearance of two further works – a drawing and a painting – which served to clarify the problem. The drawing (Fig. 70) was identified in 1907 as Leonardo's preparatory study for the angel's sleeve in the Uffizi *Annunciation*.[64] And the painting, a *Madonna* (Fig. 142) that came to light the following year in a private collection at St. Petersburg, linked the early pictures, to which it was clearly related, with the *Adoration of the Magi* from the end of the artist's first Florentine period.[65]

Berenson remained the last stumbling-block to the acceptance of Leonardo's early paintings. Faced with this new evidence, however, he exercised the privilege of the connoisseur and changed his mind. By this time Berenson's faith in the infallibility of Morelli's method had yielded to a more pragmatic concept of connoisseurship as a process of trial and error. In this spirit he examined the newly discovered *Madonna* shortly before Nicholas II, last tsar of Russia, acquired it for an unprecedented sum in 1914 and reluctantly accepted the pictures. Ironically Berenson's disenchantment with this work (as seen in his iconoclastic essay on Leonardo of 1916) dispelled his doubts about the paintings he had felt compelled to give to Verrocchio.[66] He duly reattributed them to Leonardo in the revised edition of the Lists of 1932.[67] And the next year he spelled out the reasons for his "trip to Canossa" in the detailed study of the relation between Verrocchio, Leonardo, and Credi, already mentioned.[68] This essay in turn formed the basis for the new chapter replacing the earlier one in the author's monumental corpus of Florentine drawings first published in 1903.[69] In the text of 1933/1938 Berenson acknowledged that although the early pictures did not conform to the notion of Leonardo's style "derived from his few classical" masterworks, they shared many of the same idiosyncrasies.[70] His defection from the Morellian camp had another important result as well: the two versions of the *Annunciation*, he realized, could not be by the same hand: if that in the Uffizi was Leonardo's, then the panel in the Louvre, hitherto taken as the touchstone of his early manner, must be by Credi. In keeping with his view that Leonardo guided Credi, Berenson allowed that Lorenzo's mentor might have retouched the little painting.[71]

Other scholars investigating Verrocchio's shop also lighted on Credi, even though, as Leonardo's junior by seven years or so, he cannot have been active until the second half of the 1470s, when Leonardo left to become an independent master. In reality, the investigators showed little interest in how the shop functioned; their goal was merely to reopen the attribution problems that had occupied their predecessors. The pendulum had restored to Leonardo works that were once ascribed to his teacher; now it continued to swing with the result that Credi's earliest pictures were given to him as well. Bernhard Degenhart, for example, claimed the little *Madonna of the Pomegranate* (Fig. 150) for Leonardo in a long article seeking to establish the authorship and chronology of all the major paintings and drawings produced in the Verrocchio shop.[72] After the art dealer Duveen acquired this *Madonna*, with the rest of the Dreyfus Collection, in 1930, another

advocate appeared in the form of Robert Langton Douglas. A clergyman turned art critic, Douglas lost no opportunity to promote the picture as Leonardo's first work.[73] Though bitterly opposed by Berenson, who gave the *Madonna* to Credi, Douglas further championed as Leonardo's the *St. Donato and the Tax Collector* (Fig. 148), which he had sold to a client in Worcester, Massachusetts.[74] This little panel, together with its more famous companion, the Louvre *Annunciation*, had originally formed part of the predella of the *Madonna di Piazza* (Fig. 144).

Attempts to expand Leonardo's production beyond the pictures linked to the Baptismal angel now centered on the Pistoia altarpiece and its predella. In several articles on Leonardo's relation to Verrocchio, W. R. Valentiner, a Bode protégé who pursued a museum career in America, rejected Vasari's claim that the *Madonna di Piazza* had been executed entirely by Credi.[75] If he could not quite make out Leonardo's hand in the main section of the altarpiece, Valentiner felt he may have collaborated with Credi on the predella panels in Paris and Worcester.[76] The tiny *Madonna of the Pomegranate* might also be a joint work, according to Valentiner, who exhibited it in 1949 at the Los Angeles County Museum, of which he was director.[77] Apart from the improbability that pictures this small were collaborative, Valentiner was right to raise the issue of collaboration in the shop. But he was operating on the false premise that Verrocchio had Leonardo complete his own (and Credi's) works because the master somehow saw his most outstanding pupil as the harbinger of the High Renaissance. Collaboration, as Valentiner understood the term, did not mean a working arrangement that benefited both parties; it signified the grudging concession of talent to genius and of the older to the younger generation.

Kenneth Clark's contribution marks the final phase in the rediscovery of Leonardo's earliest works. While serving as director of the National Gallery, London, Clark compiled a catalogue of the Leonardo drawings at Windsor Castle. He followed that publication of 1935 with a perceptive monograph on the artist that subsequently became a classic.[78] Clark's interest in Leonardo grew out of his work assisting Berenson to revise the corpus of Florentine drawings, and it seems fitting that just as Berenson's conversion was the crucial turning-point in the acceptance of the early works, so any lingering doubts about them were largely dispelled by his disciple.[79] Clark's monograph still provides the best account of Leonardo's formation: it remains valid from the standpoint of attribution (he rejected the Louvre *Annunciation* and the *Madonna of the Pomegranate*) and chronology (except for Leonardo's share in the *Baptism*, which he placed first). And Clark made two fundamental observations about the early works, noting the strong influence of Verrocchio's sculpture and persuasively linking their twilight tone and delicate detail with the *Madonna of the Rocks* in the Louvre, the first documented picture that Leonardo completed.[80] The format of Clark's monograph, with its goal of tracing the artist's stylistic development, hardly allowed for a complete picture of his beginnings, however.[81] The author's treatment of Leonardo's early works is not definitive, therefore, but can be seen as the culmination of the process by which they gradually gained acceptance. This century-long undertaking fittingly concluded when the portrait of *Ginevra de' Benci*, the only early picture Clark found "wholly successful as a work of art," was purchased in 1967, for the then-highest price ever paid for a painting, from the Prince of Liechtenstein for the National Gallery of Art in Washington. With this acquisition, all of Leonardo's youthful paintings became available in public museums.

Notes

Introduction

1 The arguments advanced for and against these works are complicated. Berenson, for example, claimed (before changing his mind) that the *Madonna of the Carnation* was a copy of a lost work by Credi executed in Verrocchio's shop under Leonardo's guidance! In the context of the attribution debate, which culminated in the 1930s, Emil Möller's lengthy articles, accepting and fully exploring *Ginevra de' Benci* and the *Madonna of the Carnation*, cited below in the relevant chapters, read like a breath of fresh air.

2 For Leonardo's early debt to Brunelleschi and other engineers see Paolo Galluzzi, "The Career of a Technologist," in *Leonardo da Vinci: Engineer and Architect*, ed. Paolo Galluzzi, Exhibition Catalogue, Montreal Museum of Fine Arts, Montreal, 1987, pp. 48–54 (41–109).

3 Giorgio Vasari, *Le vite de' più eccellenti pittori, scultori ed architettori*, ed. Gaetano Milanesi, 9 vols., Florence, 1878–85, vol. II, 1878, p. 299.

4 André Chastel made two points about Verrocchio and Leonardo that are important here. He identified Verrocchio, whom Vasari described as a "prospettivo" and "musico" as well as a painter and sculptor, as the model for Leonardo's many-sidedness and intellectual interests (*Art et humanisme à Florence au temps de Laurent le Magnifique*, Paris, 1959, p. 405). Chastel also rightly claimed that the "activité encore si mystérieuse du jeune Léonard" could only be understood in the context of his master's shop ("Les capitaines antiques affrontés dan l'art florentin du xve siècle," in *Mémoires de la Société Nationale des Antiquaires de France*, vol. LXXXIII, 1954, pp. 279–89; and reprinted in his *Fables, formes, figures I*, Paris, 1978, p. 238 [236–47]). The problem of Verrocchio's lasting importance for Leonardo (Pietro C. Marani, "Tracce ed elementi Verrocchieschi nella tarda produzione grafica e pittorica di Leonardo" in *Verrocchio and Late Quattrocento Italian Sculpture*, ed. Steven Bule, Alan Phipps Darr, and Fiorella Superbi Gioffredi, Florence, 1992, pp. 141–52) lies outside the scope of this book.

5 Petrarch's account is given in translation in *The Renaissance Philosophy of Man*, ed. Ernst Cassirer, Paul Oskar Kristeller, and John Herman Randall, Jr., Chicago, 1961, pp. 36–46.

6 Lorenzo de' Medici, *Selected Poems and Prose*, ed. and trans. Jon Thiem, University Park, PA, 1992.

7 For two fundamental studies of Leonardo as an artist/scientist see: Martin Kemp, *Leonardo da Vinci: The Marvellous Works of Nature and Man*, London, 1981; and James S. Ackerman, "Leonardo's Eye," in his *Distance Points. Essays in Theory and Renaissance Art and Architecture*, Cambridge, MA, and London 1991, pp. 97–150.

Rivalry and Realism

1 Luca Beltrami, *Documenti e memorie riguardanti la vita e le opere di Leonardo da Vinci*, Milan, 1919, no. 2, pp. 2–3. For what little is known about Leonardo's family and upbringing see Renzo Cianchi, *Vinci: Leonardo e la sua famiglia*, Milan, 1952, pp. 36–85 (esp. pp. 39–40 for a document detailing Leonardo's baptism); and by the same author, *Ricerche e documenti sulla madre di Leonardo*, Florence, 1975. Shortly after his birth Leonardo's parents were both married, Piero into a distinguished Florentine family, the Amadori, and Caterina to a manual laborer named Accattabriga. Cianchi deduced that Caterina initially cared for the infant and that Ser Piero lived mainly in Florence during Leonardo's childhood. James Beck has published a document locating Ser Piero in Florence, where he served as a notary for Cosimo de' Medici, as early as 1462 ("Leonardo's Rapport with his Father," in *Antichità viva*, vol. XXVII, nos. 5–6, 1988, pp. 5–12). Leonardo's stepmother died in 1464, and his father remarried the next year. In common with other authors, William R. Valentiner traced Leonardo's love of nature to a youth spent in the countryside around Vinci ("Leonardo's Early Life," in *Leonardo da Vinci Loan Exhibition 1452–1519*, Los Angeles County Museum, Los Angeles, 1949, p. 46 [43–61]).

2 According to Cianchi (*Vinci*, 1952, p. 54), on the other hand, Leonardo's father had little choice but to apprentice the boy, whose illegitimacy would have prevented him from pursuing a professional career.

3 The standard edition of the *Vite*, published originally in 1550 and in a revised and expanded version of 1568, is: Giorgio Vasari, *Le vite de' più eccellenti pittori, scultori ed architettori*, ed. Gaetano Milanesi, 9 vols., Florence, 1878–85. The life of Leonardo is in vol. IV, 1879, pp. 17–90.

4 The translation quoted here is based on the one by A. B. Hinds (Vasari, *Lives*, 4 vols., London, 1927, vol. II, pp. 156–68), an annotated version of which appears in Ludwig Goldscheider, *Leonardo da Vinci*, London, 1959, pp. 9–23. For the Italian text see Vasari, *Vite*, ed. Milanesi, vol. IV, 1879, p. 19.

5 Vasari, *Vite*, ed. Milanesi, vol. IV, 1879, pp. 19–20. Among the engineering feats, Vasari cited a project to canalize the Arno river; the plan occupied Leonardo following his return to Florence from Milan in 1500.

6 Vasari, *Vite*, ed. Milanesi, vol. IV, 1879, pp. 22–23, 25.

7 Vasari, *Vite*, ed. Milanesi, vol. IV, 1879, pp. 25–26. Neither painting survives, though the existence of the first is attested by historical records, including a Medici inventory. Even if it was really by Leonardo, which is doubtful, the *Medusa* may not have been early. The *Angel* inspired several copies, which demonstrate that it was not a youthful production either. About these works see Pietro Marani, *Leonardo: Catalogo completo dei dipinti*, Florence, 1989, cat. no. 3A, p. 125; and cat. no. 12A, pp. 145–47.

8 About Vasari's method of description see Svetlana Alpers, "*Ekphrasis* and Aesthetic Attitudes in Vasari's *Lives*," in *Journal of the Warburg and Courtauld Institutes*, vol. XXIII, nos. 1–2, 1960, pp. 190–215.

9 For Vasari's literary portrait of Leonardo see: Patricia Rubin, "What Men Saw: Vasari's Life of Leonardo da Vinci and the Image of the Renaissance Artist," in *Art History*, vol. XIII, no. 1, 1990, pp. 34–46; and A. Richard Turner, *Inventing Leonardo*, New York, 1993, pp. 55–68.

10 Goldscheider, *Leonardo*, 1959, pp. 13–14; and Vasari, *Vite*, ed. Milanesi, vol. IV, 1879, pp. 23–25.

11 But see Jack Wasserman, "The Monster Leonardo Painted for his Father," in *Art Studies for an Editor: 25 Essays in Memory of Milton S. Fox*, New York, 1975, pp. 261–65; and Marani, *Leonardo*, 1989, cat. no. 1A, p. 123.

12 *Il libro di Antonio Billi*, ed. Carl Frey, Berlin, 1892, p. 47: "et in Santo Salui una tauola di battesimo di Nostro Signiore"; and Anonimo Gaddiano, *Il Codice Magliabechiano*, ed. Carl Frey, Berlin, 1892, p. 89: "Dipinse una tauola

del baptesimo del Nostro Signore, laquale poi fu posta in San Saluj," implying, perhaps, that Verrocchio painted the altarpiece for another church. Billi's book dates from around 1520, while the Anonimo was writing two decades later.

13 Francesco Albertini somewhat confusingly cited only the angel, not the rest of the altarpiece, in his guidebook entitled *Memoriale di molte statue et picture sono nella inclyta cipta di Florentia*, published in Florence in 1510: "Lascio in Sancto Salvi tavole bellissime & uno Angelo di Leonardo Vinci. . . ." (ed. Milanesi, 1863, p. 17). The passage is reported by Beltrami in *Documenti e memorie*, 1919, no. 203, pp. 128–29. While it has occasionally been argued that the angel cited by Albertini was the one known from copies, the latter must have been a separate composition (see note 7 above), and this thesis has rightly been rejected. Albertini's reference can be understood only in conjunction with Vasari and the other early sources.

14 Goldscheider, *Leonardo*, 1959, p. 13; and Vasari, *Vite*, ed. Milanesi, vol. IV, 1879, p. 22. Unlike his rather cryptic source, Vasari specified (in the edition of 1550) which of the two angels in the picture was by Leonardo, suggesting that he knew the work itself and not only the tradition reported by Albertini.

15 Vasari, *Vite*, ed. Milanesi, vol. III, 1878, p. 366 (also in the edition of 1550).

16 Goldscheider, *Leonardo*, 1959, p. 9; and Vasari, *Vite*, ed. Milanesi, vol. IV, 1879, p. 17.

17 For Raphael and Titian see Vasari, *Vite*, ed. Milanesi, vol. III, 1878, pp. 545–47, and vol. VII, 1881, pp. 430–31; and for the young Michelangelo's superiority to his master Ghirlandaio see Kathleen Weil-Garris Brandt, "'The Nurse of Settignano': Michelangelo's Beginnings as a Sculptor," in *The Genius of the Sculptor in Michelangelo's Work*, Exhibition Catalogue, Montreal Museum of Fine Arts, Montreal, 1992, p. 24 (21–43). Regarding this and other classically inspired topoi about artists see Ernst Kris and Otto Kurz, *Legend, Myth, and Magic in the Image of the Artist*, New Haven and London, 1979.

18 Vasari pointedly contrasts Verrocchio's talent ("nell'arte della scultura e pittura ebbe la maniera alquanto dura e crudetta, come quello che con infinito studio se la guadagnò, più che col beneficio o facilità della natura") with Leonardo's genius (*Vite*, ed. Milanesi, vol. III, 1878, p. 357).

19 In the life of Perugino Vasari wrote that Leonardo "fu discepolo del medesimo Andrea" when the apprentice from Vinci was "allora giovanetto" (*Vite*, ed. Milanesi, vol. III, 1878, pp. 366, 371). Credi, Vasari further stated, "si pose con Andrea del Verrocchio, che allora . . . si era dato al dipignere; e sotto lui, avendo per compagni e amici, sebbene concorrenti, Pietro Perugino e Lionardo da Vinci, attese con ogni diligenza alla pittura" (vol. IV, 1879, p. 564). He accounted for the later friendship between Rustici (born in 1474) and Leonardo by their common presence in Verrocchio's shop (vol. VI, 1881, pp. 599–600). Pomponius Gauricus had already referred to Leonardo as Verrocchio's pupil in his treatise *De sculptura*, published in Florence (during Leonardo's lifetime) in 1504 (ed. André Chastel and Robert Klein, Geneva, 1969, pp. 260–61): "Aluerochii discipulus Leonardus Vincius.'

20 About the huge copper ball, which was placed on the dome on May 27, 1471, as recorded in Luca Landucci's *Diary*, see Dario Covi, "Verrocchio and the *Palla* of the Duomo," in *Art the Ape of Nature: Studies in Honor of H. W. Janson*, ed. Moshe Barasch and Lucy Freeman Sandler, New York, 1981, pp. 151–69, esp. p. 167 note 25. Leonardo's reference to its construction is in his MS. G, fol. 84 verso: "Ricordati delle saldature con che si saldò la palla di sancta maria del fiore."

21 Among the writers cited in the Appendix, Müntz (1898), Seidlitz (1909), Thiis (n.d. [1913]), and Douglas (1944) believed that Leonardo joined Verrocchio between 1465 and 1467. To them should be added C. J. Holmes, "The Shop of Verrocchio," in *Burlington Magazine*, vol. XXIV, no. 131, 1914, p. 283 (279–87); Raimond Van Marle, *The Development of the Italian Schools of Painting*, The Hague, vol. XI, 1929, p. 498; Janice Shell, *Leonardo*, London, 1992, p. 8; Dario Covi, "Work in Progress: Workshops and Partnerships," in *Verrocchio and Late Quattrocento Italian Sculpture*, ed. Bule, Darr, and Superbi Gioffredi, 1992, p. 369; and Beck in *Antichità viva*, 1988, pp. 5–6. Covi favors a date "perhaps as early as 1467," as did L. H. Heydenreich, *Leonardo da Vinci*, 2 vols., New York and Basel, 1954, vol. I, p. 11). A possible link between Leonardo's father and Verrocchio may lie in the fact that Ser Piero rented his house in Florence from the Mercanzia, who commissioned the sculptor's *Christ and St. Thomas* for Orsanmichele late in 1466, about the time, it seems, Leonardo was apprenticed.

22 Three of the authorities discussed in the Appendix, Venturi (1920), Clark (1939), and Valentiner (1950), agreed that Leonardo joined Verrocchio late in 1469 or 1470. Most modern writers, including Angela Ottino della Chiesa (*L'opera completa di Leonardo pittore*, Milan, 1967, p. 83) and Anna Padoa Rizzo ("La bottega come luogo di formazione," in *Maestri e botteghe: Pittura a Firenze alla fine del Quattrocento*, ed. Mina Gregori, Antonio Paolucci, and Cristina Acidini Luchinat, Exhibition Catalogue, Palazzo Strozzi, Florence, 1992–93, Milan, 1992, p. 56 [53–59]), favor the same date. The fact that Leonardo is cited, with other family members, in the tax records of Vinci in 1469 (Beltrami, *Documenti e memorie*, 1919, no. 3, p. 2) simply indicates that he was a "bocca" or dependant (literally "mouth"), not necessarily that he was still living there.

23 Beltrami, *Documenti e memorie*, 1919, no. 8, pp. 4–5.

24 Leonardo himself repeatedly uses the term "sta con" to mean that certain pupils were living, and thus also working, with him (Jean Paul Richter, *The Literary Works of Leonardo da Vinci*, 3rd rev. ed., 2 vols., London and New York, 1970, vol. II, nos. 1458, 1459, 1461, 1463, and 1466, pp. 363–65).

25 A chapbook in the Biblioteca Riccardiana, Florence (MS. 1591), fol. 175 recto, mentions a payment of February 12, 1463 (1462, Florentine year), to an artist named "verrochino", whose shop was located at the head of via Ghibellina, for illustrating the manuscript: "Tutto chuesto libro è paghato, chostò lire dieci. Chostò lire tre e mezo la dipintura a'ndre' del verrocchino esta a cchapo a via ghibellina, lire sette e mmezzo chostò la scrittura, a paghare piero dei rici. Paghossi detti danari a dì 12 di ferraio 1462." About the book containing this passage, which Dale Kent kindly brought to my attention and transcribed for me, see Giuliano Tanturli, "Rapporti del Brunelleschi con gli Ambienti Letterari Fiorentini," in *Filippo Brunelleschi: La sua opera e il suo tempo*, vol. I, Florence, 1980, note 27, pp. 137–38 (125–44). The inscription, locating the shop in question across from the Bargello a short distance from Leonardo's family dwelling, might seem to refer to the *bottega* where he trained, assuming that the "andre del verrochino" referred to is his teacher. The problem with such an identification is that the amateurish illustrations in the book (Bernhard Degenhart and Annegrit Schmitt, *Corpus der italienischen Zeichnungen 1300–1450*, Berlin, 1968, Part I, vol. 2, cat. no. 557, pp. 558–59; and vol. 4, Plates 373–74) bear no relation to Verrocchio's style in painting or sculpture. Only on the hypothesis that Andrea employed a hack book-painting assistant before taking on Leonardo in the mid-1460s can via Ghibellina be accepted as the site of his shop.

Verrocchio's *portata al catasto* (tax declaration) of 1470 mentions only his dwelling, not his shop, and lists no dependants (Rufus Graves Mather, "Documents Mostly New Relating to Florentine Painters and Sculptors of the Fifteenth Century," in *Art Bulletin*, vol. XXX, no. 1, 1948, doc. no. 4, pp. 30–31 [20–65]; and Günter Passavant, *Andrea del Verrocchio als Maler*, Düsseldorf, 1959, doc. no. IV, pp. 217–18). According to the *catasto* of 1480, he was living (and ostensibly working) in rented quarters that have been identified with those formerly occupied by Donatello behind the cathedral (Mather in *Art Bulletin*, 1948, doc. no. 5, p. 31; and Passavant, *Verrocchio*, 1959, doc. no. V, pp. 218–19). A document postdating his death in 1488 lists the contents of his "botega" but fails to specify its location (Dario A. Covi, "Four New Documents concerning Andrea del Verrocchio," in *Art Bulletin*, vol. XLVIII, no. 1, 1966, p. 103 [97–103]). Though Clarence Kennedy hypothesized that "since Verrocchio never mentions his workshop in his tax returns and since he was a favorite Medici artist," he carried on his trade "in the Medici palace or one of its dependencies" ("A Clue

to a Lost Work by Verrocchio," in *Festschrift Ulrich Middeldorf*, ed. Antje Kosegarten and Peter Tigler, 2 vols., Berlin, 1968, vol. I, p. 160 note 6 [158–60]), Andrea never enjoyed the kind of household status won by his contemporary Bertoldo.

26 Nino Smiraglia Scognamiglio, "Nuovi documenti su Leonardo da Vinci," in *Archivio storico dell'arte*, vol. II, 1896, pp. 313–15; and by the same author, *Ricerche e documenti sulla giovinezza di Leonardo da Vinci, 1452–1482*, Naples, 1900, pp. 47–51. The relevant documents in the Florentine archives, the *Deliberazioni degli Ufficiali di Notte* for the year 1476 (folios 41 verso and 51 recto), are given in *Archivio storico dell'arte*, 1896, p. 315; and in *Giovinezza di Leonardo*, 1900, p. 145. Statistics compiled by Michael J. Rocke reveal that more than ten thousand Florentine males accused of sodomy were tried – and one in five was found guilty – over a seventy-year period ("Il Controllo dell'Omosessualità a Firenze nel XV secolo: Gli *Ufficiali di Notte*," in *Quaderni storici*, n. s. vol. XXII, no. 3, 1987, pp. 701–23). For Rocke's thesis that sodomy was primarily a passing phase in the sex life of ordinary males see his *Forbidden Friendships: Homosexuality and Male Culture in Renaissance Florence*, New York and Oxford, 1996.

27 Editing Vasari's *Vite*, Milanesi evidently knew the documents but suppressed their contents (vol. IV, 1879, p. 22). Smiraglia Scognamiglio, for whom Leonardo was "certamente superiore ad ogni sospetto" and "alieno da ogni amore, che non sia secondo le leggi di natura," suggested that the artist was unjustly accused because he had used Saltarelli as a model (*Archivio storico dell'arte*, 1896, p. 314; and *Giovinezza di Leonardo*, 1900, pp. 48–49). Richter, likewise declaring that Leonardo's "life and conduct were unfailingly governed by lofty principles and aims," claimed that both Verrocchio and his pupil were absolved of an unspecified crime (*Literary Works*, 1883, vol. II, p. 284). Gustavo Uzielli dismissed the charges as a malicious rumor (*Ricerche intorno a Leonardo da Vinci*, Rome, 1884, pp. 200–01, 441–48). Jens Thiis, who rejected the early works, similarly railed against the sodomy accusation as a stain on Leonardo's purity (*Leonardo da Vinci: The Florentine Years of Leonardo & Verrocchio*, London, n.d. [1913], pp. 135–38).

28 For Kenneth Clark, Leonardo's homosexual tendencies were implicit in the androgynous character of much of his work and life, particularly his indulgence toward the incorrigible pupil known as Salai (*Leonardo da Vinci: An Account of his Development as an Artist*, Cambridge, 1939, pp. 54–55). See also Rudolf and Margot Wittkower, *Born under Saturn*, London, 1963, pp. 170–73. More specific evidence of his sexuality is offered by a newly discovered document referring to a certain "Paulo de Leonardo de Vinci da Fiorenze," evidently an assistant punished for homosexual behavior (Carlo Pedretti, "Paolo di Leonardo," in *Achademia Leonardi Vinci*, vol.

v, 1992, pp. 120–22), as well as the inscription on one of Leonardo's drawings (Kurt R. Eissler, *Leonardo da Vinci: Psychoanalytic Notes on the Enigma*, London, 1962, pp. 105–06 and plate 11). In an imaginary dialogue in Giovanni Paolo Lomazzo's *Libro dei sogni* of about 1560, moreover, Leonardo discusses pederasty with Phidias (Eissler, *Leonardo*, 1962, p. 150 note 2; and Carlo Pedretti, *Leonardo: A Study in Chronology and Style*, Berkeley and Los Angeles, 1973, pp. 141–42).

29 Sigmund Freud, *Leonardo da Vinci and a Memory of his Childhood*, trans. Alan Tyson, Harmondsworth, 1963. Freud's image of the infant Leonardo as fatherless and fixed on his mother has little, if any, basis in fact (see note I above). In attempting to posit complex psychological sources for Leonardo's creative endeavors, Freud simply skipped over the artist's early works in favor of the *Mona Lisa* and the *Virgin and Child with St. Anne*. His argument, relying on a psychoanalytical interpretation of Leonardo's dream (about a kite beating his mouth with its tail), has been effectively refuted, from an art-historical standpoint, by Meyer Schapiro in "Leonardo and Freud: An Art-Historical Study," in *Journal of the History of Ideas*, vol. XVII, no. 4, 1956, pp. 147–78 (reprinted in *Renaissance Essays*, ed. Paul O. Kristeller and Philip P. Wiener, New York, 1968, pp. 303–36).

30 Artists' workshops might seem to be a fecund locus for illicit sexuality, but there is nothing to support that view (David F. Greenberg, *The Construction of Homosexuality*, Chicago and London, 1988, pp. 308–10), for the reason that shops of all kinds were run as family enterprises, Verrocchio's being an exception.

31 Though Ficino's influential theory of loving friendship between men and boys, found in his Commentary on Plato's *Symposium* and in his correspondence (John Charles Nelson, *Renaissance Theory of Love*, New York, 1958, pp. 61–84; and the essay by Melissa Bullard [1990, pp. 482–83 and 491 note 55], cited in note 63 below) upheld chastity, his views might have been misunderstood (Giovanni Dall'Orto, "'Socratic Love' as a Disguise for Same-Sex Love in the Italian Renaissance," in *The Pursuit of Sodomy: Male Homosexuality in Renaissance and Enlightenment Europe*, ed. Kent Gerard and Gert Hekma, New York and London, 1989, pp. 32–65). While Botticelli was simply accused of sodomy, an assistant of his was convicted of the crime in 1473 (Ronald Lightbown, *Sandro Botticelli: Life and Work*, 2 vols., London, 1978, vol. I, pp. 152, 154).

32 The chapter on "Eros Socraticus" in Chastel's *Art et humanisme*, 1959, pp. 289–98, has been superseded by a new generation of more emancipated studies that include: James M. Saslow, *Ganymede in the Renaissance: Homosexuality in Art and Society*, New Haven and London, 1986; and Andreas Sternweiler, *Die Lust der Götter: Homosexualität in der italienischen Kunst von Donatello zu Caravaggio*, Berlin, 1993.

33 Alison Cole, *The Renaissance*, London, 1994, p. 36.

34 Scholars favoring a dating to the mid-1460s include: Peter Cannon-Brookes, "Verrocchio Problems," in *Apollo*, vol. XCIX, no. 143, 1974, pp. 13–14 (8–19); Dario A. Covi, "Verrocchio and Venice, 1469," in *Art Bulletin*, vol. LXV, no. 2, 1983, p. 272 note 139 (253–73); Covi, "Per una giusta valutazione del Verrocchio," in *Verrocchio*, ed. Bule, Darr, and Superbi Gioffredi, 1992, p. 96 (91–100); and Andrew Butterfield, "Verrocchio's *David*," in *Verrocchio*, ed. Bule, Darr, and Superbi Gioffredi, 1992, pp. 110–12 (107–16). There is a suggestive resemblance between the profile view of David (Fig. 4) and Leonardo's features in a pupil's portrait drawing at Windsor Castle (no. 12726), which can be regarded as the most authentic image of the aged artist (Jane Roberts in Martin Kemp and Jane Roberts, *Leonardo da Vinci*, Exhibition Catalogue, Hayward Gallery, London, 1989, cat. no. I, pp. 46–47).

35 Leonardo's early biographers are unanimous in praising his beauty (Vasari, *Vite*, ed. Milanesi, vol. IV, p. 17; and Goldscheider, *Leonardo*, 1959, pp. 9, 29–30).

36 Mather in *Art Bulletin*, 1948, doc. no. 2, pp. 29–30; and Passavant, *Verrocchio*, 1959, doc. no. III, pp. 216–17. Though the evidence for the artist's birthdate is contradictory (the *catasto* of 1457 suggests 1436), the generally accepted date is 1435. Doris Carl deduced from newly discovered documents that Verrocchio ("Andrea di Michele") learned his craft in the Dei family shop of goldsmiths between 1453 and 1456 and that after 1457 he was associated with another goldsmith, Francesco Verrocchio, from whom he took his name ("Zur Goldschmiedefamilie Dei mit neuen Dokumenten zu Antonio Pollaiuolo und Andrea Verrocchio," in *Mitteilungen des kunsthistorischen Institutes in Florenz*, vol. XXVI, no. 2, 1982, pp. 140–41 [129–66]). Covi has objected that Verrocchio claimed he was abandoning the goldsmith's trade at this time ("More about Verrocchio Documents and Verrocchio's Name," in *Mitteilungen des kunsthistorischen Institutes in Florenz*, vol. XXXI, no. 1, 1987, pp. 157–61; and "The Current State of Verrocchio Study," in *Verrocchio*, ed. Bule, Darr, and Superbi Gioffredi, 1992, pp. 14–15 [7–23]).

37 For conflicting views about Verrocchio's training as a sculptor in marble see: Covi, "Current State," in *Verrocchio*, ed. Bule, Darr, and Superbi Gioffredi, 1992, pp. 15–16. Cannon-Brookes's theory that Verrocchio was not a marble carver (in *Apollo*, 1974, pp. 8–19) is contradicted by the patently autograph *Lady with a Bunch of Flowers* in the Bargello.

38 The inventory was first published by Cornelius von Fabriczy in "Andrea del Verrocchio ai servizi de' Medici," in *Archivio storico dell'arte*, 2nd ser., vol. I, no. 3, pp. 163–76. Transcriptions of it are given in Maud Cruttwell, *Verrocchio*, London and New York,

1904, pp. 242–44; and Passavant, *Verrocchio*, 1959, doc. no. IX, p. 221, while Charles Seymour (*The Sculpture of Verrocchio*, Greenwich, CT, 1971, pp. 174–75) offers an English translation. Dating from 1496 (1495, Florentine year), the list comprises some fifteen works, for which Tommaso hoped to collect payment as his brother's heir.

39 A munificent patron, Cosimo was on friendly terms with Donatello, but he does not seem to have employed Andrea, unless Artur Rosenauer is right in ascribing a bronze bell, ordered by Cosimo for San Marco, to Verrocchio ("Proposte per il Verrocchio giovane," in *Verrocchio*, ed. Bule, Darr, and Gioffredi, 1992, pp. 101–05).

40 Maud Cruttwell, *Antonio Pollaiuolo*, London and New York, 1907, pp. 263–67. Lorenzo de' Medici was on the advisory committee.

41 Dario Covi, "Nuovi documenti per Antonio e Piero del Pollajuolo e Antonio Rossellino," in *Prospettiva*, no. 12, 1978, pp. 61–72.

42 Passavant, *Verrocchio: Sculptures, Paintings and Drawings. Complete Edition*, trans. Katherine Watson, London, 1969, cat. no. 13, pp. 183–84 and plate 54. For further details of the commission see Passavant, "Beobachtungen am Silberaltar des Florentiner Baptisteriums," in *Pantheon*, vol. XXIV, no. I, 1966, pp. 10–23.

43 Leopold D. Ettlinger's monograph (*Antonio and Piero Pollaiuolo*, London, 1978) is a good source for the documents. Far better in its treatment of the paintings is Nicoletta Pons, *I Pollaiolo*, Florence, 1994.

44 Alison Wright, "Piero de' Medici and the Pollaiuolo," in *Piero de' Medici "il Gottoso" (1416–1469)*, ed. Andreas Beyer and Bruce Boucher, Berlin, 1993, pp. 129–49.

45 Albertini, *Memoriale*, ed. Milanesi, 1863, p. 15. About the Uffizi panels see Martin Kemp in *Circa 1492: Art in the Age of Exploration*, ed. Jay A. Levenson, Exhibition Catalogue, National Gallery of Art, Washington, 1992, cat. no. 161, p. 262.

46 Frederick Hartt, Gino Corti, and Clarence Kennedy, *The Chapel of the Cardinal of Portugal, 1434–1459, at San Miniato in Florence*, Philadelphia, 1964. Most of the pictorial decoration, including an *Annunciation* above the cardinal's throne, was allotted to Alesso Baldovinetti.

47 John Pope-Hennessy, review of Ettlinger, *Pollaiuolo*, 1978, in *New York Review of Books*, March 8, 1979, p. 39 (39–40). Compare also Hartt, *Chapel*, 1964, p. 103.

48 The discussion of costume in the text draws on the following recent studies: Elizabeth Birbari, *Dress in Italian Painting 1460–1500*, London, 1975; Jacqueline Herald, *Renaissance Dress in Italy 1400–1500*, London, 1981; and Rosalia Bonito Fanelli, *Five Centuries of Italian Textiles 1300–1800: A Selection from the Museo del Tessuto, Prato*, Traveling Exhibition Catalogue, Prato, 1981, pp. 35–75. The way in which weaving techniques are elaborated upon in a fifteenth-century Florentine treatise on silk production (G. Gargiolli, *L'arte della seta in Firenze: Trattato del secolo XV*, Florence,

1868) suggests that the contemporary eye would have been most discerning about painted textiles.

49 *L'Oreficeria nella Firenze del Quattrocento*, ed. Maria Grazia Ciardi Duprè dal Poggetto, Exhibition Catalogue, Florence, 1977, cat. no. 204, pp. 304–05. Nearly all of Pollaiuolo's small-scale precious metalwork is lost.

50 In his life of Botticelli, Vasari describes the "dimestichezza grandissima, e quasi una continova pratica tra gli orefici ed i pittori" (*Vite*, ed. Milanesi, vol. III, 1878, p. 310). Both arts are linked in Pollaiuolo's famous series of embroidered vestments in the Museo dell'Opera del Duomo in Florence. Botticelli also provided designs for weavers (Annarosa Garzelli, *Il ricamo nella attività artistica di Pollaiollo, Botticelli, Bartolomeo di Giovanni*, Florence, 1973).

51 On cloth manufacturing in Florence see Herald, *Renaissance Dress*, 1981, pp. 66–96. About the rise of the silk industry, see: Gene Brucker, *Renaissance Florence*, New York, 1969, pp. 85–86; and Richard A. Goldthwaite, *Private Wealth in Renaissance Florence*, Princeton, 1968, p. 243.

52 Creighton E. Gilbert, *L'Arte del Quattrocento nelle testimonianze coeve*, Florence and Vienna, 1988, pp. 205–06.

53 Luca Landucci, *A Florentine Diary from 1450 to 1516*, trans. Alice de Rosen Jervis and ed. Iodoco del Badia, London and New York, 1927, pp. 5–7.

54 The artist and his patron sought a lavish effect rather than accuracy of detail (*Oreficeria nella Firenze*, 1977, cat. no. 160, p. 273: "Da un punto di vista orafo è interessante notare che . . . si riscontra relativamente poca fedeltà degli oggetti e dei gioielli a quelli reali.").

55 Vasari, *Vite*, ed. Milanesi, vol. III, 1878, p. 291.

56 A parallel exists between Pollaiuolo's altarpiece, with its illusionistic painting technique, and the embroidered vestments he designed for the Florentine Baptistery beginning in 1466. The embroideries were woven with a new Flemish technique which attempted to capture the pictorial values of the cartoons, eliminating the distortions of the weaving process. About this technique of *or nué*, which used gold threads to suggest light, see Pauline Johnstone, "Antonio Pollaiuolo and the Art of Embroidery," in *Apollo*, vol. LXXXI, no. 38, 1965, pp. 306–09.

57 Meryl Johnson and Elizabeth Packard, "Methods Used for the Identification of Binding Media in Italian Paintings of the Fifteenth and Sixteenth Centuries," in *Studies in Conservation*, vol. XVI, 1971, pp. 145–74; and Edgar Peters Bowron, "Oil and Tempera Mediums in Early Italian Paintings. A View from the Laboratory," in *Apollo*, vol. C, no. 153, 1974, pp. 380–87.

58 Hartt (*Chapel*, 1964, pp. 105–06), noting that the "particular kind of pictorialism represented by Antonio's St. James is unprecedented in Florentine painting," suggested the picture now in the Städelsches Kunstinstitut, Frank-

furt, as a source. Paula Nuttall discusses van der Weyden's works usually associated with the Medici ("The Medici and Netherlandish Painting," in *The Early Medici and their Artists*, ed. Francis Ames-Lewis, London, 1995, pp. 144–49 [135–52]) and posits instead as Pollaiuolo's model Nicholas Froment's *Raising of Lazarus* triptych, then located in a convent in the Mugello outside Florence and now in the Uffizi ("'Fecero al Cardinale di Portogallo una tavola a olio': Netherlandish Influence in Antonio and Piero Pollaiuolo's San Miniato Altarpiece," in *Nederlands kunsthistorisch jaarboek*, vol. XLIV, 1993, pp. 111–24 and figs. 7–8). For the Netherlandish manner of rendering textures and its influence, see E. H. Gombrich, "Light, Form and Texture in Fifteenth-Century Painting North and South of the Alps," in his *The Heritage of Apelles. Studies in the Art of the Renaissance*, London, 1976, pp. 19–35.

59 Jill Dunkerton, Susan Foister, Dillian Gordon, and Nicholas Penny, *Giotto to Dürer: Early Renaissance Painting in the National Gallery*, New Haven and London, 1991, pp. 201–03 and cat. no. 40, p. 316.

60 About Piero's panoramic views see Richard Cocke, "Piero della Francesca and the Development of Italian Landscape Painting," in *Burlington Magazine*, vol. CXXII, no. 930, 1980, pp. 627–31. Building on Piero's achievement, Baldovinetti "dilettosi molto di far paesi," according to Vasari, but he can scarcely have portrayed them "dal vivo e naturale, come stanno appunto" (*Vite*, ed. Milanesi, vol. II, 1878, p. 595). Surveys of landscape painting like Kenneth Clark's *Landscape into Art* (London, 1940) deal only generally with the topographical tradition, while monographs on the individual artists tend to isolate their contributions. The topographical type had its origins in Siena during the preceding century (Uta Feldges, *Landschaft als topographisches Porträt: Der Wiederbeginn des europäischen Landschaftsmalerei in Siena*, Bern, 1980).

61 Brucker, *Florence*, 1969, pp. 1–3.

62 Peter Burke, *Tradition and Innovation in Renaissance Italy*, London, 1974, pp. 50–96.

63 Melissa Meriam Bullard thoughtfully analyzes the changing relation between the "subsidized scholar" and his Medici patrons in "Marsilio Ficino and the Medici: The Inner Dimensions of Patronage," in *Christianity and the Renaissance: Image and Religious Imagination in the Quattrocento*, ed. Timothy Verdon and John Henderson, Syracuse, NY, 1990, pp. 467–92.

64 The Italian version of the treatise is available in L. B. Alberti, *Opere volgari*, ed. Cecil Grayson, 3 vols., Bari, 1960–73, vol. III, 1973, pp. 7–107, 299–340. For a critical edition and English translation of the Latin version see *On Painting and On Sculpture: The Latin Texts of De pictura and De statua*, ed. Cecil Grayson, London, 1972; and for an English translation of the Italian text see *On Painting*, trans. John R. Spencer, 2nd rev. ed., New Haven and London, 1966 (reviewed by Samuel Y.

Edgerton, Jr., in *Art Bulletin*, vol. LI, no. 4, 1969, pp. 397–99).

65 Though forward-looking artists, like Piero della Francesca, must have eagerly read *Della pittura* (Francis Ames-Lewis, "A Portrait of Leon Battista Alberti by Uccello?," in *Burlington Magazine*, vol. CXVI, no. 851, 1974, pp. 103–04; Colin Eisler, "A Portrait of L. B. Alberti," in *Burlington Magazine*, vol. CXVI, no. 858, 1974, pp. 529–30; and Liana Castelfranchi, "L'Angelico e il 'De Pictura' dell'Alberti," in *Paragone*, vol. XXXVI, 1985, pp. 97–106), the relation of Alberti's theories to actual artistic practice is problematical, enough so to make Spencer's claim that Florentine painting "fell rapidly under the influence of the concepts advanced in the treatise" seem exaggerated (Alberti, *On Painting*, 1966, p. 11).

66 For good recent analyses of the content and implications of Alberti's treatise see: Clark Hulse, *The Rule of Art: Literature and Painting in the Renaissance*, Chicago and London, 1990, pp. 47–76; and Martin Kemp's introduction to *On Painting*, trans. Cecil Grayson, Harmondsworth, 1991, pp. 1–29.

67 Michael Baxandall, *Painting and Experience in Fifteenth-Century Italy*, Oxford, 1972, pp. 1–108.

68 Baxandall, *Giotto and the Orators: Humanist Observers of Painting in Italy and the Discovery of Pictorial Composition 1350–1450*, Oxford, 1986 (orig. ed. 1971), pp. 51–120; and *Painting and Experience*, 1972, pp. 109–51. The masters of illusion most admired by the early court-centered humanists were the non-Florentine Pisanello and the Netherlandish painters, beginning with Jan Van Eyck, while in Florence Cristoforo Landino, writing in 1480, reserved his praise for an earlier generation of artists rather than contemporaries like Pollaiuolo or Verrocchio.

69 Jan Bialostocki, "The Renaissance Concept of Nature and Antiquity," in *Studies in Western Art*, Acts of the Twentieth International Congress of the History of Art, Princeton, 1963, pp. 19–30 (reprinted in his *The Message of Images: Studies in the History of Art*, Vienna, 1988, pp. 64–76).

70 "The genius of Giotto," according to Boccaccio's *Decameron*, "was of such excellence that there was nothing [produced] by nature . . . which he did not depict . . . with such truthfulness that the result seemed to be not so much similar to one of her works as a work of her own. Wherefore the human sense of sight was often deceived by his works and took for real what was only painted. Thus he restored to light that art which for many centuries had been buried under the errors of some who painted in order to please the eyes of the ignorant rather than satisfy the intelligence of the experts." (as cited by Erwin Panofsky in *Renaissance and Renascences in Western Art*, Stockholm, 1960, pp. 12–13). See also Creighton Gilbert, *Poets Seeing Artists' Work: Instances in the Italian Renaissance*, Florence, 1991, pp. 49–65, 167–96. For the

terminology of post-Boccaccian writers and its meaning see Martin Kemp, "From 'Mimesis' to 'Fantasia': The Quattrocento Vocabulary of Creation, Inspiration and Genius in the Visual Arts," in *Viator*, vol. VIII, 1977, pp. 347–98.

71 K. Jex-Blake and E. Sellers, *The Elder Pliny's Chapters on the History of Art*, London and New York, 1896.

72 Alberti, *On Painting*, ed. Grayson, 1972, pp. 9, 74–75, 88–89, and 98–100. Alberti associates antique painting mainly with emotional (rather than physical) realism in the sense of decorum or appropriateness of expression and action.

73 Julius von Schlosser, *Lorenzo Ghibertis Denkwürdigkeiten*, 2 vols., Berlin, 1912, vol. I, pp. 19–31; and vol. II, pp. 14–17, 79–85, and 99–106. About Ghiberti's treatise, composed in the late 1440s and early 1450s, see also Richard Krautheimer, *Lorenzo Ghiberti*, 2 vols., Princeton, 1970, vol. I, pp. 307–08; Patrizia Castelli, "Ghiberti e gli Umanisti: Il significato dei 'Commentari'," and Mina Bacci, "Ghiberti e gli umanisti: I commentarii," in *Lorenzo Ghiberti*, Exhibition Catalogue, Accademia di Belle Arti and Museo di San Marco, Florence, 1978, pp. 518–20 and 550–52. Though full of errors and misunderstandings, Ghiberti's Italian paraphrase of Pliny (whom he calls "Prinio") made the essential matter of the text available to other artists twenty years before a vernacular version appeared in print (see note 76 below). Significantly, the author turns the competition between Apelles and Protogenes recounted by Pliny into one involving perspective, thereby recasting their contest in contemporary terms (Schlosser, *Denkwürdigkeiten*, 1912, vol. I, pp. 24–25; and vol. II, p. 16). Another Florentine artist-theorist who, like Alberti and Ghiberti, drew on Pliny's account of ancient art was Antonio Filarete, whose treatise dates from the early 1460s (*Treatise on Architecture*, trans. and ed. John R. Spencer, 2 vols., New Haven and London, 1965, vol. I, pp. 259–69).

74 Jacob Isager, *Pliny on Art and Society: The Elder Pliny's Chapters on the History of Art*, London and New York, 1991, pp. 10–11. Cosimo de' Medici and his humanist friend Niccolò Niccoli, among others, owned manuscript copies of the *Historia naturalis* (Martin Davies, "Making sense of Pliny in the Quattrocento," in *Renaissance Studies*, vol. IX, no. 2, 1995, pp. 240–57).

75 See: Richter, *Literary Works*, 1970, vol. II, p. 366, no. 1469; and Leonardo da Vinci, *The Madrid Codices*, vol. III, Commentary by Ladislao Reti, New York, 1974, p. 93. Leonardo's debt to Pliny was demonstrated by Edmondo Solmi in *Le fonti dei manoscritti di Leonardo da Vinci*, Turin, 1908, pp. 235–48. Solmi and other scholars have argued that Leonardo derived the disastrous encaustic technique of the *Battle of Anghiari* from his reading of Pliny. Kathleen Weil-Garris Posner (*Leonardo and Central Italian Art 1515–1550*,

New York, 1974, pp. 17–20) relates Pliny's description of Apelles' dark varnish or "atramentum" to Leonardo's dark manner; and John F. Moffitt to his *sfumato* ("Leonardo's 'Sfumato' and Apelles' 'Atramentum'," in *Paragone*, vol. XL, n.s. no. 16 [473], 1989, pp. 88–92).

76 Caius Plinius Secundus, *Historia naturale*, trans. Cristoforo Landino, Venice, 1476. This version, printed by Nicholas Jenson, had many errors (Poliziano counted seven hundred) which were corrected in later editions (of which six are listed before 1543 [*Short-Title Catalogue of Books Printed in Italy . . . from 1465 to 1600 now in the British Museum*, London, 1958, p. 527]). Known copies of the first vernacular edition are all on parchment and several are illuminated, including one attributed to Jacometto Veneziano (Giordana Mariani Canova, *La miniatura veneta del rinascimento 1450–1500*, Venice, 1969, cat. no. 49, p. 150). Landino (1424–1504), as fellow humanist and friend of Alberti and Ficino as well as tutor of Lorenzo the Magnificent, was a luminary of the Medici circle. The translation of Pliny, which he undertook while Leonardo was in Verrocchio's workshop, must have been eagerly anticipated by artists. The somewhat different views on art Landino expressed in the preface to his Dante commentary of 1481 have been analyzed by Baxandall. See note 68 above, as well as Baxandall, "Alberti and Cristoforo Landino: The Practical Criticism of Painting," in *Convegno internazionale indetto nel V centenario di Leon Battista Alberti* (1972), Accademia Nazionale dei Lincei, Rome, 1974, vol. CCCLXXI, no. 209, pp. 143–54. About Landino's translation of Pliny see: E. W. Gudger, "Pliny's Historia naturalis: The Most Popular Natural History ever Published," in *Isis*, vol. VI, no. 3, 1923, p. 276 [269–81]); Charles G. Nauert, Jr., "Humanists, Scientists, and Pliny: Changing Approaches to a Classical Author," in *American Historical Review*, vol. LXXXIV, no. 1, 1979, p. 75 (72–85); and by the same author, "Caius Plinius Secundus," in *Catalogus translationum et commentariorum: Medieval and Renaissance Latin Translations and Commentaries*, ed. F. Edward Cranz, vol. IV, Washington, 1980, pp. 307, 316 (297–422); and Mario Schiavone, "Dall'*Editio princeps* della *Naturalis historia* ad opera di Giovanni da Spira all'Edizione Lione 1561," in *Plinio e la natura*, ed. Angelo Ronconi, Como, 1982, pp. 101–02 (95–108).

77 Pollaiuolo's teacher and partner, Maso Finiguerra, may have modeled his linear art on what Pliny reported about Parrhasios, according to Alessandro Angelini (*Disegni italiani del tempo di Donatello*, Exhibition Catalogue, Gabinetto Disegni e Stampe degli Uffizi, Florence, 1986, p. 77) and Pons (*Pollaiolo*, 1994, p. 6).

78 André Chastel, *Marsile Ficin et l'art*, Geneva, 1954 (reprinted 1975), p. 32; and by the same author, *Art et humanisme*, 1959, p. 374. The epitaph on Pollaiuolo's tomb also describes him as "pictor insign."

79 Wright in *Piero de' Medici*, ed. Beyer and Boucher, 1993, pp. 129–31 (citing Eve Borsook's publication of the letter in *Burlington Magazine*, vol. cxv, 1973, p. 468). See also Eric Frank, "Antonio Pollaiuolo, 'Il Principale Maestro di questa Città'?" in *Source*, vol. xi, no. 1, 1991, pp. 14–17. Earlier writers, beginning with Cruttwell (*Pollaiuolo*, 1907, pp. 15 and 257–58), wrongly ascribed this praise to Lorenzo de' Medici, who cited the artist in a letter of 1489. Lanfredini belonged to a family that patronized Pollaiuolo.

80 Vasari, *Vite*, ed. Milanesi, vol. iii, 1878, pp. 292–93.

81 About this practice see: Laurie Fusco, "The Use of Sculptural Models by Painters in Fifteenth-Century Italy," in *Art Bulletin*, vol. lxiv, no. 2, 1982, pp. 175–94; and Wolfram Prinz, "Dal vero o dal modello? Appunti e testimonianze sull'uso dei manichini nella pittura del Quattrocento," in *Scritti di storia dell'arte in onore di Ugo Procacci*, ed. Paolo and Maria Dal Poggetto, 2 vols., Milan, 1977, vol. i, pp. 200–08.

82 Hartt, *Chapel*, 1964, pp. 59 and 160, doc. no. 20.

83 See: Dora Liscia Bemporad, "Appunti sulla bottega orafa di Antonio del Pollaiolo e di alcuni suoi allievi," in *Antichità viva*, vol. xix, no. 3, 1980, pp. 47–53; Carl in *Mitteilungen*, 1982, pp. 134–38; and Nicoletta Pons, "I Pollaiolo," in *Maestri e botteghe*, ed. Gregori, Paolucci, and Acidini Luchinat, 1992, pp. 97–99. The documents discovered by Carl reveal that another brother of Antonio's named Salvestro assisted him in the late 1460s. Emil Möller argued from the fact that his name is inscribed on a drawing by Antonio in the Uffizi (no. 669E) that Salvestro was a painter ("Salvestro di Jacopo Pollaiuolo dipintore," in *Old Master Drawings*, no. 38, 1935, pp. 17–21), but the documents cite him only in connection with metalwork. Carl's conclusion that Antonio was just an occasional painter (p. 138) seems unjustified in light of the number of pictures attributable to him.

84 Vasari, *Vite*, ed. Milanesi, vol. iii, 1878, pp. 290–91. Vasari is here evidently correcting his sources, which agree in assigning the paintings in Pollaiuolo's style to Piero (Alberto Busignani, *Pollaiolo*, Florence, 1970, pp. 73–74).

85 Ettlinger (*Pollaiuolo*, 1978, pp. 11–14) tried unsuccessfully to defend Piero against Cruttwell (*Pollaiuolo*, 1907, pp. 9, 185), who, following Berenson, labeled the artist a "hopeless mediocrity."

86 In conformity with the pre-Vasarian sources, Ettlinger (*Pollaiuolo*, 1978, cat. no. 5, p. 139, and cat. no. 6, pp. 139–40) gives both works mainly to Piero. Though we must rely on stylistic analysis and the sense of quality to isolate the parts for which each brother may have been responsible, the many striking innovations in each picture, amounting to the creation of a new style of painting, must surely be credited to Antonio. About the problem of their collaboration in general see

Pons, "I Pollaiolo," in *Maestri e botteghe*, ed. Gregori, Paolucci, and Acidini Luchinat, 1992, pp. 97–99; and Pons, *Pollaiolo*, 1994, pp. 5–25.

87 Ettlinger, *Pollaiuolo*, 1978, pp. 30 and 138, cat. no. 2; and Pons, *Pollaiolo*, 1994, pp. 17–18, and cat. no. 11, pp. 98–99.

88 For the vicissitudes of the commission see Passavant, *Complete Edition*, 1969, pp. 24–25, 177–78, and 314–15; and Elizabeth Wilder, Clarence Kennedy, and Peleo Bacci, *The Unfinished Monument by Andrea del Verrocchio to the Cardinal Niccolò Forteguerri at Pistoia*, Northampton, MA, 1932. Ironically Wilder attributed Verrocchio's model to his competitor Piero Pollaiuolo.

Verrocchio the Painter

1 Clark, *Leonardo*, 1939, rev. ed. 1988, p. 43.

2 The document of 1485, indicating that the Pistoia altarpiece was commissioned from Verrocchio before 1479, is discussed in chapter 7. For Vasari's citation of the Budapest picture see the *Vite*, ed. Milanesi, vol. iii, 1878, pp. 365–66.

3 Verrocchio's long-lost identity as a painter was first recaptured by Cavalcaselle and Bode, as noted in the Appendix. Subsequently Bode enlarged the role of assistants in the shop ("Verrocchio und des Altarbild der Sakramentskapelle im Dom zu Pistoja," in *Repertorium für Kunstwissenschaft*, vol. xxii, 1899, pp. 390–94), a process that was continued by other scholars.

4 Ettore Camesasca, *Artisti in bottega*, Milan, 1966, p. 429, and by the same author, *L'opera completa del Perugino*, Milan, 1969, p. 85; Cannon-Brookes in *Apollo*, 1974, pp. 16–17; Sheldon Grossman, "Ghirlandaio's 'Madonna and Child' in Frankfurt and Leonardo's Beginnings as a Painter," in *Städel-Jahrbuch*, vol. vii, 1979, pp. 101–02, 116, 121 (101–25); and Anna Padoa Rizzo, "Introduzione," in *Maestri e botteghe*, ed. Gregori, Paolucci, and Acidini Luchinat, 1992, p. 21 (19–22).

5 For the inventory see chapter 1, note 38. The portrait is cited in connection with *Ginevra de' Benci* in chapter 5 below.

6 Verrocchio received final payment from the Opera del Duomo in Florence (through an intermediary) on July 21 and 24, 1475, for the "dipintura del gonfalone" (Enzo Settesoldi, "Il Gonfalone del Comune di Carrara dipinto da Andrea del Verrocchio," in *Paragone*, vol. xxxi, no. 363, 1980, pp. 87–91).

7 In the entry in the *Libro rosso* of the Compagnia di San Luca, dating from 1472, Andrea is referred to as "dipintore e intagliatore" (Passavant, *Verrocchio*, 1959, doc. no. vi, p. 219). See also the list of "pittori nella città di Firenze 1470" in Benedetto Dei's *Memorie* in the Biblioteca Laurenziana, Florence, published in Creighton E. Gilbert, *Italian Art 1400–1500: Sources and Documents*, Englewood Cliffs, NJ, 1980, p. 183; and Gilbert, *L'arte del Quattrocento* 1988, p. 203

(a parallel enumeration of sculptors again includes Verrocchio). A slightly abbreviated copy of the list was published in Giuseppina Carla Romby, *Descrizioni e rappresentazioni della città di Firenze nel XV secolo*, Florence, 1976, pp. 71–72. For an analysis of the list see Annamaria Bernacchioni, "Le botteghe di pittura: Luoghi, strutture e attività," in *Maestri e botteghe*, ed. Gregori, Paolucci, and Acidini Luchinat, 1992, pp. 29–31 (23–33). The humanist Ugolino Verino in a Latin poem written about the time of Verrocchio's death in 1488, comparing the best Florentine artists with their ancient predecessors (Herbert Horne, *Botticelli*, London, 1908, pp. 305–06, 364), claimed that Andrea surpassed Phidias because he "both casts and paints" (quoted in translation in Gilbert, *Italian Art*, 1980, pp. 192–93). Pre-Vasarian sources continue to refer to Andrea as both "scultore et pittore" (*Il Codice Magliabechiano*, ed. Frey, 1892, p. 89). And Pomponius Gauricus added that the artist's paintings were highly reputed (*De Sculptura*, ed. Chastel and Klein, 1969, pp. 258–61).

8 Passavant, *Verrocchio*, 1959. The author devotes a whole page to Christ's loincloth in the *Baptism*.

9 Passavant, *Complete Edition*, trans. Watson, 1969.

10 Alberto Busignani, *Verrocchio*, Florence, 1966, pp. 9–21, 33–36, and figs. 1–3, 7–21. The works the author grafted onto Andrea's oeuvre have been restored to Botticini by Lisa Venturini in *Francesco Botticini*, Florence, 1994.

11 John Shearman, "A Suggestion for the Early Style of Verrocchio," in *Burlington Magazine*, vol. cix, no. 768, 1967, pp. 121–27. The author's proposal was rejected by other scholars, including Passavant (*Complete Edition*, 1969, Appendix no. 41, p. 210), as the limbs and draperies in this work are simply too flat for a great relief sculptor like Andrea. Cecil Gould favored the early Signorelli ("The Gambier-Parry Madonna," in *Burlington Magazine*, vol. cix, no. 771, 1967, p. 364), while Pietro Scarpellini preferred the young Perugino (*Perugino*, Milan, 1984, cat. no. 7, pp. 70–71), and Pons, Pollaiuolo (*Pollaiolo*, 1994, p. 18, and cat. no. 14, pp. 99–101). Ironically it was Shearman who first connected the Courtauld and Hermitage pictures (p. 125, note 16), and he even allowed for the possibility that they might have the same author, a suggestion that was reinforced by the Hermitage curators (Tatyana K. Kustodieva, *Italian Painting Thirteenth to Sixteenth Centuries*, Hermitage Catalogue of Western European Painting, Florence, 1994, cat. no. 270, pp. 467–68). The opportunity to examine the two paintings within a short time supported the conclusion that they are the work of a distinct personality in Verrocchio's shop, who, like Leonardo, reacted to Pollaiuolo and Netherlandish painting as well.

12 Konrad Oberhuber ("Le probléme des premiéres oeuvres de Verrocchio," in *Revue de l'art*, no. 42, 1978, pp. 63–76) attempted to

account for faults, like the lack of spatial clarity, which disqualify the work as Andrea's, by dating it as early as the 1450s when he was training as a goldsmith. For an analysis of the problem of authorship, see the literature cited in note 58 below, as well as Dario A. Covi, "Current State," in *Verrocchio*, ed. Bule, Darr, and Superbi Gioffredi, 1992, pp. 12–13. Oberhuber's reappraisal of early Verrocchio led to two further additions to his oeuvre by Luciano Bellosi (see notes 15 and 16 below). For another attribution to Andrea see Everett Fahy cited in note 64 below.

13 Berenson's "Florentine between Castagno and Botticini" points to Andrea as the only artist who fits that description (Bernard Berenson, *Italian Pictures of the Renaissance: Florentine School*, 2 vols., London, 1963, vol. I, p. 217; and vol. II, fig. 763). And the frequently advanced names of the young Ghirlandaio (Carlo Gamba, "La mostra del tesoro di Firenze sacra: La pittura," in *Bollettino d'arte*, vol. XXVIII, no. 4, 1933, pp. 157–58, 160 [145–63]) or Perugino (Carlo Ludovico Ragghianti, "La giovinezza e lo svolgimento artistico di Domenico Ghirlandaio," in *L'arte*, vol. XXXVIII, no. 3, 1935, pp. 182–98 [167–98]; Ettore Camesasca, *Tutta la pittura del Perugino*, Milan, 1959, pp. 39–40; and by the same author, *L'opera completa*, 1969, cat. no. 3, p. 86) together suggest the master with whom they both worked. Other writers opt for a collaboration between Verrocchio and a pupil (Federico Zeri, "Il Maestro dell'Annunciazione Gardner," in *Bollettino d'arte*, vol. XXXVIII, no. 2, 1953, pp. 135–36 [125–39]; and Scarpellini, *Perugino*, 1984, cat. no. 2, p. 69), while Thomas Brachert claimed a role for Leonardo in the fingerpainting of parts of the landscape ("Hypothesen zu einem verschollen Gemälde der Verrocchio-Werkstatt," in *Maltechnik*, no. 4, 1974, pp. 187–91). Passavant suggests Ghirlandaio as Verrocchio's minor collaborator (*Verrocchio*, 1959, pp. 122–40, 143, 149, 235, and notes 353–60 [bibliography]; and *Complete Edition*, 1969, pp. 51–52, and cat. no. 20, p. 188), but since there is no perceptible divergence of style in the painting, the notion of collaboration here has little meaning except to signify its "not quite Verrocchio" status. Passavant, who describes the *Crucifixion* as thoroughly repainted, bases his attribution to Verrocchio on the monumentality of the figures and the interaction between Christ and Jerome (*Verrocchio*, 1959, pp. 125–32). The extraordinarily fertile influence of the painting on Andrea's pupils also points to him as its author. Reviewers failed to endorse Passavant's view, however (Gilbert in *Art Journal*, vol. XX, no. 1, 1960, p. 58 [58–59]; Gilbert in *Art Quarterly*, vol. XXXIII, no. 4, 1970, p. 441 [441–43]; John Pope-Hennessy in *Times Literary Supplement*, Nov. 13, 1969 [unsigned]; R. W. Lightbown in *Apollo*, vol. XCI, no. 96, 1970, p. 167 [166–67]; and Dario A. Covi in *Art Bulletin*, vol. LIV, no. 1, 1972, pp. 91–92 [90–94]).

14 The development of the type is traced by Rudolf Wittkower in "Desiderio da Settignano's *St. Jerome in the Desert*," in *Studies in the History of Art*, National Gallery of Art, Washington, 1972, pp. 18–34 (reprinted in his *Idea and Image: Studies in the Italian Renaissance*, London, 1978, pp. 141–42 [137–50]). Passavant notes Castagno's influence (*Verrocchio*, 1959, pp. 133, 139). About his craggy-featured portrayal of Jerome adoring the Trinity in SS. Annunziata, datable to the mid-1450s, see Marita Horster, *Andrea del Castagno*, London, 1980, pp. 34–35, 181–82, and Plate 98.

15 Despite Luciano Bellosi's eloquent advocacy of the picture as Verrocchio's (in *Pittura di luce: Giovanni di Francesco e l'arte fiorentina di metà Quattrocento*, ed. Bellosi, Exhibition Catalogue, Casa Buonarroti, Florence, Milan, 1990, cat. no. 32, pp. 180–81), the traditional opinion in favor of Piero Pollaiuolo (Busignani, *Pollaiolo*, 1970, p. CLXXIV; and Ettlinger, *Pollaiuolo*, 1978, cat. no. 61, p. 169 [rejected]) seems preferable, particularly if this version is compared with the kneeling saint, who has an even more caricatural aspect, in Piero's altarpiece of 1483 in San Gimignano (Busignani, *Pollaiolo*, 1970, p. CLXXII; and Ettlinger, *Pollaiuolo*, 1978, cat. no. 3, p. 138, and plates 107–09). Passavant's attribution of the Pitti panel to the young Leonardo (*Verrocchio*, 1959, p. 211, note 371) has rightly been dismissed (Maria Vittoria Brugnoli, review in *Raccolta Vinciana*, vol. XIX, 1962, p. 345 [344–46]), except by Piero Adorno (*IL Verrocchio: Nuove proposte nella civiltà artistica del tempo di Lorenzo it Magnifico*, Florence, 1991, pp. 255–56).

16 For Bellosi's attribution of what remains of this once large fresco to Verrocchio, see *Pittura di luce*, 1990, p. 179 and fig. 108; and his entry in *Una scuola per Piero: Luce, colore e prospettiva nella formazione fiorentina di Piero della Francesca*, ed. Bellosi, Exhibition Catalogue, Galleria degli Uffizi, Florence, 1992, cat. no. 18, pp. 134–38.

17 About the print and its relation to Pollaiuolo see Arthur M. Hind, *Early Italian Engraving*, Part I, London, 1938, vol. I, cat. no. A.I.58, p. 48; and vol. II, pl. 54; and Jay A. Levenson in Levenson, Konrad Oberhuber, and Jacquelyn L. Sheehan, *Early Italian Engravings from the National Gallery of Art*, Washington, 1973, cat. no. ll, pp. 44–46. The hypothesis that the print and the other works in question go back to a lost Pollaiuolo prototype is Ragghianti's (in *L'arte*, 1935, pp. 196–98).

18 The term is Cruttwell's (*Verrocchio*, 1904, p. 14).

19 The muscularity and violent action of the male nude executioner seen from behind in Verrocchio's silver relief of the *Beheading of the Baptist* derive from the combatants in Pollaiuolo's engraving of the *Battle of the Nudes*, as Marco Chiarini (*Andrea del Verrocchio*, Maestri della Scultura series, Milan, 1966 [unpaginated]) and others have observed. Verrocchio's anatomical prowess is even more

evident in the recently rediscovered sketch model for the executioner (Anthony Radcliffe, "New Light on Verrocchio's *Beheading of the Baptist*," in *Verrocchio*, ed. Bule, Darr, and Superbi Gioffredi, 1992, pp. 117–23). Franziska Windt has shown that both Verrocchio's and Pollaiuolo's figures depend on the antique ("Verrocchios 'Enthauptung des Johannes'," in *Mitteilungen des Kunsthistorischen Institutes in Florenz*, vol. XXXVII, no. 1, 1993, pp. 130–39).

20 Vasari, *Vite*, ed. Milanesi, vol. III, 1878, pp. 366–67; and vol. IV, 1878, pp. 9–10. About this project see Beth Holman, "Verrocchio's Marsyas and Renaissance Anatomy," in *Marsyas: Studies in the History of Art*, vol. XIX, 1977–78, pp. 1–9.

21 Passavant, *Verrocchio*, 1959, pp. 147–48; and Passavant, *Complete Edition*, 1969, pp. 6, 44–45. His theory was rejected by Shearman (in *Burlington Magazine*, 1967, p. 125 note 16) and by Covi (in *Art Bulletin*, 1972, p. 93). Marcel Reymond (*Verrocchio*, Paris, n.d. [1906], pp. 30–31) had earlier claimed that Lippi was a primary influence on Andrea.

22 See: Cruttwell, *Verrocchio*, 1904, p. 27; Berenson, *Italian Pictures of the Renaissance*, Oxford, 1932, p. 594; Van Marle, *Italian Schools*, 1929, vol. XI, pp. 559–60; and Aldo Bertini, "L'arte del Verrocchio," in *L'arte*, vol. XXXVIII, no. 6, 1935, p. 466 (433–72).

23 Vasari, *Vite*, ed. Milanesi, vol. III, 1878, pp. 536–37.

24 About this complex development see: Oberhuber in Levenson, Oberhuber, and Sheehan, *Early Italian Engravings*, 1973, pp. XIIII–XVIII; Jay A. Levenson, *Prints of the Italian Renaissance*, National Gallery of Art, Washington, 1973; and David Landau and Peter Parshall, *The Renaissance Print 1470–1550*, New Haven and London, 1994, pp. 81–90 ("Prints as Competitors of Paintings").

25 About the work from which the name of the Master of the Vienna Passion is derived (datable c. 1460–70), see Hind, *Early Italian Engraving*, 1938, Part I, vol. I, cat. nos. A.I.25–34, pp. 37–39; and vol. II, plates 25–34. Compare particularly the same artist's *Penitent St. Jerome* of c. 1465, known in two impressions (Hind, cat. nos. A.I.38 and 39), the latter of which is colored. For Baccio Baldini see Oberhuber in Levenson, Oberhuber, and Sheehan, *Early Italian Engravings*, 1973, pp. 13–21. Monumental figures shown in sparse natural settings abound in the album of drawings in the British Museum known as the Florentine Picture Chronicle (for reproductions see Sidney Colvin, *A Florentine Picture-Chronicle*, London, 1898). Produced in the Baldini shop, these sheets (in the style of Pollaiuolo and his goldsmith partner Maso Finiguerra) parallel Verrocchio's paintings, rather than precede them, as they have recently been dated to the early 1470s (Lucy Whitaker, "Maso Finiguerra, Baccio Baldini and *The Florentine Picture Chronicle*," in *Florentine Drawing at the Time of Lorenzo the Magnificent*, ed. Elizabeth Cropper, Bologna,

1994, pp. 181–96). Whitaker notes (p. 185) that any interest in landscape wanes as the book progresses; some of the natural settings are unfinished or are left out altogether. The neglect of nature, as contrasted with the figures' lavishly detailed dress and architectural settings, is characteristic of this and other shops specializing in engravings.

26 For indications about the convent, formerly an asylum and now a museum, and its reconstruction after the siege of 1529, see Sylvia Meloni Trkulja, "Vicende del Cenacolo di San Salvi," in Serena Padovani and Silvia Meloni Trkulja, *Il Cenacolo di Andrea del Sarto a San Salvi: Guida del Museo*, Florence, 1982, pp. 1–4. A careful search for documents about San Salvi among the Conventi Soppressi records in the Archivio di Stato (Ornella Tabani and Maria Filomena Vadalà, *San Salvi e la storia del movimento vallombrosano dall' XI al XVI secolo*, Florence, 1982) shed no light on the *Baptism*. Domenico Moreni cites Vasari (but not the painting itself) to indicate that it was among the works preserved there (*Notizie istoriche dei contorni di Firenze*, vol. VI, Florence, 1795, p. 173). The Anonimo Gaddiano's statement that the altarpiece "poi fu posta" in San Salvi led Passavant to suppose that it was originally made for another church outside Florence (*Complete Edition*, 1969, p. 52).

27 Carlo L. Ragghianti, "Inizio di Leonardo," in *Critica d'arte*, no. 2, March 1954, pp. 102–18; and no. 4, July 1954, pp. 302–29. The author hypothesizes that after a minor artist began the painting, Verrocchio took it over, assigning it first to Botticini, then to Botticelli, who did the figures of the Baptist and the angel on the right, as well as part of the foreground and the design for Christ, and to Leonardo, who undertook the left-hand angel and the distant landscape. Though Botticelli experts disagreed about his participation, Ragghianti's notion of collaboration between several members of the shop has proved more attractive (Luciano Berti, "Il Battesimo di Cristo," in *Leonardo: La pittura*, Florence, 1977, p. 18 [15–24]; ed. Pietro Marani, Florence, 1985, p. 18 [16–22]). The technical evidence suggests, nevertheless, that mainly two individuals, one more accomplished than the other, worked on the picture.

28 Covi notes that the "sharp insistent realism of the parts that can be assigned to Verrocchio point to a beginning date of *c.* 1468" (review of Passavant, *Complete Edition*, 1969, in *Art Bulletin*, 1972, p. 93).

29 Cruttwell, *Pollaiuolo*, 1907, pp. 52–54; and Passavant, *Verrocchio*, 1959, pp. 82–84; and Passavant, *Complete Edition*, 1969, pp. 53–54 and fig. 42. For the relief see Ettlinger, *Pollaiuolo*, 1978, cat. no. 23, pp. 152–54, and pl. 10. Verrocchio's source has been dated to around 1468, about the same time as his painting (*Oreficeria nella Firenze*, 1977, cat. no. 17D, p. 41). Both Cruttwell and Passavant cite Baldovinetti's painted version of the *Baptism* in San Marco as a further source, but the way Verrocchio's figures fill the foreground is closer to sculpture.

30 The exact dimensions, sometimes given incorrectly in the literature, are 179.5 × 152.5 cm. (from the technical analysis prepared by Maurizio Seracini, Editech, Florence).

31 Andrew Butterfield, "Verrocchio's Christ and St. Thomas: Chronology, Iconography, and Political Context," in *Burlington Magazine*, vol. CXXXIV, no. 1069, 1992, pp. 225–33.

32 See note 19 above.

33 About the drawing, which measures 20.9 by 18.1 cm. (8¼ × 7⅛ in.) and which has apparently been reworked in ink and wash, see Annamaria Petrioli Tofani, *Inventario, l: Disegni esposti*, Gabinetto Disegni e Stampe degli Uffizi, Florence, 1986, no. 130E, p. 57. The tentative association with the painting made by Cruttwell (*Verrocchio*, 1904, pp. 46–47, 230) and Berenson (*The Drawings of the Florentine Painters*, 2nd rev. ed., 3 vols., Chicago, 1938, vol. I, p. 47; and vol. II, cat. no. 2781, p. 359) was doubted by Van Marle (*Italian Schools*, vol. XI, 1929, p. 514) and rejected by A. E. Popham (in *Italian Drawings*, Exhibition Catalogue, Royal Academy, 1930, London, 1931, cat. no. 53, p. 16). Noncommittal about the identification, Jean K. Cadogan dates the drawing *c.* 1470 ("Verrocchio's Drawings Reconsidered," in *Zeitschrift für Kunstgeschichte*, vol. XLVI, no. 4, 1983, pp. 373–74 [367–400]).

34 Passavant proposed that the drawing "perhaps represents the original appearance of this part of the painting before Leonardo's intervention" (*Complete Edition*, 1969, pp. 56–57 and cat. no. D1, p. 191), and Petrioli Tofani called it "una prima idea" for the angel in the picture (Anna Forlani Tempesti and Annamaria Petrioli Tofani, *I grandi disegni italiani degli Uffizi di Firenze*, Milan, n.d. [1973?], cat. no. 14).

35 The sculptural quality of the drawing was noted by Petrioli Tofani, *Inventario*, 1986, p. 57.

36 ". . . sempre o di pittura o di scultura lavorava qualche cosa; e qualche volta tramezzava l'un opera con l'altra. . . ." (Vasari, *Vite*, ed. Milanesi, vol. III, 1878, p. 365).

37 Except for Passavant (*Complete Edition*, 1969, pp. 38–39 and cat. no. A1, pp. 195–96 [with bibliography]), scholars are unanimous in accepting the *Resurrection* as Verrocchio's, but they disagree about its date. Noting the resemblance to the *Baptism*, Bertini (in *L'arte*, 1935, pp. 438–45 [433–72]), Leo Planiscig (*Andrea del Verrocchio*, Vienna, 1941, p. 47), and Seymour (*Verrocchio*, 1971, cat. no. 14, p. 167) date the relief respectively to the early, mid- or late 1460s, while Pope-Hennessy (*An Introduction to Italian Sculpture, II: Italian Renaissance Sculpture*, London, 1958, p. 311), among others, would place it more than a decade later. Covi is also in favor of an early date ("An Unnoticed Verrocchio?," in *Burlington Magazine*, vol. CX, no. 778, 1968, pp. 8–9; in *Art Bulletin*, 1972, pp. 91–92, 94; and in *Art Bulletin*, 1983, p. 272). The relatively immature style of the piece, as well as the particular interest young Leonardo took in

it (see chapter 4 below), supports a dating during the period of his apprenticeship in the late 1460s.

38 Heydenreich astutely noted "how little [Verrocchio's landscapes] reflect any genuine interest in natural forms" (*Leonardo*, Berlin, 1943, p. 25; and *Leonardo*, 1954, vol. I, pp. 25–26). Covi claimed that the rocky bluff in the *Baptism* reflected Andrea's knowledge of Mantegna's landscapes (in *Art Bulletin*, 1983, p. 267). Günter Panhans ("Florentiner Maler Verarbeiten ein Eyckisches Bild," in *Wiener Jahrbuch für Kunstgeschichte*, vol. XXVII, 1974, pp. 194–95 [188–98]), on the other hand, proposed that Verrocchio borrowed the rocks from Van Eyck's *Stigmatization of St. Francis*, which exists in two versions (in the Galleria Sabauda, Turin, and the Philadelphia Museum of Art. Though Panhans's claim has been widely accepted (Michael Rohlmann, *Auftragskunst und Sammlerbild: Altniederländische Tafelmalerei in Florenz des Quattrocento*, Alfter, 1994, pp. 105–07), Verrocchio's purported borrowing, it if occurred (there is no evidence either picture was in Florence), only underlines the comparative poverty of his representation. And it certainly does not demonstrate that he was influenced in any important way by Van Eyck, let alone by Flemish painting in general. The motif corresponds more closely to the rock formation on the right in Botticelli's early *Adoration of the Magi* in the National Gallery, London (Roberto Salvini, *Banchieri fiorentini e pittori di Fiandra*, Modena, 1984, pp. 32–33, 48, and figs. 89–91), but here, too, the question arises as to why the artist ignored the rest of his prototype.

39 Verrocchio's share in the *Baptism* may be compared with a polychromed wood statue of the *Crucified Christ* recently ascribed to him (Beatrice Paolozzi Strozzi, "An Unpublished Crucifix by Andrea del Verrocchio," in *Burlington Magazine*, vol. CXXXVI, no. 1101, 1994, pp. 808–15).

40 For Santi's poem, which contains a similarly revealing passage on Leonardo and Perugino, see Gilbert, *L'arte del Quattrocento*, 1988, pp. 118–19, 123. The artist-writer's evaluation of Andrea is quoted in translation in Seymour, *Verrocchio*, 1971, p. 30. An alternate reading has Verrocchio himself as the bridge to painting and sculpture over which others pass (Gilbert, *Italian Art*, 1980, p. 99).

41 Covi in *Art Bulletin*, 1966, pp. 99–100, 103. The document, dated Nov. 5, 1490, listing the contents of Verrocchio's Florentine shop (see chapter 1 note 25), also includes a "panel with Verrocchio's portrait." Though this work and the "quadro grande" may have been executed by Credi, they belonged to his employer.

42 Vasari, *Vite*, ed. Milanesi, vol. III, 1878, p. 363.

43 Verrocchio had three older brothers (Covi in *Art Bulletin*, 1972, p. 93), none of whom seems to have been a painter. A nephew (the son of his younger brother Tommaso) did became a painter, however, and he in turn bore a son who also practiced the art, accord-

ing to the family tree in Cruttwell, *Verrocchio*, 1904, p. 123.

44 Fully trained and semi-independent shop assistants are called "làvoranti" or "garzoni" in contemporary documents, while "discepolo" refers to an apprentice (Carl in *Mitteilungen*, 1982, pp. 134, 150 note 53, and 154 note 112). For the terminology see also the literature cited in note 49 below.

45 Ugolino Verino's poem *De Illustratione Urbis Florentiae* was written about 1502. The passage on Florentine artists from Giotto to Leonardo is cited from the published edition of 1583 in Gilbert, *L'arte del Quattrocento*, 1988, pp. 213–14. The reference to Andrea ("not unequal to Lysippus') is given in translation in Seymour, *Verrocchio*, 1971, p. 30. Many of the artists are paired with Greek forerunners known from Pliny, Leonardo with Protogenes, Botticelli with Zeuxis, and Perugino with "Apelleos."

46 Neri di Bicci, *Le ricordanze*, ed. Bruno Santi, Pisa, 1976. See also the review by Eve Borsook in *Art Bulletin*, vol. LXI, no. 2, 1979, pp. 313–18. Though this artist's account books date from the time (1453–75) when Verrocchio was setting up his *bottega*, procedures no doubt varied from shop to shop, according to the master's abilities and goals and the personnel available to him.

47 Benozzo Gozzoli, for example, worked first with Ghiberti, as one of many assistants, and then with Angelico, as an experienced painter, on the fresco decoration of Orvieto Cathedral.

48 Leonardo's inability to paint diligently was notorious, and it is relevant here that one exasperated patron, Ludovico Sforza, threatened to bring in Verrocchio's former pupil Perugino as a replacement to complete the *Last Supper*. Similarly, when Leonardo failed to finish (or even begin) the altarpiece ordered by the Florentine Signoria in 1478, the commission was turned over to Filippino Lippi, who, as Botticelli's pupil, also descended artistically from Andrea.

49 Though acknowledged to be the most important Florentine art center in the 1470s, Verrocchio's *bottega* is slighted in recent workshop studies because it is practically undocumented. About Renaissance workshops in general see: Ettore Camesasca, *Artisti in bottega*, Milan, 1966, pp. 189–218; Martin Wackernagel, *The World of the Florentine Renaissance Artist: Projects and Patrons, Workshop and Art Market* (orig. ed. 1938), trans. Alison Luchs, Princeton, 1981, pp. 308–37; Bruce Cole, *The Renaissance Artist at Work from Pisano to Titian*, New York, 1983, pp. 13–34; Francis Ames-Lewis and Joanne Wright, *Drawing in the Italian Renaissance Workshop*, Exhibition Catalogue, University Art Gallery, Nottingham, and Victoria and Albert Museum, London, 1983; Laura Indrio, "Firenze nel Quattrocento: Divisione e organizzazione del lavoro nelle botteghe," in *Ricerche di storia dell'arte*, no. 38, 1989, pp. 61–70; Harriet McNeal, "Work in Progress: Workshops and Partnerships," in *Verrocchio*, ed. Bule, Darr, and Superbi Gioffredi, 1992, pp. 356–59 (followed

by further discussion, pp. 359–73); and Anabel Thomas, *The Painter's Practice in Renaissance Tuscany*, Cambridge, 1995 (emphasizing Neri di Bicci's well-documented practice). The issues relating to Florentine shop organization and practice are discussed at length in *Maestri e botteghe*, ed. Gregori, Paolucci, and Acidini Luchinat, 1992.

50 Kemp, *Leonardo*, 1981, p. 61.

51 Covi in *Verrocchio*, ed. Bule, Darr, and Superbi Gioffredi, 1992, pp. 367–69. For an exception see note 6 above.

52 About this painting, discussed in detail in chapter 7, see most recently Gigetta Dalli Regoli in *Maestri e botteghe*, ed. Gregori, Paolucci, and Acidini Luchinat, 1992, cat. no. I.5, p. 52.

53 Oberhuber (in *Revue de l'Art*, 1978, pp. 63–76) gives a number of key Verrocchiesque works by Biagio d'Antonio, Perugino, and Ghirlandaio to Verrocchio himself, and he attempts to account for their differences by dating them earlier or later in the master's career. Cadogan (in *Zeitschrift*, 1983, pp. 367–400) adopts Oberhuber's corpus and chronology. Grossman, on the other hand, takes paintings away from Verrocchio (and thereby diminishes his importance), misattributes Perugino's early works to Botticelli, and exaggerates Ghirlandaio's role in the shop at the expense of Leonardo (in *Städel-Jahrbuch*, 1979, pp. 100–25), while Ragghianti ascribed the majority of Verrocchio's paintings and drawings to Botticelli in the publications cited in notes 27 above and 64 below.

54 The view that painting in Verrocchio's shop was essentially collaborative derives not only from the *Baptism* but also from the now discredited theory that the master was assisted on the Pistoia altarpiece by Leonardo and Perugino, as well as Credi (William R. Valentiner, *Studies of Italian Renaissance Sculpture*, London, 1950, pp. 140–51), thus bringing together all three of the pupils mentioned by Vasari. Cannon-Brookes (in *Apollo*, 1974, pp. 16–17), furthermore, claimed that painters in Verrocchio's shop worked "from designs provided by the master," but the pictures that Botticelli, Ghirlandaio, and Perugino completed there are, strictly speaking, individual not collaborative endeavors.

55 The documents, first published by Jacques Mesnil ("Les figures des Vertues de la Mercanzia," in *Miscellanea d'arte*, vol. I, 1903, pp. 43–46), were reprinted and analyzed further by Cruttwell (*Pollaiuolo*, 1907, pp. 147–49 and 267–71) and Ettlinger (*Pollaiuolo*, 1978, pp. 29–30 and 142–45). Pons views Verrocchio's intervention as part of a continuing rivalry between him and the Pollaiuolo brothers (*Pollaiolo*, 1994, p. 120).

56 Following Berenson, Cruttwell (*Pollaiuolo*, 1907, pp. 137, 143), among others, rightly ascribed the drawing of *Charity*, and likewise (part of) the painting of *Prudence*, to Antonio. Busignani (*Pollaiolo*, 1970, p. LXXVIII), calling the latter figure "forse la più bella delle sei tavole," similarly ascribed it partly to the elder

brother. Despite variations among the panels, Pons (*Pollaiolo*, 1994, cat. no. 8, pp. 97–98) gives them all to Piero.

57 Cruttwell ("Un disegno del Verrocchio per la 'Fede' nella Mercatanzia di Firenze," in *Rassegna d'arte*, vol. VI, no. I, 1906, pp. 8–10) tried to identify Verrocchio's entry with the Uffizi drawing (Gabinetto Disegni e Stampe no. 208E) of the same subject, but Passavant was closer to the truth in tentatively claiming that the drawing was a copy by Biagio d'Antonio of the lost original (*Complete Edition*, 1969, cat. no. App.50, p. 212). He aptly compared the facial type and draperies to those in Biagio's Budapest altarpiece. See also Everett Fahy, "Florence, Palazzo Strozzi: Late Fifteenth-Century Florentine Painting," in *The Burlington Magazine*, vol. CXXXV, no. 1079, 1993, p. 170 (169–71). The drawing appears to be by the same hand responsible for a study in the Uffizi (no. 1254E), formerly given to Verrocchio but now correctly identified as a preparatory study for the head of the Virgin in Biagio d'Antonio's *Adoration of the Child* in the Chigi Saracini Collection in Siena (Roberta Bartoli in *Maestri e botteghe*, ed. Gregori, Paolucci, and Acidini Luchinat, 1992, cat. no. 2.5, pp. 73–74, and cat. no. 2.21, pp. 86–87). Oberhuber (in *Revue de l'art*, 1978, pp. 71–72) and following him, Cadogan (in *Zeitschrift*, 1983, pp. 376–78) return the drawing (together with the altarpiece) to Verrocchio. For the attribution to Botticelli see Dalli Regoli (in *Maestri e botteghe*, 1992, cat. no. 2.17, pp. 83–84 [with bibliography]), who, like Cadogan, notes a *pentimento* on the sheet, suggesting it is not a copy.

58 About the recently restored altarpiece, formerly in the Florentine church of San Domenico del Maglio, see: Miklós Móré, "Compte rendu de la restauration du retable de la Vierge en trône à l'Enfant avec cinq saints et deux anges per Andrea del Verrocchio," in *Bulletin du Musée Hongrois des Beaux-Arts*, vol. LXXX–LXXXI, 1994, pp. 59–75; and János Eisler, "Dans l'atelier de Verrocchio," in *Bulletin du Musée Hongrois des Beaux-Arts*, vol. LXXX–LXXXI, 1994, pp. 76–90. On the basis of Vasari's account and of an engraving in the *Etruria pittrice* of 1791, a former owner of the picture claimed it was by Verrocchio, but most scholars have consigned it to the shop. See Roberta Bartoli as cited by Lisa Venturini, "Modelli fortunati e produzione di serie," in *Maestri e botteghe*, ed. Gregori, Paolucci, and Acidini Luchinat, 1992, p. 155 note 16 (147–57). Miklós Boskovits (*Tuscan Paintings of the Early Renaissance*, trans. Eva Rácz, Budapest, 1968, commentary to plates 36 and 37), Passavant (*Verrocchio*, 1959, pp. 88–94; and *Complete Edition*, 1969, p. 44 and cat. no. App.52, pp. 212–13), and Everett Fahy (*Some Followers of Domenico Ghirlandaio*, Garland Series of Outstanding Dissertations, New York and London, 1976, p. 205) all correctly opt for the artist now known as Biagio. The flattened figures are sufficient to show that Verrocchio

did not design the picture, and the cleaning demonstrates that he did not have a hand in its execution either. A *terminus ante quem* is provided by another altarpiece of 1471 (Oberhuber in *Revue de l'art*, 1978, fig. 5), in which the pose and drapery of Biagio's St. James recur. For the attribution of this work in the Musée Jacquemart André, Paris, to Francesco Botticini, see Venturini, *Botticini*, 1994, cat. no. 20, pp. 106–07, and fig. 21.

59 The unusual profile portrayal of the Virgin in the altarpiece conforms to a series of representations that Biagio painted of her kneeling in prayer (e.g. in the National Gallery of Ireland in Dublin and in the Musée des Beaux-Arts, Strasbourg). About these and another stylistically analogous series of the Virgin seated with the Child in her lap, see: Berenson, *Italian Pictures . . . Florentine School*, 1963, vol. I, pp. 209–12; Fahy, *Ghirlandajo*, 1976, pp. 204–11; and David Alan Brown in *Italian Paintings: XIV–XVIIIth Centuries from the Collection of the Baltimore Museum of Art*, ed. Gertrude Rosenthal, Baltimore, 1981, cat. no. 4, pp. 42–53.

60 "Una bottegha di mastro Chosimo e maestro Biagio fiorentino" (Benedetto Dei's list in Gilbert, *Italian Art*, 1980, p. 183; and Gilbert, *L'arte del Quattrocento*, 1988, p. 204).

61 For the commission wrested from Piero Pollaiuolo see Ronald Lightbown, *Botticelli*, 1978, vol. I, pp. 31–32; and vol. II, cat. no. B10, pp. 24–25.

62 Pope-Hennessy (review of four books on Botticelli in *Times Literary Supplement*, Feb. 18, 1977) noted how Botticelli's personification appears "thoroughly capable of wielding the mace she holds across her knees." Richer than in the other *Virtues*, the ornate decoration of the throne specifically resembles that of the Medici tomb, which Verrocchio had under way at this time. The element of fantasy in the headdress also recalls Andrea, as does the bright (if now somewhat obscured) color, unlike the brownish tones of the Pollaiuoli.

63 Hermann Ulmann (*Sandro Botticelli*, Munich, n.d. [1893], pp. 35–38) and Bode (*Botticelli: Des Meisters Werke*, Klassiker der Kunst, Stuttgart, 1926, pp. XIV–XVIII) agreed that Botticelli worked with Verrocchio in the late 1460s, and Roberto Salvini (*Tutta la pittura del Botticelli*, 2 vols., Milan, 1958, vol. I, p. 14) tended to concur. Yukio Yashiro (*Sandro Botticelli and the Florentine Renaissance*, London and Boston, 1929, pp. 12–23) believed that Verrocchio's influence was one with Pollaiuolo's, while Lightbown finds it difficult to trace the effect of a painter so little understood as Andrea (*Botticelli*, 1978, vol. I, p. 22).

64 Benedetto Dei's mention of Botticelli as head of his own workshop in 1470 (see note 7 above) means that he only passed through Verrocchio's *bottega*. Ragghianti, who knew this reference, accordingly placed Botticelli's activity in the shop before 1470 (see in addition to the articles cited in note 27 above, his "Collezioni Americane," in *Critica d'arte*, vol.

XXVII, no. 1, 1949, pp. 81–82 (76–82); "Studio del Verrocchio," in *Critica d'Arte*, n. s. vol. XII, no. 73, 1965, pp. 63–64; and in Carlo L. Ragghianti and Gigetta Dalli Regoli, *Firenze, 1470–1480: Disegni dal modello*, Pisa, 1975, pp. 1–44). And yet Botticelli's several paintings of the Virgin done after his return to Florence about 1468, when compared specifically with Verrocchio's *Madonna* (Fig. 29) in Berlin and not some vague notion of his style, bear a more cogent relation to Lippi, Botticelli's former master. One of the finest of these panels, in the Galleria Nazionale di Capodimonte at Naples (Lightbown, *Botticelli*, 1978, vol. I, plate 10, and vol. II, cat. no. B8, pp. 22–23), for example, lacks the almost harsh realism of a closely related composition in the National Gallery, London (Lightbown, vol. II, cat. no. A4, pp. 12–13). The latter is by a pupil or follower of Botticelli who approaches Verrocchio more nearly than does Sandro himself, except in the *Fortitude*. The same can be observed about two further works which appear to be by another artist between Verrocchio and Botticelli: the *Madonna* ascribed to Sandro in the Accademia, Florence (Pons in *Maestri e botteghe*, ed. Gregori, Paolucci, and Acidini Luchinat, 1992, cat. no. 2.1, pp. 70–71 [illus.]); and the altarpiece of the *Virgin and Child Enthroned with Saints* in the church of San Martino a Strada south of Florence, recently given to Andrea himself by Everett Fahy ("Two Suggestions for Verrocchio," in *Studi di storia dell'arte in onore di Mina Gregori*, Milan, 1994, pp. 51–55 and fig. 1). Though the figures in the altarpiece, datable 1472, lack the robust realism of Verrocchio, Fahy is surely right to find in the overabundance of goldsmith's work a clue to its authorship. This puzzling situation can be clarified only by re-examining all the "early Botticelli's," which suggest that Sandro, while associated with Verrocchio, already had assistants of his own.

65 The autograph standard for these pieces is set by Verrocchio's magnificent (and once fully colored) terracotta *Virgin* from the hospital of Santa Maria Nuova, now in the Bargello, in which the blessing Christ Child stands on the right rather than the left, as in all the versions painted in the shop (Francesco Caglioti in *Eredità del Magnifico*, ed. Paola Barocchi, Francesco Caglioti, Giovanna Gaeta Bertelà, and Marco Spallanzani, Exhibition Catalogue, Museo Nazionale del Bargello, Florence, 1992, cat. no. 152, pp. 173–74 [illus.]). The related marble *Virgin* of lesser quality in the same museum corresponds more nearly to the painted type. This relief has been attributed to Francesco di Simone Ferrucci (most recently by Caglioti in *Eredità*, 1992, cat. no. 24, pp. 54–56 [illus.]), who resembles Verrocchio's major painting assistants in having been previously trained (by Desiderio da Settignano). Vasari numbered Francesco, together with the equally skilled and unimaginative Credi, among Andrea's pupils (*Vite*, ed. Milanesi, vol. III, 1878, p. 371).

A pair of identical stucco reliefs of a *Virgin and Child*, one of unknown location (called the "Signa Madonna," formerly in the Dibblee Collection, Oxford), and the other in the Allen Memorial Art Museum, Oberlin, OH, appear to reflect a lost original by Verrocchio, which, to judge from the casts, considerably antedated the Bargello terracotta. The Child here stands on the left, as in the painted versions of the theme. Verrocchio's composition and its many repercussions are analyzed by Ronald G. Kecks in *Madonna und Kind: Das häusliche Andachtsbild in Florenz des 15. Jahrhunderts*, Berlin, 1988, pp. 107–10, and figs. 82a–86 (the author groups the painted Madonnas with the Bargello marble [pp. 110–11 and fig. 87]). See also: Passavant, *Complete Edition*, 1969, cat. nos. App.18 and 20, p. 206; Seymour, *Verrocchio*, 1971, cat. no. 13, pp. 166–67; and (on the Oberlin piece) Covi in *Italian Renaissance Sculpture in the Time of Donatello*, Exhibition Catalogue, Detroit Institute of Arts, Detroit, 1985, cat. no. 70, pp. 206–07 (with bibliography). The "Signa Madonna" was given to Leonardo by Theodore Cook (*Leonardo da Vinci Sculptor*, London, 1923) and Adolfo Venturi (*Storia dell'arte italiana*, vol. IX, Part I, Milan, 1925, pp. 48–50 and fig. 2), but denied by Eric Maclagan ("Leonardo as Sculptor," in *Burlington Magazine*, vol. XLIII, no. 245, 1923, pp. 67–69). Venturini (in *Maestri e botteghe*, ed. Gregori, Paolucci, and Acidini Luchinat, 1992, pp. 147–48) contends that sculptural reliefs, like those in the Bargello, lie behind the shop paintings of the same theme.

66 See Shearman in *Burlington Magazine*, 1967, p. 122 and figs. 14 and 15. Passavant prefers Hugo van der Goes as the Netherlandish source ("Die Courtauld Institute Galleries," in *Kunstchronik*, vol. XX, no. 10, 1967, pp. 316–19 [311–19]), but his Portinari altarpiece arrived in Florence in 1483, too late, surely, to have served for the London picture.

67 The painting is in the Städelsches Kunstinstitut in Frantfurt. Bode's attribution to Verrocchio himself having been abandoned, except by Berenson (*Italian Pictures . . . Florentine School*, 1963, p. 212) and Oberhuber (in *Revue de l'art*, 1978, p. 74 and fig. 20), it was given to the so-called Master of the Gardner *Annunciation*, identified as Piermatteo d'Amelia, by Zeri (in *Bollettino d'arte*, 1953, pp. 136–37 and fig. 19); tentatively to Cosimo Rosselli by Passavant (*Complete Edition*, 1969, cat. no. App.31, p. 208); and to Ghirlandaio by Grossman (in *Städel-Jahrbuch*, 1979, pp. 101–11 and fig. 1).

68 Unfortunately poor condition prevents any judgment about an intriguing version of the theme in the Musée Jacquemart-André, Paris, correctly associated with the Verrocchio shop by Zeri (in *Bollettino d'arte*, 1953, p. 134 and fig. 10) and Oberhuber (in *Revue de l'art*, 1978, p. 72 and fig. 17).

69 Federico Zeri with the assistance of Elizabeth E. Gardner, *Italian Paintings: A Catalogue of the Collection of the Metropolitan Museum of*

Art. Florentine School, New York, 1971, no. 14.40.647, pp. 151–52 (with bibliography): as "Workshop of Verrocchio, *c.* 1470."

70 Passavant, *Complete Edition*, 1969, cat. no. App.32, p. 208. Anna Padoa Rizzo ("Botticini, Francesco," in *Dizionario biografico degli italiani*, Rome, 1960–98, vol. XIII, 1971, p 454 [453–55]) accepts the *Virgin* as Botticini's, though Venturini (*Botticini*, 1994) does not. For Botticini's stint with Verrocchio, see Venturini, pp. 41–56.

71 Craig Hugh Smyth, "Venice and the Emergence of the High Renaissance in Florence: Observations and Questions," in *Florence and Venice: Comparisons and Relations*, Acts of Two Conferences, Villa I Tatti, 1976–77, 2 vols., Florence, 1979, vol. I, pp. 224–25 (209–49); Covi, in *Art Bulletin*, 1983, pp. 263–64, 272; and Adorno, *Verrocchio*, 1991, p. 88.

72 The attribution of this double-sided sheet (Département des Arts Graphiques, Musée du Louvre, inv. no. R.F. 2) to Andrea, based originally on the Latin verses on the verso dedicated to "Varochie," has never been contested. See: Passavant, *Complete Edition*, 1969, p. 60 and cat. no. D10, pp. 193–94; Seymour, *Verrocchio*, 1971, p. 27 and cat. no. 7, p. 173; Cadogan in *Zeitschrift*, 1983, p. 373; A. Natali in *Il disegno fiorentino del tempo di Lorenzo il Magnifico*, ed. Annamaria Petrioli Tofani, Exhibition Catalogue, Galleria Uffizi degli, Florence, 1992, cat. no. 6.5, pp. 132–33; and Michael Wiemers, *Bildform und Werkgenese: Studien zur zeichnerischen Bildvorbereitung in der italienischen Malerei zwischen 1450 und 1490*, Berlin, 1996, pp. 138–40. The drawing, which Passavant dates to the late 1470s, is but one of what must have been many such life-studies by Verrocchio, now lost.

73 For the origin of the name see Covi, in *Mitteilungen*, 1987, pp. 157–61.

74 Christie's, *Fine Old Master Drawings*, London, April 8, 1986, lot. no. 1: "Follower of Verrocchio." The interest this sheet has for studio practice no doubt recommended it to a succession of distinguished owners, including Jonathan Richardson, who ascribed it to Andrea. For studies of a similar blessing infant from Francesco di Simone's so-called Verrocchio sketchbook see: Brown in *Italian Paintings*, ed. Rosenthal, 1981, p. 49 and fig. 4; and Ames-Lewis and Wright, *Drawing in the Italian Renaissance Workshop*, 1983, cat. no. 25, pp. 140–43.

75 Bode made a convincing case for Verrocchio's authorship in Julius Meyer, *Königlich Museen in Berlin: Beschreibendes Verzeichnis der Gemälde*, Berlin, 1878, inv. no. 104A, p. 42 (and later editions). Though Cruttwell, following Morelli, rejected the picture (*Verrocchio*, 1904, pp. 118–21), Berenson significantly listed it as an early work by Andrea (*Italian Pictures*, 1932, p. 594; and 1963, vol. I, p. 212). Passavant's chapter on the painting (*Verrocchio*, 1959, pp. 95–102, 235–36) stresses its sculptural character and summarizes the previous literature. Agreeing with Berenson, he dates it 1468–70 (*Complete Edition*, 1969, pp. 45–48 and cat. no.

18, p. 187). Rightly calling the landscape "naive," Shearman (in *Burlington Magazine*, 1967, p. 127) opts for Botticini. Also noting the "inert" landscape with its concentric rings of rocks and foliage, Seymour (*Verrocchio*, 1971, p. 27) found that "nowhere does one sense the sculptor in the painter more directly than here." Oberhuber (in *Revue de l'art*, 1978, p. 71), while accepting the picture as Verrocchio's, allows that the "arbres purement décoratifs" might be a pupil's work. Erich Schleier, taking the Baptist from San Salvi as the touchstone for Verrocchio's painting style (in *The Gemäldegalerie, Berlin: A History of the Collection and Selected Masterworks*, London, 1986, pp. 298–99), dates both the Uffizi and Berlin pictures to *c.* 1470.

76 Passavant, *Verrocchio*, 1959, p. 101; and *Complete Edition*, 1969, p. 46 and fig. 33. See also: Kecks, *Madonna*, 1988, pp. 105–06 and fig. 114; and Jeffrey Ruda, *Fra Filippo Lippi: Life and Work with a Complete Catalogue*, London, 1993, p. 251 and plate 140. Botticelli's so-called *Madonna Guidi* (in the Louvre) of the late 1460s (Lightbown, *Botticelli*, 1978, vol. II, cat. no. A7, p. 14) manifests a much closer affinity with the Lippi prototype (in the Alte Pinakothek, Munich).

77 In his review of Passavant, 1969 (*Times Literary Supplement*, Nov. 13, 1969) Pope-Hennessy judged the Berlin picture the "closest equivalent in quattrocento painting to a carved Madonna relief."

78 Having been cut down, the panel was made up with wood strips, 3 to 5 cm. (1¼ to 2 in.) wide, along three edges, and there is a vertical crack running through the center from top to bottom. Except for losses and discolored repaint around these damages, the surface is quite well preserved. Curator Erich Schleier kindly facilitated my study of this painting.

79 Endorsing the Verrocchio attribution, Covi (*Art Bulletin*, 1983, pp. 265–66, 272) finds evidence in the landscape that the trip Andrea made to Venice and the Veneto to gather copper in 1469 had lasting consequences for his art. Though often approvingly cited, the whole notion of Venetian influence on Andrea, turns out, when examined carefully, to be rather dubious. Verrocchio's sojourn lasted only a few weeks, and whatever he managed to see of Venetian art and architecture must have seemed quite backward by the standards of his own work. The exception is the Venetian-inspired coloristic richness of the Medici tomb in the San Lorenzo sacristy (about which see Wendy Stedman Sheard, "Verrocchio's Medici Tomb and the Language of Materials," in *Verrocchio*, ed. Bule, Darr, and Superbi Gioffredi, 1992, pp. 75–76 [63–90]). It was the general aspect of the city, not specific elements of individual paintings, which struck Andrea as he was carrying out his mission.

80 Schlosser, *Ghibertis Denkwürdigkeiten*, 1912, vol. I, p. 20: "capellature in diuersi modi, mostrando la nobiltà dell'arte."

81 About the picture see Fern Rusk Shapley,

Catalogue of the Italian Paintings, National Gallery of Art, 2 vols., Washington, 1979, vol. I, no. 1412, p. 205. Writers disagree on the possibility that Ghirlandaio studied with Verrocchio, and there is no document to support it, unless the "orafo" with whom he was working in 1470 was Andrea (Jean K. Cadogan, "Reconsidering Some Aspects of Ghirlandaio's Drawings," in *Art Bulletin*, vol. LXV, no. 2, 1983, p. 277 note 23 [274–90]). Visual evidence, on the other hand, favors the assumption that Domenico may have briefly joined Verrocchio as a previously trained assistant in the early 1470s. Ghirlandaio's early frescoes are full of echoes of Andrea's works, particularly the *Baptism* (Angelini, "Domenico Ghirlandaio 1470–1480," in *Domenico Ghirlandaio: Restauro e storia di un dipinto*, Exhibition Catalogue, Arciconfraternità di Misericordia, Figline Valdarno, Fiesole, 1983, pp. 8–23). Furthermore, at least one of the linen drapery studies that originated in the Verrocchio shop is demonstrably by Ghirlandaio (see pp. 79–82 below). Cadogan's conclusion that Domenico "supplemented his education with a stint in Verrocchio's workshop" falls well short, however, of the extreme view taken by Grossman, according to whom the younger artist "was for a period the leading painter [there and also the one] who exercised the initial influence on Leonardo" (in *Städel-Jahrbuch*, 1979, pp. 116–21). Grossman's theory that Ghirlandaio was the guiding force for painting in the shop is based partly on the misattribution to him of sections of Leonardo's Uffizi *Annunciation* (Passavant, "Beobachtungen am Verkündigungsbild aus Monte Oliveto," in *Mitteilungen des Kunsthistorischen Institutes in Florenz*, vol. IX, no. 2, 1960, pp. 71–98). For a further (insignificant) link between Ghirlandaio and Verrocchio, see Covi in *Verrocchio*, ed. Bule, Darr, and Superbi Gioffredi, 1992, p. 368. As for the probable date of Ghirlandaio's stay in the shop, Emma Micheletti (*Domenico Ghirlandaio*, Florence, 1990, p. 12) suggests the later 1470s, but by then he had a nearly mature style and assistants of his own.

82 Compare in particular the *Virgin Enthroned with Saints* in the church of Sant'Andrea at Brozzi (Ronald G. Kecks, *Ghirlandaio*, Florence, 1995, cat. no. 2, pp. 98–99, and illus. on pp. 26–27).

83 About Ghirlandaio's debt to the tradition going back to Masaccio, see Artur Rosenauer, "Zum Stil der frühen Werke Domenico Ghirlandajos," in *Wiener Jahrbuch für Kunstgeschichte*, vol. XXII, 1969, pp. 59–85.

84 The attribution to the young Leonardo (Alberto Martini, "Ipotesi Leonardesca per la 'Madonna' Ruskin," in *Arte figurativa*, vol. VIII, no. 1, 1960, pp. 32–39; and Renzo Baschera, "E di Leonardo la 'Madonna con Bambino' di Sheffield," in *Arte cristiana*, vol. L, nos. 1–2, 1962, pp. 14–15) can be dismissed, as the architectural background cited in favor of his authorship is actually typical of

Ghirlandaio, as noted by Everett Fahy, ascribing the picture to Domenico (unpublished lecture, National Gallery of Art, January 23, 1977, and elsewhere). The types and treatment of the figures are closer than is the setting to Verrocchio, to whom the picture was given (somewhat doubtfully) by Berenson ("Verrocchio e Leonardo, Leonardo e Credi," in *Bollettino d'arte*, vol. XXVII, 1933, no. 5, pp. 203–04 [193–214, and no. 6, pp. 241–64]; and *Italian Pictures . . . Florentine School*, 1963, vol. I, p. 212); this attribution was followed by Oberhuber (in *Revue de l'art*, 1978, pp. 72–73 and Cadogan (in *Zeitschrift*, 1983, pp. 371–72). The badly abraded paint, transferred from panel to canvas, makes it difficult to reach a definite conclusion. For a thoughtful analysis of the attribution problem, see Hugh Brigstocke, "Verrocchio's *Ruskin Madonna*," in *A Dealer's Record. Agnew's 1967–81*, London, 1981, pp. 24–29; and Brigstocke, *Italian and Spanish Paintings in the National Gallery of Scotland*, 2nd rev. ed., Edinburgh, 1993, inv. no. 2338, pp. 201–05 (with bibliography). The kneeling Virgin in the Edinburgh picture finds a parallel in a ruined fresco also plausibly attributed to Ghirlandaio and dated *c.* 1475 (Edgar Peters Bowron, *European Paintings before 1900 in the Fogg Art Museum*, Cambridge, MA, 1990, cat. no. 598, pp. 109 and 311 [illus.]).

85 For the attribution to Ghirlandaio see Berenson in *Bollettino d'arte*, vol. XXVII, no. 6, 1933, p. 256, and fig. 20. Oberhuber gives the picture to Verrocchio in *Revue de l'art*, 1978, pp. 72–73 and fig. 19. About the specific source, a portrait by Memling in the Lehman Collection at the Metropolitan Museum, New York, see Lorne Campbell, "Memlinc and the Followers of Verrocchio," in *Burlington Magazine*, vol. CXXV, no. 968, 1983, pp. 675–76. The Netherlandish-inspired landscape vista was omitted in a variant of the Louvre panel (Alex Wengraf, "A 'Virgin and Child' from the Circle of Verrocchio," in *Burlington Magazine*, vol.CXXVI, no. 971, 1984, pp. 91–92). Of all Verrocchio's assistants it was Ghirlandaio who responded most keenly to Flemish painting (Francis Ames-Lewis, "On Domenico Ghirlandaio's Responsiveness to North European Art," in *Gazette des Beaux-Arts*, 6th ser., vol. CXIV, no. 1449, 1989, pp. 111–22; and Michael Rohlmann, "Ein Flämisches Vorbild für Ghirlandaios 'Prime Pitture'," in *Mitteilungen des kunsthistorischen Institutes in Florenz*, vol. XXXVI, 1992, pp. 388–96). Not coincidentally his chief patrons, the Portinari, were the leading collectors of northern art in Florence, after the Medici, and their favorite Flemish artist was Memling, whom Ghirlandaio often imitated.

86 About this work see most recently Anna Padoa Rizzo in *Maestri e botteghe*, ed. Gregori, Paolucci, and Acidini Luchinat, 1993, cat. no. 2.2, p. 71. The attribution to Ghirlandaio is due to Anna Maria Maetzke (in *Arte nell'Aretino: Recuperi e restauri dal 1968 al 1974*, Exhibition Catalogue, Arezzo, 1974–75,

Florence, 1974, cat. no. 37, pp. 100–03), for whom the landscape recalls Venetian painting (see also Smyth in *Florence and Venice*, 1979, vol. I, pp. 224–25 and fig. 27; and Covi in *Art Bulletin*, 1983, pp. 263–65, 272). For a rather similar work in the Galleria Nazionale, Urbino, also given to Andrea, see Pietro Zampetti, "Ancora un Verrocchio," in *Emporium*, vol. LVII, no. 4, 1951, pp. 154–62.

87 In the life of Perugino (*Vite*, ed. Milanesi, vol. III, 1878, p. 568), Vasari stated that Pietro "studiò sotto la disciplina d'Andrea Verrocchio." In that of Verrocchio the author confirmed that "fu discepolo del medesimo Andrea, Pietro Perugino e Lionardo da Vinci" (*Vite*, vol. III, 1878, p. 371). Vasari added in the Credi biography that that artist had for "compagni e per amici, sebbene erano concorrenti, Pietro Perugino e Lionardo da Vinci" (*Vite*, vol. IV, 1879, pp. 563–64). Though Vasari thus lumped him together with Andrea's apprentices, Perugino's birthdate of *c.* 1445 puts him in the category of the slightly older semi-independent helpers. And like them, the (Umbrian) substratum of his work indicates that he was already trained. Recorded in his native town in 1469, Perugino's name appears in the ledger of the Florentine painters' confraternity in 1472, suggesting that he entered Verrocchio's shop sometime in the early 1470s.

88 Zeri in *Bollettino d'arte*, 1953, pp. 125–39. Zeri was here mainly concerned with the author of the *Annunciation* in the Gardner Museum, Boston, whom he identified as Piermatteo d'Amelia.

89 Zeri's attributions were accepted by: Camesasca, *Perugino*, 1959, pp. 11–15; Camesasca, *L'opera completa*, 1969, pp. 85–89; Francesco Negri Arnoldi, *Perugino*, Milan, 1965; and Francesco Santi, "Perugino," in *Encyclopedia of World Art*, New York, Toroneo, and London, 1959–87, vol. XI, 1966, cols. 266–67 (265–71). The Argiano *Crucifixion* and the *Tobias and the Angel* in London, first given to Perugino in 1935 by Ragghianti (see note 13 above), were restored to Verrocchio by Passavant (*Verrocchio*, 1959, and *Complete Edition*, 1969), as we have seen. Oberhuber (in *Revue de l'art*, 1978) likewise returned to Andrea the paintings of the *Virgin* in Berlin and London, which Zeri had ascribed to Perugino and which are, in fact, persuasive as his work (see notes 90 and 92 below). Scarpellini rejected all these attributions (in favor of the Courtauld *Madonna* as an early effort by Pietro [*Perugino*, 1984, pp. 18–27, and cat. no. 7, pp. 70–71]), and so did Jeryldene Marie Wood, "The Early Paintings of Perugino," Ph.D. thesis, University of Virginia, 1985.

90 Attributed to Leonardo in the Solly Collection, from whence it came to the museum, the picture (no. 108), painted in tempera on a panel measuring 74 by 46 cm., was recognized as a characteristic product of the Verrocchio shop by both Cavalcaselle (in J. A. Crowe and G. B. Cavalcaselle, *Storia della*

pittura in Italia, Florence, 1875–1908, vol. VI 1894, pp. 193–94) and Bode (in *Repertorium für Kunstwissenschaft*, 1899, pp. 391–92). Berenson, on the other hand, gave it to the master himself (*Italian Pictures*, 1932, p. 594; and in *Bollettino d'arte*, 1933, p. 202 [193–214]), as did Oberhuber (in *Revue de l'art*, 1978, p. 70), Scarpellini (*Perugino*, 1984, p. 19 and cat. no. 4, pp. 69–70 [with bibliography]), and Bellosi (in *Pittura di luce*, 1990, p. 179). Adorno regards an infant on the already cited sheet (Fig. 28) by Verrocchio in the Louvre as a study for the Berlin picture (*Verrocchio*, 1991, p. 112). Roberto Longhi first ascribed the *Madonna* to Perugino ("Quadri italiani di Berlino a Sciaffusa," in *Paragone*, vol. III, no. 33, 1952, pp. 41–42 [39–46]), followed by Zeri (in *Bollettino d'arte*, 1953, p. 136), Sinibaldi (as cited in note 92 below), and Covi (in *Art Bulletin*, 1983, pp. 265–67), among others. Passavant's proposal in favor of Ghirlandaio (*Complete Edition*, 1969, cat. no. App.23, p. 207) and Grossman's for Botticelli (in *Städel-Jahrbuch*, 1979, p. 125 note 53) are unacceptable.

91 The bland quality of this lovely *Virgin* is at odds with an otherwise closely related picture in the Musée Jacquemart-André, Paris. Though often ascribed to Pietro (Berenson, *Italian Pictures*, 1932, p. 438; Zeri in *Bollettino d'arte*, 1953, pp. 133–34 and fig. 9; and Oberhuber in *Revue de l'art*, 1978, p. 70 and fig. 10; but not Scarpellini, *Perugino*, 1984, pp. 18–20, cat. no. 6, p. 70 [with bibliography], and fig. 9), this work appears to be by one of the Umbrian *équipe* who joined him in executing the well-known series of eight panels depicting miracles of San Bernardino in the Galleria Nazionale, Perugia. Perugino's own contribution to the series, the *Healing of a Young Girl*, dated 1473, is akin in style to the Berlin picture, while two of the other panels share the lively eccentricity of the one in Paris (*Healing of a Trampled Youth* and *Healing of the Blind Man*). The San Bernardino panels (about which see Sylvia Ferino Pagden and Vittoria Garibaldi in *Rinascimento da Brunelleschi a Michelangelo: La rappresentazione dell'architettura*, ed. Henry Millon and Vittorio Magnago Lampugnani, Exhibition Catalogue, Palazzo Grassi, Venice, Milan, 1994, cat. nos. 36 and 37 respectively, pp. 447–52) suggest that Perugino, all the while serving under Verrocchio, may have had a shop in Perugia as well, where he made Andrea's style familiar to a wider circle. Either here or in Florence Pietro painted the *Birth of the Baptist* (Walker Art Gallery, Liverpool), which, until its true companion came to light, was believed to belong to the predella of the *Madonna di Piazza* (Scarpellini, *Perugino*, 1984, cat. nos. 8 and 9, p. 71 [with bibliography] and figs. 11 and 12).

92 The attribution of this tempera painting (inv. no. 296), measuring 96.5 by 70.5 cm., is contested between Verrocchio himself or some member of his shop. Favoring Andrea are Berenson (*Italian Pictures*, 1932, p. 594

["designed and superintended by Verrocchio"]; and in *Bollettino d'arte*, 1933, pp. 200, 202 [as Verrocchio but close to Perugino]; and *Drawings*, 1938, vol. I, pp. 53–54 [as Andrea's masterpiece in painting]); Oberhuber (in *Revue de l'art*, 1978, pp. 70 and 75 note 54; and Scarpellini (*Perugino*, 1984, cat. no. 5, p. 70 [with bibliography]). Among the master's assistants, Ghirlandaio was tentatively proposed by Bertini (in *Encyclopedia of World Art*, vol. XIV, 1967, col. 763 [757–66]), while Passavant (*Complete Edition*, 1969, cat. no. App.38, pp. 209–10) tried to revive Cavalcaselle's ascription to Credi (in Crowe and Cavalcaselle, *Storia della pittura*, 1894, vol. VI, pp. 197–98). Grossman suggests Botticelli (in *Städel-Jahrbuch*, 1979, p. 125 note 53. Martin Davies (*The Earlier Italian Schools*, National Gallery, 2nd rev. ed., London, 1961, pp. 534–35), noting the resemblance to the Berlin *Madonna* (no. 108), preferred to leave the attribution question open. The correct view would seem to be Zeri's in favor of Perugino (in *Bollettino d'arte*, 1953, pp. 134–36, accepted by Camesasca (*perugino*, 1959, cat. no. 7, pp. 41–42; and *L'opera completa*, 1969, cat. no. 7, p. 87) and Sinibaldi (see below).

The London picture is the only one of the half-length Madonnas produced in the Verrocchio shop for which preparatory drawings survive. A composition sketch in the Uffizi (Giulia Sinibaldi, "Drawings by Perugino," in *Master Drawings*, vol. II, no. 1, 1964, pp. 29–30 [27–32] and plate 17; and Cadogan in *Zeitschrift*, 1983, pp. 380–82 and fig. 17) and two studies for the angels' heads on a double-sided sheet in the Kupferstichkabinett, Berlin (Cadogan in *Zeitschrift*, 1983, pp. 374–75 and figs. 11 and 12) have, like the painting, generally been ascribed to Andrea (Wiemers, *Bildform*, 1996, pp. 147–52) or his circle. Cadogan follows Passavant (*Complete Edition*, 1969, p. 59; cat. no. D7, pp. 192–93) in giving the studies to Andrea, but if the picture is Perugino's, then the drawings might be his too. A well-known Leonardo study of a lily at Windsor, discussed on pp. 88–89, is also associated with the painting.

93 The jewelled brooch worn by the Virgin and the angel on the left in this painting, like the one in the Berlin *Madonna with the Blessing Child*, was probably a Verrocchio shop property (Dunkerton, Foister, Gordon, and Penny, *Giotto to Dürer*, 1991, pp. 149–50 and figs. 195–97).

94 Richter, *Italian Art in the National Gallery*, London, 1883, p. 33; and Passavant, *Complete Edition*, 1969, cat. no. App. 38, p. 209.

95 Noting the resemblance between the two angels, Thiis ascribed the works in which they appear to his so-called "Alunno di Andrea" (*Leonardo*, n.d. [1913], pp. 66–67). Wilhelm Lübke (*Geschichte der italienischen Malerei*, 2 vols, Stuttgart, 1878–79, vol. I, p. 318) had already wondered if the London picture might not be by Leonardo. Salomon Reinach ("New Facts and Fancies about Leonardo da

Vinci," in *Art Journal*, vol. LXXIV, no. 883, 1912, p. 8 [6–25]) actually attributed the painting to him, and so did Frank Jewett Mather, Jr. ("Some Recent Leonardo Discoveries," in *Art and Archaeology*, vol. IV, no. 2, 1916, pp. 111, 117 [111–22]; and *A History of Italian Painting*, New York, 1923, pp. 229, 481). Adorno (*Verrocchio*, 1991, pp. 110–11) called it a workshop product by Leonardo and Perugino working together. Shell (*Leonardo*, 1992, p. 14) noted that both "angels from the *Baptism*, their poses altered, appear to either side of the Madonna." Other authors compared the landscape with that in Leonardo's famous drawing of 1473 (Woldemar von Seidlitz, *Leonardo da Vinci der Wendepunkt der Renaissance*, 2 vols., Berlin, 1909, vol. I, pp. 56–57; Charles Holmes, *Old Masters & Modern Art: The National Gallery. Italian Schools*, London, 1923, p. 61; Bertini in *L'arte*, 1935, p. 468 note 2 [433–72]; and Passavant, *Complete Edition*, 1969, cat. no. App. 38, p. 209). Sinibaldi (in *Master Drawings*, 1964, pp. 28–29) stressed Leonardo's influence on the tender psychology of the angel on the left, which recurs throughout Perugino's oeuvre (Tobias in the polyptych in the National Gallery, London, for example).

96 Gilbert, *Italian Art*, 1980, p. 99; and Gilbert, *L'arte del Quattrocento*, 1988, p. 123: "dui giouin par d'etate e par d'amori."

The Apprentice

1 Vasari, *Vite*, ed. Milanesi, vol. IV, 1879, pp. 22–23; and Goldscheider, *Leonardo*, 1959, p. 13.

2 Goldscheider (*Leonardo*, 1959, p. 13) identified Leonardo's "uncle" as his stepmother's brother Alessandro degli Amadori, who concerned himself with the artist's affairs. The Anonimo simply records that Leonardo "dipinse Adamo et Eva d'acquerello, hoggi in casa messer Ottaviano de' Medici" (Anonimo Gaddiano, *Codice*, ed. Frey, 1892, p. 111). The tapestry was never executed. Wilhelm Suida surmised that Raphael's *Fall of Man* in the Stanza della Segnatura and other sixteenth-century depictions of the theme were freely copied from Leonardo's drawing (*Leonardo und sein Kreis*, Munich, 1929, pp. 37–39; and "Kleine Beiträge zum Werke Leonardos," in *Raccolta vinciana*, vol. XIII, 1926–29, pp. 71–79 [63–79]). A Verrocchiesque drawing of the subject by Francesco di Giorgio is a better candidate, at least for the figures (Marani, *Leonardo*, 1989, pp. 123–24 and fig. 23). Ottaviano de' Medici (1482–1546) was a major patron of Verrocchio's heir Lorenzo di Credi (Anna Maria Bracciante, *Ottaviano de' Medici e gli artisti*, Florence, 1984, pp. 29–36), from whom he might have obtained the cartoon.

3 Davies, *Earlier Italian Schools*, 1961, no. 781, pp. 555–57: as "Follower of Verrocchio." The panel, which measures 84 × 66 cm. or 33 × 26 in. (including additions at the sides),

belonged to Count Galli Tassi of Florence, before going to the gallery via the dealer Baslini in 1867.

4 Frits Lugt, "Man and Angel. II," in *Gazette des Beaux-Arts*, 6th ser., vol. XXV, no. 908, 1944, pp. 321–34 (321–45); and Gertrude M. Achenbach, "The Iconography of Tobias and the Angel in Florentine Painting of the Renaissance," in *Marsyas*, vol. III, 1943–45, pp. 71–86 (her thesis that only minor artists like Neri di Bicci depicted the popular theme [he records treating it nine times] needs revision). Gombrich, on the other hand, claimed that the Tobias pictures reflected confraternity members' veneration for St. Raphael and were not votives for business travelers (see note 24 below).

5 As with the Argiano *Crucifixion*, the attribution history of *Tobias and the Angel* leads from a diversity of views to a growing consensus in favor of Verrocchio and/or his shop. Since Pollaiuolo is the principal inspiration for the picture, Morelli's attribution to Piero's shop (*Die Werke italienischer Meister in den Galerien von München, Dresden und Berlin: Ein kritischer Versuch*, Leipzig, 1880, p. 391 note 1) and Adolfo Venturi's to Antonio (*Studi dal Vero attraverso le raccolte artistiche d'Europa*, Milan, 1927, pp. 44–48) are understandable, as is that of Cruttwell (*Verrocchio*, 1904, p. 121) to an artist influenced by both Pollaiuolo and Verrocchio. Mackowsky (*Verrocchio*, Bielefeld and Leipzig, 1901, p. 86) preferred Botticini, while Berenson opted for that artist working on Verrocchio's design (*Italian Pictures*, 1932, p. 595; in *Bollettino d'arte*, 1933, pp. 202–03; *Drawings*, 1938, vol. I, pp. 53, 70; and *Florentine School*, 1963, vol. I, p. 212). Adorno similarly suggested Andrea assisted by Botticini (*Verrocchio*, 1991, pp. 15–16). Van Marle (*Italian Schools*, vol. XI, 1929, pp. 539–41) called the picture shop work, as did Luitpold Dussler ("Verrocchio," in *Allgemeines Lexikon der bildenden Künstler*, ed. Ulrich Thieme and Felix Becker, 37 vols., Leipzig, 1907–50, vol. XXXIV, 1939, p. 295 [292–98]) and Scarpellini (*Perugino*, 1984, cat. no. 3, p. 69). The Verrocchio pupil most often credited with the work is Perugino, despite the fact that it lacks his tranquillity and spaciousness. See: Ragghianti in *L'arte*, 1935, p. 196 note 1; Zeri in *Bollettino d'arte*, 1953, pp. 134–36; Camesasca, *Perugino*, 1959, pp. 12–13, 40–41; and Camesasca, *L'opera completa*, 1969, no. 5, p. 86. Stressing the sculptural character of the figures and their sense of motion, Passavant (*Verrocchio*, 1959, pp. 103–21, 237; and *Complete Edition*, 1969, pp. 48–51, and cat. no. 19, p. 188) revived Bode's attribution to the master himself with a date of *c.* 1473. As Passavant noted, Bode was the first to recognize the quality and importance of the picture ("Die italienischen Skulpturen der Renaissance in den königlichen Museen, II: Bildwerke des Andrea del Verrocchio," in *Jahrbuch der königlich Preussischen Kunstsammlungen*, vol. III, 1882, pp. 247–48 (235–67); and *Italienische Bildhauer der Renaissance*, Berlin, 1887, pp.

126–29). In reviews of Passavant's books, Gilbert accepted his attribution (in *Art Journal*, 1960, p. 58), while Covi (in *Art Bulletin*, 1972, p. 92) gave the painting tentatively to Ghirlandaio in Andrea's shop. The correct designation seems to be that of John Hale (*Italian Renaissance Painting from Masaccio to Titian*, Oxford and New York, 1977, no. 40), who favored Verrocchio with a dating of *c.* 1467.

6 Vasari, *Vite*, ed. Milanesi, vol. III, 1878, pp. 291–92 (erroneously as on canvas rather than panel). About the picture, which measures 188 by 119 cm., see Noemi Gabrielli, *Galleria Sabauda: Maestri italiani*, Turin, 1971, cat. no. 117, pp. 208–09 (with bibliography).

7 Scholars, though disagreeing about each brother's share in the painting, nearly all date it to the mid-1460s. See: Cruttwell, *Pollaiuolo*, 1907, pp. 93–97; Attilio Sabatini, *Antonio e Piero del Pollaiolo*, Florence, 1944, pp. 21, 71; Busignani, *Pollaiolo*, 1970, p. 1; Ettlinger, *Pollaiuolo*, 1978, cat. no. 7, pp. 140–41; and Pons, *Pollaiolo*, 1994, pp. 10–11, and cat. no. 4, p. 95. According to Sergio Ortolani (*Il Pollaiuolo*, Milan, 1948, pp. 192–93), the Turin picture inspired the one in London, which he gave to Verrocchio.

8 Passavant contrasts the way Andrea integrated figures formally and emotionally as a group (*Verrocchio*, 1959, pp. 107–08, 143, 157–58) with the shortcomings of Pollaiuolo's model (pp. 119–20). The originality of Verrocchio's conception can also be seen by comparison with a *Tobias* associated with Baldovinetti, formerly on loan to the Rijksmuseum (Christie's, *Important Old Master Pictures*, London, December 11, 1984, lot no. 127, p. 25l [illus.]), in which the protagonists look out at the viewer.

9 According to Vasari (*Vite*, ed. Milanesi, vol. III, 1878, pp. 372–73; and Seymour, *Verrocchio*, 1971, p. 31), Verrocchio made gesso casts from nature of hands, feet, limbs, and torsos, to represent them in his works better and more conveniently. Though Cruttwell (*Verrocchio*, 1904, pp. 18, 108) rejected the hand type (and thus the paintings in which it appears) as Verrocchio's, Passavant (*Complete Edition*, 1969, p. 46) regarded its occurrence in Berlin *Madonna* no. 104A as a signature of the artist. The repetition of the motif has often been noted (for example, by Passavant, *Verrocchio*, 1959, pp. 119–20; and Ragghianti in Ragghianti and Dalli Regoli, *Disegni*, 1975, p. 19). Tobias's right hand is also similar to the angel's, though positioned differently.

10 Davies (*Earlier Italian Schools*, 1951, p. 428) contrasted the refinement of the figures with the "very summary" landscape. Valentiner similarly found Andrea's painted landscapes insignificant and "entirely subordinated to the plasticity of the figures, in which Verrocchio the sculptor was interested above everything else... one of the essential differences between the art of Verrocchio and that of Leonardo is the great love of the younger

master for landscape art" (in *Art Bulletin*, 1930, pp. 58–59 [43–89]; reprinted with revisions in *Italian Renaissance Sculpture*, 1950, pp. 134–77). The admiration Berenson expressed for Verrocchio as a landscapist was based on his attribution of the Uffizi *Annunciation* and *Ginevra de' Benci* to Andrea (*The Florentine Painters of the Renaissance*, New York and London, 1896, pp. 57–60). Compare also Thiis, *Leonardo*, n.d. [1913], pp. 89–90.

11 With its bristly hair and awkward gait, the dog cannot be by Antonio, who displays considerable skill as an *animalier* in a black chalk drawing of a pair of hounds on the reverse of a study for Hercules and the Hydra (A. E. Popham and Philip Pouncey, *Italian Drawings in the Department of Prints and Drawings in the British Museum: The Fourteenth and Fifteenth Centuries*, 2 vols., London, 1950, vol. I, cat. no. 225 verso, pp. 138–39; and vol. II, plate CXCV). Antonio's keen observation here was stressed by A. M. Cetto in *Animal Drawings from the 12th to the 19th Century*, London, n.d. [1936], cat. no. 8, p. IX.

12 Compare the metalpoint studies of a cat and dog in the British Museum, which Popham and Pouncey date to "Leonardo's earlier Florentine period" (*Italian Drawings*, 1950, vol. I, cat. no. 101, p. 61; and vol. II, plate XCVIII). Popham elsewhere refers to the sheet as "perhaps the earliest drawing of animals by Leonardo" (*The Drawings of Leonardo da Vinci*, New York, 1945, p. 28 and plate 63A). See also Cetto, *Animal Drawings*, n.d. [1936], cat. no. 10, pp. IX–X. Another red chalk study of a dog with raised forepaw was accepted as Leonardo's by Popham (*Drawings*, 1945, cat. no. 82, p. 112) but not by Kenneth Clark, who considered it a copy (*The Drawings of Leonardo da Vinci in the Collection of her Majesty the Queen at Windsor Castle*, 2nd rev. ed. with the assistance of Carlo Pedretti, 3 vols., London, 1968, vol. I, no. 12361, pp. 48–49). Apart from horses, only a handful of Leonardo's animal studies have survived, leading Clark to wonder why the artist "did not make more [of them]" (*Animals and Men*, London, 1977, p. 28). Actually, to judge from those few that are extant, Leonardo must often have sketched from nature, but his drawings, made as part of a learning process, were simply not preserved.

13 Compare also the terrier in Memling's *Vanity* in the Musée des Beaux-Arts, Strasbourg (Max J. Friedländer, *Early Netherlandish Painting: Hans Memlinc and Gerard David*, trans. Heinz Norden, Leyden and Brussels, 1971, plate 63) and the similarly realistic dog in Fouquet's *Nativity* in the Book of Hours of Etienne Chevalier at Chantilly (Sandro Lombardi, *Jean Fouquet*, Florence, 1983, fig. 85).

14 William Suida, "Leonardo's Activity as a Painter: A Sketch," in *Leonardo: Saggi e ricerche*, ed. Achille Marazza, Rome, 1954, pp. 317–18 (315–29). The author rightly saw that Leonardo emulated Pollaiuolo's animals.

15 Davies (*Earlier Italian Schools*, 1961, p. 557 note 12) was "not sure that a special category should be made for the dog and fish but [thought] that the claim of Leonardo's intervention deserves careful discussion."

16 Passavant (*Verrocchio*, 1959, pp. 104, 109) simply claimed that Andrea's execution varied according to the motifs represented.

17 About the painting see Janice Shell and Grazioso Sironi, "Cecilia Gallerani: Leonardo's Lady with an Ermine," in *Artibus et historiae*, no. 25, 1992, pp. 47–66. Paul Barolsky has underlined the witty similarity in pose between the portrait sitter and the animal she holds ("La Gallerani's *Galée*," in *Source: Notes in the History of Art*, vol. XII, no. 1, 1992, pp. 13–14). The ermine in an allegorical drawing by Leonardo (Metropolitan Museum, New York) has exactly the same attitude as the dog in Verrocchio's *Tobias* (Popham, *Drawings*, 1945, cat. no. 109A [illus.]).

18 Jex-Blake and Sellers, *Pliny's Chapters*, 1896, pp. 137–39. Leonardo also related how he had seen "dogs barking and trying to bite painted dogs" (*Leonardo on Painting*, ed. and trans. Martin Kemp and Margaret Walker, New Haven and London, 1989, p. 34). As Anna Cavina pointed out to me, Giacomo Balla's painting *Dynamism of a Dog in Motion* of 1912 (Virginia Dortch Dorazio, *Giacomo Balla: An Album of his Life and Work*, New York, n.d. [1969], nos. 59–62) raises the same timeless issues as Leonardo's conception.

19 "Only the thicker white lines... remain, making [the dog's form] seem less substantial than intended. But the artist's touch is delightfully evident here" (Dunkerton, Foister, Gordon, and Penny, *Giotto to Dürer*, 1991, no. 39, p. 314).

20 Identifiable as a carp by the characteristic barbels at the sides of the mouth, Leonardo's fish, as Smithsonian Curator Victor G. Springer has noted, adds an anal fin and lateral line to Pollaiuolo's.

21 Vasari, *Vite*, ed. Milanesi, vol. IV, 1879, p. 21; and Goldscheider, *Leonardo*, 1959, p. 12. For the letter that Andrea Corsali sent to Leonardo's patron Giuliano de' Medici in 1516, see Beltrami, *Documenti e memorie*, 1919, no. 229, p. 145. Leonardo's deep curiosity about natural phenomena should not be confused with St. Francis of Assisi's spiritual exaltation of birds and beasts as God's creation. Though united in their love of nature, Francis Christianized it (the wolf of Gubbio tamed by the sign of the cross) in a way that Leonardo would doubtless have found naive and foolish.

22 To Otto Pächt's fundamental study, "Early Italian Nature Studies and the Early Calendar Landscape," in *Journal of the Warburg and Courtauld Institutes*, vol. XIII, nos. 1–2, 1950, pp. 13–47, should be added Francis Ames-Lewis, *Drawing in Early Renaissance Italy*, New Haven and London, 1981, pp. 63–79; and Ames-Lewis and Wright, *Renaissance Workshop*, 1983, pp. 95–101; cat. no. 15, pp. 102–05; and cat. no. 17, pp. 108–10. See also

Gigetta Dalli Regoli, "Animal and Plant Representation in Italian Art of the Fourteenth and Fifteenth Centuries: An Approach to the Problem," in *Die Kunst und das Studium der Natur vom 14. zum 16. Jahrhundert*, ed. Wolfram Prinz and Andreas Beyer, Weinheim, 1987, pp. 83–89. The process by which such ancient authorities as Aristotle and Pliny were corrected by first-hand observation began in the thirteenth century with Albertus Magnus (*Man and the Beasts: De Animalibus [Books 22–26]*, trans. James J. Scanlan, Binghamton, NY, 1987). For an overview with reference also to medieval bestiaries see Francis Klingender, *Animals in Art and Thought to the End of the Middle Ages*, Cambridge, MA, 1971, pp. 439–94. The real and fanciful creatures illustrated in the bestiaries and the early printed books that derive from them are consistently shown in heraldic profile. The model-book artists conform to this tradition, except for Pisanello (1395–1455), the greatest animal interpreter before Dürer, who shared the northerner's deep curiosity about nature and whose album of life-studies in the Louvre was once thought to be by Leonardo. While Dürer rejected the bestiaries as unscientific (Colin Eisler, *Dürer's Animals*, Washington and London, 1991), Leonardo, with his keen interest in animal life and behavior, continued to consult them, even compiling one of his own from medieval sources.

23 On Uccello's nature studies see Vasari, *Vite*, ed. Milanesi, vol. II, 1878, pp. 208–09; and on Gozzoli's frescoes, Cristina Acidini Luchinat, *Benozzo Gozzoli: La Cappella dei Magi*, Milan, 1993. Pesellino's work in this vein for the Medici, now lost, can be imagined from the left-hand section of his *David and Goliath*, one of a pair of *cassone* panels dating from about 1450 on loan to the National Gallery, London (Dunkerton, Foister, Gordon, and Penny, *Giotto to Dürer*, 1991, pp. 89–90, 109–10 and fig. 145). Florentine artists also made model-books (Robert W. Scheller, *Exemplum: Model-Book Drawings and the Practice of Artistic Transmission in the Middle Ages (ca.900–ca.1470)*, trans. Michael Hoyle, Amsterdam, 1995, cat. no. 32, pp. 331–40; and cat. no. 36, pp. 371–80 and Roland Zentai, "Un livre de patrons d'animaux florentin au Musée des Beaux-Arts," in *Bulletin du Musée Hongrois des Beaux-Arts*, no. 40, 1973, pp. 25–39). The animal motifs found in model-books and paintings, finally, were echoed in contemporary prints (Hind, *Early Italian Engraving*, 1938, Part I, vol. I, cat. nos. A.II.1 and 2, pp. 61–62; and vol. II, plates 86 and 87).

24 E. H. Gombrich, "Tobias and the Angel," in his *Symbolic Images: Studies in the Art of the Renaissance*, London, 1972, pp. 28–29 (26–30).

25 The author benefited greatly from examining the picture in the National Gallery conservation laboratory on February 19 and 21, 1992, and again on May 15, 1992, with Nicholas Penny and David Bomford, whose microphotographs illustrate the text. Gallery records

state that the painting was restored at the time of its acquistion in 1867. Then after undergoing a series of minor treatments, it was cleaned and restored once more in 1966. Strips have been added to the sides of the original panel, measuring about 1 cm. on the left and 2 cm. on the right. The condition of the paint is good with only scattered losses and some abrasion of the shadows in the angel's flesh tones. Small flake losses in the figures and animals do not affect the arguments advanced in the text.

26 On the issue of shell gold, so-called because the paint was contained in a shell, see Francis Ames-Lewis, "Matteo de' Pasti and the Use of Powdered Gold," in *Mitteilungen des kunsthistorischen Institutes in Florenz*, vol. XXVIII, no. 3, 1984, pp. 351–61. The technique, which took the place of gilding, came into Tuscan painting around the mid-fifteenth century.

27 Richter, *Literary Works*, 1970, vol. I, no. 501, p. 309. Vasari claimed that Ghirlandaio was the first to use yellow paint instead of gold (*Vite*, ed. Milanesi, vol. III, 1878, p. 257). Passavant excepts Leonardo from the Verrocchio shop practice of mixing the use of gold and yellow (*Verrocchio*, 1959, p. 199 note 321).

28 Alberti, *On Painting*, ed. Grayson, 1972, pp. 92–93. See also: Baxandall, *Painting and Experience*, 1972, pp. 14–23 (tracing Alberti's influence on artists' contracts); and Dunkerton, Foister, Gordon, and Penny, *Giotto to Dürer*, 1991, pp. 207–08 (citing Leonardo as the first to heed Alberti's admonition).

29 The "pomegranate" pattern (a collective term designating a variety of floral designs, including thistles and pine cones) of Raphael's sleeve is particularly close to one illustrated in Herald, *Renaissance Dress*, 1981, fig. 39. For the decoration of the garments in the Berlin *Madonna*, Verrocchio also used yellow pigment (later touched up with gold).

30 The x-radiograph confirms the difference visible on the surface, namely, the design of Raphael's brocade is clearly visible, while that of Tobias is painted freely over a preparation using white lead. The laces of the sleeve unfastened at the elbow to facilitate the boy's fishing also suggest how such a garment would look if worn.

31 Claude Phillips ("Verrocchio or Leonardo da Vinci?," in *Art Journal*, vol. LXII, no. 170, 1899, p. 38 [33–39]) and Adorno (*Verrocchio*, 1991, p. 115) both claimed that the Uffizi study for an angel's head (Fig. 19) served for Raphael in the London painting, but the dimensions do not agree. The facial type and expression are the same, however.

32 In place of the hat Pollaiuolo gave his Tobias, the youth in the London panel has a slight glory of radiating gold lines behind his head to indicate that he is blessed.

33 Alberti, *On Painting*, ed. Grayson, 1972, p. 87. Compare Leonardo's own advice to "depict hair which an imaginary wind causes

to play about youthful faces" (Leonardo da Vinci, *Treatise on Painting*, ed. A. Philip McMahon, 2 vols., Princeton, 1956, vol. I, no. 442, pp. 163–64). See also *Leonardo on Painting*, ed. and trans. Kemp and Walker, 1989, p. 227.

34 The matter of left-handedness in Leonardo's drawings is discussed by Clark in *Drawings*, 1968, vol. I, p. xvii. The issue is more complicated in painting where brushstrokes describe a variety of forms rather than having an independent character of their own. To be fully indicative of Leonardo's hand, the brushwork in all the pictures by or attributed to him would need to be analyzed and correlated with other evidence of authorship. It is clear in any case that Leonardo did not paint uniformly with the left hand in the sense of his so-called mirror writing. Not all of his brushstrokes are recognizably left-handed, but the few such hatchings evident under a microscope presumably indicate his presence in the work in question.

35 The list on fol. 324 recto of the Codex Atlanticus was published by Richter in *Literary Works*, 1970, vol. I, no. 680, pp. 387–88, and it was analyzed by Kemp in Kemp and Roberts, *Leonardo*, 1989, pp. 42–48. The items in question are: "a head, full face, of a young man with fine flowing hair; a head, full face, with curly hair; and a head in profile with fine hair."

36 The Milanese pupil of the master known as Salai was a "graceful and beautiful youth with fine curly hair, in which Leonardo greatly delighted," according to Vasari (*Vite*, ed. Milanesi, vol. IV, 1879, pp. 37–38; and Goldscheider, *Leonardo*, 1959, p. 19). The boy's likeness is supposedly preserved in a series of drawings of curly-haired youths by Leonardo's own hand.

37 Passavant's chapter on the *Tobias* discusses at great length the place of the picture in the iconographic tradition to which it belongs (*Verrocchio*, 1959, pp. 109–14, 150–51), particularly in relation to the *Three Archangels* now in the Uffizi. That work was previously regarded as the prime version of which the London panel was a variant. Correcting Ernst Kühnel (*Francesco Botticini*, Strasbourg, 1906, pp. 43–62), Passavant established the originality and priority of Andrea's picture with respect to Botticini's numerous depictions of the theme, which take both the London *Tobias* and Pollaiuolo's prototype as models. Filippino Lippi's various treatments of the subject echo the work of all three artists. Accessible as it was on the altar of the Compagnia dell'Arcangelo Raffaelle (called "Il Raffa") in the church of Santo Spirito, Botticini's painting competed successfully with Verrocchio's for influence. Though the *Three Archangels*, variously dated between 1467 and 1477 (Anna Padoa Rizzo, "Per Francesco Botticini," *Antichità viva*, vol. XV, no. 5, 1976, p. 8 [3–19]; Creighton Gilbert, "Peintres et menuisiers au début de la Renaissance en

Italie," in *Revue de l'art*, no. 37, 1977, p. 25 [9–28]; and Venturini, *Botticini*, 1994, cat. no. 23, p. 108, and plate II), provides only an approximate *terminus ante quem* for the London panel, Neri di Bicci's version of the theme in the Detroit Institute of Arts (Thomas, *Practice*, 1995, pp. 312–13 and fig. 93), which echoes both Verrocchio's and Botticini's treatments, is dated 1471, placing the London panel in the period of Leonardo's apprenticeship.

38 In the *St. Sebastian and a Franciscan Saint* in the Musée des Beaux-Arts, Nantes (Scarpellini, *Perugino*, 1984, cat. no. 26, p. 75, and fig. 28), Perugino derived the youthful figure from the *Tobias*, as well as Pesellino's *Trinity* altarpiece, both in the National Gallery, London. The *Tobias* derivation is clearer in two of the San Bernardino panels (Scarpellini, figs. 17 and 18), by or closely associated with the Umbrian artist when in Verrocchio's shop. The *Tobias* was echoed by another assistant, Ghirlandaio, in his *Meeting of the Young Christ and St. John* in the Gemäldegalerie, Berlin, ascribed to the young Leonardo by Valentiner ("Über Zwei Kompositionen Leonardos," in *Jahrbuch der preuszischen Kunstsammlungen*, vol. LVI, 1935, pp. 213–27 and esp. fig. 5 [213–30]).

39 The documentary evidence for Leonardo as a sculptor was collected by Maria Vittoria Brugnoli in her "Documenti, notizie e ipotesi sulla scultura di Leonardo," in *Leonardo: Saggi e richerche*, ed. Achille Marazza, Rome, 1954, pp. 359–89 (pp. 375–82 are on the relation between Verrocchio and Leonardo). In the famous letter of self-recommendation to Ludovico Sforza, Leonardo claimed to be capable of "sculptura di marmore, di bronzo, e di terra" (Richter, *Literary Works*, 1970, vol. II, no. 1340, p. 326; and *Leonardo on Painting*, ed. and trans. Kemp and Walker, 1989, p. 252), and the list of works the artist took to Milan accordingly includes "una storia di Passione fatta in forma [meaning a relief or mold]" (Richter, as above; and vol. I, no. 680, p. 388). Later in discussing the superiority of painting over sculpture, Leonardo professed to have experience "non meno in iscultura che in pittura e faciendo l'una e l'altra in un medesimo grado" (Richter, vol. I, no. 655, p. 369).

40 Vasari, *Vite*, ed. Milanesi, vol. IV, 1879, p. 19: Leonardo "operò nella scultura, facendo nella sua giovanezza di terra alcune teste di femine che ridono, che vanno formate per l'arte di gesso, e parimente teste di putti che parevano usciti di mano d'un maestro."

41 Clark plausibly connected two studies of an infant at Windsor with Lomazzo's mention of a terracotta bust of the Christ Child by Leonardo (*Drawings*, 1968, vol. I, no. 12519, p. 92; and no. 12567, p. 108). The vast majority of Leonardo's drawings associated with sculpture are for the two equestrian monuments that occupied him in Milan.

42 After Bode's failed attempt to reconstruct Leonardo's early activity as a sculptor ("Leonardo als Bildhauer," in *Jahrbuch der*

königlich preussischen Kunstsammlungen, vol. XXV, 1904, pp. 125–41), Venturi took up the challenge in a series of studies in the 1920s and 1930s, in which he sought to credit whatever is most innovative about Verrocchio's sculpture to the young Leonardo ("Leonardiana," in *L'arte*, vol. XXVIII, nos. 4–5, 1925, pp. 137–52; "Leonardo scultore nella bottega del Verrocchio," in *Nuova antologia*, vol. LXIX, March 1934, pp. 34–39; and *Storia*, vol. X, part I, 1935, pp. 1–36). Venturi's attributions were based less on an appraisal of the works in question than on the low estimate of Verrocchio he shared with Vasari. Now that Andrea is recognized for the extraordinary master that he was, Leonardo's participation in his most famous works seems more doubtful than ever. The younger artist's role cannot be established according to the usual criterion of greater or lesser quality. The latter applies to large-scale projects like the Forteguerri monument for which Verrocchio turned to assistants whose skills were manifestly inferior to his own, but not to anything Leonardo might have produced in the shop. Nor do compositional patterns or motifs which Leonardo shares with Andrea form a basis for distinguishing the pupil's hand (Raymond S. Stites, "Leonardo da Vinci Sculptor," in *Art Studies*, vol. IV, 1926, pp. 103–09; vol. VI, 1928, pp. 73–77; and vol. VIII, 1930, pp. 289–300; "Leonardo scultore e il busto di Giuliano de' Medici del Verrocchio," in *Critica d'arte*, vol. X, 1963, nos. 57–58, pp. 1–32; and nos. 59–60, pp. 25–38; and *The Sublimations of Leonardo da Vinci*, Washington, 1970, pp. 17–18, 68, 70–71, 74–78, and 86–87 [the author's unwarranted psychologizing lends little credence to his attributions]). Equally unreliable as a touchstone is the smiling expression, which is not unique to Leonardo (Pope-Hennessy, "The Virgin with the Laughing Child," in his *Essays on Italian Sculpture*, London and New York, 1968 [orig. ed., Victoria and Albert Museum, London, 1949], pp. 72–77 [as Antonio Rossellino]). The theoretical basis for Leonardo's sculpture – the interest he took in it – has been analyzed by Kemp (*Leonardo e lo spazio dello scultore*, Lettura Vinciana no. XXVII, 1987, Florence, 1988) and Pedretti ("A Proem to Sculpture," in *Achademia Leonardi Vinci*, vol. II, 1989, pp. 11–39 [with bibliography pp. 131–47]), and this may provide a framework for further attributions. Kemp (p. 22 and fig. 29) and Pedretti (p. 37 and figs. 48–49) both tentatively ascribe a terracotta *Bust of the Youthful Christ* to the artist, which appears more convincing as his work than do the attributions advanced by Alessandro Parronchi ("Nuove proposte per Leonardo scultore," in *Achademia Leonardi Vinci*, vol. II, 1989, pp. 40–67) on the belief that Verrocchio's apprentice worked in the manner of Donatello and Desiderio.

43 Vasari, *Vite*, ed. Milanesi, vol. II, 1878, pp. 370–414. See also *Libro*, ed. Frey, 1892, p. 40; and Anonimo Gaddiano, *Codice*, ed. Frey,

1892, pp. 76, 90. Vasari's sources specifically credit Verrocchio with the ornamentation of the lavabo, the significant part here. Parronchi has tried to revive the Donatello attribution ("L'arpia svela: è Donatello," in *La nazione*, Jan. 4, 1991).

44 Hans Mackowsky, the first to discuss the wash-basin in detail ("Das Lavabo in San Lorenzo zu Florenz," in *Jahrbuch der königlich preussischen Kunstsammlungen*, vol. XVII, 1896, pp. 239–44), claimed it was conceived and executed in two styles by two different artists and their shops. Rossellino, whom Albertini (*Memoriale*, 1510) named as author of the work, did the wall section, while Andrea, according to Mackowsky (see also his *Verrocchio*, 1901, pp. 29–32), designed the projecting elements of the monument, leaving their execution to an assistant. The idea of dual authorship, going back to the early sources and based on a perceptible gap between the sections in high and low relief, runs through the subsequent literature. Comparing the coloristic treatment of the back panel to the tombs of Cosimo de' Medici and of his sons in San Lorenzo, Planiscig, however, ascribed the entire monument to Andrea (*Verrocchio*, 1941, pp. 15–17, 48). Pope-Hennessy called it his "earliest marble sculpture" (*Italian Renaissance Sculpture*, 2nd ed., London, 1971, p. 293). Seymour (*Verrocchio*, 1971, pp. 116–18, 165) allotted parts of the background and of the basin to helpers, as Cruttwell (*Verrocchio*, 1904, pp. 72–75) had done. Adorno (*Verrocchio*, 1991, p. 42) also gives the work to Andrea with assistance. In keeping with his view that Verrocchio was not a marble carver, Cannon-Brookes (in *Apollo*, 1974, pp. 14–15, 17–18) simply designated the "strange assemblage" as "mid-fifteenth-century Florentine."

45 About lavabos in general see: Hilda Weigelt, "The Minor Fountains of Florence," in *International Studio*, vol. XCIV, no. 391, 1929, pp. 87–90, 122; and Bertha Harris Wiles, *The Fountains of Florentine Sculptors and their Followers from Donatello to Bernini*, Cambridge, MA, 1933, pp. 6–7. Sacristy fountains, like those by Andrea Cavalcanti (known as Buggiano), dating from the early 1440s, in the cathedral are based on tabernacles or tombs. The lavabo in the Badia of Fiesole by Gregorio di Lorenzo, dated 1461, combines an arrangement similar to Verrocchio's with the traditional type of architectural surround.

46 Among modern writers, Passavant is practically alone in denying the lavabo to Andrea (*Complete Edition*, 1969, pp. 41–42 and cat. no. A4, pp. 197–99). He claimed that, as a composite work converted to church use, it included the base said to have been carved by Desiderio for Donatello's bronze *David* ("Beobachtungen am Lavabo von San Lorenzo in Florenz," in *Pantheon*, vol. XXXIX, no. 1, 1981, pp. 33–50). His account of how the lavabo came into being, while based on careful observation of the work *in situ*, was rejected as unconvincing by both Covi (in *Art*

Bulletin, 1972, pp. 91, 94; and 1983, p. 271 note 138; and in *Verrocchio*, ed. Bule, Darr, and Superbi Gioffredi, 1992, pp. 9–10); and Pope-Hennessy (*Italian Renaissance Sculpture*, 3rd rev. ed., Oxford, 1985, p. 357). The lavabo, while indebted to Desiderio, is not in his style. According to Francesco Guerrini (*La Sagrestia Vecchia di S. Lorenzo*, Florence, 1986, pp. 27–28), moreover, the small room adjoining the "scarsella" was used as a sacristy from the beginning.

47 Seymour, *Verrocchio*, 1971, pp. 116–18, 165.

48 Francis Ames-Lewis, "Early Medicean Devices," in *Journal of the Warburg and Courtauld Institutes*, vol. XLII, 1979, pp. 134–40 (122–43); and Ames-Lewis, *The Library and Manuscripts of Piero di Cosimo de' Medici*, Garland Series of Outstanding Dissertations, New York and London, 1984, pp. 78–90. On Piero's device as it appears on the lavabo see Franco Cardini, "Le insegne laurenziane," in *Le tems revient: 'L tempo si rinuova: feste e spettacoli nella Firenze di Lorenzo il Magnifico*, ed. Paola Ventrone, Exhibition Catalogue, Palazzo Medici Riccardi, Florence, Milan, 1992, p. 67 (55–74).

49 The view of Piero as a patron advanced by E. H. Gombrich ("The Early Medici as Patrons of Art," in his *Norm and Form: Studies in the Art of the Renaissance*, London, 1966, pp. 35–57) is undergoing revision. See Ames-Lewis, "Art in the Service of the Family. The Taste and Patronage of Piero di Cosimo de' Medici," in *Piero de' Medici 'il Gottoso' (1416–1469)*, ed. Andreas Beyer and Bruce Boucher, Berlin, 1993, pp. 207–20. Lorenzo Gnocchi ("Le preferenze artistiche di Piero di Cosimo de' Medici," in *Artibus et historiae*, vol. XVIII, no. 18, 1988, pp. 41–78) deduces much from works not necessarily ordered by Piero.

50 For the decoration of this Aristotle manuscript in the Biblioteca Laurenziana, see Annarosa Garzelli, *Miniatura fiorentina del Rinascimento 1440–1525: Un primo censimento*, 2 vols., Florence, 1985, vol. I, pp. 176–78, and vol. II, fig. 503. Differently from Andrea's, the sphinxes on Pollaiuolo's reliquary cross in the Opera del Duomo, on Desiderio's Marsuppini monument, and in a Florentine engraving (Hind, *Early Italian Engraving*, 1938, Part I, vol. I, cat. no. A.II.11, pp. 67–68 [citing the lavabo]; and vol. II, plate 96) all have bird's wings. The same holds true for the sphinxes of the Prato Cathedral pulpit, whose attribution to Verrocchio by Pope-Hennessy (in "Deux Madones en marbre de Verrocchio," in *Revue de l'art*, no. 80, 1988, p. 21 [17–25]) was rightly rejected by Adorno (*Verrocchio*, 1991, p. 40).

51 See Wiles, *Fountains*, 1933, fig. 8–10.

52 Ames-Lewis, *Library*, 1984, pp. 209–10, 225, and as typical examples cat. nos. 84–85 (Piero's Pliny manuscripts), pp. 330–33. The author associates the fauna of mid-century decorated borders with those in Gozzoli's frescoes in the Medici palace.

53 Lucia Tongiorgi Tomasi in *Disegno fiorentino*, ed. Petrioli Tofani, 1992, cat. no. 9.4, p. 183.

54 The model for Verrocchio's falcon is found on the Crucifixion tabernacle in San Miniato (Adorno, *Verrocchio*, 1991, p. 41 and fig. 24).

55 Seymour, *Verrocchio*, 1971, p. 118 and figs. 130, 131. Compare also the lions by Donatello cited by Passavant (in *Pantheon*, 1981, p. 45); Ghiberti's lions' heads praised for their realism by Pope-Hennessy ("The Sixth Centenary of Ghiberti," in his *The Study and Criticism of Italian Sculpture*, New York, 1980, pp. 45–46 and fig. 7 [39–70]); and the example in the Quartiere di Eleanora in the Palazzo della Signoria (photo Brogi 17306). Smithsonian Curator Charles Handley kindly pointed out that the lion on the lavabo incorporates such well-observed features as spotted jowls, broad nose, contracted forehead muscles, and irregularly fringed ears, together with a gracefully unrealistic mane.

56 Jerome's lion in the Argiano *Crucifixion* was repainted like much of the rest of the painting, according to Passavant (*Verrocchio*, 1959, p. 129).

57 See: Gustave Loisel, *Histoire des ménageries de l'antiquité a nos jours*, 3 vols., Paris, 1912, vol I, pp. 152–53, 198–99; and Maria Matilde Simari, "Menageries in Medicean Florence," in *Natura viva. Animal Paintings in the Medici Collections*, ed. Marilena Mosco, Florence, 1985, p. 27 (27–29). Leonardo counted "twenty-five to thirty" caged lions, one of which he observed devouring a lamb (Edward MacCurdy, *The Notebooks of Leonardo da Vinci*, 2 vols., London, 1956, vol. II, p. 475).

58 The lion's head on the lavabo also resembles the docile creature accompanying Hercules in a late drawing which Carlo Pedretti has restored to Leonardo (*Disegni di Leonardo da Vinci e della sua scuola alla Biblioteca Reale di Torino*, Florence, 1975, cat. no. 8, pp. 21–23). The lion in the drawing (inv. no. 15630) turns its head and flexes a forepaw, as do the dog in the London *Tobias* and the ermine in the Kraków portrait. Compare also the full-face lion's head on a sheet at Windsor (Clark, *Drawings*, 1968, vol. I, no. 12586 verso, p. 116).

59 As cited in Tommaso's inventory, the original base of Verrocchio's bronze *Putto with a Dolphin* included four "boche dj lione dj marmo." Passavant has rejected attempts to identify this motif with the three lion's heads decorating the Cinquecento statue base in the courtyard of the Palazzo della Signoria (*Complete Edition*, 1969, cat. no. 6, pp. 174–75) and with the fountain from the Medici villa at Castello, now in the Palazzo Pitti, connected by Seymour (*Verrocchio*, 1971, p. 162) with the *Putto* (Passavant, review of Seymour in *Burlington Magazine*, vol. CXVII, no. 862, 1975, p. 56 [55–56]). The lost carvings were presumably imbued with the same spirit as the lion's head on the lavabo. With the mechanical lion he constructed late in his career for Francis I, King of France, Leonardo used actual movement to heighten the illusion of vitality (Giambattista De Toni, *Le Piante e gli Animali in Leonardo da Vinci*, Bologna, 1922, pp. 119–21).

60 See Passavant, *Complete Edition*, 1969, p. 42 and cat. no. A4, pp. 197–99; and in *Pantheon*, 1981, pp. 33–50. Cannon-Brookes argued that the dragons' and lion's heads of the vase and basin once held metal rings and that the shaft above them was inserted later, at which time the original dragons' heads attached to it were broken off (in *Apollo*, 1974, pp. 14–15). Parronchi (in *La nazione*, 1991) interpreted the three heads (for him a wolf, lion, and dog) as an allegory of Time and Prudence, like that of Titian's painting in the National Gallery, London (where, however, the heads are juxtaposed); he meant to discuss the dragons in another essay which was apparently never published. Whether the dragons' heads originally served as water spouts or not has no bearing on the question of their authorship.

61 Pietro Ruschi, "Troppe mani sul lavamano," in *Giornale dell'arte*, no. 87, March 1991, p. 63. Ruschi, who directed the restoration for the Soprintendenza per i Beni Ambientali e Architettonici, kindly facilitated my study of the lavabo.

62 Carlo Del Bravo, *Scultura senese del Quattrocento*, Florence, 1970, pp. 79–80 and fig. 261.

63 About dragons in general see Louise W. Lippincott, "The Unnatural History of Dragons," in *Philadelphia Museum of Art Bulletin*, vol. LXXVII, no. 334, 1981, pp. 2–24. An example of the standard type occurs in a Florentine engraving of an Animal Combat, dating from about 1460 (Hind, *Early Italian Engraving*, Part I, vol. I, 1938, cat. no. A.II.2, and vol. II, plate 87). A similar winged two-legged creature illustrates Conrad Gesner's *Historia animalium* of 1587 (Uwe Steffen, *Drachenkampf: Der Mythos vom Bösen*, Stuttgart, 1984, fig. 1).

64 Vasari, *Vite*, ed. Milanesi, vol. III, 1878, p. 294. Lippincott reproduces a dog-like dragon from a Flemish manuscript of *c.* 1460 (in *Philadelphia Bulletin*, 1981, fig. 8).

65 Despite the somewhat more wolf-like appearance of the animal on the left, both dogs seem to belong to the same breed, according to Smithsonian Curator Charles Handley. The knobs and mane pertain to their nature as dragons. The unusual dog-headed knockers of the sacristy doors may, as Philipp Fehl claims, be overlooked works by Andrea ("Verrocchio's Tomb of Piero and Giovanni de' Medici: Ornament and the Language of Meaning," in *Italian Echoes*, ed. Matteo, Noble, and Sowell, 1990, pp. 50–51 [47–60]). The intarsiated doors feature a candelabrum motif combining features of both the lavabo and the tomb. Adjacent to the canine knockers are pairs of wings extending over vases in the manner of the lavabo dragons. As Margaret Haines kindly confirmed for me, the doors are doubtless contemporary with the sacristy.

66 See: Matteo Marangoni, *La Basilica di S. Lorenzo in Firenze*, Florence, 1922, p. 31;

Anna Maria Brizio, "Per il quinto centenario verrocchiesco," in *Emporium*, vol. LXXXII, no. 24, 1935, p. 296 (293–303); and Planiscig, *Verrocchio*, 1941, p. 17.

67 Clark, *Drawings*, 1968, vol. I, pp. 8–9, no. 12282 recto.

68 Compare especially the *Head of a Bear*, which belongs to the same series as the *Bear Walking* in the Metropolitan Museum, New York (Kemp in Kemp and Roberts, *Leonardo*, 1989, cat. no. 37, p. 96).

69 Richter, *Literary Works*, 1970, vol. I, no. 585, p. 342: "You know that you cannot invent animals without limbs, each of which, in itself, must resemble those of some other animal. Hence if you wish to make an animal, imagined by you, appear natural – let us say a dragon, take for its head that of a mastiff or hound, with the eyes of a cat, the ears of a porcupine, the nose of a greyhound, the brow of a lion, the temples of an old cock, the neck of a water-tortoise." Pedretti dates this passage in MS B.N. 2038 fol. 29 recto, *c.* 1490–92 (*Commentary*, 1977, vol. I, no. 585, p. 349. It recurs in Leonardo's *Treatise on Painting,* ed. McMahon, 1956, vol. I, no. 554, p. 199. See also *Leonardo on Painting*, ed. Kemp and Walker, 1989, p. 224.

70 About the drawing see: Clark, *Drawings*, 1968, vol. I, no. 12370 recto, p. 51 (noting the Verrocchiesque cuirass on the verso); and Pedretti in Carlo Pedretti and Jane Roberts, *Leonardo da Vinci: Drawings of Horses and Other Animals from the Royal Library at Windsor Castle* (Exhibition Catalogue, National Gallery of Art, Washington, 1985), New York, 1984, cat. no. 7A, pp. 36–37. Kemp finds evidence beyond the "snarling head of a dog" that Leonardo adopted the combinatory principle for his dragon (in Kemp and Roberts, *Leonardo*, 1989, cat. no. 84, p. 158; and Kemp, "Leonardo da Vinci: Science and the Poetic Impulse," in *Royal Society of Arts Journal*, vol. CXXXIII, no. 5343, 1985, pp. 206–07 [196–213]).

71 Compare the crouching dragons (and cats and horses) on two much later sheets at Windsor (Clark, *Drawings*, 1968, vol. I, no. 12331, pp. 29–30; and no. 12363, p. 49). See also about these drawings: Kemp in Kemp and Roberts, *Leonardo*, 1989, cat. no. 71, pp. 144–45; and cat. no. 38, pp. 96–97. Brigit Blass-Simmen (*Sankt Georg: Drachenkampf in der Renaissance. Carpaccio–Raffael–Leonardo*, Berlin, 1991, pp. 101–34) stresses the serpentine movement of Leonardo's dragons. The artist took up the theme of dragon combats both early (Arthur Ewart Popham, "The Dragon-Fight," in *Leonardo*, ed. Marazza, 1954, pp. 223–27) and late in his career. The majority of his dragons have the usual type of head with a long snout.

72 Vasari, *Vite*, ed. Milanesi, vol. IV, 1879, p. 46; and Goldscheider, *Leonardo*, 1959, p. 21.

73 Richter, *Literary Works*, 1970, vol. I, no. 660, pp. 371–72: young Giotto "began by drawing . . . the movements of the goats of which he was the keeper. And thus he began

to draw all the animals which were to be found in the country, and in such wise that after much study he excelled not only all the masters of his time but all those of many bygone ages." This passage in the Codex Atlanticus (*Leonardo*, ed. Kemp and Walker, 1989, p. 193), dating from *c.* 1490, resembles Vasari's account of Giotto's formation given in chapter 1.

74 Venturi's claim that Leonardo was largely responsible for the tomb (*Storia*, vol. X, Part 1, 1935, pp. 20–25) was rightly rejected by Bertini (in *L'arte*, 1935, pp. 436–37 [433–72]) and Planiscig (*Verrocchio*, 1941, pp. 20–21), among others.

75 Recent writers on the tomb have identified sources for its precious reliquary-like character (Christine M. Sperling, "Verrocchio's Medici Tombs," in *Verrocchio*, ed. Bule, Darr, and Superbi Gioffredi, 1992, pp. 55–61 [51–61]) and its chromaticism (Sheard in *Verrocchio*, ed. Bule, Darr, and Superbi Gioffredi, 1992, pp. 63–78).

76 Sheard (in *Verrocchio*, ed. Bule, Darr, and Superbi Gioffredi, 1992, pp. 86–90 [63–90]: "Excursus: The Tortoises on Verrocchio's Medici Tomb") interprets the animals as symbolic of the motto *festina lente* ("make haste slowly").

77 While Seymour found the naturalism of the tortoises characteristic of Andrea and his age (*Verrocchio*, 1971, p. 55 and fig. 45), the detail with which they are depicted (the blunt, jowelled head, for example, or the scutes, or scales, on the dome-shaped shell) and the way the animals' clawed forelegs are raised and their heads are turned are exceptionally accurate, according to Smithsonian Curator George R. Zug.

78 Fehl in *Italian Echoes*, ed. Matteo, Noble, and Sowell, 1990, p. 52. This method is more familiar, of course, in the work of Leonardo's contemporary, the Paduan bronze sculptor Riccio (Norberto Gramaccini, "Das genaue Abbild der Natur–Riccios Tiere und die Theorie des Naturabgusses seit Cennino Cennini," in *Natur und Antike in der Renaissance* (Exhibition Catalogue, Museum alter Plastik, 1985–86), Frankfurt, 1985, pp. 198–225).

79 Smithsonian Curator George Zug finds Pollaiuolo's (unfinished?) tortoises amorphous compared with the ones more accurately rendered on Verrocchio's monument. Though Antonio's statuette is usually dated to the mid-1470s and associated with Lorenzo the Magnificent (Beatrice Paolozzi Strozzi in *Eredità del Magnifico*, ed. Barocchi, Caglioti, Gaeta Bertelà, and Spallanzani, 1992, cat. no. 3, pp. 12–15 [with bibliography]), there seems no reason why this seminal work could not have been made around 1470.

80 Professor Lucia Tongiorgi Tomasi has kindly identified the following species in the wreath on the chapel side of the tomb (clockwise from the bottom): strawberries, chestnut, poppies, grapes, pine cones, broad beans,

Alder, pear, Medlar, and oak with acorns. The plants in the sacristy-side wreath are the same, but they appear in a somewhat different order.

81 For Verrocchio's debt to Vittorio Ghiberti's framing of Andrea Pisano's doors, see: Planiscig, *Verrocchio*, 1941, p. 20; and Pope-Hennessy in *Times Literary Supplement*, Nov. 13, 1969. Modeled on his father's two previous door frames, Vittorio's work was in progress between 1456 and 1463 (Krautheimer, *Ghiberti*, 1970, vol. I, pp. 212–13; and vol. II, pp. 420–21). For all their realism, however, Vittorio's vegetative motifs are essentially variants in high relief of Lorenzo's, which draw upon late Gothic botanical designs like the animal studies discussed. on pp. 51–52. Wolfram Prinz, nevertheless, sees the keenly-observant Lorenzo as a precursor for Leonardo ("Die Kunst und das Studium der Natur im 14. und 15 Jahrhundert in Italien," in *Die Kunst und das Studium der Natur vom 14. zum 16. Jahrhundert*, ed. Wolfram Prinz and Andreas Beyer, Weinheim, 1987, pp 9–11 [5–16]). True, the elder Ghiberti loved nature, unlike Verrocchio, but his plant and animal depictions, however lifelike in context, look stylized compared with Leonardo's (including the wreaths). Significantly, the heightened realism of Vittorio's framework may be due in part to Andrea's arch-rival Antonio Pollaiuolo. Vasari and his sources credit Pollaiuolo with the figure of a quail represented on the left side of the framework of the second doors or "Gates of Paradise" (accepted by Ettlinger, *Pollaiuolo*, 1978, pp. 14–15, cat. no. 19, and fig. 1). But if he worked for the Ghiberti, Antonio is perhaps more likely to have assisted Vittorio (Krautheimer, *Ghiberti*, 1970, vol. I, p. 213). If one assumes that Pollaiuolo first distinguished himself as a naturalist in the Ghiberti shop, there is all the more reason for Verrocchio to wish to emulate the work produced there.

82 Pinin Brambilla Barcilon and Pietro C. Marani, *Le lunette di Leonardo nel Refettorio delle Grazie*, Quaderni del Restauro no. 7, ed. Renzo Zorzi, Milan, 1990. Passavant considered that "in the bronze decoration of the Medici sarcophagus Verrocchio's imitation . . . of natural forms blazed the trail for Leonardo. . . ." (*Complete Edition*, 1969, p. 14), thereby imputing the pupil's achievement to the master. The foliate frieze of the tomb of Bishop Donato de' Medici, undertaken by the Verrocchio shop around 1474 in Pistoia Cathedral, has a naturalistic character that (in view of the present argument) may also reflect Leonardo's plant studies (Dalli Regoli, "Una *Sepoltura* di Andrea del Verrocchio: Note sui rapporti tra figuralità e astrazione nella scultura toscana del XV secolo," in *La scultura decorativa del Primo Rinascimento*, Atti del I Convegno Internazionale di Studi, Università di Pavia, 1980, Pavia, 1983, pp. 67–74 and figs. 5–8).

83 Seymour, *Verrocchio*, 1971, p.118; Passavant in

84 Vasari mentions two large dishes Verrocchio ornamented with "animali ed altre bizzarrie" (*Vite*, ed. Milanesi, vol. III, 1878, p. 358), in the planning of which Leonardo might also have had a hand.

85 Ellen Callmann, *Apollonio di Giovanni*, Oxford, 1974.

86 Vasari, *Vite*, ed. Milanesi, vol. III, 1878, pp. 373–75.

87 Fahy, *Ghirlandajo*, 1976, pp. 31–45; and Pons, "Precisazioni su tre Bartolomeo di Giovanni: Il Cartolaio, il Sargiaio e il Dipintore," in *Paragone*, vol. XLI, nos. 479–81, 1990, pp. 115–28.

88 Nicole Dacos and Caterina Furlan, *Giovanni da Udine 1487–1561*, 3 vols., Udine, 1987, vol. I, pp. 9–33.

89 Richter, *Literary Works*, 1970, vol. I, no. 37, p. 91; and Leonardo, *Treatise on Painting*, ed. McMahon, 1956, vol. I, no. 51, pp. 36–37.

90 "Consiglio" was what Leonardo later offered to his disciple Rustici, who reportedly used it to create the bronze figures over the north doors of the Baptistery (Vasari, *Vite*, ed. Milanesi, vol. IV, 1879, p. 50). By this time of course Leonardo's advice went beyond studies from nature.

91 Vasari, *Vite*, ed. Milanesi, vol. III, 1878, p. 361.

92 Vasari implied as much when he stated (*Vite*, ed. Milanesi, vol. III, pp. 301–62) that it was partly on the basis of these reliefs that Verrocchio was awarded the commission for Piero's tomb in 1469.

93 After wavering between Verrocchio and Leonardo, Bode settled on Francesco di Simone (imitating the lost bronze) as the author of the Louvre relief (*Studien über Leonardo da Vinci*, Berlin, 1921, pp. 28–32), and his suggestion gains plausibility from the Desiderio-like softness of its style. Emil Möller, preceded by Müntz, Mackowsky, and Reymond, opted for Leonardo ("Beiträge zu Leonardo da Vinci als Plastiker und sein Verhältnis zu Verrocchio," in *Mitteilungen des kunsthistorischen Institutes in Florenz*, vol. IV, nos. 1–2, 1933, pp. 138–39; and "Leonardo e il Verrocchio: Quattro rilievi di capitani antichi lavorati per Re Mattia Corvino," in *Raccolta vinciana*, vol. XIV, 1930–34, pp. 4–22 [4–38]), as did Parronchi in *Achademia Leonardi Vinci*, 1989, pp. 43–44 (40–67).

94 The exceedingly graceful style of the relief, which seemed Leonardesque, also led to the suspicion that it was a forgery (Brugnoli in *Leonardo*, ed. Marazza, 1954, p. 380). The related Renaissance stucco eliminates that possibility, however (Eric Maclagan, "A Stucco after Verrocchio," in *Burlington Magazine*, vol. XXXIX, no. 222, 1921, pp. 131–37; and Pope-Hennessy, *Catalogue of Italian Sculpture in the Victoria and Albert Museum*, 3 vols., London, 1964, vol. I, cat. no. 148, pp. 174–76; and vol. III, fig. 167 (as a plaster copy of Francesco di Simone's relief in the Louvre).

95 National Gallery of Art, Washington, no. 1956.2.1. The gift of Therese K. Straus, the relief, which supposedly reappeared in Hungary, measures 55.9 × 36.7 cm. (21 × 14½ in.). It is broken in several places, and pieces are missing, notably the dragon's neck, wing, and tail, as well as the gorgon's nose.

96 Planiscig, "Andrea del Verrocchios Alexander-Relief," in *Jahrbuch der kunsthistorischen Sammlungen in Wien*, vol. VII, 1933, pp. 89–96 (citing the Hungarian provenance on pp. 92–93); and Planiscig, *Verrocchio*, 1941, pp. 26–28, 50. Seymour De Ricci ("Une sculpture inconnue de Verrocchio," in *Gazette des Beaux-Arts*, 6th ser., vol. XI, 1934, pp. 244–45) and Möller (in *Raccolta Vinciana*, 1930–34, pp. 26–30 [4–38]), both agreed that this relief was one of the Corvinus gifts, though the latter appraised it negatively. For a complete survey of the literature up to 1963, see Jolán Balogh, *A Müvészet Mátyás Király Udvarában*, 2 vols., Budapest, 1966, vol. I, pp. 514–16. Covi (in *Art Bulletin*, 1966, p. 100; and in *Art Bulletin*, 1972, p. 91) and Pope-Hennessy (in *Times Literary Supplement*, 1969; and *Italian Renaissance Sculpture*, 2nd ed., 1971, pp. 293–94) also concurred in ascribing the relief to Verrocchio. A variant of the *Alexander*, a marble bust of a warrior attributed to Francesco di Simone Ferrucci, is in the Art Institute of Chicago (inv. no. 1968.2). Like the *Scipio*, this relief (illustrated in *Art Quarterly*, vol. XXXIII, no. 1, 1970, cover and p. 83) avoids Verrocchio's ambitious foreshortening in favor of a pure profile pose. Ascribed to Andrea at the time of its sale (Sotheby's, London, July 8, 1949, lot no. 2, pp. 5–11), the relief, rather, confirms the authenticity of the one by him in the National Gallery of Art, Washington. The conventional dragon and unrealistic lion's head ornamenting the warrior's armor contrast with their Leonardo-ideated counterparts on the lavabo.

97 Passavant, *Complete Edition*, 1969, pp. 42–44, and cat. no. A5, pp. 199–201; and Seymour, *Verrocchio*, 1971, p. 127, and cat. no. 25, pp 170–71. Passavant rejected the relief altogether, while Seymour found it puzzling; both regarded its breakage as suspicious.

98 Planiscig (in *Jahrbuch*, 1933, p. 92; and *Verrocchio*, 1941, p. 50) dated the relief *c.* 1480, likening it to the *Beheading of the Baptist*, installed in that year, and Adorno (*Verrocchio*, 1991, p. 176) makes the same comparison. Valentiner also favored a relatively late date for political reasons (*Italian Renaissance Sculpture*, 1950, pp. 126–27), as do Lajos Vayer ("Il Vasari e l'arte del Rinascimento in Ungheria," in *Il Vasari storiografo e artista*, Acts of the Conference, Arezzo and Florence, 1974, Florence, 1976, pp. 522–23 [501–32]) and Nancy Lodge ("A Renaissance King in Hellenistic Disguise: Verrocchio's Reliefs for King Matthias Corvinus," in *Italian Echoes*, ed. Matteo, Noble, and Sowell, 1990, pp. 38–40 [23–46]). Political circumstances, like the threat of a Turkish invasion, may well bear on

99 Planiscig (*Verrocchio*, 1941, p. 27) made both comparisons.

100 The iconographic type derives from the *uomini famosi* series of antique and biblical heroes, according to André Chastel (in *Memoires*, 1954, pp. 279–89; reprinted in his *Fables*, 1978, pp. 236–47). About the Verrocchio-associated prints see Hind, *Early Italian Engraving*, Part I, 1938, vol. I, cat. nos. A.I.55–57, pp. 47–48. For the place of the Washington relief in the Alexander iconography see Sabine Poeschel, "Alexander Magnus Maximus: Neue Aspekte zur Ikonographie Alexanders des Grossen im Quattrocento," in *Römisches Jahrbuch für Kunstgeschichte*, vol. XXIII–XXIV, 1988, pp. 68–69 (63–74).

101 Planiscig (in *Jahrbuch*, 1933, p. 91) already suggested an antique source. Lodge (in *Italian Echoes*, ed. Matteo, Noble, and Sowell, 1990, pp. 32–34 [23–46]) proposed a Hellenistic coin, as she did for the type of Alexander, who, however, is characteristically Verrocchiesque. The model for the triton group is more likely to have been an engraved gem or cameo. Piero de' Medici's inventory of 1464 includes a "corniuola legata in oro con uno homo, mezzo pesscie et una fanciulla in cavo" (Eugène Müntz, *Les collections des Médicis au XVe siècle*, Paris, 1888, p. 38) and Lorenzo de' Medici's inventory of 1492, a "corniuola leghata in oro intagl[i]ata di chavo, suvi uno mostro marino chon una femina in groppa" (*Libro d'inventario dei beni di Lorenzo il Magnifico*, ed. Marco Spallanzani and Giovanna Gaeta Bertelà, Florence, 1992, p. 36). These commonly framed sea creatures in a round format (Gisela M. A. Richter, *Engraved Gems of the Romans*, London, 1971, cat. nos. 227–28, p. 51; and cat. no. 713, p. 152). Federighi's holy water font in Siena Cathedral, already mentioned in connection with the lavabo in San Lorenzo, also includes a triton and nereid, comparable with Andrea's (Del Bravo, *Scultura*, 1970, fig. 262). Mantegna's contemporary engraving of the *Battle of the Sea Gods*, featuring a similar group, is based on a damaged relief fragment well known in Quattrocento Italy (Phyllis Pray Bober, "An Antique Sea-Thiasos in the Renaissance," in *Essays in Memory of Karl Lehmann*, ed. Lucy Freeman Sandler, New York, 1964, pp. 43–48). About sarcophagi as sources for marine creatures like Verrocchio's, see Bober and Ruth Rubenstein, *Renaissance Artists & Antique Sculpture: A Handbook of Sources*, Oxford, 1986, pp. 130–35.

102 The relief has been given to Leonardo by Susan V. Lenkey (*An Unknown Leonardo Self-Portrait*, Stanford, CA, 1963), who tried to identify one of the six little heads decorating the flaps below the shoulder-guard as a self-portrait of the artist, and by Michael Hall ("Reconsiderations of Sculpture by Leonardo da Vinci: A Bronze Statuette in the J. B. Speed Art Museum," in *J. B. Speed Art*

the date the gift was made but should not be used to establish the time of its inception.

Museum Bulletin, vol. XXIX, 1973, p. 14 note 3 [7–59]). The shell and other similar motifs ornament the armor Leonardo gave a warrior in his *Battle of Anghiari*.

103 The widely reproduced copy in the Kaiser-Friedrich Museum, Berlin (Allan Marquand, *Giovanni della Robbia*, Princeton, 1920, cat. no. 218, p. 214) was destroyed during the Second World War, as Dr. Volker Krahn informed me in a letter of May 5, 1992. Even closer to Leonardo's drawing, however, is the version I studied in the Museu Nacional de Arte Antiga, Lisbon, in 1991, photographs of which were kindly provided by Rafael Calado. Both the drawing and this terracotta give Darius a winged helmet. Möller's "reconstruction" of a lost Verrocchio original, based on the Lisbon example, which he labelled "Annibali" (in *Raccolta Vinciana*, 1930–34, pp. 33–35 and fig. 12), has wrought havoc in the literature on the problem: several authors confused the hypothetical Hannibal with the Lisbon relief, which bears no inscription (Vayer in *Vasari*, 1976, p. 513 [501–32]; and Lodge in *Italian Echoes*, 1990, pp. 30–31, and 41 note 2).

104 About the drawing (inv. no. 1895-9-15-474), which measures 28.5 × 20.8 cm. (11 1/4 × 8 1/2 in.), see Popham and Pouncey, *Italian Drawings*, 1950, vol. I, cat. no. 96, pp. 57–58; and Flavio Caroli, *Leonardo: Studi di fisiognomia*, Milan, 1990, p. 177 (with bibliography). First published (as Leonardo's) by the noted expert J. C. Robinson (*Descriptive Catalogue of Drawings by the Old Masters, forming the Collection of John Malcolm of Poltalloch Esq.*, London, 1876, cat. no. 38, p. 14), the drawing was occasionally doubted or rejected (by Venturi [*Storia*, vol. X, part I, 1935, p. 36 note I], for example) before gaining universal acceptance. The attribution predictably pitted Morelli against Bode, who first connected the sheet with Verrocchio's Darius (*Studien*, 1921, pp. 28–32), as Leonardo's study for, or copy of, the lost bronze reflected in the Berlin terracotta (his fig. 11).

105 Chastel, *Fables*, 1978, pp. 240–42; and Luisa Vertova, *Maestri toscani del Quattro e del primo Cinquecento*, Biblioteca di Disegni, vol. XIX, Florence, 1981, cat. no. 27, pp. 74–77, esp. p. 75.

106 Möller in *Raccolta Vinciana*, 1930–34, pp. 23–26; and Valentiner in *Art Quarterly*, 1941, pp. 4, 21–28; reprinted with revisions in *Italian Renaissance Sculpture*, 1950, pp. 113, 126–28.

107 Popham, *Drawings*, 1945, p. 6 and cat. no. 129, p. 126; and Natali in *Disegno fiorentino*, ed. Petrioli Tofani, cat. no. 12.5, pp. 246–47.

108 Heinrich Bodmer, *Leonardo: Des Meisters Gemälde und Zeichnungen*, Klassiker der Kunst, Stuttgart, 1931, p. 378 note to pl. 112 ("Die Zeichnung macht ... einen schülerhaften Eindruck...."); Cecil Gould, *Leonardo: The Artist and Non-Artist*, London, 1975, pp. 29–30; Roberts in Kemp and Roberts, *Leonardo*, 1989, cat. no. 2, p. 48; and Michael W. Kwakkelstein, *Leonardo da Vinci as a physiognomist: Theory and Drawing Practice*,

Leiden, 1994, pp. 15–16 and fig. 1. The Corsini drapery study (Fig. 65), discussed in chapter 4, also belongs to a distinct category of draughtsmanship Leonardo had in mind when later advising young artists to draw carefully in order to gain mastery (*Leonardo on Painting*, ed. Kemp and Walker, 1989, p. 198).

109 As early a writer as Paul Müller-Walde (*Leonardo da Vinci: Lebensskizze und Forschungen*, Munich, 1889, pp. 68–69) compared the drawing with the *Annunciation*.

110 *Leonardo on Painting*, ed. Kemp and Walker, 1989, p. 197.

111 Clark, *Leonardo*, 1939, pp. 7, 68–70, rev. ed. 1988, pp. 46, 120–24; Popham, *Drawings*, 1945, pp. 39–44; and E. H. Gombrich, "The Grotesque Heads," in his *The Heritage of Apelles: Studies in the Art of the Renaissance*, Oxford, 1976, pp. 65–69 (57–75).

112 Clark, *Drawings*, 1968, vol. I, cat. no. 12326 recto, pp. 24–25; and cat. no. 12502, pp. 87–88. About these two sheets see also Kemp in Kemp and Roberts, *Leonardo*, 1989, cat. no. 87, p. 161; and cat. no. 33, p. 90. For a leonine image of a warrior by Leonardo see Peter Meller, "Physiognomical Theory in Renaissance Heroic Portraits," in *The Renaissance and Mannerism: Studies in Western Art*, Acts of the Twentieth International Congress of the History of Art, 2 vols., Princeton, 1963, vol. II, pp. 55–58 (53–69).

113 Berenson, *Drawings*, 1903, vol. II, cat. no. 1035, p. 58; and 1938, vol. II, cat. no. 1035, p. 114. Cruttwell (*Verrocchio*, 1904, p. 170) argued to the contrary that Andrea took the spirited type and bat-winged helmet in the silver relief from his former pupil, and Busignani agreed (*Verrocchio*, 1966, p. 27). The connection between the *Colleoni* monument and Leonardo's contemporary studies of horses has been repeatedly noted (Cruttwell, *Verrocchio*, 1904, p. 190; Bertini in *L'arte*, 1935, pp. 460–61; Brugnoli in *Leonardo*, ed. Marazza, 1954, p. 377; and Covi in *Art Bulletin*, 1983, pp. 260–62). Andrea's model for the bronze statue dates from 1481, when Leonardo was working on the *Adoration of the Magi*, containing several analogous equestrian motifs. The horse study attributed to Verrocchio in the Metropolitan Museum of Art, New York, was not made from a living model, according to Gustina Scaglia ("Leonardo's Non-Inverted Writing and Verrocchio's Measured Drawing of a Horse," in *Art Bulletin*, vol. LXIV, no. 1, 1982, pp. 32–44).

114 Venturi, *Storia*, vol. X, part I, 1935, pp. 16–18; and Venturi in *L'arte*, 1936, p. 265; John Goldsmith Phillips, "Hand of the Master: Did Verrocchio's Apprentice, a Lad Named Leonardo da Vinci, Create Some of his Teacher's Best Sculptures?," in *Connoisseur*, vol. CCXVI, no. 888, 1986, p. 83 (80–83); and Adorno, *Verrocchio*, 1991, p. 152.

115 About the series see Popham, *Drawings*, 1945, pp. 14–15; and Virginia Budny, "The Pose of the Child in the Composition Sketches by Leonardo da Vinci for *The Madonna and Child

with a Cat* and in Other Works Related to this Group," in *Bulletin of the Weatherspoon Gallery Association*, 1979–80, pp. 4–11. Marani aptly compared the drawings with Verrocchio's *Putto*, but he did so to show the statue's influence on Leonardo (in *Verrocchio*, ed. Bule, Darr, and Superbi Gioffredi, 1992, p. 151. The sophisticated movement of the figure around an axis suggests the likelihood of a date later than those usually proposed for the bronze (Seymour, *Verrocchio*, 1971, cat. no. 4, p. 162). In earlier examples of the theme – a contemporary bronze *Putto* from Donatello's shop and its antique precedent – the dolphin borne on the boy's shoulder is merely an accessory (Pope-Hennessy, *Catalogue*, 1964, vol. I, pp. 78–80; and vol. III, figs. 82, 83; and Passavant, *Complete Edition*, 1969, fig. 10). According to Smithsonian Curator Charles Handley, Verrocchio's depiction of the dolphin's form (unaided by Leonardo) is wholly fictitious, like those of the lavabo.

The Annunciation

1 The document (Archivio di Stato, Florence, Compagnia di San Luca, vol. 2, Debitori, Creditori e Ricordi, fol. 93 verso) is transcribed in Beltrami, *Documenti e memorie*, 1919, no. 5, p. 3. See also Smiraglia Scognamiglio, *Giovinezza di Leonardo*, 1900, p. 37.

2 See: Fiorenzo Canuti, *Il Perugino*, 2 vols., Siena, 1931, vol. II, doc. nos. 101–03, pp. 116–19; Passavant, *Verrocchio*, 1959, doc. no. VI, p. 219; and Lightbown, *Botticelli*, 1978, vol. I, doc. no. 15, pp. 170–71.

3 About the guild and the painters' place in it see: Carlo Fiorilli, "I dipintori a Firenze nell'arte dei medici speziali e merciai," in *Archivio storico italiano*, vol. LXXVIII, no. 2, 1920, pp. 5–74; and Raffaele Ciasca, *L'arte dei medici e speziali nella storia e nel commercio fiorentino, dal secolo XII al XV*, Florence, 1927 (reprinted 1977). For the actual practice see Irene Hueck, "Le matricole dei pittori fiorentini prima e dopo il 1320," in *Bollettino d'arte*, vol. LVII, no. 2, 1972, pp. 114–21.

4 About the monastery (now a military hospital), located in the hills southwest of Florence beyond the Porta San Frediano, see Giovanni Poggi, "La chiesa di San Bartolommeo a Monte Oliveto presso Firenze," in *Miscellanea d'arte*, vol. I, no. 4, 1903, pp. 57–64. Citing the *Catalogue de la R. Galerie de Florence*, Florence, 1869, p. 147, Poggi stated that the *Annunciation* came from the church sacristy (*Leonardo da Vinci*, Florence, 1919, p. III), and this is confirmed by a paper label on the back of the panel. The oblong format of the painting, like those of Baldovinetti's *Annunciation* in the Chapel of the Cardinal of Portugal in San Miniato and of Giuliano da Maiano's intarsiated version of the theme in the North Sacristy of the cathedral, suggests that it was painted for a site above furniture in the church sacristy at Monte Oliveto. Poggi, nevertheless, found no

documents recording the commission or original location of the painting among the conventual records in the Florentine archives (1903, p. 63). Girolamo Calvi ("Vecchie e nuove riserve sull' 'Annunziazione' di Monte Oliveto," in *Raccolta Vinciana*, vol. XIV, 1930–34, pp. 204–05 [201–39]) noted that it was at one time in the monks' refectory (Moreni, *Notizie*, vol. VI, Florence, 1793, p. 161 note 1: as by Ghirlandaio). Attributed to Michelozzo, the church portal bears the date 1472 (Francesco Gurrieri, "Una conferma per Michelozzo: Il portale del San Bartolommeo di Monteuliveto," in *Antichità viva*, vol. IX, no. 4, 1970, pp. 24–32).

5 The works by Ghirlandaio that Calvi cites for comparison (in *Raccolta Vinciana*, 1930–34, pp. 201–39) are all later than the Uffizi picture.

6 Those authors who see collaboration as the way to explain the inconsistencies in the picture (Thiis, *Leonardo*, n.d. [1913], p. 104; Hellmut Wohl, *Leonardo da Vinci*, New York, 1967, p. 36; Gould, *Leonardo*, 1975, pp. 24 and 29; A. Richard Turner, "The Linear and the Sculptural Traditions in the 1470s: Botticelli and Leonardo," in Glenn Andres, John M. Hunisak, and Turner, *The Art of Florence*, New York, 1988, pp. 826–27 (801–43); and Alessandro Vezzosi, *Leonardo da Vinci: Arte e scienza dell'universo*, Milan, 1996, pp. 35–37) ascribe the design and/or the execution of the angel (Aldo De Rinaldis, *Storia dell'opera pittorica di Leonardo da Vinci*, Bologna, 1926, p. 28; Edmund Hildebrandt, *Leonardo: Der Künstler und sein Werk*, Berlin, 1927, pp. 249–52; Dussler in *Lexikon* ed. Thieme and Becker, 1939, p. 295; and Heydenreich, *Leonardo*, 1954, vol. I, pp. 31, 180, and vol. II, p. iii) or of the landscape (Jack Wasserman, *Leonardo da Vinci*, New York, 1975, pp. 84–88) to Leonardo, while they relegate the Virgin to a lesser hand (Gustavo Frizzoni, "I nostri grandi maestri in relazione al quinto fascicolo dei disegni di Oxford," in *L'arte*, vol. X, no. 2, 1907, pp. 83–84 ([81–96]), whether Credi (Holmes in *Burlington Magazine*, 1914, p. 284; Bernhard Degenhart, "Di alcuni problemi di sviluppo della pittura nella bottega del Verrocchio, di Leonardo e di Lorenzo di Credi," in *Rivista d'arte*, vol. XIV, no. 4, 1932, pp. 438, 441, 443 [403–44]; and Edward McCurdy, *The Mind of Leonado da Vinci*, London and Toronto, 1932, pp. 315–16) or Ghirlandaio (Robert Langton Douglas, *Leonardo da Vinci: His Life and his Pictures*, Chicago, 1944, p. 58).

7 See: Cruttwell, *Verrocchio*, 1904, p. 52; Reymond, *Verrocchio*, n.d. [1906], p. 121; Thiis, *Leonardo*, n.d. [1913], p. 100; De Rinaldis, *Storia*, 1926, p. 22; and Calvi in *Raccolta Vinciana*, 1930–34, pp. 216–17, 230. The *Head of a Youth* (inv. no. IV.34A) in the Pierpont Morgan Library, New York, was considered by Valentiner first as a copy of a lost study by Leonardo used for the Virgin Annunciate (in *Art Quarterly*, 1941, p. 30 [3–31] and fig. 18; reprinted with revisions in his *Italian Renaissance Sculpture*, 1950, pp. 130–131

[113–33] and fig. 146]) and then as a reworked original (in *Leonardo da Vinci Loan Exhibition 1452–1519*, Exhibition Catalogue, Los Angeles County Museum, 1949, cat. no. 74, p. 109). The left-handed shading also persuaded Cadogan tentatively to accept the study as Leonardo's (in *Zeitschrift*, 1983, pp. 398–99 [367–400] and note 65). Passavant (*Complete Edition*, 1969, cat. no. App.25, p. 207), on the other hand, argued that the drawing was by Antonio Pollaiuolo but reworked by Ghirlandaio for the Uffizi *Annunciation*. Pedretti returned to the Leonardo attribution ("Leonardo at the Morgan Library," in *Achademia Leonardi Vinci*, vol. I, 1988, p. 144 [142–44] and fig. 9), which was seconded by Patricia Trutty-Coohill in Pedretti and Trutty-Coohill, *The Drawings of Leonardo da Vinci and his Circle in America*, Florence, 1993, cat. no. 3, p. 36; and by Vezzosi (*Leonardo*, 1996, pp. 36–37). The drawing is not reworked and it is not, in my view, by Leonardo either, as is shown by the youth's heavy features and mechanical curls, which differ from the Virgin's head in the Uffizi picture.

8 Writers who found the awkwardly elongated arm of the Virgin unworthy of Leonardo include: Jacques Mesnil, "Botticelli, les Pollaiuoli et Verrocchio. II," in *Rivista d'arte*, vol. III, 1905, p. 37 note 2 (35–45); Seidlitz, *Leonardo*, 1909, vol. I, p. 51; Thiis, *Leonardo*, n.d. [1913], p. 99; and Calvi in *Raccolta Vinciana*, 1930–34, pp. 218–19. Clark (*Leonardo*, 1939, p. 14, rev. eds. 1952, p. 12, and 1988, p. 53) rightly regarded it as a mistake, and a further such error involves the cypress obscuring the corner of the Virgin's dwelling: either this tree is closer to the foreground than the others or else the building extends impossibly far into the distance.

9 As has been frequently noted, the pedestal of the Virgin's lectern echoes the Marsuppini monument, not only the Medici tomb, thus raising the issue of Leonardo's indebtedness to Desiderio. Even so the precise shape and decoration of the lectern find their closest analogues in works associable with the Verrocchio shop. See: Annarosa Garzelli, *La Bibbia di Federico da Montefeltro: Un'officina libraria fiorentina 1476–1478*, Rome, 1977, p. 20 (frontispiece); Alessandro Cecchi in *Disegno fiorentino*, ed. Petrioli Tofani, 1992, cat. no. 12.9, p. 252 (candelabrum study); and Gianvittorio Dillon, "Una serie di figure grottesche," in *Florentine Drawing*, ed. Cropper, 1994, pp. 217–30 and esp. figs. 18 and 19 (engraving).

10 Except for Pedretti, who assigns the *Annunciation* to the late 1470s (*Chronology and Style*, 1973, p. 30; and *Leonardo*, Bologna, 1979, pp. 24, 26, and notes to figs. 6 and 7), all authors who have given the painting entirely to Leonardo recognized that it must be early, with the dates proposed ranging from *c.* 1470 (Marani, *Leonardo*, 1989, cat. no. 2, pp. 30–31; and in *Verrocchio*, ed. Bule, Darr, and Superbi Gioffredi, 1992, p. 145; to *c.* 1472–73

(Venturi, *Leonardo da Vinci pittore*, Bologra, 1920, p. 15; Bode, *Studien*, 1921, p. 18; Valentiner, *Italian Renaissance Sculpture*, 1950, pp. 129–33; Clark, *Leonardo*, 1939, p. 14, rev. eds. 1952, p. 12, and 1988, p. 52; Ludwig Baldass, "Zu den Gemälden der ersten Periode des Leonardo da Vinci," in *Zeitschrift für Kunstwissenschaft*, vol. VII, nos. 3–4, 1953, p. 166 [165–82]; and Kemp in Kemp and Roberts, *Leonardo*, 1989, pp. 48–49 and pl. 9); and to *c.* 1475 (Giorgio Castelfranco, *La pittura di Leonardo da Vinci*, Milan, 1956, pp. 13 and 55; and Angela Ottino della Chiesa, *L'opera completa*, 1967, cat. no. 2, pp. 88–89). Giuseppe Marchini ("L'Annunciazione," in *Leonardo. La pittura*, Florence, 1977, pp. 25–36; 2nd ed., ed. Pietro Marani, 1985, pp. 23–29) favors the early 1470s.

11 The writing on the pages of the book, which bend under the pressure of the Virgin's fingers, is illegible, though it might well be intended as an Old Testament prophecy of Christ's conception.

12 The drawing, which measures 25.7 × 19 cm. (10 × 7$\frac{1}{2}$ in.) and which belongs to the Istituto Nazionale della Grafica, is in the Gabinetto Nazionale delle Stampe, Palazzo Corsini, Rome (inv. no. F.C.125770). On the reverse is a scarcely visible sketch of a seated figure (a Madonna of Humility?). The dates proposed for the sheet range from the early to the late 1470's (Enrichetta Beltrame Quattrocchi, *Disegni toscani e umbri del Primo Rinascimento dalle collezione del Gabinetto Nazionale delle Stampe*, Rome, 1979, cat. no. 19, pp. 37–38 [with bibliography]; and Viatte, as cited in note 21 below, 1989, cat. no. 17, pp. 176–77). Valentiner is the only author to have rightly discerned that the drawing served for the "position of the Uffizi Madonna as it was originally planned" (in *Art Quarterly*, 1941, pp. 28–29; and in his *Italian Renaissance Sculpture*, 1950, pp. 129–33).

13 Berenson, *Drawings*, 1938, vol. I, pp. 61–62; and vol. II, cat. no. 1082B, p. 121.

14 While Venturi, who in effect discovered the drawing, called it preparatory for the Louvre *Annunciation* (*Leonardo*, 1920, pp. 70–71; *Storia*, vol. IX, part I, 1925, pp. 106–07; and *I disegni di Leonardo da Vinci*, Rome, 1928, p. 8 and cat. no. XVII, p. 23), Popham (*Drawings*, 1945, p. 13) countered that Leonardo's drapery was simply used (in reverse) for the picture, which is attributed to Credi on pp. 154–55.

15 Heydenreich, "Leonardo's Drawings," in his *Leonardo-Studien*, ed. Günter Passavant, Munich, 1988, p. 159 (157–62). About Leonardo's revolutionary draughtsmanship see E. H. Gombrich, "Leonardo's Method for Working out Compositions," in his *Norm and Form*, 1966, pp. 58–63.

16 The Virgin Annunciate, when portrayed kneeling to receive the angel's benediction, usually has both knees on the ground, as in the so-called Gardner *Annunciation* by a fellow pupil of Leonardo's in the Verrocchio shop (Oberhuber in *Revue de l'art*, 1978, fig. 21). In such cases the lectern, when present, may

be represented behind the Virgin, as in Pesellino's *Annunciation* in the Courtauld Institute Galleries, London (Anthony Blunt, "Thomas Gambier-Parry: A Great Art Collector," in *Apollo*, vol. LXXI, no. 38, 1965, p. 293 fig. 9 [288–95]), or in front of her, as in Pollaiuolo's silver cross in the Museo dell'Opera del Duomo, Florence (Photo Soprintendenza 20116) or in Andrea della Robbia's glazed terracotta version of the theme in the Ospedale degli Innocenti, Florence (Pope-Hennessy, "Thoughts on Andrea della Robbia," in *Apollo*, vol. CIX, no. 205, 1979, p. 179 fig. 2 [176–97]). Comparing these examples with Leonardo's drawing shows the difficulty he faced in relating the lectern (especially one so elaborate as that in the Uffizi painting) to a Virgin posed in mirror image to the angel. Giotto had attempted to solve the problem in his Arena Chapel fresco at Padua, and so did Antonello da Messina in his depiction of the subject of 1474 in the Museo Nazionale in Syracuse. The "angelic" pose with one knee raised is rare for figures other than angels (the Virgin in a Ferrarese engraving of the 1470s reproduced in *Boston Museum Bulletin*, vol. LXV, no. 341, 1967, p. 109), but Leonardo favored it not only for his first draught of the Virgin but also for St. Jerome in the Vatican painting.

17 Vasari, *Vite*, ed. Milanesi, vol. IV, 1879, p. 20; Goldscheider, *Leonardo*, 1959, pp. 11–12.

18 Vasari, *Vite*, ed. Milanesi, vol. II, 1878, pp. 498–99; and for Filarete see Fusco in *Art Bulletin*, 1982, p. 185 (175–94).

19 Berenson (in *Bollettino d'arte*, 1933, pp. 244–54 and *Drawings*, 1938, vol. I, pp. 60–64 [1961 ed., vol. I, pp. 100–05]) even tried to put the drawings in chronological order. Popham's reservations (*Drawings*, 1945, pp. 11–13 and cat. nos. 2–5, p. 101–02) still apply.

20 *Leonardo's Return to Vinci: The Countess de Béhague Collection*, ed. Alessandro Vezzosi, Exhibition Catalogue, Castello, Vinci, and University Art Museum, Berkeley, CA, and elsewhere, Florence, 1980, with intro. by Carlo Pedretti, pp. 11–13, and entries on the four drapery studies then belonging to the Marquis de Ganay by Alessandro Vezzosi, pp. 19–26.

21 *Léonard de Vinci: Les études de draperie*, ed. Françoise Viatte, Exhibition Catalogue, Musée du Louvre, 1989–90, Paris, 1989. Viatte's essay "Corpo vestito d'ombre," (pp. 20–33) was summarized in *Giornale dell'arte*, no. 72, Nov. 1989, pp. 14–15. Reviewing the exhibition, David Scrase ("Paris and Lille. Leonardo; Italian Drawings," in *Burlington Magazine*, vol. CXXXII, no. 1043, 1990, pp. 151–54) tended to side with the view taken there that virtually all of the drawings were by Leonardo.

22 Vasari (*Vite*, ed. Milanesi, vol. IV, 1879, p. 564) fails to mention linen, however, suggesting that none of that particular group of studies is by Credi.

23 Imitating Donatello, Verrocchio dipped cloth in wax or plaster to shape sculpted draperies, according to Cannon-Brookes in *Apollo*, 1974, p. 16.

24 Though she ascribed all the linen drawings to Leonardo, Dalli Regoli ("Il 'Piegar de' Panni'," in *Critica d'arte*, vol. XXII, no. 150, 1976, pp. 35–48), as part of a larger analysis of workshop methods, particularly the use of models, in fifteenth-century Florence, attempted to define distinctive ways of representing draperies in the paintings and sculpture of Verrocchio and his pupils. On this basis Cadogan ("Linen Drapery Studies by Verrocchio, Leonardo, and Ghirlandaio," in *Zeitschrift für Kunstgeschichte*, vol. XLVI, no. 1, 1983, pp. 27–62) went on to distribute the drawings to three individuals, but with problematical results owing to the misattribution to Verrocchio of pictures by Perugino and others. Cadogan's approach and criteria, but not her attributions, were accepted in a review of the Louvre exhibition by Keith Christiansen, entitled "Leonardo's Drapery Studies," in *Burlington Magazine*, vol. CXXXII, no. 1049, 1990, pp. 572–73. In dividing up the drawings, Christiansen gives nearly all of the standing figure draperies to Verrocchio and most of the kneeling and seated ones to Leonardo.

25 Berenson doubted that the drawings were directly connected with the *Annunciation* (in *Bollettino d'arte*, 1933, p. 246; and *Drawings*, 1938, vol. I, p. 61), while Popham (*Drawings*, 1945, p. 12) interpreted their failure to correspond to the painting to mean either that they were merely exercises or that they were made for the picture but discarded.

26 The Uffizi drawing (Gabinetto Disegni e Stampe inv. no. 420E), given to Leonardo by both Cadogan (in *Zeitschrift*, 1983, pp. 48–50) and Viatte (*Léonard*, ed. Viatte, 1989, cat. no. 2, pp. 46–47), as well as by Christiansen (in *Burlington Magazine*, 1990, pp. 572–73) and Dalli Regoli (in Pedretti and Dalli Regoli, *I disegni di Leonardo da Vinci e della sua cerchia nel Gabinetto Disegni e Stampe della Galleria degli Uffizi*, Florence, 1985, cat. no. 3, pp. 50–51), is apparently by the same hand as an analogous study of the drapery of a figure kneeling to the right in the Louvre (inv. no. 2256), also catalogued (Viatte in *Léonard*, 1989, cat. no. 1, pp. 44–45) and generally accepted as Leonardo's. The third of these studies, now also in the Louvre (Viatte in *Léonard*, 1989, cat. no. 3, pp. 48–49), differs sufficiently in style to be by another hand.

27 Passavant (in *Mitteilungen*, 1960, pp. 92–95 [71–98]) analyzed all three drawings as Leonardo's preparatory studies for the Virgin's draperies in the painting. The one in the Louvre (inv. no. RF41905) was also given to the artist by Cadogan (in *Zeitschrift*, 1983, pp. 56–57) and Viatte (in *Léonard*, 1989, cat. no. 4, pp. 50–51), but Christiansen (in *Burlington Magazine*, 1990, pp. 572–73) opted for Verrocchio. A similar sheet in the Uffizi (inv. no. 437E), already connected with the Virgin Annunciate by Thiis (*Leonardo*, n.d. [1913], pp. 101–02), was ascribed to Leonardo by Dalli Regoli (in Pedretti and Dalli Regoli, *Disegni*, 1985, cat. no. 2, pp. 49–50), Viatte (in *Léonard*, 1989, cat. no. 5, pp. 52–53), and Petrioli Tofani (in *Disegno fiorentino*, 1992, cat. no. 3.3, pp. 85–86). Annarosa Garzelli ("Problemi del Ghirlandaio nella Cappella di Santa Fina: Il ciclo figurativo nella cupola e i probabili disegni," in *Antichità viva*, vol. XXIV, no. 4, 1985, pp. 18–21 [11–25]) may be closer to the mark in tentatively proposing Ghirlandaio. The third of these drawings has been almost unanimously given to Leonardo (Viatte in *Léonard*, 1989, cat. no. 6, pp. 54–55) on account of its extreme beauty. About this sheet and the problem of the drapery studies in general see also James Byam Shaw, *The Italian Drawings of the Frits Lugt Collection*, 3 vols., Paris, 1983, vol. I, cat. no. 6, pp. 10–12.

28 About the drawing (inv. no. 2255) see Viatte in *Léonard*, 1989, cat. no. 16, pp. 74–75.

29 Fahy ("The Earliest Works of Fra Bartolommeo," in *Art Bulletin*, vol. LI, no. 2, 1969, pp. 152–53 [142–54]) first revived Franz Wickhoff's attribution to Ghirlandaio ("Über einige italienische Zeichnungen im British Museum," in *Jahrbuch der preussischen Kunstsammlungen*, vol. XX, 1899, pp. 212–13 [202–15]), followed with cogent arguments by Cadogan (in *Zeitschrift*, 1983, pp. 33–38; and in *Art Bulletin*, 1983, p. 280).

30 Richter, *Literary Works*, 1970, vol. I, nos. 390–92, pp. 269–70; Leonardo, *Treatise on Painting*, ed. McMahon, 1956, vol. I, pp. 203–08; and *Leonardo on Painting*, ed. and trans. Kemp and Walker, 1989, pp. 153–55. While most authors have cited Leonardo's precept that the "draperies that clothe figures must show that they are inhabited by these figures . . . avoiding the confusion of many folds" to justify the linen studies, Dalli Regoli correctly takes it as a critique of the practice (Pedretti and Dalli Regoli, *Disegni*, 1985, p. 51).

31 Leonardo, *Treatise on Painting*, ed. McMahon, 1956, vol. I, no 564, p. 204: "drapery should be arranged in such a way that it does not seem uninhabited; that is it should not seem simply a piling up of drapery as is so often done by many who are so much enamored of groupings of various folds that they cover the whole figure with them forgetting the purpose for which the fabric is made . . . I do not deny that some handsome folds should be made, but let them be placed upon some part of the figure where they can be assembled and fall appropriately between the limbs and the body."

32 For the dating about 1470 see: Cruttwell, *Pollaiuolo*, 1907, pp. 97–99 (also identifying the landscape viewed through the windows); Busignani, *Pollaiolo*, 1970, p. CXXXIV; Ettlinger, *Pollaiuolo*, 1978, p. 30 and cat. no. 2, p. 138; and Erich Schleier in *The Gemäldegalerie, Berlin: A History of the Collection and Selected Masterworks*, London, 1986, pp. 296–97. The way Piero absurdly balanced the

little book on the Virgin's knee may have led Leonardo to introduce the lectern into his work.

33 The measurements of $38^3/_4 \times 85^3/_4$ in. (98.5×218 cm.), which differ from those given in the literature, were taken by Maurizio Seracini as cited in note 66 below.

34 Osvald Sirén (*Leonardo da Vinci: The Artist and the Man*, New Haven and London, 1916, p. 20) and Venturi (*Leonardo*, 1920, pp. 12–18), among others, have cited Baldovinetti and Lippi as sources for Leonardo's figural scheme.

35 Though admitting that the overall iconography of Leonardo's painting is "surprisingly orthodox," Paul J. Cardile ("Observations on the Iconography of Leonardo da Vinci's Uffizi *Annunciation*," in *Studies in Iconography*, vols. VII–VIII, 1981–82, pp. 189–208), nevertheless, goes on to explicate its imagery in terms of the mid-century Florentine archbishop Antoninus's *Summa theologica*, in spite of Leonardo's often-expressed aversion to theology.

36 Gabriele Morolli, "Architetture laurenziane," in *"Per bellezza, per studio, per piacere" Lorenzo il Magnifico e gli spazi dell'arte*, ed. Franco Borsi, Florence, 1991, p. 254 (195–262). However different from the traditional painted type, the Virgin's dwelling, with its dark brownish walls, low window, and quoins missing at the far end, is essentially a pictorial construction, adapted to the figures and not corresponding to any actual building.

37 Venturi (*Leonardo*, 1920, p. 16) noted the correct scale relationship. Alberti related how "another thing I often see deserves to be censured, and that is men painted in a building as if they were shut up in a box in which they can hardly fit." (*On Painting*, ed. Grayson, 1972, p. 77). For the cramped type of portico rendered in perspective see: David M. Robb, "The Iconography of the Annunciation in the Fourteenth and Fifteenth Centuries," in *Art Bulletin*, vol. XVIII, no. 4, 1936, pp. 480–526; John R. Spencer, "Spatial Imagery of the Annunciation in Fifteenth Century Florence," in *Art Bulletin*, vol. XXXVII, no. 4, 1955, pp. 173–80; and Samuel Y. Edgerton, Jr., "*Mensurare temporalis facit Geometria spiritualis*: Some Fifteenth-Century Italian Notions about When and Where the Annunciation Happened," in *Studies in Late Medieval and Renaissance Painting in Honor of Millard Meiss*, ed. Irving Lavin and John Plummer, 2 vols., New York, 1977, vol. I, pp. 115–30. The type, particularly associated with Fra Angelico, was so ingrained that even an architect like Francesco di Giorgio could paint it (Pinacoteca, Siena). Lippi's numerous portrayals of the Annunciation (National Gallery, London, and elsewhere) show that, well before Leonardo, he had begun to address the problem of a disproportionately small architecture which directed attention into depth at the expense of the event depicted.

38 Diagrams of Leonardo's perspective scheme, which has two vanishing-points, in and off-center to the right, are offered by the following: Piero Sanpaolesi, "I dipinti di Leonardo agli Uffizi," in *Leonardo*, ed. Marazza, 1954, pp. 34–35 (27–56); Marco Carpi Ceci, "Verifica delle prospettive contenute nei due quadri dell'Annunciazione di Leonardo da Vinci," in *Notiziario vinciano*, no. 1, 1977, pp. 17–21 (15–21); Giovanni Degl'Innocenti, "Restituzioni prospettiche: Proposte e verifiche di un metodo," in Carlo Pedretti, *Leonardo architetto*, Milan, 1978, pp. 274–78; Joseph Polzer, "The Perspective of Leonardo Considered as a Painter," in *La prospettiva rinascimentale: Codificazioni e trasgressioni*, ed. Marisa Dalai Emiliani, Florence, 1980, pp. 233–47; Kim H. Veltman in collaboration with Kenneth D. Keele, *Linear Perspective and the Visual Dimensions of Science and Art*, Munich, 1986, pp. 338–39; and Martin Kemp, *The Science of Art*, New Haven and London, 1990, pp. 44–45. Through studying how the eye perceives space and distance, Leonardo eventually diverged from the Albertian system.

39 Vasari, *Vite*, ed. Milanesi, vol. III, 1878, pp. 357–58.

40 The drawing, measuring 8.1×9.4 cm. ($3^3/_{16} \times 3^{11}/_{16}$ in.), was first identified by Sidney Colvin (*Drawings of the Old Masters in the University Galleries and in the Library of Christ Church, Oxford*, 3 vols., Oxford, 1907, vol. I, part I, note to plate 14A), whose view was accepted by nearly all subsequent writers (James Byam Shaw, *Drawings by Old Masters at Christ Church Oxford*, 2 vols., Oxford, 1976, vol. I, cat. no. 16, p. 36 [with bibliography]). The fragment of a curly-haired head on the right appears too weak for Leonardo and, drawn as it is in red chalk, must postdate the pen study.

41 Birbari (*Dress*, 1975, pp. 91, 100–01) notes the knowledgeable construction of the angel's sleeve and of the Virgin's similarly pleated pink dress in the painting.

42 Sirén, *Leonardo*, 1916, p. 21; and Gert Duwe, *Der Wandel in der Darstellung der Verkündigung an Maria vom Trecento zum Quattrocento*, Frankfurt, 1988, p. 192 (and for a good analysis of the composition in general, pp. 191–200) both observed the angel's forward momentum.

43 Leonardo's habit of buying caged birds and freeing them may have facilitated his lifelong studies of bird flight, which began in the 1480s and which culminated in a manuscript of 1505 (*Il Codice sul volo degli uccelli della Biblioteca Reale di Torino*, ed. August Marinoni, Florence, 1976). The artist's efforts to design a machine enabling man to fly (C. H. Gibbs-Smith, *Leonardo da Vinci's Aeronautics*, London, 1967; and Clive Hart, *The Prehistory of Flight*, Berkeley, Los Angeles, and London, 1985, pp. 94–115) were based on the notion of attaching (constructed) wings to the human body, and in this sense the angel is the first of his "birdmen."

44 Leonardo devised the epaulet to disguise what might otherwise have been the awkward attachment of the angel's wings to his shoul-

ders – a problem having to do with the naturalistic appearance of the figure that no other artist even considered. His depiction of the wings was presumably based on firsthand observation, though nothing survives by him like Dürer's well-known watercolors of birds. Nor can the species be exactly identified, though Suida (*Leonardo*, 1929, p. 18) suggested a falcon. Yet his rendering is remarkable for its attention to ornithological detail, according to Smithsonian curators Carla Dove and Roxie Laybourne, who note, however, that the angel is equipped with four (and not the correct three) layers of feathers. Cruttwell (*Verrocchio*, 1904, p. 55) and Clark (*Leonardo*, 1939, p. 15, rev. eds. 1952, p. 13, and 1988, pp. 53–54) believed that a later restorer lengthened the plumage, but careful examination shows that (contrary to what Sanpaolesi stated, in *Leonardo*, ed. Marazza, 1954, p. 46 note 5) the tree trunks are painted around (and not under) the wings, suggesting that Leonardo gave them the dimensions he felt were needed for human flight. Technical evidence also reveals that he originally painted the wings closer together. Citing the angel in the Uffizi picture, Valentiner ascribed a pair of Verrocchiesque angel reliefs in the Louvre to Leonardo ("Two Terracotta Reliefs by Leonardo," in his *Italian Renaissance Sculpture*, 1950, p. 190 [178–92]). Passavant, making the same comparison, gave only one of the angels to him (*Complete Edition*, 1969, pp. 28–31; cat. no. 14, pp. 184–85; and plate 58). Though not by Leonardo, this relief does seem to echo Gabriel's figure, demonstrating how his naturalistic studies served the shop.

45 About the drawing (no. 449E recto and verso, measuring some 10.7×7.7 cm. or $4^1/_4 \times 3$ in.), see Petrioli Tofani, *Inventario*, 1986, p. 201; and for the identification, David Alan Brown, "The Profile of a Youth and Leonardo's *Annunciation*," in *Mitteilungen des kunsthistorischen Institutes in Florenz*, vol. XV, no. 3, 1971, pp. 265–72. The author's hypothesis was accepted by Dalli Regoli (in Pedretti and Regoli, *Disegni*, 1985, cat. no. 6, pp. 54–55). Later trimming of the drawing ignores the correct orientation of the head, tilted slightly to the right, which is restored in Fig. 73.

46 See: Popham, *Drawings*, 1945, pp. 39–42; and Caroli, *Leonardo*, 1990, pp. 46–49, 178–80.

47 Sanpaolesi in *Leonardo*, ed. Marazza, 1954, pp. 33–39.

48 Passavant (in *Mitteilungen*, 1960, pp. 71–98; and *Complete Edition*, 1969, cat. no. App.29, pp. 207–08) partly revived the old attribution to Ghirlandaio based on qualitative differences he found between the preliminary and final version of the painting.

49 For a detailed analysis showing that the Uffizi drawing of the profile of a youth precedes the initial conception of the angel on the panel, which thus belongs to Leonardo, see Brown in *Mitteilungen*, 1971, pp. 270–71.

50 About this study of a stream of water flowing

through an opening in a wall see Clark, *Draw-ings*, 1968, vol. I, no. 12662, pp. 153–54.

51 Leonardo himself drew an analogy between the movement of hair and water (Richter, *Literary Works*, 1970, vol. I, no. 389, p. 269). About his water studies in general see: Gombrich, "The Form of Movement in Water and Air," in *Leonardo's Legacy*, ed. C. D. O'Malley, Berkeley and Los Angeles, 1969, pp. 171–204 (reprinted in his *The Heritage of Apelles: Studies in the Art of the Renaissance*, London, 1976, pp. 39–56); Pedretti and Clark, *Leonardo da Vinci Nature Studies from the Royal Library at Windsor Castle*, Exhibition Cata-logue, Royal Academy, London, 1981, pp. 42–50; and Kemp, "The Vortex," in Kemp and Roberts, *Leonardo*, 1989, pp. 118–40. John F. Moffitt ("The *Evidentia* of Curling Waters and Whirling Winds: Leonardo's *Exphraseis* of the Latin Weathermen," in *Achademia Leonardi Vinci*, vol. IV, 1991, pp. 23–26 [11–33]) iden-tifies Pliny's *Natural History* as a source for Leonardo's concept of natural forces in conflict.

52 Leonardo's pupils in Milan took up the idea as well (Suida, *Leonardo*, 1929, figs. 37, 223, and 302).

53 About this earliest of Leonardo's surviving botanical studies (no. 12418), which measures 31.4 × 17.7 cm. (12⅜ × 7 in.) and which was done in pen and ink and wash over black chalk, heightened with white, see: Pedretti in Pedretti and Clark, *Nature Studies*, 1981, cat. no. 2, pp. 29–30 (comparing the drawing sty-listically to the Oxford sleeve and the Uffizi profile studies); and Pedretti, *The Drawings and Miscellaneous Papers of Leonardo da Vinci in the Collection of Her Majesty the Queen at Windsor Castle, I: Landscapes, Plants, and Water Studies*, London, 1982, cat. no. 2, pp. 32–33 (doubting any direct connection with the Uffizi picture). To draw the lily Leonardo turned around the sheet on which he had previously sketched a perspective construction suggestive of the architecture in the *Annunciation* (Kemp in Kemp and Roberts, *Leonardo*, 1989, cat. no. 42, p. 101 [dated *c.* 1472–75]).

54 Richter, *Literary Works*, 1970, vol. I, no. 680, p. 387: "molti fiori ritratti di naturale." All of Leonardo's other plant studies date from long after his first Florentine period. Some are asso-ciated with the lost *Leda and the Swan*, while others appear to be for a treatise (William A. Emboden, *Leonardo da Vinci on Plants and Gardens*, Portland, OR, 1987, pp. 141–61; and Kemp in Kemp and Roberts, *Leonardo*, 1989, cat. nos. 27–28, pp. 84–85; nos. 43–44, pp. 102–03; and no. 57, p. 123).

55 Emboden (*Plants*, 1987, p. 143) finds the lily, with its buds and blossoms, stamens and pistils, "accurate in every botanical detail." Though clarity was essential to identify species for medicinal purposes, the plants illustrating manuscript and printed herbals were for a long time less realistic than ones painted by artists. See: Paul Hulton and Lawrence Smith, *Flowers in Art from East and West*, London, 1979, pp. 16–26; Wilfrid Blunt and Sandra Raphael, *The Illustrated Herbal*, New York, 1979; James S. Ackerman, "Early Renaissance 'Naturalism' and Scientific Illustration," in *Figura*, vol. XXII, 1985, pp. 1–17 (reprinted in his *Distance Points: Essays in Theory and Renaissance Art and Architecture*, Cambridge, MA, and London, 1991, pp. 185–207); Lucia Tongiorgi Tomasi, "Toward the Scientific Naturalism: Aspects of Botanical and Zoological Iconography in Manuscripts and Printed Books in the Second Half of XV Century," in *Die Kunst und das Studium der Natur vom 14. zum 16. Jahrhunderts*, ed. Wolfram Prinz and Andreas Beyer, Weinheim, 1987, pp. 91–101; and Landau and Parshall, *Renaissance Print*, 1994, pp. 245–59. Among the very few flower studies surviving from before the Cinquecento, a recently dis-covered *Study of Peonies*, exactly contemporary with Leonardo's *Lily*, served for Schongauer's *Madonna of the Rose-Garden* (Frits Koreny, "A Coloured Flower Study by Martin Schongauer and the Development of the Depiction of Nature from van der Weyden to Dürer," in *Burlington Magazine*, vol. CXXXIII, no. 1062, 1991, pp. 588–97).

56 Clark (*Drawings*, 1968, vol. I, no. 12418, p. 65), Sinibaldi (in *Master Drawings*, 1964, pp. 28–29 [27–32]), and Tongiorgi Tomasi (in *Disegno*, ed. Petrioli Tofani, 1992, cat. no. 9.3, p. 182) all noted the relation between the Windsor study and the London painting. Depicted slanting at the same angle as in the drawing, Perugino's lily repeats directly or in reverse several of Leonardo's carefully observed flowers. The scale of the lily differs, however, as does that in the Uffizi picture, so some Verrocchio pupil other than Leonardo or Perugino may have pricked the outlines (of the stem and blossoms, not the buds) for transfer. The drawing is also lightly squared for enlargement.

57 Emboden, *Plants*, 1987, pp. 116 and 119. Mirella Levi d'Ancona (*The Garden of the Renaissance: Botanical Symbolism in Italian Paint-ing*, Florence, 1977, pp. 17, 390–91) succeeded in identifying little more than the tulip, as Leonardo's painted floral motifs are, in the view of one expert (De Toni, *Piante*, 1922, p. 15), "di meno facile riferimento," and, of another (Ray Desmond, *Wonders of Creation: Natural History Drawings in the British Library*, London, 1986, p. 43), "far inferior to those in his drawings." Wilfrid Blunt (*The Art of Botanical Illustration*, London, 1950, pp. 29–30) similarly found the plants Leonardo repre-sented in his paintings "relatively feeble and ill-constructed." Discerning a strong admix-ture of fantasy in Leonardo's much-vaunted naturalism, Emboden's work supersedes intel-lectually and in its thoroughness such earlier treatments as Goldscheider's *Leonardo da Vinci Landscapes and Plants*, London, 1952.

58 About these problems see Guido Moggi, "Le piante nella pittura italiana dei secoli XV e XVI: Problemi e metodi di identificazione botanica," in *Studium der Natur*, ed. Prinz and Beyer, 1987, pp. 61–73. The tradition of accurately painting plants has its roots in the Middle Ages (Lottlisa Behling, *Die Pflanze in der mittelalterliche Tafelmalerei*, Weimar, 1957), and to those should be added the even more meticulous examples by Memling and the other early Netherlandish masters. Antonio Pollaiuolo's *Martyrdom of St. Sebastian* (see chapter 1) belongs to the same current, which culminated a few years later in Botticelli's *Primavera*. After the Uffizi picture was restored, no fewer than forty different plant species could be identified (Mirella Levi D'Ancona, *Botticelli's Primavera: A Botanical Interpretation*, Florence, 1983).

59 Quoted in E. H. Gombrich, "Botticelli's Mythologies," in his *Symbolic Images: Studies in the Art of the Renaissance*, London, 1972, p. 77 (31–81).

60 As Leonardo has represented it, with a rectan-gular flowery lawn called a "viridarium," a path, and a low wall, the enclosed garden adjoining the Virgin's dwelling is typical of fifteenth-century gardens, about which see Marilyn Stokstad and Jerry Stannard, *Gardens of the Middle Ages*, Spencer Museum of Art, Lawrence, KS, 1983. Closely associated by Fra Angelico with the Annunciation theme, the Virgin's garden (*hortus conclusus*) symbolizes her chastity, as does the lily.

61 Clark, *Leonardo*, 1939, p. 16, (rev. ed. 1988, pp. 55–56).

62 Venturi, *Storia*, 1925, vol. IX, part I, p. 61: "Le erbe e i fiori del viridario piegano verso la Vergine al soffio dell'aria mossa dall'Angelo."

63 Leonardo, *Treatise on Painting*, ed. McMahon, 1956, vol. I, no. 966, pp. 320–21.

64 Hart (*Prehistory*, 1985, pp. 44–51), offers an illuminating discussion of the idea of damp air as a medium which sustained the flight of angels and other aerial creatures. One possible source for Leonardo's pervasive atmosphere lies in the *schiacciato* reliefs, in which Donatello carved the stone so as to dissolve the background.

65 Dunkerton, Foister, Gordon, and Penny (*Giotto to Dürer*, 1991, pp. 200–02) offer a short but reliable discussion of oil painting in fifteenth-century Florence based on scientific examination of pictures in the collection at the National Gallery, London. See also Alfio Del Serra, "A Conversation on Painting Techniques," in *Burlington Magazine*, vol. CXXVII, no. 982, 1985, pp. 7–8 (4–16). The Florentines were slower to adopt oil than their Venetian counterparts, and when they used it in conjunction with tempera, did so more as an oil-tempera emulsion than in the form of transparent glazes over tempera in the Netherlandish manner.

66 Thanks to Annamaria Petrioli Tofani, Director of the Uffizi, and Curators Alessandro Cecchi and Antonio Natali, early in May 1994 the author and his colleague David Bull were able to study the *Annunciation* and the *Baptism* undisturbed by throngs of visitors. Subsequently we analyzed the techni-cal evidence, chiefly a new x-radiograph and an infra-red reflectogram, with Dr. Seracini, who re-examined his material with me in

September that year. Any faults in interpretation are the author's own.

67 Sanpaolesi, in *Leonardo*, ed. Marazza, 1954, pp. 33–39; Passavant in *Mitteilungen*, 1960, pp. 71–98; Passavant, *Complete Edition*, 1969, cat. no. App.29, pp. 207–08; and Umberto Baldini, *Un Leonardo inedito*, Florence, 1992, pp. XIX–XX, 149–73.

68 About the time Leonardo painted the *Annunciation* Federico da Montefeltro, "being very knowledgeable in matters of painting," according to Vespasiano da Bisticci, "and unable to find an Italian master who could paint in oil, approached a Flemish painter [Justus of Ghent] and had him come to Urbino" to paint the central panel of the altarpiece for the Confraternity of Corpus Domini (Baxandall, *Painting and Experience*, 1972, pp. 138–39). For the developement in general see Marcia Hall, *Color and Meaning: Practice and Theory in Renaissance Painting*, Cambridge, 1992, pp. 47–74.

69 The Virgin's head was not replaced, as has been claimed, as no scrape marks are visible. The dark area in the x-radiograph simply represents the area left in reserve for her head. The kind of cracking found there is fairly common; Vasari (*Vite*, ed. Milanesi, vol. III, 1878, p. 574) noted it as a defect in the work of Perugino, who seems to have taken up oil painting after leaving Verrocchio's shop.

70 Leonardo's mature works in the Louvre were painted in a technique leaving only the faintest image in x-radiographs (Magdaleine Hours, "Radiographies de tableaux de Léonard de Vinci," in *Revue des arts*, vol. II, no. 4, 1952, pp. 227–35; and Hours, "Étude analytique des tableaux de Léonard de Vinci au laboratoire du Musée du Louvre," in *Leonardo*, ed. Marazza, 1954, pp. 15–26). Jean Rudel ("Le métier du peintre," in *Amour de l'art*, vol. XXXI, nos. 67–69, 1952, pp. 35–48; and "Technique picturale de Léonard de Vinci," in *Études d'art*, nos. 8–10, 1953–54, pp. 287–309) linked Leonardo's mature practice with Jan Van Eyck, as has Ames-Lewis ("Leonardo's Techniques," in *Nine Lectures on Leonardo da Vinci*, ed. Ames-Lewis, London, n.d. [1990?], pp. 41–42 [32–44]).

71 Shearman, "Leonardo's Colour and Chiaroscuro," in *Zeitschrift für Kunstgeschichte*, vol. XXV, no. 1, 1962, pp. 16–22 (13–47), agreeing with Passavant that Leonardo overpainted a composition by Ghirlandaio. About medieval and Early Renaissance modeling methods in general see: Paul Hills, *The Light of Early Italian Painting*, New Haven and London, 1987; Hall, "From Modeling Techniques to Color Modes," in *Color and Technique in Renaissance Painting*, ed. Marcia Hall, Locust Valley, NY, 1987, pp. 1–29; and Ackerman, "On Early Renaissance Color Theory and Practice," in his *Distance Points: Essays in Theory and Renaissance Art and Architecture*, Cambridge, MA, 1991, pp. 151–84.

72 For Lippi's modeling techniques, see Jeffrey Ruda, "Color and the Representation of Space in Paintings by Fra Filippo Lippi," in *Color and Technique*, ed. Hall, 1987, pp. 41–53. Leonardo's darkened hues also recall Pollaiuolo's brownish palette rather than Verrocchio's typically Florentine reds and blues.

73 Leonardo's *chiaroscuro* was developed from similar effects on the Medici tomb and the Orsanmichele group (analyzed as to their source by Covi (in *Art Bulletin*, 1983, pp. 267–70; and in *Verrocchio*, ed. Bule, Darr, and Superbi Gioffredi, 1992, p. 95), according to Timothy Verdon ("Pictorialism in the Sculpture of Verrocchio," in *Verrocchio*, ed. Bule, Darr, and Superbi Gioffredi, 1992, pp. 25–31). Clark had also argued that Leonardo was influenced by Verrocchio's sculpture rather than his painting (*Leonardo*, 1939, p. 6). Stefano Bottari preferred Donatello as a source ("Verrocchio, Leonardo e Donatello," in *La cultura*, vol. XIV, no. 4, 1935, pp. 67–70; and "Sulla formazione artistica di leonardo," in *Emporium*, vol. LXXXIX, 1939, pp. 247–62).

74 About the evolution of the sculptural group, still basically in the planning stage while Leonardo was in Verrocchio's shop, see Butterfield in *Burlington Magazine*, 1992, 225–33; and Butterfield, "The Christ and St. Thomas of Andrea del Verrocchio," in *Verocchio's Christ and St. Thomas: A Masterpiece of Sculpture from Renaissance Florence*, ed. Loretta Dolcini, Exhibition Catalogue, Palazzo Vecchio, Florence, and Metropolitan Museum of Art, New York, 1992–93, New York, 1992, pp. 52–79. The forceful modeling of the work and its resemblance to the linen drapery studies are even more striking after the recent cleaning.

75 Passavant (*Complete Edition*, 1969, pp. 59–60 and cat. no. D9, p. 193 and plate 92), Cadogan (in *Zeitschrift*, 1983, pp. 40–42 and fig. 12), and Christiansen (in *Burlington Magazine*, 1990, p. 542) all regard the drawing (Uffizi, Gabinetto di Disegni no. 433E) as preparatory for Verrocchio's Christ, while Viatte (in *Léonard*, 1989, cat. no. 15, pp. 72–73) and Dalli Regoli (in Pedretti and Dalli Regoli, *Disegni*, 1985, cat. no. 4, pp. 51–53; and in *Maestri e botteghe*, ed. Gregori, Paolucci, and Acidini Luchinat, 1992, cat. no. 2.18) give it to Leonardo.

76 Alberti, *On Painting*, ed. Spencer, 1966, pp. 49–51, 81–82; and Alberti, *On Painting*, ed. Grayson, 1972, pp. 44–47, 87–89. For Alberti's system, which Leonardo varied in practice, see Ackerman, "Alberti's Light," in his *Distance Points*, 1991, pp. 59–96.

77 *Leonardo on Painting*, ed. and trans. Kemp and Walker, 1989, p. 13. For this visionary passage from Leonardo's treatise (ed. McMahon, 1956, vol. I, part 1, no. 6, p. 5), see also Claire J. Farago, *Leonardo da Vinci's Paragone: A Critical Interpretation with a New Edition of the Text in the Codex Urbinas*, Leiden, 1992, pp. 194–95.

78 For the distinction, rooted in classical philosophy, see Bialostocki in his *Message of Images*, 1988, pp. 64–68.

79 The angel is the first of a series of mysterious messenger-type figures depicted by Leonardo, culminating in the unforgettable late drawing of a lady, pointing out nature's secrets, in a landscape similar to that in the *Annunciation* (Kemp in Kemp and Roberts, *Leonardo*, 1989, cat. no. 79, p. 153).

80 The drawing (Kunsthalle, Hamburg, inv. no. 21487), which is in pen and ink over metalpoint and measures 9.3 × 13.5 cm. ($3\frac{3}{4}$ × $5\frac{5}{16}$ in.), came from the collection of the Parisian expert Robert-Dumesnil (his sale, Phillips, London, May 14, 1838, lot no. 779: "an old Man on the ground at the feet of an Assassin" by Leonardo), whose mark it bears (Lugt, *Les marques de collections*, Amsterdam, 1921, no. 2199, pp. 410–12). See Eckhard Schaar, *Italienische Zeichnungen der Renaissance aus dem Kupferstichkabinett der Hamburger Kunsthalle*, Exhibition Catalogue, Kunsthalle, Hamburg, 1997, cat. no. 25, pp. 92–93.

81 Bodmer (*Leonardo*, 1931, pp. 110, 378), who reproduces the Hamburg drawing next to the Oxford sleeve study, dated them both to the early 1470s. Valentiner (in *Loan Exhibition*, 1949, cat. no. 75, p. 109) proposed about 1478, while Popham (*Drawings*, 1945, cat. no. 110B, p. 120) and Pedretti (*Leonardo*, 1978, p. 305) prefer a dating early or late in the following decade.

82 The poor perspective led Veltman to doubt whether the drawing was by Leonardo (*Perspective*, 1986, p. 338 and plate 1.3).

83 The inscription in Leonardo's mature hand on the verso reads: "compagnie / volupta. dispiacere / amore. gielosia / felicita. invidia / fortuna. penitenza / sospetto." As Dale Kent pointed out to me, such word-pairs ("Companions / desire. displeasure / love. jealousy / happiness. envy / good fortune. penitence / suspicion") are of the sort commonly found in Quattrocento writings.

84 For depictions of the foolish Aristotle ridden by Phyllis (also called Campaspe), many of them by northern printmakers, see Wolfgang Stammler, "Aristoteles," in *Reallexikon zur deutschen Kunst-Geschichte*, ed. Otto Schmitt, vol. I, Stuttgart, 1937, cols. 1027–40; and for the iconography in general, Dawson King, "Aristotle and Phyllis: Leonardo's Drawing of an *Exemplum*," in *Achademia Leonardi Vinci*, vol. VII, 1994, pp. 75–80, esp. n. 12, p. 76, with further bibliography. Though acknowledging that the Hamburg sheet "differs from the other allegorical drawings [by Leonardo] with which it is usually classified," King, nevertheless, follows Pedretti in dating it to the 1480s.

85 Hind, *Early Italian Engraving*, Part I, vol. I, 1938, no. A.IV. 20, pp. 92–93.

86 Leonardo's debt to Verrocchio's lunette-shaped relief (originally over the chapel door at Careggi) was noted by Valentiner (in *Art Bulletin*, 1930, pp. 74–87 [43–89]; and in his *Italian Renaissance Sculpture*, 1950, pp. 166–77 [134–77]), who went on to assign the artist a share in the work. Venturi (in *L'arte*, vol. XXXIX, no. 4, 1936, pp. 262–65 [243–65]) agreed, and so tentatively did Brugnoli (in *Leonardo*, ed. Marazza, 1954, p. 379 [359–89])

and Caglioti (in *Eredità*, 1992, cat. no. 151, pp. 70–73). Passavant (*Complete Edition*, 1969, pp. 38–39, and cat. no. A1, pp. 195–96) claimed Leonardo designed the relief and executed it together with a fellow pupil. Actually Andrea's *Resurrection* and the way it dramatized Luca Della Robbia's version of the theme in Florence Cathedral must have impressed Leonardo deeply, for apart from the Hamburg drawing, the warriors in the *Battle of Anghiari* continue to echo it. In borrowing the complex pose of the crouching soldier, Leonardo changed his left hand, which in the drawing resembles the Virgin's right hand in the *Annunciation*. A dating of the drawing to the early 1470s presumes that the *Resurrection* was finished by that time (see chapter 2, note 37). Gamba, who first published the relief ("Una terracotta del Verrocchio a Careggi," in *L'arte*, vol. VII, 1904, pp. 59–61), called it Andrea's first work, though he claimed afterwards that it was an ex-voto made after the Pazzi conspiracy of 1478 ("La Resurrezione di Andrea Verrocchio al Bargello," in *Bollettino d'arte*, vol. XXV, no. 5, 1931, pp. 193–98).

87 For the book, listed as "Trionfi del Petrarcha" in the artist's library, see Covi in *Art Bulletin*, 1966, pp. 99, 103. As a popular subject for painted marriage or birth salvers and *cassoni*, as well as engravings, the folly of Aristotle was often represented with related themes, like Samson and Delilah, under the rubric of the Triumph of Love. See the *desco* catalogued by Giovanna Lazzi in *Tems revient*, ed. Ventrone, 1992, cat. no. 2.8, pp. 156–57 (and for other examples, pp. 39 and 109).

88 Fabriczy in *Archivio*, 1895, pp. 167, 176: "Per lo adornamento e aparato del ducha Ghaleazo."

89 From the time it gained popularity, the story of Aristotle and Phyllis was used to discredit his philosophy and classical learning in general. Jane Campbell Hutchison ("The Housebook Master and the Folly of the Wise Man," in *Art Bulletin*, vol. XLVIII, no. 1, 1966, pp. 73–78) identifies an anti-Aristotelian bias in an engraving contemporary with Leonardo's drawing.

90 About the drawing (Gabinetto di Disegni, Uffizi, no. 8P), which measures 19.6 × 28.7 cm. (7³/₄ × 11¹/₄ in.), see most recently Dillon in *Disegno fiorentino*, ed. Petrioli Tofani, 1992, cat. no. 10.1, pp. 208–09; and for a thorough discussion with bibliography, Dalli Regoli in Pedretti and Dalli Regoli, *Disegni*, 1985, cat. no. 1, pp. 47–49. The mountainous landscape, together with sketches of a nude man running and of a curly-haired youth, on the reverse of the sheet (reproduced in Goldscheider, *Landscapes*, 1952, fig. 8) are not by Leonardo, in my opinion, and neither is the inscription, which reads "Io Morando dant[oni]o sono chontento." It might possibly be by Biagio d'Antonio, who, presumably because he encountered them in Verrocchio's shop, imitated Leonardo's landscapes in his own paintings.

91 The inscription reads: "di di sta Maria della neve addi 5 daghossto 1473." The miraculous snowfall in August, designating the spot where the Virgin ordered Pope Liberius to found a church (later identified with Santa Maria Maggiore), has no likely connection with Leonardo's landscape, apart from indicating its date of origin.

92 Lacking figures, Leonardo's sketch was unique in its time. Subsequent Italian landscape drawings, like those by Fra Bartolomeo or the pastoral scenes from Giorgione's circle, though postdating Leonardo's by at least thirty years, still have human protagonists. See Curtis O. Baer, *Landscape Drawings*, New York, n.d. [1973]. Larry Silver ("Town and Country: Early Landscape Drawings," in *Landscape Drawings of Five Centuries, 1400–1900 from the Robert Lehman Collection, Metropolitan Museum of Art*, ed. George Szabo, Exhibition Catalogue, Mary and Leigh Block Gallery, Northwestern University, Evanston, IL, New York, 1988, pp. 3–17), ably summarizing the whole development, particularly credits the northern contribution to the genre.

93 For various identifications of the landscape see Alessandro Vezzosi, *Toscana di Leonardo*, Florence, 1984, cat. no. 6a, pp. 8–10; Pedretti, "Introduzione," in Pedretti and Dalli Regoli, *Disegni di Leonardo*, 1985, pp. 20–22; and Vezzosi, *Leonardo*, 1996, pp. 28–29. Though it is reasonable to suppose that Leonardo explored the Tuscan landscape as a boy (Valentiner in *Loan Exhibition*, 1949, p. 46 [43–61]), any attempt to identify the scene is futile, not only because the landscape would have changed greatly in half a millennium but also because the sketch so obviously blends the real with the imaginary.

94 Gombrich relates Leonardo's landscape to northern painting (in *Heritage*, 1976, pp. 33–34.

95 The rocky ledge motif is so common, being found not only in Verrocchio and Pollaiuolo but also in Netherlandish and even in Venetian painting, that it cannot be used to determine the pictorial source of Leonardo's landscape, as Gombrich (in *Heritage*, pp. 33–34) and Smyth (in *Florence and Venice*, 1979, pp. 227–28) have attempted.

96 Alexander Perrig ("Die theoriebedingten Landschaftsformen in der italienischen Malerei des 14. und 15. Jahrhunderts," in *Natur*, ed. Prinz and Beyer, 1987, pp. 52–53 [41–60]) stresses water as the focus of Leonardo's landscape.

97 Compare the chapter entitled "The River" in Pedretti, *Leonardo*, 1973, pp. 9–24; and for the citation, Leonardo, *Treatise on Painting*, ed. McMahon, 1956, vol. I, p. 13. In another passage Leonardo asks rhetorically, "What moves you, man, to abandon your home in town . . . going to country places over mountains and up valleys, if not the natural beauty of . . . shady valleys watered by twisting streams" (vol. I, pp. 30–31).

98 Pedretti (*Leonardo*, 1973, p. 9) has noted, however, that the graphic convention

Leonardo employs for the trees is also found in contemporary prints (his fig. 2).

Ginevra de' Benci

1 About the painting (National Gallery of Art, Ailsa Mellon Bruce Fund, inv. no. 1967.6.1a–b [2326]) see Shapley, *Catalogue*, 1979, vol. I, pp. 251–55.

2 It is not known whether the painting belonged to the Benci family in the early sixteenth century, as Billi (see note 5 below), who presumably saw it, does not give its location. It may well have entered the Liechtenstein Collection in the seventeenth century, as the 1733 seal designated works inherited by the then reigning Prince Joseph Wenzel (1696–1772) (Reinhold Baumstark, "Collecting Paintings," in *Liechtenstein: The Princely Collections*, Exhibition Catalogue, Metropolitan Museum of Art, New York, 1985, pp. 183–85). The founder of the picture gallery at Feldsberg was Prince Karl Eusebius (1611–84), a distinguished connoisseur who liked small cabinet-type paintings. He was succeeded by his son Prince Johann Adam (1657–1712), also an avid collector who, however, preferred the Italian Baroque. Either could have obtained the painting in Florence, where they both traveled (Olga Raggio, "The Collection of Sculpture," in *Liechtenstein*, 1985, pp. 63–65). Leonardo's authorship, in any case, came to be forgotten, as the panel was attributed (not altogether arbitrarily) to Lucas Cranach, who often placed the figures in his paintings against evergreen trees (see note 3 below). During the Second World War the picture was transferred, with the rest of the collection, from the Garden Palace in Vienna to the castle at Vaduz in the principality of Liechtenstein, and from there it was acquired from Prince Franz Joseph II for the National Gallery. The name "Ginevra" was too common in the Renaissance for Jean Adhémar ("Une galerie de portraits italiens à amboise en 1500," in *Gazette des Beaux-Arts*, 6th ser., vol. LXXXVI, no. 1281, 1975, pp. 99–104) to be correct in assuming that a portrait of a lady so named in an inventory made at Amboise in 1500 refers to Leonardo's painting, which the early sources, on the contrary, place in Florence.

3 At some time before 1780 (as indicated by the measurements of 16 by 14 "pouces" given in *Description des tableaux . . . que renferme la Gallerie . . . de Liechtenstein*, Vienna, 1780, cat. no. 117, p. 48), the panel, which now measures 38.1 × 36.7 cm. (15 × 14¹/₂ in.), was cut off at the bottom, presumably because the lower part had been damaged, and a wooden strip 4.5 cm. (1³/₄ in.) high, painted to match the original, was added. This strip, which appears in old reproductions of the picture, is covered by the frame. On the inscription, see note 80 below.

4 Apart from some losses around the edges, the only major damage affects the bridge of the lady's nose. See: Eric Gibson, "Leonardo's

Ginevra de' Benci: The Restoration of a Renaissance Masterpiece," in *Apollo*, vol. CXXXIII, no. 349, 1991, pp. 161–65; and David Bull, "Two Portraits by Leonardo: *Ginevra de' Benci* and the *Lady with an Ermine*, in *Artibus et historiae*, no. 25, 1992, pp. 67–83.

5 *Libro*, ed. Frey, 1892, p. 51: "Ritrasse la Ginevra di Amerigho Benci, tanto bene finita, che ella propria non era altrimenti." The Anonimo adds that the portrait was done from the life in Florence: "Ritrase in Firenze dal naturale la Ginevra d'Amerigho Bencj, laquale tanto bene fini, che non il ritratto, ma la propria Ginevra pareva" (Anonimo Gaddiano, *Codice*, ed. Frey, 1892, p. 111). Since his sources failed to specify that Leonardo's portrait was early, Vasari simply inserted a perfunctory mention of it ("Ritrasse la Ginevra d'Amerigo Benci, cosa bellissima') in his discussion of the artist's maturity in both the 1550 and 1568 editions of the *Vite* (vol. IV, ed. Milanesi, 1879, p. 39). His interpolation has no chronological bearing, and there is no reason to conclude, as some critics have done, that Vasari was referring to a lost work. Further evidence that he was not acquainted with the painting and simply repeated his sources is his identification of the very different looking lady on the right in Ghirlandaio's *Visitation* in Santa Maria Novella, who is certainly Giovanna Tornabuoni, as Ginevra de' Benci (*Vite*, ed. Milanesi, vol. III, 1878, pp. 266–67). Vasari's misidentification led Giovanni Rosini to try to associate a Ghirlandaiesque *Profile of a Lady* in his possession with Leonardo's portrait mentioned in the early sources (*Storia della pittura italiana esposta coi monumenti*, 7 vols. in 9, Pisa, 1839–55, vol. III, 1841, pp. 292–94). Enrico Ridolfi corrected Vasari's error in "Giovanna Tornabuoni e Ginevra de' Benci nel coro di Santa Maria Novella in Firenze," in *Archivio storico italiano*, vol. VI, 1890, pp. 426–56.

6 Bode's attribution (in *Jahrbuch*, 1882, pp. 260–61) was based first on the painting's stylistic resemblance to Leonardo's early works, including the Uffizi *Annunciation*, and then on Vasari (*Italienische Bildhauer*, 1887, pp. 156–58; and *Die Fürstlich Liechtensteinische Galerie in Wien*, Vienna, 1896, pp. 64–69).

7 Bode, "Leonardos Bildnis der Ginevra dei Benci," in *Zeitschrift für bildende Kunst*, vol. XIV, no. 11, 1903, pp. 274–76.

8 About Ginevra see: Möller, "Leonardos Bildnis der Ginevra dei Benci," in *Münchner Jahrbuch der bildenden Kunst*, vol. XII, no. 3, 1937–38, pp. 185–209; A. Alessandrini, "Benci, Ginevra," in *Dizionario biografico degli italiani*, vol. VIII, 1966, pp. 193–94, and John Walker, "*Ginevra de' Benci* by Leonardo da Vinci," in *Report and Studies in the History of Art*, National Gallery of Art, Washington, 1967, pp. 1–38 (with a Benci family genealogy compiled by Alessandro Contini-Bonacossi on p. 23).

9 Ginevra's father recorded in his tax return of February 1458 (1457 Florentine year) that she

was six months old (Walker in *Report*, 1967, p. 21 note 1).

10 On Ginevra's dowry and on the respective wealth of the two families as seen in their *catasto* declarations, see Anthony Molho, *Marriage Alliance in Late Medieval Florence*, Cambridge, MA, and London, 1994, pp. 57, 380, 397.

11 The age difference separating bride and groom was typical (David Herlihy and Christiane Klapish-Zuber, *Tuscans and their Families: A Study of the Florentine Catasto of 1427*, New Haven and London, 1978, pp. 210, 216. About the Niccolini clan in general see: Ginevra Niccolini di Camugliano, *The Chronicles of a Florentine Family 1200–1470*, London, 1933 (no mention of Luigi); and about their presumed matrimonial strategy, Klapish-Zuber, "'Kin, Friends and Neighbors': The Urban Territory of a Merchant Family in 1400," in her *Women, Family and Ritual in Renaissance Italy*, trans. Lydia Cochrane, Chicago and London, 1985, pp. 68–93.

12 "Inferma," according to her husband, "ed è stata assai tempo ed è in mano di Medicj," (Möller in *Münchner Jahrbuch*, 1937–38, p. 198 note 21), Ginevra lived with Luigi in a modest dwelling in via San Procolo (now via Pandolfini).

13 In lieu of her dowry Ginevra obtained the Niccolini wool shop, which she bequeathed to her brother Giovanni, who in turn sold it in 1521; this suggests that she died about 1520 (Möller in *Münchner Jahrbuch*, 1937–38, pp. 198–99).

14 Professor Paul Oskar Kristeller first realized that the subject of the poems was the same Ginevra portrayed by Leonardo. Walker (in *Report*, 1967, pp. 28–35) gives the Latin texts (originally published by Arnaldo Della Torre, "La prima ambasceria di Bernardo Bembo a Firenze," in *Giornale storico della letteratura italiana*, vol. XXXV, 1900, pp. 322–33 [258–333]; and in Cristoforo Landino, *Carmina omnia*, ed. Alexander Perosa, Florence, 1939, pp. 158–72) and English translations of Landino's poems. Sonnet no. III (Walker, pp. 28 and 32) cites the object of Bembo's "chaste love" as an exemplar of nuptial fidelity like the ancient Penelope, while Sonnet no. V (Walker, pp. 29 and 33) conventionally praises her "snow white brow, her teeth like ivory, and her dark eyes set in rosy cheeks." Sonnet no. VII (Walker, pp. 30 and 34) goes on to describe Landino's own love as having "golden hair and dark eyes" in the manner of Ginevra, who surpasses [Petrarch's] Laura in her "chastity, beauty, kindness, moderation, and pure morals." Walker (pp. 36–37) further gives the Latin texts (published by Della Torre in *Giornale*, 1900, pp. 320–22; and Alessandro Braccesi, *Carmina*, ed. Alexander Perosa, Florence, 1943, pp. 71–74) of the poems by Braccesi, according to whom it was Ginevra's chastity, even more than her beauty, that constituted her appeal for Bembo. The writers' accounts of Ginevra's despair at Bembo's departure could refer to either of his missions

to Florence. Della Torre (in *Giornale*, 1900, pp. 310–12) and Perosa (in Landino, *Carmina*, 1939, pp. XLII–XLIII; and Braccesi, *Carmina*, ed. Perosa, 1943, p. XVIII) dated the poems to the time of Bembo's first embassy, while Walker preferred the second (p. 4). For Naldi's poem similarly honoring Ginevra see his *Epigrammaton liber*, ed. Perosa, Budapest, 1943, no. 121, p. 39.

15 Walker (in *Report*, 1967, p. 38) gives the Italian texts and English translations of Lorenzo's sonnets addressed to Ginevra as a "devout spirit." Möller (in *Jahrbuch*, 1937–38, p. 201) connected Ginevra's seeking refuge with a scandal involving her aunt Bartolomea Benci, who was Lorenzo's mistress, while Walker (p. 6) related it to Bembo's departure. The "Ginevra Benci, called la Bencina," mentioned in an anecdote told by the Medici tutor and poet Poliziano, is another member of the family, according to Enrica Viviani della Robbia, "Ginevra de' Benci nel 'Tagebuch' del Poliziano e nella realtà," in *Il Poliziano e il suo tempo*, Atti del IV Convegno Internazionale di Studi sul Rinascimento, Florence, 1954, p. 22.

16 The letter was first published by Carlo Carnesecchi ("Il ritratto leonardesco di Ginevra Benci," in *Rivista d'arte*, vol. VI, nos. 5–6, 1909, pp. 293–96 [281–96]); reprinted by Walker (in *Report*, 1967, pp. 24–25; English translation, pp. 25–27).

17 Alessandrini (in *Dizionario*, 1966, p. 193 [193–94]) doubts that the line of poetry quoted in the letter – "Chieggio merzede e sono alpestre tygre" – is Ginevra's.

18 In the words of John Canaday ("Art: Debut of Leonardo's *Ginevra*," in *New York Times*, March 17, 1967): "a curious representation of a rather unpleasant personality."

19 Though often invoked in connection with Ginevra, Leonardo's concept of the "motions of the mind" and of the body actually pertain to pictorial narrative, not psychological portraiture (*Leonardo on Painting*, ed. and trans. Kemp and Walker, 1989, pp. 144–45).

20 Perry B. Cott, *Leonardo's Portrait of Ginevra de' Benci*, National Gallery of Art, Washington, 1967 [unpaginated]. Ernst Liphart ("Kritische Gänge und Reiseeindrücke," in *Jahrbuch der königlich preussischen Kunstsammlungen*, vol. XXXIII, nos. 2–3, 1912, pp. 210–12 [193–224]) made the same observation.

21 Walker (in *Report*, 1967, pp. 2, 4, 6–7, 18) viewed the portrait as the "witness to some unhappy experience, which [he] postulated as a disastrous love affair." Leonardo here "conveyed what he himself described as the 'motions of the mind.' When we look at Ginevra we feel we are in the presence of a soul numbed by suffering." Gottfried Boehm (*Bildnis und Individuum: Über den Ursprung der Porträtmalerei in der italienischen Renaissance*, Munich, 1985, p. 220) agreed with Walker. To Gould (*Leonardo*, 1975, pp. 31, 73), on the other hand, the portrait betrayed Leonardo's "dislike of the sitter."

22 Jennifer Fletcher, "Bernardo Bembo and

Leonardo's Portrait of Ginevra de' Benci," in *Burlington Magazine*, vol. cxxxi, no. 1041, 1989, pp. 811–16.

23 Both of the writers who occupied themselves with the sitter's biography – Möller (in *Jahrbuch*, 1937–38, pp. 202, 206) and Walker (in *Report*, 1967, pp. 18–19) – dated the painting 1479–80. See also: Heydenreich, *Leonardo*, 1954, vol. I, p. 12, 180; and vol. II, p. IV; Castelfranco, "Momenti della recente critica vinciana," in his *Studi vinciani*, Rome, 1966, p. 102 (54–124); and Marco Rosci, *The Hidden Leonardo*, trans. John Gilbert, Chicago, 1977, pp. 41, 44. Kemp first dated this "awkwardly original" work to *c.* 1474 (*Leonardo*, 1981, pp. 49–53) or to the time (1475–76) of Bembo's first embassy (in *Circa 1492*, 1992, cat. no. 169, pp. 270–71).

24 Clark, *Leonardo*, 1939, p. 16, rev. ed. 1988, p. 57. Pedretti agrees (*Leonardo . . . Chronology and Style*, 1973, pp. 54–55; and *Leonardo*, 1979, note to plate 5).

25 The discrepancy between the three-quarter view adopted for the head and bust and the somewhat fuller face in the painting might be accounted for by assuming that in Leonardo's (or Verrocchio's) preliminary sketch for the portrait Ginevra's features were rendered frontally – an error in foreshortening, in other words, similar to that which affects the Virgin's figure in the *Annunciation*. Ginevra's slitted eyes and moon-shaped head gave rise to the notion that she was of Slavic origin (Thiis, *Leonardo*, n.d. [1913], p. 108, Beltrami, *Leonardo e i disfattisti suoi*, Milan, 1919, p. 90; Attilio Schiaparelli, *Leonardo ritrattista*, Milan, 1921, p. 15; and Suida, *Leonardo*, 1929, p. 25). John N. Lupia III ("The Secret Revealed: How to Look at Italian Renaissance Paintings," in *Medieval & Renaissance Times*, vol. 1, no. 2, 1994, pp. 6–17) claimed her face was rendered in anamorphic perspective.

26 Bode, *Studien*, 1921, p. 38.

27 Carnesecchi (in *Rivista d'arte*, 1909, p. 282 [281–96]) showed that it was not Ginevra but Niccolini's first wife who died in mid-August 1473.

28 For the background to Ginevra's portrayal as an upper-class virgin bride-to-be, see Klapisch-Zuber, "The 'Cruel Mother': Maternity, Widowhood, and Dowry in Florence in the Fourteenth and Fifteenth Centuries," and "Zacharias or the Ousted Father: Nuptial Rites in Tuscany between Giotto and the Council of Trent," in her *Women*, 1985, pp. 117–31 and 178–212; and Klapisch-Zuber, "Images without Memory: Women's Identity and Family Consciousness in Renaissance Florence," in *Fenway Court*, Isabella Stewart Gardner Museum, Boston, 1990–91, pp. 37–43. To her sobering account of how female identity could be expressed in Renaissance Florence, add the criticism of Peter Burke (review of Boehm, *Bildnis*, 1985, in *Kunstchronik*, vol. xli, 1988, p. 24 [24–26]): "portraits were commissioned essentially for family reasons, particularly at the time of betrothals or weddings."

29 Richter, *Literary Works*, 1970, vol. II, p. 416 and nos. 1416, 1444, and 1454, pp. 354, 359, and 362. Carlo Pedretti (*Commentary to the Literary Works of Leonardo da Vinci*, ed. Jean Paul Richter, 2 vols., Oxford, 1977, vol. II, pp. 331, 341, and 346) dates the citations to the beginning of the sixteenth century. Sandra Sider has kindly suggested to me that the "mappamondo" referred to may be a book rather than a map.

30 Vasari, *Vite*, ed. Milanesi, vol. IV, 1879, p. 27; and Goldscheider, *Leonardo*, 1959, p. 16.

31 Möller (in *Jahrbuch*, 1937–38, pp. 192–94 and Fig. 13) claimed that about 15 cm. (5⅞ in.) were removed, while Bode (*Italienische Bildhauer*, 1887, pp. 87, 91; in *Zeitschrift*, 1903, pp. 274, 276; and *Studien*, 1921, pp. 33–34) correctly opted for about 20 cm. (8 in.) or more.

32 Assuming that the juniper stem on the reverse marks the central axis, we can conclude that the panel was trimmed by about 1.3 cm. (½ in.) on the right side (from the front), since the stem is now closer by this distance to that edge.

33 About the picture (inv. no. 43.86.5), which Bode and Möller exceptionally gave to Sogliani, see Dalli Regoli, *Lorenzo di Credi*, Cremona, 1966, cat. no. 89, p. 145; and Zeri, *Catalogue*, 1971, pp. 154–57 (with bibliography). Though in Credi's style, the picture, particularly the landscape, does not seem sufficiently accomplished for him, even if one allows for its poor condition. Nor does the tree inspired by Leonardo's juniper necessarily mean that the sitter was named Ginevra. Though his identity has not yet been clearly defined (Berenson, *Florentine School*, 1963, vol. I, pp. 207–08), "Tommaso"'s knowledge of Leonardo's early work sets him apart from Credi's other pupils. The disciple may have based his composition (in reverse) on some drawing for *Ginevra de' Benci*, preserved in Verrocchio's shop, long after Leonardo had completed his picture. A *Portrait of a Lady*, formerly in the Otto Kahn Collection, New York (Lionello Venturi, *Italian Paintings in America*, 2 vols. New York, 1933, vol. II note to plate 283), represents Credi's response to the Leonardo prototype, as noted by Sirén (*Leonardo*, 1916, vol. II, pp. 24–26).

34 The x-radiograph of the picture in New York, cited by Walker (in *Report*, 1967, pp. 16–17 and Fig. 15), does not reveal another head in the underpaint broadly shaped like Ginevra's, as he claimed, but simply a contour change (the eyes were also repositioned). Keith Christiansen kindly checked the inscription, which is not completely legible.

35 About the drawing (inv. no. 12558), which measures 21.4 × 15 cm. (8½ × 5⅞ in.), in the Royal Library, Windsor Castle, see Roberts in Kemp and Roberts, *Leonardo*, 1989, cat. no. 4, p. 51.

36 Müller-Walde (*Leonardo da Vinci*, 1889, p. 52) first suggested that the Windsor drawing might have served for the Liechtenstein painting. Scholars who doubted or denied the attri-

bution of the picture to Leonardo naturally disagreed. But Bode endorsed Müller-Walde's proposal (*Studien*, 1921, p. 40), dating both the painting and the presumed preparatory study to the later 1470s. Popham (*Drawings*, 1945, pp. 17–18) and Heydenreich (*Leonardo*, 1954, vol. I, p. 31; and vol. II, p. IV) concurred, and so did Clark, who, after first tentatively dating the drawing, together with the portrait, *c.* 1474 (*Leonardo*, 1939, p. 17), later placed both works (and the Uffizi *Annunciation*) *c.* 1478–80 (*Drawings*, 1968, vol. I, no. 12558, pp. 104–05). Clark's reservations about an early date for such an accomplished drawing were shared by Berenson (*Drawings*, 1938, vol. II, no. 1173) and many later scholars, including Wasserman (review of Clark, *Drawings*, 1968, in *Burlington Magazine*, vol. cxvi, 1974, p. 113 [111–13]), who preferred to connect the hands with a (quite differently modeled) study of a female profile also at Windsor (no. 12505). This hypothesis was further explored by Herman T. Colenbrander ("Hands in Leonardo Portraiture," in *Achademia Leonardi Vinci*, vol. v, 1992, pp. 37–43). The grotesque profile in the upper left of the sheet is of the kind that Leonardo drew throughout his career.

37 The computer reconstruction of *Ginevra de' Benci* (Figs. 94, 108), which attempts to suggest forms originally in the missing part of the picture, was undertaken by the author in conjunction with the National Gallery's Department of Imaging and Visual Services, headed by Ira Bartfield. Under the supervision of Bob Grove, Coordinator of Digital Imaging Services, Alexi Bryant completed the computer work. The process of digitally reconstructing Leonardo's portrait began on paper by estimating the dimensions of the original panel. The present height and width are 38.1 × 36.7 cm. (15 × 14½ in.). The original width was projected by measuring the distance from the juniper stem on the reverse to the right edge of the panel, which is 19 cm. Assuming that the juniper marks the central axis of the composition, the distance to the left edge of the reverse should also measure 19 cm., but is only 17.7 cm. Thus 1.3 cm. (½ in.) have presumably been cut from the original panel (left side of the reverse; right side of the obverse), giving an original width of 38 cm. (15 in.). For the height of the panel, a 3 to 2 height-to-width ratio, consonant with other portraits of the period, especially the variant of *Ginevra* (Fig. 92) in the Metropolitan Museum, New York, suggested a height of around 57 cm. The exact height envisaged in the present reconstruction is 57.8 cm. (22¾ in.). By this calculation the lower third of Leonardo's portrait is missing.

After determining the general dimensions of the original painting, color transparencies of the front and the reverse and of the other essential visual element – Leonardo's drawing of hands at Windsor Castle (Fig. 93) – were scanned. The computer work was done on an Apple Macintosh 8600/300 with 120 mega-

bytes of memory using the software application Adobe Photoshop 4.0 and Fractal Painter 5 and a Cal Comp Drawing Slate stylus and drawing pad. Because Photoshop has the capability of "layering" images, it was possible to keep separate the various components of the reconstruction and to manipulate and readjust them in a process of trial and error.

The hands in the drawing were first combined digitally, so that the right rests in the left, as described in the text. Then the folded hands were brought into the scan of the original painting as separate layers in Photoshop and scaled to match the proportions of the picture. The hands and the left forearm were colored slightly so as to blend, and Leonardo's original shading was retained. Despite the addition of the hands, much was still needed to complete the reconstruction, including almost the entire right arm, the upper left arm, and the torso from the bust down. The length and placement of the arms were roughly determined by photographing a live model presumed to be of similar size to Ginevra. Several slightly different positions were scanned into the computer and layered with scans of the original painting and the drawing, and the composite which appeared most convincing was selected. A general framework was provided by the variant in New York, with the hands held before the sitter shown standing in a landscape.

Once the composite was chosen, both Adobe Photoshop and Fractal Painter were used to digitally "paint" the sleeves and bodice of the dress. This process involved laying color down with a computer stylus and pad and blending in shadows and highlights for a three-dimensional effect. Costume details, such as the high-waisted dress with laces extending below the belt, were suggested by the *Portrait of a Lady* in the National Gallery, London, which Everett Fahy has convincingly attributed to the early Fra Bartolomeo (in *Art Bulletin*, 1969, p. 150 and fig. 24 [142–54]). The motif of flowers held between the sitter's thumb and index finger was also suggested by the London portrait, which seems clearly to have been based (in reverse) on Leonardo's. The missing strip was added on the right side, and the green of the landscape beside the lady was continued to the bottom edge of the painting.

The reverse of the double-sided portrait, finally, was reconstructed in Photoshop using a combination of "cloning" and cutting and pasting. Sections of the upper part of the wreath, including leaves, branches and stems, were individually selected and then copied and rotated to complete the bottom third. The bottom section of the painting with losses was filled in by completing the juniper stem and branches. The speckled background was duplicated by cloning the upper portion of the painting, and the exposed edge of the panel was continued around the reconstructed area.

The reconstruction brings *Ginevra de' Benci* into conformity with Leonardo's other certain female portraits, not only *Mona Lisa* but the *Lady with an Ermine* in Kraków, as well as the cartoon for a projected likeness of Isabella d'Este, in the Louvre, in which he consistently uses the sitter's hands as a formal and expressive device.

38 Closest to Leonardo's cradled hands is the *Portrait of a Bride Holding a Carnation*, ascribed to Sebald Bopp, in the Thyssen Collection (Gertrude Borghero, *Thyssen-Bornemisza Collection*, Milan, 1986, cat. no. 35, p. 42), a formula later adopted by Dürer. Compare also the German *Lady Holding a Forget-Me-Not* of *c.* 1470 in the National Gallery, London (Dunkerton, Foister, Gordon, and Penny, *Giotto to Dürer*, 1991, cat. no. 34, pp. 300–01). Italian examples include the *Portrait of a Lady*, attributed to Lorenzo di Credi, at Forlì (Giordano Viroli, *La Pinacoteca Civica di Forlì*, Forlì, 1980, pp. 46–47), the sitter of which Herbert Cook wished to identify as Ginevra ("The Portrait of Ginevra dei Benci by Leonardo da Vinci," in *Burlington Magazine*, vol. xx, no. 108, 1912, pp. 345–46); and the similar waist-length portrait of a lady in three-quarter view holding a flower against a landscape background, given to Domenico Ghirlandaio, in Williamstown (*List of Paintings in the Sterling and Francine Clark Art Institute*, ed. Steven Kern, Williamstown, MA, 1992, inv. no. 938, p. 51).

39 The poetic image of a young lady offering flowers to her beloved can be seen best, perhaps, in the woodcut illustrating the *Storia di due amanti* of Braccesi, whose poems honoring Ginevra are cited in note 14 above. For the illustration to Braccesi's text, an Italian version printed in many editions of a romance by Enea Silvio Piccolomini (later Pope Pius II), see Kristeller, *Early Florentine Woodcuts*, London, 1897, plate 13.

40 For an extended analysis see Jean Lipman, "The Florentine Profile Portrait in the Quattrocento," in *Art Bulletin*, vol. XVIII, no. 1, 1936, pp. 54–102. Barbara K. Debs ("From Eternity to Here: Uses of the Renaissance Portrait," in *Art in America*, Jan.–Feb. 1975, p. 51 [48–55]) links the profile as a "highly selective projection" to the humanist concept of personality, while in Patricia Simons's feminist interpretation ("Women in Frames: The Gaze, the Eye, the Profile in Renaissance Portraiture," in *The Expanding Discourse: Feminism and Art History*, ed. Norma Broude and Mary D. Garrard, New York, 1992, pp. 38–57) Florentine female profiles were constructed as objects to be displayed to the "male gaze."

41 About the Milan portrait see: Pope-Hennessy, *The Portrait in the Renaissance*, New York, 1966, p. 48; and Mauro Natale, "Dipinti," in *Museo Poldi Pezzoli: Dipinti*, Milan, 1982, cat. no. 186, pp. 151–52 (wrongly ascribed to Piero). For the slightly earlier example in Berlin see: Pope-Hennessy, *Portrait*, 1966, p. 48 and Fig. 45; and Schleier, *Gemäldegalerie*, 1986, pp. 294–95. Another of these Pollaiuolesque profiles in the Uffizi was attrib-

uted by Suida (*Leonardo*, 1929, pp. 26–27 and Fig. 12) to the young Leonardo. Damaged though it is, the portrait in the Metropolitan Museum (Zeri, *Catalogue*, 1971, no. 50.135.3, pp. 123–25) seems superior to Piero's own effort in the Gardner Museum (Philip Hendy, *European and American Paintings in the Isabella Stewart Gardner Museum*, Boston, 1974, pp. 186–88). Piero's *Galeazzo Maria Sforza* of 1471 in the Uffizi tops the three-quarter bust with a head in near profile. Leonardo's rejection of the profile, and not only the poor quality of the picture, disqualifies the *Lady* attributed to him by Valentiner ("Verrocchio or Leonardo," in *Bulletin of the Detroit Institute of Arts*, vol. XVI, no. 4, 1936–37, pp. 50–59). Adorno (*Verrocchio*, 1991, pp. 141–42) prefers Verrocchio for this work, which the museum gives to the Ghirlandaio shop.

42 The inclusion of the lady's hands, a setting, and even a suitor in Filippo Lippi's much-discussed *Double Portrait* in the Metropolitan Museum (Zeri, *Catalogue*, 1971, no. 89.15.19, pp. 85–87), only serves to point up the deficiencies of the strict profile. Lippi's bold if awkward attempt to overcome its limitations was not taken up by other artists like Leonardo, who opted for the three-quarter pose familiar in Netherlandish art.

43 A *Bust of a Lady* in the Frick Collection, New York, ascribed to Verrocchio (Pope-Hennessy in *Revue de l'art*, 1988, pp. 22–23 [17–25] and Fig. 12) belongs to the standard type studied by Irving Lavin in "On the Sources and Meaning of the Renaissance Portrait Bust," in *Art Quarterly*, vol. XXXIII, no. 3, 1970, pp. 207–26. Verrocchio's painted portrait of Lorenzo de' Medici's *innamorata* Lucrezia Donati was also bust length, according to Tommaso's list (see chapter 1 note 38 above). About the more innovative Bargello bust see Caglioti in *Eredità*, ed. Barocchi, Caglioti, Gaeta Bertelà, and Spallanzani, 1992, cat. no. 23, pp. 50–54 (with bibliography). He dates the work *c.* 1475, though most writers, including Pope-Hennessy (*Introduction*, 1958, p. 312) and Passavant (*Complete Edition*, 1969, cat. no. 10, pp. 180–81), have favored a dating to the late 1470s. Even if the marble postdates *Ginevra*, Leonardo could have known drawings or a model for the sculpture in time for his portrait.

44 Following Mackowsky (*Verrocchio*, 1901, pp. 45–46), Bode (see Appendix note 39) attributed the bust at least partly to Leonardo. Venturi (*Storia*, vol. X, Part I, 1935, pp. 12–16) also favored a collaboration with Verrocchio, while Möller (*La Gentildonna dalle belle mani di Leonardo da Vinci*, Bologna, 1954) credited Leonardo with sole responsibilty for the work. Phillips further championed Leonardo's authorship of a polychrome plaster cast of the marble acquired by the Metropolitan Museum ("The Lady with the Primroses," in *Metropolitan Museum of Art Bulletin*, vol. XXVII, no. 8, 1969, pp. 385–95). Most writers who gave the Bargello bust to Leonardo identified the subject as Ginevra de' Benci by comparison

with the ex-Liechtenstein portrait, as did Jane Schuyler (*Florentine Busts: Sculpted Portraiture in the Fifteenth Century*, New York and London, 1976, pp. 176–206), who suggested that Bernardo Bembo may have owned both bust and picture representing his beloved.

45 Kemp, *Leonardo*, 1981, p. 49.

46 Farago, *Paragone*, 1992, pp. 266–73.

47 Sheard (in *Verrocchio*, ed. Bule, Darr, and Superbi Gioffredi, 1992, p. 79 note 57) hypothesizes that the "topic became an important issue within Verrocchio's circle from the early 1470s onwards, stimulated by Verrocchio's workshop practice of producing works of both sculpture and painting."

48 See: chapter 3 note 89; and Farago, *Paragone*, 1992, pp. 256–57.

49 Ames-Lewis ("Fra Filippo Lippi and Flanders," in *Zeitschrift für Kunstgeschichte*, vol. XLII, no. 3, 1979, pp. 255–73) argued that Lippi traveled to the Low Countries to find examples of Netherlandish art, while Ruda ("Flemish Painting and the Early Renaissance in Florence," in *Zeitschrift für Kunstgeschichte*, vol. XLVII, no. 2, 1984, pp. 210–36), disagreeing about the trip, concluded that "Flemish art was little known in Florence in the first half of the Quattrocento" (p. 235). The keen interest Pollaiuolo took, beginning in the 1460s, in the illusionism of works by Roger van der Weyden, like the *Virgin with Four Saints* (Städelsches Kunstinstitut, Frankfurt) and the Uffizi *Entombment*, both apparently painted for the Medici, has been described in chapter 1. About van der Weyden's works see: Liana Castelfranchi Vegas, *Italia e Fiandra nella pittura del Quattrocento*, Milan, 1983, p. 68 and Figs 27 and 29; and Salvini, *Banchieri*, 1984, pp. 20–21 and Figs 37 and 39. The many unconvincing comparisons made in the literature suggest that Netherlandish art was something of a novelty in Florence in the mid-1470s. Northern influence culminated after the arrival in May 1483 (following Leonardo's departure for Milan) of Hugo van der Goes's Portinari triptych (Bianca Hatfield Strens, "L'arrivo del trittico Portinari a Firenze," in *Commentari*, vol. XIX, nos. 1–2, 1968, pp. 315–19).

50 See chapter 2 notes 11, 38, 66, and 85.

51 Gombrich in *Heritage*, 1976, p. 33 (19–35); and Castelfranchi Vegas, *Italia e Fiandra*, 1983, p. 197. Smyth (in *Florence and Venice*, 1979, p. 242 note 142) and even more explicitly Hills ("Leonardo and Flemish Painting," in *Burlington Magazine*, vol. CXXII, no. 930, 1980, p. 615 [609–15]) linked Leonardo's and Christus's portraits.

52 Scholars have come to doubt the identification of the Berlin panel, dated toward 1470 (Joel M. Upton, *Petrus Christus: His Place in Fifteenth-Century Flemish Painting*, London, 1990, 29–32, 44 note b; and Maryan W. Ainsworth, *Petrus Christus: Renaissance Master of Bruges*, Exhibition Catalogue, Metropolitan Museum of Art, New York, 1994, cat. no. 19, pp. 166–69 and 210), with the one listed in the inventory: "Una tavoletta, dipintovi di una testa di dama franzese, cholorita a olio,

opera di Pietro Cresci da Bruggia" (*Libro d'inventario*, ed. Spallanzani and Bertelà, 1992, p. 52. The inventory also cites a small panel of St. Jerome by Van Eyck in Lorenzo's study, (for which see Garzelli, "Sulla fortuna del *Gerolamo* mediceo del van Eyck nell'arte fiorentina del Quattrocento," in *Scritti di storia dell'arte in onore di Roberto Salvini*, Florence, 1984, pp. 347–53). Active in Bruges, where the Medici had a branch office, Christus's connection with Italy and Italian painters like Antonello da Messina is still much debated.

53 The issue of is discussed by Richard Brilliant (*Portraiture*, Cambridge, MA, 1991), who remarks that a portrait subject could conceivably have "a face not wholly his own, or even someone else's face."

54 Though Ginevra's grandfather Giovanni had been Cosimo de' Medici's chief adviser in business matters, Raymond De Roover (*The Rise and Decline of the Medici Bank 1397–1494*, New York, 1966, pp. 57–58, 234–35, and 284–88) surmised that a rift developed between Giovanni's son Amerigo and his patron. Interestingly enough, Botticelli's contemporary and also Netherlandish-influenced *Portrait of a Young Man with a Medallion of Cosimo de' Medici* in the Uffizi associates the (unknown) sitter iconographically with the leading member of Florence's greatest family.

55 Bull in *Artibus*, 1992, p. 80 (67–83). Perhaps because he was painting a portrait, Leonardo felt the need to use a pricked cartoon as a guide for the sitter's features; no pounce marks can be detected in the rest of the painting, nor in the underdrawing of the *Annunciation*.

56 Bull in *Artibus*, 1992, Fig. 21.

57 Brachert, "A Distinctive Aspect in the Painting Technique of the 'Ginevra de' Benci' and of Leonardo's Early Works," in *Report and Studies in the History of Art*, National Gallery of Art, Washington, 1969, pp. 85–104. Leonardo's fingerpainting had already been noted by Möller in *Jahrbuch*, 1937–38, p. 190 (185–209). What Brachert takes to be papillar "wipings," as opposed to fingerprints, are not easily distinguishable from brushstrokes. The fingerprints impressed in the *Annunciation* and *Ginevra* are insufficiently detailed for a match; nor do they indicate left-handedness. The technique is ironic on the part of an artist who aspired to raise painting above handicraft.

58 Proposing Memling as a source are: Gould, *Leonardo*, 1975, p. 30; Shapley, *Catalogue*, 1979, p. 252; Hills in *Burlington Magazine*, 1980, p. 615; Marani in *Verrocchio*, ed. Bule, Darr, and Superbi Gioffredi, 1992, p. 143; Padoa Rizzo in *Maestri e botteghe*, ed. Gregori, Paolucci, and Acidini Luchinat, 1992, p. 56; and Dirk De Vos, *Hans Memling. The Complete Works*, Ghent and Antwerp, 1994, pp. 368, 399.

59 To Aby Warburg's classic study "Arte fiamminga e Primo Rinascimento fiorentino," in his *La rinascita del paganesimo antico*, ed. Gertrud Bing and trans. Emma Cantimori,

Florence, 1966, pp. 147–70 (orig. German ed., 1902) should be added: Castelfranchi Vegas, *Italia e Fiandra*, 1983, pp. 195–97, 226; Salvini, *Banchieri*, 1984, pp. 35–38; Guy Bauman, "Early Flemish Portraits 1425–1525," in *Metropolitan Museum of Art Bulletin*, vol. XLIII, no. 4, 1986, pp. 42–44, 50–61 (1–64); and Lorne Campbell, *Renaissance Portraits: European Portrait-Painting in the 14th, 15th and 16th Centuries* (New Haven and London, 1990), pp. 120–21. Though scholars once believed Memling was influenced by Italian art, the visual evidence seems to point in the other direction, with some artists, like Ghirlandaio, Filippino Lippi, Credi, and Fra Bartolomeo, borrowing individual landscape motifs from the Flemish master (*Portrait* in the Lehman Collection, Metropolitan Museum, New York, and Uffizi *Virgin Enthroned*), and others, like Perugino and Raphael, taking over his method of organizing landscapes (Munich-Washington diptych). In accordance with the dates when his works were imported, Memling's impact was felt mainly from about 1480 onwards. *Ginevra de' Benci* and Botticelli's *Portrait of a Young Man with a Medallion of Cosimo de' Medici* (Uffizi), both dating from before 1475, have landscapes that do not relate specifically to Memling.

60 Bernice Davidson ("Tradition and Innovation: Gentile da Fabriano and Hans Memling," in *Apollo*, vol. XCIII, no. 111, 1971, pp. 380–85 [378–85]) notes that whereas a window frame separates the subject from the landscape in Memling's earlier portraits, his later sitters are placed "in, not in front of" nature. For the earlier type see De Vos, *Memling*, 1994, cat. nos. 7, 12, 14, 22; and for the slightly later and more evolved group, cat. nos. 28, 40, 42, 44, 46, and 49. De Vos's attempted dating of the *Portrait of a Young Man in a Loggia* in the Lehman Collection (cat. no. 48) to 1480 or later is belied by the citation of Memling's landscape in Ghirlandaio's early Verrocchiesque *Virgin and Child* in the Louvre (see chapter 2 note 85). Leonardo's use of aerial perspective, in any case, is more schematic (the distance is uniformly blue and lacks detail) than in Memling, as if the Italian were seeking to demonstrate in his painting how atmosphere affects visual perception.

61 Pope-Hennessy ("Leonardo: Landscape Painter," in *Antaeus*, no. 54, 1985, pp. 41–54) deduced from Leonardo's use of oil for landscape that he had trained with Pollaiuolo before working with Verrocchio.

62 Leonardo later counseled artists to avoid depicting lavish costumes lest the "resplendent beauty of youth lose its excellence through excessive devotion to ornament" (*Leonardo on Painting*, ed. and trans. Kemp and Walker, 1989, p. 196).

63 About the panel, which is datable stylistically to the 1430s, see: Campbell, *Renaissance Portraits*, 1990, p. 81; Norbert Schneider, *The Art of the Portrait: Masterpieces of European Portrait-Painting 1420–1670*, Cologne, 1994, p. 52; and Dominique Cordellier, *Pisanello: La princesse*

au brin de genévrier, Musée du Louvre, Paris, 1996. Though Hill, cited by Cordellier, argued that the juniper played on the sitter's name, for the latter it symbolizes the "felicity" of his candidate Lucia d'Este. In Leonardo's case the plant would refer to both the sitter's name and to her character.

64 Shearman in *Zeitschrift*, 1962, pp. 19, 23–24.

65 As in the *Annunciation*, the sky is freely brushed in around the area of the juniper, which Leonardo left in the stage of dark green underpaint to the right of the sitter's head. The leaves, once bright green, have turned brown, adding to the autumnal look of the background.

66 Richter, *Literary Works*, 1970, vol. I, no. 456, p. 292: "Wherever the trees or branches are thickest they will be darkest, because there are no little intervals of air. But where the boughs lie against a background of other boughs, the brighter parts are seen lightest and the leaves lustrous from the sunlight falling on them."

67 Leonardo's juniper is far in advance of his time. The example illustrated in Leonhard Fuchs's *De historia stirpium* of 1542 shows foliage (p. 78) that is detailed, like Leonardo's, but still schematically arranged. Not until later in the sixteenth century, with the publication of Pierandrea Mattioli's *Commentarii* in Venice in 1554, do we find (1558 ed., pp. 91–92) a juniper with dense growth comparable with Leonardo's. The berries, paramount in the earlier woodcuts, are scaled more naturalistically in the later ones. Leonardo's portrayal of light filtering through the plant is, in the context of botanical illustration, unique. Linda Lott facilitated my study of the pertinent herbals at Dumbarton Oaks.

68 Levi D'Ancona, *Garden*, 1977, no. 83, pp. 197–99.

69 For the social background to Ginevra's portrait see, in addition to the literature cited in note 28 above, Molho, *Marriage Alliance*, 1994, pp. 137–43.

70 About the drawing, which is in pen and brown ink over stylus indentations and which, having been cropped at the top, measures 9.5 × 7.5 cm. (3¾ × 3 in.), see: Colvin, *Drawings*, 1907, vol. I, Part I, note to plate 15A; Popham, *Drawings*, 1945, cat. no. 28B, p. 105; and K. T. Parker, *Catalogue of the Collection of Drawings in the Ashmolean Museum, II: Italian Schools*, Oxford, 1956, cat. no. 15, p. 10.

71 On the unicorn see: Odell Shepard, *The Lore of the Unicorn*, New York, 1967; and Rüdiger Robert Beer, *Unicorn. Myth and Reality*, trans. Charles M. Stern, New York, 1977. Leonardo, who was familiar with the unicorn from bestiaries (see Francesco di Giorgio's miniature illustrating Albertus Magnus's *De animalibus*, [reproduced in Mario Salmi, *La miniatura italiana*, Milan, 1955, plate LI]), cited it as a symbol of concupiscence rather than chastity (Richter, *Literary Works*, 1970, vol. I, no. 1232, p. 265).

72 The chapel founded in the Florentine church of Santa Croce by a sixteenth-century descendant of Luigi Niccolini's uncle Ottobuono includes what can be regarded as a typical figure of Chastity (with a unicorn as attribute) carved in marble by Francavilla; see Anthony Calarco, "A Note on the Significance of Moses and Aaron in the Sculptural Program of the Cappella Niccolini," in *Acta toscana* (Bulletin of the Tuscan-American Archaeological Association), 1974, p. 33 (33–44) and Fig. 3.

73 Stites pointed out the resemblance to Walker (in *Studies*, 1967, pp. 19–20) and elaborated on it in his *Sublimations*, 1970, pp. 66, 68. Citing Walker, Kristen Lippincott ("The Genesis and Significance of the Fifteenth-Century Italian Impresa," in *Chivalry in the Renaissance*, ed. Sydney Anglo, Woodbridge, 1990, p. 73 note 97 [49–76]) suggests that the drawing could equally represent an "early attempt at formulating an appropriately virginal *impresa*."

74 A Florentine engraving of a *Lady with a Unicorn*, approximately contemporary with Leonardo's drawing, involves the animal in a marriage context, as indicated by the shields left bare for the coats of arms of the wife and her husband (Hind, *Early Italian Engraving*, 1938, Part I, vol. I, cat. no. A.IV.4, p. 88; and vol. II, plate 134). Though wearing a robe embroidered with the name Marietta, the female figure in the print may personify Chastity rather than an individual. The lady in an engraving (1516) of the theme by Agostino Veneziano, associated with Leonardo's drawing by Popham (*Drawings*, 1945, p. 18), is merely allegorical (Oberhuber, ed., *The Illustrated Bartsch*, New York, 1978, vol. XXVII, no. 379, p. 68).

75 In his double-sided diptych of *c.* 1475 Piero depicts the recently deceased Battista Sforza before a panoramic landscape representing the territory over which she and her husband ruled (Schneider, *Portrait*, 1994, pp. 48–51).

76 Beer, *Unicorn*, 1977, p. 140 and Figs 49, 50.

77 Pope-Hennessy (*The Robert Lehman Collection, I: Italian Paintings*, New York, 1987, cat. nos. 89–90, pp. 214–19) ascribes the diptych, representing a member of the Gozzadini family and his wife, to the fifteenth-century Emilian School. That the lady is portrayed again at a smaller scale in the background is made clear by her hairdress and costume, which are the same as those of the bust-length effigy.

78 Two further sheets by Leonardo depicting the unicorn theme – one in the British Museum with two sketches of the lady with the beast within frame lines (Popham, *Drawings*, 1945, cat. no. 27, p. 105; and Popham and Pouncey, *Italian Drawings*, 1950, vol. I, cat. no. 98 verso, p. 59; and vol. II, plate XCI); and the other at Oxford showing the unicorn alone (Popham, *Drawings*, 1945, cat. no. 60A, p. 109; and Parker, *Drawings*, 1956, cat. no. 16, pp. 10–11 and plate VI) – have often been associated with the Oxford *Lady with the Unicorn* and dated, together with that work, to the end of the artist's first Florentine period (Parker, *Drawings*, 1956, p. 10; and Kemp in Kemp and Roberts, *Leonardo*, 1989, cat. nos. 80 and 81,

p. 154). Popham believed that the Oxford *Lady with the Unicorn* was the final version of the design (*Drawings*, 1945, p. 18). But those authors connecting the three drawings have admitted that they are not wholly consistent in style, and Venturi would seem to be right in differentiating between them (*Disegni*, 1928, vol. I, pp. 16–17, 20–21, and cat. nos. V and XXXII). In the Oxford *Lady*, which seems to be a portrait, the unicorn is merely an attribute, while in the other two drawings the focus shifts to the animal, integrated with the (generic) maiden in the British Museum sheet and shown alone without her in the second drawing at Oxford. Venturi's juxtaposed illustrations of the two versions of the lady with the unicorn (*Leonardo e la sua scuola*, Novara, 1941, p. X and plates 14 and 15) make clear that the British Museum drawing (and the Oxford study of the unicorn alone) must be later, having been made about the same time as the studies for a Virgin with a cat on the obverse of the sheet (Popham, *Drawings*, 1945, cat. no. 11, p. 103; and Popham and Pouncey, *Italian Drawings*, 1950, vol. I, cat. no. 98 recto, pp. 58–59; and vol. II, plate XC), which date from the late 1470s.

79 Reconstructions of the reverse agree in showing the connecting branches tied at top and bottom. The diagrams in Thiis, *Florentine Years*, n.d. [1913], p. 105, and in Möller in *Jahrbuch*, 1937–38, Fig. 13, p. 209, are based on Bode's (see notes 6 and 7 above). See also Angelica Dülberg, *Privatporträts: Geschichte und Ikonologie einer Gattung im 15. und 16. Jahrhundert*, Berlin, 1990, pp. 23–24 and Fig. 73.

80 Shapley (*Catalogue*, 1979, p. 251 and note 2, p. 253) translates the inscription "She adorns her virtue with beauty." The meaning, in any case, is that the lady's outward appearance enhances her inner virtue.

81 About the multi-valent symbolism of the laurel and palm see Levi D'Ancona, *Garden*, 1977, no. 86, pp. 201–04; and no. 119, pp. 279–89.

82 Gibson in *Apollo*, 1991, p. 161 (161–65).

83 Walker in *Studies*, 1967, p. 8; and Fletcher in *Burlington Magazine*, 1989, pp. 811–16. As Kemp (in *Circa 1492*, 1992, cat. no. 169, pp. 270–71) notes, however, there is no evidence that Bembo actually owned the painting.

84 Father of the more famous Pietro Bembo, Bernardo was relatively neglected until the publication of Giannetto's biography (emphasizing his book collection) in 1985. For earlier accounts of his missions to Florence see: Della Torre, in *Giornale*, 1900, pp. 258–333 (focusing on his humanist connections); F. Pintor, "Le due ambascerie di Bernardo Bembo a Firenze e le sue relazioni coi Medici," in *Studi letterari e linguistici dedicati a Pio Rajna*, Florence, 1911, pp. 785–813 (about his more conflicted second embassy); and Angelo Ventura and Mauro Pecoraro, "Bembo, Bernardo," in *Dizionario biografico degli italiani*, Rome, 1960–98, vol. VIII, 1966, pp. 103–09. The

Verrocchio-Leonardo standard is discussed on pp. 123–26.

85 About this social convention and its cultural ramifications see Charles Dempsey, *The Portrayal of Love: Botticelli's Primavera and Humanist Culture at the Time of Lorenzo the Magnificent*, Princeton, 1992.

86 Mary D. Garrard, "Leonardo da Vinci: Female Portraits. Female Nature," in *The Expanding Discourse: Feminism and Art History*, ed. Norma Broude and Mary D. Garrard, New York, 1990, pp. 62–63 (59–86).

87 Also visible in the x-radiograph, the letters "VIRTU . . . HONOR" are slightly larger and more widely spaced.

88 In one instance where Bembo used the wreath – the tomb monument he erected for Dante in Ravenna, soon after leaving Florence, in 1482 – the juniper reappears as on the reverse of Leonardo's portrait, as noted by Sheard ("Bernardo e Pietro Bembo, Pietro, Tullio e Antonio Lombardo: Metamorfosi delle tematiche cortigiane nelle tendenze classicistiche della scultura veneziana," in *Tiziano: Amor sacro e amor profano*, Exhibition Catalogue, Palazzo delle Esposizioni, Rome, Milan, 1995, pp. 125–26 [118–32]. For an illustration of the device as well as an account of the Dante project in general, see Corrado Ricci, *L'ultimo rifugio di Dante*, 2nd rev. ed., Milan, 1921, pp. 332–36 and Fig. opp. p. 336; and Nella Giannetto, *Bernardo Bembo: Umanista e politico veneziano*, Florence, 1985, pp. 156–59. The marble plaque with Bembo's *impresa* is now immured in a wall near the sepulchre attached to the church of S. Francesco. A second display of his device at the tomb omits the juniper.

89 Dülberg's survey (*Privatporträts*, 1990) of Renaissance panels with decorated reverses or covers makes clear that, inspired by Netherlandish examples, Jacometto Veneziano (cat. nos. 183–184, pp. 236–37, and Figs 75–80) first consistently adopted the type in Italy. Closest to the *Ginevra* reverse is one by Jacometto (cat. no. 168, p. 228, and Figs 121–23), but the resemblance (more of design than of style) is not sufficient to deny the back of the Washington panel to Leonardo (Shearman, *Only Connect . . . Art and the Spectator in the Italian Renaissance*, Mellon Lectures in the Fine Arts, National Gallery of Art, Washington, 1988, Princeton, 1992, p. 118 note 29). The Venetian art critic Marcantonio Michiel records two portraits by Jacometto, one of Pietro Bembo as a child and another of his brother Carlo as a newborn infant in 1472 (Peter Humfrey, "Jacometto Veneziano," in *The Dictionary of Art*, ed. Jane Turner, vol. 16, 1996, pp. 835–36). The boys' father, who obviously commissioned these works, might have brought them to Florence on his embassies there later in the 1470s. Perhaps they had emblematical reverses like those found in Jacometto's other known portraits. Bembo might, therefore, have directed Leonardo to treat the reverse of Ginevra's portrait in a manner analogous to Jacometto's, with a

monochromatic foliate wreath accompanied by a Latin motto against a painted porphyry background – all elements that occur (but not together) in the Venetian artist's works. On the other hand, Leonardo's laurel and palm share the organic quality of the foliage ornamenting the armor in his *Warrior* (Fig. 59), just as the juniper sprig displays more than a little of the realism of the leaves that he depicted on the obverse. The closet parallel to Leonardo's formulation is offered by the foliate ornament of the stone lectern in the *Annunciation* (Fig. 64). Also indicative of his authorship is the way the scroll coils around the plants.

90 As noted by E. James Mundy, "Porphyry and the 'Posthumous' Fifteenth Century Portrait," in *Pantheon*, vol. XLVI, 1988, pp. 38–40 (37–43).

91 According to Elizabeth Cropper ("The Beauty of Woman: Problems in the Rhetoric of Renaissance Portraiture," in *Rewriting the Renaissance: The Discourses of Sexual Difference in Early Modern Europe*, ed. Margaret W. Ferguson, Maureen Quilligan, and Nancy J. Vickers, Chicago and London, 1985, pp. 183, 187–90 [175–90]), Leonardo here demonstrated the painter's ability to rival the poet.

92 Fletcher credits Bembo with the invention of the reverse in *Burlington Magazine*, 1989, pp. 811–12 (811–16). For the poems see note 14 above.

93 Compare the following passages from Landino: "Her figure indeed is beautiful, and her soul too is beautiful within it" (Walker in *Report*, 1967, p. 32 from poem V verse 13); "Learn, you mortals, that beauty is to be desired for the mind and not the body, and learn to love its true glory" (Walker, 1967, p. 34, from poem VI, verses 27–28); "But if perhaps you ask what parents Love has, Form is his mother and the Beautiful itself is his father . . . [mortals] love whatever beauty the variegated earth has borne, since these things are images of heavenly fitness [*simulacra decori*] . . . and [man] loves the things which shine on earth . . . for these are images of the highest good [*simulacra boni*]" (Walker, 1967, p. 35 from poem VIII, verses 43–82).

94 Ficino's letter thanking Benci was published by Della Torre, *Storia dell'Accademia Platonica di Firenze*, Florence, 1902, p. 542. On the relation between the philosopher and other Benci family members see Giuliano Tanturli, "I Benci Copisti: Vicende della cultura fiorentina volgare fra Antonio Pucci e il Ficino," in *Studi di filologia italiana*, vol. XXXVI, 1978, pp. 197–313.

95 Marsilio Ficino, *Commentary on Plato's Symposium on Love*, trans. Sears Jayne, Dallas, TX, 1985: "the virtue of the soul seems to display a certain virtuous beauty" (p. 84).

96 For Bembo's marginal annotation (on fol. 21 recto) to his copy of Ficino's *Commentarium*, now in the Bodleian Library, Oxford, see Cecil H. Clough, "The Library of Bernardo and of Pietro Bembo," in *Book Collector*, vol. XXXIII, no. 3, 1984, pp. 310–11 (305–31); and

Giannetto, *Bembo*, 1985, pp. 138–19, 332–34. Bembo here refers to Ginevra as a "beautiful matron" (*matronarum pulcherimam*).

97 According to Garrard (in *Discourse*, ed. Broude and Garrard, 1992, pp. 62–63) and Sheard (in *Tiziano*, 1995, pp. 122–26), Leonardo here portrayed Ginevra as a gifted if troubled individual.

The Collaborator

1 Richter, *Literary Works*, 1970, vol. II, no. 1368A, p. 343: "Li Medici me crearono e destrussono." But Leonardo actually wrote "medici," so he may have meant "doctors." See on this point Pedretti, *Commentary*, 1977, vol. II, pp. 313–14.

2 For Pedretti ("'li medici mi crearono e destrussono'," in *Achademia Leonardi Vinci*, vol. VI, 1993, pp. 173–84) the second part of the statement remains puzzling, as Giuliano at least is known to have sustained the aged artist in Rome.

3 For an enthusiastic if uncritical endorsement of Lorenzo's importance for the young Leonardo see Enrico Barfucci, *Lorenzo de' Medici e la società artistica del suo tempo*, Florence, 1945, pp. 208–17.

4 Gombrich distinguishes Lorenzo's patronage from that of his father and grandfather (in *Norm and Form*, 1966, pp. 35–57); to this classic essay should now be added the exhibition catalogues marking the five-hundredth anniversary of Lorenzo's death (see Ames-Lewis, "Lorenzo de' Medici Quincentenary," in *Apollo*, vol. CXXXVI, no. 366, 1992, pp. 113–16).

5 *Codice*, ed. Frey, 1892, p. 110: "dal detto Magnifico Lorenzo fu mandato al duca di Milano . . . a presentarli una lira." Vasari adds that the lyre was in the shape of a horse's head (*Vite*, ed. Milanesi, vol. IV, 1879, p. 28).

6 *Codice*, ed. Frey, 1892, p. 110: Leonardo "stette da giovane col Magnifico Lorenzo de Medici et dandoli provisione per se il faceva lavorare nel giardino sulla piazza di San Marco di Firenze." Also quoted in Beltrami, *Documente memorie*, 1919, no. 9, p. 5.

7 Caroline Elam's research ("Lorenzo de' Medici's Sculpture Garden," in *Mitteilungen des kunsthistorischen Institutes in Florenz*, vol. XXXVI, nos. 1–2, 1992, pp. 41–84), establishing the precise location of the garden, has lent credibility to the belief going back to Vasari that it served as an informal training center for Florentine artists of Michelangelo's generation. The complex is said to have contained not only antique sculpture but also works by the founders of Florentine Renaissance art. The bronze sculptor Bertoldo, acting as a kind of curator, reportedly made the collection available to younger painters and sculptors, among whom Vasari names Credi as well as Michelangelo and his associates. But the Anonimo's implication of an earlier phase of artistic activity in the garden, involving the young Leonardo, remains problematical, even

if the garden already existed then (Elam, 1992, pp. 44–46), as Medici antiquities find no echo in the painter's youthful work.

8 As suggested by Chastel, *Art et humanisme*, 1959, pp. 403–04. Alternatively, the Anonimo's statement that Leonardo "stayed" with Lorenzo could be construed to mean that the artist entered the latter's service after leaving Verrocchio's tutelage about 1477.

9 Eleonora Plebani, *Lorenzo e Giuliano de' Medici tra potere and legami di sangue*, Rome, 1993, pp. 91–142.

10 Though Levi D'Ancona (*Due quadri del Botticelli eseguiti per nascite in Casa Medici*, Florence, 1992, pp. 7–35) argues that Botticelli's *Primavera* was begun for Giuliano, he is unknown as an art patron apart from associating himself with his older brother in the commission for the Medici tomb of 1472 and in the sale of Verrocchio's *David* to the Signoria in 1476.

11 About the drawing (Musée Bonnat, Bayonne), datable to December 1479, see Barfucci, *Lorenzo*, 1945, pp. 214–16 (illus.).

12 For a snythesis of the principal sources for the tournament see Salvatore Settis, "Citarea 'Su una impresa di Bronconi'," in *Journal of the Warburg and Courtauld Institutes*, vol. XXXIV, 1971, pp. 135–77, esp. p. 138 note 16. One of the accounts, that of the Riminese humanist Giovanni Aurelio Augurelli, was addressed to Bernardo Bembo, who, shortly after his arrival in Florence, took part in the event (Giannetto, *Bembo*, 1985, pp. 30, 100–02, and 133–35). For such festivities in general see *Tems revient*, ed. Ventrone, 1992.

13 Since Lorenzo was frequently absent during the period of intense preparations for the tournament in November and December 1474 (Emma Tedeschi, *Alcune notizie fiorentine tratte dall'archivio Gonzaga di Mantova*, Badia Polesine, 1925, pp. 12–23), Giuliano claimed that he himself was "in buona parte . . . autore" of the event (in a letter to Galeazzo Sforza of November 15, 1474, quoted in André Rochon, *La jeunesse de Laurent de Médicis*, Paris, 1963, pp. 284–85 note 193; and in E. Fumagalli, "Nuovi documenti su Lorenzo e Giuliano de' Medici," in *Italia medioevale e umanistica*, vol. XXIII, 1980, p. 146 [115–64]).

14 Fabriczy in *Archivio*, 1895, p. 173: "Per dipintura d'uno stendardo ch[on] lo spiritello per la giostra di Giuliano." Tommaso's inventory (pp. 171–72) also lists a helmet and a "stendardo per la giostra di Lorenzo," held on February 7, 1469. For this same tournament Antonio Pollaiuolo had his younger brother Piero paint a banner (Covi in *Prospettiva*, 1978, pp. 61–72). The commission for the Carrara *gonfalone* in 1475 makes clear that the Verrocchio shop only had to paint a stiffened cloth standard manufactured by other specialized craftsmen (Settesoldi in *Paragone*, 1980, pp. 87–91).

15 Fabriczy, cited in the previous note, assumed that Verrocchio made the *spiritello* standard for Giuliano, but Giovanni Poggi adduced another document to show that his pennant had as its main subject Pallas ("La Giostra Medicea del 1475 e la 'Pallade' del Botticelli," in *L'arte*, vol. V, 1902, pp. 71–77). Poggi identified the Verrocchio standard with one carried by another contender named Giovanni Morelli. About the Uffizi drawing (Gabinetto Disegni e Stampe, inv. no. 212E, measuring 14.8 × 25.9 cm. or $5^3/_4$ × $10^1/_4$ in.) see Dillon in *Disegno*, ed. Petrioli Tofani, 1992, cat. no. 7.5, pp. 150–51. Venturi first tentatively connected the sketch with Verrocchio's documented standard (*Storia*, vol. IX, part I, 1925, p. 51 note 1), and his attractive hypothesis was endorsed by all later writers except for Vertova (*Maestri*, 1981, cat. no. 8b, pp. 49–51), who interprets the subject as Cupid wounding Venus. In that role Venus is usually shown awake (*Venus and Adonis* by the so-called "Tommaso," at Christie's, New York, May 21, 1992, lot no. 10, p. 22), not asleep, however, and the attributes of the female figure in the drawing – the bow and arrows and the flowers in the folds of her dress – denote the activities of hunting and gathering flowers that typify nymphs. As for its purpose, the Uffizi drawing does not correspond to any of the standards (one, interestingly, featured a juniper) mentioned in the most comprehensive account of the tournament, that of an anonymous chronicler cited by Poggi (*L'arte* 1902), but only seven of the thirteen standards are described in any detail.

16 The panel, which features a standard with a seated female figure on the right, is given to Apollonio di Giovanni and dated *c.* 1460–65 by Charles Seymour, Jr., *Early Italian Paintings in the Yale University Art Gallery*, New Haven and London, 1970, cat. no. 80, pp. 116–19; the joust has not been identified.

17 Venturi first gave the sketch to Leonardo (*Storia*, vol. IX, part I, 1925, pp. 50–51), considering it his earliest extant drawing (*Disegni*, vol. I, 1928, p. 15, and cat. no. I, p. 22). Berenson (in *Bollettino d'arte*, 1933, p. 263 [241–64]; *Drawings*, 1938, vol. I, p. 68, and vol. II, cat. no 674A, p. 71; and *I disegni dei pittori fiorentini*, trans. Luisa Vertova Nieolson, 3 vols., Milan, 1961, vol. I, pp. 114–15, and vol. II, cat. no. 674A, p. 128), followed by Dalli Regoli (*Credi*, 1966, p. 22, and cat. no. 24, p. 109), ascribed it to Credi. Otherwise the Verrocchio attribution has predominated among advocates of a single author for the sheet (see the bibliography in Passavant, *Complete Edition*, 1969, cat. no. D6, p. 192).

18 The division of labor is based on the technique of the drawing, rather than its style, which is more nearly uniform. The initial working sketch (in black chalk, only a few traces of which remain) is given to Verrocchio and the completion of the sheet (in pen and ink resembling metalpoint), to Leonardo by the following: Passavant, *Complete Edition*, 1969, p. 58, and cat. no. D6, p. 192; Pedretti, *Leonardo . . . Chronology and Style*, 1973, p.

176; Brown and Seymour, "Further Observations on a Project for a Standard by Verrocchio and Leonardo," in *Master Drawings*, vol. XII, no. 2, 1974, pp. 127–33; Vertova, *Maestri*, 1981, pp. 49–51; Cadogan in *Zeitschrift*, 1983, p. 373; and Brown, "Verrocchio and Leonardo: Studies for the *Giostra*," in *Florentine Drawing at the Time of Lorenzo the Magnificent*, ed. Elizabeth Cropper, Bologna, 1994, pp. 99–109. Dalli Regoli (in Pedretti and Dalli Regoli, *Disegni*, 1985, cat. no. 12, pp. 61–63) and Marani (*Leonardo*, 1989, pp. 13–14; and in *Verrocchio*, ed. Bule, Darr, and Superbi Gioffredi, 1992, p. 151 note 40 are less than fully convinced. Degenhart (in *Rivista d'arte*, 1932, p. 433) first pointed out Leonardo's left-handed hatchings in the landscape forms.

19 Passavant (*Complete Edition*, 1969, p. 58) noted Cupid's awkward foreshortening, while Clark ("Italian Drawings at Burlington House," in *Burlington Magazine*, vol. LVI, no. 325, 1930, p. 181 [175–87]) aptly compared the "peculiar drawing" of his figure to that of the Virgin Annunciate as a mark of Leonardo's authorship.

20 Though Antonio Baldacci ("Le piante nelle pitture di Leonardo," in *Memorie della R. Accademia delle scienze dell'Istituto di Bologna*, 8th ser., vol. VII, 1930, p. 25 [21–33]) identified the plant, which he associated with Leonardo, as a lily, Brian Morley (as reported in Pedretti, *Drawings . . . at Windsor Castle*, 1982, p. 30 note 4 [giving the drawing to Verrocchio and Leonardo as a study for the *giostra*]) opted for *panicum miliaceum*, and his view was confirmed by Dr. Paul M. Peterson, Associate Curator of Grasses, Department of Botany, National Museum of Natural History, Smithsonian Institution. Another study of millet by Leonardo (Brian Morley, "The Plant Illustrations of Leonardo da Vinci," in *Burlington Magazine*, vol. CXXI, no. 918, 1979, p. 559 [553–60]; and Emboden, *Plants*, 1987, pp. 142–43 and Fig. 73), includes the spikelets missing in the Uffizi sheet, the upper left corner of which has been cropped. The standard drawing thus joins the Windsor lily as a rare survivor from among Leonardo's numerous early plant studies, most of which were probably made in connection with the lost tapestry cartoon.

21 Kemp (in *Circa 1492*, 1992, cat. no. 160, pp. 261–62) dates the engraving *c.* 1465 and, referring to the earlier literature, alludes to the plant symbolism. Pons (*Pollaiolo*, 1994, p. 19) prefers a dating to the early 1470s.

22 Figures and landscape might have been similarly juxtaposed on the standard, which Piero Pollaiuolo painted (on Antonio's design?) for Lorenzo de' Medici's tournament of 1469 (Covi in *Prospettiva*, 1978, p. 63). Made for Benedetto Salutati, this work featured, according to contemporary accounts, a nude goddess seated in a meadow.

23 Levi D'Ancona, *Garden*, 1977, no. 101, pp. 230–31.

24 Thiis (*Leonardo*, n.d. [1913], p. 71) and

Venturi (*Disegni*, 1928, vol. I, p. 15) both noted Cupid's Leonardesque face.

25 Compare the Chatsworth sketch catalogued by Kemp in Kemp and Roberts, *Leonardo*, 1989, cat. no. 75, p. 148.

26 Paul Joannides, "Leonardo and Tradition," in *Nine Lectures on Leonardo da Vinci*, ed. Francis Ames-Lewis, London, n.d. [1990?], p. 27 (22–31).

27 British Museum, London, inv. no. 1895-9-15-785. About the drawing, which measures 32.5 × 27.3 cm. (12⅞ × 10¾ in.), see: Popham and Pouncey, *Italian Drawings*, 1950, vol. I, cat. no. 258, pp. 160–61; and more recently Vertova, *Maestri*, 1981, cat. no. 9, p. 51. Cruttwell (*Verrocchio*, 1904, p. 113) first tentatively connected the recto with the Uffizi sheet, while Passavant preferred to consider it as preparatory for the Virgin in the Pistoia altarpiece (*Complete Edition*, 1969, p. 58, and cat. no. D5, p. 192).

28 Brown and Seymour in *Master Drawings*, 1974, pp. 129–30.

29 Alexander Nagel, "Leonardo and *Sfumato*," in *Anthropology and Aesthetics*, vol. XXIV, 1993, pp. 11–12 (7–20).

30 The drawing (Fitzwilliam Museum, Cambridge, inv. no. 2930), in metalpoint and black chalk heightened with white, is clearly a life study, possibly for one of the infants in the project for the Vendramin tomb, which occupied Verrocchio in Venice the 1480s (Passavant, *Complete Edition*, 1969, cat. no. D11, p. 194, and plate 101). Attributed by Popham to the Verrocchio School (in *Italian Drawings*, Exhibition Catalogue, Royal Academy, 1930, London, 1931, cat. no. 56, p. 17) and by Berenson (in *Bollettino d'arte*, 1933, p. 262; and *Drawings*, 1938, vol. II, cat. 670C, p. 70) and Dalli Regoli (*Credi*, 1966, cat. no. 19, p. 108) to Credi, the study was rightly restored to Verrocchio by Sheldon Grossman, "The 'Madonna and Child with a Pomegranate' and some New Paintings from the Circle of Verrocchio," in *Report and Studies in the History of Art*, vol. II, 1968, p. 67 (47–71); and "An Early Drawing by Fra Bartolommeo," in *Studies in the History of Art*, National Gallery of Art, Washington, vol. VI, 1974, pp. 7–8 (6–22). Curator David Scrase kindly provided a photograph and information about the sheet, which, to judge from the drawn frame, may once have belonged to Vasari.

31 Writers from Bode to Passavant (cited by Covi in *Art Bulletin*, 1983, p. 272 note 146) have observed that the picture was partly painted in oil. The Virgin's head, which does indeed appear to have been glazed, is linked with the green lining of her robe, also completed in an oil-like medium (but not worked with the fingers, as Brachert claimed in *Report and Studies*, 1969, pp. 88, 93 [85–104]).

32 Vasari, *Vite*, ed. Milanesi, vol. III, 1878, pp. 363–64: "alcune teste di femina con bell'arie ed acconciature di capelli, quali, per la sua bellezza, Lionardo da Vinci sempre imitò."

33 Richter, *Literary Works*, 1970, vol. I, no. 680,

pp. 387–88: "head of a girl with knotted hair" and "head with hair elaborately coiled."

34 The drawing (Département des Arts Graphiques, Musée du Louvre, Paris, inv. no. 18.965), in pen and ink heightened with white on red prepared paper, was given to the young Leonardo by Suida (*Leonardo*, 1929, p. 20) and Berenson (as the artist's earliest extant work in *Bollettino d'arte*, 1933, p. 242 [241–64]; and *Drawings*, 1938, vol. I, p. 55, and vol. II, cat. no. 1070c, p. 120). Those authors favoring Verrocchio (Cadogan in *Zeitschrift*, 1983, pp. 391–92, note 58) or his shop (Passavant, *Complete Edition*, 1969, cat. no. App. 39, p. 210; and Caterina Caneva in *Disegno fiorentino*, ed. Petrioli Tofani, 1992, cat. no. 4.14, p. 112) have consistently linked the head in the drawing with those in the Verrocchiesque Madonnas in Berlin and London, which, it is argued here, are actually by Perugino. For the Louvre sheet in context see Françoise Viatte, "Verrocchio et Leonardo da Vinci: A propos des 'têtes ideales'," in *Florentine Drawing*, ed. Cropper, 1994, pp. 45–53.

35 Möller (in the article cited in note 38 below) claimed that the drawing derived from the painted head, while Goldscheider believed that both represent the same model (*Leonardo*, 1959, p. 166). Bode ("Leonardos Bildnis der jungen Dame mit dem Hermelin aus dem Czartoryski-Museum in Krakau und die Jugendbilder des Künstlers," in *Jahrbuch der königlich preuszischen Kunstsammlungen*, vol. XXXVI, 1915, pp. 202–03 [189–207] and *Studien*, 1921, p. 26) attributed the drawing, like the painting for which it served, to Leonardo. The correct view is that of Valentiner, who noted that Leonardo used Verrocchio's drawing for the Virgin in the painting (in *Art Bulletin*, 1930, pp. 50–51).

36 Sabba da Castiglione, *Ricordi*, Venice, 1563, fol. 115 verso: "discepolo del Verocchio, come alla dolcezza dell'aria si conosce."

37 The painting has been dated as early as *c.* 1473 (Marani, *Leonardo*, 1989, cat. no. 3, p. 34) and as late as 1478–80 (Ottino della Chiesa, *Leonardo*, 1967, cat. no. 12, p. 91).

38 About the painting (inv. no. 7779) see Rolf Kultzen, *Italienische Malerei*, Alte Pinakothek, Munich, 1975, pp. 58–60 (with bibliography), preceded by the fundamental study of Emil Möller, "Leonardos Madonna mit der Nelke in der Älteren Pinakothek," in *Münchner Jahrbuch der bildenden Kunst*, vol. XII, nos. 1–2, 1937–38, pp. 5–40. The possibility of examining the unframed painting, first with Kultzen and Heydenreich in 1976 and again with Cornelia Syre and Jan Schmidt almost twenty years later, made clear that it is not poorly preserved and repainted, as has been repeatedly asserted. Though the (bowed) panel has suffered extensive worm damage, the paint surface is in very good condition, apart from losses in the Child's right foot, the cushion, and the mountains on the left. The Virgin's blue robe is also damaged. Strips 1.5 cm. on the left and 0.5 cm. on the right

have been added to the original panel, which measures 62 × 46.7 cm. (24⅜ × 18⅜ in.). The thin strip cut from the left doubtless contained the more complete form of the Virgin's hand. The only important *pentimento* is in the Child's head, which was originally larger.

39 Clark, *Leonardo*, 1939, p. 20, rev. ed. 1952, p. 17 (omitted in later editions).

40 Doubts about the Leonardo attribution expressed by Hildebrandt (*Leonardo*, 1927, cat. no. 2, pp. 246–48) and others still linger (Wasserman, *Leonardo*, 1975, p. 160; and Franco Mazzini in *Leonardo: Tutta la pittura*, ed. Maria Siponta de Salvia Baldini, Florence, 1988, commentary to plates 11, 11A). The most authoritative voice for collaboration was Heydenreich (*Leonardo*, 1954, vol. I, p. 31; and vol. II, p. iv) until he came out in favor of Leonardo (as the first work he painted independently in Verrocchio's shop in "La Madonna del Garofano," in *Leonardo: La pittura*, Florence, 1977, pp. 59–64, rev. ed. Marani, 1985, pp. 33–36; and "Leonardos 'Madonna mit der Nelke'," in his *Leonardo-Studien*, ed. Passavant, Munich, 1988, pp. 97–100).

41 Kecks (*Madonna*, 1988, pp. 104–17) agrees with Passavant (*Complete Edition*, 1969, pp. 31–33; cat. no. 4, p. 173, and plate 15) that the only extant autograph Madonna sculpted by Andrea is the terracotta from Santa Maria Nuova now in the Bargello, but that work does not seem to have been as widely influential as the lost relief with the Child standing on the left, and it may well postdate Leonardo's painting.

42 As noted by Fahy, *The Legacy of Leonardo: Italian Renaissance Paintings from Leningrad*, Exhibition Catalogue, National Gallery of Art, Washington, New York, 1979, p. 18.

43 Hills in *Burlington Magazine*, 1980, pp. 609–10. Memling's oeuvre in particular offers many examples. Even closer to Leonardo's composition, with the Child seated on a cushion, is the *Virgin and Child* after Roger van der Weyden in the Musée des Beaux-Arts, Tournai, as noted by Paula Nuttall, "Early Netherlandish Painting in Florence," Ph.D. Thesis, Courtauld Institute of Art, London, 1989, p. 304 and plate 91.

44 Möller (in *Jahrbuch*, 1937–38, Fig. 27 on p. 40) provides an accurate diagram of the interior setting, which demonstrates that the ledge continues along the side margins of the picture (cut down on the left), forming a kind of pictorial threshold. Leonardo's painting contrasts in this respect with two other Flemish-inspired workshop Madonnas (in Städelsches Kunstinstitut, Frankfurt, and the Louvre; see chapter 2 notes 67 and 85); it is closer to the one at the Courtauld Galleries in London (Fig. 14 and chapter 2 note 66).

45 Shearman in *Zeitschrift*, 1962, pp. 18–19.

46 According to Vasari (*Vite*, ed. Milanesi, vol. IV, 1879, p. 25), the dew on the flowers in the vase was so realistic that they looked more real than reality itself," an ekphrasis that evokes, but does not actually describe, Leonardo's

painting: "Fece poi Lionardo una Nostra Donna in un quadro che era appresso papa Clemente VII, molto eccellente; e fra l'altre cose che v'erano fatte, contraffece una caraffa piena d'acqua con alcuni fiori dentro, dove, oltra la maraviglia della vivezza, aveva imitato la rugiadra dell'acqua sopra, sì che ella pareva più viva che la vivezza."

47 Möller in *Jahrbuch*, 1937–38, pp. 14, 30. About the copy see Sylvie Béguin, *Leonard de Vinci au Louvre*, Paris, 1983, p. 88.

48 Emboden, *Plants*, 1987, pp. 124–25.

49 A precedent for this motif lies in Domenico Veneziano's *Virgin* in the Berenson Collection at Settignano, but there the seated Child reaches eagerly for the flower, whereas in Leonardo's picture he marvels at it. This is shown not only by the infant's open-handed gestures, but also by the glance he directs upwards. Kecks (*Madonna*, 1988, p. 132 and Fig. 96) cites Domenico's prototype, which is dated to the 1430s (Helmut Wohl, *The Paintings of Domenico Veneziano*, New York and London, 1980, cat. no. 2, pp. 117–18, and plate 24).

50 The carnation symbolizes divine love and redemption (Levi D'Ancona, *Garden*, 1977, no. 29, pp. 79–84; and Kecks, *Madonna*, 1988, pp. 63–64).

51 Lightbown, *Botticelli*, 1978, vol. II, cat. no. B9, pp. 23–24, and plate 11.

52 Möller in *Jahrbuch*, 1937–38, pp. 33–34, 36; Pedretti, *Leonardo*, 1973, p. 176; and Pedretti, *Leonardo*, 1979, note to plate 12. No picture corresponding to the Munich *Madonna* has been identified in Medici inventories, however. Nor is it clear from published biographies whether Giulio, born out of wedlock a month after Giuliano was assassinated, inherited his father's property (Gaetano Pieraccini, *La stirpe de' Medici di Cafaggiolo*, 3rd ed., 3 vols., Florence, 1986, vol. I, pp. 141–45; A. Prosperi, "Clemente VII," in *Dizionario*, vol. XXVI, 1982, pp. 237–59; and Sheryl E. Reiss, *Cardinal Giulio de' Medici as a patron of art, 1513–1523*, Ph. D. Thesis, Princeton University, 1992, pp. 105–31 [on his youth]). The alternative that Clement acquired the *Madonna* later (if Vasari was right in claiming that he owned it) would still tend to suggest that the picture (by then outmoded in style) had once belonged to his father.

53 A ring of smaller balls ornaments the vase in the painting.

54 As observed by Reymond (*Verrocchio*, n.d. [1906], p. 127) and Möller (in *Jahrbuch*, 1937–38, p. 15). About the windows, with their characteristic colonettes and pilasters, see Brenda Pryer, "L'architettura del Palazzo Mediceo," in *Il Palazzo Medici Riccardi di Firenze*, ed. Giovanni Cherubini and Giovanni Fanelli, Florence, 1990, p. 59 (58–75) and Fig. 92. Similar windows, also presumably inspired by those of the Medici palace, appear in the work of other artists, such as Filippo Lippi and Pollaiuolo, so the motif in the Munich *Madonna* is not unique.

55 The pearl-bordered gem has been identified

an opal (*Oreficeria nella Firenze*, 1977, no. 232, pp. 349–50).

56 Marani, *Leonardo*, 1989, cat. no. 3, p. 34. Other Verrocchiesque Madonnas share the motif of the Virgin's drapery falling on a parapet (Kecks, *Madonna*, 1988, figs. 89 and 90).

57 Pope-Hennessy in *Antaeus*, 1985, p. 45.

58 Jane Andrews Aiken (in "Andrea del Verrocchio as a Teacher: Did Leonardo da Vinci Pass the Course?," in *Italian Echoes*, 1990, pp. 75–76 note 13 [67–80]) plausibly suggests that Andrea returned to the *Baptism* because in 1472–76 his brother Simone Cioni was abbot of the monastery of San Salvi, where the picture was located.

59 Berenson in *Bollettino d'arte*, 1933, pp. 198, 200; and *Drawings*, 1938, vol. I, pp. 51–52.

60 Clark (*Leonardo*, 1939, p. 12; rev. eds. 1952, pp. 9–10, and 1988, p. 46) is in a minority in believing that Leonardo's share in the *Baptism* is his first work in painting to survive. Agreeing with Suida (*Leonardo*, 1929, pp. 23–24) and others, Marani (*Leonardo*, 1989, cat. no. 6, pp. 41–45; and in *Verrocchio*, ed. Bule, Darr, and Superbi Gioffredi, 1992, pp. 143–44) would place his contribution as late as about 1480, by comparison with the *Adoration of the Magi*. Kemp's dating (*Leonardo*, 1981, pp. 60–61) of *c.* 1476, just before Leonardo left Verrocchio's employ, seems preferable.

61 Sanpaolesi in *Leonardo*, ed. Marazza, 1954, pp. 29–32.

62 Brachert in *Report and Studies*, 1969, p. 88 (85–104) and figs. 12 and 13; and "Ein unvollendetes Madonnengemälde von Leonardo da Vinci?" in *Schweizerisches Institut für Kunstwissenschaft: Jahresbericht und Jahrbuch*, 1967, pp. 22–28 (1–110).

63 Berti in *Leonardo*, 1977, pp. 19–22; and "Schizzi a tergo del Battesimo di Cristo di Verrocchio e Leonardo," in *Critica d'arte*, vol. LIII, no. 17, 1988, pp. 52–56.

64 Baldini, *Leonardo*, 1992, pp. 176–202. In this preliminary presentation of the technical evidence gathered by Seracini of Editech, Florence, the composite x-radiograph is reproduced on p. 198, followed by two details on pp. 199 and 200; the reflectogram is illustrated on p. 177, followed by a series of details on pp. 178–97 and 201–02.

65 The halo of Leonardo's angel, painted over the hair, is evidently not original, whereas that of his companion is integral to the figure.

66 The gold-toned decoration shows that the (originally red) robes are not unfinished, as they have appeared to some observers.

67 Geneviève Rodis-Lewis ("Léonard et le 'Baptême du Christ' de Verrocchio," in *Rinascimento*, vol. XXVIII, 1988, pp. 357–59; and in her *Regards sur l'art*, Paris, 1993, pp. 65–67) hypothesizes that Leonardo did both angels, while William E. Wallace ("Verrocchio's *Giudizio dell'occhio*," in *Source: Notes in the History of Art*, vol. XIV, no. 2, 1995, pp. 7–10) contends that Verrocchio added the second angel as a critique of Leonardo's solitary figure. But since the left-hand angel turns to observe the Baptism, the

pair must have been designed in conformity with the standard iconographic scheme of two or three angels balancing John around the central figure of Christ. Verrocchio's figure, in deference to his companion, is wingless – the only such angel in the artist's oeuvre.

68 Compare also Antonio's drawing of *St. John the Baptist* in the Uffizi, dated by Alessandro Cecci (in *Disegno fiorentino*, ed. Petrioli Tofani, 1992, cat. no. 6.4, pp. 130–31) to around 1475, in which the feet are even closer to those of Christ.

69 Unable to alter the foreground of the *Baptism* significantly, Leonardo seems to have critiqued it in a sketch of a watery ravine associated with the *Virgin of the Rocks* (Kemp in Kemp and Roberts, *Leonardo*, 1989, cat. no. 45, p. 107).

70 Passavant (*Verrocchio*, 1959, p. 74; and *Complete Edition*, 1969, p. 189) claimed that the stream was altered by a later restorer.

71 A pen and ink sketch of a kneeling angel by Leonardo in the British Museum, connected with the Uffizi *Baptism* by Valentiner (in *Art Quarterly*, 1941, pp. 14–19; reprinted with revisions in his *Italian Renaissance Sculpture*, 1950, pp. 121–24 [113–33]), is closer in style and date to the Louvre version of the *Virgin of the Rocks* (Kemp in Kemp and Roberts, *Leonardo*, 1989, cat. no. 76, p. 149).

72 "Here," as Heydenreich stated, "we find for the first time a principle of Leonardo's figure composition that was to be clarified and brought to perfection in the years to come." (*Leonardo*, 1954, vol. I, p. 25).

73 Joannides in *Nine Lectures*, ed. Ames-Lewis, n.d. [1990?], p. 28. Compare in particular the angel kneeling to the left of the Virgin in Lippi's *Coronation* in Spoleto Cathedral. His complex *contrapposto* differentiates the baptismal angel from the Magdalen kneeling on the left in Roger van der Weyden's Uffizi *Entombment*, often cited as a source for Leonardo's figure.

74 Verrocchio's figure is closer to Leonardo's than is the kneeling Magdalen in van der Weyden's *Entombment* in the Uffizi (Nuttall in *Medici*, ed. Ames-Lewis, 1995, p. 146 [135–52]). The *bozzetto* is datable between 1474, when the idea of the Forteguerri monument was raised, and 1476, when Verrocchio's project for it was tentatively approved (Pope-Hennessy, *Catalogue*, 1964, vol. I, cat. no. 140, pp. 164 – 66; and Passavant, *Complete Edition*, 1969, pp. 24–28, and cat. no. 9, pp. 179–80). In a drawing in the British Museum (Dalli Regoli, *Credi*, 1966, cat. no. 1, p. 101, and Fig. 2), Credi copied (and subsequently used for a picture) the motif of the angel in the upper right of the relief. Proposed echoes of the angels in the monument in Leonardo's later work are cited by Marani in *Verrocchio*, ed. Bule, Darr, and Superbi Gioffredi, 1992, pp. 146–47.

75 Numerous scholars, including Wölfflin (as cited by Lottlisa Behling, *Pflanze*, 1957, p. 102), Mackowsky (*Verrocchio*, 1901, p. 79), Seidlitz (*Leonardo*, 1909, vol. I, p. 44), and

Hildebrandt (*Leonardo*, 1927, p. 46), have ascribed the naturalistic grasses to Leonardo. The plant has been identified as a reedmace (Pedretti, *Drawings . . . at Windsor Castle*, 1982, p. 57).

76 About the angel's collar see *Oreficeria nella Firenze*, 1977, cat. no. 234, p. 350.

77 Heydenreich, *Leonardo*, 1954, vol. I, p. 25.

78 Richter, *Literary Works*, 1970, vol. I, no. 680, p. 387: "una testa ritratta d'Atalante che alzava il volto." The list also mentions "several compositions of Angels," which might refer to studies for the San Salvi angel.

79 Gerolamo Calvi (*I manoscritti di Leonardo da Vinci*, Bologna, 1925, p. 57) identified the "Atalante" of the list with Migliorotti, who, according to the Anonimo Gaddiano, learned how to play the lute from Leonardo and accompanied his teacher to Milan. Born in 1466, Atalante would have been about ten years old when Leonardo painted the angel. About him see Pedretti (in *Achademia Leonardi Vinci*, 1993, p. 177), who suggests that the entry in the list refers to "un'opera per la quale il Migliorotti si fosse prestato come modello."

80 Credi's angelic group in the *Baptism* in the church of San Domenico at Fiesole adopts Verrocchio's prototype but not Leonardo's (Dalli Regoli, *Credi*, 1966, cat. no. 96, pp. 148–49, and Fig. 143). Aiken (in *Italian Echoes*, ed. Matteo, Noble, and Sowell, 1990, pp. 78–79 note 20 [67–80]) notes that in his fresco of the theme at Sant' Andrea in Brozzi, the young Ghirlandaio failed to "fall under the spell of Leonardo's angel."

81 About the miniatures with a baptismal angel supposedly derived from Leonardo's, see Otto Georg von Simpson, "Leonardo and Attavante," in *Gazette des Beaux-Arts*, 6th ser., vol. XXV, no. 921, 1943, pp. 305–12. His observations were misrepresented by Chastel, *Art et humanisme*, 1959, p. 406; Ottino della Chiesa, *L'opera completa*, 1967, no. I, p. 88; Berti in *Leonardo*, 1977, p. 16 (15–24); and Garzelli, *Miniatura*, 1985, vol. I, pp. 219, 224–26, and vol. II, figs. 789 and 790. Like von Simpson, Passavant (*Complete Edition*, 1969, pp. 54, 189) correctly notes that the two missals in question, dating from 1483 and 1487, actually differ in the angels, but he wrongly concludes that this part of the painting was still incomplete, when in fact Attavante typically altered the angelic group.

82 The *Virgin and Child with Two Angels* in the Detroit Institute of Arts echoes several motifs in Leonardo's early works. After removal of the Virgin's kneeling figure, revealing the Verrocchiesque underdrawing presently visible, the theory that Andrea planned the picture, leaving the angels and the landscape for Leonardo to complete, was advanced by museum director E. P. Richardson ("A Rare Panel by Verrocchio and Leonardo," in *Bulletin of the Detroit Institute of Arts*, vol. XXXVI, no. 4, 1956–57, pp. 79–81; and *The Adoration with Two Angels by Andrea del Verrocchio and Leonardo da Vinci*, Detroit, 1957, citing a string of experts who agreed) and Valentiner ("A Newly Discovered Leonardo," in *Art Quarterly*, vol. XX, no. 3, 1957, pp. 234–43). While the underdrawing demonstrates that the panel, now labeled "School of Leonardo," originated in Verrocchio's shop, it is too restored to be ascribed to any of the master's known pupils, least of all Leonardo. The premise for giving the picture partly to Leonardo – that two or even three artists worked on it – is not borne out visually, and the comparisons with his works made in support of his hypothetical authorship all show the contrary.

Epilogue

1 About the painting see Hans Ost, *Leonardo-Studien*, Berlin and New York, 1975, pp. 3–97; and Marani, *Leonardo*, 1989, cat. no. 8, pp. 50–52.

2 For the engraving see chapter 2 note 17. Known in Verrocchio's shop through the print or in some other form, Antonio's composition is also recorded in a poorly preserved cartoon in the Uffizi, which scholars now tend to regard as autograph (Angellini, *Donatello*, 1986, cat. no. 162, pp. 120–22, and fig. 191). Assuming Leonardo took over Pollaiuolo's design, he typically omitted the crucifix before which the semi-nude penitent saint kneels and featured one of the lions.

3 Fahy (*Legacy*, 1979, pp. 9–24) notes the poor state of preservation of the picture, which has suffered abrasion, losses, and a flattening of the impasto due to the transfer. For a further discussion of the painting (inv. no. 2773), with bibliography, see Kustodieva, *Italian Painting*, 1994, cat. no. 115, pp. 217–19, where the dimensions (49.5 × 30.5 cm. or $19^1/_2$ × 12 in.), including an added strip along the bottom of the panel, differ from those given in the literature.

4 The inscription reads: ". . . bre 1478 inchominciai le 2 Vergini marie." Another inscription on this double-sided sheet has a personal (and possibly homoerotic) meaning. About the drawing in general see: Dalli Regoli in Pedretti and Dalli Regoli, *Disegni*, 1985, cat. no. 7, pp. 55–56; and A. Cecchi in *Disegno fiorentino*, ed. Petrioli Tofani, 1992, cat. no. 6.6, pp. 134–35. The principal subject contrasts aged and youthful male types, of which the latter is animated in the manner of the Baptismal angel. Recto and verso also offer the first sign of Leonardo's lifelong interest in machines.

5 For the relationship with the sculptor see Valentiner, "Leonardo and Desiderio," in *Burlington Magazine* vol. LXI, no. 353, 1932, pp. 53–61; and for the London marble, Pope-Hennessy, *Catalogue*, 1964, vol. I, cat. no. 114, pp. 138–41; and vol. III, fig. 135. Parronchi (in *Achademia Leonardi Yinci*, 1989, pp. 49–51) claims the relief for Leonardo, while Caglioti argues for Donatello (in *Il giardino di San Marco: Maestri e compagni del giovane Michelangelo*, ed. Paola Barocchi, Exhibition Catalogue, Casa Buonarroti, Florence, 1992, cat. no. 14, pp. 72–78).

6 Passavant, *Complete Edition*, 1969, p. 211.

7 Emboden (*Plants*, 1987, p. 120 and fig. 60) rejects the usual identification of the flower as a jasmine.

8 Heydenreich, *Leonardo*, 1954, vol. I, p. 30.

9 For the drawing, in the British Museum, see Popham and Pouncey, *Italian Drawings*, 1950, vol. I, cat. no. 100, pp. 60–61. Three related studies (cat. nos. 97–99) show the Virgin and Child with a cat.

10 About this revolutionary new drawing practice see: Gombrich in *Norm and Form*, 1966, pp. 58–63; and Wiemers, *Bildform*, 1996, pp. 269–76.

11 After having been given to Piero on December 24, 1477 (Pons, *Pollaiolo*, 1994, p. 114), the commission passed to Leonardo (Beltrami, *Documenti*, 1919, no. 10, p. 5). Further about this project see Gaetano Milanesi, *Documenti inediti riguardanti Lionardo da Vinci*, Florence, 1872, pp. 15–16; and Marani, *Leonardo*, 1989, cat. no. 4A, pp. 125–27.

12 Beltrami, *Documentie memorie*, 1919, no. 11, p. 6.

13 Vasari, *Vite*, ed. Milanesi, vol. IV, 1879, pp. 563–64. Credi's birthdate is properly calculated from his mother's tax declarations of 1470 and 1480, in which his age is given respectively as twelve and twenty-one (Dalli Regoli, *Credi*, 1966, pp. 8, 89–91).

14 Lorenzo's mother's tax declaration of 1480, cited in the previous note, says that Verrocchio paid him the small sum of 12 florins annually to paint.

15 Dalli Regoli, *Credi*, 1966, p. 92.

16 The bishop died late in 1474, the date on his tomb attributed to Verrocchio by Dalli Regoli, in *Scultura decorativa*, 1983, pp. 67–74.

17 Vasari, *Vite*, ed. Milanesi, vol. IV, 1879, p. 566.

18 Alessandro Chiappelli and Alfredo Chiti, "Andrea del Verrocchio in Pistoia," in *Bollettino storico pistoiese*, vol. I, no. 2, 1899, pp. 41–49; and Chiappelli, "Il Verrocchio e Lorenzo di Credi a Pistoia," in *Bollettino d'arte*, vol. V, no. 2, 1925, pp. 54–65 (49–68): "la quale si dice esser facta o mancarvi pocho et è più di sei anni l'harebbe finita se da detti executori havesse avuto interamente el debito suo" (1899, p. 48). The authors interpret the document of November 1485 to mean that the painting was nearly finished by 1479. The Pollaiuolo brothers, whose connection with Verrocchio seems inescapable, also received in November 1485 final payment for a (now lost) altarpiece they had painted for the chapel of Corpus Domini in Pistoia Cathedral (Pons, *Pollaiolo*, 1994, p. 113).

19 Passavant, *Verrocchio*, 1959, pp. 29–57; and *Complete Edition*, 1969, pp. 55–56, and cat. no. 22, pp. 190–91 (with bibliography). Cadogan (in *Zeitschrift*, 1983, pp. 372–73) agrees with the division of hands proposed by Passavant and with his thesis that the differences separating this work from the *Baptism* represent Verrocchio's stylistic development.

20 Covi in *Art Bulletin*, 1966, pp. 99, 103. The document of November 5, 1490 alleges that Credi painted "una tavola di nostra Dona e più altre cose [predella panels?]" during the period 1473–74. Credi acknowledged having painted the picture in question but not at the time specified in the document. Even supervised by Andrea, he could scarcely have executed a work as accomplished as the Pistoia altarpiece earlier than the late 1470s, when he was approaching the age of twenty.

21 Dalli Regoli, *Credi*, 1966, pp. 11–17, and cat. no. 30, pp. 111–14 (with bibliography); Gigetta Dalli Regoli, "La Madonna di Piazza: '. . . Ce n'è d'assai più belle, nessuna più perfetta'," in *Scritti di storia dell'arte in onore di Federico Zeri*, 2 vols., Milan, 1984, vol. I, pp. 213–34; and Dalli Regoli in *Maestri e botteghe*, ed. Gregori, Paolucci, and Acidini Luchinat, 1992, cat. no. 1.5, p. 52.

22 The restorer Signora Pennucci kindly allowed me to examine the picture while it was undergoing treatment; neither of us could discern any inconsistency of painting handling that would point to collaboration. The execution appears to have been at least partly in oil, which Verrocchio did not practice.

23 As noted by Fahy in *Burlington Magazine*, 1993, pp. 169–70.

24 Passavant (*Complete Edition*, 1969, p. 57; cat. nos. D2 and D3, p. 191; and plates 88 and 90) attributed the two drawings in the Uffizi to Verrocchio, and Cadogan (in *Zeitschrift*, 1983, pp. 389–91 [367–400] and note 57) agreed. For later and somewhat differing views see: Andrea De Marchi in *Disegno fiorentino*, ed. Petrioli Tofani, 1992, cat. no. 7.4, pp. 148–49; and Caterina Caneva in *Disegno fiorentino*, ed. Petrioli Tofani, 1992, cat. no. 4.5, p. 98.

25 Attributed to Leonardo by a Pistoiese writer named Michelangelo Salvi (*Historie di Pistoia e fazioni d'Italia*, 3 vols., Rome, 1656–62, vol. II, 1657, p. 422), the picture was painted under his influence, according to Berenson (in *Bollettino d'arte*, 1933, pp. 210–12; and *Drawings*, 1938, pp. 57–58). Other scholars, including Valentiner (in *Art Bulletin*, 1930, pp. 54–60) and Douglas (*Leonardo*, 1944, pp. 69–70), wished to credit Leonardo with some of its more remarkable features, like the intricately foreshortened geometric pattern of the carpet. Suida (in *Leonardo*, ed. Marazza, 1954, pp. 316–17) proposed that Leonardo partly finished the painting. About his presumed presence there see: Dalli Regoli, *Credi*, 1966, p. 113; and Dalli Regoli in *Scritti*, 1984, p. 226.

26 Petrioli Tofani, *Inventario*, 1986, no. 446E, p. 199: "e chompa in Pisstoja."

27 Valentiner in *Art Bulletin*, 1930, p. 58. Later, in the revised version of this article (*Italian Renaissance Sculpture*, 1950, pp. 144–45), he found that the drawing was "connected in one way or another" with the figure in the painting.

28 Clark (*Drawings*, 1968, vol. I, no. RL12572, p. 111 [with bibliography]) agreed with Berenson and Valentiner in dating the drawing (on blue prepared paper measuring 17.8 × 12.2 cm. or 7 × 4³⁄₄ in.) *c*. 1476. Also dating the drawing to *c*. 1475–78, Martin Clayton (*Leonardo da Vinci: A Singular Vision*, New York, 1996, cat. no. 2, p. 16) notes that the reed cross shown twice on the sheet identifies the youth as the Baptist. Since the direction of his pointing gesture differs from that in the painting, the drawing might alternatively have been made for the St. Bernard altarpiece, which occupied Leonardo early in 1478 and which would probably have included Florence's patron saint John. But whichever *pala* this highly resolved figure study was made for, it clearly served as the model for the Baptist's pose in the *Madonna di Piazza*.

29 For Ghirlandaio's treatment see chapter 3 note 38.

30 Passavant (*Complete Edition*, 1969, pp. 57–58, and cat. no. D4, pp. 191–92) ascribes the drawing (Louvre, Cabinet des Dessins, inv. no. 455) to Andrea reworked by Credi, while Dalli Regoli (*Credi*, 1966, cat. no. 13, pp. 105–06), followed by Bartoli (in *Disegno fiorentino*, ed. Petrioli Tofani, 1992, cat, no. 2.30, pp. 74–75), gives it entirely to the pupil. A related study in Edinburgh, attributed to Credi by Dalli Regoli (1966, cat. no. 14, p. 106, and fig. 52) and to his teacher by Cadogan (in *Zeitschrift*, 1983, pp. 385–88 and note 49), appears instead to be a copy after the St. Donato in the painting.

31 Credi's recourse in normalizing Leonardo's indecorously erotic conception was the Baptist in Domenico Veneziano's St. Lucy altarpiece in the Uffizi.

32 Valentiner in *Loan Exhibition*, 1949, p. 17 (11–27).

33 Vasari, *Vite*, ed. Milanesi, vol. IV, 1879, p. 564: "E perchè a Lorenzo piaceva fuor di modo la maniera di Lionardo, la seppe così bene imitare, che niuno fu che nella pulitezza e nel finir l'opere con diligenza l'imitasse più di lui."

34 The panel (Musée du Louvre, inv. no. M.I. 598), measuring 16 × 60 cm. (6¹⁄₄ × 23¹⁄₂ in.), was acquired from the Campana Collection in Rome in 1861 for the Musée Napoléon III and went to the Louvre two years later. Like its counterpart in the Uffizi, the picture bore an attribution to Domenico Ghirlandaio, which the museum changed to Credi long before it was linked to the Pistoia altarpiece.

35 For Berenson's view see the Appendix note 71. Clark grew disenchanted with the *Annunciation*. Having first credited its "unusual perfection" and "subdued colour" to Leonardo (*Leonardo*, 1939, p. 25), he then opted for Credi influenced by Leonardo (1939, p. 26 note 2) and finally concluded that the picture was indeed by Credi (*Leonardo*, rev. eds. 1952, p. 24, 1959, pp. 34–35, and 1988, pp. 67–68).

36 Clark, *Leonardo*, 1939, p. 25.

37 See the Appendix notes 76 and 77.

38 Dalli Regoli (*Credi*, 1966, cat. no. 32, pp. 114–17) gives both design and execution to Lorenzo, while Ottino della Chiesa (*L'Opera completa*, 1967, cat. no. 11, p. 91) favors

Leonardo. For more recent opinions about the work, cautiously attributed in the museum to Credi (Béguin, *Louvre*, 1983, p. 90), see Marani, *Leonardo*, 1989, cat. no. 5, pp. 39–40.

39 For the later dating see: Seidlitz, *Leonardo*, 1909, vol. I, pp. 71–72; Sirén, *Leonardo*, 1916, pp. 37–38; and Sirén *Léonard de Vinci: L'artiste et l'homme*, trans. Jean Buhot, 3 vols., Paris and Brussels, 1928, vol. I, pp. 30–31; Venturi, *Leonardo*, 1920, pp. 70–72; De Rinaldis, *Storia*, 1926, pp. 28–32; and Suida, *Leonardo*, 1929, p. 21.

40 For perspectival diagrams of the Louvre picture see: Ceci in *Notiziario vinciano*, 1977, pp. 15–17; and Pedretti, *Leonardo architetto*, 1978, cat. no. 2, pp. 278–80. Leonardo's perspective scheme serves mainly to define the architectural elements represented in the Uffizi *Annunciation*, whereas Credi adopted a more extensive if generalized architecture to organize space, with the vanishing point to the left of the angel's head.

41 About the *S. Donato and the Tax Collector* see: Dalli Regoli, *Credi*, 1966, p. 13, and cat. no. 31, p. 114; and the exhaustive entry by Martin Davies in his *European Paintings in the Collection of the Worcester Art Museum*, 2 vols., Worcester, 1974, vol. I, inv. no. 1940.29, pp. 382–86. Present-day reconstructions of the predella, with the Louvre *Annunciation* in the center and the Worcester panel on the right, exclude the *Birth of the Virgin*, painted by the young Perugino in Verrocchio's shop, which Valentiner proposed as the missing section (*Foreign Catalogue*, Walker Art Gallery, Liverpool, 1977, inv. no. 2856, pp. 171–73). The composition of the Worcester panel, with two kneeling figures, was obviously adapted from the *Annunciation*. The type of the bishop and his framing by the landscape were just as clearly taken over from the main panel of the altarpiece, while the tax collector's pointing gesture derives from Leonardo's Windsor drawing (Fig. 145). Though said to be in tempera, the two extant predella panels may employ some combination of tempera and oil, the uncertainty in estimating the medium arising from Credi's tempera-like use of oil. In any case, the rather pedestrian paint handling revealed by x-radiography is the same in both works (Magdeleine Hours, "Notes sur l'étude de la peinture de léonard de Vinci au laboratoire du Musée du Louvre," in *Études d'art*, nos. 8–10, 1953–54, p. 205, [201–10]; and Hours in *Leonardo*, ed. Marazza, 1954, pp. 21–22 and plates XXV, XXVII).

42 About the drawing (inv. no. 428E), which measures 28 × 19.9 cm. (11 × 8 in.), see Petrioli Tofani, *Inventario*, 1986, p. 192.

43 Rosini, *Storia*, vol. IV, 1843, pp. 10–11. The dark shading used to set off the profile and lower the eyelid in the drawing may have been added later.

44 Berenson, *Drawings*, 1903, vol. I, p. 36; and vol. II, cat. no. 2791, p. 179; and Thiis, *Leonardo*, n.d. [1913], p. 104.

45 The coiffure having inspired one of Venturi's highest flights of poetic description (*Storia*,

vol. IX, part 1, 1925, p. 110; and *Disegni*, vol. I, 1928, p. 8, and cat. no. XVI, p. 23), Berenson changed his mind (in *Bollettino d'arte*, 1933, p. 206, and pp. 241–42 [241–64]; and *Drawings*, rev. ed. 1938, vol. I, p. 60, and vol. II, cat. no. 1015A, p. 111). For later writers who concurred in their attribution to Leonardo see: Petrioli Tofani in Forlani Tempesti and Petrioli Tofani, *Grandi disegni*, cat. no. 30; Dalli Regoli in Pedretti and Dalli Regoli, *Disegni*, 1985, cat. no. 5, pp. 53–54 (with bibliography); Caneva in *Disegno fiorentino*, ed. Petrioli Tofani, 1992, cat. no. 4.15, pp. 114–15; and Wiemers, *Bildform*, 1996, p. 147.

46 Licia Ragghianti Collobi (*Il libro dei disegni del Vasari*, 2 vols., Florence, 1974, vol. I, p. 92) hypothesized that Vasari may even have owned this sheet.

47 The (winged) clasp of the headband also recalls the brooches commonly featured in Verrocchio workshop depictions of the Virgin.

48 Credi also used the type for an early *Madonna* in the Cleveland Museum of Art, as Dalli Regoli (*Credi*, 1966, cat. no. 8, p. 103, and fig. 11) noted.

49 For examples by Verrocchio and Biagio di Antonio see respectively: Caterina Caneva in *Disegno*, ed. Petrioli Tofani, 1992, cat. no. 4.13, pp. 110–11; and Roberta Bartoli in *Maestri e botteghe*, ed. Gregori, Paolucci, and Acidini Luchinat, 1992, cat. no. 2.21, pp. 86–87. Somewhat later Leonardo adopted the same type in a drawing in the Louvre for the *Madonna Litta* (Popham, *Drawings*, 1945, cat. no. 19, p. 104).

50 About the panel (inv. no. 1952.5.65 [1144]), which measures 15.7 × 12.8 cm. (6⅛ × 5⅛ in.), see Shapley, *Catalogve*, 1979, pp. 531–34: as "Circle of Verrocchio, possibly Leonardo." This designation was suggested by Everett Fahy (review of Shapley's Kress Catalogue in *Art Bulletin*, vol. LVI, no. 2, 1974, p. 285 [283–85]), who himself believes, nevertheless, that the picture is an early Lorenzo di Credi.

51 For a survey of attributions see Shapley, *Catalogue*, 1979, pp. 532–33 note 1.

52 Passavant (*Complete Edition*, 1969, cat. no. App. 42, p. 210) opposed the Verrocchio attribution advanced by L. Venturi (*Italian Paintings*, 1933, vol. II, note to plate 239) and Shearman (in *Burlington Magazine*, 1967, p. 127). Joannides (in *Nine Lectures*, n.d. [1990?], p. 27) accepts it, however.

53 Berenson, *Drawings*, 1903, vol. I, p. 42; in *Bollettino d'arte*, 1933, pp. 258–62; and *Drawings*, 1938, vol. I, pp. 66–67 (as Credi echoing Leonardo). Berenson also briefly considered Ghirlandaio as the possible author of the painting (annotated photograph at I Tatti), while the posthumous edition of his *Italian Pictures . . . Florentine School*, 1963, vol. I, p. 212) simply calls it "Verrocchio studio." Among writers on Credi, Georg Gronau (in *Lexikon*, ed. Thieme and Becker, vol. VIII, 1913, p. 75) agreed with Berenson's original view, while Dalli Regoli (*Credi*, 1966, pp.

113, 117, and 197) preferred Leonardo. Wasserman (*Leonardo*, 1975, p. 162) attributed the picture to the artist (for him a Credi follower) who did the Louvre *Annunciation*.

54 Clark, *Leonardo*, rev. eds. 1959, p. 30, and 1988, p. 62. Other writers on Leonardo who also relegated the picture to Credi include Sirén, *Léonard*, 1928, vol. I, p. 21; and Möller in *Jahrbuch*, 1937–38, p. 27 (5–40).

55 Though Suida (*Leonardo*, 1929, pp. 15–17) found the *Madonna of the Pomegranate* more advanced than the one generally agreed to be Leonardo's in Munich, other writers, including Degenhart (in *Rivista d'arte*, 1932, no. 3, pp. 273–76; and no. 4, pp. 430–34), Douglas ("Leonardo and his Critics. I," in *Burlington Magazine*, vol. LXXXI, no. 475, 1942, pp. 242–47 [238–47]; and *Leonardo*, 1944, pp. 51–56), and Ottino della Chiesa (*L'opera completa*, 1967, cat. no. 8, p. 90), understood that such an immature work, if by Leonardo, would have to be earlier.

56 Though no division of hands can be discerned in this very small panel, Valentiner (*Italian Renaissance Sculpture*, 1950, p. 148) hypothesized that Leonardo began the painting and Credi finished it. Heydenreich (*Leonardo*, 1954, vol. I, 31) agreed that Leonardo might have taken part in it. Adorno (*Verrocchio*, 1991, p. 257) gives the Virgin to one Verrocchio shop assistant and the Child to another.

57 Marani, "Altre opere attribuite e derivazioni," in *Leonardo: La pittura*, ed. Marani, 2nd rev. ed., Florence, 1985, p. 222; *Leonardo*, 1989, cat. no. 1, p. 28; in *Verrocchio*, ed. Bule, Darr, and Superbi Gioffredi, 1992, p. 142 (141–52); and *Leonardo*, Milan, 1994, pp. 10–13, 26, and 146. Shell (*Leonardo*, 1992, pp. 14–17), among others, tentatively accepts Marani's reattribution.

58 A photograph of the painting cleaned but not retouched in the library at Berenson's Villa I Tatti is dated Feburary 1930. The panel has not been treated since it entered the Kress Collection in 1951. Raymond S. Stites ("La Madonna del Melograno di Leonardo da Vinci, l," in *Critica d'arte*, vol. XV, no. 93, 1968, figs. 1 and 2 on pp. 59–60 [59–73]) reproduced "before and after" photographs, but concluded from them that the restorer had merely returned the picture to its original state. Similarly Shapley (*Catalogue*, 1979, vol. I, p. 533 note 2), while noting that the restorer had "exaggerated" the modeling, did not suspect that the dealer had subjected the painting to a deceptive restoration. The dark glazes added around the Virgin's eyes, nose, and mouth reinforced the Leonardo attribution by giving her face the requisite sweetness of expression. From this time on authors invariably cite the Virgin's head as the most Leonardesque part of the painting. Significantly, however, the Leonardo scholar Giorgio Castelfranco exhibited a pretreatment photograph of the *Madonna of the Pomegranate* (made before it was sold from the Dreyfus Collection, Paris, to Duveen in 1930) in Rome in 1952, labeling it as

"Credi?" (*Mostra didattica leonardesca* Rome, 1952, photograph 2). Castelfranco thus seems to have grasped that the Virgin's face formerly looked more like Credi's work than it does today.

59 For this picture in the Gemäldegalerie Alte Meister, Staatliche Kunstsammlungen, Dresden, see: Dalli Regoli, *Credi*, 1966, pp. 26–27, and cat. no. 9, p. 104; and Gregor J. M. Weber, "Ein Gemälde Leonardos für Dresden? Der Ankauf eines Madonnenbildes von Lorenzo di Credi im Jahr 1860," in *Dresdener Kunstblätter*, vol. VI, 1995, pp. 166–72. Dr. Weber kindly provided a photograph of the recently cleaned painting, in which Credi supplied the missing landscape and substituted a grape for the flower that the Virgin offers to the Child in the Benois *Madonna*. He took over the approaching Baptist from an amazingly inventive drawing by Leonardo at Windsor Castle (Clark, *Drawings*, 1968, vol. I, inv. no. 12276, pp. 3–4). Dating from around 1480, the drawing provides a *terminus post quem* for Credi's picture.

60 Both works, in which Credi imitated his master and his mentor respectively, were sent to Spain, according to Vasari (*Vite*, ed. Milanesi, vol. IV, 1879, pp. 565–66).

61 In one of these half-length Madonnas, plausibly attributed to Ghirlandaio in Verrocchio's shop, in the monastery at Camaldoli (see chapter 2 note 86), the Child relates more nearly to the Virgin, without, however, having his legs crossed in a faltering step.

62 About this metalpoint drawing (inv. no. 1197E), which even includes the cushion found in the painting, see: Dalli Regoli, *Credi*, 1966, cat. no. 5, p. 102, and fig. 6; and Pedretti in Pedretti and Dalli Regoli, *Disegni*, 1985, p. 17 note 8, and fig. 9.

63 Dr. Wolfgang Holler, Director of the Kupferstichkabinett in Dresden, kindly provided a photograph. The attributional vicissitudes of the drawing have followed those of the Washington picture for which it was a preparatory study. Bode (*Studien*, 1921, pp. 26–27) and Suida (in *Leonardo*, ed. Marazza, 1954, p. 316 [315–29]), among others, favored Leonardo. But the metalpoint drawing is right-handed, which virtually excludes him as its possible author. Scholars trying to attribute the *Madonna of the Pomegranate* to Leonardo, therefore, are obliged to give the drawing to Verrocchio, since while Leonardo might well have executed a painting on his master's design, he would never have copied a younger and less gifted pupil of Andrea's like Credi. Though it has, in fact, been ascribed to Verrocchio (Morelli, *Italian Painters: Critical Studies of their Works. The Galleries of Munich and Dresden*, trans. Constance Jocelyn Ffoulkes, London, 1893, p. 266; Thiis, *Leonardo*, 1909, pp. 117–18; Cadogan in *Zeitschrift*, 1983, pp. 382–85; and Wiemers, *Bildform*, 1996, pp. 152–53), the drawing appears too slack for him, leaving Credi as the only remaining candidate. Degenhart (in *Rivista d'arte*, 1932, p. 268) and Berenson (in

Bollettino d'arte, 1933, p. 258; and *Drawings*, 1938, vol. I, pp. 66–73; and vol. II, cat. no. 672A, p. 70), accordingly, assigned the drawing to Lorenzo. Adorno (*Verrocchio*, 1991, p. 263) also gives the drawing to him, as a preparatory study for the *Madonna of the Pomegranate*, and this seems right.

64 Certain motifs, like the window or the Virgin's half-closed eyes, jeweled brooch, and puckered bodice, are common to the drawing and to both of the related paintings. The coiffure in the study, however, agrees with the elaborately coiled hair in the Munich picture, while the robe in the drawing falls over the Virgin's left shoulder, as in the *Madonna of the Pomegranate*. In every way, it would seem, the drawing stands between the two paintings.

65 This case, like the Uffizi drawing (Fig. 149), involves the artist's inability to reproduce a foreshortening he could not fathom.

66 Valentiner astutely observed (*Italian Renaissance Sculpture*, 1950, p. 148) that "while the attitude of the hand with the flower held between thumb and forefinger is quite plausible in [Leonardo's Munich *Madonna*], it is less convincing in the Dreyfus painting. Who would hold a heavy pomegranate in this manner? We detect here the imitator who substitutes another motif without being able to give a convincing position to the hand." See also Brown in *Small Paintings of the Masters*, ed. Leslie Shore, New York, 1980, cat. no. 84. As opposed to Leonardo's theme of the just-picked flower, that of the Virgin holding a pomegranate was commonplace. Going back to Filippo Lippi's great tondo of 1452 in the Palazzo Pitti (Salvini, *Banchieri*, 1984, plate 24), it appears frequently in works by artists who trained with Verrocchio, including Botticelli's *Madonna del Roseto* in the Uffizi (Caterina Caneva, *Botticelli: Catologo completo dei dipinti*, Florence, 1990, p. 30); his *Madonna with Angels* in the Louvre (Caneva, *Botticelli*, 1990, p. 28); Botticini's triptych in Avignon (Venturini, *Botticini*, 1994, p. 185; and the *Madonna* by the Master of the Gardner Annunciation in Berlin (Zeri in *Bollettino d'arte*, 1953, p. 243). In all of these examples the Virgin holds the fruit firmly in her hand. Significantly, even artists imitating the *Madonna of the Pomegranate* corrected this fault in their model. Compare Grossman in *Report and Studies*, 1968, figs. 8 and 10. Naive though they are in some ways, the figures in the *Madonna of the Pomegranate* are, in terms of the way they were constructed, complex composites typical of the Verrocchio shop. The Virgin's right hand supporting the Child is an extremely common motif, while the Child's left-handed gesture recalls the infant's resting arm in reliefs associated with the master (see chapter 3 note 65).

67 X-radiography also shows that, as far as the schematic architecture goes, the incised lines for the window sills were originally higher, further reducing the initial dimensions of the openings onto the landscape.

68 Though Marani (in *Leonardo: La pittura*, ed.

Marani, 1985, p. 222) claims the landscape was inspired by Bellini, its real source would seem to be Memling, in particular the verdant view seen through a window in his *Portrait of a Man* in the Lehman Collection at the Metropolitan Museum, New York (Salvini, *Banchieri*, 1984, plate 129). About the influence of this work in the Verrocchio shop, see chapter 2 note 85. Any assessment of the landscape in the *Madonna of the Pomegranate* must allow for the fact, established during the recent technical examination, that the soft atmospheric effect is due at least partly to abrasion.

69 The variant of *Ginevra* in the Metropolitan Museum, New York, seems unworthy of Credi (chapter 5 note 33). For his derivations from Leonardo's portrait, in Forlì and Turin, see: Dalli Regoli, *Credi*, 1966, cat. no. 59, pp. 130–131, and fig. 197; and cat. no. 119, p. 156, and fig. 124. Credi's portraits retain the hands and, in one case, the flower-holding gesture of his model.

70 For a thorough discussion of the iconography and a dating to the late 1480s, see Cadogan in *Wadsworth Atheneum, II: Italy and Spain. Fourteenth through Nineteenth Centuries*, ed. Jean K. Cadogan, Hartford, CT, 1991, pp. 122–25.

71 Another possible model for Piero's figure is Botticelli's Venus, shown before the dark leaves of a myrtle bush silhouetted against the sky, in the *Primavera*. Thiis (*Leonardo*, n.d. [1913], p. 112) aptly compared Botticelli's arrangement with that found in the slightly earlier *Ginevra*, without proposing the latter as a source.

72 The most striking derivation is that of the right-hand angel in Piero's wonderfully bizarre *Virgin and Child with Angels* in the Cini Foundation, Venice, from Leonardo's *Kneeling Leda* (Sharon Fermor, *Piero di Cosimo: Fiction, Invention and Fantasia*, London, 1993, pp. 140, 145, and figs 66, 67).

73 Piero's figure in this work of *c.* 1505 may also combine an echo of Leonardo's half-length *St. John the Baptist* in the Louvre, the origin of which would have to be earlier, then, than is commonly believed (Marani, *Leonardo*, 1989, cat. no. 24, pp. 115–18).

74 Vasari, *Vite*, ed. Milanesi, vol. IV, 1879, pp. 175–76.

75 Grossman in *Studies*, 1974, pp. 13–15 (6–22).

76 The brilliant reconstruction of the artist's beginnings by Fahy (in *Art Bulletin*, 1969, p. 142 [142–54], updated in his "Ritornando alle origini: Reconsiderazione della produzione giovanile di Fra' Bartolomeo," (in Serena Padovani, *L'età di Savonarola: Fra' Bartolomeo e la Scuola di San Marco*, Exhibition Catalogue, Palazzo Pitti and Museo di San Marco, Florence, 1996, pp. 3–11), makes clear that it was by building on Leonardo's example in the 1490s that Bartolomeo anticipated the High Renaissance.

77 About this work, first restored to Bartolomeo by Longhi, and its indebtedness to Leonardo see: Fahy in *Art Bulletin*, 1969, pp. 143–44; Venturini in *Maesti e botteghe*, ed. Gregori, Paolucci, and Acidini Luchinat, 1992, cat. no.

2.11, p. 79; and now especially Fahy in Padovani, *Bartolomeo*, 1996, cat. no. 1, pp. 49–52.

78 For this work, now universally acknowledged to be by the youthful Bartolomeo, see: Fahy in *Art Bulletin*, 1969, pp. 145–47; and Fahy in Padovani, *Bartolomeo*, 1996, cat. no. 3, pp. 53–54.

79 For Bartolomeo's source, a triptych by Memling well known in Florence, see: Michael Rohlmann, "Zitate flämischer Landschaftsmotive in Florentiner Quattrocentomalerei," in *Italienische Frührenaissance und nordeuropäisches Spätmittelalter*, ed. Joachim Poeschke, Munich, 1993, p. 244 (235–58) and figs. 16, 17, and 20.

80 Fahy (*Legacy*, 1979, pp. 23–24) aptly contrasts Bartolomeo's picture with Credi's Dresden version of the Benois *Madonna* (Fig. 151).

81 About the *Adoration* see: Ludovico Borgo, *The Works of Mariotto Albertinelli*, New York and London, 1976, pp. 30–31, 40–41, and cat. no. 9, pp. 283–85; and Fahy in Padovani, *Bartolomeo*, 1996, cat. no. 2, pp. 52–53.

82 J. A. Crowe and G. B. Cavalcaselle (*A New History of Painting in Italy*, 6 vols., I–IV ed. Robert Langton Douglas, VI, ed. Tancred Borenius, London, 1903–14, vol. VI, p. 107) mention Leonardo in connection with the painting.

83 Pedretti (*Leonardo*, 1973, pp. 31–32; and *Disegni . . . Biblioteca Reale di Torino*, 1975, cat. no. 15, p. 32) considers the drawing a reworked original study for the angel and the "earliest document of Leonardo's activity."

84 Zeri (*Italian Paintings in the Walters Art Gallery*, 2 vols., Baltimore, 1976, vol. II, cat. no. 209, pp. 322–23) dates the picture to the early 1520s and notes the Leonardo influence. A tondo attributed to Raffaellino del Garbo in Kraków (Jerzy Szablowski, *Collections of the Royal Castle of Wawel*, Warsaw, 1969, cat. no. 62, p. 346) also borrows the Child (and the cushion) from Leonardo's painting.

85 David Alan Brown, "Raphael, Leonardo, and Perugino: Fame and Fortune in Florence," in *Leonardo, Michelangelo, and Raphael in Renaissance Florence from 1500 to 1508*, ed. Serafina Hager, Washington, pp. 29–53.

86 About the painting see: Nicholas Penny, "Raphael's 'Madonna dei garofani' Rediscovered," in *Burlington Magazine*, vol. CXXXIV, no. 1067, 1992, pp. 67–81; and Jürg Meyer zur Capellen, *Raphael in Florence*, London, 1996, pp. 162–69. For another adaptation of Leonardo's most popular early work see the *Virgin* ascribed to Bugiardini in the National Gallery of Ireland in Dublin (Laura Pagnotta, *Giuliano Bugiardini*, Turin, 1987, cat. no. 90, p. 229, and fig. 89), which also echoes Fra Bartolomeo's version in the Metropolitan Museum, New York. The impression gained from comparing these Leonardo derivations is that they represent a common enterprise.

87 Dalli Regoli, "Raffaello e Lorenzo di Credi: Postilla," in *Critica d'arte*, nos. 154–56, 1977, pp. 84–90; and Dalli Regoli, "Raffaello 'Angelica Farfalla': Note sulla struttura e sulle

fonti della Pala Ansidei," in *Paragone*, vol. XXXIV, no. 399, 1983, pp. 8–19.

88 Clark, *Leonardo*, 1939, pp. 26–27, rev. eds. 1952, pp. 24–25, 1959 and 1967, p. 35, and 1988, pp. 68–69.

Appendix

1 Raffaello Borghini simply referred to the painting (*Il riposo*, Florence, 1584, p. 355), while Filippo Baldinucci (*Notizie de' professori del disegno da Cimabue in qua*, 6 vols., Florence, 1681–1728, vol. III, 1728, p. 119) retold Vasari's story about it. The connoisseur of drawings Padre Sebastiano Resta tried to relate three sketches in his own collection (one of which, deriving from Perugino, is now in the Fitzwilliam Museum, Cambridge) to the project of Verrocchio and Leonardo (*Indice del libro intitolato "Parnaso de' pittori"*, Perugia, 1707, pp. 21–22 [fol. 23]). See also Giulio Bora, *I disegni del Codice Resta*, Bologna, 1976, p. 266. Leonardo's angel was further identified with one in a *Nativity* in the Villa Capponi at Arcetri once ascribed to Verrocchio (Baldinucci, *Notizie*, ed. Giuseppe Piacenza, 6 vols., Turin, 1768–1820, vol. II, 1770, p. 258), and now given to a pupil of Lorenzo di Credi named Tommaso di Stefano Lunetti (Berenson, *Italian Pictures . . . Florentine School*, 1963, vol. I, p. 208, and vol. II, plate 1354).

2 The Vallombrosan convent and adjoining church of San Salvi were badly damaged in the siege of Florence in 1529–30. Restored afterwards by nuns belonging to the order, the convent is now divided between a museum housing the *Last Supper* that Andrea del Sarto painted for the refectory and a psychiatric hospital. Giovanni Bottari, editing Borghini's *Il riposo* (Florence, 1730, p. 289 note 1), failed to locate the *Baptism*. His edition of Vasari (3 vols., Rome, 1759–60), though it long formed the basis for later publications of the *Vite*, omits the whereabouts of the *Baptism*. The book does provide a list of works then believed to be Leonardo's (vol. II, 1759, Appendix pp. 22–23). Subsequent editions of the *Vite*, like that of Guglielmo della Valle (11 vols., Siena, 1791–94, vol. IV, 1791, p. 225 note 3; and vol. V, 1792, p. 48 [citing a work in Leonardo's "prima maniera"]), update the list as each editor saw fit.

3 The edition I have used is Luigi Lanzi, *Storia pittorica della Italia*, 3rd ed., 6 vols., Bassano, 1809, vol. I, p. 122. On p. 64 Lanzi repeats Vasari's familiar story about the *Baptism*, from which he concludes that for Verrocchio painting was a mere pastime. Stendhal's influential *Histoire de la peinture en Italie* (2 vols., Paris, 1817, vol. I, pp. 166–69) unquestioningly takes over Lanzi's attributions.

4 One of Lanzi's "early Leonardo's" was Perugino's *Magdalen* in the Palazzo Pitti, Florence (Scarpellini, *Perugino*, 1984, cat. no. 107, pp. 101–02, and fig. 191). About another of them – the *Infant in a Crib* in the Pinacoteca,

Bologna – see Maria Teresa Cantaro, *Lavinia Fontana bolognese*, Milan, 1989, cat. no. 4a.51, pp. 135–36.

5 *Gli Uffizi: Catalogo generale*, ed. Luciano Berti, Florence, 1979, cat. no. P1472, p. 485. According to William Young Ottley, "much uncertainty prevails as to the works of painting executed by Leonardo during his youth," but the *Head of Medusa* was "amongst those which are the least subject to doubt. . . ." (*The Italian Schools of Design*, London, 1823, p. 18). The painting inspired a poem by Shelley, and it appealed no less to Walter Pater, who half a century later called it the "one great picture which [Leonardo] left behind him in Florence" (*The Renaissance* [orig. ed. 1873], ed. Kenneth Clark, London, 1961, p. 108), even though by this time he and Milanesi, editing Vasari (*Vite*, vol. IV, 1879, p. 26 note 1), were practically alone in accepting it as Leonardo's. For the fame of the *Medusa* see Richard Turner, "Words and Pictures: The Birth and Death of Leonardo's Medusa," in *Arte Lombarda*, vol. LXVI, 1983, pp. 103–11.

6 Carlo Amoretti, *Memorie storiche sulla vita, gli studi e le opere di Leonardo da Vinci*, Milan, 1804. Vasari's anecdote about the angel is quoted on pp. 11–12, though the *Baptism* does not figure in the list of Leonardo's paintings and drawings (pp. 154–67). Compiled by Amoretti, the list emphasizes works in his native Milan, for example the *Madonna Litta* (later Hermitage, St. Petersburg), which he considered to be in the artist's "prima maniera" (p. 158).

7 Amoretti sought to identify a *Virgin and Child with the Infant St. John* in the Galleria Borghese, Rome, with the *Madonna with a Vase of Flowers* cited by Vasari, on the evidence of the floral motif behind the figures (*Memorie*, 1804, p. 160). The Borghese picture was correctly reattributed to Credi in Crowe and Cavalcaselle, *History*, vol. III, 1866, pp. 408–09. For the history of the painting see: Paola Della Pergola, *Galleria Borghese. I dipinti*, 2 vols., Rome, 1959, vol. II, cat. no. 36, pp. 31–32; and Dalli Regoli, *Credi*, 1966, cat. no. 75, pp. 136–37.

8 *Description de L'I. et R. Académie des Beaux Arts de Florence*, 3rd ed., Florence, 1836, cat. no. 23, p. 38. Having been deposited in the Galleria dell'Accademia in 1810, the picture was transferred to the Uffizi in 1919.

9 Carl Friedrich von Rumohr, *Italienische Forschungen*, 3 vols., Berlin, 1827–31, vol. II, 1827, pp. 304–10; and Rumohr, *Drey Reisen nach Italien*, Leipzig, 1832, pp. 83–84. He rejected the *Head of Medusa* in favor of a few other "early" works, which were not accepted by Franz Kugler (*Handbook of Painting: The Italian Schools*, ed. Charles Eastlake, 2 vols., London, 1869, vol. II, pp. 214, 278–79 [2nd German ed., 2 vols., Berlin, 1847, vol. I, pp. 419–20, 498–99]). Kugler also doubted the *Medusa*, noting that aside from the angel in the *Baptism*, "little is known of other early works of Leonardo," the critical investigation of which "has as yet been only partially

undertaken," so that "by far the greater part of those which bear his name in galleries are later imitations or the work of his scholars." He himself opted for two portraits neither of which is by Leonardo.

10 See, for example, Ludwig Schorn's edition of Vasari (*Leben der ausgezeichnetsten Maler, Bildhauer und Baumeister*, 6 vols., Stuttgart and Tübingen, 1832–49, vol. II, part 2, 1839, p. 272 note 21), quoted approvingly in Mrs. Jonathan Foster's translation (*Lives of the Most Eminent Painters, Sculptors and Architects*, 5 vols., London, 1852–59, vol. II, 1853, p. 371 note): "The figures of Andrea are without doubt hard and dry, while the Angel of Leonardo is full of life and expression." Charles Clément was unusual in claiming that since Leonardo executed only the angel, the *Medusa* was his chief work before the Uffizi *Adoration* (*Michel-ange, Léonard, Raphael*, Paris, 1861, pp. 180–81). More typical is the contrast Jacob Burckhardt drew between Verrocchio's "really poverty-stricken" style and Leonardo's (*Der Cicerone* [orig. ed. Basel, 1855], 2nd rev. ed., ed. A. von Zahn, 3 vols., Leipzig, 1869, vol. III, pp. 810–11). Mrs. [Anna Brownell] Jameson joined the growing chorus of praise for Leonardo's angel (*Memoirs of Early Italian Painters*, rev. ed. London, 1859 [orig. ed. 1845], p. 166). Ruskin, championing the Primitives, chose to defend Verrocchio's angel, in a notebook of 1845 (*The Works of John Ruskin*, 39 vols., 1903–12, ed. E. T. Cook and Alexander Wedderburn, vol. IV, London, 1903, p. 267).

Pater's vivid image of Leonardo's angel as a "space of sunlight in the cold laboured old picture" (*Renaissance* [1873], 1961, p. 106) was echoed by Mrs. Charles W. Heaton in her *Leonardo da Vinci and his Works*, London and New York, 1874, p. 227. Noting that "almost all traces of Leonardo's youthful works are lost" (p. 7), Mrs. Heaton's list of paintings (including the *Medusa* [no. 44, p. 255]), was generally based on that of Marcel Rigollot (*Catalogue de l'oeuvre de Léonard de Vinci*, Paris, 1849). Rigollot, acquiescing in some of the old attributions (Lanzi's *Infant in a Crib*, pp. 13–14) but not others (*Medusa*, p. 55), reports Passavant's observation that "l'expression de la tête de l'ange est délicieuse, et, en général, le dessin contraste beaucoup avec celui d'André Verocchio, qui est . . . maigre et dont les figures . . . sont . . . d'une nature pauvre et sans noblesse" (pp. 1–2). Like Rumohr, Rigollot deplored the fact that Vasari, whose line of interpretation they followed, failed "a nous faire connaître avec des détails suffisants . . . la manière dont se développa le génie de ce grand peintre. Sans doute il nous le montre dans son jeune age" (p. XXII).

The still unsatisfactory state of the question regarding Leonardo's beginnings can be seen, half a century after Amoretti, in the *Neues allgemeines Künstler-Lexikon* of G. K. Nagler, who refers to "das Dunkel . . . welches über der frühesten Periode des künstlers schwebt. . . ." (Munich, vol. XX, 1850, p.

284). Like his contemporaries, Nagler claimed that the artist's angel ("lebensvollen und schön behandelten") cast Verrocchio's otherwise "dürftigen" picture into the shade (p. 173). Leonardo's figure was so superior, in fact, that Nagler doubted it could be his first work (p. 283).

11 Delacroix, who greatly admired Leonardo, adhered to the Romantic notion of him as a youthful prodigy: "dans l'atelier de Verrocchio, il rompt d'un coup avec la peinture traditionelle du quinzième siècle, il arrive sans erreurs . . . et comme d'un seul bond, à ce naturalisme judicieux et savant" (entry for April 3, 1860, in *Journal de Eugène Delacroix*, ed. Paul Flat and René Piot, 3 vols., Paris, 1893–95, vol. III, 1895, pp. 392–94). A considered echo of this attitude persists in S. J. Freedberg, who finds "no bridge between the style of [Leonardo's angel] and that of Verrocchio's portions of the painting . . . nor is there any evolution toward it we can document in prior work of the young Leonardo himself. Its appearance is . . . sudden" (*Painting of the High Renaissance in Rome and Florence*, 2 vols., Cambridge, MA, 1961, vol. I, p. 3).

12 Diana Louisa MacDonald, *Villa Verrocchio or the Youth of Leonardo da Vinci*, London, 1850, pp. 257–84. While passages in the book, such as "Da Vinci had enjoyed but little of the society of boys [before entering Verrocchio's shop], and he now felt a thrill of pleasure at finding himself amongst so many of his own age and sex," can no longer be read as innocently as they were intended, it is worth noting that the author's narrative necessarily poses the question of why Leonardo took part in the *Baptism* well before art historians raised the issue.

13 About Cavalcaselle's achievement see: Lino Moretti, *G. B. Cavalcaselle: Disegni da antichi maestri*, Vicenza, 1973; Donata Levi, "L'officina di Crowe e Cavalcaselle," in *Prospettiva*, no. 26, July 1981, pp. 74–87; and Levi, *Cavalcaselle: Il pioniere della conservazione dell'arte italiana*, Turin, 1988. Cavalcaselle's working material, consisting of several thousand annotated drawings, is in the Biblioteca Marciana, Venice, while Crowe's papers are in the Victoria and Albert Museum, London. Crowe's contribution was long underrated (Denys Sutton, "Aspects of British Collecting. Part IV, XVI: Crowe and Cavalcaselle," in *Apollo*, vol. CXXIII, no. 282, 1985, pp. 111–29).

14 The overall sketch and the detail, both unpublished, are in Marciana Cod. IT IV, 2036 (= 12277).

15 The illustration in Crowe and Cavalcaselle (*History*, vol. II, 1864, p. 407) merely reproduces earlier engravings of the altarpiece. Much removed from the original, as the author himself complained (Levi, *Cavalcaselle*, 1988, pp. 222 and 242–43 notes 222–25), the illustration takes as its primary source the line engraving in *Galleria dell'I. e Reale Accademia di Belle Arti di Firenze pubblicata con incisioni in rame*, Florence, 1845. Another engraved plate

illustrates Giovanni Rosini's *Storia* (vol. I, 1839, plate XLVII); Rosini's account of the young Leonardo (vol. III, 1841, pp. 136, 287–94) follows Vasari in stressing the artist's precocity.

16 The first Alinari catalogue to list a detail pairing the angels is *Seconda appendice al catalogo generale delle riproduzioni fotografiche*, Part II, Florence, 1881 (available in both small and large format). In 1878 their competitors had already offered a detail comprising Leonardo's figure (*Catalogue des photographies publiées par la maison Giacomo Brogi*, Part I, Florence, 1878). By 1903 Brogi could supply no fewer than three detailed images of the angel (*Catalogo delle fotografie*, Part I, Florence, 1903). The selection of the motif was clearly determined by its critical fortune going back to Vasari.

17 Crowe and Cavalcaselle, *History*, vol. II, 1864, pp. 406–10. The focus on the angel as the "youthful effort" of a "budding genius" no doubt reflects the origin of the book as a critical edition of Vasari's *Lives*.

18 Crowe and Cavalcaselle, *History*, vol. II, 1864, pp. 410–13.

19 Crowe and Cavalcaselle, *History*, vol. II, 1864, p. 409.

20 Sutton, "Gustav Friedrich Waagen, First Director of the Berlin Gallery," in *Apollo*, vol. CII, no. 166, 1975, pp. 396–403.

21 Sutton in *Apollo*, 1985, p. 112.

22 Gustav Friedrich Waagen, *Treasures of Art in Great Britain*, 3 vols., London, 1854, vol. I, p. 319 (*Christ among the Doctors*).

23 Waagen, *Die vornehmsten Kunstdenkmäler in Wien*, Vienna, 1866, Part I, p. 276. If not by Leonardo himself, the picture might be the work of an accomplished pupil like Boltraffio, Waagen suggested.

24 Waagen, "Über das Leben und die Werke des Leonardo da Vinci," in his *Kleine Schriften*, Stuttgart, 1875, p. 150 (145–83), reprinted from his *Leonardo da Vinci*, Berlin, n.d. [1861]. The limits of Waagen's connoisseurship can be seen in his acceptance, following Amoretti, of the Borghese *Madonna* (1875, pp. 150–51). He essentially conceived the early Leonardo as a superior version of Credi (*Treasures*, 1854, vol. III, pp. 196–97).

25 About Liphart and his painter-curator son Ernst, who also identified an early Leonardo painting, see Giacomo Agosti, "Una famiglia di studiosi Leonardeschi nei ricordi di Adolfo Venturi: I Liphart, padre e figlio," in *I Leonardeschi a Milano: Fortuna e collezionismo*, ed. Maria Teresa Fiorio and Pietro C. Marani, Milan, 1991, pp. 255–66. See also the chapter on Liphart senior in Siegfried Käss, *Der heimliche Kaiser der Kunst: Adolph Bayersdorfer, seine Freunde und seine Zeit*, Munich, 1987, pp. 165–77.

26 According to the Uffizi catalogue of 1869, some critics agreed with Liphart, while others gave the picture to Ridolfo Ghirlandaio or Lorenzo di Credi (*Catalogue de la R. Galerie de Florence*, Part II, 1869, cat. no. 1288, p. 147). Wilhelm Lübke was the first to support Liphart's attribution in print ("Über einige

Werke Lionardos," in *Jahrbuch für Kunstwissenschaft*, vol. III, 1870, pp. 70–74; and *Geschichte*, 1878–9, vol. II, pp. 39–40). Ruskin also vehemently defended this "most true early Leonardo, of extreme interest" against the "savants who doubt it" (*Mornings in Florence* [1875] in *Works*, ed. Cook and Wedderburn, vol. XXIII, 1906, p. 325); and he wrote from Florence on August 21, 1874, recommending the painting in the same terms to his American disciple Charles Eliot Norton (*The Correspondence of John Ruskin and Charles Eliot Norton*, ed. John Lewis Bradley and Ian Ousby, Cambridge, 1987, pp. 327–28).

27 Käss, *Bayersdorfer*, 1987; and *Adolph Bayersdorfers Leben und Schriften*, ed. Hans Mackowsky, August Pauly, and Wilhelm Weigand, 2nd ed., Munich, 1908. Weigand's biography is pp. 1–25 and Mackowsky's analysis of the work is pp. 29–55. Bayersdorfer (1842–1901) sojourned in Florence from 1874 to 1880; his realist bias pointed him to the Uffizi *Baptism*, while a special interest in landscape led him to perceive Leonardo's expanded role in the picture. His influence went far beyond the posthumous edition of his (mostly unpublished) writings.

28 *Bayersdorfers Leben*, 1908, pp. 72–76: "Zwei Gemälde von Andrea del Verrocchio in der Akademie zu Florenz, I: Die Taufe Christi."

29 For the acquisition of the picture from a collector in Günzburg and its critical reception see Käss, *Bayersdorfer*, 1987, pp. 160–63.

30 About Bode (1845–1929), whose obituary of Liphart appeared in *Repertorium für Kunstwissenschaft*, vol. XIV, 1891, pp. 448–50, see: *Jahrbuch der Berliner Museen*, vol. XXXVIII, Beiheft, 1996 [whole volume devoted to Bode].

31 The acquisition, made in Florence, is discussed in Bode's *Mein Leben*, 2 vols., Berlin, 1930, vol. I, pp. 77, 89.

32 Bode in *Jahrbuch*, 1882, pp. 237–51; and Bode, *Italienische Bildhauer*, 1887, pp. 110–37.

33 Bode mistakenly regarded the *Narcissus* (Uffizi: *Catalogo*, 1979, cat. no. P221, p. 168), by the Leonardo follower known as the "pseudo-Boltraffio," as the master's earliest work (*Jahrbuch*, 1882, p. 261 [235–67]; and *Italienische Bildhauer*, 1887, pp. 155–56). Another "early" picture Bode persistently advocated, the *Resurrection* in Berlin, is also Milanese (Shell and Sironi, "Giovanni Antonio Boltraffio and Marco d'Oggiono: The Berlin Resurrection of Christ with Saints Leonard and Lucy," in *Raccolta vinciana*, vol. XXIII, 1989, pp. 119–66).

34 Bode in *Jahrbuch*, 1882, pp. 236–37, 258–62; and *Italienische Bildhauer*, 1887, pp. 111–12, 152–58. Compare also Bode's definitive characterization of the angel in his *Studien* of 1921 (see note 38 below). Milanesi, on the basis of documents showing Leonardo was still with Verrocchio as late as 1476, similarly concluded that the pupil may not have painted the angel when he was a "fanciullo," as Vasari stated (*Vite*, vol. IV, 1879, p. 22 note 2).

35 According to Bode (in *Jahrbuch*, 1882, p. 261

note 1; and *Italienische Bildhauer*, 1887, pp. 155, 158), it was Bayersdorfer who first attributed the Louvre painting to Leonardo and noted its link with the Uffizi drawing.

36 Bode, *Italienische Bildhauer*, 1887, pp. 156–57; Vasari, *Vite*, ed. Milanesi, vol. IV, 1879, p. 39. In further studies Bode probed the double-sided portrait, offering reconstructions of the fragmented reverse ("Die Bilder italienischer Meister in der Galerie des Fürsten Liechtenstein in Wien," in *Graphischen Künste*, vol. XV, 1892, pp. 86–91 [85–102]) and of the front, including the sitter's missing hands (in *Zeitschrift*, 1903, pp. 274–76).

37 Bode in *Jahrbuch*, 1915, pp. 202–03.

38 Bode, *Studien*, 1921: "Leonardos Betätigung als Maler in Verrocchios Werkstatt," pp. 9–27; and "Leonardos Anteil an der Porträtplastik Verrocchios und sein Bildnis der Ginevra de' Benci," pp. 28–41.

39 Bode, *Studien*, 1921, pp. 32–33.

40 In a series of polemical publications reattributing Italian paintings in German and Roman galleries, Morelli (1816–91) adopted the pseudonym "Ivan Lermolieff." He has been a subject of intensive research since the conference on Morelli and connoisseurship held at Bergamo in 1987 (reviewed by Jaynie Anderson in *Burlington Magazine*, vol. CXXXIX, no. 1014, 1987, pp. 596–98). See: *Giovanni Morelli e la cultura dei conoscitori* (Acts of the International Conference, June 1987), ed. Giacomo Agosti, Maria Elisabetta Manca, Matteo Panzeri, and Marisa Dalai Emiliani, 3 vols., Bergamo, 1993.

41 Bode criticized Morelli's method as too one-sided in a review of the Italian edition of his study of the galleries in Munich, Dresden, and Berlin (1886) in *Deutsche Literaturzeitung*, vol. VII, no. 42, 1886, cols. 1497–1501 (reprinted in *Mein Leben*, 1930, vol. II, pp. 57–64).

42 Morelli, *Italian Masters in German Galleries: A Critical Essay on the Italian Pictures in the Galleries of Munich, Dresden, Berlin*, trans. Louise M. Richter, London, 1883, pp. 345–47 (orig. German ed. 1880, pp. 383–84).

43 Morelli, *Kunstkritische Studien über italienische Malerei. Die Galerien zu München und Dresden*, Leipzig, 1891, pp. 341–56; and *Munich and Dresden*, trans. Ffoulkes, 1893, pp. 263–75 (quotation from p. 265). About the attributional vicissitudes of Credi's picture see Weber in *Dresdener Kunstblätter*, 1995, pp. 166–72. Morelli also dismissed Amoretti's wishful attribution of Credi's tondo in the Galleria Borghese (*Kunstkritische Studien über italienische Malerei. Die Galerien Borghese und Doria Panfili in Rom*, Leipzig, 1890, pp. 112–13; and *Borghese and Doria-Pamfili Galleries*, trans. Ffoulkes, 1892, pp. 88–89). Morelli's disciple Gustavo Frizzoni also rejected virtually all of Bode's attributions of paintings to Verrocchio and Leonardo in "L'archivio storico dell'arte e gli scultori italiani della Rinascenza," in *Archivio storico dell'arte*, vol. I, 1888, pp. 68–69 (67–69).

44 Morelli, *München und Dresden*, 1891, p. 350; trans. Ffoulkes, 1893, pp. 270–71.

45 Morelli, *München und Dresden*, 1891, pp. 349–56; trans. Ffoulkes, 1893, pp. 270–75.

46 Morelli, *Kunstkritische Studien über italienische Malerei: Die Galerie zu Berlin*, Leipzig, 1893, p. 37.

47 Morelli, *Berlin*, 1893, p. 24. The author adduces further (and not strictly Morellian) citeria in favor of attributing the Uffizi *Annunciation* to Ridolfo Ghirlandaio (p. 22).

48 Richter, *Literary Works*, 1883.

49 Morelli and Richter, *Italienische Malerei der Renaissance im Briefwechsel von Giovanni Morelli und Jean Paul Richter 1876–1891*, ed. Irma and Gisela Richter, Baden-Baden, 1960, pp. 83, 148, 152, 157–61, 163–64, 175, 178–81, and 230–32.

50 See: David Alan Brown, *Berenson and the Connoisseurship of Italian Painting*, Exhibition Catalogue, National Gallery of Art, Washington, 1979; Ernest Samuels, *Bernard Berenson: The Making of a Connoisseur*, Cambridge, MA, 1979; and Samuels, *Bernard Berenson: The Making of a Legend*, Cambridge, MA, and London, 1987.

51 Berenson, *Florentine Painters*, 1896. As early works by Leonardo Berenson listed the Louvre *Annunciation* and the notorious "Donna Laura Minghetti" portrait, which had once belonged to Morelli (pp. 115–16). He gave the Uffizi *Annunciation* and the Liechtenstein portrait to Verrocchio (pp. 130–31). The Munich *Madonna* was, he elsewhere decided, a Flemish "copy after an original executed in Verrocchio's shop, under the inspiration and guidance of Leonardo, by Lorenzo di Credi" (*Drawings*, 1903, vol. I, p. 42).

52 Sirén agreed with Bode about the pupil's expanded role in the *Baptism*, though he reserved judgment about the Liechtenstein portrait. Like Bode (and Morelli), he gave the Louvre *Annunciation* to Leonardo; and the design of the Uffizi version, Sirén felt, was partly his too (*Leonardo da Vinci*, Stockholm, 1911, pp. 97–109, 120–21, 144–45). Five years later he claimed Leonardo also had a hand in executing the Uffizi *Annunciation*, though he now rejected the portrait as his work (*Leonardo*, 1916, pp. 13–26, 36–38). Sirén finally decided that Leonardo may have helped to design some or all of the pictures, including the Munich *Madonna*, painted by his fellow "Pupil A" (*Léonard*, trans. Buhot, 1928, vol. I, pp. 11–24).

53 Seidlitz (*Leonardo*, 1909, vol. I, pp. 49–55; rev. ed. 1935, pp. 42–48) was inclined to identify the pupil as Credi.

54 Seidlitz, *Leonardo*, 1909, vol. I, pp. 53–54: "vorlaufer der Mona Lisa wird man jedenfalls in diesem Bilde nicht zu erkennen haben." About the Louvre *Annunciation* see pp. 71–72.

55 For the installation see *Uffizi: Catalogo*, ed. Berti, 1979, pp. 37, 39. I am indebted to Dottoressa Silvia Meloni for the photograph, of which a detail is reproduced here. At this time Herbert Cook observed that "no real reconstruction of the Verrocchiesque Leonardo will ever succeed until we rule out the *Mona Lisa* standard" ("Leonardo da Vinci and Some Copies," in *Burlington Magazine*, vol. XX, no. 105, 1911, p. 130 [129–33]; reprinted in his *Reviews and Appreciations of Some Old Italian Masters*, London, 1912, pp. 22–29).

56 Thiis, *Leonardo*, n.d. [1913], pp. 63–130. For Thiis the lack of expression in these works (see pp. 100, 111–12, and 129), among much else, disqualified them as Leonardo's. The original Norwegian edition of 1909 was reviewed by Seidlitz in *Internationale Wochenschrift für Wissenschaft, Kunst, und Technik*, vol. IV, no. 52, 1910, cols. 1649–56 (summarized in *Raccolta vinciana*, vol. VII, 1911, pp. 112–16).

57 For the practice of inventing artistic personalities to account for troublesome aspects of known artists' works see Brown, *Berenson*, 1979, p. 42.

58 Crowe and Cavalcaselle, *Storia della pittura*, trans. Mazza, vol. VI, 1894, pp. 180–83 (admitting Leonardo's participation in the landscape of the *Baptism*). Annotating the original edition of Crowe and Cavalcaselle (1864–66), Edward Hutton followed Berenson and the Morellians (*History*, 1909, vol. II, pp. 393–99), while Douglas (*A History of Painting in Italy*, 6 vols., London and New York, 1903–14, vol. IV, 1911, p. 247 note 1) sided with Bode.

Solely or with others, Bode revised eight editions of Burckhardt's *Der Cicerone* between 1874 and 1910 (*Verzeichnis der Schriften von Wilhelm von Bode*, ed. Ignaz Beth, Berlin and Leipzig, 1915, p. 101). Morelli's disciple Frizzoni criticized Bode's handiwork in *Archivio storico dell'arte*, vol. I, 1888, pp. 289–300 (esp. p. 292). Karl Woermann also took the Morellian line in his *Geschichte der Kunst aller Zeiten und Völker*, 3 vols., Leipzig and Vienna, 1900–11, vol. II, 1905, pp. 594–96.

The controversy over Leonardo's early work provoked a skirmish between two American academics, William Rankin and Frank Jewett Mather, Jr. See: Rankin, "Leonardo's Early Work," in *The Nation*, vol. LXXXIV, no. 2185, May 16, 1907; Mather, "Verrocchio and Early Leonardo," in *The Nation*, vol. LXXXV, no. 2192, July 4, 1907, pp. 11–12; Rankin, "The Early Works of Leonardo," in *The Nation*, vol. XCIX, no. 2561, July 30, 1914, pp. 133–34; Rankin and Alice van Vechten Brown, *A Short History of Italian Painting*, London and New York, 1914, pp. 124–26, 213–16; and Mather, *Italian Painting*, 1923, pp. 226–31, 481.

59 Müntz, "Notes sur Verrocchio considéré come maître et précurseur de Léonard de Vinci," in *L'art*, vol. XII, no. 2, 1886, pp. 89–96; "Une éducation d'artiste au XVe siècle: La jeunesse de Léonard de Vinci," in *Revue des deux mondes*, vol. LXXXIII, 1887, pp. 647–80; and *Leonardo da Vinci: Artist, Thinker, and Man of Science*, 2 vols., London and New York, 1898, vol. I, pp. 21–54. Predicting that the connoisseurship of Leonardo's early works would "exercise the sagacity of critics for a

long time to come," Müntz himself side-stepped the issue, taking refuge in Vasari (*Leonardo*, 1898, pp. 43, 49–54). He was opposed by Jacques Morland ("Le maître de Léonard," in *Mercure de France*, April 1, 1908, pp. 426–40; summarized by Ettore Verga in *Raccolta vinciana*, vol. IX, 1913–17, pp. 119–20]).

60 Mackowsky (*Verrocchio*, 1901, pp. 46, 76–81) adhered to Bode's views, while Cruttwell (*Verrocchio*, 1904, pp. 21–24, 44–56, and 105–09) and Reymond (*Verrocchio*, Paris, n.d. [1906], pp. 103–34, 158; and "L'éducation de Léonard," in *Leonardo da Vinci: Conferenze fiorentine*, Milan, 1910, pp. 49–79) echoed Berenson. For Cruttwell, who allowed for some mutual influence between the two artists, the Uffizi *Annunciation* and its cognates lacked the expressivity of the Louvre version of the theme. Adolf Rosenberg (*Leonardo da Vinci*, Bielefeld and Leipzig, 1898, pp. 25–28, 35–36), similarly found these works (again excepting the Louvre picture) "devoid of charm" and "unworthy of a great artist."

61 Venturi, *Storia*, vol. VII, Part I, 1911, pp. 783–84, 799–800, and 819–26. In a review Frizzoni agreed that the Liechtenstein portrait lacked the "morbidezza" and "grazia" of *Mona Lisa* ("La pittura italiana del Quattrocento secondo un'opera recente," in *Nuova antologia*, vol. CLIV, 1911, pp. 60–62 [50–63]).

62 Venturi, *Leonardo*, 1920, pp. 3–21, 66–72, and 186–87; *Storia*, vol. IX, Part I, 1925, pp. 3–9, 48–79 (plate 1, opposite p. 52, reproduces the portrait for the first time in color).

63 Venturi, *Storia*, vol. IX, Part I, 1925, pp. 68–78.

64 Colvin, *Drawings*, 1907, vol. I, part I, note to plate 14A.

65 Fittingly it was Liphart's son Ernst who recognized the Benois *Madonna* (so-called because its Russian owner was the wife of an architect named Benois) as Leonardo's (*Les anciennes écoles de peinture dans les palais et collections privées russes représentées a l'exposition organisée a St. Pétersbourg en 1909*, Brussels, 1910, pp. 30–32). The younger Liphart argued vehemently against Thiis in favor of the early works in

Jahrbuch, 1912, pp. 201–03). Though the differences between the Benois and Munich Madonnas were sufficient for Liphart to reject the latter, he preceded Berenson in eliminating the Louvre *Annunciation*, hitherto favored over the one in the Uffizi.

66 In "Leonardo," in *The Study and Criticism of Italian Art*, 3rd ser., London, 1916, p. 37 (1–37), Berenson wrote "The Hermitage 'Madonna' obliges me to reconsider the canon of Leonardo's works. The man who could do a thing as bad as that may have done others."

67 Berenson, *Italian Pictures*, 1932, p. 279; and *Italian Pictures . . . Florentine School*, 1963, vol. I, pp. 107–08. Never outgrowing his distaste for the early works, Berenson felt compelled to believe that Leonardo "had a hand in Verrocchio's 'Baptism,' that not only the pretty angel, but much else there that is not so pretty, is his . . . that the hideous Madonna of the Hermitage and the somewhat simpering one of Munich, as well as the rather empty 'Annunciation' of the Uffizi are from his brain and hand" (*Aesthetics and History in the Visual Arts*, New York, 1948, p. 224).

68 Berenson in *Bollettino d'arte*, 1933, pp. 193–214 and 241–64.

69 Berenson, *Drawings*, 1903, vol. I, pp. 32–33, 38–39, and 42–43; and 2nd rev. ed. 1938, vol. I, pp. 49–50, 54–56; and *Disegni*, trans. Vertova Nicolson, 1961, vol. I, pp. 87–89, 92–94.

70 Berenson in *Bollettino d'arte*, 1933, p. 193; and *Drawings*, 1938, p. 50.

71 Berenson, *Pitture italiane del Rinascimento*, Milan, 1936, p. 240; and in *Bollettino d'arte*, 1933, pp. 212–14; and *Drawings*, 1938, vol. I, pp. 58–59; and *Disegni*, 1961, vol. I, p. 97.

72 Degenhart in *Rivista d'arte*, vol. XIV, 1932, pp. 263–300 and pp. 403–44; on the *Madonna* see pp. 273–76, 404–05, and 430–34.

73 Douglas in *Burlington Magazine*, 1942, pp. 242–47; and Douglas, *Leonardo*, 1944, pp. 51–56. About this writer see Sutton, "Robert Langton Douglas, Connoisseur of Art and Life," in *Apollo*, vol. CIX, 1979, no. 206, pp. 248–315; no. 207, pp. 334–93; no. 208, pp. 412–75; and vol. CX, no. 209,

pp. 2–56, esp. p. 46 for the *Madonna of the Pomegranate*. Working for Duveen, Douglas is said to have "made himself useful by proving that second-rate paintings were by first-rate artists" (Pope-Hennessy in *New York Review of Books*, vol. XXXIV, no. 4, March 12, 1987, p. 19).

74 Douglas, *Leonardo da Vinci: His San Donato of Arezzo and the Tax Collector*, London, n.d. [1933?]; and *Leonardo*, 1944, pp. 61–71. The acquisition is discussed by Sutton in *Apollo*, 1979, no. 209, pp. 3, 30–31.

75 About Valentiner see Margaret Sterne, *The Passionate Eye: The Life of William R. Valentiner*, Detroit, 1980, esp. pp. 69–78 on his debt to Bode, with whom he shared many interests, particularly Rembrandt and Italian Quattrocento sculpture.

76 Valentiner in *Art Bulletin*, 1930, pp. 43–89, and in *Art Quarterly*, 1941, pp. 3–31; reprinted with revisions in his *Italian Renaissance Sculpture*, 1950, pp. 134–77 and 113–33.

77 *Leonardo da Vinci Loan Exhibition*, Exhibition Catalogue, Los Angeles County Museum, 1949, cat. no. 15, p. 78. See also Valentiner, *Italian Renaissance Sculpture*, 1950, pp. 146–49.

78 Clark's *Leonardo* (1939), which had its origin in a lecture series at Yale University in 1936, has appeared in many editions, of which the following contain revisions: Cambridge, 1952; Harmondsworth, 1959; Harmondsworth, 1967; and Harmondsworth and New York, 1988. The edition of 1988 has an introduction, updated bibliography, and notes by Martin Kemp.

79 Clark noted that when he began his Leonardo studies in the late 1920s there was still "much uncertainty" about the artist's early works (*Another Part of the Wood: A Self-Portrait*, London, 1974, pp. 174–75).

80 Clark, *Leonardo*, 1939, pp. 5–7, 10; rev. eds. 1952, pp. 5–8, 1959 and 1967, pp. 21–23, and 1988, pp. 43–46.

81 Joannides has aptly noted the tendency of writers to "isolate Leonardo from his time and training, from his artistic contemporaries and predecessors" in *Nine Lectures*, n.d. [1990?], p. 23.

Bibliography

Sole-author catalogues and individual essays in multi-author volumes are cited under the name of the author; otherwise, catalogues are entered alphabetically by title.

Achenbach, Gertrude M., "The Iconography of Tobias and the Angel in Florentine Painting of the Renaissance," in *Marsyas*, vol. III, 1943–45, pp. 71–86

Acidini Luchinat, Cristina, *Benozzo Gozzoli: La Cappella dei Magi*, Milan, 1993

Ackerman, James S., "The Involvement of Artists in Renaissance Science," in *Science and the Arts in the Renaissance*, ed. John W. Shirley and F. David Hoeniger, Washington, London, and Toronto, 1985, pp. 94–129

Ackerman, James S., "Early Renaissance 'Naturalism' and Scientific Illustration," in *Figura*, vol. XXII, 1985, pp. 1–17; reprinted in his *Distance Points: Essays in Theory and Renaissance Art and Architecture*, Cambridge, Mass. and London, 1991, pp. 185–207

Ackerman, James S., "Alberti's Light," in his *Distance Points: Essays in Theory and Renaissance Art and Architecture*, Cambridge, Mass., 1991, pp. 59–96

Ackerman, James S., "Leonardo's Eye," in his *Distance Points: Essays in Theory and Renaissance Art and Architecture*, Cambridge, Mass. and London, 1991, pp. 97–150

Ackerman, James S., "On Early Renaissance Color Theory and Practice," in his *Distance Points: Essays in Theory and Renaissance Art and Architecture*, Cambridge, Mass., 1991, pp. 151–82

Adhémar, Jean, "Une galerie de portraits italiens à Amboise en 1500," in *Gazette des Beaux-Arts*, 6th ser., vol. LXXXVI, no. 1281, 1975, pp. 99–104

Adorno, Piero, *Il Verrochio: Nuove proposte nella civiltà artistica del tempo di Lorenzo il Magnifico*, Florence, 1991

Agosti, Giacomo, "Una famiglia di studiosi leonardeschi nei ricordi di Adolfo Venturi: I Liphart, padre e figlio," in *I Leonardeschi a Milano: Fortuna e collezionismo*, ed. Maria Teresa Fiorio and Pietro C. Marani, Milan, 1991, pp. 255–66

Aiken, Jane Andrews, "Andrea del Verrocchio as a Teacher: Did Leonardo da Vinci Pass the Course?," in *Italian Echoes in the Rocky Mountains*, ed. Sante Matteo, Cinzia Donatelli Noble, and Madison V. Sowell, Provo, Utah. 1990, pp. 67–80

Ainsworth, Maryan W., *Petrus Christus: Renaissance Master of Bruges*, Exhibition Catalogue, Metropolitan Museum of Art, New York, 1994

Alberti, L. B., *On Painting*, trans. John R. Spencer, 2nd rev. ed., New Haven and London, 1966

Alberti, L. B., *On Painting and On Sculpture: The Latin Texts of De pictura and De statua*, ed. Cecil Grayson, London, 1972

Alberti, L. B., *Opere volgari*, ed. Cecil Grayson, 3 vols., Bari, 1960–73, vol. III, 1973

Alberti, L. B., *On Painting*, trans. Cecil Grayson, with an introduction and notes by Martin Kemp, Harmondsworth, 1991

Albertini, Francesco, *Memoriale di molte statue et picture sono nella inclyta Cipta di Florentia*, Florence, 1510, ed. Gaetano Milanesi, Florence, 1863

Alessandrini, A., "Benci, Ginevra," in *Dizionario biografico degli italiani*, Rome, 1960–98, vol. VIII, 1966, pp. 193–94

Alinari, *Seconda appendice al catalogo generale delle riproduzioni fotografiche*, Part II, Florence, 1881

Alpers, Svetlana, "*Ekphrasis* and Aesthetic Attitudes in Vasari's *Lives*," in *Journal of the Warburg and Courtauld Institutes*, vol. XXIII, nos. 1–2, 1960, pp. 190–215

Ames-Lewis, Francis, "A Portrait of Leon Battista Alberti by Uccello?," in *Burlington Magazine*, vol. CXVI, no. 851, 1974, pp. 103–04

Ames-Lewis, Francis, "Early Medicean Devices," in *Journal of the Warburg and Courtauld Institutes*, vol. XLII, 1979, pp. 122–43

Ames-Lewis, Francis, "Fra Filippo Lippi and Flanders," in *Zeitschrift für Kunstgeschichte*, vol. XLII, no. 3, 1979, pp. 255–73

Ames-Lewis, Francis, *Drawing in Early Renaissance Italy*, New Haven and London, 1981

Ames-Lewis, Francis, *The Library and Manuscripts of Piero di Cosimo de' Medici*, Garland Series of Outstanding Dissertations, New York and London, 1984

Ames-Lewis, Francis, "Matteo de' Pasti and the Use of Powdered Gold," in *Mitteilungen des kunsthistorischen Institutes in Florenz*, vol. XXVIII, no. 3, 1984, pp. 351–61

Ames-Lewis, Francis, "On Domenico Ghirlandaio's Responsiveness to North European Art," in *Gazette des Beaux-Arts*, 6th ser., vol. CXIV, no. 1449, October 1989, pp. 111–22

Ames-Lewis, Francis, "Leonardo's Techniques," in *Nine Lectures on Leonardo da Vinci*, ed. Ames-Lewis, London, n.d. [1990?], pp. 32–44

Ames-Lewis, Francis, "Lorenzo de' Medici Quincentenary," in *Apollo*, vol. CXXXVI, no. 366, 1992, pp. 113–16

Ames-Lewis, Francis, "Art in the Service of the Family: The Taste and Patronage of Piero di Cosimo de' Medici," in *Piero de' Medici "il Gottoso" (1416–1469)*, ed. Andreas Beyer and Bruce Boucher, Berlin, 1993, pp. 207–20

Ames-Lewis, Francis and Joanne Wright, *Drawing in the Italian Renaissance Workshop*, Exhibition Catalogue, University Art Gallery, Nottingham, and Victoria and Albert Museum, London, 1983

Amoretti, Carlo, *Memorie storiche sulla vita, gli studi e le opere di Leonardo da Vinci*, Milan, 1804

Anderson, Jaynie, "The Morelli Conference in Bergamo," in *Burlington Magazine*, vol. CXXXIX, no. 1014, 1987, pp. 596–98

Angelini, Alessandro, "Domenico Ghirlandaio 1470–1480," in *Domenico Ghirlandaio: Restauro e storia di un dipinto*, Exhibition

Catalogue, Arciconfraternità di Misericordia, Figline Valdarno, Fiesole, 1983, pp. 8–23

Angelini, Alessandro, *Disegni italiani del tempo di Donatello*, Exhibition Catalogue, Gabinetto Disegni e Stampe degli Uffizi, Florence, 1986

Anonimo Gaddiano, *Il Codice Maliabechiano*, ed. Carl Frey, Berlin, 1892

Arte nell'Aretino: Recuperi e restauri dal 1968 al 1974, Exhibition Catalogue, Arezzo, 1974–5, Florence, 1974

Avery, Charles, *Florentine Renaissance Sculpture*, London, 1970

Bacci, Mina, "Ghiberti e gli umanisti: I commentarii," in *Lorenzo Ghiberti*, Exhibition Catalogue, Accademia di Belle Arti and Museo di San Marco, Florence, 1978, pp. 518–20 and 550–52

Baer, Curtis O., *Landscape Drawings*, New York, n.d. [1973]

Baldacci, Antonio, "L'adolescenza di Leonardo da Vinci e il mondo verde," in *Raccolta vinciana*, vol. XIII, 1926–29, pp. 114–29

Baldacci, Antonio, "Le piante nelle pitture di Leonardo," in *Memorie della R. Accademia delle scienze dell'Istituto di Bologna*, 8th ser. vol. VII, 1930, pp. 21–33

Baldass, Ludwig, "Zu den Gemälden der ersten Periode des Leonardo da Vinci," in *Zeitschrift für Kunstwissenschaft*, vol. VII, nos. 3–4, 1953, pp. 165–82

Baldini, Umberto, *Un Leonardo inedito*, Florence, 1992

Baldinucci, Filippo, *Notizie de' professori del disegno da Cimabue in qua*, 6 vols., Florence, 1681–1728

Baldinucci, Filippo, *Notizie de' professori del disegno da Cimabue in qua*, ed. Giuseppe Piacenza, 6 vols., Turin, 1768–1820

Balogh, Jolán, *A Müvészet Mátyás Király Udvarában*, 2 vols., Budapest, 1966

Barcilon, Pinin Brambilla and Pietro C. Marani, *Le lunette di Leonardo nel Refettorio delle Grazie*, Quaderni del Restauro no. 7, ed. Renzo Zorzi, Milan, 1990

Barfucci, Enrico, *Lorenzo de' Medici e la società artistica del suo tempo*, Florence, 1945

Barolsky, Paul, "La Gallerani's *Galée*," in *Source: Notes in the History of Art*, vol. XII, no. 1, 1992, pp. 13–14

Baschera, Renzo, "E di Leonardo la 'Madonna con Bambino' di Sheffield," in *Arte cristiana*, vol. L, nos. 1–2, 1962, pp. 14–15

Bauman, Guy, "Early Flemish Portraits 1425–1525," in *Metropolitan Museum of Art Bulletin*, vol. XLIII, no. 4, 1986, pp. 1–64

Baumstark, Reinhold, "Collecting Paintings," in *Liechtenstein: The Princely Collections*, Exhibition Catalogue, Metropolitan Museum of Art, New York, 1985, pp. 183–85

Baxandall, Michael, *Painting and Experience in Fifteenth-Century Italy*, Oxford, 1972

Baxandall, Michael, "Alberti and Cristoforo Landino: The Practical Criticism of Painting," in *Convegno internazionale indetto nel V centenario di Leon Battista Alberti* (1972), Accademia Nazionale dei Lincei, Rome, 1974, vol. CCCLXXI, no. 209, pp. 143–54

Baxandall, Michael, *Giotto and the Orators: Humanist Observers of Painting in Italy and the Discovery of Pictorial Composition 1350–1450*, Oxford, 1986 (orig. ed. 1971)

Bayersdorfer, Adolph, *Adolph Bayersdorfers Leben und Schriften*, ed. Hans Mackowsky, August Pauly, and Wilhelm Weigand, 2nd ed., Munich 1908

Beck, James, "Leonardo's Rapport with his Father," in *Antichità viva*, vol. XXVII, nos. 5–6, 1988, pp. 5–12

Beer, Rüdiger Robert, *Unicorn: Myth and Reality*, trans. Charles M. Stern, New York, 1977

Béguin, Sylvie, *Leonard de Vinci au Louvre*, Paris, 1983

Behling, Lottlisa, *Die Pflanze in der mittelalterliche Tafelmalerei*, Weimar, 1957

Beltrame Quattrocchi, Enrichetta, *Disegni toscani e umbri del Primo Rinascimento dalle collezione del Gabinetto Nazionale delle Stampe*, Rome, 1979

Beltrami, Luca, *Documenti e memorie riguardanti la vita e le opere di Leonardo da Vinci*, Milan, 1919

Beltrami, Luca, *Leonardo e i disfattisti suoi*, Milan, 1919

Berence, Fred, "Une terre cuite du jeune Léonard de Vinci?," in *Bulletin de l'Association Léonard de Vinci*, no. 3, Oct. 1962, pp. 13–17

Berenson, Bernard, *The Florentine Painters of the Renaissance*, New York and London, 1896

Berenson, Bernard, *The Drawings of the Florentine Painters*, 2 vols., London, 1903; and 2nd rev. ed., 3 vols., Chicago, 1938

Berenson, Bernard, "Leonardo," in *The Study and Criticism of Italian Art*, 3rd ser. London, 1916, pp. 1–37

Berenson, Bernard, *Italian Pictures of the Renaissance*, Oxford, 1932

Berenson, Bernard, "Verrocchio e Leonardo, Leonardo e Credi," in *Bollettino d'arte*, vol.

XXVII, 1993, no. 5, pp. 193–214; no. 6, 1933, pp. 241–64

Berenson, Bernard, *Pitture italiane del Rinascimento*, Milan, 1936

Berenson, Bernard, *Aesthetics and History in the Visual Arts*, New York, 1948

Berenson, Bernard, *I disegni dei pittori fiorentini*, trans. Luisa Vertova Nicolson, 3 vols., Milan, 1961

Berenson, Bernard, *Italian Pictures of the Renaissance: Florentine School*, 2 vols., London, 1963

Bernacchioni, Annamaria, "Le botteghe di pittura: Luoghi, strutture e attività," in *Maestri e botteghe: Pittura a Firenze alla fine del Quattrocento*, Exhibition Catalogue, Palazzo Strozzi, Florence, 1992–93, ed. Mina Gregori, Antonio Paolucci, and Cristina Acidini Luchinat, Milan, 1992, pp. 23–33

Berti, Luciano, "Il Battesimo di Cristo," in *Leonardo: La pittura*, Florence, 1977, pp. 15–24; rev. ed. Pietro Marani, Florence, 1985, pp. 16–22

Berti, Luciano, "Schizzi a tergo del Battesimo di Cristo di Verrocchio e Leonardo," in *Critica d'arte*, vol. LIII, no. 17, 1988, pp. 52–56

Bertini, Aldo, "L'arte del Verrocchio," in *L'arte*, vol. XXXVIII, no. 6, 1935, pp. 433–72

Bertini, Aldo "Verrocchio," in *Encyclopedia of World Art*, 17 vols., 1959–1987, New York, Toronto, and London, vol. XIV, 1967, col. 763 (757–66)

Bialostocki, Jan, "The Renaissance Concept of Nature and Antiquity," in *Studies in Western Art*, Acts of the Twentieth International Congress of the History of Art, Princeton, 1963, pp. 19–30; reprinted in his *The Message of Images: Studies in the History of Art*, Vienna, 1988, pp. 64–76

Birbari, Elizabeth, *Dress in Italian Painting 1460–1500*, London, 1975

Bittner, Jörg, "Verrocchio und die 'Ruskin-Madonna,'" in *Giessener Beiträge zur Kunstgeschichte*, vol. VIII, 1990, pp. 77–97

Blass-Simmen, Brigit, *Sankt Georg: Drachenkampf in der Renaissance. Carpaccio–Raffael–Leonardo*, Berlin, 1991

Blunt, Anthony, "Thomas Gambier-Parry: A Great Art Collector," in *Apollo*, vol. LXXI, no. 38, 1965, pp. 288–95

Blunt, Wilfrid, *The Art of Botanical Illustration*, London, 1950

Blunt, Wilfrid and Sandra Raphael, *The Illustrated Herbal*, New York, 1979

Bober, Phyllis Pray, "An Antique Sea-Thiasos in the Renaissance," in *Essays in Memory of*

Karl Lehmann, ed. Lucy Freeman Sandler, New York, 1964, pp. 43–48

Bober, Phyllis Pray and Ruth Rubenstein, *Renaissance Artists & Antique Sculpture: A Handbook of Sources*, Oxford, 1986

Bode, Wilhelmvon, "Die italienischen Skulpturen der Renaissance in den königlichen Museen, II: Bildwerke des Andrea del Verrocchio," in *Jahrbuch der königlich preussischen Kunstsammlungen*, vol. III, 1882, pp. 235–67

Bode, Wilhelmvon, review of Giovanni Morelli, *Le opere dei maestri italiani nelle gallerie di Monaco, Dresda e Berlino* in *Deutsche Literaturzeitung*, vol. VII, no. 42, 1886, cols. 1497–1501; reprinted in Bode's *Mein Leben*, Berlin, 1930, vol. II, pp. 57–64

Bode, Wilhelmvon, *Italienische Bildhauer der Renaissance*, Berlin, 1887

Bode, Wilhelmvon, obituary of Karl Eduard von Liphart in *Repertorium für Kunstwissenschaft*, vol. XIV, 1891, pp. 448–50

Bode, Wilhelmvon, "Die Bilder italienischer Meister in der Galerie des Fürsten Liechtenstein in Wien," in *Graphischen Künste*, vol. XV, 1892, pp. 85–102

Bode, Wilhelmvon, *Die Fürstlich Liechtensteinische Gallerie in Wien*, Vienna, 1896

Bode, Wilhelmvon, "Verrocchio und des Altarbild der Sakramentskapelle im Dom zu Pistoja," in *Repertorium für Kunstwissenschaft*, vol. XXII, 1899, pp. 390–94

Bode, Wilhelmvon, "Leonardos Bildnis der Ginevra dei Benci," in *Zeitschrift für bildende Kunst*, vol. XIV, no. 11, 1903, pp. 274–76

Bode, Wilhelmvon, "Leonardo als Bildhauer," in *Jahrbuch der königlich preuszischen Kunstsammlungen*, vol. XXV, 1904, pp. 125–41

Bode, Wilhelmvon, "Leonardos Bildnis der jungen Dame mit dem Hermelin aus dem Czartoryski-Museum in Krakau und die Jugendbilder des Künstlers," in *Jahrbuch der königlich preussischen Kunstsammlungen*, vol. XXXVI, 1915, pp. 189–207

Bode, Wilhelmvon, *Studien über Leonardo da Vinci*, Berlin, 1921

Bode, Wilhelmvon, *Botticelli: Des Meisters Werke*, Klassiker der Kunst, Stuttgart, 1926

Bode, Wilhelmvon, *Mein Leben*, 2 vols., Berlin, 1930

Bodmer, Heinrich, *Leonardo: Des Meisters Gemälde und Zeichnungen*, Klassiker der Kunst, Stuttgart, 1931

Boehm, Gottfried, *Bildnis und Individuum: Über den Ursprung der Porträtmalerei in der italienischen Renaissance*, Munich, 1985

Bonito Fanelli, Rosita, *Five Centuries of Italian Textiles 1300–1800: A Selection from the Museo del Tessuto, Prato*, Traveling Exhibition Catalogue, Prato, 1981

Bora, Giulio, *I disegni del Codice Resta*, Bologna, 1976

Borenius, Tancred, "A Picture from the School of Verrocchio," in *Burlington Magazine*, vol. XXX, no. 119, 1917, p. 129

Borenius, Tancred, "Andrea del Verrocchio," in *Apollo*, vol. v, no. 29, 1927, p. 189

Borghero, Gertrude, *Thyssen-Bornemisza Collection*, Milan, 1986

Borghini, Raffaello, *Il riposo*, Florence, 1584

Borghini, Raffaello, *Il riposo*, ed. Giovanni Bottari, Florence, 1730

Borgo, Ludovico, *The Works of Mariotto Albertinelli*, New York and London, 1976

Borsook, Eve, review of Neri di Bicci, *Le ricordanze*, ed. Bruno Santi, in *Art Bulletin*, vol. LXI, no. 2, 1979, pp. 313–18

Boskovits, Miklós, *Tuscan Paintings of the Early Renaissance*, trans. Eva Rácz, Budapest, 1968

Bottari, Stefano, "Verrocchio, Leonardo e Donatello," in *La cultura*, vol. XIV, no. 4, 1935, pp. 67–70

Bottari, Stefano, "Sulla formazione artistica di Leonardo," in *Emporium*, vol. LXXXIX, 1939, pp. 247–62

Bowron, Edgar Peters, "Oil and Tempera Mediums in Early Italian Paintings: A View from the Laboratory," in *Apollo*, vol. C, no. 153, 1974, pp. 380–87

Bowron, Edgar Peters, *European Paintings before 1900 in the Fogg Art Museum*, Cambridge, MA, 1990

Braccesi, Alessandro, *Carmina*, ed. Alexander Perosa, Florence, 1943

Bracciante, Anna Maria, *Ottaviano de' Medici e gli artisti*, Florence, 1984

Brachert, Thomas, "Ein unvollendetes Madonnengemälde von Leonardo da Vinci?" in *Schweizerisches Institut für Kunstwissenschaft: Jahresbericht und Jahrbuch*, 1967, pp. 1–110

Brachert, Thomas, "A Distinctive Aspect in the Painting Technique of the 'Ginevra de' Benci' and of Leonardo's Early Works," in *Report and Studies in the History of Art*, National Gallery of Art, Washington, 1969, pp. 85–104

Brachert, Thomas, "Hypothesen zu einem verschollen Gemälde der Verrocchio-Werkstatt," in *Maltechnik*, no. 4, 1974, pp. 187–91

Brandt, Kathleen Weil-Garris, "'The Nurse of Settignano': Michelangelo's Beginnings as a Sculptor," in *The Genius of the Sculptor in Michelangelo's Work*, Exhibition Catalogue, Montreal Museum of Fine Arts, June 12–Sept. 13, 1992, Montreal, 1992, pp. 21–43

Brigstocke, Hugh, "Verrocchio's *Ruskin Madonna*," in *A Dealer's Record: Agnew's 1967–81*, London, 1981, pp. 24–29

Brigstocke, Hugh, *Italian and Spanish Paintings in the National Gallery of Scotland*, 2nd rev. ed., Edinburgh, 1993

Brilliant, Richard, *Portraiture*, Cambridge, MA, 1991

Brizio, Anna Maria, "Per il quinto centenario verrocchiesco," in *Emporium*, vol. LXXXII, no. 24, 1935, pp. 293–303

Brown, David Alan, "The Profile of a Youth and Leonardo's *Annunciation*," in *Mitteilungen des kunsthistorischen Institutes in Florenz*, vol. XV, no. 3, 1971, pp. 265–72

Brown, David Alan and Charles Seymour, Jr., "Further Observations on a Project for a Standard by Verrocchio and Leonardo," in *Master Drawings*, vol. XII, no. 2, 1974, pp. 127–33

Brown, David Alan, *Berenson and the Connoisseurship of Italian Painting* (Exhibition Catalogue, National Gallery of Art), Washington, 1979

Brown, David Alan, in *Small Paintings of the Masters*, ed. Leslie Shore, New York, 1980, cat. no. 84

Brown, David Alan, in *Italian Paintings: XIV–XVIIIth Centuries from the Collection of the Baltimore Museum of Art*, ed. Gertrude Rosenthal, Baltimore, 1981, cat. no. 4, pp. 42–53

Brown, David Alan, "Raphael, Leonardo, and Perugino: Fame and Fortune in Florence," in *Leonardo, Michelangelo, and Raphael in Renaissance Florence from 1500 to 1508*, ed. Serafina Hager, Washington, 1992, pp. 29–53

Brown, David Alan, "Verrocchio and Leonardo: Studies for the *Giostra*," in *Florentine Drawing at the Time of Lorenzo the Magnificent*, ed. Elizabeth Cropper, Bologna, 1994, pp. 99–109

Brucker, Gene, *Renaissance Florence*, New York, 1969

Brugnoli, Maria Vittoria, "Documenti, notizie e ipotesi sulla scultura di Leonardo," in *Leonardo: Saggi e ricerche*, ed. Achille Marazza, Rome, 1954, pp. 359–89

Brugnoli, Maria Vittoria, review of Günter Passavant, *Andrea Verrocchio als Maler*, in *Raccolta vinciana*, vol. XIX, 1962, pp. 344–46

Budny, Virginia, "The Pose of the Child in the Composition Sketches by Leonardo da Vinci for *The Madonna and Child with a Cat* and in Other Works Related to this Group," in *Bulletin of the Weatherspoon Gallery Association*, 1979–80, pp. 4–11

Bull, David, "Two Portraits by Leonardo: *Ginevra de' Benci* and the *Lady with an Ermine*," in *Artibus et historiae*, no. 25, 1992, pp. 67–83

Bullard, Melissa Meriam, "Marsilio Ficino and the Medici: The Inner Dimensions of Patronage," in *Christianity and the Renaissance: Image and Religious Imagination in the Quattrocento*, ed. Timothy Verdon and John Henderson, Syracuse, N.Y., 1990, pp. 467–92

Burckhardt, Jakob, *Der Cicerone* (orig. ed. Basel, 1855), 2nd rev. ed., ed. A. von Zahn, 3 vols., Leipzig, 1869

Burke, Peter, *Tradition and Innovation in Renaissance Italy*, London, 1974

Burke, Peter, review of Gottfried Boehm, *Bildnis und Individuum*, in *Kunstchronik*, vol. XLI, no. 1, 1988, pp. 24–26

Busignani, Alberto, *Verrocchio*, Florence, 1966

Busignani, Alberto, *Pollaiolo*, Florence, 1970

Butterfield, Andrew, "The Christ and St. Thomas of Andrea del Verrocchio," in *Verocchio's Christ and St. Thomas: A Masterpiece of Sculpture from Renaissance Florence*, ed. Loretta Dolcini, Exhibition Catalogue, Palazzo Vecchio, Florence, and Metropolitan Museum of Art, New York, 1992–93, New York, 1992, pp. 52–79

Butterfield, Andrew, "Verrocchio's Christ and St. Thomas: Chronology, Iconography, and Political Context," in *Burlington Magazine*, vol. CXXXIV, no. 1069, 1992, pp. 225–33

Butterfield, Andrew, "Verrocchio's *David*," in *Verrocchio and Late Quattrocento Italian Sculpture*, ed. Steven Bule, Alan Phipps Darr, and Fiorella Superbi Gioffredi, Florence, 1992, pp. 107–16

Cadogan, Jean K., "Linen Drapery Studies by Verrocchio, Leonardo, and Ghirlandaio," in *Zeitschrift für Kunstgeschichte*, vol. XLVI, no. 1, 1983, pp. 27–62

Cadogan, Jean K., "Reconsidering Some Aspects of Ghirlandaio's Drawings," in *Art Bulletin*, vol. LXV, no. 2, 1983, pp. 274–90

Cadogan, Jean K., "Verrocchio's Drawings Reconsidered," in *Zeitschrift für Kunstgeschichte*, vol. XLVI, no. 4, 1983, pp. 367–400

Cadogan, Jean K., *Wadsworth Atheneum, II: Italy and Spain. Fourteenth through Nineteenth Centuries*, Hartford, Conn., 1991

Calarco, Anthony, "A Note on the Significance of Moses and Aaron in the Sculptural Program of the Cappella Niccolini," in *Acta toscana* (Bulletin of the Tuscan-American Archaeological Association), 1974, pp. 33–44

Callmann, Ellen, *Apollonio di Giovanni*, Oxford, 1974

Calvi, Girolamo, *I manoscritti di Leonardo da Vinci*, Bologna, 1925

Calvi, Girolamo, "Vecchie e nuove riserve sull 'Annunziazione' di Monte Oliveto," in *Raccolta Vinciana*, vol. XIV, 1930–34, pp. 201–39

Camesasca, Ettore, *Tutta la pittura del Perugino*, Milan, 1959

Camesasca, Ettore, *Artisti in bottega*, Milan, 1966

Camesasca, Ettore, *L'opera completa del Perugino*, Milan, 1969

Campbell, Lorne, "Memlinc and the Followers of Verrocchio," in *Burlington Magazine*, vol. CXXV, no. 968, 1983, pp. 675–76

Campbell, Lorne, *Renaissance Portraits: European Portrait-Painting in the 14th, 15th, and 16th Centuries*, New Haven and London, 1990

Canaday, John, "Art: Debut of Leonardo's Ginevra," in *The New York Times*, March 17, 1967

Caneva, Caterina, *Botticelli: Catalogo completo dei dipinti*, Florence, 1990

Cannon-Brookes, Peter, "Verrocchio Problems," in *Apollo*, vol. XCIX, no. 143, 1974, pp. 8–19

Cantaro, Maria Teresa, *Lavinia Fontana bolognese*, Milan, 1989

Canuti, Fiorenzo, *Il Perugino*, 2 vols., Siena, 1931

Cardile, Paul J., "Observations on the Iconography of Leonardo da Vinci's Uffizi *Annunciation*," in *Studies in Iconography*, vols. VII–VIII, 1981–82, pp. 189–208

Cardini, Franco, "Le insegne laurenziane," in *Le tems revient. 'L Tempo si rinuova: Feste e spettacoli nella Firenze di Lorenzo il Magnifico*, ed. Paola Ventrone, Exhibition Catalogue, Palazzo Medici Riccardi, Florence, Milan, 1992, pp. 55–74

Carl, Doris, "Zur Goldschmiedefamilie Dei mit neuen Dokumenten zu Antonio Pollaiuolo und Andrea Verrocchio," in *Mitteilungen des Kunsthistorischen Institutes in Florenz*, vol. XXVI, no. 2, 1982, pp. 129–66

Carnesecchi, Carlo, "Il ritratto leonardesco di Ginevra Benci," in *Rivista d'arte*, vol. VI, nos. 5–6, 1909, pp. 281–96

Caroli, Flavio, *Leonardo: Studi di fisiognomia*, Milan, 1990

Castelfranchi, Liana, "L'Angelico e il 'De pictura' dell'Alberti," in *Paragone*, vol. XXXVI, 1985, pp. 97–106

Castelfranchi Vegas, Liana, *Italia e Fiandra nella pittura del Quattrocento*, Milan, 1983

Castelfranco, Giorgio, *Mostra didattica leonardesca*, Rome, 1952

Castelfranco, Giorgio, *La pittura di Leonardo da Vinci*, Milan, 1956

Castelfranco, Giorgio, "Momenti della recente critica vinciana," in his *Studi vinciani*, Rome, 1966, pp. 54–124

Castelli, Patrizia, "Ghiberti e gli umanisti: Il significato dei 'Commentari'," in *Lorenzo Ghiberti* (Exhibition Catalogue, Accademia di Belle Arti and Museo di San Marco), Florence, 1978, pp. 518–20 and 550–52

Catalogo delle fotografie [Giacomo Brogi], Part I, Florence, 1903

Catalogue de la R. Galerie de Florence, Part II, Florence, 1869

Catalogue des photographies publiées par la maison Giacomo Brogi, Part I, Florence, 1878

Ceci, Marco Carpi, "Verifica delle prospettive contenute nei due quadri dell'Annunciazione di Leonardo da Vinci," in *Notiziario vinciano*, no. 1, 1977, pp. 15–21

Cetto, A. M., *Animal Drawings from the 12th to the 19th Century*, London, n.d. [1936]

Chastel, André, "Les capitaines antiques affrontés dans l'art florentin du XVe siècle," in *Memoires de la Société Nationale des Antiquaires de France*, vol. LXXXIII, 1954, pp. 279–89; reprinted in his *Fables, Formes Figures I*, Paris, 1978, pp. 236–47

Chastel, André, *Marsile Ficin et l'art*, Geneva, 1954 (reprinted 1975)

Chastel, André, *Art et humanisme à Florence au temps de Laurent le Magnifique*, Paris, 1959

Chastel, André, Carlo Pedretti, and Françoise Viatte, *Léonard de Vinci: Les études de draperie* (Exhibition Catalogue, Musée du Louvre, 1989–90), Paris, 1989

Chiappelli, Alessandro, "Il Verrocchio e Lorenzo di Credi a Pistoia," in *Bollettino d'arte*, vol. V, no. 2, 1925, pp. 49–68

Chiappelli, Alessandro, and Alfredo Chiti, "Andrea del Verrocchio in Pistoia," in

Bollettino Storico Pistoiese, vol. I, no. 2, 1899, pp. 41–49

Chiarini, Marco, *Andrea del Verrocchio*, Maestri della Scultura series, Milan, 1966

Christiansen, Keith, "Leonardo's Drapery Studies," in *Burlington Magazine*, vol. CXXXII, no. 1049, 1990, pp. 572–73

Christie's, *Important Old Master Pictures*, London, December 11, 1984

Christie's, *Fine Old Master Drawings*, London, April 8, 1986

Cianchi, Renzo, *Vinci: Leonardo e la sua famiglia*, Milan, 1952

Cianchi, Renzo, *Ricerche e documenti sulla madre di Leonardo*, Florence, 1975

Ciasca, Raffaele, *L'arte dei medici e speziali nella storia e nel commercio fiorentino, dal secolo XII al XV*, Florence, 1927; reprinted 1977

Circa 1492: Art in the Age of Exploration, ed. Jay A. Levenson, Exhibition Catalogue, National Gallery of Art, Washington, 1992

Clark, Kenneth, "Italian Drawings at Burlington House," in *Burlington Magazine*, vol. LVI, no. 325, 1930, pp. 175–87

Clark, Kenneth, *The Drawings of Leonardo da Vinci in the Collection of her Majesty the Queen at Windsor Castle*, 1935, 2nd rev. ed. with the assistance of Carlo Pedretti, 3 vols., London, 1968

Clark, Kenneth, *Leonardo da Vinci: An Account of his Development as an Artist*, Cambridge, 1939, rev. eds. 1952, 1959, 1967, and 1988

Clark, Kenneth, *Another Part of the Wood: A Self-Portrait*, London, 1974

Clark, Kenneth, *Animals and Men*, London, 1977

Clayton, Martin, *Leonardo da Vinci: A Singular Vision*, New York 1976

Clément, Charles, *Michel-ange, Léonard, Raphael*, Paris, 1861

Clough, Cecil H., "The Library of Bernardo and of Pietro Bembo," in *Book Collector*, vol. XXXIII, no. 3, 1984, pp. 305–31

Cocke, Richard, "Piero della Francesca and the Development of Italian Landscape Painting," in *Burlington Magazine*, vol. CXXII, no. 930, 1980, pp. 627–31

Cole, Alison, *The Renaissance*, London, 1994

Cole, Bruce, *The Renaissance Artist at Work from Pisano to Titian*, New York, 1983

Colenbrander, Herman T., "Hands in Leonardo Portraiture," in *Achademia Leonardi Vinci*, vol. V, 1992, pp. 37–43

Colvin, Sidney, *A Florentine Picture-Chronicle*, London, 1898

Colvin, Sidney, *Drawings of the Old Masters in the University Galleries and in the Library of Christ Church, Oxford*, 3 vols., Oxford, 1907

Cook, Herbert, "Leonardo da Vinci and Some Copies," in *Burlington Magazine*, vol. XX, no. 105, 1911, pp. 129–33; reprinted in his *Reviews and Appreciations of Some Old Italian Masters*, London, 1912, pp. 22–29

Cook, Herbert, "The Portrait of Ginevra dei Benci by Leonardo da Vinci," in *Burlington Magazine*, vol. XX, no. 108, 1912, pp. 345–46; reprinted in his *Reviews and Appreciations of Some Old Italian Masters*, London, 1912, pp. 40–43

Cook, Theodore, *Leonardo da Vinci Sculptor*, London, 1923

Cordellier, Dominique, *Pisanello: La princesse au brin de genévrier*, Musée du Louvre, Paris, 1996

Corrain, Lucia, "Il punto di vista nell' 'Annunciazione' di Leonardo da Vinci," in *Versus (VS)*, vol. XXXVII 1984, pp. 35–65

Cott, Perry B., *Leonardo's Portrait of Ginevra de' Benci*, National Gallery of Art, Washington, 1967

Covi, Dario A., "Four New Documents concerning Andrea del Verrocchio," in *Art Bulletin*, vol. XLVIII, no. 1, 1966, pp. 97–103

Covi, Dario, "An Unnoticed Verrocchio?," in *Burlington Magazine*, vol. CX, no. 778, 1968, pp. 4–10

Covi, Dario A., review of Günter Passavant, *Verrocchio: Sculptures, Paintings and Drawings. Complete Edition*, in *Art Bulletin*, vol. LIV, no. 1, 1972, pp. 90–94

Covi, Dario, "Nuovi documenti per Antonio e Piero del Pollajuolo e Antonio Rossellino," in *Prospettiva*, no. 12, 1978, pp. 61–72

Covi, Dario, "Verrocchio and the *Palla* of the Duomo," in *Art the Ape of Nature: Studies in Honor of H. W. Janson*, ed. Moshe Barasch and Lucy Freeman Sandler, New York, 1981, pp. 151–69

Covi, Dario A., "Verrocchio and Venice, 1469," in *Art Bulletin*, vol. LXV, no. 2, 1983, pp. 253–73

Covi, Dario A., in *Italian Renaissance Sculpture in the Time of Donatello*, Exhibition Catalogue, Detroit Institute of Arts, Detroit, 1985, cat. no. 70, pp. 206–07

Covi, Dario, "More about Verrocchio Documents and Verrocchio's Name," in *Mitteilungen des kunsthistorischen Institutes in Florenz*, vol. XXXI, no. 1, 1987, pp. 157–61

Covi, Dario, "The Current State of Verrocchio Study," in *Verrocchio and Late Quattrocento Italian Sculpture*, ed. Steven Bule, Alan Phipps Darr, and Fiorella Superbi Gioffredi, Florence, 1992, pp. 7–23

Covi, Dario, "Per una giusta valutazione del Verrocchio," in *Verrocchio and Late Quattrocento Italian Sculpture*, ed. Steven Bule, Alan Phipps Darr, and Fiorella Superbi Gioffredi, Florence, 1992, pp. 91–100

Covi, Dario, "Work in Progress: Workshops and Partnerships – Respondents and Comments – Dario Covi," in *Verrocchio and Late Quattrocento Italian Sculpture*, ed. Steven Bule, Alan Phipps Darr, and Fiorella Superbi Gioffredi, Florence, 1992, p. 369 (367–69)

Cropper, Elizabeth, "The Beauty of Woman: Problems in the Rhetoric of Renaissance Portraiture," in *Rewriting the Renaissance: The Discourses of Sexual Difference in Early Modern Europe*, ed. Margaret W. Ferguson, Maureen Quilligan, and Nancy J. Vickers, Chicago and London, 1985, pp. 175–90

Crowe, J. A., and G. B. Cavalcaselle, *A New History of Painting in Italy*, 3 vols., London, 1864–66, and ed. Edward Hutton, 3 vols., London and New York, 1909

Crowe, J. A., and G. B. Cavalcaselle, *Storia della pittura in Italia*, trans. Alfredo Mazza, 11 vols., Florence, 1875–1908

Crowe, J. A., and Cavalcaselle, G. B., *A New History of Painting in Italy*, 6 vols., I–IV ed. Robert Langton Douglas, VI ed. Tancred Borenius, London, 1903–14

Cruttwell, Maud, *Verrocchio*, London and New York, 1904

Cruttwell, Maud, "Un disegno del Verrocchio per la 'Fede' nella Mercatanzia di Firenze," in *Rassegna d'arte*, vol. VI, no. 1, 1906, pp. 8–10

Cruttwell, Maud, *Antonio Pollaiuolo*, London and New York, 1907

Dacos, Nicole, and Caterina Furlan, *Giovanni da Udine 1487–1561*, 3 vols., Udine, 1987

Dalli Regoli, Gigetta, *Lorenzo di Credi*, Cremona, 1966

Dalli Regoli, Gigetta, "Il 'Piegar de' Panni'," in *Critica d'arte*, vol. XXII, no. 150, 1976, pp. 35–48

Dalli Regoli, Gigetta, "Raffaello e Lorenzo di Credi: Postilla," in *Critica d'arte*, nos. 154–56, 1977, pp. 84–90

Dalli Regoli, Gigetta, "Raffaello 'Angelica Farfalla': Note sulla struttura e sulle fonti

della Pala Ansidei," in *Paragone*, vol. XXXIV, no. 399, 1983, pp. 8–19

Dalli Regoli, Gigetta, "Una *Sepoltura* di Andrea del Verrocchio: Note sui rapporti tra figuralità e astrazione nella scultura toscana del XV secolo," in *La scultura decorativa del Primo Rinascimento* (Atti del I Convegno Internazionale di Studi, Università di Pavia, 1980), Pavia, 1983, pp. 67–74

Dalli Regoli, Gigetta, "La Madonna di Piazza: '. . . Ce n'è d'assai più belle, nessuna più perfetta'," in *Scritti di storia dell'arte in onore di Federico Zeri*, 2 vols., Milan, 1984, vol. I, pp. 213–34

Dalli Regoli, Gigetta, "Animal and Plant Representation in Italian Art of the Fourteenth and Fifteenth Centuries: An Approach to the Problem," in *Die Kunst und das Studium der Natur vom 14. zum 16. Jahrhundert*, ed. Wolfram Prinz and Andreas Beyer, Weinheim, 1987, pp. 83–89

Dall'Orto, Giovanni, "'Socratic Love' as a Disguise for Same-Sex Love in the Italian Renaissance," in *The Pursuit of Sodomy: Male Homosexuality in Renaissance and Enlightenment Europe*, ed. Kent Gerard and Gert Hekma, New York and London, 1989, pp. 32–65

Davidson, Bernice, "Tradition and Innovation: Gentile da Fabriano and Hans Memling," in *Apollo*, vol. XCIII, no. 111, 1971, pp. 378–85

Davies, Martin, *The Earlier Italian Schools*, National Gallery, London, 1951, 2nd rev. ed., 1961

Davies, Martin, *European Paintings in the Collection of the Worcester Art Museum*, 2 vols., Worcester, 1974

Davies, Martin, "Making Sense of Pliny in the Quattrocento," in *Renaissance Studies*, vol. IX, no. 2, 1995, pp. 240–57

Debs, Barbara K., "From Eternity to Here: Uses of the Renaissance Portrait," in *Art in America*, Jan.–Feb. 1975, pp. 48–55

Degenhart, Bernhard, "Di alcuni problemi di sviluppo della pittura nella bottega del Verrocchio, di Leonardo e di Lorenzo di Credi," in *Rivista d'arte*, vol. XIV, no. 3, 1932, pp. 263–300; and no. 4, 1932, pp. 403–44

Degenhart, Bernhard and Annegrit Schmitt, *Corpus der italienischen Zeichnungen 1300–1450*, Berlin, 1968

DeGirolami Cheney, Liana, "Andrea del Verrocchio's Celebration 1488–1988," in *Italian Echoes in the Rocky Mountains*, ed.

Sante Matteo, Cinzia Donatelli Noble, Madison v. Sowell, Provo, Utah, 1990, pp. 1–22

Delacroix, Eugène, *Journal de Eugène Delacroix*, ed. Paul Flat and René Piot, 3 vols., Paris, 1893–95

Degl'Innocenti, Giovanni, "Restituzioni prospettiche: Proposte e verifiche di un metodo," in Carlo Pedretti, *Leonardo architetto*, Milan, 1978, pp. 274–78

Del Bravo, Carlo, *Scultura senese del Quattrocento*, Florence, 1970

Della Pergola, Paola, *Galleria Borghese: I dipinti*, 2 vols., Rome, 1959

Della Torre, Arnaldo, "La prima ambasceria di Bernardo Bembo a Firenze," in *Giornale storico della letteratura italiana*, vol. XXXV, 1900, pp. 258–333

Della Torre, Arnaldo, *Storia dell'Accademia Platonica di Firenze*, 1902

Del Serra, Alfio, "A Conversation on Painting Techniques," in *Burlington Magazine*, vol. CXXVII, no. 982, 1985, pp. 4–16

Dempsey, Charles, *The Portrayal of Love: Botticelli's Primavera and Humanist Culture at the Time of Lorenzo the Magnificent*, Princeton, 1992

De Ricci, Seymour, "Une sculpture inconnue de Verrocchio," in *Gazette des Beaux-Arts*, 6th ser., vol. XI, no. 852, 1934, pp. 244–45

De Rinaldis, Aldo, *Storia dell'opera pittorica di Leonardo da Vinci*, Bologna, 1926

De Roover, Raymond, *The Rise and Decline of the Medici Bank 1397–1494*, New York, 1966

Déscription de L'I. et R. Académie des Beaux Arts de Florence, 3rd ed., Florence, 1836

Déscription des tableaux . . . que renferme la Gallerie . . . de Liechtenstein, Vienna, 1780

Desmond, Ray, *Wonders of Creation: Natural History Drawings in the British Library*, London, 1986

De Toni, Giambattista, *Le piante e gli animali in Leonardo da Vinci*, Bologna, 1922

De Vos, Dirk, *Hans Memling: The Complete Works*, Ghent and Antwerp, 1994

Dillon, Gianvittorio, "Una serie di figure grottesche," in *Florentine Drawing at the Time of Lorenzo the Magnificent*, ed. Elizabeth Cropper, Bologna, 1994, pp. 217–30

Il desegno fiorentino del tempo di Lorenzo il Magnifico, ed. Annamaria Petrioli Tofani, Exhibition Catalogue, Galleria degli usfizi, Florenco, 1992

Douglas, Robert Langton, *Leonardo da Vinci: His San Donato of Arezzo and the Tax Collector*, London, n.d. [1933?]

Douglas, Robert Langton, "Leonardo and his Critics. I," in *Burlington Magazine*, vol. LXXXI, no. 475, 1942, pp. 238–47

Douglas, Robert Langton, *Leonardo da Vinci: His Life and his Pictures*, Chicago, 1944

Dülberg, Angelica, *Privatporträts: Geschichte und Ikonologie einer Gattung im 15. und 16. Jahrhundert*, Berlin, 1990

Dunkerton, Jill, Susan Foister, Dillian Gordon, and Nicholas Penny, *Giotto to Dürer: Early Renaissance Painting in the National Gallery*, New Haven and London, 1991

Dussler, Luitpold, "Verrocchio," in *Allgemeines Lexikon der bildenden Künstler von der Antike bis zur Gegenwart*, ed. Ulrich Thieme and Felix Becker, 37 vols., Leipzig, 1907–50, vol. XXXIV, 1939, pp. 292–98

Duwe, Gert, *Der Wandel in der Darstellung der Verkündigung an Maria vom Trecento zum Quattrocento*, Frankfurt, 1988

Edgerton, Samuel Y., Jr., review of Leon Battista Alberti, *On Painting*, trans. John R. Spencer, 2nd rev. ed., New Haven and London, 1966, in *Art Bulletin*, vol. LI, no. 4, 1969, pp. 397–99

Edgerton, Samuel Y., Jr., "*Mensurare temporalis facit Geometria spiritualis*: Some Fifteenth-Century Italian Notions about When and Where the Annunciation Happened," in *Studies in Late Medieval and Renaissance Painting in Honor of Millard Meiss*, ed. Irving Lavin and John Plummer, 2 vols., New York, 1977, vol. I, pp. 115–30

Eisler, Colin, "A Portrait of L. B. Alberti," in *Burlington Magazine*, vol. CXVI, no. 858, 1974, pp. 529–30

Eisler, Colin, *Dürer's Animals*, Washington and London, 1991

Eisler, János, "Dans l'atelier de Verrocchio," in *Bulletin du Musée Hongrois des Beaux-Arts*, vol. LXXX–LXXXI, 1994, pp. 76–90

Eissler, Kurt R., *Leonardo da Vinci: Psychoanalytic Notes on the Enigma*, London, 1962

Elam, Caroline, "Lorenzo de' Medici's Sculpture Garden," in *Mitteilungen des kunsthistorischen Institutes in Florenz*, vol. XXXVI, nos. 1–2, 1992, pp. 41–84

Emboden, William A., *Leonardo da Vinci on Plants and Gardens*, Portland, OR, 1987

Eredità del Magnifico, ed. Paola Barocchi, Francesco Caglioti, Giovanna Gaeta Bertelà, and Marco Spallanzani, Exhibition

Catalogue, Museo Nazionale del Bargello, Florence, 1992

Ettlinger, Leopold D., *Antonio and Piero Pollaiuolo*, London, 1978

Fabriczy, Cornelius von, "Andrea del Verrocchio ai servizi de' Medici," in *Archivio storico dell'arte*, 2nd. ser, vol. I, no. 3, 1895, pp. 163–76

Fahy, Everett, "The Earliest Works of Fra Bartolommeo," in *Art Bulletin*, vol. LI, no. 2, 1969, pp. 142–54

Fahy, Everett, review of Fern Rusk Shapley, *Catalogue* [Kress Collection], in *Art Bulletin*, vol. LVI, no. 2, 1974, pp. 283–85

Fahy, Everett, *Some Followers of Domenico Ghirlandajo*, Garland Series of Outstanding Dissertations, New York and London, 1976

Fahy, Everett, *The Legacy of Leonardo: Italian Renaissance Paintings from Leningrad*, Exhibition Catalogue, National Gallery of Art, Washington, New York, 1979

Fahy, Everett, "Florence, Palazzo Strozzi: Late Fifteenth-Century Florentine Painting," in *Burlington Magazine*, vol. CXXXV, no. 1079, 1993, pp. 169–71

Fahy, Everett, "Two Suggestions for Verrocchio," in *Studi di storia dell'arte in onore di Mina Gregori*, Milan, 1994, pp. 51–55

Fahy, Everett, "Ritornando alle origini: Reconsiderazione della produzione giovanile di Fra' Bartolomeo," *L'età di Savonarola: Fra' Bartolomeo e la Scuola di San Marco*, ed. Serena Padovani, Exhibition Catalogue, Palazzo Pitti and Museo di San Marco, Florence, 1996, pp. 3–11

Farago, Claire J., *Leonardo da Vinci's Paragone: A Critical Interpretation with a New Edition of the Text in the Codex Urbinas*, Leiden, 1992

Fehl, Philipp, "Verrocchio's Tomb of Piero and Giovanni de' Medici: Ornament and the Language of Meaning," in *Italian Echoes in the Rocky Mountains*, ed. Sante Matteo, Cinzia Donatelli Noble, and Madison V. Sowell, Provo, Utah, 1990, pp. 47–60

Feldges, Uta, *Landschaft als topographisches Porträt: Der Wiederbeginn des europäischen Landschaftsmalerei in Siena*, Bern, 1980

Fermor, Sharon, *Piero di Cosimo: Fiction, Invention and Fantasia*, London, 1993

Ficino, Marsilio, *Commentary on Plato's Symposium on Love*, trans. Sears Jayne, Dallas, Tex., 1985

Filarete, Antonio, *Treatise on Architecture*, trans. and ed. John R. Spencer, 2 vols., New Haven and London, 1965

Fiorilli, Carlo, "I dipintori a Firenze nell'arte dei medici speziali e merciai," in *Archivio storico italiano*, vol. LXXVIII, no. 2, 1920, pp. 5–74

Fletcher, Jennifer, "Bernardo Bembo and Leonardo's Portrait of Ginevra de' Benci," in *Burlington Magazine*, vol. CXXXI, no. 1041, 1989, pp. 811–16

Forlani Tempesti, Anna, and Annemaria Petrioli Tofani, *I grandi disegni italiani degli Uffizi di Firenze*, Milan, n.d. [1973?]

Frank, Eric, "Antonio Pollaiuolo, 'Il principale maestro di questa Città'?" in *Source*, vol. XI, no. I, 1991, pp. 14–17

Freedberg, S. J., *Painting of the High Renaissance in Rome and Florence*, 2 vols., Cambridge, Mass., 1961

Freud, Sigmund, *Leonardo da Vinci and a Memory of his Childhood*, trans. Alan Tyson, Harmondsworth, 1963

Friedländer, Max J., *Early Netherlandish Painting: Hans Memlinc and Gerard David*, trans. Heinz Norden, Leyden and Brussels, 1971

Frimmel, Theodor, "Der Lionardo in der Fürst Liechtensteinischen Galerie," in *Studien und Skizzen zur Gemäldekunde*, vol. II, 1913, pp. 40–41

Frizzoni, Gustavo, "L'archivio storico dell'arte e gli scultori italiani della Rinascenza," in *Archivio storico dell'arte*, vol. I, 1888, pp. 67–69

Frizzoni, Gustavo, "La quinta edizione del Cicerone di Burckhardt," in *Archivio storico dell'arte*, vol. I, 1888, pp. 289–300

Frizzoni, Gustavo, "I nostri grandi maestri in relazione al quinto fascicolo dei disegni di Oxford," in *L'arte*, vol. X, no. 2, 1907, pp. 81–96

Frizzoni, Gustavo, "La pittura italiana del Quattrocento secondo un'opera recente," in *Nuova antologia*, vol. CLIV, 1911, pp. 50–63

Fuchs, Leonhard, *De historia stirpium*, 1542

Fumagalli, E., "Nuovi documenti su Lorenzo e Giuliano de' Medici," in *Italia medioevale e umanistica*, vol. XXIII, 1980, pp. 115–64

Fusco, Laurie, "The Use of Sculptural Models by Painters in Fifteenth-Century Italy," in *Art Bulletin*, vol. LXIV, no. 2, 1982, pp. 175–94

Gabrielli, Noemi, *Galleria Sabauda: Maestri italiani*, Turin, 1971

Galleria dell'I. e Reale Accademia di Belle Arti di Firenze pubblicata con incisioni in rame, Florence, 1845

Galluzzi, Paolo, "The Career of a Technologist," in *Leonardo da Vinci: Engineer and Architect* ed. Paolo Galluzzi, Exhibition Catalogue, Montreal Museum of Fine Arts, Montreal, 1987, pp. 41–109

Gamba, Carlo, "Una terracotta del Verrocchio a Careggi," in *L'arte*, vol. VII, 1904, pp. 59–61

Gamba, Carlo, "La Resurrezione di Andrea Verrocchio al Bargello," in *Bollettino d'arte*, vol. XXV, no. 5, 1931, pp. 193–98

Gamba, Carlo, "La mostra del tesoro di Firenze sacra: La pittura," in *Bollettino d'arte*, vol. XXVIII, no. 4, 1933, pp. 145–63

Gargiolli, G., *L'arte della seta in Firenze: Trattato del secolo XV*, Florence, 1868

Garrard, Mary D., "Leonardo da Vinci: Female Portraits. Female Nature," in *The Expanding Discourse: Feminism and Art History*, ed. Norma Broude and Mary D. Garrard, New York, 1990, pp. 59–86

Garzelli, Annarosa, *Il ricamo nella attività artistica di Pollaiolo, Botticelli, Bartolomeo di Giovanni*, Florence, 1973

Garzelli, Annarosa, *La Bibbia di Federico da Montefeltro: Un'officina libraria fiorentina 1476–1478*, Rome, 1977

Garzelli, Annarosa, "Sulla fortuna del *Gerolamo* mediceo del van Eyck nell'arte fiorentina del Quattrocento," in *Scritti di storia dell'arte in onore di Roberto Salvini*, Florence, 1984, pp. 347–53

Garzelli, Annarosa, *Miniatura fiorentina del Rinascimento 1440–1525: Un primo censimento*, 2 vols., Florence, 1985

Garzelli, Annarosa, "Problemi del Ghirlandaio nella Cappella di Santa Fina: Il ciclo figurativo nella cupola e i probabili disegni," in *Antichità viva*, vol. XXIV, no. 4, 1985, pp. 11–25

Gauricus, Pomponius, De sculptura, Florence, 1504, ed. André Chastel and Robert Klein, Geneva, 1969

Geymüller, H. von, "La Vierge à l'oeillet," in *Gazette des Beaux-Arts*, 3rd ser., vol. XXXII, no. 4, pp. 97–104

Giannetto, Nella, *Bernardo Bembo: Umanista e politico veneziano*, Florence, 1985

Il giardino di San Marco: Maestri e compagni del giovane Michelangelo, ed. Paola Barocchi, Exhibition Catalogue, Casa Buonarroti, Florence, 1992

Gibbs-Smith, C. H., *Leonardo da Vinci's Aeronautics*, London, 1967

Gibson, Eric, "Leonardo's Ginevra de' Benci: The Restoration of a Renaissance Masterpiece," in *Apollo*, vol. CXXXIII, no. 349, 1991, pp. 161–65

Gilbert, Creighton, review of Günter Passavant, *Andrea Verrocchio als Maler* in *Art Journal*, vol. xx, no. 1, 1960, pp. 58–59

Gilbert, Creighton, review of Günter Passavant, *Verrocchio: Sculptures, Paintings and Drawings. Complete Edition* and John Pope-Hennessy, *Paolo Uccello* in *Art Quarterly*, vol. xxxiii, no. 4, 1970, pp. 441–43

Gilbert, Creighton, "Peintres et menuisiers au début de la Renaissance en Italie," in *Revue de l'art*, no. 37, 1977, pp. 9–28

Gilbert, Creighton E., *Italian Art 1400–1500: Sources and Documents*, Englewood Cliffs, NJ, 1980

Gilbert, Creighton E., *L'arte del Quattrocento nelle testimonianze coeve*, Florence and Vienna, 1988

Gilbert, Creighton, *Poets Seeing Artists' Work: Instances in the Italian Renaissance*, Florence, 1991

Giovanni Morelli e la cultura dei conoscitori (Acts of the International Conference, Bergamo, 1987), ed. Giacomo Agosti, Maria Elisabetta Manca, Matteo Panzeri, and Marisa Dalai Emiliani, 3 vols., Bergamo, 1993

Gnocchi, Lorenzo, "Le preferenze artistiche di Piero di Cosimo de' Medici," in *Artibus et historiae*, vol. xviii, no. 18, 1988, pp. 41–78

Goldscheider, Ludwig, *Leonardo da Vinci Landscapes and Plants*, London, 1952

Goldscheider, Ludwig, *Leonardo da Vinci*, London, 1959

Goldthwaite, Richard A., *Private Wealth in Renaissance Florence*, Princeton, 1968

Gombrich, E. H., "The Early Medici as Patrons of Art," and "Leonardo's Method for Working out Compositions," in his *Norm and Form: Studies in the Art of the Renaissance*, London, 1966, pp. 35–57 and pp. 57–75

Gombrich, E. H., "Tobias and the Angel," and "Botticelli's Mythologies," in his *Symbolic Images: Studies in the Art of the Renaissance*, London, 1972, pp. 26–30 and 31–81

Gombrich, E. H., "The Form of Movement in Water and Air," in *Leonardo's Legacy*, ed. C. D. O'Malley, Berkeley and Los Angeles, 1969, pp. 171–204; reprinted in his *The Heritage of Apelles: Studies in the Art of the Renaissance*, London, 1976, pp. 39–56

Gombrich, E. H., "Light, Form and Texture in Fifteenth-Century Painting North and South of the Alps," and "The Grotesque Heads," in his *The Heritage of Apelles: Studies in the Art of the Renaissance*, Oxford, 1976, pp. 19–35 and 57–75

Gould, Cecil, "The Gambier-Parry Madonna," in *Burlington Magazine*, vol. cix, no. 771, 1967, p. 364

Gould, Cecil, *Leonardo: The Artist and Non-Artist*, London, 1975

Gramaccini, Norberto, "Das genaue Abbild der Natur: Riccios Tiere und die Theorie des Naturabgusses seit Cennino Cennini," in *Natur und Antike in der Renaissance*, ed. Sybille Ebert-Schifferer; Exhibition Catalogue, Museum alter Plastik, 1985–86, Frankfurt, 1985, pp. 198–225

Greenberg, David F., *The Construction of Homosexuality*, Chicago and London, 1988

Gronau, Georg, "Credi, Lorenzo di," in *Allgemeines Lexikon der bildenden Künstler*, ed. Ulrich Thieme and Felix Becker, 37 vols., Leipzig, 1907–50, vol. viii, 1913, pp. 73–77

Grossman, Sheldon, "The 'Madonna and Child with a Pomegranate' and some New Paintings from the Circle of Verrochio," in *Report and Studies in the History of Art*, vol. ii, 1968, pp. 47–71

Grossman, Sheldon, "An Anonymous Florentine Drawing and the "So-Called Verrocchio Sketchbook," in *Master Drawings*, vol. x, no. 1, Spring 1972, pp. 15–19

Grossman, Sheldon, "An Early Drawing by Fra Bartolommeo," in *Studies in the History of Art*, National Gallery of Art, Washington, vol. vi, 1974, pp. 6–22

Grossman, Sheldon, "Ghirlandaio's 'Madonna and Child' in Frankfurt and Leonardo's Beginnings as a Painter," in *Städel-Jahrbuch*, vol. vii, 1979, pp. 101–25

Gudger, E. W., "Pliny's Historia naturalis: The Most Popular Natural History ever Published," in *Isis*, vol. vi, no. 3, 1923, pp. 269–81

Guerrini, Francesco, *La Sagrestia Vecchia di S. Lorenzo*, Florence, 1986

Gurrieri, Francesco, "Una conferma per Michelozzo: Il portale del San Bartolommeo di Monteuliveto," in *Antichità viva*, vol. ix, no. 4, 1970, pp. 24–32

Hale, John, *Italian Renaissance Painting from Masaccio to Titian*, Oxford and New York, 1977

Hall, Marcia, "From Modeling Techniques to Color Modes," in *Color and Technique in Renaissance Painting*, ed. Marcia Hall, Locust Valley, N.Y., 1987, pp. 1–29

Hall, Marcia, *Color and Meaning: Practice and Theory in Renaissance Painting*, Cambridge, 1992

Hall, Michael, "Reconsiderations of Sculpture by Leonardo da Vinci: A Bronze Statuette in the J. B. Speed Art Museum," in *J. B. Speed Art Museum Bulletin*, vol. xxix, 1973, pp. 7–59

Hart, Clive, *The Prehistory of Flight*, Berkeley, Los Angeles, and London, 1985

Hartt, Frederick, Gino Corti, and Clarence Kennedy, *The Chapel of the Cardinal of Portugal, 1434–1459, at San Miniato in Florence*, Philadelphia, 1964

Hatfield Strens, Bianca, "L'arrivo del trittico Portinari a Firenze," in *Commentari*, vol. xix, nos. 1–2, 1968, pp. 315–19

Heaton, Mrs. Charles W., *Leonardo da Vinci and his Works*, London and New York, 1874

Hendy, Philip, *European and American Paintings in the Isabella Stewart Gardner Museum*, Boston, 1974

Herald, Jacqueline, *Renaissance Dress in Italy 1400–1500*, London, 1981

Herlihy, David, and Christiane Klapisch-Zuber, *Tuscans and their Families: A Study of the Florentine Catasto of 1427*, New Haven and London, 1978

Heydenreich, L. H., *Leonardo*, Berlin, 1943

Heydenreich, L. H., *Leonardo da Vinci*, 2 vols., New York and Basel, 1954

Heydenreich, Ludwig H., *Leonardo-Studien*, ed. Günter Passavant, Munich, 1988

Hildebrandt, Edmund, *Leonardo: Der Künstler und sein Werk*, Berlin, 1927

Hills, Paul, "Leonardo and Flemish Painting," in *Burlington Magazine*, vol. cxxii, no. 930, 1980, pp. 609–15

Hills, Paul, *The Light of Early Italian Painting*, New Haven and London, 1987

Hind, Arthur M., *Early Italian Engraving*, 2 vols., London, 1938

Holman, Beth, "Verrocchio's Marsyas and Renaissance Anatomy," in *Marsyas: Studies in the History of Art*, vol. xix, 1977–78, pp. 1–9

Holmes, Charles, "The Shop of Verrocchio," in *Burlington Magazine*, vol. xxiv, no. 131, 1914, pp. 279–87

Holmes, Charles, *Old Masters & Modern Art: The National Gallery. Italian Schools*, London, 1923

Horne, Herbert, *Botticelli*, London, 1908

Horster, Marita, *Andrea del Castagno*, London, 1980

Hours, Magdeleine, "Radiographies de tableaux de Léonard de Vinci," in *Revue des arts*, vol. ii, no. 4, 1952, pp. 227–35

Hours, Magdeleine, "Notes sur l'étude de la peinture de Léonard de Vinci au laboratoire du Musée du Louvre," in *Études d'art*, nos. 8–10, 1953–54, pp. 201–10

Hours, Magdeleine, "Étude analytique des tableaux de Léonard de Vinci au laboratoire du Musée du Louvre," in *Leonardo: Saggi e ricerche*, ed. Achille Marazza, Rome, 1954, pp. 15–26

Houssaye, Arsène, "La jeunesse de Léonard de Vinci," in *L'artiste*, Jan. 1868, pp. 7–23

Howe, William Norton, *Animal Life in Italian Painting*, London, 1912

Hueck, Irene, "Le matricole dei pittori fiorentini prima e dopo il 1320," in *Bollettino d'arte*, vol. LVII, no. 2, 1972, pp. 114–21

Hulse, Clark, *The Rule of Art: Literature and Painting in the Renaissance*, Chicago and London, 1990

Hulton, Paul, and Lawrence Smith, *Flowers in Art from East and West*, London, 1979

Humfrey, Peter, "Jacometto Veneziano," in *The Dictionary of Art*, ed. Jane Turner, 32 vols., London, 1996, vol. XVI, pp. 835–36

Hutchison, Jane Campbell, "The Housebook Master and the Folly of the Wise Man," in *Art Bulletin*, vol. XLVIII, no. 1, 1966, pp. 73–78

Indrio, Laura, "Firenze nel Quattrocento: Divisione e organizzazione del lavoro nelle botteghe," in *Ricerche di storia dell'arte*, no. 38, 1989, pp. 61–70

Isager, Jacob, *Pliny on Art and Society: The Elder Pliny's Chapters on the History of Art*, London and New York, 1991

Italian Drawings, Exhibition Catalogue, Royal Azademy, 1930, London, 1931

Italian Paintings: XIV–XVIIIth Centuries, from the Collection of the Battimore Museum of Art, ed. Gertrude Rosenthal, Baltimore, 1981

Italian Renaissance Sculpture in the Time of Donatello, Exhibition Catalogue, Detroit Institute of Arts, Detroit, 1985

Italienische Malerei der Renaissance im Briefwechsel von Giovanni Morelli und Jean Paul Richter 1876–91, ed. Irma and Gisela Richter, Baden-Baden, 1960

Jahrbuch der Berliner Museen, vol. XXXVIII, Beiheft, 1996 [issue devoted to Wilhelm von Bode]

Jameson, Mrs. (Anna Brownell), *Memoirs of Early Italian Painters*, rev. ed., London, 1859 (orig. ed. 1845)

Jex-Blake, K., and E. Sellers, *The Elder Pliny's Chapters on the History of Art*, London and New York, 1896

Joannides, Paul, "Leonardo and Tradition," in *Nine Lectures on Leonardo da Vinci*, ed. Francis Ames-Lewis, London, n.d. [1990?], pp. 22–31

Johnson, A. F., Victor Scholderer, and V. A. Clarke, *Short-Title Catalogue of Books Printed in Italy . . . from 1465 to 1600 now in the British Museum*, London, 1958

Johnson, Meryl and Elizabeth Packard, "Methods Used for the Identification of Binding Media in Italian Paintings of the Fifteenth and Sixteenth Centuries," in *Studies in Conservation*, vol. XVI, 1971, pp. 145–74

Johnstone, Pauline, "Antonio Pollaiuolo and the Art of Embroidery," in *Apollo*, vol. LXXXI, no. 38, 1965, pp. 306–09

Käss, Siegfried, *Der heimliche Kaiser der Kunst: Adolph Bayersdorfer, seine Freunde und seine Zeit*, Munich, 1987

Kecks, Ronald G., *Madonna und Kind: Das häusliche Andachtsbild in Florenz des 15. Jahrhunderts*, Berlin, 1988

Kecks, Ronald G., *Ghirlandaio*, Florence, 1995

Keele, Kenneth D., *Linear Perspective and the Visual Dimensions of Science and Art*, Munich, 1986

Kemp, Martin, "From 'Mimesis' to 'Fantasia': The Quattrocento Vocabulary of Creation, Inspiration and Genius in the Visual Arts," in *Viator*, vol. VIII, 1977, pp. 347–98

Kemp, Martin, *Leonardo da Vinci: The Marvellous Works of Nature and Man*, London, 1981

Kemp, Martin, "Leonardo da Vinci: Science and the Poetic Impulse," in *Royal Society of Arts Journal*, vol. CXXXIII, no. 5343, 1985, pp. 196–213

Kemp, Martin, *Leonardo e lo spazio dello scultore*, Lettura Vinciana no. XXVII, 1987, Florence, 1988

Kemp, Martin, and Jane Roberts, *Leonardo da Vinci*, Exhibition Catalogue, Hayward Gallery, London, 1989

Kemp, Martin, *The Science of Art*, New Haven and London, 1990

Kennedy, Clarence, "A Clue to a Lost Work by Verrocchio," in *Festschrift Ulrich Middeldorf*, ed. Antje Kosegarten and Peter Tigler, 2 vols., Berlin, 1968, vol. I, pp. 158–60

King, Dawson, "Aristotle and Phyllis: Leonardo's Drawing of an *Exemplum*," in *Achademia Leonardi Vinci*, ed. Carlo Pedretti, vol. VII, 1994, pp. 75–80

Klapisch-Zuber, Christiane, *Women, Family, and Ritual in Renaissance Italy*, trans. Lydia Cochrane, Chicago and London, 1985

Klapisch-Zuber, Christiane, "Images without Memory: Women's Identity and Family Consciousness in Renaissance Florence," in *Fenway Court*, Isabella Stewart Gardner Museum, Boston, 1990–91, pp. 37–43

Klingender, Francis, *Animals in Art and Thought to the End of the Middle Ages*, Cambridge, MA, 1971

Koopmann, W., "Die Madonna mit der schönen Blumenvase," in *Repertorium für Kunstwissenschaft*, vol. XIII, 1890, pp. 118–22

Koreny, Frits, "A Coloured Flower Study by Martin Schongauer and the Development of the Depiction of Nature from van der Weyden to Dürer," in *Burlington Magazine*, vol. CXXXIII, no. 1062, 1991, pp. 588–89

Krautheimer, Richard, *Lorenzo Ghiberti*, 2 vols., Princeton, 1970

Kris, Ernst and Otto Kurz, *Legend, Myth, and Magic in the Image of the Artist*, New Haven and London, 1979

Kristeller, Paul, *Early Florentine Woodcuts*, London, 1897

Kugler, Franz, *Handbook of Painting: The Italian Schools*, ed. Charles Eastlake, 2 vols., London, 1869 (2nd German ed., 2 vols., Berlin, 1847)

Kühnel, Ernst, *Francesco Botticini*, Strasbourg, 1906

Kultzen, Rolf, *Italienische Malerei*, Alte Pinakothek, Munich, 1975

Kustodieva, Tatyana K., *Italian Painting Thirteenth to Sixteenth Centuries*, Hermitage Catalogue of Western European Painting, Florence, 1994

Kwakkelstein, Michael W., *Leonardo da Vinci as a Physiognomist: Theory and Drawing Practice*, Leiden, 1994

Landau, David and Peter Parshall, *The Renaissance Print 1470–1550*, New Haven and London, 1994

Landino, Cristoforo, *Carmina omnia*, ed. Alexander Perosa, Florence, 1939

Landucci, Luca, *A Florentine Diary from 1450 to 1516*, trans. Alice de Rosen Jervis and ed. Iodoco del Badia, London and New York, 1927

Lanzi, Luigi, *Storia pittorica della Italia*, 3rd ed., 6 vols., Bassano, 1809

Lavin, Irving, "On the Sources and Meaning of the Renaissance Portrait Bust," in *Art Quarterly*, vol. XXXIII, no. 3, 1970, pp. 207–26

Lenkey, Susan V., *An Unknown Leonardo Self-Portrait*, Stanford, CA, 1963

Léonard de Vinci: Les études de draperie, ed. Françoise Viatte, Exhibition Catalogue, Musée du Louvre, 1989–90, Paris, 1989

Leonardo da Vinci Loan Exhibition, Exhibition Catalogue, Los Angeles County Museum, Los Angeles, 1949

Leonardo da Vinci, *Treatise on Painting*, ed. A. Philip McMahon, 2 vols., Princeton, 1956

Leonardo da Vinci, *The Madrid Codices*, vol. III, Commentary by Ladislao Reti, New York, 1974

Leonardo da Vinci, *Il Codice sul volo degli uccelli della Biblioteca Reale di Torino*, ed. August Marinoni, Florence, 1976

Leonardo: La pittura, Florence, 1977; rev. ed. Pietro Marani, Florence, 1985

Leonardo: Tutta la pittura, ed. Maria Siponta de Salvia Baldini, Florence, 1988

Leonardo on Painting, ed. and trans. Martin Kemp and Margaret Walker, New Haven and London, 1989

Leonardo's Return to Vinci: The Countess de Béhague Collection, ed. Alessandro Vezzosi, Exhibition Catalogue, Castello, Vinci, and University Art Museum, Berkeley, CA, and elsewhere, Florence, 1980 [with introduction by Carlo Pedretti, pp. 11–13]

Levenson, Jay A., *Prints of the Italian Renaissance*, National Gallery of Art, Washington, 1973

Levenson, Jay A., Konrad Oberhuber, and Jacquelyn L. Sheehan, *Early Italian Engravings from the National Gallery of Art*, Washington, 1973

Levi, Donata, "L'officina di Crowe e Cavalcaselle," in *Prospettiva*, no. 26, July 1981, pp. 74–87

Levi, Donata, *Cavalcaselle: Il pioniere della conservazione dell'arte italiana*, Turin, 1988

Levi d'Ancona, Mirella, *The Garden of the Renaissance: Botanical Symbolism in Italian Painting*, Florence, 1977

Levi D'Ancona, Mirella, *Botticelli's Primavera: A Botanical Interpretation*, Florence, 1983

Levi D'Ancona, Mirella, *Due quadri del Botticelli eseguiti per nascite in Casa Medici*, Florence, 1992

Il Libro di Antonio Billi, ed. Carl Frey, Berlin, 1892

Libro d'inventario dei beni di Lorenzo il Magnifico, ed. Marco Spallanzani and Giovanna Gaeta Bertelà, Florence, 1992

Lightbown, R. W., "The Attribution Game," in *Apollo*, vol. XCI, no. 96, 1970, pp. 166–67

Lightbown, Ronald, *Sandro Botticelli: Life and Work*, 2 vols., London, 1978

Liphart, Ernst, *Les anciennes écoles de peinture dans les palais et collections privées russes représentées a l'exposition organisée a St. Pétersbourg en 1909*, Brussels, 1910

Liphart, Ernst, "Kritische Gänge und Reiseeindrücke," in *Jahrbuch der königlich preuszischen Kunstsammlungen*, vol. XXXIII, nos. 2–3, 1912, pp. 193–224

Lipman, Jean, "The Florentine Profile Portrait in the Quattrocento," in *Art Bulletin*, vol. XVIII, no. 1, 1936, pp. 54–102

Lippincott, Kristen, "The Genesis and Significance of the Fifteenth-Century Italian Impresa," in *Chivalry in the Renaissance*, ed. Sydney Anglo, Woodbridge, 1990

Lippincott, Louise W., "The Unnatural History of Dragons," in *Philadelphia Museum of Art Bulletin*, vol. LXXVII, no. 334, 1981, pp. 2–24

Liscia Bemporad, Dora, "Appunti sulla bottega orafa di Antonio del Pollaiolo e di alcuni suoi allievi," in *Antichità viva*, vol. XIX, no. 3, 1980, pp. 47–53

List of Paintings in the Sterling and Francine Clark Art Institute, ed. Steven Kern, Williamstown, Mass., 1992

Lodge, Nancy, "A Renaissance King in Hellenistic Disguise: Verrocchio's Reliefs for King Matthias Corvinus," in *Italian Echoes in the Rocky Mountains*, ed. Sante Matteo, Cinzia Donatelli Noble, and Madison V. Sowell, Provo, Utah, 1990, pp. 23–46

Loisel, Gustave, *Histoire des ménageries de l'antiquité a nos jours*, 3 vols., Paris, 1912

Lombardi, Sandro, *Jean Fouquet*, Florence, 1983

Longhi, Roberto, "Quadri italiani di Berlino a Sciaffusa," in *Paragone*, vol. III, no. 33, 1952, pp. 39–46

Lorenzo de' Medici, *Selected Poems and Prose*, ed. and trans. Jon Thiem, University Park, Pa., 1992

Lübke, Wilhelm, "Über einige Werke Lionardos," in *Jahrbuch für Kunstwissenschaft*, vol. III, 1870, pp. 70–74

Lübke, Wilhelm, *Geschichte der italienischen Malerei*, 2 vols., Stuttgart, 1878–9

Lugt, Frits, *Les marques de collections*, Amsterdam, 1921

Lugt, Frits, "Man and Angel. II," in *Gazette des Beaux-Arts*, 6th ser., vol. XXV, no. 928, 1944, pp. 321–45

Lupia, John N., III, "The Secret Revealed: How to Look at Italian Renaissance Paint-ings," in *Medieval & Renaissance Times*, vol. I, no. 2, 1994, pp. 6–17

McCurdy, Edward, *The Mind of Leonado da Vinci*, London and Toronto, 1932

McCurdy, Edward, *The Notebooks of Leonardo da Vinci*, 2 vols., London, 1956

MacDonald, Diana Louisa, *Villa Verrocchio or the Youth of Leonardo da Vinci*, London, 1850

Mackowsky, Hans, "Das Lavabo in San Lorenzo zu Florenz," in *Jahrbuch der königlich preussischen Kunstsammlungen*, vol. XVII, 1896, pp. 239–44

Mackowsky, Hans, *Verrocchio*, Bielefeld and Leipzig, 1901

Maclagan, Eric, "A Stucco after Verrocchio," in *Burlington Magazine*, vol. XXXIX, no. 222, 1921, pp. 131–37

Maclagan, Eric, "Leonardo as Sculptor," in *Burlington Magazine*, vol. XLIII, no. 245, 1923, pp. 67–69

McNeal, Harriet, "Work in Progress: Work-shops and Partnerships," in *Verrochio and Late Quattrocento Italian Sculpture*, ed. Steven Bule, Alan Phipps Darr, and Fiorella Superbi Gioffredi, Florence, 1992, pp. 356–59

Maestri e botteghe: Pittura a Firenze alla fine del Quattrocento, ed. Mina Gregori, Antonio Paolucci, and Cristina Acidini Luchinat, Exhibition Catalogue, Palazzo Strozzi, Florence, 1992–93, Milan, 1992 [with introduction by Anna Padoa Rizzo, pp. 19–22]

Magnino, *La letteratura artistica*, trans. Filippo Rossi, Florence, 1956

Marangoni, Matteo, *La Basilica di S. Lorenzo in Firenze*, Florence, 1922

Marani, Pietro C., "Altre opere attribuite e derivazioni," in *Leonardo: La pittura*, rev. ed. Marani, Florence, 1985, pp. 222–27

Marani, Pietro, *Leonardo: Catalogo completo dei dipinti*, Florence, 1989

Marani, Pietro C., "Tracce ed elementi Verrocchieschi nella tarda produzione grafica e pittorica di Leonardo" in *Verrochio and Late Quattrocento Italian Sculpture*, ed. Steven Bule, Alan Phipps Darr, and Fiorella Superbi Gioffredi, Florence, 1992, pp. 141–52

Marani, Pietro, *Leonardo*, Milan, 1994

Marchini, Giuseppe, "L'Annunciazione," in *Leonardo: La pittura*, Florence, 1977, pp. 25–36; rev. ed. Pietro Marani, Florence, 1985, pp. 23–29

Mariani Canova, Giordana, *La miniatura veneta del rinascimento 1450–1500*, Venice, 1969

Marquand, Allan, *Giovanni della Robbia*, Princeton, 1920

Martini, Alberto, "Ipotesi Leonardesca per la 'Madonna' Ruskin," in *Arte figurativa*, vol. VIII, no. 1, 1960, pp. 32–39

Mather, Frank Jewett, Jr., "Verrocchio and Early Leonardo," in *The Nation*, vol. LXXXV, no. 2192, July 4, 1907, pp. 11–12

Mather, Frank Jewett, Jr., "Some Recent Leonardo Discoveries," in *Art and Archaeology*, vol. IV, no. 2, 1916, pp. 111–22

Mather, Frank Jewett, Jr., *A History of Italian Painting*, New York, 1923

Mather, Rufus Graves, "Documents Mostly New Relating to Florentine Painters and Sculptors of the Fifteenth Century," in *Art Bulletin*, vol. XXX, no. 1, 1948, pp. 20–65

Mattioli, Pierandrea, *Commentarii*, Venice, 1554, 2nd ed., 1558

Meller, Peter, "Physiognomical Theory in Renaissance Heroic Portraits," in *The Renaissance and Mannerism: Studies in Western Art*, Acts of the Twentieth International Congress of the History of Art, 2 vols., Princeton, 1963, vol. II, pp. 53–69

Meloni Trkulja, Silvia, "Vicende del Cenacolo di San Salvi," in Serena Padovani and Silvia Meloni Trkulja, *Il Cenacolo di Andrea del Sarto a San Salvi: Guida del Museo*, Florence, 1982, pp. 1–4

Mesnil, Jacques, "Les figures des Vertues de la Mercanzia," in *Miscellanea d'arte*, vol. I, 1903, pp. 43–46

Mesnil, Jacques, "Botticelli, les Pollaiuoli et Verrocchio. II," in *Rivista d'arte*, vol. III, 1905, pp. 35–45

Meyer, Julius, *Königlich Museen in Berlin: Beschreibendes Verzeichnis der Gemälde*, Berlin, 1878

Meyer zur Capellen, Jürg, *Raphael in Florence*, London, 1996

Micheletti, Emma, *Domenico Ghirlandaio*, Florence, 1990

Milanesi, Gaetano, *Documenti inediti riguardanti Lionardo da Vinci*, Florence, 1872

Moffitt, John F., "Leonardo's 'sfumato' and Apelles' 'atramentum'," in *Paragone*, vol. XL, n.s. no. 16 (473), 1989, pp. 88–92

Moffitt, John F., "The *Evidentia* of Curling Waters and Whirling Winds: Leonardo's *Ekphraseis* of the Latin Weathermen," in *Achademia Leonardi Vinci*, ed. Carlo Pedretti, vol. IV, 1991, pp. 11–33

Moggi, Guido, "Le piante nella pittura italiana dei secoli XV e XVI: Problemi e metodi di identificazione botanica," in *Die Kunst und das Studium der Natur vom 14. zum 16. Jahrhundert*, ed. Wolfram Prinz and Andreas Beyer, Weinheim, 1987, pp. 61–73

Molho, Anthony, *Marriage Alliance in Late Medieval Florence*, Cambridge, Mass. and London, 1994

Möller, Emil, "Beiträge zu Leonardo da Vinci als Plastiker und sein Verhältnis zu Verrocchio," in *Mitteilungen des kunsthistorischen Institutes in Florenz*, vol. IV, nos. 1–2, 1933, pp. 138–39

Möller, Emil, "Aggiunta al contributo 'Leonardo e il Verrocchio,'" in *Raccolta vinciana*, vol. XIV, 1930–34, pp. 345–46

Möller, Emil, "Leonardo e il Verrocchio: Quattro rilievi di capitani antichi lavorati per Re Mattia Corvino," in *Raccolta vinciana*, vol. XIV, 1930–34, pp. 4–38

Möller, Emil, "Salvestro di Jacopo Pollaiuolo dipintore," in *Old Master Drawings*, no. 38, 1935, pp. 17–21

Möller, Emil, "Leonardos Bildnis der Ginevra dei Benci," in *Münchner Jahrbuch der bildenden Kunst*, vol. XII, no. 3, 1937–38, pp. 185–209

Möller, Emil, "Leonardos Madonna mit der Nelke in der Älteren Pinakothek," in *Münchner Jahrbuch der bildenden Kunst*, vol. XII, nos. 1–2, 1937–38, pp. 5–40

Möller, Emil, *La Gentildonna dalle belle mani di Leonardo da Vinci*, Bologna, 1954

Móré, Miklós, "Compte rendu de la restauration du retable de la Vierge en Trône à l'Enfant avec cinq saints et deux anges per Andrea del Verrocchio," in *Bulletin du Musée Hongrois des Beaux-Arts*, vol. LXXX–LXXXI, 1994, pp. 59–75

Morelli, Giovanni, *Die Werke italienischer Meister in den Galerien von München, Dresden und Berlin: Ein kritischer Versuch*, Leipzig, 1880

Morelli, Giovanni, *Italian Masters in German Galleries: A Critical Essay on the Italian Pictures in the Galleries of Munich, Dresden, Berlin*, trans. Louise M. Richter, London, 1883

Morelli, Giovanni, *Kunstkritische Studien über italienische Malerei: Die Galerien Borghese und Doria Panfili in Rom*, Leipzig, 1890

Morelli, Giovanni, *Kunstkritische Studien über italienische Malerei: Die Galerien zu München und Dresden*, Leipzig, 1891

Morelli, Giovanni, *Italian Painters: Critical Studies of their Works. The Borghese and Doria-Pamfili Galleries in Rome*, trans. Constance Jocelyn Ffoulkes, London, 1892

Morelli, Giovanni, *Italian Painters: Critical Studies of their Works. The Galleries of Munich and Dresden*, trans. Constance Jocelyn Ffoulkes, London, 1893

Morelli, Giovanni, *Kunstkritische Studien über italienische Malerei: Die Galerie zu Berlin*, Leipzig, 1893

Moreni, Domenico, *Notizie istoriche dei contorni di Firenze*, 6 vols., Florence, 1791–5

Moretti, Lino, *G. B. Cavalcaselle: Disegni da antichi maestri*, Vicenza, 1973

Morland, Jacques, "Le maître de Léonard," in *Mercure de France*, April 1, 1908, pp. 426–40 (summarized by Ettore Verga in *Raccolta vinciana*, vol. IX, 1913–17, pp. 119–20)

Morley, Brian, "The Plant Illustrations of Leonardo da Vinci," in *Burlington Magazine*, vol. CXXI, no. 918, 1979, pp. 553–60

Morolli, Gabriele, "Architetture laurenziane," in *'Per bellezza, per studio, per piacere' Lorenzo il Magnifico e gli spazi dell'arte*, ed. Franco Borsi, Florence, 1991, pp. 195–262

Mostra didattica leonardesca, Rome, 1952

Müller-Walde, Paul, *Leonardo da Vinci: Lebensskizze und Forschungen über sein Verhältniss zur Florentiner Kunst und zu Rafael*, Munich, 1889

Mundy, E. James, "Porphyry and the 'Posthumous' Fifteenth Century Portrait," in *Pantheon*, vol. XLVI, 1988, pp. 37–43

Müntz, Eugène, "Notes sur Verrocchio considéré come maître et précurseur de Léonard de Vinci," in *L'art*, vol. XII, no. 2, 1886, pp. 89–96

Müntz, Eugène, "Une éducation d'artiste au XVe siècle: La jeunesse de Léonard de Vinci," in *Revue des deux mondes*, vol. LXXXIII, 1887, pp. 647–80

Müntz, Eugène, *Les collections des Médicis au XVe Siècle*, Paris, 1888

Müntz, Eugène, *Leonardo da Vinci: Artist, Thinker, and Man of Science*, 2 vols., London and New York, 1898

Nagel, Alexander, "Leonardo and *Sfumato*," in *Anthropology and Aesthetics*, vol. XXIV, 1993, pp. 7–20

Nagler, G. K., *Neues allgemeines Künstler-Lexikon*, 22 vols., Munich, 1835–52

Naldi, Naldo, *Epigrammaton liber*, ed. Alexander Perosa, Budapest, 1943

Natale, Mauro, "Dipinti," in *Museo Poldi Pezzoli: Dipinti*, Milan, 1982, cat. no. 186, pp. 151–52

Nauert, Charles G. Jr., "Humanists, Scientists, and Pliny: Changing Approaches to a Classical Author," in *American Historical Review*, vol. LXXXIV, no. 1, 1979, pp. 72–85

Nauert, Charles G. Jr., "Caius Plinius Secundus," in *Catalogus translationum et commentariorum: Medieval and Renaissance Latin Translations and Commentaries*, ed. F. Edward Cranz, vol. IV, Washington, 1980, pp. 297–422

Negri Arnoldi, Francesco, *Perugino*, Milan, 1965

Nelson, John Charles, *Renaissance Theory of Love*, New York, 1958

Neri di Bicci, *Le ricordanze*, ed. Bruno Santi, Pisa, 1976

Niccolini di Camugliano, Ginevra, *The Chronicles of a Florentine Family 1200–1470*, London, 1933

Nosotti, Stefania, *Leonardo da Vinci: L'intuizione della natura*, Exhibition Catalogue, Museo di Storia Naturale, Milan, Florence, 1983

Nuttall, Paula, "Early Netherlandish Painting in Florence," Ph.D. Thesis, Courtauld Institute of Art, London, 1989

Nuttall, Paula, "'Fecero al Cardinale di Portogallo una tavola a olio.' Netherlandish Influence in Antonio and Piero Pollaiuolo's San Miniato Altarpiece," in *Nederlands kunsthistorisch jaarboek*, vol. XLIV, 1993, pp. 111–24

Nuttall, Paula, "The Medici and Netherlandish Painting," in *The Early Medici and their Artists*, ed. Francis Ames-Lewis, London, 1995, pp. 135–52

Oberhuber, Konrad, ed., *The Illustrated Bartsch*, vol. XXVII, New York, 1978

Oberhuber, Konrad, "Le problème des premières oeuvres de Verrocchio," in *Revue de l'art*, no. 42, 1978, pp. 63–76

L'Oreficeria nella Firenze del Quattrocento, ed. Maria Grazia Ciardi Duprè dal Poggetto, Exhibition Catalogue, Florence, 1977

Ortolani, Sergio, *Il Pollaiuolo*, Milan, 1948

Ost, Hans, *Leonardo-Studien*, Berlin and New York, 1975

Ottino della Chiesa, Angela, *L'opera completa di Leonardo pittore*, Milan, 1967

Ottley, William Young, *The Italian Schools of Design*, London, 1823

Pächt, Otto, "Early Italian Nature Studies and the Early Calendar Landscape," in *Journal of the Warburg and Courtauld Institutes*, vol. XIII, nos. 1–2, 1950, pp. 13–47

Padoa Rizzo, Anna, "Botticini, Francesco," in *Dizionario biografico degli italiani*, Rome, 1960–98, vol. XIII, 1971, pp. 453–55

Padoa Rizzo, Anna, "Per Francesco Botticini," *Antichità viva*, vol. XV, no. 5, 1976, pp. 3–19

Padoa Rizzo, Anna, "La bottega come luogo di formazione," in *Maestri e botteghe: Pittura a Firenze alle fine del Quattrocento*, ed. Mina Gregori, Antonio Paolucci, and Cristina Acidini Luchinat, Exhibition Catalogue, Palazzo Strozzi, Florence, 1992–93 Milan, 1992, pp. 53–59

Pagnotta, Laura, *Giuliano Bugiardini*, Turin, 1987

Panhans, Günter, "Florentiner Maler Verarbeiten ein Eyckisches Bild," in *Wiener Jahrbuch für Kunstgeschichte*, vol. XXVII, 1974, pp. 188–98

Panofsky, Erwin, *Renaissance and Renascences in Western Art*, Stockholm, 1960

Paolozzi Strozzi, Beatrice, "An Unpublished Crucifix by Andrea del Verrocchio," in *Burlington Magazine*, vol. CXXXVI, no. 1101, 1994, pp. 808–15

Parker, K. T., *Catalogue of the Collection of Drawings in the Ashmolean Museum, II: Italian Schools*, Oxford, 1956

Parronchi, Alessandro, "Nuove proposte per Leonardo scultore," in *Achademia Leonardi Vinci*, vol. II, 1989, pp. 40–67

Parronchi, Alessandro, "L'arpia svela: è Donatello," in *La nazione*, Jan. 4, 1991

Passavant, Günter, *Andrea del Verrocchio als Maler*, Düsseldorf, 1959

Passavant, Günter, "Beobachtungen am Verkündigungsbild aus Monte Oliveto," in *Mitteilungen des kunsthistorischen Institutes in Florenz*, vol. IX, no. 2, 1960, pp. 71–98

Passavant, Günter, "Beobachtungen am Silberaltar des Florentiner Baptisteriums," in *Pantheon*, vol. XXIV, no. 1, 1966, pp. 10–23

Passavant, Günter, "Die Courtauld Institute Galleries," in *Kunstchronik*, vol. XX, no. 10, 1967, pp. 311–19

Passavant, Günter, *Verrocchio: Sculptures, Paintings, and Drawings. Complete Edition*, trans. Katherine Watson, London, 1969

Passavant, Günter, review of Charles Seymour, *The Sculpture of Verrocchio*, in *Burlington Magazine*, vol. CXVII, no. 862, 1975, pp. 55–56

Passavant, Günter, "Beobachtungen am Lavabo von San Lorenzo in Florenz," in *Pantheon*, vol. XXXIX, no. 1, 1981, pp. 33–50

Pater, Walter, *The Renaissance* (orig. ed. 1873), ed. Kenneth Clark, London, 1961

Pauli, Gustav, *Zeichnungen alter Meister in der Kunsthalle zu Hamburg: Italiener*, Frankfurt, 1927, cat. no. 8

Pedretti, Carlo, *Leonardo: A Study in Chronology and Style*, Berkeley and Los Angeles, 1973

Pedretti, Carlo, *Disegni di Leonardo da Vinci e della sua scuola alla Biblioteca Reale di Torino*, Florence, 1975

Pedretti, Carlo, *Commentary to the Literary Works of Leonardo da Vinci*, ed. Jean Paul Richter, 2 vols., Oxford, 1977

Pedretti, Carlo, *Leonardo architetto*, Milan, 1978

Pedretti, Carlo, *Leonardo*, Bologna, 1979

Pedretti, Carlo, *The Drawings and Miscellaneous Papers of Leonardo da Vinci in the Collection of Her Majesty the Queen at Windsor Castle, I: Landscapes, Plants, and Water Studies*, London, 1982

Pedretti, Carlo, "Leonardo at the Morgan Library," in *Achademia Leonardi Vinci*, vol. I, 1988, pp. 142–44

Pedretti, Carlo, "A Proem to Sculpture," in *Achademia Leonardi Vinci*, vol. II, 1989, pp. 11–39

Pedretti, Carlo, "Paolo di Leonardo," in *Achademia Leonardi Vinci*, vol. V, 1992, pp. 120–22

Pedretti, Carlo, "'li medici mi crearono e destrussono'," in *Achademia Leonardi Vinci*, vol. VI, 1993, pp. 173–84

Pedretti, Carlo and Kenneth Clark, *Leonardo da Vinci Nature Studies from the Royal Library at Windsor Castle*, Exhibition Catalogue, Royal Academy, London, 1981

Pedretti, Carlo, and Gigetta Dalli Regoli, *I disegni di Leonardo da Vinci e della sua cerchia nel Gabinetto Disegni e Stampe della Galleria degli Uffizi*, Florence, 1985

Pedretti, Carlo, and Jane Roberts, *Leonardo da Vinci: Drawings of Horses and Other Animals from the Royal Library at Windsor Castle*, Exhibition Catalogue, National Gallery of Art, Washington, 1985, New York, 1984

Pedretti, Carlo, and Patricia Trutty-Coohill, *The Drawings of Leonardo da Vinci and his Circle in America*, Florence, 1993

Penny, Nicholas, "Raphael's 'Madonna dei garofani' Rediscovered," in *Burlington Magazine*, vol. CXXXIV, no. 1067, 1992, pp. 67–81

Perrig, Alexander, "Die theoriebedingten Landschaftsformen in der italienischen Malerei des 14. und 15. Jahrhunderts," in *Die Kunst und das Studium der Natur vom 14. zum 16. Jahrhundert*, ed. Wolfram Prinz and Andreas Beyer, Weinheim, 1987, pp. 41–60

Petrioli Tofani, Annamaria, *Inventario, 1: Disegni esposti*, Gabinetto Disegni e Stampe degli Uffizi, Florence, 1986

Phillips, Claude, "Verrocchio or Leonardo da Vinci?," in *Art Journal*, vol. LXII, no. 170, 1899, pp. 33–39

Phillips, John Goldsmith, "The Lady with the Primroses," in *Metropolitan Museum of Art Bulletin*, vol. XXVII, no. 8, 1969, pp. 385–95

Phillips, John Goldsmith, "Hand of the Master: Did Verrocchio's Apprentice, a Lad Named Leonardo da Vinci, Create Some of his Teacher's Best Sculptures?," in *Connoisseur*, vol. CCXVI, no. 888, 1986, pp. 80–83

Pieraccini, Gaetano, *La stirpe de' Medici di Cafaggiolo*, 3rd ed., 3 vols., Florence, 1986

Pintor, F., "Le due ambascerie di Bernardo Bembo a Firenze a le sue relazioni coi Medici," in *Studi letterari e linguistici dedicati a Pio Rajna*, Florence, 1911, pp. 785–813

Pittura di luce: Giovanni di Francesco e l'arte fiorentina di metà Quattrocento, ed. Luciano Bellosi, Exhibition Catalogue, Casa Buonarroti, Florence, Milan, 1990

Planiscig, Leo, "Andrea del Verrocchios Alexander-Relief," in *Jahrbuch der kunsthistorischen Sammlungen in Wien*, vol. VII, 1933, pp. 89–96

Planiscig, Leo, *Andrea del Verrocchio*, Vienna, 1941

Plebani, Eleonora, *Lorenzo e Giuliano de' Medici tra potere and legami di sangue*, Rome, 1993

Poeschel, Sabine, "Alexander Magnus Maximus: Neue Aspekte zur Ikonographie Alexanders des Grossen im Quattrocento," in *Römisches Jahrbuch für Kunstgeschichte*, vol. XXIII–XXIV, 1988, pp. 63–74

Poggi, Giovanni, "La Giostra Medicea del 1475 e la 'Pallade' del Botticelli," in *L'arte*, vol. V, 1902, pp. 71–77

Poggi, Giovanni, "La chiesa di San Bartolommeo a Monte Oliveto presso Firenze," in *Miscellanea d'arte*, vol. I, no. 4, 1903, pp. 57–64

Poggi, Giovanni, *Leonardo da Vinci*, Florence, 1919

Polzer, Joseph, "The Perspective of Leonardo Considered as a Painter," in *La prospettiva rinascimentale: Codificazioni e trasgressioni*, ed. Marisa Dalai Emiliani, Florence, 1980, pp. 233–47

Pons, Nicoletta, "Precisazioni su tre Bartolomeo di Giovanni: Il Cartolaio, il Sargiaio e il Dipintore," in *Paragone*, vol. XLI, nos. 479–81, 1990, pp. 115–28

Pons, Nicoletta, "I Pollaiolo," in *Maestri e botteghe Pittura a Firenze alla fine del Quattrocento*, ed. Mina Gregori, Antonio Paolucci, and Cristina Acidini Luchinat,

Exhibition Catalogue, Palazzo Strozzi, Florence, 1992–93, Milan, 1992, pp. 97–99

Pons, Nicoletta, *I Pollaiolo*, Florence, 1994

Pope-Hennessy, John, *An Introduction to Italian Sculpture, II: Italian Renaissance Sculpture*, London, 1958

Pope-Hennessy, John, *Catalogue of Italian Sculpture in the Victoria and Albert Museum*, 3 vols., London, 1964

Pope-Hennessy, John, *The Portrait in the Renaissance*, New York, 1966

Pope-Hennessy, John, "The Virgin with the Laughing Child," in his *Essays on Italian Sculpture*, London and New York, 1968 (orig. ed., Victoria and Albert Museum, London, 1949), pp. 72–77

Pope-Hennessy, John, review of Günter Passavant, *Verrocchio: Sculptures, Paintings and Drawings. Complete Edition*, in *Times Literary Supplement*, Nov. 13, 1969 [unsigned]

Pope-Hennessy, John, *Italian Renaissance Sculpture*, 2nd ed., London, 1971, 3rd rev. ed., Oxford, 1985

Pope-Hennessy, John, review of Leopold D. Ettlinger, *Antonio and Piero Pollaiuolo*, 1978, in *New York Review of Books*, March 8, 1979, pp. 39–40

Pope-Hennessy, John, "Thoughts on Andrea della Robbia," in *Apollo*, vol. CIX, no. 205, 1979, pp. 176–97

Pope-Hennessy, John, "The Sixth Centenary of Ghiberti," in his *The Study and Criticism of Italian Sculpture*, New York, 1980, pp. 39–70

Pope-Hennessy, John, "Leonardo: Landscape Painter," in *Antaeus*, no. 54, 1985, pp. 41–54

Pope-Hennessy, John, review of Colin Simpson, *Artful Partners*, in *New York Review of Books*, vol. XXXIV, no. 4, March 12, 1987, p. 19

Pope-Hennessy, John, *The Robert Lehman Collection, I: Italian Paintings*, New York, 1987, cat. nos. 89–90

Pope-Hennessy, John, "Deux Madones en marbre de Verrochio," in *Revue de l'art*, no. 80, 1988, pp. 17–25

Popham, A. E., *The Drawings of Leonardo da Vinci*, New York, 1945

Popham, Arthur Ewart, "The Dragon-Fight," in *Leonardo: Saggi e ricerche*, ed. Achille Marazza, Rome, 1954, pp. 223–27

Popham, A. E., and Philip Pouncey, *Italian Drawings in the Department of Prints and Drawings in the British Museum: The Fourteenth and Fifteenth Centuries*, 2 vols., London, 1950

Preyer, Brenda, "L'architettura del Palazzo Mediceo," in *Il Palazzo Medici Riccardi di*

Firenze, ed. Giovanni Cherubini and Giovanni Fanelli, Florence, 1990, pp. 58–75

Prinz, Wolfram, "Dal vero o dal modello? Appunti e testimonianze sull'uso dei manichini nella pittura del Quattrocento," in *Scritti di storia dell'arte in onore di Ugo Procacci*, ed. Paolo and Maria Dal Poggetto, 2 vols., Milan, 1977, vol. I, pp. 200–08

Prinz, Wolfram, "Die Kunst und das Studium der Natur im 14. und 15. Jahrhundert in Italien," in *Die Kunst und das Studium der Natur vom 14. zum 16. Jahrhundert*, ed. Wolfram Prinz and Andreas Beyer, Weinheim, 1987, pp. 5–16

Prosperi, A., "Clemente VII," in *Dizionario biografico degli italiani*, Rome, 1960–98, vol. XXVI, 1982, pp. 237–59

Pryer, Brenda, "L'architettura del Palazzo Mediceo," in *Il Palazzo Medici Riccardi di Firenze*, ed. Giovanni Cherubino and Giovanni Fanelli, Florence, 1990, pp. 58–75

Radcliffe, Anthony, "New Light on Verrocchio's *Beheading of the Baptist*," in *Verrocchio and Late Quattrocento Italian Sculpture*, ed. Steven Bule, Alan Phipps Darr, and Fiorella Superbi Gioffredi, Florence, 1992, pp. 117–23

Ragghianti, Carlo Ludovico, "La giovinezza e lo svolgimento artistico di Domenico Ghirlandaio," in *L'arte*, vol. XXXVIII, no. 3, 1935, pp. 167–98

Ragghianti, Carlo L., "Collezioni Americane," in *Critica d'arte*, vol. XXVII, no. 1, 1949, pp. 76–82

Ragghianti, Carlo L., "Inizio di Leonardo," in *Critica d'arte*, no. 2, March 1954, pp. 102–18; and no. 4, July 1954, pp. 302–29

Ragghianti, Carlo L., "Studio del Verrocchio," in *Critica d'arte*, n. s. vol. XII, no. 73, 1965, pp. 63–64

Ragghianti, Carlo L., and Gigetta Dalli Regoli, *Firenze, 1470–1480: Disegni dal modello*, Pisa, 1975

Ragghianti Collobi, Licia, *Il libro dei disegni del vasari*, 2 vols., Florence, 1974

Raggio, Olga, "The Collection of Sculpture," in *Liechtenstein: The Princely Collections*, Exhibition Catalogue, Metropolitan Museum of Art, New York, 1985, pp. 63–65

Rankin, William, "Leonardo's Early Work," in *The Nation*, vol. LXXXIV, no. 2185, May 16, 1907

Rankin, William, "The Early Works of Leonardo," in *The Nation*, vol. XCIX, no. 2561, July 30, 1914, pp. 133–34

Rankin, William, and Alice van Vechten Brown, *A Short History of Italian Painting*, London and New York, 1914, pp. 124–26, 213–16

"Recent Accessions of American and Canadian Museums July–September 1969," in *Art Quarterly*, vol. XXXIII, no. 1, 1970, p. 83

Reinach, Salomon, "New Facts and Fancies about Leonardo da Vinci," in *Art Journal*, vol. LXXIV, no. 883, 1912, pp. 6–25

Reiss, Sheryl E., *Cardinal Giulio de' Medici as a Patron of Art, 1513–1523*, Ph.D. Thesis, Princeton University, 1992

The Renaissance Philosophy of Man, ed. Ernst Cassirer, Paul Oskar Kristeller, and John Herman Randall, Jr., Chicago, 1961

Resta, Padre Sebastiano, *Indice del libro intitolato 'Parnaso de' pittori'*, Perugia, 1707

Reymond, Marcel, *Verrocchio*, Paris, n.d. [1906]

Reymond, Marcel, "L'éducation de Léonard," in *Leonardo da Vinci: Conferenze fiorentine*, Milan, 1910, pp. 49–79

Ricci, Corrado, *L'ultimo rifugio di Dante*, 2nd rev. ed., Milan, 1921

Richardson, E. P., "A Rare Panel by Verrocchio and Leonardo," in *Bulletin of the Detroit Institute of Arts*, vol. XXXVI, no. 4, 1956–57, pp. 79–81

Richardson, E. P., *The Adoration with Two Angels by Andrea del Verrocchio and Leonardo da Vinci*, Detroit, 1957

Richter, Gisela M. A., *Engraved Gems of the Romans*, London, 1971

Richter, Jean Paul, *Italian Art in the National Gallery*, London, 1883

Richter, Jean Paul, *The Literary Works of Leonardo da Vinci*, 2 vols., London, 1883; 3rd. rev. ed., 2 vols., London and New York, 1970

Ridolfi, Enrico, "Giovanna Tornabuoni e Ginevra de' Benci nel coro di Santa Maria Novella in Firenze," in *Archivio storico italiano*, vol. VI, 1890, pp. 426–56

Rieffel, Franz, "Ein Jugendbild des Lionardo?," in *Repertorium für Kunstwissenschaft*, vol. XIV, 1891, pp. 217–20

Rigollot, Marcel, *Catalogue de l'oeuvre de Léonard de Vinci*, Paris, 1849

Rinascimento da Brunelleschi a Michelangelo. La rappresentazione dell'architettura, ed. Henry Millon and Vittorio Magnago Lampugnani, Exhibition Catalogue, Palazzo Grassi, Venice, Milan, 1994

Robb, David M., "The Iconography of the Annunciation in the Fourteenth and Fif-teenth Centuries," in *Art Bulletin*, vol. XVIII, no. 4, 1936, pp. 480–526

Robinson, J. C., *Descriptive Catalogue of Drawings by the Old Masters, forming the Collection of John Malcolm of Poltalloch, Esq.*, London, 1876

Rochon, André, *La jeunesse de Laurent de Médicis*, Paris, 1963

Rocke, Michael J., "Il controllo dell'omosessualità a Firenze nel XV secolo: Gli *Ufficiali di Notte*," in *Quaderni storici*, n. s. vol. XXII, no. 3, 1987, pp. 701–23

Rocke, Michael J., *Forbidden Friendships: Homosexuality and Male Culture in Renaissance Florence*, New York and Oxford, 1996

Rodis-Lewis, Geneviève, "Léonard et le 'Baptême du Christ' de Verrocchio," in *Rinascimento*, vol. XXVIII, 1988, pp. 357–59

Rodis-Lewis, Geneviève, *Regards sur l'art*, Paris, 1993

Rohlmann, Michael, "Ein Flämisches Vorbild für Ghirlandaios 'Prime Pitture'," in *Mitteilungen des kunsthistorischen Institutes in Florenz*, vol. XXXVI, 1992, pp. 388–96

Rohlmann, Michael, "Zitate flämischer Landschaftsmotive in Florentiner Quattrocentomalerei," in *Italienische Frührenaissance und nordeuropäisches Spätmittelalter*, ed. Joachim Poeschke, Munich, 1993

Rohlmann, Michael, *Auftragskunst und Sammlerbild: Altniederländische Tafelmalerei in Florenz des Quattrocento*, Alfler, 1994

Romano, Giovanni, *Studi sul paesaggio*, Turin, 1978

Romby, Giuseppina Carla, *Descrizioni e rappresentazioni della città di Firenze nel XV secolo*, Florence, 1976

Rosci, Marco, *The Hidden Leonardo*, trans. John Gilbert, Chicago, 1977

Rosenauer, Artur, "Zum Stil der frühen Werke Domenico Ghirlandajos," in *Wiener Jahrbuch für Kunstgeschichte*, vol. XXII, 1969, pp. 59–85

Rosenauer, Artur, "Proposte per il Verrocchio giovane," in *Verrocchio and Late Quattrocento Italian Sculpture*, ed. Steven Bule, Alan Phipps Darr, and Fiorella Superbi Gioffredi, Florence, 1992, pp. 101–05

Rosenberg, Adolf, *Leonardo da Vinci*, Bielefeld and Leipzig, 1898

Rosini, Giovanni, *Storia della pittura italiana esposta coi monumenti*, 7 vols. in 9, Pisa, 1839–55

Rubin, Patricia, "What Men Saw: Vasari's Life of Leonardo da Vinci and the Image of the Renaissance Artist," in *Art History*, vol. XIII, no. 1, 1990, pp. 34–46

Ruda, Jeffrey, "Flemish Painting and the Early Renaissance in Florence," in *Zeitschrift für Kunstgeschichte*, vol. XLVII, no. 2, 1984, pp. 210–36

Ruda, Jeffrey, "Color and the Representation of Space in Paintings by Fra Filippo Lippi," in *Color and Technique in Renaissance Painting: Italy and the North*, ed. Marcia Hall, Locust Vallery, NY, 1987, pp. 41–53

Ruda, Jeffrey, *Fra Filippo Lippi: Life and Work with a Complete Catalogue*, London, 1993

Rudel, Jean, "Le métier du peintre," in *Amour de l'art*, vol. XXXI, nos. 67–69, 1952, pp. 35–48

Rudel, Jean, "Technique Picturale de Léonard de Vinci," in *Études d'art*, nos. 8–10, 1953–54, pp. 287–309

Rumohr, Carl Friedrich von, *Italienische Forschungen*, 3 vols., Berlin, 1827–31

Rumohr, Carl Friedrich von, *Drey Reisen nach Italien*, Leipzig, 1832

Ruschi, Pietro, "Troppe mani sul lavamano," in *Giornale dell'arte*, no. 87, March 1991, p. 63

Ruskin, John, *The Works of John Ruskin*, 39 vols., ed. E. T. Cook and Alexander Wedderburn, London, 1903–12

Ruskin, John, and Charles Eliot Norton, *The Correspondence of John Ruskin and Charles Eliot Norton*, ed. John Lewis Bradley and Ian Ousby, Cambridge, 1987

Sabatini, Attilio, *Antonio e Piero del Pollaiolo*, Florence, 1944

Sabba da Castiglione, *Ricordi*, Venice, 1563

Salmi, Mario, *La miniatura italiana*, Milan, 1955

Salvi, Michelangelo, *Historie di Pistoia e fazioni d'Italia*, 3 vols., Rome, 1656–62

Salvini, Roberto, *Tutta la pittura del Botticelli*, 2 vols., Milan, 1958

Salvini, Roberto, *Banchieri fiorentini e pittori di Fiandra*, Modena, 1984

Samuels, Ernest, *Bernard Berenson: The Making of a Connoisseur*, Cambridge, MA, and London, 1979

Samuels, Ernest, *Bernard Berenson: The Making of a Legend*, Cambridge, MA, and London, 1987

Sanpaolesi, Piero, "I dipinti di Leonardo agli Uffizi," in *Leonardo: Saggi e ricerche*, ed. Achille Marazza, Rome, 1954, pp. 27–56

Santi, Francesco, "Perugino," in *Encyclopedia of World Art*, 17 vols., 1959–1987, New York, Toronto, and London, vol. XI, 1966, columns 265–71

Saslow, James M., *Ganymede in the Renaissance: Homosexuality in Art and Society*, New Haven and London, 1986

Scaglia, Gustina, "Leonardo's Non-Inverted Writing and Verrocchio's Measured Drawing of a Horse," in *Art Bulletin*, vol. LXIV, no. 1, 1982, pp. 32–44

Scarpellini, Pietro, *Perugino*, Milan, 1984

Schaar, Eckhard, *Italienische Zeichnungen der Renaissance aus dem Kupferstichkabinett der Hamburger Kunsthalle*, Exhibition Catalogue, Kunsthalle, Hamburg, 1997

Schapiro, Meyer, "Leonardo and Freud: An Art-Historical Study," in *Journal of the History of Ideas*, vol. XVII, no. 4, 1956, pp. 147–78; reprinted in *Renaissance Essays*, ed. Paul O. Kristeller and Philip P. Wiener, New York, 1968, pp. 303–36

Scheller, Robert W., *Exemplum: Model-Book Drawings and the Practice of Artistic Transmission in the Middle Ages (ca.900–ca.1470)*, trans. Michael Hoyle, Amsterdam, 1995

Schiaparelli, Attilio, *Leonardo ritrattista*, Milan, 1921

Schiavone, Mario, "Dall'*Editio princeps* della *Naturalis historia* ad opera di Giovanni da Spira all'Edizione Lione 1561," in *Plinio e la natura*, ed. Angelo Ronconi, Como, 1982, pp. 95–108

Schleier, Erich, in *The Gemäldegalerie, Berlin: A History of the Collection and Selected Masterworks*, London, 1986

Schlosser, Julius von, *Lorenzo Ghibertis Denkwürdigkeiten*, 2 vols., Berlin, 1912

Schneider, Norbert, *The Art of the Portrait: Masterpieces of European Portrait-Painting 1420–1670*, Cologne, 1994

Schuyler, Jane, *Florentine Busts: Sculpted Portraiture in the Fifteenth Century*, New York and London, 1976

Scrase, David, "Paris and Lille. Leonardo: Italian Drawings," in *Burlington Magazine*, vol. CXXXII, no. 1043, 1990, pp. 151–54

Una scuola per Piero: Luce, colore e prospettiva nella formazione fiorentina di Piero della Francesca, ed. Luciano Bellosi, Exhibition Catologue, Galleria degli Uffizi, Florence, 1992

Seidlitz, Woldemar von, *Leonardo da Vinci der Wendepunkt der Renaissance*, 2 vols., Berlin, 1909, rev. ed. Vienna, 1935

Seidlitz, Woldemar von, review of Thiis, *Leonardo*, 1909, in *Internationale Wochenschrift für Wissenschaft, Kunst, und Technik*, vol. IV, no. 52, 1910, cols. 1649–56; summarized in *Raccolta vinciana*, vol. VII, 1911, pp. 112–16

Semenzato, Camillo, *Genio e botteghe: L'arte nell'Europa tra medio evo ed età moderna*, Milan, 1992

Settesoldi, Enzo, "Il Gonfalone del Comune di Carrara dipinto da Andrea del Verrocchio," in *Paragone*, vol. XXXI, no. 363, 1980, pp. 87–91

Settis, Salvatore, "Citarea 'Su una impresa di Bronconi'," in *Journal of the Warburg and Courtauld Institutes*, vol. XXXIV, 1971, pp. 135–77

Seymour, Charles, Jr., *Early Italian Paintings in the Yale University Art Gallery*, New Haven and London, 1970

Seymour, Charles, *The Sculpture of Verrocchio*, Greenwich, Conn., 1971

Shapley, Fern Rusk, *Catalogue of the Italian Paintings*, National Gallery of Art, 2 vols., Washington, 1979

Shaw, James Byam, *Drawings by Old Masters at Christ Church Oxford*, 2 vols., Oxford, 1976

Shaw, James Byam, *The Italian Drawings of the Frits Lugt Collection*, 3 vols., Paris, 1983

Sheard, Wendy Stedman, "Verrocchio's Medici Tomb and the Language of Materials," in *Verrocchio and Late Quattrocento Italian Sculpture*, ed. Steven Bule, Alan Phipps Darr, and Fiorella Superbi Gioffredi, Florence, 1992, pp. 63–90

Sheard, Wendy Stedman, "Bernardo e Pietro Bembo, Pietro, Tullio e Antonio Lombardo: Metamorfosi delle tematiche cortigiane nelle tendenze classicistiche della scultura veneziana," in *Tiziano: Amor sacro e amor profano*, Exhibition Catalogue, Palazzo delle Esposizioni, Rome, Milan, 1995, pp. 118–32

Shearman, John, "Leonardo's Colour and Chiaroscuro," in *Zeitschrift für Kunstgeschichte*, vol. XXV, no. 1, 1962, pp. 13–47

Shearman, John, "A Suggestion for the Early Style of Verrocchio," in *Burlington Magazine*, vol. CIX, no. 768, 1967, pp. 121–27

Shearman, John, *Only Connect . . . Art and the Spectator in the Italian Renaissance* (Mellon Lectures in the Fine Arts, National Gallery of Art, Washington, 1988), Princeton, 1992

Shell, Janice, *Leonardo*, London, 1992

Shell, Janice, and Grazioso Sironi, "Cecilia Gallerani: Leonardo's Lady with an Ermine," in *Artibus et historiae*, no. 25, 1992, pp. 47–66

Shell, Janice, and Grazioso Sironi, "Giovanni Antonio Boltraffio and Marco d'Oggiono: The Berlin Resurrection of Christ with Saints Leonard and Lucy," in *Raccolta vinciana*, vol. XXIII, 1989, pp. 119–66

Shepard, Odell, *The Lore of the Unicorn*, New York, 1967

Silver, Larry, "Town and Country: Early Landscape Drawings," in *Landscape Drawings of Five Centuries, 1400–1900 from the Robert Lehman Collection, Metropolitan Museum of Art*, ed. George Szabo, Exhibition Catalogue, Mary and Leigh Block Gallery, Northwestern University, Evanston, IL, New York, 1988, pp. 3–17

Simari, Maria Matilde, "Menageries in Medicean Florence," in *Natura viva: Animal Paintings in the Medici Collections*, ed. Marilena Mosco, Florence, 1985, pp. 27–29

Simons, Patricia, "Women in Frames: The Gaze, the Eye, the Profile in Renaissance Portraiture," in *The Expanding Discourse: Feminism and Art History*, ed. Norma Broude and Mary D. Garrard, New York, 1992, pp. 38–57

Simpson, Otto Georg von, "Leonardo and Attavante," in *Gazette des Beaux-Arts*, 6th ser., vol. XXV, no. 921, 1943, pp. 305–12

Sinibaldi, Giulia, "Drawings by Perugino," in *Master Drawings*, vol. II, no. 1, 1964, pp. 27–32

Sirén, Osvald, *Leonardo da Vinci*, Stockholm, 1911

Sirén, Osvald, *Leonardo da Vinci: The Artist and the Man*, New Haven and London, 1916

Sirén, Osvald, *Léonard de Vinci: L'artiste et l'homme*, trans. Jean Buhot, 3 vols., Paris and Brussels, 1928

Small Paintings of the Masters, ed. Leslie Shore, New York, 1980

Smiraglia Scognamiglio, Nino, "Nuovi documenti su Leonardo da Vinci," in *Archivio storico dell'arte*, vol. II, 1896, pp. 313–15

Smiraglia Scognamiglio, Nino, *Ricerche e documenti sulla giovinezza di Leonardo da Vinci, 1452–1482*, Naples, 1900

Smyth, Craig Hugh, "Venice and the Emergence of the High Renaissance in Florence: Observations and Questions," in *Florence and Venice: Comparisons and Relations*, Acts of Two Conferences, Villa I Tatti, 1976–77, 2 vols., Florence, 1979, vol. I, pp. 209–49

Solmi, Edmondo, *Le fonti dei manoscritti di Leonardo da Vinci*, Turin, 1908

Sotheby's, London, July 8, 1949, 1st no. 2, pp. 5–11

Spencer, John R., "Spatial Imagery of the Annunciation in Fifteenth Century Florence," in *Art Bulletin*, vol. XXXVII, no. 4, 1955, pp. 173–80

Sperling, Christine M., "Verrocchio's Medici Tombs," in *Verrocchio and Late Quattrocento Italian Sculpture*, ed. Steven Bule, Alan Phipps Darr, and Fiorella Superbi Gioffredi, Florence, 1992, pp. 51–61

Stammler, Wolfgang, "Aristoteles," in *Reallexikon zur deutschen Kunst-Geschichte*, ed. Otto Schmitt, vol. I, Stuttgart, 1937, cols. 1027–40

Steffen, Uwe, *Drachenkampf: Der Mythos vom Bösen*, Stuttgart, 1984

Stendhal, *Histoire de la peinture en Italie*, 2 vols., Paris, 1817

Sterne, Margaret, *The Passionate Eye: The Life of William R. Valentiner*, Detroit, 1980

Sternweiler, Andreas, *Die Lust der Götter: Homosexualität in der italienischen Kunst von Donatello zu Caravaggio*, Berlin, 1993

Stites, Raymond S., "Leonardo da Vinci Sculptor," in *Art Studies*, vol. IV, 1926, pp. 103–09; vol. VI, 1928, pp. 73–77; and vol. VIII, 1930, pp. 289–300

Stites, Raymond S., "Leonardo scultore e il busto di Giuliano de' Medici del Verrocchio," in *Critica d'arte*, vol. X, 1963, nos. 57–58, pp. 1–32; and nos. 59–60, pp. 25–38

Stites, Raymond S., "La Madonna del Melograno di Leonardo da Vinci, I," in *Critica d'arte*, vol. XV, no. 93, 1968, pp. 59–73

Stites, Raymond S., *The Sublimations of Leonardo da Vinci*, Washington, 1970

Stokstad, Marilyn and Jerry Stannard, *Gardens of the Middle Ages*, Spencer Museum of Art, Lawrence, KS, 1983

Suida, Wilhelm, "Kleine Beiträge zum Werke Leonardos," in *Raccolta vinciana*, vol. XIII, 1926–29, pp. 63–79

Suida, Wilhelm, *Leonardo und sein Kreis*, Munich, 1929

Suida, William, "Leonardo's Activity as a Painter: A Sketch," in *Leonardo: Saggi e ricerche*, ed. Achille Marazza, Rome, 1954, pp. 315–29

Sutton, Denys, "Gustav Friedrich Waagen, First Director of the Berlin Gallery," in *Apollo*, vol. CII, no. 166, 1975, pp. 396–403

Sutton, Denys, "Robert Langton Douglas, Connoisseur of Art and Life," in *Apollo*, vol. CIX, 1979, no. 206, pp. 248–315; no. 207, pp. 334–93; no. 208, pp. 412–75; and vol. CX, no. 209, pp. 2–56

Sutton, Denys, "Aspects of British Collecting. Part IV, XVI: Crowe and Cavalcaselle," in *Apollo*, vol. CXXIII, no. 282, 1985, pp. 111–29

Szablowski, Jerzy, *Collections of the Royal Castle of Wawel*, Warsaw, 1969

Tabani, Ornella and Maria Filomena Vadalà, *San Salvi e la Storia del movimento vallombrosano dall' XI al XVI secolo*, Florence, 1982

Tanturli, Giuliano, "I Benci Copisti: Vicende della cultura fiorentina volgare fra Antonio Pucci e il Ficino," in *Studi di filologia italiana*, vol. XXXVI, 1978, pp. 197–313

Tanturli, Giuliano, "Rapporti del Brunelleschi con gli Ambienti Letterari Fiorentini," in *Filippo Brunelleschi: La sua opera e il suo tempo*, vol. I, Florence, 1980, pp. 125–44

Tedeschi, Emma, *Alcune notizie fiorentine tratte dall'archivio Gonzaga di Mantova*, Badia Polesine, 1925 *Le tems revient: 'L tempo si rinuova: Feste e spettacoli nella Firenze di Lorenzo il Magnifico*, ed. Paola Ventrone, Exhibition Catalogue, Palazzo Medici Riccardi, Florence, Milan, 1992

Thiis, Jens, *Leonardo da Vinci: The Florentine Years of Leonardo & Verrocchio*, London, n.d. [1913]

Thomas, Anabel, *The Painter's Practice in Renaissance Tuscany*, Cambridge, 1995

Tongiorgi Tomasi, Lucia, "Toward the Scientific Naturalism: Aspects of Botanical and Zoological Iconography in Manuscripts and Printed Books in the Second Half of XV Century," in *Die Kunst und das Studium der Natur vom 14. zum 16. Jahrhunderts*, ed. Wolfram Prinz and Andreas Beyer, Weinheim, 1987, pp. 91–101

Turner, A. Richard, *The Vision of Landscape in Renaissance Italy*, Princeton, 1966

Turner, A. Richard, "Words and Pictures: The Birth and Death of Leonardo's Medusa," in *Arte lombarda*, vol. LXVI, 1983, pp. 103–11

Turner, A. Richard, "The Linear and the Sculptural Traditions in the 1470s: Botticelli and Leonardo," in Glenn Andres, John M. Hunisak, and Turner, *The Art of Florence*, New York, 1988, pp. 801–43

Turner, A. Richard, *Inventing Leonardo*, New York, 1993

Gli Uffizi: Catalogo generale, ed. Luciano Berti, Florence, 1979

Ulmann, Hermann, *Sandro Botticelli*, Munich, n.d. [1893]

Upton, Joel M., *Petrus Christus: His Place in Fifteenth-Century Flemish Painting*, London, 1990

Uzielli, Gustavo, *Ricerche intorno a Leonardo da Vinci*, Rome, 1884

Valentiner, William R., "Leonardo as Verrocchio's Coworker," in *Art Bulletin*, vol. XII, no. 1, March 1930, pp. 43–89; reprinted with revisions as "On Leonardo's Relation to Verrocchio. Part Two," in his *Studies of Italian Renaissance Sculpture*, London, 1950, pp. 134–77

Valentiner, William R., "Leonardo and Desiderio," in *Burlington Magazine* vol. LXI, no. 353, 1932, pp. 53–61

Valentiner, William R., "Über Zwei Kompositionen Leonardos," in *Jahrbuch der preuszischen Kunstsammlungen*, vol. LVI, 1935, pp. 213–30

Valentiner, William R., "Verrocchio or Leonardo," in *Bulletin of the Detroit Institute of Arts*, vol. XVI, no. 4, 1936–37, pp. 50–59

Valentiner, William R., "On Leonardo's Relation to Verrocchio," in *Art Quarterly*, vol. IV, no. 1, 1941, pp. 3–31; reprinted with revisions as "On Leonardo's Relation to Verrocchio. Part One," in his *Studies of Italian Renaissance Sculpture*, London, 1950, pp. 113–33

Valentiner, William R., "Outlines of the Exhibition," and "Leonardo's Early Life," in *Leonardo da Vinci Loan Exhibition 1452–1519*, Exhibition Catalogue, Los Angeles County Museum, Los Angeles, 1949, pp. 11–27 and 43–61

Valentiner, William R., "Two Terracotta Reliefs by Leonardo," in his *Studies of Italian Renaissance Sculpture*, London, 1950, pp. 178–92

Valentiner, William R., "A Newly Discovered Leonardo," in *Art Quarterly*, vol. XX, no. 3, 1957, pp. 234–43

Valentiner, William R., *Foreign Catalogue*, Walker Art Gallery, Liverpool, 1977

Van Marle, Raimond, *The Development of the Italian Schools of Painting* 19 vols., The Hague, 1923–38

Vasari, Giorgio, *Vite*, ed. Giovanni Bottari, 3 vols., Rome, 1759–60

Vasari, Giorgio, *Vite*, ed. Guglielmo Della Valle, 11 vols., Siena, 1791–94

Vasari, Giorgio, *Leben der ausgezeichnetsten Maler, Bildhauer und Baumeister*, ed. Ludwig Schorn, 6 vols., Stuttgart and Tübingen, 1832–49

Vasari, Giorgio, *Lives of the Most Eminent Painters, Sculptors and Architects*, trans. Mrs. Jonathan Foster, 5 vols., London, 1852–59

Vasari, Giorgio, *Le vite de' più eccellenti pittori, scultori ed architettori*, ed. Gaetano Milanesi, 9 vols., Florence, 1878–85

Vasari, Giorgio, *Lives*, trans. A. B. Hinds, 4 vols., London, 1927

Vayer, Lajos, "Il Vasari e l'arte del Rinascimento in Ungheria," in *Il Vasari storiografo e artista*, Acts of the Conference, Arezzo and Florence, 1974, Florence, 1976, pp. 501–32

Veltman, Kim H. in collaboration with Kenneth D. Keele, *Linear Perspective and the Visual Dimensions of Science and Art*, Munich, 1986

Ventura, Angelo, and Mauro Pecoraro, "Bembo, Bernardo," in *Dizionario biografico degli italiani*, Rome, 1960–98, vol. VIII, 1966, pp. 103–09

Venturi, Adolfo, *Storia dell'arte italiana*, 11 vols., Milan, 1901–40

Venturi, Adolfo, *Leonardo da Vinci pittore*, Bologna, 1920

Venturi, Adolfo, "Leonardiana," in *L'arte*, vol. XXVIII, nos. 4–5, 1925, pp. 137–52

Venturi, Adolfo, *Studi dal vero attraverso le raccolte artistiche d'Europa*, Milan, 1927

Venturi, Adolfo, *I Disegni di Leonardo da Vinci*, 7 vols., Rome, 1928–52

Venturi, Adolfo, "Leonardo scultore nella bottega del Verrocchio," in *Nuova antologia*, vol. LXIX, March 1934, pp. 34–39

Venturi, Adolfo, *Leonardo e la sua scuola*, Novara, 1941

Venturi, Lionello, *Italian Paintings in America*, 2 vols., New York, 1933

Venturini, Lisa, "Modelli fortunati e produzione di serie," in *Maestri e botteghe: Pittura a Firenze alla fine del Quattrocento*, ed. Mina Gregori, Antonio Paolucci, and Cristina Acidini Luchinat, Exhibition Catalogue, Palazzo Strozzi, Florence, 1992–93, Milan, 1992, pp. 147–57

Venturini, Lisa, *Francesco Botticini*, Florence, 1994

Verdon, Timothy, "Pictorialism in the Sculpture of Verrocchio," in *Verrocchio and Late Quattrocento Italian Sculpture*, ed. Steven Bule, Alan Phipps Darr, and Fiorella Superbi Gioffredi, Florence, 1992, pp. 25–31

Verga, Ettore, *Bibliografia vinciana*, 2 vols., Bologna, 1931

Vertova, Luisa, *Maestri toscani del Quattro e del primo Cinquecento*, Biblioteca di Disegni XIX, Florence, 1981

Verzeichnis der Schriften von Wilhelm von Bode, ed. Ignaz Beth, Berlin and Leipzig, 1915

Vezzosi, Alessandro, *Toscana di Leonardo*, Florence, 1984

Vezzosi, Alessandro, *Leonardo da Vinci: Arte e scienza dell'universo*, Milan, 1996

Viatte, Françoise, "Verrocchio et Leonardo da Vinci: A propos des 'Têtes ideales'," in *Florentine Drawing at the Time of Lorenzo the Magnificent*, ed. Elizabeth Cropper, Bologna, 1994, pp. 45–53

Viroli, Giordano, *La Pinacoteca Civica di Forlì*, Forlì, 1980

Viviani della Robbia, Enrica, "Ginevra de' Benci nel 'Tagebuch' del Poliziano e nella realtà," in *Il Poliziano e il suo tempo*, Atti del IV Convegno Internazionale di Studi sul Rinascimento, Florence, 1954, p. 22

Voigtländer, Emmy, "Versuch über ein Leonardoproblem," in *Monatshefte für Kunstwissenschaft*, vol. XII, 1919, pp. 324–39

Waagen, Gustav Friedrich, *Treasures of Art in Great Britain*, 3 vols., London, 1854

Waagen, Gustav Friedrich, *Leonardo da Vinci*, Berlin, n.d. [1861]; the essay "Über das Leben und die Werk des Leonerdo da. Vinci" reprinted in his *Kleine Schrifren*, stuttgart, 1875, pp. 145–83

Waagen, Gustav Friedrich, *Die vornehmsten Kunstdenkmäler in Wien*, Vienna, 1866

Wackernagel, Martin, *The World of the Florentine Renaissance Artist: Projects and Patrons, Workshop and Art Market* (orig. ed. 1938), trans. Alison Luchs, Princeton, 1981

Wałek, Janusz, *Portrety Kobiece Leonarda da Vinci/Female Portraits by Leonardo da Vinci*, Kraków, 1994

Walker, John, "*Ginevra de' Benci* by Leonardo da Vinci," in *Report and Studies in the History of Art*, National Gallery of Art, Washington, 1967, pp. 1–38

Wallace, William E., "Verrocchio's *Giudizio dell'occhio*," in *Source: Notes in the History of Art*, vol. XIV, no. 2, 1995, pp. 7–10

Warburg, Aby, "Arte fiamminga e Primo Rinascimento fiorentino," in his *La Rinascita del Paganesimo Antico*, ed. Gertrud Bing and trans. Emma Cantimori, Florence, 1966, pp. 147–70 (orig. German ed., Leipzig, 1902)

Wasserman, Jack, review of Clark, *Drawings*, 1968, in *Burlington Magazine*, vol. CXVI, no. 851, 1974, pp. 111–13

Wasserman, Jack, *Leonardo da Vinci*, New York, 1975

Wasserman, Jack, "The Monster Leonardo Painted for his Father," in *Art Studies for an Editor: 25 Essays in Memory of Milton S. Fox*, New York, 1975, pp. 261–65

Weber, Gregor J. M., "Ein Gemälde Leonardos für Dresden? Der Ankauf eines Madonnenbildes von Lorenzo di Credi im Jahr 1860," in *Dresdener Kunstblätter*, vol. VI, 1995, pp. 166–72

Weigelt, Hilda, "The Minor Fountains of Florence," in *International Studio*, vol. XCIV, no. 391, 1929, pp. 87–90, 122

Weil-Garris Posner, Kathleen, *Leonardo and Central Italian Art 1515–1550*, New York, 1974

Wengraf, Alex, "A 'Virgin and Child' from the Circle of Verrocchio," in *Burlington Magazine*, vol. CXXVI, no. 971, 1984, pp. 91–92

Whitaker, Lucy, "Maso Finiguerra, Baccio Baldini and *The Florentine Picture Chronicle*," in *Florentine Drawing at the Time of Lorenzo the Magnificent*, ed. Elizabeth Cropper, Bologna, 1994, pp. 181–96

White, John, "Paragone: Aspects of the Relationship between Painting and Sculpture," in his *Studies in Renaissance Art*, London, 1983, pp. 1–67

Wickhoff, Franz, "Über einige italienische Zeichnungen im British Museum," in *Jahrbuch der preussischen Kunstsammlungen*, vol. XX, 1899, pp. 202–15

Wiemers, Michael, *Bildform und Werkgenese: Studien zur zeichnerischen Bildvorbereitung in der italienischen Malerei zwischen 1450 und 1490*, Berlin, 1996

Wilder, Elizabeth, Clarence Kennedy, and Peleo Bacci, *The Unfinished Monument by Andrea del Verrocchio to the Cardinal Niccolò Forteguerri at Pistoia*, Northampton, Mass., 1932

Wilder, Elizabeth, review of R. Langton Douglas, "Leonardo da Vinci: His 'San Donato of Arezzo and the Tax Collector,'" in *Art Bulletin*, vol. XVI, no. 2, 1934, pp. 223–224

Wiles, Bertha Harris, *The Fountains of Florentine Sculptors and their Followers from Donatello to Bernini*, Cambridge, Mass., 1933

Windt, Franziska, "Verrocchios 'Enthauptung des Johannes'," in *Mitteilungen des Kunsthistorischen Institutes in Florenz*, vol. XXXVII, no. 1, 1993, pp. 130–39

Wittkower, Rudolf, "Desiderio da Settignano's *St. Jerome in the Desert*," in *Studies in the History of Art*, National Gallery of Art, Washington, 1972, pp. 18–34; reprinted in his *Idea and Image: Studies in the Italian Renaissance*, London, 1978, pp. 137–50

Wittkower, Rudolf and Margot, *Born under Saturn*, London, 1963

Woermann, Karl, *Geschichte der Kunst aller Zeiten und Völker*, 3 vols., Leipzig and Vienna, 1900–11

Wohl, Hellmut, *Leonardo da Vinci*, New York, 1967

Wohl, Hellmut, *The Paintings of Domenico Veneziano*, New York and London, 1980

Wood, Jeryldene Marie, "The Early Paintings of Perugino," Ph.D. Thesis, University of Virginia, 1985

Wright, Alison, "Piero de' Medici and the Pollaiuolo," in *Piero de' Medici "il Gottoso" (1416–1469)*, ed. Andreas Beyer and Bruce Boucher, Berlin, 1993, pp. 129–49

Yashiro, Yukio, *Sandro Botticelli and the Florentine Renaissance*, London and Boston, 1929

Zampetti, Pietro, "Ancora un Verrocchio," in *Emporium*, vol. LVII, no. 4, 1951, pp. 154–62

Zentai, Roland, "Un livre de patrons d'animaux florentin au Musée des Beaux-Arts," in *Bulletin du Musée Hongrois des Beaux-Arts*, no. 40, 1973, pp. 25–39

Zeri, Federico, "Il Maestro dell'Annunciazione Gardner," in *Bollettino d'arte*, 1953, vol. XXXVIII, no. 2, pp. 125–39, no. 3, pp. 233–49

Zeri, Federico, with the assistance of Elizabeth E. Gardner, *Italian Paintings: A Catalogue of the Collection of the Metropolitan Museum of Art. Florentine School*, New York, 1971

Zeri, Federico, *Italian Paintings in the Walters Art Gallery*, 2 vols., Baltimore, 1976

Index

238

Photograph Credits

In many cases illustrations have been made from photographs and transparencies provided by the owners or custodians of the works. Those figures for which further credit is due are listed below:

Antonio Quattrone: frontispiece, 62–64, 77, 79, 80 83a–c; Alinari: 4, 5, 7, 15, 17, 25, 156, 158, 162; Scala: 2, 3, 8, 87, 113, 124, 139 140–42, 144, 149, 155; Antonio Quattrone, courtesy of Alfio Del Serra and with the permission of the Galleria degli Uffizi: 18, 20, 22, 40, 111, 128, 130, 132–35, 137, 138; Niccolò Orsi Battaglini: 19, 21, 23, 68, 71–73, 86; Christie's, London: 27; © Photo RMN, Paris: 28, 66, 67, 104, 120, 146, 147; Jörg P. Anders, Berlin: 12, 13, 29, 30, 97; Photo Tosi, Florence: 48–51, 53–58; The Royal Collection © Her Majesty Queen Elizabeth II: 52, 76, 78, 93, 99, 145; Courtesy Amilcare Pizzi, S.p.A., Cinisello Balsamo: 65; Courtesy Martin Kemp: 69; Editech, S.r.l., Florence: 74, 75, 81, 82, 129, 131; Elke Walford, Hamburg: 84; Hirmer, Munich; 96; Courtesy the National Gallery, London: 161.